WITHDRAWN

THE BUILDINGS OF WALES
FOUNDING EDITOR: NIKOLAUS PEVSNER

PEMBROKESHIRE

THOMAS LLOYD, JULIAN ORBACH
AND ROBERT SCOURFIELD

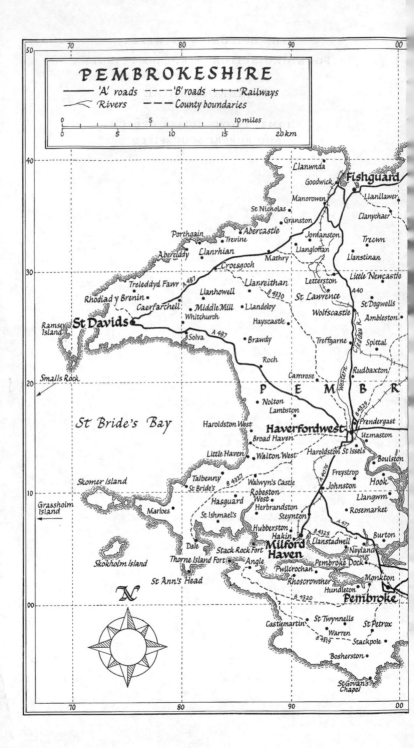

PEMBROKESHIRE

——— 'A' roads – – – – 'B' roads +—+—+ Railways
~~~ Rivers  — — — County boundaries

0 _____ 5 _____ 10 miles
0 __ 5 __ 10 __ 15 __ 20 km

Llanwnda
Goodwick
**Fishguard**
Manorowen
Llanllawer
St Nicholas
Granston
Clanychaer
Porthgain
Trevine
Abercastle
Jordanston
Trecwn
Abereiddy
Llanrhian
Llangloffan
Llanstinan
Croesgoch
Mathry
Treleddyd Fawr
*A 487*
Llanreithan
*B 4330*
Letterston
Little Newcastle
*A 40*
Rhodiad y Brenin
Llanhowell
St Lawrence
St Dogwells
Caerfarchell
Middle Mill
Llandeloy
Wolfscastle
Ambleston
**St Davids**
Whitchurch
Hayscastle
Ramsey
Island
Solva
*A 487*
Brawdy
Treffgarne
Spittal

Smalls Rock
Roch
Camrose
Rudbaxton
P   E   M   B   R
Nolton
Lambston
*A 4329*
Prendergast
St Bride's Bay
Haroldston West
**Haverfordwest**
Uzmaston
Broad Haven
Haroldston St Issels
Boulston
Little Haven
Walton West
*A 4076*
Freystrop
Hook
Skomer Island
Talbenny
St Bride's
*B 4327*
Walwyn's Castle
Johnston
Llangwm
Grassholm
Island
Marloes
Hasguard
Robeston
West
Rosemarket
St Ishmael's
Herbrandston
Steynton
*A 477*
Burton
Hubberston
Hakin
*B 4325*
Clanstadwell
Dale
Stack Rock Fort
**Milford
Haven**
Neyland
Skokholm Island
Thorne Island Fort
Angle
Pembroke Dock
Pwllcrochan
St Ann's Head
Rhoscrowther
Monkton
Hundleton
**Pembroke**
*B 4320*
St Twynnells
St Petrox
Castlemartin
Warren
*B 4319*
Stackpole
Bosherston
St Govan's
Chapel

50   70   80   90   00
40
30
20
10
00

Western Cleddau R.
Eastern Cleddau R.

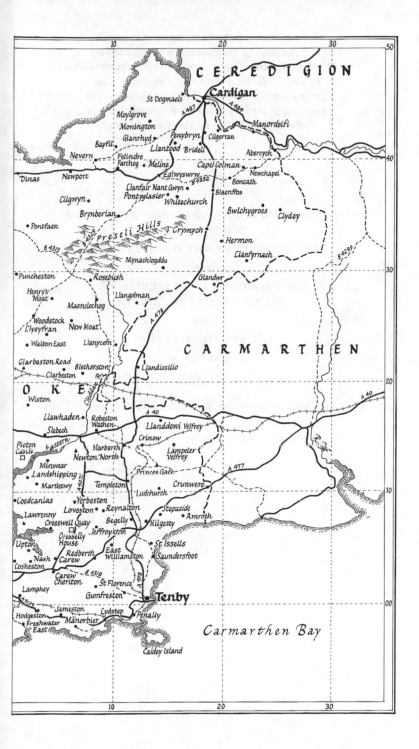

The preparation of this book has been greatly helped
by grants from

THE TRUSTEES OF THE DAVIS CHARITY

from

THE BOARD OF CELTIC STUDIES OF
THE UNIVERSITY OF WALES

from

THE BRITISH ACADEMY

and from

CADW: WELSH HISTORIC MONUMENTS

Assistance with photographs has been generously provided by

THE ROYAL COMMISSION ON THE ANCIENT
AND HISTORICAL MONUMENTS OF WALES

# Pembrokeshire

BY

## THOMAS LLOYD,

## JULIAN ORBACH

AND

## ROBERT SCOURFIELD

WITH CONTRIBUTIONS BY

## STEPHEN HUGHES,

## JOHN KENYON,

## ROGER STALLEY

AND

## ANTHONY WARD

THE BUILDINGS OF WALES

YALE UNIVERSITY PRESS
NEW HAVEN AND LONDON

YALE UNIVERSITY PRESS
NEW HAVEN AND LONDON
302 Temple Street, New Haven CT 06511
47 Bedford Square, London WC1B 3DP
www.yale.edu/yup
www.yaleup.co.uk
www.pevsner.co.uk
www.lookingatbuildings.org

Published by Yale University Press 2004
2 4 6 8 10 9 7 5 3 1

ISBN 0 300 10178 3

Copyright © Thomas Lloyd, Julian Orbach
and Robert Scourfield, 2004

Printed in China
through World Print
Set in Monotype Plantin

# CONTENTS

# LIST OF TEXT FIGURES AND MAPS

Every effort has been made to contact or trace all copyright holders. The publishers will be glad to make good any errors or omissions brought to our attention in future editions.

# PHOTOGRAPHIC ACKNOWLEDGEMENTS

A special debt is owed to Royal Commission photographer Iain Wright for taking most of the photographs for this volume. Photographs are reproduced by kind permission of the Royal Commission for the Ancient and Historic Monuments of Wales (© R.C.A.H.M.W., Crown Copyright), with the exception of the following:

Cadw Welsh Historic Monuments, Crown Copyright: 2, 10, 13, 14, 15, 16, 17, 19, 21, 23, 24, 27, 32, 38, 39, 42, 43, 54, 60, 77
Martin Charles: front jacket
Christopher Dalton: 69
Anthony Kersting: 3, 22, 72
Eddie Ryle-Hodges: 63, 67, 80, 81, 87, 105, 119, 120, 121
Robert Scourfield: 6, 7, 8, 9, 90, 91, 94, 95, 96, 113, 114, 117
Mick Sharp Photography: 49, 86, 126

# MAP REFERENCES

The numbers printed in italic type in the margin against the place names in the gazetteer of the book indicate the position of the place in question on the index map (pp. 2–3), which is divided into sections by the 10-kilometre reference lines of the National Grid. The reference given here omits two initial letters (formerly numbers) which in a full grid reference refer to the 100-kilometre squares into which the county is divided. The first two numbers indicate the *western* boundary, and the last two the *southern* boundary, of the 10-kilometre square in which the place in question is situated. For example, Abercych (reference 2540) will be found in the 10-kilometre square bounded by grid lines 20 (on the *west*) and 30, and 40 (on the *south*) and 50; Woodstock (refence 0225) in the square bounded by the grid lines 00 (on the *west*) and 10, and 20 (on the *south*) and 30.

The map contains all those places, whether towns, villages, or isolated buildings, which are the subject of separate entries in the text.

# ACKNOWLEDGEMENTS

The fourth volume of the *Buildings of Wales* series has been several years in preparation, compiled in conjunction with the forth-coming *Carmarthenshire and Ceredigion* – a vast undertaking, covering over a quarter of the land mass of Wales, where even in the cases of some major castles, we were starting from scratch. This is also the first Welsh volume to be published by Yale University Press, the transition from Penguin seamlessly overseen by Bridget Cherry, editor, cheerleader and cajoler whose long-standing experience in the Buildings of England office has been essential to the end product.

Particular thanks are due to many owners and occupiers of houses, who generously allowed us to view their homes and gave us invaluable information. In no case was access refused. It should however be firmly stated that mention of a building in the text, or reference to internal features, does not in any way imply that it is open to the public. We are also grateful to incumbents, ministers, secretaries and churchwardens for help with churches and chapels.

We are grateful to the many specialist authors who have made important contributions. In the introductory section, Prehistoric and Roman Pembrokeshire is by Anthony Ward, Castles by John Kenyon, and Industrial Structures by Stephen Hughes together with Julian Orbach. Military Buildings are by Roger Thomas and Robert Scourfield. Roger Stalley contributed the major gazetteer section on St Davids Cathedral, providing important new insight into this remarkable and complex structure.

The initial campaign of documentary research was undertaken with great enterprise and resourcefulness largely by Thomas Lloyd with help from his late wife, Juliet, who scoured a remarkable range of published and unpublished material, most notably family papers and the hitherto completely unexplored west Wales newspaper archives. In London, the Incorporated Church Building Society Papers at Lambeth Palace, many still untouched since the files were closed over 150 years ago, shed remarkable light on completely forgotten projects of the early nineteenth century, while the volumes of *The Builder* and rival journals of the Royal Institute of British Architects provided a mass of material for the later period. Assistance with some research in London was very helpfully supplied by Abigail Hart and James Nall-Cain, while locally, Edna Dale-Jones scoured some invaluable archives. All this work has informed the present volume in great depth throughout and rescued from oblivion several local architects of

the Regency period who had entirely dropped out of view. Further discoveries were regularly made by Julian Orbach while engaged in statutory listing, while Robert Scourfield, initially based in London, was able to consult libraries and archives there, before also returning to Wales to work on the listing programme.

The path was smoothed by local experts including Wyn Jones (Haverfordwest), Dillwyn Miles (Newport), Simon Hancock (Neyland), Mike Candler (Carew Castle), Neil Ludlow (Pembroke Castle), George Cavill (early Christianity in the Tenby area) and Very Rev. Wyn Evans (St Davids Cathedral). All helped us to see and understand what would have otherwise been overlooked.

Both relevant local authorities, Pembrokeshire County Council and, most notably, the committee and chief executive, Nic Wheeler, of the Pembrokeshire Coast National Park Authority, have given invaluable practical support.

Thanks are due to Heather and Terry James and Louise Austin of Cambria Archaeology for expert information on archaeological matters. The staff of the Royal Commission on the Ancient and Historic Monuments of Wales patiently endured many visits, while their photographers went to endless and patient trouble to provide photographs that were wanted. Almost every single member of staff there at some point was prevailed upon for some piece of assistance and their help is gratefully acknowledged, particularly Peter White, secretary to the Commission, for his goodwill towards the project and Hilary Malaws for overseeing endless calls on the archive of the National Monuments Record.

As ever, the staff of the National Library of Wales were helpful and efficient. Locally, the archivists at the County Records Office in Haverfordwest and Carmarthen gave us much time and help in accessing their archives. In London, the help of the staff at the Society of Antiquaries and Lambeth Palace Library is also gratefully acknowledged; as too the National Trust in relation to Stackpole Court and its landscape, the importance of which is gradually unfolding. The staff at the historic buildings section of Cadw have provided listed buildings descriptions and other information whenever requested and particular thanks in this respect are offered to David McLees, Judith Allfrey, Bill Reid and Peter Wakelin. Persons whom we wish to thank for special expert knowledge are as follows: Roger Thomas (Fortifications), Mike Garner (Picton Castle), Arabella Friesen (Stackpole Estate), Adrian Miller (Pembroke Dock), Brother Gildas (Caldey Island), Sal Gaarfi (Tenby Town Walls) Brian John, (geology) Robert Protheroe Jones, Peter Wakelin and Peter Claughton (industrial sites), Phil Thomas (buildings of John Coates Carter), Chris Day (buildings of Chris Day), Martin Harrison (stained glass), Jonathan Foyle (medieval churches), Rev. Martin Connop Price (railways and mining) and Col. Michael Portman and his successor Lt.-Col. Johnny Rogers (Castlemartin Range).

Others whose advice or information we wish to acknowledge are Peter Holden, Roger Clive-Powell, Roscoe Howells, Gerald Oliver and Stan Speight.

As always with a volume in this series, Peter Howell has been an unstinting provider of knowledge and comment on Victorian buildings, pointing out the regional or national importance of certain architects' works. Many others have answered particular queries or provided information about buildings in their care.

As for the photographs and illustrations, the first resource to examine was naturally the splendid collection at the National Monument Record at the Royal Commission on the Ancient and Historical Monuments of Wales, at Aberystwyth. Where new or different views were needed, their photographers went to great trouble to achieve the desired result. At a late stage they were extremely accommodating in answering Yale's request for additional colour photography. Other photography is the work of Eddie Ryle Hodges. Street plans and text figures were drawn by Alan Fagan, the county map by Reg Piggott. The collecting of illustrations was organized by Alison McKittrick; the later stages masterminded by Emily Rawlinson.

In spite of all this help, many gaps and mistakes will surely remain and judgements will not necessarily be agreed with now or as time passes. It has been a first attempt for many buildings never noticed before. Corrections and supplementary information will be welcomed by the authors and the publisher and will be incorporated in a subsequent reprint or edition. In particular we hope that several important buildings noted as being in disrepair and at risk, are soon mended.

Last, but not least, we are grateful to both Ruth Cook and Emily Jenkins, whose expertise with typing and orderly minds proved invaluable. To Caroline Palmer and Veronica Smith, for copy-editing, and to Sally Salvesen and Emily Winter at Yale, who oversaw the final stages of production.

# INTRODUCTION

## LANDSCAPE

Pembrokeshire at the south west corner of Wales is a relatively small county, but with a richly varied landscape, bounded on three sides by the sea. Along the coast path can be seen an unfolding variety of rocks and rock formations, in an exceptional range of colours from the grey of limestone, to the reds and purples of sandstones, to the black of mudstones. Nowhere in the county is more than ten miles from sea or estuary. The importance of the sea can be gathered from the multitude of small landing places in harbours or creeks, whilst the coastal graveyards bear testimony to seafaring as a way of life.

The boundaries of the county are still those established in the C16 apart from small variations. From 1974 to 1995 Pembrokeshire was part of Dyfed county with Carmarthenshire and Cardiganshire (now Ceredigion), and divided into two district council areas. Dyfed was dismantled and the Pembrokeshire boundaries restored in 1995. Since 1952 the Pembrokeshire Coast National Park has covered the whole of the coastline, the upper reaches of the Cleddau estuaries and the Preseli hills.

The landscape is one of rolling farmland bounded on the north by the bare rounded hills with craggy outcrops running from Frenni Fawr at the east end of the Preseli hills, by Crymych, to St Davids and Ramsey Island. The highest point, Foel Cwmcerwyn, Rosebush, rises only to 1,760 ft (536 metres), but the outline of mountains defines the long views across the whole county, whether the mass of the main Preseli range east of Fishguard, or the individual outcrops to the west, Garn Fawr by Strumble Head or Penberi and Carn Llidi behind St Davids. The hill landscape is of small fields and large areas of bracken, gorse and heather broken by outcrops of rock. The two towns of the north are coastal, Fishguard on an outcrop between two harbours, the old one at the mouth of the Gwaun, the new one at the head of a marshy valley, and Newport, against the base of Carn Ingli, the most dramatic of the Preseli outcrops. St Davids, though, lies concealed for protection, just inland, in the valley of the Alun. Rivers in the north are relatively short but dramatic; the Gwaun valley separating Carn Ingli from the main Preseli hills is the most spectacular, but also striking are the steeply-wooded Nevern valley down to Newport, and the ravine and estuary at Solva. Coastal winds have created the notably treeless undulating

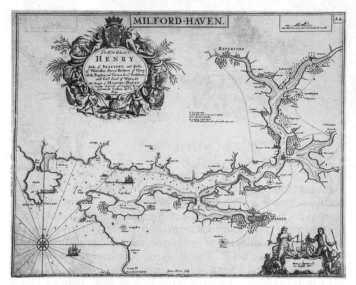

Milford Haven estuary. Map C17

landscape west of Fishguard, sectioned by earth-and-stone field boundaries.

South of the hills, the two Cleddaus form the landscape, uniting in the great fjord-like ria of Milford Haven. The rivers drain the south slopes of the hills, the eastern Cleddau following a wooded course from near Crymych, and the western Cleddau running south from behind Fishguard through the boulder-capped Treffgarne Gorge to Haverfordwest. The good farmland of the south of the county feels to the visitor more anglicized due to Norman settlement from the C12 and English and Flemish immigration thereafter. The place names, linear-planted villages like Wiston and tracts of strip-field systems, notably around Manorbier and Angle, testify to a history different from the north of the county. Nucleated villages in the south tend to be medieval in origin whereas in the north they are of C19 date, with exceptions such as Mathry, Trevine and Cilgerran. Towered churches and castles are a feature of the landscape of the south, isolated church sites and scattered farms typical of the north.

The pattern of settlement is denser in the south with more urban centres: Haverfordwest, the county town, at the highest navigable point of the western Cleddau, Tenby, a rich medieval trading port, Pembroke, the medieval power base of the region and Narberth, market town for the eastern part of the county. The C19 maritime development of the Milford Haven waterway gave the county three new towns, Milford founded in 1797, Pembroke Dock in 1812 and Neyland in 1855, each of which looked likely to overshadow the older towns, but the maritime

decline of the c20 has left Haverfordwest pre-eminent as the
county town at the centre of the county.

The impact of c20 development has been variable: the oil
industry of the Haven from the 1950s changed the landscape with
its smoke stacks. The 700 ft (210 metre) chimney of the Pem-
broke power station was the highest point south of the Preselis,
but chimney and most of the refineries have gone. The post war
military installations have largely gone, leaving the housing
estates prominent after the main structures are cleared. Holiday
sprawl affects particularly the hinterland of Tenby and Saunder-
sfoot, kept at bay to some extent by the National Park authority.
The agricultural landscape is dotted with the large barns of the
c20 and has fewer hedges than before, but the clearance is
minimal compared to English counties. Recognition of the value
of the Pembrokeshire landscapes has protected almost the whole
of the coast, Preselis and estuary within the National Park,
together with the offshore islands, mostly now nature reserves.

## BUILDING MATERIALS

The extraordinary geological variety of Pembrokeshire does not
translate into quantities of tractable building material, indeed the
county buildings are overwhelmingly rendered or roughcast, with
roofs of north Wales slate or more modern materials. The rough-
casts and renders are very ancient traditions, and indeed, histori-
cally exposed stone would have been a rarity. The walls of St
Davids Cathedral and the Bishop's Palace were rendered, and in
the case of the palace colourwashed. For centuries stonework
was roughcast with a lime-and-sand mix enriched with aggregate
or coal dust, and either left unpainted, limewashed white, or
tinted with a limited palette of earth colours, red to pink or ochre
yellow. The practice of limewashing straight on to building stones
seems to have been more common with outbuildings or the
poorest cottages, all this a function of the porosity of stone and
a damp climate. Beneath the claddings, however, are a great
variety of building stones.

In the north are areas with Precambrian, Cambrian and
Ordovician rocks: hard igneous rocks alternating with softer
slates and shales, of which very few can be worked or shaped.
The St Davids peninsula is crossed by a major anticline which
brought Precambrian volcanics and Cambrian conglomerates,
shales and sandstones to the surface. Of these only the sand-
stones, notably the purple Caerbwdy stone used in the cathedral    9
and Bishop's Palace, are adequate for carving, but prone to
spalling and lamination. The tapestry-like walling of the cathe-
dral includes the purple cut stone, purple rubble, an attractive
pale green stone found in the same areas as the purple, a deep
red sandstone, and brown mudstones. These sandstones, tuffs
and mudstones were the building rubble of the region, and being

porous, were always rough rendered or limewashed, until the
C20. In the C19 well-cut Caerbwdy stone appears on a few houses
in St Davids, a form of display related perhaps to the reopening
of the quarries for the cathedral restorations.

Also in St Davids can be seen the hard volcanic Precambrian
rocks that are found from here eastwards to the Preselis. These
were too hard for working before the C19, and generally used only
for field boundaries, but with better tools and quarrying these
stones could be squared and used. Predominant is the dark-green
6 to blue-grey dolerite, the 'bluestone' of Stonehenge, which in
boulder form has a buff outer skin, seen in C19 houses and
churches from St Davids to Newport, best perhaps in Newport.
An unusual localized building stone is Middle Mill 'granite', a
paler green igneous rock used in the C19, notably on Solva
church. Granite setts for paving were produced at Porthgain in
the later C19.

Ordovician shales were pushed up all around the older igneous
rocks, and thus slate and a slaty mudstone are to be found along
the north coast, from Abereiddy to St Dogmaels, up the Teifi
valley to Cilgerran, and along the eastern boundary of the county,
Rosebush, Glogue, Llanfyrnach and the Taf valley, with isolated
slate quarries south of the Preselis at Sealyham, St Dogwells, and
Puncheston. The coastal quarries were worked from medieval
times; George Owen mentions quarries near Newport in 1600,
and Fishguard exported slates to Ireland in the early C17. The
quality varied considerably: at its lowest, the dark mudstones of
coastal quarries provided a friable roofing slate that gave rise to
the tradition of mortaring or grouting roofs in the north west.
The grey rubble is the typical material for cottages and houses
7 of the area, but from the better quarries around Cilgerran came
a grey stone that could be squared, and is extensively used in
Cardigan, notably on the Guildhall, of 1858, but also on the late
C15 chancel there. From Cilgerran came also a fine-grained pol-
ished slate which could be used for moulded work, as on some
window mullions at Cilgerran church, local gatepiers, and even,
uniquely, for railings at the Cilwendeg pigeon house, Capel
Colman. Most of the dark slate sills, and slabs for dairies and
flooring, came from the northern sites. South east of the Preselis,
from Llangolman along the Taf valley, was a seam of Lakeland
green slate, of volcanic ash origin, exploited from the 1860s, but
mostly from 1896 by the *Whitland Abbey Slate Co*. Their slates
were admired and used in the earlier C20 by *Sir Reginald Blom-
field* and Sir Giles Gilbert Scott among others, and are an out-
standing feature of the Carmarthen County Hall, by Percy
Thomas, of 1939–55. Production on a fairly large scale contin-
ued into the C20, competing with the north Wales quarries, but
8 ultimately unsuccessfully. Slates were extensively used for
hanging on exposed walls to keep out moisture, bedded in
mortar, and sometimes also whitewashed.

In the south of the county the stones are generally sedimen-
tary rocks, Carboniferous deposits and Old Red Sandstone.
The coal measure crosses the county from Carmarthen Bay to

St Brides Bay, the end evidenced by the clifftop colliery at Trefran, between Nolton and Roch. A band of Silurian Old Red Sandstone occurs between areas where Carboniferous limestone overlies millstone grit. These stones are not of sufficient quality for carved work, and are very friable in exterior use, so usually rendered or whitewashed. A hard dull-brown millstone grit accompanies the coal measures, in the Saundersfoot, Hook and Jeffreyston areas, giving a rubble building stone, not workable to anything more ornate.

Much the best stone of the county, prized from medieval times, was the hard grey limestone that extends in a belt from Carmarthenshire through south Pembrokeshire, extensively quarried, and the quarry zones distinguished by numerous inland limekilns. Used since medieval times, for example in the town walls of Tenby and Pembroke, and at Pembroke and Carew castles, it was used in the C19 as a tooled squared masonry block in the officers' houses at Pembroke Dockyard, and in all the massive forts of the 1850s and 1860s, along Milford Haven. A 109 favourite Victorian contrast puts the rock-faced grey limestone against a yellow Bath stone ashlar, as at Bethesda Chapel, 117 Haverfordwest, 1878.

Imported stones for mouldings and dressings came in medieval times, generally the oolitic limestones of Bath and north Somerset. Dundry stone is used at the cathedral for dressings in the central and east parts, and possibly also for the C16 fan vault in Bishop Vaughan's chapel. The lovely C13 arcades of St 31 Mary, Haverfordwest, may be of Caen stone. Bath stone was used in the C16 for the great windows at Carew Castle. The fonts of 72 the county, from the C12, must have been mostly imported. Import of Bath stone for prestige projects continued through the centuries: the staircase at Ffynone, Newchapel, 1797, came from Bristol. The architect *Edward Haycock*, in the early C19, favoured a fine sandstone from Grinshill near Shrewsbury, which appears in the Doric loggia at Ffynone, Newchapel. Local importation by sea is not unknown – the façade of Ebeneser 96 Chapel, Newport, 1844, is of a rich sandstone that may come from New Quay, Cered., and grey sandstone sills for Georgian houses appear to have been imported from Carmarthenshire or Glamorgan. The railway era brought, as elsewhere, the Aberdeen granites for memorial fountains and columns; Cornish granite for the lighthouses, harbour kerbs and dressings on the fortifications; Devon and Irish marbles for church interiors; and Portland stone for commercial façades. Grey or greenish Forest of Dean stone, and grey to pink Pennant stone from Glamorgan were used from *c.* 1900. The preference for imports is well illustrated in the newspaper account of St Peter, Goodwick (1910), which says that it was built of rock-faced Irish Shamrock stone, with Box Ground (Bath) limestone dressings, Bangor green slates, and Corsham (Bath) stone interior detail, with Forest of Dean chancel floor, York stone tower stair, and Caen stone font.

BRICK is not a common material but has early origins, Fenton reported that his great-grandfather, *John Lewis* of Manorowen,

built a large brick building on the harbour at Fishguard to cure herrings in the mid-to-later C17. The large walled garden of the late C17 at Landshipping is made of brick, probably locally made. Brick was used on the Orielton estate (*see* Hundleton) from the earlier C18, there may be brick of the 1730s under the stucco of the present house, and the brick and Bath stone banqueting tower is a remarkable display for the period. Extensive brickworks were established at Cardigan in the 1860s, and bricks were made from about the same period at Porthgain. Goodwick brickmaking began in the early C20. Most brickwork visible in the county is late C19, and much, for example the yellow and hard-glazed red, is imported from Ruabon, Bristol or Ebbw Vale.

Building in CLAY, or CLOM as it is known locally, was relatively common in areas without good building stone, generally for the smallest cottages, and, more than in the adjacent counties, these buildings have disappeared from Pembrokeshire, as has the thatch that roofed them. THATCH has survived under corrugated iron to a limited extent. Alongside the more prevalent gorse underthatch, enough remains to show a local style of an underthatch of straw rope, looped from eaves to ridge and back. The beginnings of a revival of thatching may be seen with the restored cottages at Penrhos, Llangolman, and Tretio, St Davids.

Very little evidence remains of TIMBER FRAME construction, known to have been common from the late Middle Ages to the mid-C16, notably in Haverfordwest, where a very few much disguised timber frames survive. Substantial timber for roofs may not have been widely available, and the lack may account for the stone vaults of the south of the county, as well as being advanced to explain the lateral outshuts of the C16–C17 round-chimney houses of the north of the county, where the lean-to outshuts obviated the use of large roof beams. Ornate medieval timber roofs are confined to the greater churches, generally late medieval, with the Irish oak roof of the nave at St Davids being one of the outstanding pieces of Renaissance carpentry in Britain. Timber frame had a late C19 revival for economical buildings, notably on the railways, clad either in corrugated iron, commonly called zinc, or in boarding. Survivors include the zinc-clad former hotel at Rosebush (Tafarn Sinc), of 1877, and the delightful boarded engineer's office (Rosslyn) at Goodwick, *c.* 1899.

IRON is discussed with the industrial history. Its use as a building material includes the remarkable roofs of Nos. 1–3 The Terrace, Pembroke Dock (1817–18), hybrids of cast and wrought iron, and the other iron roofs of the naval dockyard buildings. Cast-iron columns and decorative panels for chapel galleries seem all to have been imported, with the Carmarthen and Cardigan foundries prominent, but it is likely that the Haverfordwest and Saundersfoot foundries also supplied such items. Corrugated iron was an economical cladding and roofing material, used in the later C19 and C20 for small houses, the more economical chapels, and mission churches and halls, such as the

Working Men's Club at Goodwick, *c.* 1900. The two most promi-
nent zinc-clad churches, at Abercych and Milford, have gone.
Zinc sheet remains in farms in the typical hoop-topped 'Dutch'
hay barns of the C20, and clads the last remaining unrestored
thatched roofs. Its most prominent C19 application, however, was
to clad the great ship-building sheds at Pembroke Dock, built
from 1844, the first of which was clad in 'No. 17 Birmingham
wire gauge' corrugated iron sheets.

ROOFING MATERIALS deserve a separate paragraph to draw
together the strands. Essentially the predominant material up to
the early C19 was thatch, mainly poor quality corn straw with
a certain amount of water reed in coastal zones; this thatch has
all but disappeared. Stone tiles were used for the most
prestigious medieval buildings, such as the Bishop's Palace, St
Davids, imported, one assumes, from Carmarthenshire or further
east, and slate was also in use from medieval times. The slate
was local to the county, and quarried in sufficient quantity to be
exported from Newport and Fishguard to Bristol and Ireland,
in the C16 and C17. It was not until the C19 that slate began to
oust thatch in the rural areas. George Owen, in 1603, had already
noticed that the quarry price of slates varied with the urban
demand, suggesting that the prime market lay in the towns. Owen
identifies the practice of cleaving very large slates for the bottom
courses of a roof, a practice found also in thatched roofs (copied
in the renewed roof at Tretio, St Davids). During the later C19,
slates from north Wales slowly ousted the local product, but it
was only in the late C20 that the majority of the roofs of the
local slate, graded in diminishing courses, were removed. In
windswept Dewisland, roofs of local slates were vulnerable to
gales, so the gaps were torched or filled with a lime cement,
gradually leading to the practice of rendering over of the whole
roof. These so-called 'grouted roofs' of pale grey cement are one
of the most distinctive features of the county. The very great
weight of cemented slates led to slippage of the entire roof, to
avoid which, strands of barbed wire were nailed from eave to eave
over the ridge and cemented over, giving the characteristic raised
bands.

The building materials of the C20 were largely imported,
cement-block walls rendered or roughcast, brick chimneys,
and imitation slates or concrete tiles to the roofs. Only slowly,
in the conservation of historic buildings, has a revival of the
use of traditional materials been seen, those materials either
recycled from old buildings or imported. The supply of local
stone has been small and comes from re-use, in the absence of
working quarries, so that stonework on modern buildings has
often been just a thin skin over cement blocks, the stones
not local even to the county. It is arguable that the local tradi-
tion of rendering buildings against the weather provides a much
more appropriate template for modern buildings than, for
example, the attempt to harmonize modern bricks with old in
brick-built regions. The bias towards traditional materials
within the National Park favours natural slate, encouraging

recycling at least of the north Wales slates, or the use of new
slates, those from Spain, Canada, India and China being much
cheaper than those from Wales. The local slate, more friable than
the north Wales variety, has rarely been re-used and survives in
too small quantities. The wholesale replacement of timber
windows with plastic-coated imitations is understandable in a
climate adverse to paints, but visually damaging. Within Conser-
vation Areas this process is resisted. Conservation takes its place
within the general building market, and in a relatively poor
county may wait long for local sources to emerge for traditional
materials, the local market not being strong enough, but it is an
advance on the later C20 that the question of local materials and
conservation of the built heritage is being addressed at all.

# PREHISTORIC AND ROMAN PEMBROKESHIRE

## BY ANTHONY WARD

The landmass which now constitutes Pembrokeshire was remote
from the principal concentrations of LOWER and MIDDLE
PALAEOLITHIC settlement in western Europe, which were con-
centrated to the east in major river valleys. The presence of
hominids predating *Homo sapiens sapiens* is currently attested only
by a single handaxe from near Narbeth. The lack of evidence is
also accounted for by subsequent glacial erosion and rises in sea
level.

The earliest activity attributable to *Homo sapiens sapiens* –
modern humans – has been found at Hoyle's Mouth cave, Tenby,
in the form of stone tools dating to the UPPER PALAEOLITHIC
around 28,000 B.C. Although the south west of Pembrokeshire
remained free of ice during the maximum encroachment of the
Devensian Glaciation, the area seems to have been abandoned
by human populations for perhaps as much as ten thousand years
from around 21,000 B.C. onwards. The reappearance of human-
kind is marked from around 10,500 B.C. by the presence of late
Upper Palaeolithic tool forms at caves such as Hoyle's Mouth,
Tenby, and Nanna's Cave on Caldey Island. Indications of activ-
ity deep within Hoyle's Mouth, well away from the natural light
provided by the entrance, suggest to some that the cave may have
been used for ritual purposes. However, no human remains of
this period have yet been recovered from southern Pem-
brokeshire, where the cave sites are concentrated, in contrast to
the Gower Peninsula just across Carmarthen Bay where the
famous and erroneously sexed ceremonial burial, the 'Red Lady
of Paviland', was discovered in the early C19. The activity from
this epoch in Pembrokeshire should be understood in the context
of a far wider region, much of it now inundated by the sea,
around which mobile groups travelled. They subsisted on larger
game animals and seasonal resources in environments ranging
through time from cold parkland to arctic or sub-arctic tundra.

The caves, which preserve evidence for their presence, were perhaps sporadically visited across generations of cyclical movement, serving as shelters but also sometimes as special places significant in the understanding of the cosmos of the time.

A milder climate from around the ninth millennium B.C. began to alter the character of the landscape. Woodland eventually became ubiquitous except around coastal and estuarine margins. Sea levels rose, altering the coastline, and the sea became warmer. Subsistence resources changed and diversified reflecting a relative abundance available to be hunted and collected in woodland and temperate aquatic environments. Tool technologies adapted to the new circumstances of this period, conventionally described as the MESOLITHIC, in the form of composite implements made of diagnostic small flints, 'microliths', which were fitted as points or cutting edges to wooden or bone hafts. Surviving concentrations of Mesolithic activity appear mostly around the present coast which during these millennia was an inland ridge overlooking a gradually disappearing coastal plain. There is very limited evidence for activity any distance inland. Therefore, in the Pembrokeshire area at least, although settlement probably continued to be transient, possibly the range of movement undertaken by communities became more restricted as people focused on the bounty of the coastal littoral. The potential importance of food derived from the coast and sea has been demonstrated by the analysis of human bones from caves on Caldey Island. The presence of human bones in these caves may indicate the ongoing importance of such locales as special places of ritual significance. Another cave used at this period is Wogan Cave beneath Pembroke Castle. The most important Mesolithic site is that of the Nab Head, St Brides, from which evidence of the manufacture of substantial numbers of perforated shale beads have been recovered in addition to large quantities of stone tools, of the seventh and sixth millennia B.C. The authenticity of a stone figurine from Nab Head is debated.

In the centuries around 4000 B.C. new methods of food production appear in the region, involving domesticated animals and to a limited extent the cultivation of cereals. The clearance of woodland begins in order to facilitate food production, processes which combined with climatic change ultimately lead to the present-day landscape. Stone-working technologies change and ceramic production is introduced. Together these characterize the NEOLITHIC. These innovations may represent the inward movement of new peoples. But they may equally indicate the adaptation of indigenous Mesolithic communities to newly available resources and ideas, perhaps in order to support an increasing population through intensified use of the landscape. Only on the rocky outcrop of Clegyr Boia near St Davids is there substantial evidence of settlement, best interpreted as three rectangular post-built structures. Small social groups probably maintained a seasonal mobility focused on the husbandry of animals, such as the cattle whose bones were recovered at Clegyr

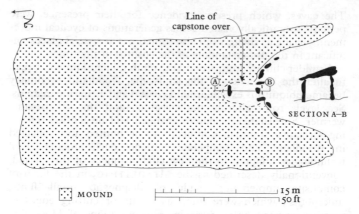

Nevern, Pentre Ifan. Simplified plan of portal dolmen.

Boia, around a recognized territory. It is possible on analogy with
sites in south-western England that some hill-top enclosures,
such as Carn Ingli, Newport, have their origins in the Neolithic.

Definition of territory by a group is likely to have involved the
construction of a 'tomb' or 'cromlech' with stones of megalithic
proportions, perhaps at some place in the landscape which held
a special significance for the group, which may account for the
dramatic location of some monuments such as King's Quoit,
Manorbier. A mound of earth and stone invariably surrounded
the surviving megalithic chamber to which access was usually
preserved. Three chambered tombs have been adequately exca-
vated: the passage grave of Carreg Samson, Mathry; the extraor-
dinarily impressive portal dolmen at Pentre Ifan, Nevern, with
its imposing façade and capstone delicately poised high on taper-
ing stone supports; and Carreg Coetan Arthur, Newport, which
along with many of the Pembrokeshire tombs defies ready clas-
sification in terms of the megalithic architectural traditions of the
Irish Sea region. Only Carreg Coetan Arthur produced absolute
dates through radiocarbon determinations of around 3500 B.C.
On the basis of ceramic associations and in some instances archi-
tectural styles, these monuments may well have been built and
used through the fourth and even into the third millennium B.C.
Carreg Samson and Carreg Coetan Arthur both produced evi-
dence for human cremations, although this does not preclude the
burial of unburned skeletal material that subsequently decayed
in the acidic soils. Elsewhere there is plentiful evidence for the
manipulation of skeletal material at such monuments, suggesting
that often they should be perceived as storage rather than resting
places for the ancestors.

The Preseli hills through the fourth and third millennia B.C.
provided sources of igneous rock prized for the production of
polished stone axes which were acquired by distant communities

through a process of exchange. Axes were functional but also seem to have had symbolic qualities linking peoples across not only Britain but also western Europe. The doleritic and rhyolite 6 'bluestone' from the Preselis, the sources of which include the atmospheric outcrops around Carn Meini, Crymych, is key to one of the vigorously contested debates in British prehistory. Over forty examples of these stones, up to four tons in weight, survive at Stonehenge, Wiltshire. It has been suggested that considerably greater numbers were originally used in the construction of various phases of the monument from c. 2500 B.C. onwards. While some have argued that these stones could only have been moved the 220 km to Salisbury Plain by the natural forces of glaciation, the balance of opinion now favours human agency, implausible as the feat initially may seem. The precise significance of the stone is speculative. Also it is unclear whether contact was always direct or more frequently via chains of intermediaries, but one can assume a framework of commonly held values which motivated connections with distant peoples. The introduction of 'bluestones' at Stonehenge is now considered to coincide with the advent of the distinctive Beaker ceramic at the monument. Beaker pottery is part of a pan-European phenomenon, possibly a diagnostic element in a widely practised cult. A few finds of Beaker pottery have been made from both ritual and domestic contexts in southern Pembrokeshire, for example from the South Hill barrow, Talbenny, from Stackpole Warren, possibly associated with a house, and from cave sites on Caldey Island.

Although chronological precision is lacking, the centuries subsequent to the middle of the third millennium B.C. witnessed much change in the archaeological record of Pembrokeshire. In addition to the appearance of new styles of pottery, such as the Beaker, to be followed by food vessels and collared urns, new forms of burial and ritual monument appear in the landscape succeeding the chambered tombs. Stone circles and their variants are laid out, such as the open circle at Gors Fawr, Mynachlogddu, or the now destroyed embanked circle at Letterston. Standing stones are raised, for example those at Tafarn-y-Bwlch, Brynberian, or Rhos y Clegyrn, St Nicholas. 3, 11 They are now the only visible element for complex ritual structures such as that revealed by excavation at the Devil's Quoits, Stackpole Warren, Bosherston, where the standing stone and associated setting of small pitched stones was preceded by a timber building argued to have a ritual function. Individuals were now interred, either inhumed or cremated beneath or within round mounds, earthen tumuli or cairns of stone such as those on the summit of Foel Drigarn. Metallurgy was practised, 12 marking the commencement of the conventional BRONZE AGE. An early example of a bronze dagger accompanying a male inhumation contained in a massive stone cist or coffin within a barrow was found at Corston Beacon, Hundleton. Evidence for settlement and economy remains elusive during the second half of the third millennium B.C. and much of the second millennium B.C.

A mobile pastoral society is often assumed but evidence for timber round houses from Stackpole Warren, preserved beneath the dunes in the vicinity of the Devil's Quoits, indicates an element of more settled exploitation of this lowland coastal landscape through much of the second millennium B.C.

Across much of Wales, as traditions of monumental construction focused on ritual and burial monuments wane, the final centuries of the second millennium B.C. are best known through increasing quantities of ever more sophisticated metalwork. However, little such material is known from Pembrokeshire. There is something of a hiatus apparent in the archaeological record. Climatic deterioration at the end of the second millennium B.C. and during the early first millennium B.C. coincides with increased evidence of settlement in many regions. Settlement increasingly is defended or is in a defensible location, presumably at least in part in response to increased competition for viable land. Even climatically favoured coastal Pembrokeshire seems not to have been immune from such pressures, with excavations at Dale Point promontory enclosure revealing a sequence of defences commencing early in the first millennium B.C. The archaeology of Pembrokeshire through much of the first millennium B.C. and early centuries A.D. is in fact dominated by large numbers of settlement enclosures of various forms. Iron working was introduced into Wales from the early C7 B.C., marking the commencement of the conventional IRON AGE, though in Pembrokeshire with little survival of the material from the period.

There is much variation in the location, size and defensive character of the enclosure sites. There are coastal enclosures, such as those at Dale Point, Bosherston, Greenala, Stackpole, or Porth y Rhaw, Solva, where sometimes multiple banks and ditches isolate a promontory which affords strong natural protection. There are many small, roughly circular, banked and ditched enclosures, sometimes described as 'raths', for example Park Rath, Carew, or Walton Rath, Walton East, which often topographically are not in particularly strong defensive positions. There are hilltop enclosures, sometimes defined by multiple banks, classic 'hillforts', such as Garn Fawr and Garn Fechan, Llanwnda. The majority of enclosures are under three acres in extent, a few coastal enclosures encompass an area of more than 25 acres.

It is important to recognize the likely chronological complexity of the settlement pattern represented by the distribution of enclosure sites, which is well illustrated by investigations in the Llawhaden area of central Pembrokeshire. Here there is a group of seven enclosures, mostly only recognizable from the air as crop marks but including Holgan Camp which can still be seen on the ground. The enclosures, closely clustering within an area of around 4 km², were found on excavation to represent an involved sequence of activity. There was a succession of enclosures commencing with small hillforts used for relatively short periods, the first from perhaps as early as the C8 B.C. These gave way to embanked homesteads towards the end of the millennium which continued into the early centuries A.D. with discontinuous use for several further centuries thereafter.

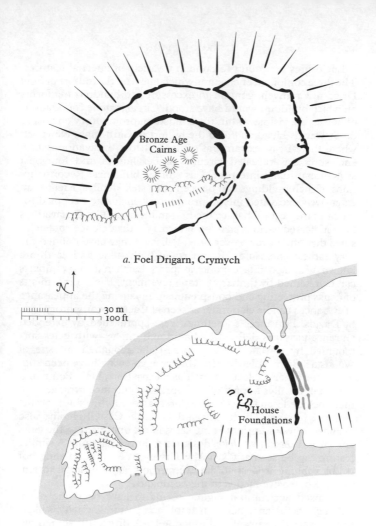

*a.* Foel Drigarn, Crymych

Bronze Age Cairns

N

30 m
100 ft

House Foundations

*b.* St David's Head Enclosure

Gates

Buildings

*c.* Woodside Camp, Llawhaden

ROCK OUTCROP     BANK     DITCH

Examples of different enclosure types of later first millennium B.C.: *a.* Crymych, the hillfort of Foel Drigarn; *b.* St Davids, the coastal promontory enclosure on St Davids Head; *c.* Llawhaden, the early phase of the excavated enclosure of Woodside Camp

Enclosures are found to contain a variety of internal features. The three conjoined enclosures which make up the hillfort of Foel Drigarn, Crymych, contain in excess of two hundred platforms on which buildings would have stood. Circular stone foundations of houses are visible within the windswept promontory enclosure on St Davids Head and also the hillfort of Carn Ingli, Newport, where there is an extramural settlement too. Excavation within enclosures has revealed circular timber houses and four-post structures usually interpreted as storage buildings. Reconstructions of such buildings can be seen at Castell Henllys, Meline, an extensively excavated inland promontory enclosure occupied for much of the second half of the first millennium B.C. Excavations have indicated various structural forms for the defences of enclosures that often evolve over time. Palisades may have defined the very earliest enclosures. Ramparts of both stone and earth are known. Walling can face stone ramparts. Earthen dump ramparts can be retained by timber or stone revetment. The arrangements of banks protecting and conspicuously enhancing the appearance of entrances can be elaborate, as seen at Caerau promontory fort, St Davids. Entrances sometimes were approached by extended entrance passages defined by banks and ditches with gates surmounted by towers, for example at the ploughed-out site of Woodside Camp, Llawhaden. Towers at gateways have been suggested for other enclosures such as Clegyr Boia, Dale Point, and at Castell Henllys as part of an impressive entrance arrangement that included 'guard chambers' recessed in the sides of the entrance passage. The northern defences at Castell Henllys also included rows of upright stone slabs in the approach to the gate, known as a *chevaux de frise*, designed to impede assault. A similar feature can be seen at Carn Alw, Crymych. A hoard of slingshot pebbles found at Castell Henllys provides an additional insight into the defensive tactics of the occupants.

A mixed agricultural regime seems to have been the norm although the balance between arable and pastoral activity is likely to have varied with soil and topography. A division is sometimes made between a lowland zone to the south, favouring arable cultivation, and a northern upland area more suited to animal husbandry. Evidence for spelt wheat has been found, for example, at the enclosures excavated in the low-lying Llawhaden area. It is, however, difficult to be certain of the relative significance of the arable component in the agricultural regime. Acidic soils usually leave little direct evidence from which to estimate the character and scale of animal husbandry. Extensive field systems probably belonging to this period are known on St Davids Head, likely to be associated with the promontory enclosure; on Skomer Island where they are closely articulated with open settlement house foundations; and at Stackpole Warren where field surfaces preserved beneath sand dunes showed evidence of cross ploughing for crops and the hoof prints of penned animals. Marine resources were exploited. The many coastal promontory enclosures may have had a role in a maritime network although its character is speculative.

The social context for the settlement is likely to have fluctuated over time as indicated by the variety of forms taken by the enclosures. Although the excavations on the Llawhaden enclosures indicate a chronological sequence for the construction of different types of relatively short-lived settlements, it is as yet uncertain if this can be widely extrapolated. Larger, hillfort-type enclosures, such as Foel Drigarn, may have served as tribal focal points for interdependent smaller settlements across a wider area. High status homesteads, most likely the residences of dominant families in a locality, may have come to the fore in the latter centuries of the last millennium B.C. These show a concern for social display, for example, through the monumental scale of the bank and ditch relative to the area enclosed, and elaborate entrance features. Such display indicates significant social competitiveness amongst relatively fractured, and quite possibly also fractious, communities.

Some enclosed areas occupied at this time, for example Carn Ingli or Foel Drigarn, could have been long-standing special places of spiritual significance in the region, perhaps on account of enduring perceptions of the exceptional character of the landscape. There is, however, limited actual evidence known for certain ritual activity from Pembrokeshire at this period. For example, the second millennium B.C. standing stone, the Devil's Quoits, Stackpole Warren, was a focus for burial in the later first millennium B.C., while the remains of a perhaps disarticulated skeleton were found in a midden at Greenala Camp. A very few cremation burials have been found at excavated enclosures. Acidic soil conditions militate against the survival of inhumations.

A ROMAN presence began to be established in west Wales by the 70s A.D. Pembrokeshire was part of the territory of a grouping of people described as the *Demetae* eventually administered from the presumed *civitas* capital of *Moridunum* (Carmarthen). Little trace of the impact of Roman administration has been found to date in the archaeological record of Pembrokeshire, but earlier perceptions of Pembrokeshire being virtually untouched by Roman administration, military or civil, are changing as new discoveries are made or old ones revisited. A Roman road running west of Carmarthen has been traced as far as the western Cleddau to an as yet unknown destination. The Roman villa with 'bath-house' seen by Fenton at Wolfscastle in the early C19, but since lost, may have been on this road and would indicate a quite different level of settlement to what is now assumed. There is no certain evidence, however, of resistance to Rome and, although suggestions have been made for other possible fort sites, no significant military presence has yet been proved. Some defended enclosures can be shown to have been abandoned, for example Castell Henllys, where a separate farmstead immediately outside the defences was in use in the Roman period, but it is an open question as to whether this dislocation was in response to military demands.

The settlement pattern of the pre-Roman Iron Age broadly continued into the period of Roman administration although

discontinuity is apparent at some sites. Use of pre-Roman locations has been demonstrated through excavation at the crop-mark enclosures of Dan y Coed and Woodside, Llawhaden, where a somewhat reduced level of activity seems to have continued into the early centuries A.D. Usually only limited cultural innovation is evident and most sites of the early centuries A.D. appear to be of relatively low social and economic status. Notably, however, excavation at the Castell Henllys farmstead has recovered pottery imported from central and southern England, France and Spain. At Trelissey in south-eastern Pembrokeshire, a mortared stone multi-roomed building, not now visible, was located through excavation. However, it is not obviously comparable with the 'villas' proper of the more Romanized Vale of Glamorgan. More usually the rectangular or sub-rectangular stone constructions of the period, invariably associated with earlier enclosures, are of basic dry stone build, with the continued use of post-built timber structures. At Walesland Rath enclosure on the shore of Milford Haven, which was excavated prior to its destruction during the development of the anchorage's oil refineries, a dry stone rectangular building, perhaps a byre or a barn, accompanied wooden round houses of the C3 and C4 A.D., possibly after a hiatus in the use of the site. It is not easy to assert changes in the economy during the Roman period. Certainly there appears to be no industrial activity, which is evident elsewhere in Wales, for example the extraction of metal ores. However, there may well have been changes invisible in the record as a consequence of a novel fiscal regime.

Barbarian raids around the coasts were one element in the gradual decline of Roman authority in Britain during the C4. However, unlike south east or north west Wales, there is no indication to date of military precautions in Pembrokeshire to counter these, presumably reflecting the absence of any strategic resource requiring protection. Irish incursions in the C4 continue into the C5, probably including settlement. However, the archaeological record for settlement during the Late Roman to Early Medieval transition is very thin, confined to sites such as the island community of Gateholm; ephemeral indications at enclosures such as that at Drim, Llawhaden, a severely plough-damaged site not visible on the ground; and possible re-occupation of the defended promontory enclosure at Castell Henllys. Certainly by around A.D 400. the regional urban centre of *Moridunum* (Carmarthen) seems no longer to be functioning as a town, suggesting the culmination of a process of administrative and economic dislocation.

## THE MIDDLE AGES

*Historical Background*

Following the Roman departure in the late C4, Pembrokeshire fell to, or was given to, Irish chieftains who probably ruled to *c.* 500, when overthrown by a British resurgence. The Voteporix

stone, now in Carmarthen museum, probably commemorates
Vortipor, the ruler of Demetia castigated by the chronicler Gildas
*c.* 540. The dynasty of Vortipor ruled in Demetia for centuries,
Demetia becoming Dyfed, the kingdom celebrated in the CII
*Mabinogion* with its court at 'Arberth' which may be Narberth,
and then Deheubarth, the south west Wales principality ruled
from Dinefwr, in Carmarthenshire, though the unit was not the
homogeneous state of modern parlance. The ascetic monastic
settlement of St David in the far west in the C6 at Mynyw, called
Menevia, now St Davids, eclipsed the other early Christian settle-
ments, but that on Caldey Island founded by Piro, linked with
St Illtyd and St Samson, was also of importance. The *llan* place
names testify to ecclesiastical settlements, the *clasau* of the Celtic
church. Local saints with more than local influence included
St Brynach at Nevern, St Dogfael at St Dogmaels, and St
Llawddog at Cilgerran. The cultural links of the age of the saints
were to Ireland, Cornwall and Britanny, primarily Ireland, and
remained so until the coming of the Normans in the later CII.
The region was harried by Vikings from Dublin in the C10 and
CII, St Davids and St Dogmaels being attacked in 988 and
Bishop Abraham of St Davids killed by raiders in 1080, but the
period is illumined by the cultural renaissance around Bishop
Sulien of St Davids in the late CII.

The kingdom of Deheubarth, riven by feuds among
the descendants of Owain ap Hywel Dda, †988, was reduced by
the Normans after 1093 to a Carmarthenshire heartland, and
Marcher lordships were established in Pembrokeshire. The
county was divided into five principal divisions, the south west
dependent on the great castle at Pembroke, the south east cross- 16, 22
ing the present boundary with castles at Narberth and St Clears,
the small lordship of Cilgerran in the north east, the lordship of 24
Cemaes in the north centred at Newport, and Pebidiog in
the north west, the lands of the bishopric, reorganized under a
Norman bishop from 1115. Pembroke Castle became the strong-
point of Norman control and the one castle that the rulers either
of Deheubarth in the CII and C12 or of Gwynedd in the C13
were unable to capture, although for two centuries, until the
Edwardian conquest of 1277–83, Norman rule was intermittent
in the north of the county. Occasionally it was shaken right
to the walls of Pembroke, principally by the Lord Rhys of
Deheubarth between 1165 and 1197, by Llywelyn the Great of
Gwynedd between 1215 and 1223 and by Llywelyn the Last
between 1257 and 1277. The earldom of Pembroke, held by the
de Clare, Marshal, and de Valence families, became a power base
independent of the crown in most matters and a springboard
for the Norman invasion of Ireland under Richard Strongbow
(†1176). The security of Pembroke sustained the Norman settle-
ment of south Pembrokeshire. 'Little England beyond Wales'
became, exceptionally in Wales, an area of English place names,
speaking English, a permanent language division along the
'Landsker' line north of Haverfordwest. The lordships were
gradually absorbed by the crown in the later middle ages and
finally abolished by the Acts of Union of 1536 and 1543 which

established the thirteen Welsh shires on the English model. Pembrokeshire's county town became Haverfordwest which had risen to prominence in the C14, eclipsing Pembroke.

## THE EARLY MEDIEVAL MONUMENTS AND SITES

Little is known of the dwelling places of the Irish chieftains followed by the local Celtic rulers who ruled the area in the post-Roman period. The story of St David identifies Clegyr Boia, St Davids, as the stronghold of a local Irish chieftain in the C6, a site of Neolithic and Iron Age occupation, but not provably C6. Iron Age sites occupied through the Roman period are known to have continued in use after the Romans left. The INSCRIBED STONES remain the principal evidence of the period. Several have parallel inscriptions in Latin and Ogham, the lettering system of straight cuts on the leading edges of stones that is also found in south west Ireland, the Ogam inscriptions using the Irish Maqi or Mac where the Latin uses Filius. The Sagranus stone at St Dogmaels with its precise correspondance of Latin and Ogam inscriptions is one of the best examples, and about half the 30 Ogam stones in Wales have been found in Pembrokeshire. They seem to predate the era of Christian conversion, most being without Christian symbols, or with superimposed crosses as at Clydey and Maenclochog. The Bridell stone has a cross and an Ogam inscription but no Latin, so one must assume the cross to be later, and the Caldey stone with its long Christian inscription must be re-used. The style of lettering in late Roman capitals intruded by Irish uncial and half-uncial letters, may give a dating series, as may the horizontal terminal 'I' that appears in many inscriptions, but not for example on the St Dogmaels or Cilgerran stones. The stones are grave markers; their general location in church sites may indicate a continuity of use from pre-Christian times, but the evidence is so confused by the moving of stones, and the re-use of pre-Christian stones in the early Christian period that their history must remain uncertain.

The early Christian history of the county is less obscure than elsewhere as it is fitfully lit by the story of St David in the C6. Surviving evidence for St David's settlement is minimal, though the odd alignments of the cathedral may hint that something much older lies beneath. David's ascetic community would have built little, but neither has the near-contemporary monastery on Caldey associated with St Illtyd and St Samson left any built remains. There were probably religious settlements at St Dogmaels and Nevern associated with Saints Dogfael and Brynach, both of whom have churches dedicated to them elsewhere in the county, indicating a wider influence. The absence of remains of buildings of the early monastic period may be in part due to the lack of excavations focused on this period,

and may also indicate the extreme fragility of the structures themselves.

By far the largest group of remnants of the period is the inscribed stones, often no more than a crudely scratched cross on a boulder. Early Christian CROSS-INSCRIBED STONES, with ring-crosses and Latin crosses, are well represented in the county. Their association is mainly with church sites, though many were moved by antiquarian vicars. The stone at Llanychaer with its incised crucified Christ and double-line outlined crosses is one of the best, the outlined crosses being dated to the C7 to C9. Another crude human form, a face, is built into Llanwnda church.

Knot designs and the greater complexity of Celtic design appear from the C9 to the C11, culminating in the STANDING CROSSES of Penally, Carew and Nevern, among the masterpieces 13, 14 of Celtic art. The Penally cross is dated to the early C10, the Carew cross is precisely dated to 1033, by the inscription to Maredudd of Deheubarth, and the Nevern cross is so similar as to be perhaps by the same hand. The Abraham stone preserved at St Davids is also datable, relating to the sons of Bishop Abraham, bishop during 1078–80. While much of the detail of these carvings is Irish, the Penally cross has a type of acanthus leaf pattern of Northumbrian origin, as does another broken cross-shaft at Penally which also has a Norse ribbon creature, showing the cultural interchange at a period notable for the ferocious Viking raids.

While many of the ROUNDED CHURCHYARDS may indicate a pre-Norman site, there is little excavated evidence in the county of what an ecclesiastical site of the early Christian period might have been like. The churchyard at St Edrens (Llanedren, Hayscastle), as it is so isolated, preserves the embanked circular form very clearly, but there are numerous others of rounded shape. A pre-Norman SETTLEMENT may be on Gateholm Island, Marloes, which has the footings of small turf-walled houses. Undatable but associated with early saints are the HOLY WELLS. Francis Jones identified some one hundred and fifty wells in the county, many associated with particular saints (eighteen with St David), some with particular healing cults and, one must assume, used since pre-Christian days. The association of church and holy well may be a sanctification of an older site, the best examples being at St Non's, near St Davids, and at Llanllawer.

# MEDIEVAL CHURCHES AND MONUMENTS

The NORMAN reorganization of the Welsh church created a vast diocese over much of south and west Wales, with its cathedral at St Davids. The cathedral, inconveniently sited so far to the west, was immovable due to the strength of the cult of the saint,

recognized from the beginning by the Normans, the Conqueror himself visiting St Davids in 1081. The first Norman bishop, Bernard, secured the canonization of St David very shortly after his election in 1115, with the extraordinary provision that two pilgrimages to St David's would be equal to one to Rome, ensuring the growth of the cult, despite the loss of the relics of the saint, despoiled in 1089 and not 'found' again until the C13. A church was 'dedicated' in 1131, but whether a re-dedication of the pre-Norman building or of a new building is unknown. Bishop Peter de Leia demolished what was there to begin the present cathedral in 1181–2, a relatively long time after the first Norman occupation. The foundation by Marcher lords of Monkton Priory c. 1098 and St Dogmaels Abbey in 1113 may have involved earlier building campaigns than that of the cathedral, and church building must have got under way early in the surrounds of the first castles and planted settlements of the south of the county. Apart from the cathedral very little survives. At St Dogmaels Abbey, the church had transepts and apsed chapels; the bases of the crossing piers are C12, cruciform with a pair of half shafts on the inner faces, similar to the crossing at Tewkesbury. The smaller churches were probably two-cell, sometimes with an apsed chancel, as existed once at St Florence. At St Davids the nave of six bays, with aisles, the transepts, crossing and four-bay choir were built c. 1182–1200 – one of the last great Romanesque churches of Britain, barely aware of the Gothic then well under way elsewhere. Despite its magnificence, it had virtually no effect on parish church building across the county. Extravagantly wide and extravagantly carved with an extraordinary variety of chevron mouldings, the nave at St Davids was a work of great aspiration, apparently intended for vaulting, despite its width. Certain features suggest awareness of the new forms of Transitional to Early English Gothic: the combination of triforium and clerestory in a single storey, and more obviously the pointed arches of the triforium, and the appearance of stiff-leaf carving in some of the nave capitals. In the smaller churches C12 evidence is minimal: a round-arched light found at Manorbier that confirms an original two-cell plan, an arched window at St Florence. That there were larger Norman churches, as one might suspect, is confirmed by Fenton's description in 1810 of St Michael, Pembroke, as 'of Norman architecture, cruciform with a stunted tower', though without ornament.

The chief surviving church fitting of the C12 and C13 is the FONT of which a large number survive, some of local grey limestone, others imported. The most common type is square with scalloped underside, for example Llanhowell, some with a cushion-capital form, as at Bosherston. Carving appears occasionally, for example moon, stars and sun carving at St Issells and foliage work at Redberth. Clydey has crude decoration in raised lines around the semicircular edges, more akin to some of the Ceredigion fonts. There is some cable moulding, for example the pedestal at Lamphey, where the bowl has six-petal flowers.

The EARLY ENGLISH period, of the earlier C13, is represented by the rebuilding of the choir and crossing arches at St Davids, where the arches are pointed. The capitals have a variety of curvaceous waterleaf (similar to those at Strata Florida) and trumpet capitals combined with the chevrons of the nave, that is, fairly old-fashioned. By contrast, at St Mary, Haverfordwest, the nave and chancel arcades are of outstanding quality, comparable with Wells. The complex piers resemble the nave at Wells, and have superb stiff-leaf capitals and very fine passages of carving, including profane scenes. This degree of display reflects the commercial prosperity of the town and presumably close trading links to the Bristol–Wells region. At St Davids the later C13 work included the extension of the cathedral east with lengthened choir aisles and ambulatory, and an eastern lady-chapel, since rebuilt.

Fragments of carved work retrieved at St Dogmaels show that the mid-C13 was the period of completion of the church. The king gave money in 1246 for the fabric. The presbytery was completed or extended square-ended, over a vaulted crypt, of which only some walls survive, but the nave was completed without the intended aisles. Haverfordwest Priory was founded c. 1210, the much depleted ruins showing a cruciform plan, though modest in size, about 50 metres long east to west. The lack of suitable stone ensured that most churches remained simple, and there are few exactly datable buildings. Castlemartin with its arcade of local limestone has shafts of the crudest form; the blocked N chancel arcade has odd scalloped abaci and roughly carved mask corbels. The lofty arcade of chamfered arches on simple round piers with cushion-type abaci at Lampeter Velfrey may, however, be a later archaism, like the cable moulding at Rudbaxton. TOWERS at this period are rare, the plain squat one at St Mary, Haverfordwest, may be co-eval with the arcades. Lancet windows are rarely dateable; one at Lamphey has a roll moulding and cusped head, and roll mouldings are to be found on two very similar early C13 round-arched doorways, at St Mary, Pembroke, and Monkton Priory. The tall chancel arch at St Issells with simple attached shafts may be C13. The C13 dates the beginning of the practice prevalent in the south of the county, of roofing with pointed barrel VAULTS rather than timber, such vaults being found up to the C16. The vault to the nave at Monkton Priory appears to be inserted, possibly in the C13, but dating is difficult. The effect is seen most remarkably at Penally where all the spaces are vaulted, a series of linked stone chambers. St Petrox has all parts vaulted except the chancel. Equally memorable are the long barrel-vaulted naves of Monkton Priory and St Twynnells.

The dating of fonts is too inexact to identify C13 fonts; at least some of the standard scalloped ones must be later than C12. The round font with pointed arcading at East Williamston looks C13 as may be the octagonal font at St Davids with its plain pointed panels. The SHRINE survives within the choir of the cathedral, erected c. 1275 for the relics of St David, a chest with three open arches and small quatrefoils in the spandrels, the latter with hidden compartments for receipt of offerings.

The DECORATED PERIOD of the earlier C14 is particularly well represented by the building activities of Bishop Henry de Gower (1328–47) who built most of the bishops' palaces at
40 St Davids and Lamphey, and also added the lavish PULPITUM SCREEN at the cathedral, which incorporates, as does the west-front screen at Exeter Cathedral, the tomb of the bishop himself. The lavish carving of the pulpitum is perhaps crude in detail but incorporates up-to-date Bristol-school motifs such as skeletal vaulting, and is lavish in its moulded detail. The rib VAULT in St Thomas's chapel in the cathedral is crude, set out with difficulty, probably later C14, a rare example of a vault amid the cathedral's series of abandoned vaulting shafts. In the pulpitum vault cells are WALL-PAINTINGS, exceptional at this date.

In parish churches C14 work at Camrose indicates a desire for longer naves and chancels. Tall moulded CHANCEL ARCHES are characteristic of the major works, as at Begelly, Carew, Slebech and St Martin, Haverfordwest. Carew, apparently an incomplete major rebuilding for the Carew family, has the square flowers in hollow mouldings typical of de Gower's works, and also ogee or wave mouldings. Begelly's chancel arch is continuously wave-moulded and St Martin, Haverfordwest, has more elaborate keel mouldings. Ballflower ornament, popular in the earlier C14, appears on the middle stage of the tower at St Davids, on an inserted N door at St Dogmaels, and also in the C14 chancel at Hodgeston, in the chancel cornice and the finely carved ogee-headed sedilia and piscina. Carew and St Martin, Haverfordwest, have similar ogee-headed features. The addition of TRANSEPTS, often as chapels for important local families, seems to be a feature of the C14. A good example with original effigies in crocketed ogee-headed tomb recesses is at Llangwm. The transept opens off the nave through a two-bay arcade and has an exceptional pinnacled piscina and traceried E window. Bosherston and Marloes have even-sized transepts, perhaps from a single rebuild; more common, as at Llangwm, are transepts of separate builds. These transepts were often accompanied by SQUINT PASSAGES, providing a view of the main altar, characteristic even in small churches, as at Pontfaen, or Llanhowell where the squint is particularly oversized. The curious chancel lean-tos called choir 'recesses' that appear in some Pembrokeshire churches may be C14, but are probably C15, as at Nevern. TOWERS of the C14 are
56 difficult to identify; the very substantial towers at Tenby and St
45 Mary Pembroke are possibly of this date, the tower at Caldey Priory is dateable to the C14 by its small traceried Dec. window. Original TRACERY is rare, but careful restoration or replication has preserved the forms of the intersecting tracery to the chancel side windows at Carew and the chancel windows at Angle and
47 Hodgeston. Chambers with stone VAULTS continued to be added, but only rarely with any detail: at Manorbier the N transept has odd parallel ribs; there is crude rib-vaulting in chapels at Gumfreston and Stackpole. The stone at Pwllcrochan recording the rebuilding of the church in 1342 is unique, but the detail of the church looks C15. Of TIMBER FURNISHINGS, the

outstanding piece is the Bishop's Throne at St Davids with its 41
nodding ogee arches and crocketed finials, possibly early C14, of
which date also is the parclose screen that encloses it. Apart from
Exeter, this is the finest throne in Britain. The reredos in Holy
Trinity chapel in the cathedral, with the Crucifixion and four
saints, is a rare piece of STONE CARVING, possibly C15.

PERPENDICULAR Gothic of the late C14 and C15 arrived in its
great-windowed form at St Mary's College chapel at St Davids of
c. 1380, the chapel raised on an undercroft with pinnacled shafts
between the windows and battlements, and overlooking an
arcaded cloister. Oddly out of place was the plain Pembrokeshire
tower over the SW corner. The period was one of very consider-
able addition and enlargement of churches by porches, aisles and
towers. It is difficult to estimate how many were entirely rebuilt
from new. Johnston and Loveston are convincingly uniform in
plan, with transepts, squints and W towers. In the county this was
the era of the TOWER, added to many churches right up to
the Reformation, though much more common in the south of the
county. A few with stepped buttresses, such as Newport of the
earlier C15, and Carew of c. 1500, are related to Somerset towers, 50
both built for lords with English connections. The plainest are
unbuttressed, tapering with corbelled battlements, looking almost
military, such as Loveston, but most are of the type, common
throughout south west Wales, with a broad splayed base and string
course. The former is probably the earlier, commoner in the his-
torically wealthier southern parts of the county. The sequence is
shown by Llawhaden, where the plain tower is enveloped in a
more imposing type with splayed base. The northernmost
example of this type is at New Moat; further north towers are far
less common and generally more primitive. The vast majority are
west towers and are clearly additions, but transeptal towers exist,
for example, Gumfreston and Robeston West. At Stackpole and
Uzmaston, the towers are added on to the transepts, while at St
Martin and St Mary, Haverfordwest, the towers are situated on 30
the W end of the aisle rather than the nave.

Belfry lights are simply traceried if at all. Bellcotes sufficed in
the poorer areas, some very substantial as at St Ishmaels, which
has the odd flat top that occurs also at Talbenny and Hasguard.
Only Tenby has a full-scale broached spire, though St Daniels 56
and Pwllcrochan have small spires, and the curious blunted
spike at Caldey Priory may be a C15 addition. There were a few 45
saddleback towers, as in Glamorgan: Castlemartin was one,
heightened later, the saddleback at Llanrhian may, however, be
a reduction of 1836. The cathedral tower was raised another stage 19
in the early C16, the pinnacles echoing Henry VII's chapel at
Westminster, the rest externally very plain.

The wealth of Tenby, outstanding among C15 Welsh ports,
explains the successive C15 enlargements that made the parish
church the largest in Wales, triple gabled with AISLES added to
both nave and chancel. The links are to Bristol and the English
west country: oolitic limestone arcades, the N arcade with
Somerset-style piers with hollow mouldings on the diagonals

and filleted shafts, without capitals. The slightly later s arcades
57 have cruder but standard Somerset Perp detail. Plenty of
churches were enlarged with aisles, the simplest with pointed
arches hacked out of the walling, as at Manorbier and Llanwnda,
the arches simply plastered. Where a degree of refinement occurs,
octagonal piers are the norm, as at Carew, but there is a C16
group of parallel roofed aisles with round piers and sometimes
cable-moulded caps combined with broad four-centred arches,
as at Rudbaxton, St Dogwells and Ludchurch. The equal-
sized aisle of the double-nave type is not as common as in
Carmarthenshire, Pembrokeshire aisles generally being narrower
than the naves, but are found at Lampeter Velfrey, Ludchurch
and Mynachlogddu. Large chancel aisles were added at Amroth,
Robeston West and Begelly. Vaulted porches, often with stone
benches, were added, those at Roch and Nolton panelled with
hollow-moulded ribs. TRACERY of the panel type, requiring good
ashlar, is found in the larger churches. At St Mary, Haverford-
west, the C15 enlargement gave the N aisle and clerestory large
panel-traceried windows. At the cathedral, large windows were
inserted in the s transept, and at the E end of the choir (the latter
removed by *Sir George Gilbert Scott*). The Lady Chapel was
rebuilt after 1500 as a two-bay rib-vaulted structure with large
traceried windows. In the smaller churches, where they survive,
windows are generally of the flat-headed type with cusped or
simply rounded heads to the lights and a hoodmould, occasion-
ally with carved stops, as at Rudbaxton. DOORWAYS remain
chamfered and arched: some have shallow mouldings, as at
Manorbier and the s porch at Tenby. At Tenby, the w doorway
has an ogee head, all that is left of a remarkable cruciform porch,
dated 1496.

Relatively few late medieval TIMBER ROOFS survive, mainly
57 on the greater churches. Tenby's panelled wagon roofs with
moulded ribs and carved bosses are of a type typical of the period
across south Wales and south west England, but of exceptional
richness for the region, the chancel roof dated by the rebus of
the vicar to *c.* 1470, the nave roof rebuilt to match. Low-pitched
roofs with carved bosses and moulded beams, typical of the
period nationally, are found at the cathedral in the choir, splen-
31, 58 didly recoloured by *Scott*, and at St Mary, Haverfordwest. Tenby
has a steep arch-braced roof of impressive span on the later C15
s aisle. Most of the smaller church roofs were replaced in the
C19, but Llanwnda has a much repaired tie-beam roof with king-
posts, one beam with a carved head. Exceptional nationally, as
one of the great pieces of Renaissance woodwork, is the C16
61 panelled nave roof at St Davids, with its extraordinary pendants
carved with an Iberian intensity. The timber fan vault under the
crossing tower is also early C16, the painted decoration renewed
by Scott.

Late medieval STONE ROOFS consisting of simple pointed
barrel vaults are common through the south of the county, more
complex ribbed vaults are restricted to the richer churches. The
rib-vaulted ceiling under the priest's room at Nevern is mostly

restoration, the crude grey stone corbels and wall arches suggesting something more primitive than what is there now. At the cathedral, late C15 and early C16 ribbed vaults were added to the ante-chapel and Lady Chapel, the latter collapsed in the late C18 and was rebuilt by *J. O. Scott*. Bishop Vaughan added the accomplished FAN VAULT to the previously unroofed space behind the choir, *c.* 1521, in yellow oolite, surely the work of west-country masons. At St Dogmaels the corbels and springers of the vaulting of a two-bay N transept fan-vault survive, remarkable in what was by then a remote and relatively poor abbey.

For later medieval TIMBER FURNISHINGS, the cathedral is by far the principal site. The STALLS with their blind tracery are rich if not especially delicate; by contrast the outstanding series of MISERICORDS, similar to those at Fairford, Gloucestershire; are 64 superb examples of late medieval profane carving. Although the corbels and stairs of rood screens commonly survive, none of the SCREENS do, apart from a coved portion at Manorbier and two bays at St Brides. At St Marys, Haverfordwest, is a fine carved 66 PEW END. Of STONE FURNISHINGS, there are a number of conventional octagonal FONTS, that at Llanrhian with reversed shields, one with the arms of Sir Rhys ap Thomas †1525. The canopied niches in Holy Trinity chapel in the cathedral, though mostly restoration, are of a fine delicacy. No medieval STAINED GLASS survives and almost no PAINTED DECORATION of the C15, apart from some geometric patterning in the porch at Manorbier and the fast-disappearing supposed Martyrdom of St Lawrence at Gumfreston. Encaustic TILES with a good variety of patterns survive in the choir at the cathedral, at Carew and, much eroded, at St Dogmaels.

CHURCH MONUMENTS are found from the C11. The slab to the sons of Bishop Abraham still in a Celtic tradition initiates a sequence of slabs and effigies at the cathedral which continue to the C16. Cross slabs with incised crosses are quite frequent from the C13, such as the large slab to Richard le Parmer at St Thomas, Haverfordwest, with floriated Latin cross in relief below a low 37 relief carved head. At Penally, the slab to William de Naunton and his wife has a pair of limestone heads. The similar slab, to Isabella Verney at Tenby, is as late as *c.* 1415. The sequence of full effigies begins at St Davids with Bishop Anselm †1247, the head 36 set under a trefoiled canopy with inscription. Well preserved facial details and detailed crozier: in all, one of the best C13 carvings in Wales. By the C14, effigies became more common across the county. At Stackpole are very fine examples: a knight with crossed legs and a separate one to his lady, both mid-to-late C14. On the male tomb, wonderfully lively figures in leafy niches, the 63 whole tomb set in a big crocketed canopy. Other knightly effigies of high quality are the mailed effigy at Manorbier and a lively cross-legged figure in the retrochoir of the cathedral, with shield and sword. At Upton, the tomb of Sir William Malefant †1362 is set in a fine ogee-cusped canopy, with carved tomb-chest. At the cathedral, the sequence of highly cusped multi-angled tomb recesses of the C14 clearly derive from the Bristol and Berkeley

group, many sadly broken and eroded. At Carew are several effi-
gies of the C14 including a miniature female. Bishop Gower,
†1347, had his tomb set within his splendid pulpitum, with
carved apostles on the chest, an early instance of apostles used
as 'mourners'. The best C14 family chapel is at Llangwm, with
two effigies in large cusped-and-crocketed recesses. Fewer
monuments survive from the C15. Within the cathedral choir, the
Purbeck marble tomb to Edmund Tudor †1450, father of Henry
VII, is a fine tomb-chest with tracery patterns and coats of arms,
but no effigy. A unique survival is the much-damaged late
medieval effigy at St Mary, Haverfordwest, a pilgrim with his
characteristic shoulder bag.

Thought to be late C15 is the cadaver at Tenby, under its richly
crocketed canopy. Easily the best of the period, however, is the
65 pair of tombs to the Tenby merchants Thomas and John White
of c. 1500–1510, in alabaster with splendidly dressed effigies and
devotional scenes on the tomb-chests. The effigy in the cathedral
of Bishop John Morgan †1504 is fully robed upon an elaborately
carved tomb-chest with grouped apostles.

CHURCHYARD CROSSES are mostly restored; that at Boshers-
ton is C14 and complete even to the carved cross head. Most of
the others are only stepped bases or shafts. The town cross at St
Davids was restored in the C19. Two CHARNEL HOUSES survive,
48 easily the best being that at Carew, C14, with vaulted ossuary and
chapel above, still with its piscina and traces of an impressive Dec
E window. That at Angle is smaller and plainer C15, vaulted at
both levels.

# CASTLES

## BY JOHN R. KENYON

The county's major castles are amongst the finest to be
seen anywhere in Britain, not just for their defences, for which
Carew, Cilgerran and Pembroke stand out, but for examples
of domestic architecture, such as the hall and chapel range
at Manorbier. There are a number of earthwork castles, both
mottes, such as New Moat and Wiston, and ringworks, includ-
ing the small enclosure of Castell Pen-gawsai (Llangolman),
whilst the great masonry strongholds of Cilgerran and Pembroke,
amongst others, as well as that which became a bishop's palace
at Llawhaden, started life as earth and timber castles. The
majority of the castles are of Anglo-Norman/Flemish build,
but it is likely that some of the smaller sites in the north of the
county, away from the 'English' heartland, are of native Welsh
origin. The earliest castles built were those associated with the
Norman incursion into south west Wales after 1093.

There are examples of both military and domestic Norman
work apparent at Carew, Manorbier and Pembroke, whilst at
Castell Nanhyfer (Nevern) a masonry inner castle, and a motte

opposite it, may have been the work of the Lord Rhys in the
late C12, added to the Norman ringwork. Both Carew and
Manorbier had square masonry towers, probably linked to earth
and timber ramparts, with gates positioned in the lee of these
towers. At Manorbier, the domestic block at the opposite end of
the inner ward to the entrance is a good example of Norman
domestic architecture, with a first-floor hall, attached to which
was a solar. There is also evidence for a Norman hall in the
inner ward of Pembroke, possibly built by Richard de Clare
(Strongbow), Earl of Pembroke, whilst at Cilgerran a fragment
of masonry by the C13 gate to the inner ward may represent a
C12 gate to the earth and timber ringwork.

The first half of the C13 is dominated by the work of William
Marshal and his sons, Earls of Pembroke, their works in both
south east Wales at Chepstow and in the south west at Pembroke
and Cilgerran transforming the castles into great symbols of lord-
ship. Although the castles always maintained great suites of
chambers and halls, the features that stood out were the defences,
particularly Pembroke's great *donjon* that was begun soon after
1204. It is fortunate that this great tower survived the Civil War
and modern restoration (apart from the newel stair, happily) to
remain as built, albeit without its fixtures and fittings. It, and
other castles of the first half of the C13, bear witness to the
changes in castle design occurring in France in the later C12 and
early C13 under Philip Augustus; for example, the Louvre, with
its round towers and gatehouse. The keep at Pembroke   16
dominates the inner ward, but lacking water supply and such
domestic amenities as latrines, both long-term defence and
permanent residence would not seem to be its main function;
indeed the function of many a castle's great tower is today
being re-examined and re-interpreted in terms of symbolism and
ceremonial.

Marshal's keep was not only the earliest such tower in Britain,
but also the largest, having three main floors over a basement,
and an attic beneath a domed vault, with entrance at first-floor
level. Mural towers defended Pembroke's inner ward, whilst
enough remains of the inner or Horseshoe Gate to show that its
original access was through two doorways at right angles to each
other (cf. the Bohun Gate at Caldicot in Monmouthshire, and
even further afield in Mediterranean countries).

It was left to the sons of the first William Marshal to complete
the scheme at Pembroke, enclosing the outer ward with a curtain   22
wall with circular mural towers, many of which were restored in
the C20 after destruction in the C17, although the Monkton Tower
retains its medieval fabric. Dominating the outer ward is the
Great Gatehouse, but owing to the method of approach from the
town to the castle, the gate is somewhat unusual in form in that
its front consists of just one rounded tower, the space for the
other being taken up by the entrance through the barbican.

At Cilgerran in 1223 we know that William Marshal II began
the construction of 'an ornate castle of mortar and stones', and
this work has been interpreted as being the eastern of two large

towers; at about the same time the outer ward defences were enclosed with a stone curtain and gatehouse. A second tower to the west of the first was built a few years later, probably *c.* 1240. It is not known why two towers that have the proportion of keeps were constructed at Cilgerran, but, as built by the Marshal family, they may have served different functions. In effect, William's tower and that built slightly later, probably by his brother, provide Cilgerran with two *donjons*. Both have arrow slits facing outwards, whilst windows opened on to the inner ward. Only the upper storey of the earlier tower had a fireplace, and it would seem that the later, west tower became the main residential tower, with its porch and first-floor entrance, and fireplaces on both upper floors. The entrance to the main floors of the east tower was less grand, being up a spiral stair accessed through a doorway at courtyard level.

About the same time that the Marshals were building Cilgerran improvements were made to Manorbier by the de Barri family, the main defensive effort coming at the entrance front. It was clearly felt that, with the ground falling away from the castle on all sides other than the east, little more than a curtain wall was required. A gate with portcullis was added against the south wall of the old tower, and this was to be extended and raised into a proper tower with additional portcullis later in the C13. At the north east corner a semicircular tower flanked the adjacent curtain wall, whilst at the south east corner a four-storey circular mural tower of Pembroke fashion was built, still surviving virtually in its medieval state. The east curtain wall has evidence for having been heightened a number of times, blocked crenellations clearly visible, and the mural gallery from the south east tower to the gatehouse was originally an open-battlemented wall-walk. The remaining main feature of the C13 refurbishment of Manorbier is the first-floor chapel built against the earlier hall block.

Although mentioned in the late C12, and with a rectangular tower or small keep perhaps dating to that period, most of what stands at Haverfordwest, albeit the shell of a castle, is late C13, and largely domestic, with chambers, hall and chapel, and seemingly begun by Queen Eleanor in 1289. For finer examples of castle building in this period it is to Carew, Newport, and ruinous Narberth that we look. The fragmentary remains of the Mortimer stronghold of Narberth are enough to show that its *enceinte* consisted of two large and two smaller round towers, with a fifth circular tower that acted as the main tower of the keep, its entrance protected by a forebuilding. There was originally a twin-towered gatehouse, and that at Newport does survive to a considerable degree, in spite of later alterations. The other main feature at Newport is the large south tower with spurred base, with similarities to the towers at Carew, also built in the second half of the C13, or early C14. Adjacent to this tower is a building with a vaulted undercroft, which, in spite of the medieval masonry, is very difficult to take seriously as medieval in its existing form – a Picturesque enhancement?

The major refurbishment carried out by Sir Nicholas de Carew 23 at his eponymous castle in the later C13 and early C14 gave us the castle that we see today, apart from late C15 and early C16 altera- tions by Sir Rhys ap Thomas and the great north range put up 72 by Sir John Perrot towards the end of the C16. On the east side of the inner ward he built the round-fronted south east tower, incorporating its Norman predecessor, and the great Chapel Tower, a polygonal structure with first-floor chapel. It is on the west side at Carew, at either end of Sir Nicholas' great hall, that we find the two spur-buttressed towers to which Newport's south tower bears some resemblance. Impressive as a stronghold when viewed from the west, the two towers off the hall provided a suite of fine chambers, Sir Nicholas's own presumably in the north west tower, at the opposite end to the entrance to the hall range.

Domestic improvements were also undertaken at the county's other great castle, Pembroke. This was the great hall block, built round about the 1280s by William de Valence, at the same time that he was making improvements to the de Chaworth strong- hold of Kidwelly in Carmarthenshire. Other examples of C13 castles are Tenby, the tower of Roch, and the miniature Benton 29 on the bank of the Cleddau (*see* Burton), an enclosure with two round towers that was restored in the C20. At Upton we have 25 more of a fortified house than castle (see p. 488). C18 alterations in particular have changed the medieval appearance of Picton, 77 but enough survives of the castle built about 1300 by Sir John Wogan, and occupied ever since. Wogan's castle consisted of a central rectangular building originally of two storeys, with a small tower or turret at each corner. It must have looked akin to such castles in Ireland as Carlow, Ferns and Lea, dating to the early to mid-C13. What the main block at Picton also had was a small twin-towered gatehouse, evidence for which cannot be seen at the earlier, and ruinous, Irish examples.

In the C14, apart from work continuing, no doubt, at Carew, the main new build was at Llawhaden, the property of the 43, 60 bishops of St Davids. This castle had started life as an earth and timber ringwork, but in the C13 its defences were replaced in masonry, although only fragments remain, including the foundations of a circular tower and a rectangular structure that was later incorporated into a new gatehouse. In the late C14 Llawhaden was transformed into an imposing residence for the bishops of St Davids by Bishop Adam de Houghton, *John Fawle* being the master of works. An impressive, although not particu- larly strong, gatehouse was built, running east from which was a lodgings range, including a chapel and a tower with small cham- bers (Closet Tower). A fine five-storey porch off the courtyard gave access to this range. Across the courtyard from the gate- house was the hall range, with hall, chamber and kitchen on the first floor over undercrofts.

A refurbishment of Carew was undertaken at both the begin- ning and the end of the Tudor period. Sir Rhys ap Thomas had added the heraldic porch to the great hall and undertaken some refenestration, as well as adding a small gate-tower on the east

side, no doubt by the time of the great tournament of 1507. The medieval N front was swept away by Sir John Perrot who began the existing range *c.* 1588, work that was perhaps left unfinished at his death in 1592 (see p. 153).

The English Civil War of the C17 saw the strengthening of some castles, albeit on a small scale. Both Carew and Manorbier had small redans built in front of vulnerable gateways, V-shaped fortified positions to take musketeers or small cannon, and traces of these still remain. At Pembroke, reinforcing the defences took the form of 'vamuring' or strengthening the inner face of the outer curtain wall to the west of the great gatehouse.

### Town Defences

A circuit of walls was associated with many boroughs in Wales, notably in the south. Walled towns in the county were found at Haverfordwest, Pembroke and Tenby, but little or nothing remains at Haverfordwest. The C13 walls at Pembroke survive in a number of sections, but the most notable feature of the defences, with few parallels in Britain, is Barnard's Tower, at the north east angle of the town walls. This three-storey circular tower projects from the walls, to which it is linked by a 'fore-building', with originally a portcullis separating the two sections. Arrow slits emphasize the military aspect of this tower, whilst fireplace, windows with seats, and a latrine in the forebuilding suggest that when first built Barnard's Tower was expected to be permanently manned.

Tenby's walls date from the C13 to the C15, and rank amongst the best in Wales. They may well have replaced an earth bank with palisade, possibly dating to the C12. The sequence of buildings appears to have been the walls themselves, to which the towers and South Gate were added later, with a third phase in which walls and towers were heightened. An unusual feature of the town walls, at least in Wales, is a series of gun loops of inverted-keyhole design, part of the C15 improvements. These may date to around the year 1457 when the citizens of Tenby agreed to share the cost of improvements made to the walls with Jasper Tudor, Earl of Pembroke.

# MEDIEVAL DOMESTIC ARCHITECTURE

Rich soil, a temperate climate and an abundance of building stone – particularly in the more prosperous south of the county – enabled a settled population by the C13 and the building of substantial houses. Due to the hardness of most local stones, the medieval domestic architecture of Pembrokeshire is characterized by ruggedness and lack of carved detail, except in buildings of highest status. This is very different from either the Welsh borders or parts of north east Wales where most medieval build-

ings are identifiable by fine carpentry details, or in Glamorgan, where carved stonework provides a ready source of clues for dating. None of these criteria can be used for any but the finest of Pembrokeshire houses. The few probably medieval details which do occur – such as pointed doorways and circular chimneys and vaulting – may have continued in use well into the C16.

The lack of good building materials is one reason for some of the special characteristics of Pembrokeshire buildings. The absence of local workable stone may account for the popularity of circular chimneys which did not require quoin stones, and together with the shortage of good timber by the C16, favoured rubble vaults without ribs in houses as well as churches. However there were timber buildings: the Elizabethan George Owen commented that '*in old tyme there was in manye places of the county sufficient store of timber to have framed fayer buildings*'. Apart from a much altered group in Haverfordwest, virtually none survive.

## Great Houses

The Bishop's Palace at St Davids, built between the C13 and C15, represents the apogee of the medieval magnate's house, with major and minor halls for ceremonial purposes, private suites of rooms and expensive ranges of service rooms, all arranged within a quasi-defensive curtilage. All of the main rooms are set on undercrofts and, in keeping with the status of its occupants, carved detail abounds on corbels, door surrounds and windows, including an exceptional wheel window in the gable of the Great Hall built by Henry de Gower (Bishop 1328–47). Even more exotic was the chequered stonework of the arcaded parapet, possibly in imitation of an even grander model such as the papal palace at Avignon. Originally, the drama would have been highlighted by strongly coloured limewash rather than the stripped rubble walls of today. The great hall measures 60 ft by 24 ft (18 by 7 metres) and originally had an open timber roof with louvre to vent the open hearth. The bishops also built ambitiously on their other estates. In the fertile south, amid good hunting country lay the Bishop's Palace at Lamphey, where two halls were built between the early C13 and mid-C14, the second larger and more splendid that its predecessor. The fine range of accommodation built by Bishop Henry de Gower has an arcaded parapet which is a clear echo of his lavish remodelling at St David's. All of these structures were raised above ground level, the earliest with a timber floor, the later ones with barrel vaults. By the C14, there were at least two courtyards with outer and inner gatehouses, the latter one remodelled in the C16; oddly with an arcaded parapet, imitating de Gower's work.

At Llawhaden Castle, Thomas Bek, bishop from 1280, built a hall block with solar and service wings, all over vaulted undercrofts, and in c. 1380, Bishop Adam de Houghton remodelled the south range to provide well-appointed apartments and a large chapel. Other medieval castles were also remodelled to provide

38, 39

4, 32, 42

23 more comfortable accommodation. Carew is the supreme
example, grandly embellished with Bath stone windows and fire-
places by Sir Rhys ap Thomas from c. 1485, with a grand porch
to the Great Hall, complete with the royal arms of c. 1502.

The buildings of Monkton Priory are puzzling. On the north
side of the former claustral enclosure is Priory Farm, a vaulted
tower-like structure with corbelled wall-walk, clearly intended at
least to look defensive; was this the prior's house – or was it built
by an early post-dissolution owner? Just south east of the priory
church is the rather grander Old Hall, begun in the C14, with an
impressive rib-vaulted undercroft, with a hall and cross-wing
above. The function of the building is unclear, and is made all
the more puzzling by the survival of a tall blind arch to the main
approach. Was the building designed to look like a grand gate-
house and did it also function as a guest hall?

By the C14, first-floor hall houses were being built by wealthy
landowners and farmers, especially in the south. In its simplest
form, such a house was a rectangular block on two floors,
the lowest generally vaulted and unheated, providing storage.
An external (or occasionally an internal) stair led to the upper
floor which normally consisted of two rooms, a hall and smaller
parlour. A good example is the ruined 'palace' at Lydstep, late
C13 or early C14, where the hall was accessed at first-floor level
via an external stair, and was heated by a central hearth. Better
preserved is the probably C14 first-floor hall in the priory
complex at Caldey Island, the upper room with a good kingpost
roof. The presence of the building adds an unexpectedly secular
44 note to the priory. A more ambiguous case is Eastington, Rho-
scrowther, which seems to be a large C14 cross wing to a now
vanished hall, consisting of a long main block with a vaulted base-
ment, first floor and crenellated wall-walk. At one end is a narrow
turret, vaulted at both levels, and the range seems to have abutted
a ground-floor hall, which was subsequently demolished. Oddly,
there is no communication with the lost range; the first floor is
reached by an external stair. Was this range a dower house or the
equivalent of the 'private hall' of the bishops' palaces? Problem-
atic too is the building at Pentre Ifan, Nevern, thought to be a
gatehouse range for a now-vanished manorial complex. The
building, late C15 or early C16, is a single long range with a Tudor-
arched central access way. Over a low ground floor with timber-
beamed ceiling was a first-floor room with fine oak collar-truss
roof, partly smoke blackened. The original function of this build-
52 ing is far from clear. On a lesser scale is Carswell, Penally, a late
C14 or C15 rectangular hall house with barrel-vaulted undercroft
and vast square gable chimney heating both floors. Each storey
is separately accessed.

## Tower Houses

Tower houses can be found throughout Wales, but are most
common in the more prosperous parts of the south, especially
close to the sea. No doubt the majority were built to take into

account pirate attack from navigable rivers. In Pembrokeshire, two main types existed, the truly defensible tower, and the combination of towers with hall.

The late c14 or c15 Old Rectory, Angle, is a tall square tower, with projecting stair-turret in one corner and vaulted basement, above which are three storeys, each comprising a timber-ceiled room complete with fireplace and plenty of windows. Large double corbels no doubt supported a timber wall-walk and the well-carved first-floor doorway was originally reached by a ladder. The tower forms part of an earlier complex, originally moated. Sandyhaven, St Ishmaels, seems to have begun as a late medieval or c16 tower house, much extended and raised in the c17. 51

More overtly defensive is Upton Castle, complete with turrets, where the c13 hall seems to have been at second-floor level, heated by a fine fireplace. First-floor entrances existed to the north and south, defended by small turrets and corbelled battlements. 25

By far the majority of towers appear to have been combined with a hall, as at the Fortified Rectory, Carew, where the hall was much remodelled since, and at Haroldston and Upper Lamphey Park where in both cases the hall has been destroyed. At the very ruined Boulston, a tower-like structure of three storeys was attached to the first floor, perhaps in the c16. No detail survives, but the very thick walls suggest it may have been defensive.

*Ground-Floor Hall Houses*

Across Wales, few hall houses of this type survive unaltered: many have been reconstructed and floors inserted. Yet clues in the form of blocked openings and smoke-blackened trusses usually exist. In Pembrokeshire, due to the lack of dateable stone details and the virtual non-survival of medieval carpentry, ground-floor halls are harder to identify. Fenton (1810) described one of the houses in the cathedral close, the Chancellor's House, as having 'a great hall . . . with a dais . . . at the end'. Two main plan-types occur, the three-unit hall (hall flanked by service rooms at one end and private rooms at the other) and the end-hall (hall with a storeyed unit at the screen end, containing service rooms with the solar above).

Garn, Llanychaer, is a rare survival of a house which never had a first floor inserted. The plan is of three units. It may well be c16 or even c17 rather than genuinely medieval as it has many of the typical hallmarks of post-medieval Pembrokeshire vernacular architecture, such as outshuts, and a massive lateral chimney with conical shaft. Much more altered is Good Hook, Uzmaston, where the arched cross-passage doorway survives and the later fireplace has a circular chimney. Old Chimneys, St Florence, has two massive rounded lateral chimneys, that to the rear possibly later. The plan is much altered, but the pointed door looks late medieval. 55

Thorne, St Twynnells, shows the complexity of hall-house development. Its massive projecting square stack and arched entry may be early c16. The original building may have been a hall and narrower parlour and a now-missing service unit. The hall was open to the roof and the parlour lofted, with a stone stair from the hall. The lateral fireplace may have been added within the width of the original hall when the eaves were raised and the service end rebuilt in the c17. The outshut by the fireplace rather than being a later addition may actually represent the original width and height of the medieval hall.

53    Pricaston, Castlemartin, was an end-hall, with the solar above the service rooms at the screens end. The cross-passage has pointed doors each end and a flattened vault. The similar arches in the passage partition led into two vaulted storage rooms. From the hall (much remodelled in the c18), a stone stair wound over the end of the passage into the solar, which was heated by a lateral fireplace. The core of nearby Flimston, similarly ruined, seems to be an end-hall and cross-wing, but later modifications make the location of the medieval cross-passage uncertain.

*Town Houses*

Continuous rebuilding in the medieval towns of the county has left few medieval houses intact. What survive are vaulted under-crofts and cellars, the best of which is the c13 crypt near the top of High Street, Haverfordwest, with quadripartite vaults upon round piers. In towns like Haverfordwest, where the terrain is steep, some houses had a vault entered from a lower level, as at the three houses now forming Swale's shop in St Mary's Street. Timber building was another option for steep streets and Nos. 9–13 High Street are the sole survivors of a number recorded before the c20 in Haverfordwest, though altered. No other medieval timber-framed buildings are known to survive in the county: indeed timber construction may be more related to met-ropolitan status rather than to lost buildings in the countryside. Stone corbelling, as seen in Sun Alley, Tenby, or on the group of medieval houses at Westgate, Pembroke, perhaps preserve a memory of widespread timber construction in the county before timber became scarce in the c16. Of houses with upper floors that survive to an appreciable extent, No. 15 High Street, Haver-fordwest, seems to have been a first-floor hall with a large c15 mullioned window. The c16 'Old Chapel' behind No. 73 Main Street, Pembroke, also has the main accommodation on the first (altered) floor above a vaulted undercroft.

A few houses show that not all had their main rooms on the first floor. Plantaganet House, Tenby, has its main fireplace on the ground floor, with a fine circular chimney. The adjacent
54    Tudor Merchant's House also has a large fireplace on the ground floor. The gabled façade with its corbelled upper chimney and mullioned window is the best preserved medieval town house and even retains its original roof of raised crucks. However, even this

was part of a much larger complex, traces of which remain embedded in the immediately surrounding houses.

Nothing survives in the north of the county, where perhaps not all the earliest medieval buildings were of stone or even timber. Excavations in Newport, in 1991, revealed the remains of three rectangular buildings which were originally walled in clom (clay) and roofed in slate.

# CHURCHES FROM THE SIXTEENTH CENTURY

*Churches and Monuments C16–1750*

Despite the vast amount of destruction to monastic buildings and church fittings, church building is unlikely to have come to a complete standstill during the rest of the C16. Some of the towers may date from this period: Begelly and Lawrenny in particular seem to be distant echoes of the richly Tudor tower at Carew, 50 and the odd turrets at Minwear, Cosheston, Yerbeston and East Williamston seem post-medieval in appearance. A number of arcades are C16, most notably that at Ludchurch with round piers and Tudor arches and also the similar if cruder aisle at Rudbaxton. A group of small chancel aisles belongs to this period also, including Llanddewi Velfrey, Rudbaxton, Llawhaden and St Florence, all with Tudor arches or similar, with round piers, their caps either ornamented with shields or, rather archaically, cable mouldings. Of the C17 virtually no identifiable work survives and certainly nothing which can be regarded as up-to-date. Indeed, by the late C17, the decline of Anglicanism was exacerbated by the steady growth of Nonconformist societies which, by the early C18, were building their own meeting houses.

MONUMENTS, especially of the C17, are the largest survival. The elaborate White tombs at Tenby of *c.* 1500–10 have already 65 been mentioned. The Bath stone chest tomb of Richard Wogan, †1541, at Burton has arcaded sides with heraldry and rebuses, but a reused earlier lid. At Monkton, a well-carved canopy tomb survives, probably early C16, with spiralled columns and leafy crestings, but the inset brasses are missing. By the C17, chest tombs become rarer, but that to Sir John Carew, †1637, and his 68 wife at Carew is complete with finely dressed effigies, the chest with characteristic kneeling children.

From the early C17, a popular monument was the canopied chest tomb, set against a wall, a type in vogue from the late C16 across Britain. No doubt they were imported, perhaps from the Midlands or, given close trade links with the west country, the Bristol area. The series begins with the tomb of Sir Francis Meyrick, †1603, at Monkton, the chest with kneeling children, the fragment of the upper part in finely carved alabaster, suggesting a Midlands workshop. In the same church, the tomb of Sir John Owen has carved panels, the upper portion with typically debased Ionic columns. The monuments to Margaret

Mercer, †1610, at Tenby, and Thomas Lloyd, †1612, at St Davids, both have effigies with carved children on the chest. The tomb
67 of Roger Lort, †1612, at Stackpole preserves its original colouring, the chest characteristically crowded with kneeling children, but instead of recumbent effigies, Lort and his wife are shown as praying figures within niches, a very popular type in the early C17. The wall monument to William Risam, †1633, at Tenby has a single kneeling figure framed by Ionic columns.

Pembrokeshire is not rich in BAROQUE MONUMENTS. Some are crude, such as that to Jenkin Vaughan, †1675, at Jordanston, with swan-necked pediment, but still with Jacobean-style tapering pilasters. Some are of real quality such as Evan Owen, †1662, at Llawhaden, an oval plaque with fine lettering in Latin and elaborate surround. The monument of Lewis Barlow, †1681, at Lawrenny, has an oval tablet within a canopy, its curtains pulled by putti. The tablet to Lady Jane Mansel, †1692, at St Petrox, is surprisingly large with an elaborately carved surround: especially notable is the deeply undercut heraldic cartouche.

Most memorable of all the C17 memorials is that to the
69 Howard family at Rudbaxton, of *c.* 1685, occupying the whole east wall of the aisle, with near-lifesize figures set high in theatrical recesses, husband and wife in the centre, flanked by son and daughter, all splendidly dressed.

C18 monuments display a more restrained classical taste. At Stackpole is a large veined-marble tablet to Sir John and Hester Lort, erected 1712, a fine piece, stepped back each side and topped by a large cartouche. The monument to Owen and Elinor Phillips at St Thomas, Haverfordwest, erected after 1748, has scrolled sides, the vase in the broken pediment adding a classical note. The tablet is signed by *Thomas Beard* of London.
70 Another London piece, but unsigned, is the fine classical marble column in St Mary, Tenby, erected *c.* 1737, in memory of Thomas Rogers, London mercer.

The large tablet at St Michael, Pembroke, to Dr John Powell †1734, is more characteristic of the period, with fluted Corinthian pilasters, segmental pediment with cartouche, and gadrooned apron. The finest of the early C18 is that to Sir John Philipps, †1736,
71 at St Mary, Haverfordwest, one of the commissioners for the fifty new churches of the Act of 1711. This is a large and finely carved tablet by *Christopher Horsnaile* of London, one of Gibbs' chief masons and partner to Edward Stanton, made of finely-veined marble, with composite columns carrying a broken pediment which bears lively putti. The composition of the bust atop the monument was, according to Margaret Whinney, inspired by Rysbrack's monument to Matthew Prior (1723) at Westminster Abbey.

A few small BRASSES survive at St Mary, Haverfordwest (†1654), St Mary, Pembroke (†1688), and St Petrox (†1674).

*Churches from 1750*

The period 1750 to 1830 has left very little in the county. This was a time more significant for minor repairs or dilapidation than

rebuilding, and the repairs have been obliterated by Victorian restorers. The turning point at St Davids may be between the collapse of the Lady Chapel vaults in 1775 and the launch of the appeal for *Nash*'s new west front in 1789, but elsewhere it was not until much later that the era of restoration dawned. Typically in 1802 the spire of St Marys, Haverfordwest, was removed as dangerous, and parsimony prevented its replacement. The only significant new church of the LATE GEORGIAN period was at St Katharine, Milford (1802–8), where the ugly exterior rough- 89 cast (replacing a stone-coloured stucco) conceals a plaster Gothic interior of spare elegance, designed possibly by the exiled French naval architect *J.-L. Barrallier*. There was a naval context to the next important church, the Dockyard Chapel at Pembroke Dock, of 1830–1, by *G. L. Taylor*, architect to the navy; a simple late Georgian classical church with tower and cupola, the only classical church in the county. The tiny church at Capel Colman, 90 1835–7, designed by the Cilwendeg estate builder, *Daniel Davies*, suggests that even where money was available, church building was not a prime area for gentry spending, as compared in this case with housing pigeons. In contrast, Slebech, 1838–40 by *J. H. Good*, built for the Baron de Rutzen, stands alone as the quintessential estate church, spired and sited for prominence, in a lancet Gothic of a metropolitan confidence, if not correctness.

The era of what might be termed CHURCHWARDENS' REPAIRS transformed the churches of the county with sash windows and simple timber furnishings, but the evidence of this phase has been all but obliterated. Photographs and plans before the Victorian restorations tend to show the smaller churches of the north of the county as already almost without medieval features. Bridell was rebuilt in 1812, Moylgrove in 1814, Eglwyswrw in 1829, Newport in 1834–5 and Cilgerran in 1839. Pre-ecclesiological interiors are at Bayvil, of delightful and luminous 92 simplicity, probably *c.* 1830, and Manordeifi, where the ranks of box pews, with larger gentry pews at the four corners, seem quintessentially late Georgian though the evidence points to an extraordinarily late date of 1847. Nash (1842), rebuilt by *George Gwyther*, still has its double-decker pulpit, west gallery and box pews. Llanstinan, repaired without a trace of ecclesiology between the 1830s and 1850s, shows that a poor parish without patronage mended where it could, without higher aspirations.

## The Gothic Revival

The foundations of Anglican regeneration in the diocese were laid by Bishop Thomas Burgess from 1803, but the era of church rebuilding follows the succession of Connop Thirlwall, bishop 1840–74, the first for centuries to be enthroned in the diocese, to be resident, to learn Welsh, and not to have more important preferments elsewhere. The architectural tide turned slowly: Llanrhian, 1836, has crude battlements and transepts but large Georgian Gothic windows, which were still being installed as late as 1859 at Llanfihangel Penbedw (Boncath), and 1861–3 at

Hayscastle. A thin Tudor characterizes Llanfyrnach, 1842, with its delightful struggle to suggest that the tower openings are functional. Redberth, of 1841, is lancet Gothic with a curious tower, an engineer's version of the simplest Commissioners' church designs, and Clarbeston, also of 1841, was similar. Correct Gothic detail arrived, as might be expected, from outside, with *J. P. Harrison* of Oxford, whose church at Pembroke Dock, 1845–8, is also notably advanced in looking to local models, the Tenby triple gable, and the south Pembrokeshire tower. Remarkably, a local architect, *Joseph Jenkins*, looked to the same tower type at St Edrens (Hayscastle), in 1846. Next, at St Dogmaels, 1848–52, *A. Ashpitel*, of London, introduced a simple but well-detailed E.E., the style recommended for torrid climes and low budgets.

New churches and restorations were funded from local sources, generally inadequate, aided by the Incorporated Church Building Society, whose heroic efforts to foist good design on parishes with minimal funds deserve recognition. The cry that the church was ruinous, the parish both impoverished and Nonconformist in religion, and that there were no resident gentry, echoes through the diocesan files. Church building funds were generally raised by subscription, rarely given by a single patron, Lord Cawdor being the only church-building landowner of significance, the gentry generally contributing to subscription lists organized by the clergy. Pembroke Dock church was promoted by the Rev. James Allen, successively Canon, Chancellor and Dean at St Davids from 1847 to 1895, whose influence, more than that of any of the bishops, guided and animated Anglican rebuilding. Two notable clerical patrons each introduced their own architect to the region: Bishop Lewis of Llandaff employed *Prichard & Seddon* around his home estate at Llanddewi Velfrey, and the Rev. Gilbert Harries, rector of Gelligaer, Glamorgan, employed *Charles Buckeridge* and then *J. L. Pearson* around his home estate at Solva. Wholly new churches were rare, though the more thoroughgoing restorations might finish as apparently new buildings, and the new churches were economical by national standards. The £4,000 spent at Pembroke Dock, at the beginning of the period, and the £6,400 at Goodwick at the end, in 1910, were exceptional sums, and give a regional perspective set against the £70,000 spent at All Saints, Margaret Street, London, or the £10,000 at St Augustine, Penarth, Glamorgan.

At the CATHEDRAL, *Butterfield*'s repairs of 1847 introduced careful Dec tracery, admittedly where none was previously present. Puginian dislike of late Gothic influenced a generation of restorers at St Davids, though it must be said to less destructive effect ultimately than elsewhere in Britain, as funds were not available for more than a limited return to C12 and C13 originals. The major restoration started with *George Gilbert Scott*'s report of 1862, initiating a half-century programme that began with the rescue of the tower, and continued with the repair of the choir, the re-roofing of the choir aisles, the transept ceilings, the restoration of the nave and the rebuilding of the west front in the early

1880s. Undoubtedly Scott saved the building, and his replacement of the C15 E window with lancets was based on evidence found. His own contribution is generally workmanlike and unostentatious. His new West front follows what was known of the pre-Nash front, if anything the main aesthetic failure being that here he did not go far enough, in keeping the late medieval low-pitched gable. The encaustic tiles of the choir are particularly fine. *John Oldrid Scott*, already assisting his father in the 1880s, continued the work, re-roofing the eastern chapels in the 1890s and restoring the Lady Chapel vault in 1900–02, finishing in 1912–14 with Lady Maidstone's restoration of St Edwards chapel, work completed by his successor *W. D. Caröe*.

The era of Victorian CHURCH RESTORATIONS began in earnest by 1850, with individual architects garnering numerous commissions which, mostly by reason of cost, were neither memorable nor sensitive. Two early restorations stand out: *George Gilbert Scott* rebuilt Stackpole church for Lord Cawdor in 1851–2, with solid Dec detail, notably the roof; and Pugin's biographer, *Ferrey*, rebuilt Cilgerran (replacing a church badly built in 1839) in 1853–5 with tracery of luxuriant English Dec taken from Parker's *Glossary*. These two represent that first phase of ecclesiology as defined by the Cambridge Camden Society, later the Ecclesiological Society, rooted in C14 Dec culled from the best English examples. That there were few such restorations was a function of cost: Cawdor's bill, at £1,800, though not high by comparison with England, much exceeded the norm of between £500 and £1,200. Cilgerran cost only £700, without the fittings and glass.

Relatively few architects gathered in the majority of restoration commissions, hardly any of them local. *Joseph Jenkins*, of Haverfordwest, had some minor work in the 1840s and rebuilt Walton East in 1853, and probably Llanfair Nant y Gof (Trecwn), 1856, but his Gothic was already old-fashioned. The outsiders generally had a large, even national, practice in which their west Wales commissions were relatively minor, and few stand out as major works of a particular architect. *David Brandon*, with the patronage of Lord Cawdor, had the best commissions in the south of the county from 1850 (Penally 1850, Carew 1856, Castlemartin 1857, St Twynnells 1858, Wiston 1864). His major work was at Tenby 1855–69, where typically he replaced the original but plain late Gothic windows with more conventional designs. *R. K. Penson* restored across the county, as he did across Wales, from the 1850s (St Petrox 1853, Angle 1855, Amroth 1855, Roch 1858, St Nicholas 1865), building new at Dinas 1860 and Mathry 1865–8, the latter on its hilltop site of a rugged appropriateness. In the 1870s *Lingen Barker*, of Hereford, garnered many of the commissions where a few hundred pounds were spent gutting, rewindowing and refitting a small church. His bi-colour voussoirs and pitch-pine pulpits may stand for a workmanlike insensitivity (Freystrop 1873, Nolton 1876, St Lawrence 1876, Granston 1877, Steynton 1879, Henry's Moat 1884 and many others), but Barker wrote sensitively in the local press about the buildings

he so altered. *F. Wehnert* seems to have been kindred in spirit, at Manorbier 1865, Rhoscrowther 1869, Walwyn's Castle 1869 and Uzmaston 1871, spoiling the Georgian character at Milford, 1866–9. *John Middleton* of Cheltenham had commissions across Wales, his High Victorian punch rarely present in the Pembrokeshire works. Newport 1878, has some vigorous detail, and there are good roofs at Maenclochog 1880, Eglwyswrw 1883 and Clydey 1889, but the restorations erase any earlier character. *C. E. Giles* of London restored St Mary and St Martin, Haverfordwest, in the 1860s, but the broach spire he designed for St Mary was not built.

Of the leading Gothic architects, *G. G. Scott* secured no more parish work, and major names occur sparsely. *Prichard & Seddon* had early commissions through Bishop Lewis of Llandaff, at Lampeter Velfrey and Llanddewi Velfrey, both 1861, with characteristic big-boned roofs, but their new church for him at Templeton, 1862, is more economical than characterful. *R. J. Withers*, an under-rated High Victorian with a national practice, restored Nevern with elegant ogee tracery, 1862–5, but his most interesting work is where the money was short and his angular solid geometries and spare detail are more characterful than others could be with far greater resources: Monington 1860, Meline 1863, and Moylgrove 1866. His early Llanfair Nant Gwyn 1855, shows a more attenuated character with its sharp timber spire. *Talbot Bury*, a Pugin pupil, restored Burton 1867, and Jeffreyston 1868, with sturdy arcades based on Castlemartin. *Charles Buckeridge* was employed by the Rev. Gilbert Harries, restoring St Brides 1869, Whitchurch 1872, and Marloes 1875, all with sensitive detail. Buckeridge died in 1873 so *J. L. Pearson* came in to finish the works, also to restore St Mary, Pembroke, 1874–8, without particular character. Pearson's little church at Solva, 1877, does have a finesse of detail combined with robust structural colour. *Edwin Dolby* of Abingdon, a little-known figure who had two commissions in the county, shows a similar finesse at Llanychaer, 1876, for only £700, the handling of the stonework enough to show the gulf between skill and run-of-the-mill. *T. G. Jackson* restored Gumfreston 1869, and Robeston Wathen 1876, both attractively roofed, but his work at Narberth, 1881, is of a different order, a rare step aside from the conventional, the very broad nave ending at a triple chancel arch on thin columns, a novel variant on the Gerona cathedral plan.

Late C19 restorations of note are rare: *J. P. Seddon*'s roof at Camrose, 1883, *S. W. Williams*' expensive and old-fashioned High Victorian work at Cosheston, 1885, *Bruce Vaughan* at Begelly 1887, a sensitive unknown hand at Llanhowell, 1889, and some attractive tracery at Llanrhian, 1891, by *Seddon & Coates Carter*. The unfinished R.C. church at Tenby, 1892–3, by *F. A. Walters* shows a nice touch of sensitivity in a well-judged relation of wall to tracery. *F. R. Kempson* restored widely but unexceptionally, at Dale 1890, Johnston 1890, Ludchurch 1892, and Clarbeston 1892. Smaller church works in an Arts and Crafts vein are the Church Hall at Camrose, *c.* 1884, probably by *Coates Carter*,

and the Art-Nouveau-tinged lychgate at Stackpole, 1898, by *C. H. P. Turnor*.

In the early C20 *W. D. Caröe*, as diocesan architect, restored unobtrusively at St Mary, Haverfordwest, in 1903–5, but his best church work in the diocese is at the cathedral, or outside the county. *Coates Carter*'s restoration of the island church on Caldey, 1907 and 1923, is of exemplary simplicity. At Llandeloy, which he restored from roofless ruin in 1926, Carter showed, too late, how the small churches of the county could have been restored without alien tracery and mechanical furnishings. The local architects *Wood & Gaskell* neatly extended the remarkable plaster Gothic of 1802 at Milford in 1906, though their added chancel is more conventional.

Of new churches, *Coates Carter*'s Caldey Abbey church of 1907–13 is in a simplified Romanesque, a distillation of historic precedent, stripped to bare essentials primarily for reasons of cost. The fire of 1940 destroyed the interior, but the modernity of the white roughcast exterior still startles, as does the stylistic freedom of the abbey buildings themselves. Goodwick church, 1910, by *E. M. Bruce Vaughan*, with railway money, is a sole example of that free late Gothic that Vaughan, and also G. E. Halliday, introduced across industrial south Wales, in the school of G. F. Bodley, its tower a fine landmark. The Fishguard R.C. Church, 1916, is a simple roughcast building with arched windows.

After the First World War only two churches, at Neyland, 1928–30, and Hundleton, 1933, by *W. E. Anderson* stand out, the one roughcast in a minimal Gothic, and the other in brick in the round-arched Italian style then enjoying a revival. There has been no post-war new church building of note.

*Church Fittings*

Hardly any fittings of the Georgian period remain, apart from the fine white marble bowl font at Dale, 1761, a late C18 baluster font at Roboston Wathen, and the Egyptian porphyry urn at Milford that Bishop Burgess rejected as a font, not as un-Christian but as idolatrous of Lord Nelson.

Plain late Georgian to early Victorian panelled box pews and pulpits survive at Bayvil and Manordeifi. Manordeifi has painted timber rails to a pretty quatrefoil pattern. Milford has some brought-in earlier C19 timber stalls and sedilia of unknown provenance, of an exaggerated Gothic angularity. A w gallery of 1835 survives at Capel Colman, and one of 1842 at Nash, which is a model pre-ecclesiological interior with box pews and two-stage pulpit. Redberth, of 1841, has Gothic panels to box pews and pulpit, but no gallery.

With the restorations after the mid-C19 the standard set of parts: pulpit, lectern, pews, stalls, rails and tiles, rarely achieves the notable. The radical clarity of *Withers*' very simple timber furnishings stands out, at Llanfair Nant Gwyn, Meline, Nevern, Moylgrove and Monington, as do the High Victorian geometries

of his stone fonts and pulpits. *Prichard & Seddon*'s High Victorian emphasis on exposed construction shows in the pews at Llanddewi Velfrey and Lampeter Velfrey, the latter also with good stalls and pulpit. Later furnishings by *Seddon* at Camrose and Llanrhian are less doctrinaire, the pews at Llanrhian, 1891, particularly neat. *T. G. Jackson*'s tub font and oak pulpit at Robeston Wathen, and polychrome pulpit at Narberth, show a High Victorian vigour, lost by his last work in the county at Lawrenny. The quintessential High Victorian squat columns crushed by massive masonry appear in the pulpit at Pembroke Dock, of 1879, by *Wilson, Willcox & Wilson* of Bath, together with a ponderous font and, unusually, a wrought-iron screen. Another such, by Lingen Barker, is at St Michael, Pembroke, 1887. *Brandon*'s fittings are rarely memorable but the iron railings at Tenby churchyard, 1869, are the best Victorian Gothic wrought ironwork in the county. *F. A. Walters*' font at Tenby, 1886, may stand for all that money could buy in over-indulgence in carved Caen stone, and the rescued font and reredos of 1879, by *J. P. St Aubyn*, at Manordeifi New Church, demonstrate the same in multi-coloured marbles, both forms of display rare in the county. *Pearson*'s reredos at St Mary, Pembroke, 1893, carved by *Nathaniel Hitch*, and the reredos of 1895 at Cosheston, are other examples. *Scott*'s fittings at St Davids, by contrast are modest, only the encaustic tiles and the mosaic panels of 1871, by *Hardman*, made by *Salviati*, stand out. His fittings at Stackpole of 1851 are correct, if not exceptional. The chancel at Monkton, restored 1887–95, has the remnant of a full scheme of painted decoration, which with the stained glass and two superb hanging coronae makes for a lavish late-Victorian ensemble, better from a distance than in detail.

Notable fittings of the early C20 include the font by *Eric Gill* at Caldey, 1906, massively square with twisted corner shafts, in the spirit of the C12. *Coates Carter*'s painted reredoses at Carew, Angle and Walwyn's Castle, are less conventional than his elegant late-Gothic carved screens at Milford and Pembroke Dock, but disappointing. His screen at Llandeloy, 1927, is a quite delightful work; the incorporation of the pulpit into the screen is done in a similar way at Hubberston, 1929–31, by *J. B. Fletcher*. At Herbrandston, a *Coates Carter* altar and reredos of 1927, accompanies a good set of conventional oak fittings of 1904 by *C. F. Whitcombe*. Goodwick has carved stone and wood work of quality made by *Clarke* of Llandaff, including the font and pulpit. *Caröe*'s fittings at Haverfordwest, 1905, oak pulpit at St Issells, 1920, and hanging rood at St Davids, 1932, are fine works, though it still seems hard to love the superbly-carved alabaster fitting-out of St Edward's Chapel at the cathedral for Lady Maidstone, 1914–25. The painted carved reredos at Manordeifi New Church, by *Martin Travers*, 1922, shows an attempt to leave the Gothic, but for an unconvincing semi-Baroque. Caldey Abbey had the finest collection of early C20 fittings, including the reredos by *F. C. Eden*, all dispersed, or lost in the fire of 1940. The principal new fittings of after the Second World War are in the cathedral. The

rebuilt organ, of 1953, had a case by *Alban Caroe*, in a late C17 style with delicately carved scrollwork. Caröe's charming choir organ case, of 1956, survives, the main organ being rebuilt in 2000, for which *Peter Bird* redesigned the case in similar style, but with more emphatic cornicing. The gates to the Lady Chapel, designed by *Martin Caroe* and made by *Frank Roper*, 1977–8, with applied linear metal extrusions, have an acid modern Gothic character, akin to Roper's heavily-leaded stained glass.

## Stained Glass

The first Gothic revival glass in the county may be the brightly coloured window, dated 1843, in St Mary, Haverfordwest, the artist unknown. A set by *Hardman* is said to have been installed at Castlemartin in 1850–1; one window survives. The *Wailes* window at Penally, 1851, and the E window of 1852 at St Dogmaels, by *Joseph Bell*, may have been the next. Most churches had to be content with patterned or stamped quarries until stained glass was donated. This patterned glass can be attractive, for example, the grisaille glass at Stackpole, of 1852, and stamped quarries at Roch, of 1860, by *Powell*. Cilgerran has a particularly fine set of glass of 1854–60, spanning the period of change from painterly designs to those where the lead-work delineates the composition. The two large E windows, by *Wailes* and *O'Connor*, are of the latter type, and the set of deep-coloured windows by *Ballantine*, of the earlier. Other notable mid-Victorian windows include those by *Wailes* at Tenby 1856, Angle 1860, St Mary, Haverfordwest 1864, and St Issells 1865, and by the *O'Connor* brothers at Angle 1860s, and Stackpole 1862. The *Clayton & Bell* windows at Lampeter Velfrey 1860, and Llanddewi Velfrey 1861, have a particularly fine Gothic line and colouring, the large window at Tenby 1869, is more conventional. The *Lavers & Barraud* little E window at Meline 1865, has a lovely rich colour, by them also windows at Nevern 1864, and Lamphey 1871. The work of *Hardman* is reliably good, at Burton 1867, though the presbytery lancets at St Davids 1870, are set too high to appreciate. The fine E window of 1869 at St Brides has been attributed to *Bell & Almond*. Early *Heaton, Butler & Bayne* glass at Wiston *c.* 1865, Burton *c.* 1867, and Jeffreyston 1868, shows the High Victorian quality of the firm before their late-C19 slide into muddy colours. There are interesting windows by unknown artists at Walton West *c.* 1860 and 1870, and at St Brides *c.* 1870 and *c.* 1880.

Later Victorian and Edwardian glass is mixed in quality. The later Clayton & Bell is more muted, but still good, at St Mary Pembroke *c.* 1879, and Stackpole 1882. The *Morris & Co.* window at St Florence, 1873, is the real thing; the Annunciation by Morris, first used at Dalton, Yorks., in 1868. The other Morris windows are of the earlier C20, still using Burne-Jones designs, at Roch and St Martin, Haverfordwest, the Burne-Jones colours still richly glowing. The *Cox & Co.* window at St Michael, Pembroke, 1887, is bizarrely coloured; by contrast the *W. Taylor*

window at Tenby, of 1894, is attractively muted. *Herbert Davis*, at the turn of the century, has a particularly opulent palette, at Pembroke Dock 1898, and Monkton *c.* 1902–6. *C. E. Kempe*'s E window at St Mary, Haverfordwest, 1893, is particularly rich in Kempe's German C16 style, with a much more startling coloration than the later works of the firm, after his death. The E window at St Mary, Pembroke, 1907, is one of Kempe's last works. The works of the firm, *Kempe & Co.*, from 1907 to the 1930s, continue the superb craftsmanship, though it became repetitive in drawing style and more conventional in coloration. Notable examples are at St Mary, Pembroke, Pembroke Dock, Tenby and St Davids Cathedral.

Other than *Kempe & Co.*, post-1918 glass rarely lifts above the commonplace; Fishguard is particularly full of the ordinary. However the N-aisle window at Tenby, by *Karl Parsons*, 1920, is outstanding in its deep colours and use of opaque and rough glass in a modern way. His other window at Tenby, 1909, still Arts and Crafts, is less striking. The window by *Mary Lowndes* at Spittal, 1920, uses a similar palette and textures. The glass made by the monks of Caldey Abbey in the 1920s under *Dom Theodore Baily*, a quintessential Arts and Crafts studio, produced some windows of exceptional brilliance, notably those in the two island churches, and in the abbey itself. The unexceptional middle ground of the pre-1939 period is represented by the glass by *C. C. Powell*, at Goodwick and Walton East, and the numerous works of *R. J. Newbery*.

Postwar stained glass in the region is dominated by the Swansea firm of *Celtic Studios*, founded by *Howard Martin* just after the war. Martin's designs are Modernist-Figurative, with some boldness of colour and leadwork, the best of the 1960s, the later work tending towards acid colours and repetitive design. There are windows in the county from the beginnings of the firm, Jordanston 1949, through to the 1980s, a set of the 1970s at Hundleton. The principal national firm of the period was *Powell* of Whitefriars, whose competent glass of the 1950s can be seen at St Mary, Haverfordwest, Herbrandston, and Uzmaston. At the cathedral the two W roundels, of 1956, by *William Morris Studios*, have a robust brightness and intense drawing; the *Carl Edwards* window of 1958, by contrast, sets the figures against pale-to-clear backgrounds striated with diagonal crossed lines. The county has little in the way of really modern glass; the *Roy Lewis* window at Little Newcastle, 1966, has the angry strength and bold colour that marks Lewis as a remarkable talent, lost to Wales when he emigrated to Australia. *John Petts*, of Llansteffan, produced fine glass from the 1970s, his best work in Carmarthenshire; the E and W windows at Fishguard, of 1986 and 1989, are figurative with a childlike concentrated simplicity both of colour and drawing. The windows of 1974 and 1978 at Talbenny, by *Frank Roper*, have his characteristic very heavy leading, single hieratic figures on backgrounds of curving lines. One notable late C20 commission was at Little Newcastle, where *Caroline Loveys*, recently graduated, was given a commision for five windows in

1996, where muted colours and lead-work in simple intersecting curves give a focus on single figures (each of Christ), in grisaille with single-colour drapery.

## Church Monuments 1750–1950

Locally, the Baroque influence in church monuments carried on well into the late C18, the usual composition of pilasters, pediment and vase or shield increasingly restrained. A good example is Sir John Philipps, †1764, at St Mary, Haverfordwest. Many of these are of good quality, but nearly all are unsigned and one suspects that the majority were imported from Bristol or London. The monuments to William Allen, †1758, Marloes, and David Mackenzie, †1781, at St Michael, Pembroke, are among a small group expensively utilizing a variety of coloured marbles, as so often found in later C18 chimneypieces. Much more serious is the tablet to Charles Gibbon, †1779, at Uzmaston, with Ionic pilasters and broken pediment. The NEOCLASSICAL style is well seen at St Thomas, Haverfordwest, with the monument to Elizabeth Eliot, †1780, accompanied by a carefully carved landscape containing a mourning woman. Such motifs, as well as wreathed urns and sarcophagi, remained popular well into the mid-C19, many made by Bristol firms such as *Tyleys*. Mention here must be made of the memorial to John Grant, †1790, at Roch, made of *Mrs Coade*'s artificial stone, a delicate female on a classical pedestal. The highly prolific *John Bacon the younger*, made the monument to Hugh Owen, †1809, at Monkton, complete with the weeping woman, sarcophagus and broken columns. Rather more chaste, and also of 1809, is Hugh Barlow's large white-marble sarcophagus at Lawrenny, accompanied by a big pair of Neoclassical vases. A prolific and highly competent local maker was *Daniel Mainwaring*, of Carmarthen, who could be relied on to work up a variety of Grecian patterns, but largely based on fairly standard formulae, e.g. his monuments of 1823 and 1833 at Capel Colman, 1822 at Cilgerran and, more individually, that of 1815 at Rudbaxton, a big sarcophagus with recumbent lion. *John Phillips* of Haverfordwest signed the large memorial to Richard Philipps, Lord Milford, †1823, at St Mary, Haverfordwest, ambitious in scale, but utterly disparate in composition. *Edward Physick* signed three monuments (Jordanston 1837, Tenby 1841, and Manordeifi 1852). According to Gunnis, the Tenby monument to Captain Bird Allen is his best work, a tablet of pure white marble depicting a seated mourning youth with a banner on his shoulders, the folds falling behind him. Also providing a telling contrast with local makers is the work of *J. Evan Thomas* of Brecon and London, who studied under Chantrey. His monument to Hannah Bowen, †1845, at Carew has the usual formula, a weeping woman and sarcophagus, but typically crisply executed.

After this period, the Grecian style remained the province of local masons, of diminishing quality. The GOTHIC STYLE is far less represented, but began early at Cilgerran in 1837, where the

white tablet to Abel Gower is signed *T. Marsh*, of London. The big tablet to John Hensleigh Allen, †1843, at Jeffreyston, is far more flamboyant, with crocketed gable and pinnacles.

The best of all later C19 monuments is that to John Frederick, Earl Cawdor, †1860, at Stackpole, by *James Forsyth*, and illustrated in *The Builder* in 1862. This takes the form of a well-carved effigy on an ornate chest, a thoroughly Victorian response to the fine medieval tombs in the church.

Mosaic tablets became increasingly in vogue from *c*. 1900: much the best is that to Bessie Henderson, †1919, at Tenby, made by *Karl Parsons*, Art Nouveau, depicting a woman with lamp. In the Lady Chapel of St Davids Cathedral is the memorial of Bishop John Owen, †1926, (who oversaw the restoration of the chapel), an effigy in full-blown Gothic style, complete with elaborate pinnacled canopy by *W. D. Caröe*. The story ends, also at the cathedral, with the extraordinary tomb to the Countess of Maidstone, †1932, also by *Caröe*, a massive tomb-chest with reredos, all carved of alabaster, Gothic in form but with Greek key ornamentation copied from the Romanesque building. This set-piece is perhaps more impressive for its craftsmanship than good taste.

EXTERIOR MEMORIALS are all too often ignored. Most are C19 and display the real talent of local masons. Of note are the gravestones of north east Pembrokeshire, using local slate. The vast graveyard at Newport is particularly memorable for its fine gravestones, many with half-columns and pediments, many in memory of local sea-captains. At St Brides is a fine sarcophagus of 1836, near the s porch, signed by *Thomas Morgan*, of Haverfordwest. Interesting too, are the memorials in the same churchyard, 1881–91 in memory of the Kensingtons of St Brides Castle, full of Celtic detail and Freemasonry symbols. Of note also, the oak Celtic crosses in St Davids churchyard, at Caldey Island, made to the designs of *Coates Carter c*. 1907–1915, as well as the C13-style stone slab to Dame Margaret Egerton, †1919, surely also by *Coates Carter*. The late C19 foundry of *David & Co.*, at Woodside near Coppett Hall, Saundersfoot, produced some simple Gothic memorials in cast iron: a good group survives in the cemetery of St Issells Church.

## Vicarages and Church Schools

The vicarages of the early C19 at Penally, *c*. 1822, and Nevern, are attractive late-Georgian houses, not unlike the Archdeacons' houses of the Cathedral Close. From the 1830s to the 1860s, came a sequence of late-Georgian-style houses, distinctive as having a blank centre bay and the door on the end wall, that is, a two-room plan with corridor and stair behind, Camrose of the 1830s, Whitchurch 1842, Rudbaxton 1845, and St Lawrence 1860, conform to the type. St Ishmaels, of 1835, copied a Tudor Gothic design by *Papworth*, of 1819, and Herbrandston, 1839, was also Tudor. Manordeifi, *c*. 1839, is a late-Georgian-style symmetrical front, but Cilgerran, 1845, and Llanfyrnach, 1849, have

a more Victorian Italianate touch as does Pembroke Dock, 1858. St Dogmaels, 1870, one of the larger vicarages, of five bays of Georgian sashes, is Victorian only in its gable bargeboards. By the later C19 vicarage design seems to have settled on a styleless asymmetry, like *Ewan Christian*'s Stackpole, 1878, or those by *W. Newton Dunn* at Gumfreston, 1873, Tenby, 1878, and Jeffreyston, 1892. More Gothic with polychrome stonework was Ludchurch, 1868, by *Foster & Wood* of Bristol, and St Davids (Penrhiw), 1882–4, by *Middleton & Son*. The stuccoed Arts-and-Crafts-influenced vicarage at Pontfaen, by *J. H. Morgan*, 1903, is exceptional – most early C20 clergy houses were plain, like Ambleston, 1909.

Church schools of the small churchyard type are rare in the county, the one at Rhoscrowther, 1851, prettily Tudor. Tudor Gothic was chosen for the National Schools at Llanrhian, 1851, and Spittal, 1855, both by *Joseph Jenkins*, the latter with iron lattice windows. Wiston, 1859, by *Henry Ashton*, for the Cawdor estate, is plainly functional, whereas Narberth, 1869, (now an R.C. church) by *T. David* is Gothic, with a bellcote, and St Davids, 1873, more so, with circular chimneys. The Trecwn schools of 1876–7 by *E. C. Lee*, built for the Barham estate, are wholly different, an extensive stone group beautifully detailed in a free style, owing a debt to Philip Webb. Sadly they had been derelict for over a decade in 2004.

# NONCONFORMIST CHAPELS FROM THE SEVENTEENTH TO TWENTIETH CENTURY

Nonconformity established itself early in south west Wales: Albany Congregational Chapel, Haverfordwest, claims a foundation date of 1638; the mother Baptist cause of the county, Rhydwilym, just over the border in Carmarthenshire, dates from 1667; and many causes were founded after the Toleration Act of 1689. The C17 congregations were Independent, Baptist or Quaker.

The Quaker George Fox came to Haverfordwest in 1657, but the cause never developed strongly, the meeting house in Haverfordwest closed in 1829. The meeting house in Milford, of 1811, survives, and is remarkable in having been built for the Nantucket whalers for whom the town was founded.

During the C18 Welsh Methodism reached the county through the tours of Howel Harris from Breconshire, after 1739, and settled when Howell Davies, 'the apostle of Pembrokeshire', built the chapel at Woodstock in 1755. Wesleyan Methodism was brought by John Wesley himself, in fourteen visits to the county, from 1763; George Whitefield brought the more Calvinist version that ultimately held greater appeal, from 1768. Wesley, and the leading Welsh Methodists, William Williams and Daniel Rowlands, were welcomed, notably to Nevern and Newport,

by George Bowen of Llwyngwair and by the vicar of Newport, the Rev. David Pugh. Their support gave rise to the remarkable 'church chapels', built at Newport, 1799, Nevern, 1800, Eglwyswrw and St Dogmaels, where evangelical services could be held under the wing of the established church. This co-existence could not survive the conflict over ordinations, and the schism of 1811 established Calvinistic Methodism as the dominant Welsh form of Methodism. Wesleyan Methodism remained more of an English variant, notably stronger, for example, in the port and dockyard towns of the Haven, where there was substantial Cornish immigration.

Moravians came to Haverfordwest in the 1740s, and built a chapel in 1773, with branches in Pendine and Tenby in the early C19, but never expanded. Unitarianism, so potent in the upper Teifi valley from the late C18, never established a presence in the county. Primitive Methodism, seceding from Wesleyan Methodism in 1810, had a limited presence in the south of the county in the early C19. By the mid-C19 the pattern, as elsewhere in Wales, was of three major denominations each with parallel Welsh and English branches: Baptists, Calvinistic Methodists (Presbyterians), and Independents (Congregationalists), with a fourth, the Wesleyan Methodists, less widespread, and several much smaller groups with a few chapels apiece.

Architecturally nothing survives of the C17, and almost nothing of the C18, testimony to the growth of individual congregations that could see up to four rebuildings in a century, as at Llwynyrhwrdd, Llanfyrnach. The earliest rural chapels were cottage-like, a long-wall façade with generally two doors, and one or two raised centre windows lighting the pulpit. Rhodiad y Brenin, St Davids, 1788, the former chapel at Felindre Farchog, 1805, and Burnett's Hill, Martletwy, 1813, are of this type, and there must have been a smaller cottage type, thatched and simple, all since rebuilt. Already in 1811 Fenton wrote that 'conventicles are almost as numerous over our mountains as tumuli'. An illustration of the 1774 chapel at Tabernacle, Haverfordwest, shows something wholly different, a gable-fronted Georgian urban chapel, akin to English town chapels of the period, but it seems to have been unique in the region.

The long-wall façade remained the principal type from the late C18 to the mid-C19, the two-door and two-window model enhanced by two outer windows at an upper level, to light gallery stairs. This type was influenced by the C17 English chapels, in turn influenced by the Protestant meeting houses of the low countries. From the 1820s galleries became part of the original design, though not always inserted at the time of building. The earliest chapel roofs were gable-ended, but from about 1820 to 1860, the hipped roof was a favoured alternative, with half-hipped roofs a variation popular in the 1830s and 1840s, as at Trevine, 1834. Caerfarchell, St Davids, 1827, is hipped, without gallery windows, but within is a tightly composed five-sided gallery that might seem an addition, were it not for similar unlit galleries in Gedeon, Dinas, 1830, and Newchapel, 1848. Gallery windows

appear at Pentwr, Fishguard, as early as 1824. Brynhenllan, Dinas, of 1842, shows the form fully developed, a tall façade with arched centre windows and domestic sashes set high in the outer corners, over the doors. This syncopation of long centre windows, and short outer ones set higher, was not universal: Ffynnon, Llanddewi Velfrey, 1832, has a hipped two-storey front, with centre door and even floor-levels, sober and domestic.

The trend from long-wall to end-wall or gable entries began outside the region, with the architectural possibilities of the temple-front in mind, but first appears in the region as an almost-square variant on the hipped roof chapels, but crucially with the pulpit on the rear wall. Rhosycaerau, St Nicholas, of 1826, has a half-hipped front and the paired doors of the long-wall chapels, but the pulpit on the back wall. The last of the hipped chapels, Nebo, Efailwen, of 1860, has the entry on the narrower wall, but the pulpit still backing on to the entrance wall, by then very archaic. Another hybrid type was the provision of a lateral façade, but with the seating oriented to the gable-end, as at Zion, Begelly, and Martletwy Baptist Chapel, both of the 1860s. This plan is mirrored in larger chapels of the lead mining areas of Ceredigion and it is interesting that Begelly and Martletwy also catered for an industrial (coalmining) population. The possibilities of the temple front were exploited early and remarkably at Hermon, Fishguard, 1832, where for the first 94 time in Wales the motif of a giant arch under an open pediment appears, a triumphal arch motif with Renaissance roots, most improbably flowering here. With Hermon, the name of an architect first appears, *Daniel Evans*, by attribution only, but remarkable nonetheless, as most chapels were built by a mason and a carpenter, the design coming from one or the other. For reasons not known, most of the early gable-fronted chapels were built by the Baptists, including Hermon. Other early gable fronts, are Tretio, 1839, and Seion, 1843, both at St Davids. After Hermon, Ebeneser, Newport, of 1844–5, by the mason *David Salmon* 96 is the next developed architectural façade, minimally classical with giant arched recesses under an open pediment, in worked stone.

Worked stone was relatively rare, stucco was generally the choice for architectural embellishment. Tabernacle, Fishguard, 1845, has a broad half-hip to the front, and some stucco detail similar to Hermon. Tabernacle (Zion), Pembroke Dock, by *John Road*, of 1848, still the largest chapel west of Swansea, has a two-storey pilastered front of considerable sophistication. More typical were simple two-storey fronts with pedimental gables and arched windows, like Blaenffos, 1856, Tyrhos, Cilgerran, 1859, and Penybryn, 1862, possibly all by the same hand. Full classical fronts of the mid-c19 are rare; Tabernacle, Narberth, of 1858, in stucco, and Nolton Haven of the same date in the 97 local sandstone, are examples.

Gothic, even of the minimal Georgian type, with pointed small-paned windows, was just as rare, though appearing very early in the 'church chapels' of Newport and Nevern. A pair of

chapels by *Joshua Morris*, Bethlehem, at Newport, 1855, and Mount Pleasant, Solva, 1863, use a giant Tudor arch as a façade recess, over long pointed windows. Morris may have been the designer of a series of north Pembrokeshire Baptist chapels, with slightly Gothic glazing in arched windows and open pediments, and sometimes with a giant arch: the group includes Llangloffan, 1863, Glanrhyd, 1870, Bethabara at Pontyglasier, 1872, and Bethel, at Mynachlogddu, 1875.

The interiors as late as 1860 were of the late Georgian type with painted panelling both to gallery fronts and pews, the painting usually in imitation woodgrain, pews with doors and pulpits of the single wine-glass type with steps. The chapels associated with *Joshua Morris* have galleries on timber columns, the bases raised above the pew level, in the manner of Wren, whereas elsewhere the iron column is dominant. As there were no publications on chapel architecture, and almost no trained architects before the 1860s, stylistic change was slow, and conservatism especially apparent in woodwork detail. With the larger congregations that followed the revival of 1859, and increased public participation in worship, came changes, primarily the introduction of the platform pulpit with room for several ministers, and the enhancement of the 'great seat', or elders' enclosure in front of the pulpit. Hence, while surviving original pews and galleries are not uncommon, pulpits and great seats are generally later C19 replacements.

*The Later Nineteenth Century*

After 1860, a full-blown Victorian style reached chapel design, animated as much as anything by an expensive desire to compete with neighbouring chapels. Where even larger chapels before 1860 had generally cost a thousand pounds or less, the later Victorian rebuildings could cost two thousand pounds or more. Stuccoed Italianate remained the standard model, with arched windows and pedimental gable, like Ebenezer, St Davids, 1872, and Cilfowyr at Manordeifi, 1879. The potent Italianate design, where a giant arch on pilasters breaks into the pediment in a triumphal arch motif, associated with the Rev. *Thomas Thomas* of Swansea, found an extraordinarily inflated echo in *K. W. Ladd*'s Wesleyan chapel, Pembroke, 1872. This combines giant ashlar columns and the giant arch with Gothic-to-Romanesque window and door motifs. Ladd, never less than hamfisted, introduced a round-arched Romanesque at St Andrews chapel, Pembroke Dock, in 1865, with twin towers reminiscent of the Neo-Norman Bute Town church in Cardiff of the 1840s. If Ladd was perhaps a throw-back, what can be said of *George Morgan*'s masterpiece, Bethesda, Haverfordwest, 1878, in that architect's fully-confident Italian Romanesque, seemingly born already mature at Priory Chapel, Carmarthen, just three years earlier. John Gibson's Bloomsbury Temple, London, of 1845–8, may be the root of this Baptist Romanesque, but Morgan's work is surely the principal flowering in Britain. A close echo, apparently by a local builder, is

114

117

Bethesda, Narberth, of 1889. An extraordinary hybrid Italianate-cum-Romanesque with a touch of Glasgow Greek appears at Bethel, Pembroke Dock, 1873, by *Hans Price* of Weston–super–Mare.

Incomers from England remained rare, but leading Welsh chapel specialists from outside the county, *Morgan, Thomas, Humphrey, Owens* and *Lawrence* all had commissions. Local architects with significant chapel practices in the later C19 were *Ladd* of Pembroke Dock, and *D.E. Thomas* of Haverfordwest, whose pleasant stucco gable fronts feature in numerous rural chapels. His Italianate front block at Ebenezer, Haverfordwest, 1885, has a town-hall solidity, and his recasing of Pentwr, Fishguard, 1889, covers the sober Georgian stonework in busy stucco detail.

Victorian Gothic came late to Pembrokeshire chapels, in 1865 with the demolished Albany, Pembroke Dock, by *R. Sutton* of Nottingham, *Thomas Thomas*'s Tabernacle, Pembroke, 1867, both still thin in detail, and with High Victorian muscularity in 1869 at the Congregational chapel (St Johns), Tenby, by *Paull & Robinson* of Manchester. *Richard Owens* of Liverpool gave   118
Tabernacle, St Davids, 1874, a vigorously acid asymmetry, and *George Morgan*'s two Gothic works, North Road, Milford, 1879, and Deer Park, Tenby, 1885, have a muscular confidence, with well-carved stonework. A late example, Priory Road, Milford, 1901, by *John Wills* of Derby is more remarkable for its richly Gothic pitch-pine interior.

The interiors of these later chapels show a richness in contrast with the austerity of the earlier chapels. Massive pulpit platforms gave rein to Gothic, Romanesque and Italianate arcading, fretwork piercings, notchings and chamferings, and giant-scaled turned newels with all manner of finials, in varnished pitch-pine, or sometimes colour-contrasted hardwoods. Even stained glass appears, as at St Andrew, Pembroke Dock. Notable too is the wealth of cast-iron work: columns, panel inserts into gallery fronts and, most spectacularly, the continuous pierced iron gallery fronts of Alhambra intricacy, as at Tabernacle, Haver-   116
fordwest, 1874, and Bethany, Pembroke Dock, 1877. The exterior railings at Bethesda, Haverfordwest, by *W. Baker* of Newport, Monmouthshire, are the finest in the county. Chapel ironwork was largely Carmarthen-made, but catalogue pieces from *Macfarlane* of Glasgow, *Baker*, and others appear. Behind the pulpit the simple timber pulpit-back gave way to a giant plaster aedicule, and later still to an organ recess, ocasionally with a fourth gallery, for a choir, as at Hermon, Fishguard, altered with organ gallery in 1906 by *Morgan & Son*. Ceilings were elaborated by large plaster roses, by the late C19 set often in a framing of timber ribs and match-boarding. Finest of all the interiors is   115
Tabernacle, Haverfordwest, with its basilican curved roof, apse, and quasi-aisles divided off by full-height iron columns, rising through the galleries with their vinework iron frontals.

Refittings and refurbishments were as common as rebuildings, though some, like *John Humphrey*'s remodelling of Glandwr in 1876, so thorough as to amount to a rebuilding.

By the turn of the century fewer new chapels of note were being built. *J. Howard Morgan*, George Morgan's son, designed in an up-to-date free style at Jabes, Pontfaen, and Galilee, Llangwm, both of 1904. The Hen Gapel, Maenclochog, 1904, shows a similar vein, but by *D. E. Thomas*. The most remarkable of the early C20 chapels is Tabernacle, Milford, 1909, by *D. E. Thomas & Son*, red brick, to a church-like plan, with tower, but freely detailed in a squared-up late-C17 manner, with chequerwork and a little Art Nouveau carving. Most modern is the extraordinary tower with its pillbox cap. The interior with its arcades, deep galleries and free classical woodwork is remarkably original too. One other early C20 interior deserves mention: Tabernacle, Fishguard, of 1915 and 1924, with neo-C18 detail applied in fibrous plaster.

    *122, 123* (margin)

## COUNTRY HOUSES AND GARDENS

*Sixteenth Century to the Early Eighteenth Century*

The typical Pembrokeshire country seat is ancient in origin, overlain and expanded by successive remodellings. No wall was knocked down unnecessarily, so that much lies beneath the plain rendered and sash windowed elevations that one still commonly finds. The local stone was not easily workable to provide long lasting decorative features.

    C16 GENTRY HOUSES are exceptionally rare. The splendid updating of Carew Castle by Sir Rhys ap Thomas opens the Tudor age, completed in time for his great tournament in 1507. This lavish work produced moulded Bath stone windows, heraldic chimneypieces and a porch to the great hall with the grandly carved arms of Prince Henry. This work stands alone in south west Wales, taking medieval castle forms into the new age of architectural invention and show. In the same bold spirit but without the finesse is the startling five-storey porch built for Bishop Vaughan (1509–22) at Llawhaden Castle, oversailing everything older.

    For later C16 activity, one turns again to Carew and to the even grander north range added by Sir John Perrot. The huge mullion-and-transom windows of Bath stone, some projecting as fully half-round bows, are at one with the structurally daring new designs of Smythson and his contemporaries who moved, like Perrot, in court circles. As such, Carew has received too little attention as the most westerly 'prodigy house' in the country, though it is not clear to what extent it was ever completed following Perrot's sudden fall from grace in 1591 and death. One may speculate that the mullioned windows inserted into the medieval house at Coedcanlas, Lawrenny, were first unloaded at Carew but the latter house has changed too much to make any clear judgement of its character.

    Coedcanlas was presumably once a courtyard house. Other examples are very fragmentary. Trefloyne, Penally, had a double

courtyard but Civil War sacking, abandonment and long reuse for farming have eroded most of its character. Plas, Narberth, likewise now offers little: the substantial gatehouse shown by Buck in 1740 has long vanished. Houses converted out of the dissolved abbeys and priories in the mid-c16 have not survived well. On Caldey Island there is a small group of considerable charm if devoid of decorative features. At Pill Priory, Milford, the Priory Inn comprises some part of the claustral buildings but now with minimal architectural detail. The Commandery building of the Knights of St John at Slebech became an important house but was removed in the 1770s without record.

Of houses of the lesser Elizabethan gentry, only Llwynygoras and Trewern, Nevern, give an insight. Llwynygoras is dated 1578, 74 modest in size but built with an awareness of architecture, being cruciform in plan, the gables all originally capped with chimneys. Perhaps it is a provincial echo of the symbolic designs of John Thorpe and his circle. Trewern has matching mouldings but an off-centre porch bay, making it possible that Llwyngwair, also in the same parish, was similar. The Elizabethan historian and recorder of local affairs, George Owen (1552–1613) actually gives the dates when some of the new houses of his friends were built, but most have been quite altered. The site of his own (long abandoned) house Henllys, Felindre Farchog, is being excavated currently. He speaks of a fine hall there but the well-preserved foundation walls so far unearthed reveal nothing to match: was he was exaggerating?

More typical are the lateral-chimneyed houses, vernacular in look but homes of minor gentry and wealthy merchants. Pembrokeshire can offer a really quite distinctive group. Most are of three unit plan, a central hall flanked by secondary rooms, an arrangement not in itself uncommon. Their huge chimneys however, often with a big bread oven bulging out beside, set them apart, randomly placed along the side of the building, sometimes with another, no less dominant, on the gable-end, also by no means always in the centre. At Good Hook, Uzmaston; Old 73 Chimneys, St Florence; Garn, Llanychaer; Rhosson and Hendre Eynon, St Davids and others, they are rounded. At Trewern, Nevern and at Thorne, St Twynnells for example, they are square or rectangular. Antiquarian drawings attest the former existence of plenty now lost and distribution indicates that the type, with all its idiosyncratic variations including small outshut rooms, was the favoured form during the c16 and c17. Significantly it is only in Devon and Cornwall that one finds close comparisons, with a few on the Glamorgan coast, but there is, by and large, a rugged solidity that gives the Pembrokeshire type a look of its own. Dating however is difficult. Old Chimneys may go back to the earliest c16 as it has a pointed stone door. The best preserved internally is Garn, with a fine hall open to the roof, which seems to suggest that such chimneys could be built before the hall was, as in so many cases, given an upper floor. Trewern and Llwynygoras were clearly storeyed from the outset.

Little can be said of C16 GARDENS. The small walled garden at Carew Castle must belong to the Perrot era. A larger, double walled one that survives at St Brides, associated with the late medieval ruins there, appears to be C16 with embattled parapet walls and gateway. Terracing and slight raised earthworks can still be traced at Haroldston, reminders of fine gardens marvelled at by George Owen.

Of C17 COUNTRY HOUSE DESIGN, there is even less to be said. With one notable exception, nothing changed, save perhaps in minor details of refinement and scale: Coedmelyn, St Petrox, has diagonally set flues. Poyers at Templeton is dated 1672 to underline the point. Thus the overdue move to centralized planning and symmetry is introduced seriously only by the unex-

75, 76 pected Glandovan, Cilgerran, of c. 1660–70, double pile, hipped and symmetrical with axial chimneys. Equally modern was the basement, as well as the open-well stair in its own tower at the back, not quite treated with assurance. An earlier and curious interloper is long ruined Cresswell Castle, a small courtyard house with diminutive corner turrets for William Barlow (†1636), a distant imitation perhaps of the late Elizabethan sham castle, as seen in full flowering at Ruperra, Glamorgan. A few, lesser followers of fashion are just detectable. Medieval Norchard, Manorbier, had a C17 symmetrical front put on, the diagonally set flues of which still survive. Nearby East Jordanston, St Florence, of similar later century date, is five bays with a tall central porch. Good Hook, Uzmaston, has a fine late C17 stair, as too had the lost Kilgetty House, the stair now elsewhere.

The outlines of two fine C17 GARDENS on the other hand survive, albeit as fields. From the air, they show up with a clarity and detail that may make them the best survivors of their age in Wales. There is a dated reference for the better one, at long-lost Great House, Landshipping, where one *Hancock* was constructing a water folly in 1697, presumably connected to the large tank or pond that is clearly visible from the ground. Complex terracing and bedding can be seen from the air, while on foot one can survey the very early brick wall of the pleasure garden, with large viewing 'windows' evenly spaced, looking down on the terraces. The gardens were laid out for Sir Arthur Owen also then of Coedcanlas where the other similar garden shows up from above with long lines of ridge and furrow, a double walled garden and a run of square beds. On foot, only the stone-lined central pond is evident. Of the same era, but just post 1700 is equally tucked away Henllan, Rhoscrowther, where a surprisingly large brick garden arch, apparently dated 171?, leads from a garden with substantial earthworks into a field with a small circular ancient grove. More easily comprehensible but probably only a partial survival, is the stepped terrace garden at Slebech, running down to the river estuary. Fenton (1810) confirms that this is of the late C17.

Of the QUEEN ANNE period Vaynor, Llawhaden, dated 1707 and single pile only is a rare survivor. Its originally handsome, long sash-windowed, six-bay front has been much refenestrated.

But the well-carved Bath stone doorcase with heraldry in the pediment does remain (much weathered), surprisingly the only such example in the county. Had it survived, old Lawrenny Hall would have been of considerable significance. A big upstanding rectangle of four storeys, the top floor with circular windows and fluted pilasters ornamenting the façades, it is known only from drawings and from the surviving part of its staircase and two doors now at the Fortified Rectory at Carew.

## Mid- to Late Georgian

The story of MID-GEORGIAN domestic architecture in the county is told by two great houses, one now lost. This latter was Stackpole Court, removed in the last days of country-house demolitions in 1964. The enlargement of the house from 1839 overwhelmed the work of a century earlier, but now it can be discerned from drawings as a remarkably pure example of first-phase Palladian architecture with an attribution (admittedly speculative) to no less than *Colen Campbell*. He was a cousin of the owner, John Campbell but had died in 1729, five years before Stackpole was begun. No accounts survive but a long correspondence details building progress and it is notable that no architect is ever named: were they building from the plans of one then dead? There must have been some supervision but it is clear that the two projecting wings, added at the same time as the centre was being built, were a long way short in quality, indeed positively ill-matched. So perhaps John Campbell and the clerk of works, *Frank Evans*, saw it through themselves.

An architect is equally hard to find at Picton Castle, where 77, 78
from 1749 to 1752 major internal alterations were made, also in the smartest London style. By then Palladian was more to be expected but even so the principal rooms at Picton retain their impact, with bold classical detailing in the great hall, magnificent curving joinery in the circular library and elegant plasterwork there and in the old drawing room (here with the profiles of poets). Sir John Philipps 4th Bart. (†1737) was one of the Commissioners for Queen Anne's fifty new churches in London, so would have known all the leading architects. Speculation that Gibbs was involved at Picton must be discounted, as he was undoubtedly too old. The long lost Italianate belvedere in the grounds was designed by *John James* in 1728 but he had predeceased both Gibbs and the work at Picton. The work was certainly that of London craftsmen – one such joiner is known – but the nature of the work, essentially refashioning old interiors, need not have required an overall guiding hand, especially given Sir John's own experience. His sons employed *Christopher Horsnaile*, a marble mason 71
favoured by Gibbs, to make his fine monument in Haverfordwest church, while a particular glory of the Picton interiors is the five chimneypieces commissioned from *Henry Cheere* in 1753.

More typical provincial mid-c18 country houses can be found in several places. Panteg, Llanddewi Velfrey, has a remarkably

intact panelled interior with pleasing detail but is quite straight-forward externally. Harmeston, Steynton, is likewise but longer and lower, with panelling and a contemporary landscaped garden. The centre part of much altered Penty Park, Walton East, indicates a house of quality, with panelling, a broad staircase and a painted overmantel. The average country house standard is 81 however eclipsed by the interiors of 111 Main Street, Pembroke. More externally conscious are two near neighbours, perhaps sharing craftsmen, Camrose House and Great Westfield (Rosemarket). The latter has a central Venetian window above the porch, the former has cambered headed windows, both with good stairs of three-to-a-tread turned balusters.

79, 80 The LATE EIGHTEENTH CENTURY is represented principally by two houses, Cresselly and Slebech. The first, though altered, is interesting on two counts – firstly as a Palladian villa originally with pavilion wings and secondly as a probable work of the county's first native architect, *William Thomas* from Pembroke (†1800), who under the patronage of John Campbell of Stackpole Court was enabled to make a career in London as a successful, if never quite top grade, architect in the Adam style. He did however publish a very grand pattern book in 1783 and the subscribers' list includes a small number of the greater Pembrokeshire gentry, though his only documented work known to date in the county is at Stackpole.

One design in his book is for Brownslade, Castlemartin (demolished), a new house for the Stackpole agent, built at John Campbell's expense. It was simplified in construction, losing its pavilion wings, but the plan is close to Cresselly as built in 1770, with a big canted bay in the garden front. Nothing of Thomas's early career (before he suddenly appears with some major English projects in the 1780s) is known. So Cresselly at the moment stands alone but the attribution seems logical.

Slebech is the biggest single build house of the C18 in the county. Many unsigned drawings survive but the hand and style of *Anthony Keck* can be discerned. Of 1774–6 (and ambitious enough to bankrupt its owner), it is one of three Roman gatehouse-type castellated mansions being built in south Wales at the same time. The others were Wenvoe Castle by Adam and Gnoll by John Johnson, both in Glamorgan and both lost now. Had they been conferring or even competing? Essential to the proportion and effect was the mural crown of grandly scaled castellations. The removal of these from Slebech in the 1950s gives the house a regrettable bareness. Keck was a craftsman turned architect and it shows inside where the layout is completely straightforward. On the other hand, the eye for detail is charming, with the tablets of chimneypieces in main rooms replicating sections of the friezes above.

Slebech has the finest stable block of this period, an Adamish complement to the house, still retaining its castellations round a big, three-sided courtyard. In the 1780s another huge stable block appeared, this at Stackpole Court by *William Thomas*. The plan in Thomas's book was simplified, externally

rather domestic with eleven bays of two storeys, the centre one a carriage arch with domed turret above. Thomas also published plans for a rich, classical refronting of the long service wing between house and stables, possibly as a home for Campbell's collection of Grand Tour antiquities. But Campbell designed a museum for these in his London house and had to sell them soon after anyway.

More provincial design of this period is best represented not by external forms but by a fashion for Chinese Chippendale staircases. About thirty are recorded in the county, nearly all in the south. Part of one is still preserved at Cresselly (now in the back stair) of 1770; Freestone Hall, a mile south (*see* Carew), dated 1768, has one too. Probably the best is at Ridgeway, Llawhaden. They are not identical in design and unlikely to be by one hand, so what gave stimulus to this interesting phenomenon? There is only one in Carmarthenshire (close by, in Laugharne), none in Ceredigion and only a scattering elsewhere in Wales.  82

Vestiges of a few mid-C18 PARKS AND GARDENS can still be detected. At Kilgetty House, gardens were laid out in the early 1740s in the old-fashioned geometrical manner terminating at a belvedere (perhaps never completed). There was presumably some rivalry here with Picton Castle between the two Philipps brothers. Another large garden building survives, as a shell, at Orielton, Hundleton, this a fine red brick banqueting tower of *c.* 1730. Of three storeys, it is set over a drive with carriage arch beneath. Harmeston, Steynton, has a D-shaped pond with the excavated earth thrown up as two mounds on the curved side. No old avenues of any consequence exist: maps show that there had been fine ones at Lawrenny and Landshipping. Only the remains of the lime avenue to the belvedere at Picton speak of this fashion and perhaps that standing at Berllan, Eglwyswrw.

The great work of late C18 landscape design lies at Stackpole Court, under-appreciated despite ownership by the National Trust since the 1960s. The archive is only now being comprehensively studied, so that more clarity can be shed on this great landscaped park, with its remarkable man-made lakes ingeniously created by *John Mirehouse* and *James Cockshutt* in the 1780s and 1790s. The latter's magnificent eight-arched bridge across the principal lake is an eyecatcher to compare with many in the best parks in England. Finally at the turn of the century, Castell Malgwyn, Manordeifi, played host to the only indigenous Welsh professional landscape gardener, *Charles Price* of Llechryd (just over the river in Ceredigion), who laid out a fine woodland walk behind the house with picturesque bridges over the gorge, which partly survives.  85

### Regency to the Twentieth Century

The REGENCY PERIOD, which one may take as starting from the last decade of the C18, is, on account of one personality, remarkable in the architectural history of west Wales. In 1783, the

young and precocious *John Nash*, hounded from London by
bankruptcy and scandal, fled to Carmarthen where (it may be
postulated) he had made friends while supervising the erection
of his master Sir Robert Taylor's guildhall in the mid-1770s. His
resumption of business was humble enough as a builder but he
soon picked himself up and returned to design. It does not help
our knowledge that Nash lied about this part of his life later on,
but when he bursts on the scene at the end of the 1780s as the
only pure architect west of Swansea, the record shows his genius
fully fledged and his ideas entirely innovative to west Wales.
Indeed to the locals used to straightforward arrangements, his
new villas with their subtle internal complexities and decorative
plaster vaults would have been startling.

The results have not survived well. Sion House in Tenby,
*c*. 1795, a seaside villa which owed much to the training
of Taylor, has gone, as too has most of Temple Druid,
84  Maenclochog, of the same year, with no image surviving. Foley
House in Haverfordwest of 1794 stands well enough, a little
muted by office use and unsympathetic 1960s re-rendering. Its
return elevation with canted bay is strongly Taylorian. At
Ridgeway, Llawhaden, an enlargement attributable to Nash gave
a flamboyant divided staircase rising in opposed flights around
the entrance into the new hall, then flying directly back
overhead as one. Though the heavy balustrade is a replacement,
it is otherwise identical to Nash's stairs at Llanwysc, Breconshire.
The client was brother to the owner of Foley House.

119, 120,   The finest survival though is Ffynone, Newchapel, where
121  Nash's felicitous handling of interior space can still be admired
despite two periods of remodelling to front and sides. Externally
four-square, with three pedimented façades, it is a box of delights
within, starting with the delicate plaster umbrella dome in the
octagonal vestibule, now the inner hall, and leading to a splendid
Bath stone cantilevered stair in its own semicircular space to the
left. The stair looks very similar to that at (sadly lost) Middleton
Hall, Carmarthenshire, by S. P. Cockerell, being built at the same
time in the early 1790s: it is interesting that in the tale that
Nash told about the resumption of his career in Wales, it was
Cockerell's arrival at Middleton that stimulated Nash back to
designing. On Ffynone's upper floor, Nash really shines, with
delicate plasterwork and theatrical spaces.

Despite his achievements, Nash left in 1796 largely unlamented
and leaving no obvious disciple. One assistant *Robert George*
appears only at the unsatisfactory Colby Lodge, Amroth, of 1803.
However by the early 1800s many of Nash's ideas had become
mainstream and have accounted for a number of hopeful
attributions in the area. Not everything built here in the Nash
years was his though. He did not for example enlarge Picton
Castle in the early 1790s, Lord Milford preferring to entrust the
design and building to his own estate architect, *Griffith Watkins*,
of limited ability. His tall square block there is lumpish outside
and planned without subtlety within (especially upstairs) but it
gave large new drawing and dining rooms, the latter with original

decorative plasterwork twenty years behind the times. The new
staircase is fine enough but likewise very Georgian. At the other
great house, Stackpole Court, John Campbell employed *William
Thomas*. Nor did Nash receive the call to plan the new town of
Milford in the early 1790s: he would surely have traced out
something with more flourish than the simple grid plan that
proceeded.

Houses built immediately following Nash's departure confirm
that his ideas had not yet taken root. Plas Glynmel, Fishguard,
of 1796–9 for Richard Fenton, the county's historian, would be
no more than a standard, hipped-roof box were it not for the old-
fashioned Venetian window above the door, topped in the third
floor by an oval. The high basement required dividing steps up
to the front door and all these elements have been ascribed to
Fenton's French wife, but without obvious reason. Plainer still,
indeed disappointingly so, is Castell Malgwyn, Manordeifi,
completed in 1798 for Sir Benjamin Hammet, who had bought
the local tin works. A London banker originally from Taunton,
where he had masterminded considerable building development,
he was content here with a plain three-storey, five-bay, hipped
roof house. Fenton noted 'handsome apartments within' and
enough remains to show this may have been so. The plan did have
the stair hall offset to the left, lit by a pointed Gothic window
and as such, may be a Nash legacy (cf. Ffynone). The plan is
found more widely from *c.* 1810, as at Berry Hill, Nevern, and
Cleddau Lodge, Camrose.

Boulston House, Boulston, finely set above the ruins of its
predecessor down on the banks of the Haven, was begun in 1797
and presents a more interesting garden front, which may reflect
its owner's early years in pre-Independence America, more so as
it too is redolent of the style of at least a decade earlier. Outer
bays, set forward, with two storeys of round-headed windows,
enclose a broader centre with a large Venetian window on each
floor. A handsome segmentally bowed and Tuscan columned
veranda runs across, originally with an ornamental wooden
canopy above.

The EARLY NINETEENTH CENTURY ushers in little of
significance for over a decade but in the 1820s the first substantial
local architects appear. The spotlight falls primarily on *William
Owen* of Haverfordwest, as remarkable for his business acumen
(which brought great wealth and local offices) as for his efficient
and well-considered architecture. His rivals numbered *Thomas
Rowlands* also of Haverfordwest, contrastingly inept financially
but more prepared to experiment in style (if not always
convincingly); *James Hughes* of Narberth, whose career was cut
short by a fatal accident in 1832, whereafter William Owen
succeeded him as county surveyor; *David*, and later his son
*Daniel*, *Evans* in the north of the county, based at Cardigan and
Fishguard; lesser figures such as *William Hoare* of Lawrenny
and his son *Hugh* in the south west; and finally a group of
shadowy but capable builder architects in Tenby, principally the
appropriately named *John Smith*, who produced a distinctive

stripped-down classical style, still very evident in that town and area (e.g. Ivy Tower, St Florence). Outside architects of greater note made occasional excursions as shown below.

The first major domestic work appears to be the recasting and enlargement of Orielton, Hundleton, probably in 1810. The result, with two apparently equal, porticoed entrances set three bays apart was odd, looking more like a stuccoed terrace off Hyde Park. An attribution made *c.* 1900 was to *William Owen* and it is just possible that his father, also *William*, principally a cabinet maker but also a housebuilder later in life, could have done it: one doubts a senior architect.

The building boom began with Lamphey Court, Lamphey, in 1823, a new house on a new site. Though not large, it was intended to impress and was designed by the London architect *Charles Fowler*, then in the news as winner of the competition for the new London Bridge. Set on the hill just above the picturesque ruins of medieval Lamphey Palace, it was a deliberate, if belated, attempt to create an Arcadian landscape, the house taking the role of classical temple with its full Ionic portico, the front lodge on the distant rise ahead being Gothic windowed, a little across from the tall medieval church tower. These elements were in reality too spread out for the image to be coherent and it is lost today.

The internal joinery of Lamphey Court was by *William Owen*. Trewern, Llanddewi Velfrey, rebuilt *c.* 1824–5 is probably his, the garden (rear) front terminating in two full height bows, recalling Slebech of the 1770s. Such paired bows are found elsewhere in his work (and handled with more verve) – at the now ruined Landshipping House of 1837; on the front of Hermon's Hill, his own house in Haverfordwest of the same year; and at remodelled Clareston at Freystrop, here single storey only but originally with wonderful half-domed lead verandas above.

He was able enough where money allowed to show skilful planning inside. At Clareston and at Hillborough House in Haverfordwest, domed ceilings are set above the semicircular half-landings of the cantilevered stairs, while at Glanafon, Prendergast, the wooden tightly curving stair is lit by an octagonal lantern. Avallenau, Haverfordwest, and Pantsaeson, Monington, have similar ground plans with apsed stairs. Though this suggests an architect given to grand flourishes, in fact it is a strong sense of the sober and rational that predominates, especially as to exteriors, which often have little decoration beyond a fat string course in the render. Owen was a strictly practical man, striving for quality but not excess. His cabinet-making business certainly supplied impressive mahogany doors to his buildings, much the finest at Picton Castle, where he partly refitted the 1790s wing in the late 1820s. His only house documented with building accounts is Scolton, Spittal, of 1840 which is almost severe in its plainness, save that the centre of the three-bay entrance front is set back with a classical porch, recalling Nash's Llanerchaeron, Ceredigion. It is sad that none of Owen's houses survive complete with furnishings, given that

he designed them, his building team (under his brother *James*) built them and his cabinet-making business furnished them. It appears he suppressed all evidence of his working past (including all drawings) when his earnings brought him into the ranks of the gentry.

For twenty years Owen was also county surveyor, succeeding *James Hughes* in 1832. Hughes is a more shadowy figure but was well thought of in his newspaper obituary. In his own Narberth area, he appears from 1812 onwards as a house builder and later an architect. Domestic plans survive only for two typical hipped-roof rectories, but there is a circle of small Regency country houses around Narberth which surely are his. Nothing is at all adventurous, the best of the attributions being Parc Glas, Crinow, with some delicate internal detail.

The career of *Thomas Rowlands* of Haverfordwest is more interesting for two brushes with disaster when attempting to build his own designs at his own unrealistic estimates in the 1830s. He claimed a London training and indeed his first job was a spectacular catch, being commissioned to do great works at Picton Castle in the mid-1820s. This included a big new stable courtyard, rather effective as a sort of collegiate Gothic fortress on an eminence, and an impressively large and well-planned model home farmyard. Less successful perhaps was his remodelling of the entrance front of the castle in straightforward Neo-Norman, presumably inspired by Penrhyn in north Wales, and appropriate to a medieval castle (even if Picton was not a Norman foundation). His two stuccoed entrance lodges, faintly in the same style, have minor charm and his service courtyard looked better than the heavy 1880s enlargement that exists now. Beyond that we know little of his domestic work for sure but the quite ambitious St Brides Castle of 1833 may be his, in castellated Tudor dress – something that Owen never attempted but Rowlands did (e.g. his St Michael, Pembroke).  106

On Pembrokeshire's northern border, *David Evans* of Eglwyswrw (†*c.* 1840) is the only known architect. His church plans show some training and come nearer than anyone to showing a knowledge of Nash, whom he could quite possibly have worked for in the Cardigan area. In 1810 he turns up as far away as Carmarthen, designing a long lost terrace, being hailed as 'that ingenious architect'. One country house in north Pembrokeshire one might reasonably point to is Berry Hill, also built 1810 with the stairs offset and lit by a Gothic window. It is a pity we do not know more of a practitioner capable of laying out a large development scheme at St Dogmaels (now part of Ceredigion) in 1830, only in very small part built.

Of the outsider architects, *Edward Haycock* of Shrewsbury makes early and late entries. It is hard to see who else could have remodelled the 1770s cube at Cilwendeg, Capel Colman, *c.* 1830, throwing out wings and matching conservatories and filling a pediment with plaster scrolls and the owner's coat of arms (much altered in the 1880s). The entrance lodges at the broad park entrance are typical of him, as too the big stable block, though

curiously he was not used in 1835 to rebuild the church almost in the park, which went to the local builder. It is likely that he had already added the new front range on to Ffynone in the mid-1820s: the purity of the Doric classicism chimes in with his early work as at Clytha Park, Monmouthshire. He returned to the area (Manordeifi) in 1849 to design Clynfyw (*see* Abercych), a modest essay in the Tudor style with which he was then struggling: it worked better at his larger Stradey, Carmarthenshire, going up at the same time.

This leaves two final works by London architects. The first is 105 Lancych, Abercych of 1831–4. Though undocumented, this is a perfect Tudor style *cottage orné* of good size, obviously by *P.F. Robinson*, being very like one in Surrey in one of his pattern books. Hidden away on the narrow floor of the Cych valley, it is a delight to come on. Its complex gables and different roof heights are deftly handled, to give the impression that this is a family home developed over many generations. In fact the Jones family was old but had made new money and they continued their delightful deceit by putting a drum tower folly on the hilltop above the house. In contrast, the interior is calmly laid out but with equal charm, so that as one ascends the stair, one sees up ahead a rose window ablaze with family heraldry in contemporary stained glass, not apparent at all from the exterior.

The other work, now lost, was at Stackpole Court, where in 1839 *Sir Jeffry Wyatville* (with *Henry Ashton*) designed huge alterations to the existing house of the 1730s. It is not possible to like what he did but more space was needed and the enclosed site gave little choice. The house had long projecting wings and Wyatville simply shoehorned a new front range into the space between, creating huge lighting problems for the previously front-facing rooms. It has all gone now, save for his grey limestone ancilliary buildings, some lodges and his slight remodelling of the big Georgian stable block. A poor note to end on.

Of EARLY C19 GARDEN BUILDINGS, Cilwendeg is the principal survivor. Here a sudden influx of wealth allowed not 88 only a grand remodelling of the house and the building of a huge model farmyard but also two delightful follies. The first is a shell house, a simple square in ground plan but externally of white quartz boulders and cut Cilgerran slate (the veranda is missing), topped by wonderful pyramidal white, almost flame like, quartz boulders. Inside are exuberant shell designs on the walls and patterns in bone set in plaster on the floor. More astonishing is 87 the Pigeon House, below the farmyard, also in sad disrepair. This is pure (and very expensive) fancy, a wedding cake confection of stone and slate, dated 1835, set in front of a long rectangular pond. The tall slate railings are a wonder of local craftsmanship and cry out to be saved. More with an eye to productive function, there are at Castle Hall (Milford) the ruins of substantial hot houses of *c.* 1810, wherein Benjamin Rotch was reported to be growing more than 250 pineapples a year.

Only a few LODGES catch the eye. That at Slebech by *P.F. Robinson* was the prototype for one of his most successful pattern

book designs but now lacks key details. Llwyngwair, Nevern, has a surprising circular one of two storeys and the small west lodge at Orielton entertains in its desire to be picturesque. Picton Castle has a neat matching pair, suitably castellated behind impressive gates, but Cilwendig, Capel Colman, has two pairs, the front drive pair set widely and self-importantly apart, hipped and pilastered, probably by *Haycock*, the other pair with columned porticos.

Several of the greater estates had MODEL FARMYARDS. Most consciously architectural is that at Castell Malgwyn, Manordeifi, a miniature fort with gatehouse entrance and a walled square with rounded corners. That serving Picton Castle too is coherently architect-designed (by *Thomas Rowlands* in the mid-1820s), a large enclosed courtyard with the farm manager's house set in the fourth side. John Mirehouse's enclosed courtyard at Brownslade, Castlemartin, also entered under a gatehouse, is ruinous but from here he had set new standards locally for stock breeding and the science of agriculture. Most opulent and spacious is that at Cilwendeg, with ranges of large scale, the generously spaced group including a big stable block, the highly ornamental pigeon house and a small room proclaiming itself over the door as the Counting House.

The VICTORIAN PERIOD is by contrast surprisingly thin, though the losses, such as the grand but cheerless Lawrenny Castle (by *Henry Ashton* 1856) and the bizarre Castle Hall at Milford Haven (by the local *W. H. Lindsey* 1854), have left gaps. The only baronial castle is Hean, St Issells, of 1875–6, which looks well composed when seen (as intended) from the town of Saundersfoot below – Mr Vickerman of Hean Castle owned the coal business there. Close to, the elevations (by *Pennington & Bridgen* of Manchester, but with much interference from the client) are perhaps not quite taut enough to impress – nor indeed high enough – and the detailing is simple, but the red Runcorn sandstone gives cheer.

*J. P. Seddon* had one domestic work at Grove, Templeton for the Lewis family, for whom Seddon did church work in the area. He was asked to remodel this, the second house on the Lewis estate, for a moderate sum but found it hard to graft his strong Gothic on to a Georgian house: his exterior section is awkward but inside his character shows, albeit muted.

Rhosygilwen, Cilgerran, was the first of two ill advised invitations to the chapel architect *George Morgan* of Carmarthen to try his hand at large houses. Rhosygilwen (now fire damaged) is in fact a competent, rather dour pattern-bookish essay in Neo-Jacobean of 1885 (James Birch has something close to it in his pattern book) with three non-matching gables across the E-plan front and very tall, brick chimneys. The second is the rebuilding of Bush House, opposite Pembroke Castle. By now, 1902, George Morgan had been joined by his properly trained son *Howard* but the result was worse. Preliminary drawings indicate agonies of indecision, trying to find the solution to a scheme flawed from the start. The outside had no emphasis and the inside no

coherence. The clients, the Meyricks, who had lost their large
Georgian house here to fire, did not stay with it for long.

The TWENTIETH CENTURY into which we have already
moved is notable for only three works, one at least a virtuoso
performance. Firstly though, at Poyston, Rudbaxton (a house
bought by William Owen in the 1860s), a splendid private library
was commissioned by Dr Henry Owen, William's historian son.
He went in 1901 to local architect, *D. E. Thomas*, who excelled his
normal dull style with this galleried two-storey rectangular room,
a true bibliophile's delight.

In 1905–13 the under-age Lord Kensington seems to have
persuaded his trustees that a grander house would be needed
for his majority and his mother engaged *James Barbour & Bowie*
from her native Scotland to make St Brides Castle more of a
castle. They proceeded successfully, adding a new block behind
with a four-storey tower, breaking the line of the 1830s Tudor
rectangle with a strong upward emphasis. His Lordship had but
a year before war changed the house's ongoing use.

Much more significant though and a fine ending to the
country-house tradition in the county is the remodelling of
Ffynone, Newchapel by *Inigo Thomas* in 1904–8. Thomas was
primarily a garden architect and his flamboyant carving-out of a
broad terrace from the slope immediately behind the house is a
triumph of bold vision, flagged and balustraded by the lovely
workable Cilgerran slate and with intimate alcoves at each end.
Apart from refacing the house and adding bold limestone quoins,
he added wings each side, altering Nash's concept but yet
comfortable with it, creating two splendid new reception rooms
with rich moulded plasterwork. Not many houses have been so
refreshingly reinvented.

## VERNACULAR HOUSES AND
## FARM BUILDINGS

The rural building of the county was determined by the available
building materials, almost universally stone with roofs of reed or
straw thatch before the opening of the slate quarries in the early
C19. The stone being variably porous, the slaty stones especially
so, buildings were lime-rendered and limewashed. The exposure
of stone to the elements was not common until the later C19, and
then only the more impressive stones, the grey limestone or the
Preseli dolerite. While houses were generally rendered and then
limewashed, outbuildings were more commonly just limewashed.
The age range of the smaller rural houses of the county is not
great, the mid-C18 is an early date, most date from the C19, the
big dividing line in building being access to non-local materials,
especially brick, north Wales slate, and sawn pine, widely avail-
able only at the end of the C19.

Writings on the county from George Owen, from 1603 onward,
confirm the predominance of thatch until the later C19, a mate-

rial vanished except in fragments surviving under corrugated iron, or in a few reinstatements. They also note the small cottage as the typical house, of which, it must be assumed, almost all those built before 1800 have been demolished or rebuilt. The few c16 and c17 buildings that survive are houses of relatively high status, and those with side-wall or lateral chimneys, and the particular feature associated with Pembrokeshire, the massive round chimney, are discussed with the gentry houses.

The principal surviving type for rural farmhouses overwhelmingly has chimneys at each end and a near-central door. The façades, while symmetrical in the arrangement of windows and door, would often be offset overall, having a greater depth of wall to the kitchen end than the parlour end. The earliest end-chimney houses, of the later c17 to early c18, are farmhouses concentrated in the south of the county. They have particularly massive external chimney-breasts, see the groups around Bosherston, Hundleton, and the two survivors at Jameston. The typical central-stair, two-storey farmhouse of the later c18 onward had rear service rooms under an outshut roof, generally a dairy and scullery, separated by the stair. The stair often features at the rear under a gabled or hipped roof, and these rear stair-towers continue to be built into the mid-c19, before the stairs come to be absorbed into the main bulk of the house, or set in a separate rear wing with the kitchen. Tremynydd Fawr, St Davids, has a hipped rear stair-tower of c. 1800, Penarthur, St Davids, a gabled one of the c18. From the later c18, window size and height gradually increases, the farmhouses of the c18 having very low upper floors with small windows at floor level, those of the c19 gradually increasing the wall-height of the upper floor to a full storey. By the late c19 the symmetrical three bay end-chimney house was almost universal. Windows, until late into the c19, remained the small-paned sashes of the late Georgian type, often economically with only one half made to open, the opening regulated by chocks not sash cords and weights. Interiors were partitioned with walls of thin tongue-and-groove board with a dog-leg centre stair at the back of the entrance hall. The board walls are successors to the plank partitions of the c17 and c18, of which few survive in the county. The central stairs are general in the county, the older arrangement of a winding stair by the kitchen fireplace being almost unknown. Roof timbers in a county not rich in building timber tended to be relatively thin, with considerable use of timbers other than oak, of lesser strength, such as elm, sycamore and ash. Often the massive chimney beams of farmhouses were reused older beams or belonged to older chimneys: timber bressumers remained common well into the c19.

The smallest houses, associated in the main with very small holdings, of one to five acres, were of the single-storey type, with possibly a loft. The cottages were almost all built of local rubble stone. There were some earth-walled houses on the eastern border and inland from Saundersfoot, but none have survived sufficiently intact to mention. The cottage type at its smallest was of a single room with hearth, and a single window and door

to the front. Its characteristic in Pembrokeshire was that the chimney was of stone, unlike the wicker fireplace hoods of Ceredigion and Carmarthenshire, and very substantial. The big chimney or *simne fawr* with a chimney-breast frequently stepped back at the upper levels, was a deep inglenook with the hearth at floor level, and iron arms to hang the cooking pots. Many had a small slate-topped stone platform in front of one jamb, called the *mainc* or bench, to place hot utensils. Breadovens were set in the back of the chimney, marked externally by a curved or square projection. These smallest houses had enclosed beds in the main room, and developed in size with a second narrow room at the other end, divided by a partitioned entrance passage, this room often unheated and used as a bedroom. Over the entrance passage and small room was a sleeping loft, or *croglofft*, reached by ladder from the principal room. The final phase of development was for the smaller room to be heated as a parlour, and for the loft floor to be extended right across, with either stairs by the main fireplace or dog-leg stairs at the end of the entry passage. These stairs tended to replace a very small cupboard space used as a dairy or pantry, later placed in a low outshut along the back wall with entry from the main room. Floors were of beaten earth, hardened with bullock's blood, or cobbles, replaced in the late C19 by quarry tiles or slate flags. Inner partitions, when not of board, were of plaster on laths, the poorest using laths of bramble. Roof timbers were of roughly-halved trees of relatively small size, made up as a collar-truss or A-frame with similar rough purlins and joists, the joists by the later C19 being replaced by sawn pine and eventually the roof timbers also. Good examples of single-storey or lofted cottages are Penrhiwlas Isaf, Brynberian, Aberbach Cottage, Granston, and Penporthclais, St Davids, the latter enlarged by a storey. Near St Davids also are the grouted-roofed small two-storey houses at Treleddyd Fawr and Gwrhyd Ganol. The revival of thatching is relatively new: Penrhos Cottage, Llangolman, restored as a museum was an early example, Tretio Cottage, St Davids, a recent one. There are village examples of single-storey cottages at Puncheston, Newport (the White House), and Corllan, Eglwyswrw, dated 1726.

The long-house type with an entry in the end-wall, often from a through passage at the upper end of the byre or cow-house, is all but unknown in the county. One example of an entrance passage backing on to the chimney is Tredefaid, Llantood, a C17 minor-gentry house where the entrance was in the end gable before the passage was added, as was also the case at Honey's Park, Carew, 1687.

Many farmhouses had an attached or detached 'outside kitchen' known as the *gegin faes* or *gegin foch* where animal food was prepared, clothes were washed, and beer made, with its own large inglenook chimney.

The FARM BUILDINGS of the county divide between those of the poorer uplands and those of the richer middle and south of the county. There is relatively little unenclosed upland

compared to other Welsh counties. Much of the farmland was tenanted until the later C19 and C20, from gentry estates. These estates varied from a few very large ones down to those of what might be called the lesser gentry. The farms themselves were overwhelmingly small, over 70 per cent of farms in 1875 being of less than fifty acres, 85 per cent of less than one hundred acres. Some eighty farms out of 6,000 were of more than three hundred acres, the largest estate by far belonging to Lord Cawdor of Stackpole, and other large ones going with Picton Castle, Orielton and Slebech.

Almost all the farm buildings that survive are of the C19 and C20, possibly a factor of the C18 practice of leaving repairs to tenants. The estates spent heavily on farm buildings particularly in the later C19, though their buildings tend not to be significantly different to those erected on individually-owned farms, except in the cases of principal or home farms.

The larger ESTATE FARMS far outstrip the average in scale and fittings. The farmstead of the 1830s at Cilwendeg, Capel Colman, has a whole range of high status buildings including barn with two sets of high doors, horse-engine house, very extensive lofted stabling, and a pigeon house. Pentre, Newchapel, has a four-sided yard with a barn, stables, cow-houses around, not all of the same date. The Home Farm at Camrose has two principal lofted buildings with single-storey ranges, enclosing a big three-sided yard, probably early to mid-C19, with an added horse-engine house behind. The Stackpole estate farm at Rowston, Stackpole, 1866, by *Poundley* is the single example of a Victorian industrialized farm, with central cow-house forming a spine, from which the subsidiary buildings extend. Lord Cawdor's estate farm at Merrion Court, Warren, improved in 1874, had a narrow-gauge railway linking the feed stores to cattle sheds.

While the larger farms had housing for horses and cows, high-door barns, and other purpose-built buildings, the typical farm was much more simply equipped. Generally there was a cow-house, distinguished by a row of doors, a stable with hay-loft over, and a cart-shed, or several, often with a grain-loft over. The cart-shed and stable could be combined in a single lofted range, two ranges thus making up the commonest farmyard, a byre, often single-storeyed, and a stable and cart-shed range, often lofted. The arrangement of the buildings was often L-plan, with the farmhouse enclosing a third side of the yard, the bottom left open for run-off. The storage of crops was of lesser significance, hay being stored outside in a rickyard, as also thatch. Corn, where grown, was stored in a loft of the house as often as the loft over the cart-shed, but grain could be stored over the stable or barn. Animal housing was rarely extensive: given the mild climate sheep, for example, were never housed, nor were the majority of cattle. Barns of the high-door type are exceptional, unlike much of Carmarthenshire; as the quantity of corn for threshing was small and not always stored within the building, many farms have no barn at all. Low barns with opposed doors at one end, inaccessible to carts, are typical, barns with central entry rarer, all

have ventilation slots and some have loft floors for grain storage. All farms had one or several pig-sties, mostly of standard construction; the beehive-shaped pig-sties of Glamorgan are not found in Pembrokeshire, though the corbelled stone roof construction is found on two square sties at Llanfyrn-y-fran, St Davids. Closer to the corbelled pig-sties of Glamorgan are the little corbelled chambers built into earth banks to shelter geese. Dove nesting boxes tend to be built into gables or front walls of farm buildings, free standing dovecotes being a relatively rare feature of gentry houses, for example, the C17 one at Llawhaden House, Llawhaden. The later C19 dovecote at Treginnis Isaf, St Davids, is exceptional, but was built as a well-house with housing for doves above. A good farmyard with low farm buildings around three sides of a yard, the farmhouse on the fourth side, is Southwood at Roch, the buildings dated 1822 and 1854. Treginnis Uchaf has an L-plan range of lofted buildings, part dated 1854. Treginnis Isaf, adjoining, by contrast has an extraordinarily scattered original layout of buildings, supplemented in the later C19 by a very formal pair of enclosed yards, one with a long lofted cart-shed range to one side.

# INDUSTRIAL STRUCTURES
# FROM EARLIEST TIMES TO MODERN TIMES

BY STEPHEN HUGHES AND JULIAN ORBACH

Pembrokeshire is an agricultural county with coastal fishing, but there is a long industrial history of coal and slate extraction, with iron works dependent on the former. Lead was mined extensively at just one site. The quarrying of limestone was a major industry in the south of the county, burnt in kilns for agricultural lime, whitewash and building mortar. Stone was also quarried for building materials and slates, and granite from Porthgain, initially exported for paving setts, was in the early C20 crushed for roadstone. The largest industrial plant by far in the county was the naval dockyard at Pembroke Dock, 1812–1926, (the defensive military structures are discussed elsewhere), and from the early C19 to the later C20 the military were the largest single employers of civilian labour in the county, mostly employed in industrial processes at the dockyard.

## The Land

Agriculture transformed the landscape from the earliest times, (Farm buildings are discussed with vernacular buildings), but certain points about the C19 industrialization of process can be made here. The use of water power for farm processing is a feature of the later C19, with machinery available from foundries, primarily at Carmarthen or Cardigan. Numerous farm water-wheels survive. Industrialized farmsteads are rare in the county, but

gentry estates might have a horse-engine house, as at Camrose and Cilwendeg, Capel Colman, and those without adequate water power might use steam power to drive the same belt-driven machines. Lord Cawdor built model farms on his south west Wales estates, of which the Pembrokeshire example is Rowston, Stackpole, 1866, by *Poundley*, with its centralized cattle sheds.

## The Sea

Most coastal trading was to beaches and estuaries, formal HARBOURS being restricted to a few protected sites, and to quays on the estuaries. Records of harbours date from very early: St Elvis landed at Porthclais (St Davids) in the C6, and that harbour is mentioned in the *Mabinogion*. Tenby's wealth derived from maritime trade with Bristol channel ports in the medieval period; the harbour pier with its chapel is recorded from the C14, by which time both Pembroke and Haverfordwest quays were active, and shipments of building materials to St Davids from Ireland, Tenby and elsewhere are recorded in 1385. The records also refer to limestone being landed at Solva. Slates were exported from Newport Parrog to Bristol, and coal from Saundersfoot in the C16. The harbour at Fishguard recorded as exporting slates to Ireland in the early C17 is probably of earlier origin. The stone quays at Newport and St Dogmaels, and the tiny harbour at Porthgain, may have been first built in the C18, but evidence is lacking. The larger harbour quays were generally rebuilt from the late C18, Fishguard harbour about 1780, by Samuel Fenton, for the herring trade, Milford from the late 1790s, with a naval base in mind. Pembroke Dock was developed from new, from 1814, for the naval dockyard, and the quay at Hobbs Point was built in 1830–4 to replace Milford as the terminus of the Irish mail-coach from London. The railway era took integrated transport further, with the vision of a London to New York steam-driven train and boat connection. Brunel, in 1849–51, proposed to drive the South Wales Railway to a new port on a stormy bay at Abermawr, Granston, on the north coast, but abandoned the project, choosing to site the port at Neyland, on the Haven, which opened 1856 and was the terminus for the Irish mails until 1906. Milford's ambitious plans for a floating dock, first raised in 1814, but only realized in 1888, were also fuelled by transatlantic aspirations, animated by the abortive Manchester to Milford railway, suggested in 1845 as a means of wresting the cotton trade from Liverpool. Fishguard was considered as a terminus for the Irish mail in the 1850s, but the railway link was not built until the 1890s, and it was only with the new harbour at Goodwick, of 1893–1906, that the Irish mail was moved from Neyland. Fishguard did, for a brief period before 1914, catch some of the elusive transatlantic passenger trade, but just as Milford more prosaically finally found prosperity in fish, from c. 1900, Fishguard prospered on cattle, the new harbour having an integrated cattle-handling system, including basement access under the platforms from the lairage to the quayside.

The little harbour at Porthgain was developed from the 1840s, to export Abereiddy slate, and later granite and bricks. The quantity of shipping in so tiny a port, recorded as a fleet of 43 steamships and 52 ketches, *c.* 1900, seems unimaginable today. The harbour was remodelled in 1904, when the giant hoppers for road-stone (see below) were built to discharge on to the quay.

Stone-built WAREHOUSES of the later C18 to C19 are to be found at St Davids, on the road to Porthclais, at St Dogmaels, on the quay at Tenby, at Lower Fishguard, and at Haverfordwest. Later C19 warehouses line the Hakin side of Milford Haven docks, though the great length of brick fish markets, of *c.* 1900, has gone, leaving only a smoke-house from the fishing era. Milford has a late C18 CUSTOM HOUSE, now the museum.

SHIP-BUILDING was a small-scale affair into the later C19, mainly carried out on beaches, apart from the naval dockyard which does not appear to have stimulated any parallel civilian enterprises. The floating harbour at Milford was planned with two dry docks for ship repairs, but as completed in 1888, the larger one became the entrance lock.

LIGHTHOUSES for the busy route to Liverpool raised enormous revenues in the earlier C19, the Smalls light raising the most of any in Britain. The first lighthouse was probably at the Haven entrance, on St Ann's Head, Dale, where a tower recorded in 1662 may have been built with a chapel, in the late C15, to commemorate Henry Tudor's landing in 1485. A second tower was built in 1713, the two in line to act as a leading light, both with coal-fired beacons. These were replaced by two towers in 1800, of which the taller survives, the lower being replaced by a lighthouse in 1844. This Trinity House design is similar to the one of 1829 on Caldey
100 Island, built at the behest of Carmarthen Bay limestone traders, and the island light on South Bishop, off Ramsey Island, of 1836–9, with whitewashed limestone tower and keepers' houses and stores attached. The iron lantern, of 1838, at South Bishop, by Wilkinson of Long Acre (London), is the oldest unaltered working light in Britain. The lighthouses on Strumble Head, 1908–9, (*see* Llanwnda) and on Skokholm, 1915, are in the same tradition, among the last built in Britain, the Skokholm building with the tower rising from a two-storey building reminiscent of Scottish lights such as May and Inchkeith. A leading light of 1870, to guide shipping in the Haven, survives at Great Castle Head, St Ishmaels, with elegant later C20 concrete equivalents nearby. The design for the first Smalls lighthouse, built in 1775 at great peril on a rock seventeen miles out to sea, was by *Henry Whiteside*, Liverpool violin-maker, who won a competition held by the Liverpool merchants. Although a crude affair, an octagonal timber house with lantern above raised on long piles, it was possibly the first piled lighthouse in world, and one of the world's first structural uses of cast iron (after the supports for the mid-C18 great crane at Bristol), though most of the iron piles were soon replaced in oak. It had three 42-foot central cast-iron columns and some thirty oak piles. Some oak stumps and post holes remain. The successor light, of 1858–61, is the tallest in Wales at 142 ft (43 metres), of Cornish granite shipped out from Solva.

There are also LIFEBOAT HOUSES around the coast, Tenby having three left of a sequence of four, of 1855, 1895 and 1904, the latter corrugated-iron structure repeated at St Davids (Porthstinian) in 1911, where the house is raised above an older lifeboat house of c. 1870. Other houses are at Solva (1869), Cei Bach, St Dogmaels (1876), and Newport (1884).

NAVAL STRUCTURES. A small Royal Navy shipbuilding yard was established at Neyland Point by 1759, but did not last. Charles Greville secured the interest of Lord Nelson in his new town at Milford, and was rewarded by the establishment of a small naval dockyard there in 1802. Ships built there, of oak from the Forest of Dean, and iron from Penydarren Works, Merthyr Tydfil cost around half of the price of ships built in English yards, due to local labour costs. Splendid Neoclassical plans were made for a new dockyard c. 1809, but had to be abandoned as Greville's heir demanded too high a price for the land. Hence, in 1814, the dockyard was moved to a vacant site, named Pembroke Dockyard. The dockyard here became the largest shipbuilding yard in Britain, with no less than thirteen SHIPBUILDING SLIPS by 1850, whereas the older yards at Portsmouth and Plymouth had only five each. But Pembroke Dock had only one dry-dock, whereas they had eight and five. The yard primarily built wooden ships which were fitted out elsewhere. The first buildings, by the Admiralty architect, *Edward Holl*, of 1817–22, used CAST-IRON BEAMS for floors and roofs. The officers' houses and storehouse survive. Subsequent buildings that remain include the Captain Superintendent's Office, of 1847–8, by the engineers *Fox, Henderson & Co.*, who were responsible also for the first of the great IRON ROOFS over the building slips, forerunners of the firm's Crystal Palace, of 1851. Before the iron roofs, some slips had wooden roofs of even larger spans, the largest, of 1841, was of 100 ft (160 ft overall) span, 290 ft length and 60 ft height, by *Sir Robert Seppings*. The first two iron roofs, of 1844–5, were 262 ft long and 58 ft wide, with no iron bar larger than four inches by a half inch. Other roofs followed, two by *G. Baker & Sons*, another by *Fox, Henderson*, in 1848, until all the slips were roofed by c. 1860. All these roofs have been demolished since 1926. The foundry and sawmills of 1857 were on a very large scale, but have also been demolished. After the dockyard closure two very large HANGARS, for Short Sunderland flying-boats, were erected in the 1930s, which remain.

Just before the Second World War, a very large NAVAL MINES DEPOT was established at Trecwn, with some fifty concrete-lined tunnels cut into the sides of the valley, all served by rail. A similar facility was built at Newton Noyes, east of Milford.

*Water Power*

The harnessing of water was the single source of power for centuries, with CORN MILLS recorded from medieval times. Most surviving mills have later C19 iron wheels and machinery, the wheels generally overshot and external, though there were internal wheels at Castle Mill, Newport, and Tregwynt Mill, Granston

(1819). Working corn mills survive at St Dogmaels and Hescwm Mill, Dinas. Tregwynt is working, but converted to a woollen mill. Rural mills are widespread, with good small examples at Llanrhian and Camrose, and larger ones at Nantycoy Mill, Wolfscastle (1844), and Middle Mill. A substantial estate-farm mill of the later C19 is at Court, Llanllawer, and Hilton Mill, Roch (1851), is large and unusually architectural. Two mills on an even larger scale are in the south of the county. The four-storey

99 Blackpool Mill, Minwear, *c*. 1813, by *George Brown*, has a late Georgian design with wings, on a vaulted basement enclosing the waterwheel and turbine. There were two large TIDE MILLS, at Carew and Pembroke, the Pembroke Mill by *George Brown* *c*. 1820, now demolished, and Carew now one of the last working examples in Britain. The three-storey building, rebuilt in the mid-C19, stands on a masonry-faced clay dam to a 27-acre tidal reservoir. Vaulted basement arches through the dam contain the two undershot wheels, driving six pairs of stones.

A WOOLLEN MILL is recorded at Glandwr in 1650, but most of the remaining buildings are factories of the later C19 boom, in which the county was less involved than Carmarthenshire with its concentration of mills at Drefach Felindre. Over forty woollen mills are recorded in the county between 1800 and 1968, mostly small, scattered mainly around the Preseli rivers, but with two more distant concentrations, around Narberth and a few around the Clarbeston Road railhead. Most production was on a very small scale, producing a little flannel from local wool for local farmers, or simply carding for local home-weavers, and has left no notable buildings. Llanmill at Narberth, with some forty power looms, was the largest of the factories.

The ruins of brick buildings, at Prendergast Mill, are of a COTTON MILL of *c*. 1786, the largest textile mill in south Wales at the time, with 1512 spindles. It was converted to a PAPER MILL, in 1816, by Benjamin Harvey, who set up the Russian imperial paper mills at Peterhof, 1812–24. Haverfordwest was noted for paper making in the early C19.

## Wind Power

WINDMILLS were a feature of south Pembrokeshire, as also lowland Anglesey, but hardly any survive. The tower at Dale, and the tower built into the early C20 house at Twr y Felin, St Davids, are the two most prominent. The late C20 rush to generate electricity in Wales from wind by-passed the county, as all sites within or close to the National Park were refused permission. The windfarms at Blaenwaun and Marros, Carms., are visible from within the county.

## Extractive Industries

STONE. The building stones have been discussed earlier. SLATE was quarried in a belt around the hard rocks of the Preselis, with coastal quarries at Newport, exporting to Bristol and Ireland

probably from the C16, if not earlier. The industry was sizeable by the C19, though its production was only five to ten per cent of that of north Wales. In the last decade of the C19 some 10,000 to 17,500 tons were produced annually. The quality of the slates could be good, but much was not. The range of colours attracted custom: from purple-black to blue, green, grey, silver-grey and 'rustic' slates with orange and brown random mineral inclusions. Over a hundred deep-quarry pits and cliff-edge quarries are left, stretching along the north coast from Abereiddy to the Teifi gorge at Cilgerran, along the south side of the Preselis, from St Dogwells to the largest quarries at Rosebush and Glogue, Llanfyrnach, and running along the eastern Cleddau on the east boundary of the county. The latter were the quarries for the prized silver-grey and green slates, on the south side of Foel Dyrch, Mynachlogddu, and at Gilfach, just in Carms. The Pembrokeshire quarries never acquired the ranges of stone-built, water-powered dressing-sheds found in north Wales, so that the sites are more impressive for the size of the excavation than buildings. At Abereiddy, the picturesque 'Blue Lagoon' is the quarry begun in the 1840s, but blasted open to the sea in the late C19 to make a harbour, with quarry buildings marooned on the sides. Nearby are the ruins of a circular powder house and of a terrace of single-storey cottages by the horse-tramway to Porthgain. Porthgain produced mainly slabs, industrialized from the mid-1850s, the buildings, overlain by others, built for the brick, granite and roadstone enterprises (see below). The great pit in the cliff top west of the harbour, ruins of a cliff-top terrace, and a terrace of restored houses in the village are of the slate era, which lasted until *c.* 1900. At Cilgerran, slate workings along the gorge below the castle were noted by Fenton in 1811. The principal C19 quarries extend for half a mile upstream from the castle, with another group of riverside workings downstream, at the Welsh Wildlife Centre. Edward Cropper's Rosebush enterprise, of 1869–79, was much better financed than any other slate quarry, £22,000, sunk by 1880, with its own railway from Clunderwen, but the price of slates collapsed in 1879 and the railway closed in 1882. The towering quarries are the most impressive site in the county, and the quarry village is remarkably intact, with the row of cottages, manager's house and corrugated-iron railway hotel.

LIMESTONE was quarried for building stone, but more used for lime mortar, whitewash and for improving acid soils. The use dates back to early medieval times. A large coastal trade developed, and short CANALS were built from quarries to the Haven: on the Carew river south and west of West Williamston, on Garren Pill, north of Lawrenny, and at Llangwm Ferry (east side). Small ships took limestone and coal to LIMEKILNS at harbours and beaches around the coast. The simplest are circular, built into a bank for ease of charging the pot-like crucibles, with stone layered with coal or culm (coal dust mixed with clay), and with pointed or corbelled twin drawing-passages tapering boat-like to the low draught inlets. The group at Solva is especially good, there by 1795, and there are four at Porthclais. Large 86

square kilns are also found, on Skomer Island, at Caerbwdy near St Davids, and inland kilns along the limestone ridge. The row at Kiln Park, Penally, of twelve fronted by a stone-vaulted tunnel-passage, for covered loading, c. 1865, represent the industialization of the process that destroyed the coastal kiln. Most kilns appear to be late C18 or C19, but the base of a medieval kiln has been found in Cilgerran castle.

GRANITE was quarried at Porthgain for paving setts from the mid-C19, and exported to Dublin and London. By the early C20 the granite was being crushed for ROADSTONE and graded into the giant hoppers on the quay.

CLAY occurs around the slate deposits. Pottery was never particularly a noted manufacture in the county, but the basement of the Memorial Hall, at Newport, remarkably has a medieval pottery kiln, one of very few to survive. BRICK-making started perhaps in the C17 (see under building materials), though none of the brickworks in the county were especially large. The bricks from Porthgain are of interest, made from slate waste and clay from the quarry pits. A large machinery shed, of the 1890s, still dominates the village. Other late C19 or C20 brickworks were at Goodwick, Haverfordwest, Angle, Johnston and Llanddewi Velfrey. Fire-bricks for the coal industry were made at Wiseman's Bridge and Templeton.

*Extractive Industries*

COAL. Coal-mining began earlier in Pembrokeshire than elsewhere in the south Wales coalfield, at St Issells, Saundersfoot, by 1324. Coal was being used to burn lime at Lamphey in 1326, and in 1603 extraction at Begelly, Jeffreyston and Saundersfoot is recorded. Landshipping colliery was worked from the C16, and was the most profitable in the county in 1801, when the quay was rebuilt. Some thirty thousand tons are estimated as exported annually from the county by 1748, much to south east Ireland and Dublin, and by the late C18 also to France and Holland. There were then about a dozen collieries around Stepaside, mostly primitive and opencast. Industrial-scale exploitation began in the 1830s when Saundersfoot harbour was built, connected by a horse-drawn railway to collieries at Begelly and Kilgetty, and the growth of the town follows the fortunes of coal and iron (see below) until the closure of Bonville's Court Colliery, 1842 to 1930. The only large-scale colliery remains are at Bonville's Court, and Grove Colliery, Stepaside. The isolated chimney on the coast south of Nolton marks the western end of the coalfield. Cresswell Quay was one of several Haven shipment points for coal from small local pits in the C18. Two quays on the village side survive, and opposite are the walls of an acre-sized coal yard.

METALS. Early IRON-working sites are rare, there was an iron forge at Blackpool, Minwear, from 1635 to c. 1806. Cast-iron goods were produced at the Castell Malgwyn tinplate works in the late C18 (see below). With the coalfield came the IRONWORKS

at Stepaside, in 1848, with two blast furnaces, that ran until 1877. The shell of the casting house is the most prominent remnant on the site next to the Grove Colliery. Iron FOUNDRIES were less prominent in Pembrokeshire than in the neighbouring counties; there are cast-iron railings from the Stepaside works in the vicinity, the Woodside foundry of *Thomas David* at Saundersfoot made unusual cast-iron gravestones, as found at St Issells, and the *Marychurch* foundry, at Haverfordwest, made cast-iron milestones for the turnpike trusts. A TINPLATE works was set up *c.* 1764, at Castell Malgwyn, Manordeifi, on the Teifi. Little is known of the early history, but a brief refinancing by Sir Benjamin Hammet, in the 1790s raised the workforce to 300, and has left some elegant bridges with cast-iron keystone plaques over the broad canal parallel to the Teifi. The works were demolished in 1806. The only significant LEAD and SILVER mine, at Llanfyrnach, was worked from the mid-C18 to the 1790s, and again from the 1840s to 1890. The site has workings from the C18, ruins of a boiler house and chimney, *c.* 1850, a beam-engine house, 1860, and a row of former back-to-back cottages, Brick Row. A small COPPER mine was worked intermittently at Treginnis, St Davids.

## Oil

The very large oil tankers of the 1950s required some 20 metres depth of water to unload, and Milford Haven, like Bantry Bay in Ireland, was both suitable and surrounded by cheap land, with an abundant unemployed workforce. From 1959 refineries were built with long jetties into the Haven, for Esso at Herbrandston in 1960, Texaco at Rhoscrowther, 1962–4, Gulf at Llanstadwell, 1966–8, and Amoco, inland at Robeston West, 1971–3. The C19 fort at Fort Popton, Angle, was reused by BP for the control rooms for an offloading facility connected by a 100-kilometre pipeline to Llandarcy, Swansea. Another pipeline, 1972–3, ran some 230 kilometres to the English Midlands. Pembroke Power Station, Pwllcrochan, 1964–73, was built to burn some four million tons of oil a year, one of the largest such stations in Europe. It never ran to full capacity due to oil price rises after 1974, and by the late C20 Europe was over-supplied with refineries, and the Haven was not deep enough for the largest tankers. At the time of writing the power station has been demolished, and the Esso and BP sites cleared.

## Transport

The principal TRANSPORT arteries were the TURNPIKE ROADS of the late C18 and early C19, notably those from Saint Clears in Carmarthenshire to Haverfordwest and Pembroke, from Narberth to Tenby, and from Haverfordwest to Milford. These have cast-iron milestones of the early C19, but the TOLL-HOUSES have all been removed. Road BRIDGES are relatively modest, the earlier ones up to the later C18 of short span and with cutwaters,

sometimes carried up as refuges, and those subsequent generally with segmental arches and cut stone voussoirs, as at Wolfscastle (1793). The Old Bridge at Haverfordwest, of 1726, and the New Bridge, of 1829, are the two most architectural, apart from the estate bridges at Stackpole. The bridges of the later C19 were mostly designed by *Thomas George,* County Surveyor. The high-level CLEDDAU BRIDGE over the Haven to Pembroke Dock (1965–75) is the most dramatic modern structure in the county.

Horse-drawn RAILWAYS were introduced into the coalfield between the new harbour at Saundersfoot, and the collieries. Three small tunnels survive, along the coast, and others inland. The first passenger-carrying steam railway to arrive was *Brunel*'s South Wales Railway, extended into the county from Clunderwen to Haverfordwest, in 1854, and on to Neyland as the terminus for the Irish mail by 1856. No notable structures remain of Brunel's time, the best was the railway hotel at Neyland. A short spur off the Neyland line to Milford was added, in 1858–63, at the instigation of *R. F. Greville* to stimulate the revival of Milford port. The Pembroke Dock to Tenby line was built by the contractor *David Davies* of Llandinam in 1862–3, and extended to the main line at Whitland in 1866. The Whitland to Cardigan line reached Crymych up the Taf valley from Clunderwen in 1875, but was not extended to Cilgerran and Cardigan until the 1880s. The Maenclochog Railway, from Clunderwen to the slate-quarries at Rosebush, was built in 1872–7 by *Edward Cropper,* the quarry owner, but closed in 1882. Reopened for the tourist trade, it struggled to survive and was extended slowly to Fishguard, which it reached by 1894, but the line was made redundant by the shorter Great Western line, to Fishguard from Clarbeston Road, opened in 1899. The Manchester to Milford line, proposed in 1845, lost impetus in mid-Wales and never reached the county at all. The arches of the Tenby to Whitland line, over The Green at Tenby, are the single most notable railway structure. The Gothic station buildings at Tenby and Pembroke Dock, by *J. Szlumper*, 1870–1, are the only ones of architectural distinction, but the big overall train-shed roof at Fishguard Harbour, Goodwick, of 1904–6, is of engineering interest.

## THE TOWNS 1600–1950

John Speed's map of the county, of 1610, has tiny plans of St Davids and Pembroke, but by the C16 Haverfordwest had emerged as the principal town. Tenby and Pembroke were in severe decline, and St Davids in the long sleep of absentee bishops. Haverfordwest was second to Carmarthen in the region, and since 1479 had the status of a county borough, separate from the rest of the county. The town had a wealthy mercantile class that governed it through the common council, and seems to have been much rebuilt in the C17 with timber-framed houses. Public

buildings, however, seem to have been neglected. The Civil War was heavily fought in the county, with frequent changes of supremacy; the principal engagements were fought around Tenby and Pembroke, the Parliamentary victory was secured at Colby Moor in 1645. Cromwell himself came to Wales in the second Civil War, in 1648, to secure the surrender of Tenby and Pembroke, after which the castles at Haverfordwest and Pembroke were dismantled. The damage to towns in the Civil War may not have been very extensive, though the economic effects were severe. Haverfordwest, also affected by the plague in 1652, recovered little during the later C17, whereas Pembroke revived substantially around 1700. The built remains of before 1800 are scanty in the extreme, the timber-framed houses in the High Street at Haverfordwest are C16 to early C17, heavily disguised behind Victorian stucco, and at Tenby there may be some C17 work in the buildings of the High Street and Tudor Square.

For much of the C18 gable-fronted houses of the C17, in timber-frame or stone, remained typical of Haverfordwest and Tenby, as the era of improvement only came in the late Georgian period. At Haverfordwest there are some earlier harbingers of an altering civic society: assembly rooms (demolished) are shown in Buck's view of 1748, the medieval guildhall was rebuilt in the 1760s, and the gaol built in the castle in 1779–80. At Pembroke the long post-Civil War decay ended in the earlier C18, with a revival of the port, and the town has the best earlier-to-mid-C18 town houses of the county, notably No. 111 Main Street, with its staircase, and the fashionably fronted Brick House. For the later C18 Pembroke still has the better-quality remaining details, the staircase at No. 6 Westgate Hill, and the group of Chinese Chippendale staircases at the Kings Arms, the Royal George and No. 59 Main Street. 81

*The Nineteenth Century*

All the Pembrokeshire towns now have a predominantly C19 character. Tenby developed as a resort from 1805, Milford was a foundation of the late C18, but with its slow development, the early history forms more of an underlay than the visible character of the town. Fishguard grew in the later C18 as a herring-fishing port, until the disappearance of the shoals around 1790. Fenton, with a strong interest in the economic future of the town, described it in 1811 as second only to Haverfordwest in size and population, and almost all the houses of modern date. However, knowledge that the failure of the fishing had left the town destitute and even near to famine in 1799, may explain why the built evidence is almost all of later date. Narberth's most distinctive single development is of 1833, and at St Davids, while the rebuilding of the houses of the cathedral close began in the late C18, the little town hardly changed before the mid-C19.

The story of Milford, founded in 1792, nicely juxtaposes aspirations and achievement in late C18 town planning. Charles Greville founded the town on the expectation of relocating the

American whaling fleet from Nantucket and, with the support of Lord Nelson, established a naval dockyard, an ambitious start for a new town. The plan of three parallel streets, the main one an esplanade terminated by the church, has a formal grandeur. The two first public buildings, the Lord Nelson Hotel and the Customs House (now Museum), of 1794–5, show some sophistication, the hotel with the deep eaves of Nash's villas, and the Customs House with pediment and windows linked vertically in recessed panels, much altered now. The walled market, of 1811, was a much simpler building, now all but gone, but the model for the markets at Pembroke Dock, of 1826, and Tenby, 1829. The houses though were generally simple, and were never conceived as formal terraces, the principal ones, on Hamilton Terrace, with simple late Georgian internal detail. Relatively little of what was planned behind was built, as the building period ran with the Napoleonic Wars, and ceased with the removal of the dockyard to Pembroke Dock, in 1814, and the decision of the bulk of the American whalers to return to Nantucket. The single highest point of architectural design at Milford was the unachieved dockyard, whose great sweep of building would have eclipsed anything of its date in Wales, but it was barely begun in 1814 before being abandoned. Milford never found the success as a port (see Industrial introduction) to stimulate extensive urban building or replanning, so that the bones of the late C18 layout remain the outline of the modern town centre.

Pembroke Dock's first workers' housing, of 1814, was makeshift, and the main grid plan of the town must date from the 1830s, with an impressive breadth to the main streets. The buildings only rarely achieved three storeys, and the terraces that characterize the town are of small two-storey houses, dating mainly from c. 1840–70. The single-storey terraces of the back of the town, High Street and Military Road, are quite particular to Pembroke Dock and its neighbourhood, a house type distinct from the vernacular lofted cottage by its double-depth plan. In the dockyard itself, Nos. 2–3 The Terrace, of 1817–18, by *Edward Holl*, are, however, quite different, formal late Georgian façades in cut grey limestone, up-to-date, as by a metropolitan architect, and with their innovative iron roof structures, arguably among the most advanced houses of their date anywhere in Britain. The iron roofs of the dockyard buildings are discussed in the Industrial section, but the late Georgian formal façades of the Old Storehouse and office building, both of 1822, by *Holl*, and the Captain-Superintendent's house, of 1832–4, deserve note as part of a late Georgian group of architectural quality. It should be noted that the only formal terraced square in the county is the barrack square within the Defensible Barracks, of 1842–5.

At Tenby the renewal of the town as a seaside resort was steered by Sir William Paxton of Middleton Hall, Carms., whose sea-water baths and re-arrangement of the harbour area as promenades began in 1805. Tenby's growth parallels Aberystwyth as a resort, the latter slightly earlier, already being titled 'the Brighton of Wales' in 1797, but Tenby having the earlier spa buildings. The

baths and assembly rooms of 1806–10 by *S. P. Cockerell* are a minor public group of great charm, their setting testifying to the success of the venture, as Tenby harbour is now surrounded by terraced houses of the early to mid-C19, those in Castle Square perhaps late C18, but the others, in St Julian's Street and Crackwell Street, post 1805, late Georgian to early Victorian. Only once, at Lexden Terrace, 1843, was a formal terrace attempted; with giant Ionic pilasters; in general the houses came individually or in pairs. At Croft Terrace, 1833–64, the basic initial design was repeated as the terrace extended, giving a unity to this prominent if plain row. Tenby's last Georgian-style terraced houses overlap in date the first overtly Victorian ones, on the South Cliff, planned in 1864, built mostly in the 1870s.

Haverfordwest's renewal as the county town dates from the 1835 Municipal Reform Act, which established the municipal corporation, finally eclipsing Pembroke, where significantly an ambitious town hall and market scheme, of 1819, had stalled for lack of money. At Haverfordwest, *William Owen*, builder, architect, entrepreneur and civic leader, fashioned the remodelling of the principal entry to the town with the New Bridge, 1834, the Shire Hall, 1835, and the twin-terrace blocks of Victoria Place that frame the bridge, in a notable piece of late Georgian urban replanning. Owen did not change the whole town, there was not the economic growth to sustain a wholesale rebuilding, and elsewhere only the row on Spring Gardens, of 1839, aspires to formality, and there the two-storey iron veranda is more impressive than the architecture.

Narberth's short formal terrace, of 1833, a development by the Baron de Rutzen of Slebech, is modest, but shows up the smaller scale of the rest of the town, not just in being three-storey, but in the late Georgian stucco vocabulary of pilasters and blind arches. At Fishguard there are two individual town houses of quality, Nos. 3 and 5 Main Street, both early C19, but no formal groups. One must assume that the rendered two-storey houses of both the upper town and Lower Fishguard are at core of similar date, if only from Fenton's evidence, but the large upper windows suggest a Victorian exchange of lofts for full storeys.

The architectural highpoints of most Pembrokeshire towns of the earlier to mid-C19 are the classical CHAPEL fronts, discussed elsewhere. It is worth noting that at Pembroke Dock, Zion Chapel, of 1848, is the most prominent public building by far, just as at Pembroke and Fishguard the early C19 town halls, the most ambitious civic buildings of the towns, are eclipsed by chapels, and at Newport the gables of Ebeneser (1844–5), and Bethlehem (1855) still oversail the roofs of the town.

*Public Buildings*

After the Shire Hall at Haverfordwest, with its formal pilasters and pediment, PUBLIC BUILDINGS of note are rare – TOWN HALLS were largely subordinate to their market function. The

MARKETS without town halls, at Milford (1811, mostly demol-
ished), Pembroke Dock (1826), and Tenby (1829) form a group
of similar walled enclosures. There was a covered market behind
the 1833 de Rutzen development at Narberth, now gone. The
town halls at Pembroke (1819) and Fishguard (c. 1830) have a
formal civic presence, having halls over markets, and a hall was
added in 1861 over the market at Tenby, giving the building a
greater presence. The Narberth hall, of c. 1830, was very small,
a magistrates' room over cells, but raised a storey since.

The buildings of EDUCATION of the C19 rarely rise to the
memorable, the church schools are discussed with the churches.
The Board Schools are generally more economical than distinc-
tive, those by *K. W. Ladd*, of Pembroke Dock, (Hundleton, 1872,
Albion Square, Pembroke Dock, 1877) have a quirky Gothic-to-
round-arched character. The Intermediate or County Schools of
c. 1900 (Tenby, St Davids, Fishguard, Narberth) are just eco-
nomical. The Coronation School, Pembroke Dock, of 1901–4, a
Board School for 900 pupils, is the sole example of that tall urban
board-school type, a beacon of education over the surrounding
terraced houses.

The WORKHOUSES at St Dogmaels, Narberth, and Haver-
fordwest follow the Poor Law Commissioners' plans of the 1830s.
The one at St Dogmaels (Albro Castle) is quite exceptionally pre-
served, even down to the overnight cells for tramps. Hospitals
have not been architecturally significant buildings, the COUNTY
INFIRMARY at Haverfordwest, of 1873, is late and modest, and
the asylum is outside the county at Carmarthen, the expense
being shared between three counties. The Court House at
Narberth, 1864, by *C. Reeves* of London, shows an elegant use
of the Italianate, in contrasted grey and buff stone, not especially
grand, but the careful detailing exceptional. PUBLIC STATUARY
is confined to the Welsh National Memorial to the Prince
Consort, on the Castle Hill at Tenby, a white marble statue
by *J. E. Thomas*, on a splendid grey limestone plinth, promoted
by the mayor to put Tenby in the same category as Dublin and
Edinburgh. The walks laid out around the memorial were almost
the only significant PARK or piece of civic landscaping, apart
from the avenue to the dockyard chapel at Pembroke Dock, laid
out in 1844.

## Commercial Buildings

The first Victorian COMMERCIAL BUILDINGS up to the 1860s
followed the late Georgian pattern of small-paned shop windows
under conventional house façades, and no good examples
survive. The Ellis & Co. building at Haverfordwest, 1876–7, and
the former Post Offices at Haverfordwest and Fishguard, pos-
sibly all by *D. E. Thomas*, show a later Victorian heaviness of large
windows and pilaster strips. Commerce House, Haverfordwest,
1869, a commercial warehouse of nine bays and four storeys, has
Italianate round arches and is said to be iron-framed, not visible
now. BANKS, oddly, never achieved the architectural distinction

in Pembrokeshire that they did elsewhere, a Gothic example in Pembroke, of *c.* 1880, the most memorable. Among the few good C19 SHOPFRONTS, the Medical Hall in Tudor Square, Tenby, stands out, with its Neo-Grecian railing above. Pembrokeshire lacks a distinctive late C19 commercial architecture: unlike elsewhere there was no boom in public houses to display terracotta and glazed tile, nor local architects with a particular flair for commercial display.

The county had two gentlemen's CLUBS, both of 1877, the one at Tenby by *W. Newton Dunn*, a stone villa with ponderous Gothic porch, the one at Haverfordwest by *D. E. Thomas*, stuccoed Tudor. Pembroke Dock had a Mechanics' Institute, of 1862–3, and Haverfordwest an improbably imposing porticoed MASONIC HALL, of 1870–1, grander than any chapel in the county; the Masonic Hall in Milford, 1880–2, echoes Italianate chapels.

HOTELS developed as a distinctive form from the coaching inns, but the county's best examples were built for sea travel. Greville's New Inn, of 1794–5, at Milford (renamed after Nelson's 1802 visit), was built for the Irish trade, a distinguished design with deep-eaved hipped roofs and lunette windows. When the terminus moved to Pembroke Dock in 1832, the Royal Mail Hotel was built at Hobbs Point, 1835–6, and seems to be the plain hipped building that survives there; when it moved to Neyland in 1857, the Italianate South Wales Hotel (1857–8 by *William Owen*) followed. The seaside hotel as such begins at Tenby, the Coburg Hotel, said to date from 1798, though Sir William Paxton's Globe Inn (now Tenby House), of 1807, seems the first specifically built. Neither building was architecturally especially notable. The Royal Gatehouse Hotel, Tenby, of 1857–8, was to a quite different scale, of the generation of railway hotels (built here in advance of the railway), and designed by a London architect, *James Thomson*. Though missing the massive cornice, the inventiveness of the Italianate design stands out as quite different from the stucco norm. The last and largest hotel, the Fishguard Bay Hotel, was opened in expectation of the railway, in 1887, but the ponderous main block added in 1900–10 aspired even higher, to the elusive transatlantic trade, its saloons panelled like liner state-rooms.

*Victorian Urban Housing*

The late Georgian model was followed into the 1860s. The three-storey Cambrian Terrace, Saundersfoot, of *c.* 1865, is plain but for some stucco architraves to the ground floor. Expansion of window size, scale, and some greater use of moulded detail also dates the later houses in Crackwell Street and St Julian's Street, Tenby. The Prize House, High Street, Tenby, 1851, stands quite alone with a precise Bath-stone façade, reminiscent of Clifton, Bristol, and presumed to be by a Bristol architect. The new town at Milford, as designed in 1857 by *Frederick Wehnert*, would have been of stuccoed terraces with curving bay windows, Llandudno with a touch of Bayswater, but only one house was built. Railway

Terrace at Neyland, of shortly after 1857, showed deep-eaved Italianate, a villa style adapted to terraces as at Cheltenham, but the detail was very modest, and is mostly now lost. It is tempting to see Wehnert's hand in the terraces of the Esplanade and Victoria Street, Tenby, of 1869–80, simpler than the Milford design, but with the three-sided bay window as the leading motif. This South Cliff development of Tenby is perhaps the one urban expansion that can be linked to railway tourism, the town seeking to attract visitors from both south Wales and the English Midlands. Orielton Terrace, at Pembroke, is similar to the Tenby Esplanade terraces, perhaps by the same hand. Even at St Davids, one terrace, Royal Terrace of 1882, rears a Victorian three storeys above the rest of the town.

The more modest terraced houses of the small towns, as a rule of two storeys, and stuccoed, show some local variations. At St Dogmaels the local features are banded stonework, and some distinctive pilastered timber doorcases. Georgian sashes and fielded-panel doors, long after their heyday, characterize Newport, where also the hard green dolerite appears as a later C19 feature. Goodwick has some unusual later C19 bay windows with the top corners of the sashes chamfered, and Fishguard has late Victorian oriel-windowed terraces in the west part of the town. Purple Caerbwdy stone and late Georgian-style houses, of the 1860s and 1870s, are typical of St Davids. At Pembroke Dock, the hardwood panelled doors, said to be of shipbuilding timber from the dockyard, are a vanishing individual touch.

A new form of the town house was the detached VILLA, introduced to the county by *John Nash* in two villas of *c.* 1790 (relatively early in Nash's short career in Wales), Foley House, at Haverfordwest, which survives, and Sion House, at Tenby, which has been demolished. They were, like his marine villa at Aberystwyth, pioneers and far from typical, compact gentlemen's houses in an urban context. *Richard Fenton*'s probably self-designed villa at Fishguard, Plas Glynymel, 1799, fits into the same romantic Picturesque context as Nash's villa for Uvedale Price, at Aberystwyth, Price being a key figure in the movement and Fenton a knowledgeable early follower. Both sites were chosen for their awe-inspiring or sublime character, at Glynymel the rocky chasm of the Gwaun, at Aberystwyth the seas crashing dangerously on the rocks in front. The villa as an urban or suburban type had little success in the county, simply because the towns were too small, and so evolved as a type for small country houses, and indeed vicarages (both discussed elsewhere). The Archdeacon of Brecon's house, 1820–1, and slightly later Archdeaconry, both in the Cathedral Close at St Davids, are hipped late-Georgian villas similar, for example, to the contemporary rectory (Llys Mair) on the edge of Fishguard, or the fully-rural rectory at Narberth (The Valley). The vicarage at Pembroke Dock, 1858, has a more Victorian amplitude on a restricted urban site, the design still in the late Georgian tradition. One suburban villa estate was at Heywood Lane, Tenby, developed from as early as 1823, though all the surviving villas, in a Tudor Gothic style, are

of *c*. 1840 and later, some stuccoed, some stone. Broad Haven was intended as a villa resort; the one stuccoed Italianate pair, built *c*. 1865, is surprisingly large, but there were no successors. Tudor Gothic was the style chosen for the rebuilding of the Deanery, St Davids, in 1851, with rather more Victorian solidity than the Heywood Lane houses, but still stuccoed. Gothic to Tudor styles were appropriate for rectories, as mentioned else-where, outdone in expense by the Chancellor's House (The Canonry), St Davids, *c*. 1847, in rock-faced stone with a tower. Tenby has a good sequence of Gothic houses for different denominations: the rectory, a substantial Congregational manse, of 1872, by *Paull & Robinson* of Manchester, in that half-hipped and bargeboarded style more modern than Gothic, while more Gothic than modern was the house attached to *George Morgan*'s Tenby Baptist Chapel, of 1885. The Roman Catholic seminary by Holy Rood church is a substantial work, with playful late Gothic detail, of 1896, by *F.A. Walters*. Tenby also has the only High Victorian Gothic town house in the county, No. 10 The Norton, of 1859, by *Ewan Christian*, with up-to-date Ruskinian polychromy, and boldly asymmetrical façade. Even now with the polychromy painted out it is a striking design.

The domestic revival villa of the late C19, all small-paned windows and red tiles, has two examples in Tenby: Nyth Aderyn, 1883, by *Ernest Newton*, is an early example, both of the type and of the work of one of the leading architects of the style, derived, of course, from Newton's master, R. Norman Shaw. Shorn of its massive chimneys the design is diminished, but the balconies and small-paned windows still offer a marine aesthetic quite differ-ent from the stucco tradition. Significantly, this was a holiday house built for the antiquarian heir of a Wolverhampton fortune, and the only other example, St Stephen's, of 1901, is by Sutton Coldfield architects for a Midlands industrialist's widow.

# NINETEENTH AND TWENTIETH CENTURY MILITARY BUILDINGS

BY ROGER THOMAS AND ROBERT SCOURFIELD

The lack of adequate defence of the Milford Haven was noted repeatedly through the C18, and the first major step to try and correct the situation was the survey of Milford Haven, under-taken by Colonel Watson in 1755. The outbreak of the Seven Years War, in 1756, emphasized the defenceless nature of the waterway, and as a result Lieutenant-Colonel Bastide carried out another survey in 1757. Bastide proposed a comprehensive fortification scheme comprising of eight 10-gun batteries and a floating battery arranged in an outer, central, and inner line of defence. Costs prohibited such a scheme and instead it was proposed to build these forts up-river, at the point where the Haven narrows between Neyland and Paterchurch Point, thus leaving the

sheltered Haven vulnerable to attack. Land was purchased and the Paterchurch Fort (*see* Pembroke Dock) begun, but after slow progress work was abandoned in April 1764. In the late C18, two small batteries were built, neither part of an overall scheme. The first was at Neyland, *c.* 1775, to protect a temporary shipyard; the second was at Fishguard, in response to a privateer attack in September 1779. Fishguard Fort famously saw action on 22 February 1797, when its guns fired on the French lugger *Vantour*, part of the ill-fated last invasion attempt of Britain. From the early C19, with the great investment in the new towns of Milford, Neyland and Pembroke Dock, the Haven became a harbour of strategic importance.

The various invasive scares of the Napoleonic Wars produced a number of defence schemes around Britain, but it was not until the outbreak of the second phase of the war, in 1803, that temporary batteries were built in west Wales. The Pater Battery was reconstructed from 1840, in order to protect the rapidly expanding Pembroke Dockyard: traces of this survive, including the tall
107 ashlar rampart. Alongside this work, a large defensible barracks, protected by a deep dry ditch, was begun in January 1841, on Treowen Hill, overlooking the dockyard and the rapidly growing town, and completed in 1846. The barracks marked a major improvement for the Royal Marines guarding the dockyard, but was incapable of resisting artillery fire and was too close to the dockyard to prevent bombardment.

Between 1848 and 1851, in response to the possibility of an
108 American raid during the Oregon crisis, two Martello gun towers were built at opposing corners of the dockyard. These allowed unrestricted enfilade fire along all four sides of the dockyard, except for the re-entrant angle around the Market Hall, which was covered by musketry loopholes in the dockyard wall.

Having provided for the immediate locality of Pembroke Dockyard, thought turned to defending the lower reaches of the Milford Haven. Three sites were chosen at the mouth of the
110 Haven: West Blockhouse (*see* Dale), Dale Point, and Thorne Island, supported by a further gun tower on Stack Rock, in the middle of the waterway. These forts were commissioned in the early 1850s and were completed by the period of the Crimean War: they are of particular significance as the last generation to be built to combat sailing ships with smooth-bore guns, and were quickly rendered obsolete by the introduction of steam-driven armoured warships armed with rifled guns.

The launch by the French of the world's first ocean-going iron-clad warships, in 1858, abruptly ended the piecemeal development of British military architecture. The ascendancy of the French ensured that the Royal Dockyard at Pembroke Dock was considered under threat. A government committee on the sea defences of Milford Haven and the dockyard was set up, and proposed in December 1858 the building of four large forts: South Hook (*see* Herbrandston), Hubberston, Stack Rock and Popton. A further fort was proposed at Chapel Bay, Angle, the latter not begun until the 1890s. In 1860, it was proposed to strengthen the

defences of the Haven by building two lines of land-forts, and a series of batteries to cover nearby navigable beaches. Of these, financial considerations led to only two forts materializing: Scoveston, near Llanstadwell, commanding the approach to the dockyard from well inland to the north, and St Catherine's, Tenby, protecting the town's harbour, beaches and anchorages: the large beaches at Tenby would have permitted the off-loading of heavy stores by the enemy, who would also have access to the newly built Tenby and Pembroke Railway.

From the outset, the forts were designed to mount and resist the fire of large smooth-bore muzzle loading guns: during construction, the more powerful Rifled Breech Loader was developed, closely followed by the more accurate Rifled Muzzle Loader. This continuing development was a challenge to the Royal Engineers, who frequently updated their designs to take into account the ever-increasing power of the guns – the building of Stack Rock Fort, for instance, was halted four times to improve the level of protection from increasingly powerful guns. Where topography allowed protection against direct fire, the guns were mounted in open batteries behind earthen ramparts. Where the battery was low-lying, the guns were mounted within substantial brick chambers called casemates. The disadvantages of the casemates – a narrow arc of fire and a tendency to fill with smoke – were overcome by the development of the Moncreiff Carriage in the 1860s, which was located in a concrete-lined pit, where it could be loaded and trained in relative safety. Such pits were built at Hubberston and Popton in the 1870s.

All of the forts are spectacular, both in scale and construction, the latter usually of south Pembrokeshire limestone ashlar, with detail of Cornish granite. In total, there were four lines of defence of the Haven. The first covered the Haven entrance, Thorne Island, Dale and West Blockhouse (*see* Dale); the second involved South Hook, Stack Rock and Chapel Bay batteries; the third included Hubberston and Popton Forts. The final defences were on the flanks of the dockyard itself. The strongest of the forts, at Popton and Hubberston, were designed to hold garrisons of over 200 men. Hubberston is perhaps the most impressive, and sadly the most ruinous. The garrison was housed in a bomb-proof D-shaped barracks set back from the coast, while the gun emplacements were directly above the headland. Stack Rock Fort 109 is located on a small rock located mid-channel, the trefoil-plan gun tower, of 1852, encircled by a mighty circular fort, of 1870, providing casemates for massive guns. The vast hexagonal enclosure of Scoveston Fort (1861–8), is deeply moated and barely visible even from close proximity. Many of the forts lie derelict; some, like Thorne Island, Popton and West Blockhouse, have been converted to sympathetic new uses since they were sold off in the early c20.

Chapel Bay Fort was constructed in the 1890s, a new low-profiled design similar to that used in the experimental Twydall Redoubts at Chatham. It also marks the transition from the large masonry works of the c19 to the low-profile mass concrete

batteries of the C20. The battery is a hybrid: it contains a dry moat flanked by caponiers, typical of the C19, with mass-concrete gun emplacements, casemate shelters, and ancillary buildings more typical of the C20. However, it is the manner in which it is profiled into the surrounding countryside that really sets it apart from earlier gun batteries, presenting a low inauspicious target, protected to the rear by an earthen rampart with a musketry firing step running its full length.

The Second World War was the first in history to touch the lives of all levels of society in Wales. Physical evidence of the conflict remains extant in many parishes; despite their lack of aesthetic value and public appreciation, many represent important steps in the development of technology, industrial processes and construction techniques, and a small selection deserves careful conservation. There is no more evocative a survival of the period than Dale Camp, almost a village in itself, complete with its own chapel.

## THE TWENTIETH CENTURY

### 1900–1918

The buildings of the EARLY TWENTIETH CENTURY are not generally remarkable apart from the monastery buildings at 126, 127 Caldey Island, begun in 1906–7. These, by *John Coates Carter*, defy categorizing. They have roots in the Gothic revival and are imbued with the spirit of the Arts and Crafts movement, but the sweeping red-tiled roofs over white roughcast walls suggest Spain or Latin America, the massive stone arches of the basement the American Romanesque of H.H. Richardson, and the riot of towers and turrets children's book illustrations. The disposition of roofs, towers and turrets on the clifftop, as viewed from outside the Post Office below, monumental yet informal, has no equal in Edwardian architecture, and the Post Office itself, with its swept-out roof skirts, is a minor delight. The abbey, sadly, is no longer the treasury of early C20 church furnishings that it was, but the stained glass made at Caldey remains a tribute to Arts and Crafts ideals, some of the best pieces within the abbey and the island churches. A minor Arts and Crafts building to set with Coates Carter's work is the Village Hall, Manorbier, 1908, by the furniture designer and successor to Morris at Morris & Co., *W.A.S. Benson*, a nice combination of vernacular stonework and little Palladian windows.

Of Edwardian HOUSES, *Coates Carter*'s Ty Gwyn, Caldey Island, of 1911–12, still has its remarkable Arts and Crafts interior, though the exterior has been spoilt. West Lodge, Lydstep, by *Baillie Scott & Beresford*, 1912, has the sweeping roofs and buttressing chimneys of the Arts and Crafts tradition, though the exposed stonework was intended to be colourwashed. Westaway at Hakin, of 1904, by an unknown architect, has the sweeping roofs, but walls here slate-hung and roughcast with sash

windows. Amid the HOUSING of the early C20, the Harbour Village at Goodwick, built for Great Western Railway staff in 1902–8, should stand for the garden village ideals of the time, but the extent of alteration has left the original quality to the eye of faith. The railway workers' houses of St Davids Road estate in Goodwick are better preserved, with hipped roofs and pretty, small-paned casements, the walling of concrete block.

There are few good COMMERCIAL BUILDINGS of the Edwardian period, the former Post Office, Milford, 1908, was the best example of the revived early C18 style of the Edwardian period, but its red brick and Bath stone have been painted over. The Liberal Club, Tenby, 1912, by *E. G. Thomas*, introduces half-timber to an already mixed Tudor Square.

### 1918–1945

After the First World War, the WAR MEMORIALS took the form of MEMORIAL HALLS (e.g. the City Hall, St Davids) as often as sculptural pieces. The county memorial at Haverfordwest, 1921, by *Oswald Milne and Paul Phipps*, stands out for the noble dragon in Forest of Dean stone, and the Tenby memorial is an attractive classical design, contrasting grey limestone and white marble with elegant bronze capitals and urn, by *J. Howard Morgan*, 1923.  128

Between the wars, suburban expansion around Pembrokeshire towns was limited in comparison with other counties, and none of the council estates are especially worthy of note. The small-holding scheme around Jordanston Hall, Rosemarket, of 1936–7, by *T. A. Lloyd*, for the Welsh Land Settlement Society, is the most interesting social experiment. Some of the SCHOOLS stand out. They are in a Neo-Georgian to modern idiom, probably all by *Owain Thomas*, the county architect: the Neo-Georgian Central School, Milford, of 1929–35, the whitewashed hipped-roofed school at Solva, 1933, and the butterfly-plan building at Herbrandston, 1935. The only PUBLIC BUILDING of note is the Neo-Georgian Post Office, 1934–6, in Haverfordwest, in finely detailed Bath stone.

### 1945–1970

Schools, again, are the dominant buildings of the early POST-WAR years, with secondary schools at Crymych, 1953–7, Fishguard, 1954, Milford, 1962–4, and elsewhere, by the county architect, *Lt.-Col. W. Barrett*. They were modern for their day, composed of flat-roofed cubic blocks, the classroom tower at Crymych a particular landmark. Cambria House, 1964–7, the county council offices at Haverfordwest, was a rare example of the textured concrete of that period, and public dislike, as much as any redundancy, secured its demolition. The other public buildings of the 1960s and 1970s, including the county library at Haverfordwest, do not deserve to be singled out any more than the commercial buildings that began to break into the shopping streets. The Round House at St Davids, of 1964–8, by *James*  130

*Gowan*, is a solitary distinctive note among the cacophony of 1960s house design in the county, playful in its references to the International Modern, innovative in its planning.

## 1970–2002

The most notable facet of architecture in the county in the later C20 has been the emergence of a body of work on ecological principles, much of it of a nationally pioneering nature. *Christopher Day*'s Ty Cwrdd Bach, at Pontfaen, 1974, opened a sequence of buildings by him designed to harmonize with the landscape, using local materials and a design ethic of softer forms, echoing those of nature rather than the straight lines of conventional architecture. Here was pioneering work that sought to answer the question asked in Day's book *Places of the Soul*, 1990 (subtitled *Architecture and Environmental Design as a Healing Art*), of how far buildings can be made to enhance the lives of those who use them. The Nant-y-cwm Steiner School, Llanycefn, of 1982, altered a Victorian Board School with subtle curves, adapting the windows to the classrooms within, the square lines of the interiors modified with rough plaster curving over the angles of wall to wall and wall to ceiling, to give learning spaces scaled to the children. At the adjacent kindergarten, of 1989, Day achieved an iconic building of the then barely nascent ecological movement, a little building where the forms flow from the earth in battered roughcast walls, anchored by a turfed roof (first used at Ty Cwrdd Bach). Inside the flow of spaces is complex and organic, the access to the two circular classrooms an object lesson in drawing the visitor or user into the heart of the building, and the classrooms themselves with their niche retreats are delightful in their recognition that the individual child's needs may not always be the same as the group's. The Ffald-y-Brenin Retreat Centre, Pontfaen, 1985–6, echoes the surrounding hills in its undulating roofline, and the interior spaces give lessons in the human-scale approach, the windows arranged to cast light discreetly into smaller spaces, generously into the common room, the finishes rugged and tactile. The chapel, at the upper end, circular with a conical roof, appears rooted in the bedrock, an impression confirmed by the great boulder left within to form the altar. Day's heart and soul approach necessarily favours the hand-made and individual, a late C20 equivalent of the radical Arts and Crafts architects like Gimson and Ashbee.

The ecological movement has, since the 1980s, pushed at least its questions into the mainstream of architecture. In Pembrokeshire elements of the ecological strain can be detected in each of the small group of significant modern buildings built since 1990. The Visitor Centre at Scolton Manor, Spittal, 1993, by *Peter Holden Architects*, was designed to minimize energy use, and its octagonal interior with a spiral of pine poles supporting the roof emphasizes natural materials. The sequence of buildings by *Peter Roberts*, designed first for *Niall Phillips Associates* and then on his own, illustrate an environmental concern for setting and

an ecological concern for materials. The conversion of the farm buildings at Treginnis Isaf, St Davids, 1990–2, to a centre for children, has something of Day's concern to make child-friendly spaces for groups and individuals, and for tactile materials. The Welsh Wildlife Centre at Cilgerran, 1993–4, is designed to nestle 133 into a cleft, barely showing from the marshes of the wildlife reserve, the entrance front to the valley a sheer screen of glass to the exhibition and eating spaces within. The marriage of timber boarding and plate glass gives the building a lightness appropriate to its purpose, and despite its size. The visitor centre at Castell Henllys, Meline, 1993–4, designed for minimal environmental impact, has a partly-turfed roof and curving form to fit the site between drive and river. The use of materials emphasizes the natural, stripped-pine posts, oak and limewashed plaster walls, and the teaching spaces flow outward to the field in front. *Roberts'* Tourist Information Centre at St Davids, another curved build- 135 ing seeking to blend with the environment, takes on also the challenge of softening car parking with landscaping, too often the forgotten element in designs. The main curved block has elements from the other Roberts buildings: glass wall, pine posts, flow of space from inside to out. Visually the dominant element is a stone-clad circular tower with conical roof, picturesque and a good foil for the glass front of the main building, but the lecture-room purpose perhaps does not require such a structure. Roberts' curving glass walls found echo in the Sail Training Centre at Goodwick, 1996–7, by *Tim Colquhoun*, for the district council. As county architect, Colquhoun oversaw the design of the County Hall, Haverfordwest, 1998–9, a long riverside range in painted stucco, animated by three bowed projections with conical roofs, a building of modest ambitions given its scale. The stucco nods to the terraces of the early C19, the curved roofs to the Carmarthen County Hall of the 1930s, and, with that post-modern desire to be odd, the thin clock tower on the landward side seems to echo Great West Road factories of the 1930s.

The SCHOOLS of the later C20 were built by Dyfed County Council from 1974, under *Roy Howell*, among the best the well-planned Primary School at Newport, 1991, built around a small internal courtyard. The Primary School at St Davids, 2002, by *Pembroke Design*, is a linear design to take advantage of the outlook over the cathedral, the glazed front wall dramatically crowning the contour.

One other house deserves mention, Malator, Nolton, 1998, by 134 *Future Systems*, a holiday house hidden under a carpet of turf, but opening an oval glass wall to the sea. This marriage of the environmental with science-fiction highlights the degree to which mistrust of the modern guides design, or more pointedly planning, the earth blanket here a design rather than ecological criterion. In the context of finding a new language for the holiday house, Malator is a success, the more shining amid the general failure of housing design of the later C20. The failure has come about not from a desire to impose design, rather because very often no architect was involved at all. The National Park

authority restricted the scale of development in the coastal area, but was no more successful than the county in stimulating good design among private builders.

The failures, both before and after 1974, to protect the stock of HISTORIC BUILDINGS, or control the deterioration of the townscape, began to change in the late 1980s, primarily with the Town Scheme administered by the National Park, in Tenby, followed by a similar scheme in St Davids. The advent of European Union money for urban improvement has tended more to street furniture than new buildings or restoration, but the clearance and repair of the Milford docks has eased the transition from working port to marina. Heritage rebuilding in Tenby tends to a hybrid Georgian-to-Victorian shopfront, and bright paint colours, neither authentic, but both perhaps necessary in re-inventing the resort. The advent of National Lottery money has encouraged far more ambitious restoration schemes. The one for Pembroke Dock, begun in 2001, has already turned around a seemingly unstoppable slide to dereliction in the important buildings of the dockyard, and that for Caldey Abbey has restored features lost since the 1940s, both restoration schemes undertaken by *Acanthus Holden* of Pembroke.

# FURTHER READING

Pembrokeshire is richly blessed with written material even from
the earliest period: enviably so compared to its adjacent coun-
ties. The first to write extensively of Pembrokeshire was Gerald
of Wales, Giraldus Cambrensis, a native of Manorbier, who
accompanied Archbishop Baldwin preaching the crusade in 1188,
and wrote entertainingly of the mission and the country in his
*Itinerary through Wales*. The earliest general source on the county,
with particular reference to industry and agriculture, is George
Owen's *The Description of Pembrokeshire*, written by 1603, a
remarkable testimony to Renaissance enquiry which even pin-
points the building dates of some houses. Richard Fenton's *His-
torical Tour through Pembrokeshire*, 1810, must be among the best
county topographies in Britain; warm, witty, erudite and written
with the eye of a native, who himself knew the leading figures of
the time and had a feel for contemporary history. Thus while pre-
historic monuments and churches are all described, so also is the
French invasion of 1797, the foundation of the town of Milford,
and the birth of Tenby as a holiday resort. Another native,
Edward Laws, published *The History of Little England beyond
Wales*, 1888, scholarly, trenchant and with a competent eye for
architecture, particularly the medieval. These two remain the best
general reading on the county. Pembrokeshire parishes are
treated in Samuel Lewis' *Topographical Dictionary of Wales*, 1833
(updated in several later additions), and also briefly in the Post
Office Directories of South Wales, notably *Kelly's* of 1884 and
1914, the entries brief but useful. Early maps and drawings are
few: the ever valuable John Speed includes tiny plans of St Davids
and Pembroke in his county map of 1610, and Joseph Lord's
wonderful plan of St Davids, of 1720, catches a medieval cathe-
dral close in a detail unmatched anywhere in Britain. Samuel and
Nathaniel Buck's views, of 1740, capture the castles in great detail
but also include a great deal more topographical information. A
number of gentlemen's and antiquarian tours of south Wales in
the decades around 1800 also shed useful insights into the
county.

The Royal Commission on the Ancient and Historic Monu-
ments of Wales volume, *Pembrokeshire*, 1925, may be outdated as
an inventory of the ancient monuments of the county, but with
no successor, it remains a standard text. *The Pembrokeshire County
History* produced by the Pembrokeshire Historical Society lacks
still the first volume, on the prehistoric to early Christian periods,
but the three produced between 1987 and 2002, on medieval,

early modern, and modern, are essential reading, a series of essays by specialists on a wide variety of topics, though the built environment generally and architecture specifically are unfortunately largely ignored in the modern volume.

Of widely available C20 guides, the majority drearily repeat themselves, but two are essential to any architectural library. *The Shell Guide to South West Wales*, by Vyvyan Rees, 1976, has wonderful photographs by John and Edward Piper, Roger Worsley and Peter Burton, and a text that so often captures the unexpected in miniature. *The Companion Guide to South Wales*, 1977, by Peter Howell and Elizabeth Beazley, has a fine architectural eye, and is particularly good on Victorian buildings. *Pembrokeshire Past and Present*, 1995, by Brian John, a geographer, is good on the landscape and its changes.

Primary sources for individual buildings and archaeological sites are the statutory Lists of protected buildings and of scheduled ancient monuments, kept by Cadw: Welsh Historic Monuments and the files of the National Monuments Record, Aberystwyth. *Cambria Archaeology* is constantly adding to the knowledge of the earlier phases of built history.

The most important periodical for Wales has been *Archaeologia Cambrensis* (*Arch. Camb.*) since 1847, and its volumes contain a great deal of value for the prehistoric, Early Christian and medieval periods. The fourteen large annual volumes of the *West Wales Historical Society Transactions* from 1911–29 contain much on the county, while the intermittent issues of *Pembrokeshire Historian* and then the *Journal of the Pembrokeshire Historical Society* have published valuable essays since the later C20.

For geology, Brian John's short book, *The Geology of Pembrokeshire*, 1979, remains the most accessible guide to the complexities of the subject, some of which are explored in the essays in *Geological Excursions in Dyfed*, 1982, edited by M. Bassett.

For ancient monuments up to the medieval period Sian Rees' publication for Cadw, *A Guide to Ancient and Historic Wales: Dyfed*, 1992, is by far the most accessible and useful general guide. For prehistoric monuments, *Prehistoric Wales*, 2000 by Frances Lynch, S. Aldhouse-Green and J. L. Davies, as well as Lynch's *Megalithic Tombs and Long Barrows in Britian*, 1997, are overviews, with more local studies in C. T. Barker, *The Chambered Tombs of SW Wales*, 1992, G. Nash & G. Children, *Guide to Neolithic Sites of Cardiganshire, Carmarthenshire and Pembrokeshire*, and N. P. Figgis, *Prehistoric Preseli*, 2001. The monuments at Pentre Ifan and Carreg Coetan Arthur are mentioned in the 1992 *Cadw guidebooks* to Cilgerran Castle and St Dogmaels Abbey. For the Roman period there is C. J. Arnold and J. L. Davies, *Roman and Early Medieval Wales*, 2000.

For the inscribed stones and Early Christian period, the reprints by the Llanerch Press of J. O. Westwood's *Lapidarium Walliae*, 1875–9, and J. Romilly Allen's *Celtic Crosses of Wales*, 1899, are invaluable for the illustrations. *The Ogham Monuments in Wales*, 1992, reprints early material with valuable editorial

comment by J. Sharkey. The overview remains V.E. Nash-Williams, *The Early Christian Monuments of Wales*, 1950. For the early medieval period Nancy Edwards and A. Lane (eds.), *Early Medieval Settlement in Wales AD 400–1100*, 1988, explores the themes, while the context of the inscribed stones and sculpture is covered by Nancy Edwards in *Medieval Archaeology*, 45, 2001, and the early medieval sculpture of St Davids specifically in her article: 'Monuments in a landscape: The early medieval sculpture of St Davids', in H. Hamerow and A. McGregor (eds.), *Image and Power in the archaeology of Early Medieval Britain*, 2001. Jeremy Knight sets the context of the early Latin inscriptions in his article in *The Early Church in Wales and the West* (Oxbow monograph 16) 1992, which also has an essay by Terrence James on air photography of ecclesiastical sites, while his booklet *Ancient West Wales from the Air*, 1980, is the best published collection of aerial views of sites from hillforts to castles.

For a survey of the county's castles, prepared in the early 1990s, see J.R. Kenyon and the late D.J.C. King, 'The Castles of Pembrokeshire', in R.F. Walker (ed.), *Pembrokeshire County History. 2. Medieval Pembrokeshire*, 522–47. Haverfordwest, 2002. It should be noted, however that recent work on Wiston and Cilgerran has thrown greater light on the phasing of these castles (see the relevant Cadw guidebooks).

The castles have been well served by Cadw guidebooks, to Cilgerran, 1992, by J.B. Hilling, Llawhaden, 1991, by R. Turner, and Wiston, 1996, by R. Turner. Newport has a full monograph by the Royal Commission: *Newport Castle*, 1992. Pembroke Castle is described by D.J. Cathcart King in *Arch. Camb.* 1978, Carew by Cathcart King and J.C. Perks in the *Archaeological Journal 119*, and Manorbier by the same authors in *Archaeologia Cambrensis 1970*. Mike Garner's excellent report on Picton Castle remains unpublished. An overview of castle building is provided by D.J. Cathcart King, *The Castles of England and Wales*, 1988. The town walls of Tenby are described by W. Gwyn Thomas in *Arch. Camb.* 1993.

The extraordinary growth of medieval Haverfordwest is covered by Terrence James, in the *Journal of the Pembrokeshire Historical Society*, 4, 1990–1. Medieval houses from tower houses to the episcopal palaces are the subject of the Welsh chapters of Anthony Emery's superb *Great Medieval Houses of England and Wales 1300–1500*, vol. 2, 2000. The standard history of the cathedral is by W.B. Jones and E.A. Freeman, *The History of Antiquities of Saint David's* (1856, reprinted 1998). E.W. Lovegrove did his best to unravel the sequence of building in 'St Davids Cathedral', *Archaeologia Cambrensis*, 77 (1922) and there is a detailed consideration of the fabric by Roger Stalley, 'The Architecture of St David's Cathedral; chronology, catastrophe and design', *Antiquaries Journal*, 82 (2002). The motives for embarking on the reconstruction in the late twelfth century are examined by Peter Draper, 'St David's cathedral: provincial or metropolitan?' in *Pierre, lumière, couleur. Etudes d'histoire de l'art du Moyen Age en l'honneur d'Anne Prache*, (ed.) F. Joubert and D. Sandron, Paris,

1999. Important insights into the later history of the fabric are provided by Wyn Evans, 'St Davids Cathedral: The Forgotten Centuries', *Journal of Welsh Ecclesiastical History*, 3 (1986). Valuable earlier material includes Browne Willis, *A survey of the Cathedral Church of St Davids*, 1717 and Edward Yardley's *Menevia Sacra*, written before 1770 and published for the Cambrian Archaeological Association in 1927. Recent monographs, on the misericords, 1995, by Nona Rees, and the organs, 2001, by Geraint Bowen are valuable. The medieval stalls are covered in *Arch. Camb.* 1957, and the misericords in *Arch. Camb.* 1900. Rick Turner discussed the Bishop's Palace in the *Antiquaries Journal*, 80, 2000, pp. 87–194, the information condensed in the very good Cadw guide by Wyn Evans, 1991, revised 2001, and Turner also wrote the Cadw guide to the palace at Lamphey, 1991. There are two splendid pictorial guides, Wyn Evans and Roger Worsley, *Eglwys Gadeiriol Tyddewi, St Davids Cathedral, 1181–1981* (1981), and Wyn Evans, *St Davids Cathedral* (2002).

The general outline of Welsh medieval church history is Glanmor Williams, *The Welsh Church from Conquest to Reformation*, 1962. Medieval churches, pre-restoration, are described in Fenton in 1810 and then in the invaluable mid-C19 notes of Sir Stephen Glynne, published in *Arch. Camb.* 1902. A systematic modern archaeological survey of all the churches of medieval origin was undertaken by Neil Ludlow for the Cadw: Historic Churches Project (*Cambria Archaeology 1998–2000*), changing many assumptions. Neil Ludlow also investigated the priory buildings at Caldey for Cambria Archaeology. The monastic buildings at St Dogmaels have a Cadw guidebook by J. B. Hilling, 1992. Individual church guides of quality are rare, but those for Tenby, by W. Gwyn Thomas, 2000 (following his account in *Arch. Camb.* 1966), St Martin Haverfordwest, 1992 by D. Smith, and St Mary Haverfordwest, *c.* 1960, stand out, the St Mary guide deriving from F. J. Warren, *The History and Antiquities of St Mary Haverfordwest*, 1914. Holy wells are covered in Francis Jones, *The Holy Wells of Wales*, 1954. In *Welsh Society and Nationhood*, essays for Glanmor Williams, 1984, an article by Peter Smith, 'Hall, Tower and Church', some theories and sites reconsidered', is illuminating for connections between secular and religious building.

Local histories of towns or regions from the earliest times include D. W. James, *St Davids and Dewisland*, 1981, a comprehensive account of the region, particularly strong on the social history. Dillwyn Miles has contributed particularly richly as author of *The Ancient Borough of Newport in Pembrokeshire*, 1995, *A Book on Nevern*, 1998, and as editor of *A History of Haverfordwest*, 1999. Cilgerran parish was given very early coverage in J. R. Phillips, *History of Cilgerran*, 1867. G. W. Middleton's *The Streets of St Davids*, 1977, is useful for the post-medieval history of the town. *The History of Pembroke Dock*, by Mrs S. Peters, 1905, catches the birth and development of the town when mostly still within living memory, while Phil Carradice, *The Book of Pembroke Dock*, supplements this with photographs. Milford Haven's

erratic history is well covered by *A Vision of Greatness*, 1989, by K. D. McKay, drawing on *The Story of Milford*, 1954, by J. F. Rees. *The Story of Saundersfoot*, by T. G. Stickings, 1970, is good on the coal era. E. T. Lewis has written histories of five parishes in the north east of the county in *North of the Hills*, 1972, and individual parish histories for Llanfyrnach, and Mynachlogddu, both 1969.

For country houses, Thomas Lloyd's *Lost Houses of Wales*, 1986, records the losses, Herbert Vaughan's *The South Wales Squires*, 1926, the last heyday, and Francis Jones covers in a lifetime of writing, many of Pembrokeshire's gentry families. Francis Jones' posthumous *Historic Pembrokeshire Homes and their Families*, 2001, covers every gentry house of note, and while the bias is to family history, there are notes on buildings and references to other sources, including the many articles that he himself wrote. A list of all these is in the *Journal of the Pembrokeshire Historical Society*, 1994–5. Dillwyn Miles' *Llwyngwair and the Bowen family*, 2002, follows Jones' model closely. Architectural studies are rare: Nash's houses are carefully analysed in R. Suggett, *John Nash*, 1995; J. Orbach's *Cilwendeg 300 years*, 1995, is a brief history of that estate. The parks and gardens of south west Wales have been admirably investigated (and often completely rediscovered) in the *Cadw Register of Landscape, Parks and Gardens of Special Interest*, by Elizabeth Whittle, 2002, and set in context in her *The Historic Gardens of Wales*, 1992.

Peter Smith's *Houses of the Welsh Countryside*, 1978, expanded 1988, remains the bedrock of study of domestic architecture in Wales. His chapter on houses and building styles, in *Settlement and Society in Wales* (ed.) D. Huw Owen, 1989, is a general introduction. Martin Davies' booklet, *Save the last of the magic: Traditional qualities of the West Wales cottage*, 1991, gives a well illustrated analysis of the evolution of the small lofted cottage, and advice on conservation. The small cottage was covered in E. Wiliam's booklet, *Home-made Homes*, 1988, and Iorwerth Peate's *The Welsh House*, 1944, is still valuable, treating especially the lofted cottages on the Trecwn estate, first recorded by Sir Cyril Fox in *Antiquity*, 1937, and the round-chimneyed houses of Dewisland, recorded by Romilly Allen in the 1880s and published in *Archaeologia Cambrensis* 1902. For the farm, E. Wiliam's *The Historic Farm Buildings of Wales*, 1986 is essential, and G. Nash wrote of Pembrokeshire farm buildings in the *Journal of the Historic Farm Buildings Group*, 1989. In the same journal, for 1988, G. Darlington wrote of the farm buildings owned by the National Trust at Treginnis Isaf (St Davids) and Stackpole.

For the industrial history of the county there are the files of the National Monuments Record, and the Cadw files on *Scheduled Ancient Monuments*, the S. M. R. (Sites & Monuments Register) held by Cambria Archaeology, a few comprehensive surveys and also the chapters in the last two volumes of the county history. Notable surveys are: A. J. Richards, *The Slate Quarries of Pembrokeshire*, 1988, G. Edwards, 'The Coal Industry

in Pembrokeshire', in Field Studies' 1, 5, 1963; J.L. Brown's unpublished study *The limekilns within the Pembrokeshire Coast National Park*, 1997; P.B.S. Davies, *Dewisland limekilns*, 1989. M.R.C. Price, author of the coalfield chapter in the county history, also wrote *Industrial Saundersfoot*, 1982. Brian John's booklets, *The Milford Haven Oil Industry*, 1974, and the *Old Industries of Pembrokeshire*, 1975, remain useful. The woollen industry is treated in an article by J.G. Jenkins in the *Pembrokeshire Historian*, 2, 1966 and more generally in his *The Welsh Woollen Industry*, 1969. A local guide *About Porthgain*, by Tony Roberts, 1987, and *The railways of Porthgain and Abereiddi*, 1986, by R.C. Jeremy, are useful both for the industrial tramways and railways but also for the development of the site.

The transport history includes E. Jervoise, *The Ancient Bridges of Wales and Western England*, 1937, and railway history the *Pembroke & Tenby Railway*, 1986, by M.R.C. Price. Among useful works on maritime Pembrokeshire are B.J. George's booklet *Pembrokeshire sea-trading before* 1900, 1964, *The Lighthouses of Wales*, 1994, by Douglas Hague, and Frans Nicholas' study for ASCHB, *The Conservation of British Lighthouses*, 1994.

The fortifications of the Haven from the C19 to 1945 have been studied by Roger Thomas, as yet unpublished for the C20, but the C19 coastal defences have been the subject of a report to the Pembrokeshire Coast National Park Authority. Important research on the buildings of the Royal Dockyard at Pembroke Dock is in an unpublished, 1992, Ironbridge Institute thesis by Adrianna Miller, drawing on the extensive holdings of the Public Record Office and the Royal Engineers' archives at Chatham.

For chapels, Anthony Jones, *Welsh Chapels*, 1996, remains the overview, well-illustrated and written. A chapels database set up by the Royal Commission in Aberystwyth, and a thematic listing survey by Cadw, has greatly increased the available information, though as yet little new has been published. Robert Scourfield in the *Society of Architectural Historians of Great Britain*, newsletter, Spring 2000, and Julian Orbach in *Carmarthenshire Antiquary*, 1994, provide brief general surveys of south and south west Wales chapels, with some new thoughts on planning and design. Rees & Thomas, *Hanes Eglwysi Annibynol Cymru*, 3, 1870–5, gives the history of every Independent or Congregational chapel in the county; Evans & Symond, *The History of the South Pembrokeshire Calvinistic Methodist Churches*, 1913, and S. Griffith, *The History of the Quakers in Pembrokeshire*, 1990, are locally useful; and B. Rawlins, *The Parish Churches and Nonconformist Chapels of Wales*, 1, 1987, gives an invaluable checklist of every church and chapel in south west Wales. Chapel histories and guides are rare: T.H. James on Bethesda Baptist Church, Haverfordwest, 1980, W.L. Richards on Tabernacle, Haverfordwest, 1988, H. Ladd-Lewis, on Bethlehem, Newport, 1995, stand out.

Victorian church building generally is covered by Ieuan Gwynedd Jones, in 'Ecclesiastical economy, aspects of church building in Victorian Wales', in *Welsh Society and Nationhood: essays for Glanmor Williams*, 1984. The complex stories of Victo-

rian restorations are mostly to be found in the pages of the local newspapers, as also the scant details of local architects involved in restoration, for whom no biographies or studies yet exist. Of biographies of national architects, only Jennifer Freeman's *W. D. Caröe: his architectural achievement*, 1990, has a significant Pembrokeshire element.

Local newspapers provide an enormous trove of information for the C19 and C20, beginning with *The Cambrian*, *The Carmarthen Journal* and *The Welshman*, published outside the county, then *The Haverfordwest and Milford Telegraph*, *The Tenby Observer*, *The Pembrokeshire Herald*, *The Pembrokeshire and The County Gazette* and others. Tenders for building work were advertised nationally in *The Builder*, *Building News* and *The Architect*. For church restoration, the records of the Incorporated Church Building Society in Lambeth Palace, and the St Davids diocesan records in the National Library of Wales, containing faculty plans and also plans for parsonages, are essential unpublished sources. School plans, more for the C20 than C19, are held in the county record office.

For C20 architecture, the radical ideas of Christopher Day are presented in his two books, *Places of the Soul*, 1990, and *Spirit and Place*, 2002, and his *A Haven for Childhood*, 1998, describes the kindergarten at Llanycefn. The works of Peter Roberts at St Davids, Cilgerran and Meline have been published in the *Architects' Journal* in the 1990s, and the Stirling and Gowan house at St Davids in *Architectural Design* 1969.

# PEMBROKESHIRE

## ABERCYCH

### Manordeifi

A linear village on the slope above the confluence of Cych and Teifi, where the three counties meet. Over the Cych, PONT TRESELI, an early C19 single-arch bridge with round spandrel holes (cf. Cenarth, Carms.). The NAG'S HEAD, opposite, a C19 row of pub, stores and brewery. The main village further up also mostly C19, chapel at the s end, the former SCHOOL, 1913, by *Owain Thomas*, roughcast and half-hipped, further along.

RAMOTH BAPTIST CHAPEL. 1868. Brown stone with grey Cilgerran dressings and small-paned windows. Gable front with narrow centre arch and bracketed eaves. Old-fashioned interior: painted-panelled, three-sided gallery on slim, fluted iron columns, and box pews.

LANCYCH, 1½ m. s. The best example in the region of a country house in *cottage orné* style, mixing picturesque elements with a rustic flavour. The design derives from Millfield Cottage, Bookham, Surrey, of 1814, published in P. F. Robinson's *Rural Architecture* of 1823. Lancych, surely also by *Robinson*, was probably built *c.* 1831–4, after Dr Walter Jones of Pennar, Aberporth, inherited.*

    Low and spreading, in whitewashed roughcast, of two storeys, with an extraordinary profusion of slate roofs at opposed angles. From the cottage vocabulary come the half-hipped gables, ornate bargeboards, and the variety of chimneys with diagonally set shafts. The timber cross-windows with small panes are also deliberately 'olde'. Symmetry is everywhere avoided, but balance maintained with skill. The plan revolves like spokes issuing from a central hall, throwing out gables to each of the three main fronts, and then confusing the eye with smaller roof elements, like an interlocking puzzle. w porch between massive side-wall chimney and projecting bargeboarded gable. Behind, a half-hip intervenes, so that the bargeboarded gable becomes the focus between the main house and the service range to the r. Here, a charming, half-hipped single room with miniature oriel rises from a low roofslope to echo the half-hip behind the porch and carry the composition on to a final chimney gable, echoing the big chimney to the l. of the porch.

    Garden fronts to the N and E, also with big, asymmetric barge-boarded gables. On the s side wall, the massive drawing-room chimneystack suggests an older house incorporated, though this is difficult to reconcile with the interior plan. The long range of outbuildings running s has two rubble stacks of elongated

---

* However a date of 1820 is said to have been found under the library floor.

hexagonal plan that look C17; if so, this would indicate a house of unusual importance, which history does not indicate.

The plan turns neatly around a low Gothic plaster-vaulted hall, with stair to the r., lit from a stained-glass rose high up, the glass armorial and brightly coloured. Library to the l. with simple Tudor woodwork, and dining and drawing rooms parallel behind. On the hill to the w a plain cylindrical FOLLY TOWER.

CLYNFYW, ½ m. sw. 1849, by *Edward Haycock* for W. H. Lewis. Neo-Elizabethan, a rarity here. Plain, square and somewhat bleak, in unpainted cement with grey Cilgerran stone dressings. Central gable to the three-bay entrance front. Four-bay e façade, the gables each side with two-storey castellated bays. Large mullion-and-transom windows with hoodmoulds. Chimneys, gable copings and porch gable have unfortunately been removed.

Extensive late C18 to C19 outbuildings in courtyards to the w, including a roofless hexagonal horse engine house.

## ABEREIDDY/ABEREIDDI
### Llanrhian

Picturesque seaside cluster of cottages; the windswept charm belies an industrial history. Abereiddy developed in the 1840s as one of the principal Pembrokeshire slate quarries, producing the soft graded slates whose vulnerability to wind gave the w part of the county its distinctive mortared roofs. The quarry on the headland to the e has been blasted open to the sea as a harbour, creating the 'Blue Lagoon' and marooning the engine house and dressing-sheds to the e of the inlet. On the slope above the beach are ruins of ABEREIDDY ROW, a terrace of seven workers' cottages, built before 1849, below the tramway leading to the harbour at Porthgain. Above the tramway were manager's house, office and circular powder store, the latter still standing. Abereiddy was run with the Porthgain quarry after 1855 but abandoned in the late C19.

## AMBLESTON/TREAMLOD

Nucleated village s of the Preselis, with the church in the centre, and some single-storey houses.

ST MARY. Medieval in origin. Plain embattled tower of conglomerate stone vaulted within, the 1779 date probably repairs. Nave and long chancel restored without flair, 1906–8 by *H.J.P. Thomas*, traces of blocked windows possibly of 1825. Plain plastered interior. – FONT. C12 grey stone square bowl. – STAINED GLASS. e window of 1965, Christ at Emmaus, by *Celtic Studios*.

Opposite, the VICARAGE of 1909, by *H. J. P. Thomas*.

BETHEL CALVINISTIC METHODIST CHAPEL, at the w end of the village, 1881, altered 1906. Stucco with arched windows, still small-paned. Plain interior without galleries.

HOOK, 1 m. SW. Later C18, three-storey house. Five-bay stucco front with veranda and tripartite sashes to ground floor. In the rear wing, a fireplace beam dated 1732. Probably rebuilt for John Tucker †1794.

RINASTON, 1½ m. W. There was a small medieval chapel here, nave and chancel only, abandoned *c.* 1800 and ruinous by 1904.

CASTLE FLEMISH, 1 m. NNW (SN 007 268). A rectangular settlement enclosure in which Romanized buildings were found in excavations, and pottery of the early C2. Since the late C18 it has been identified as the lost Ad Vigesimum Roman camp of the period A.D. 70–140 on the reputed road from Carmarthen to St Davids.

PARC-Y-LLYN BURIAL CHAMBER, ½ m. N of Rinaston (SM 982 265). A collapsed cromlech with capstone and four small side stones. (Sian Rees).

*See* also Woodstock.

## AMROTH 1607

The main settlement, popular with tourists, is strung out along the sea-front, with the church some ¾ m. N amid rolling fields.

ST ELIDYR. High, secluded setting with splendid sea views. Late medieval N tower, plain and embattled, its barrel-vaulted base forming a chapel, matching the S transept. Tall arched belfry loops and square Perp window to the ground floor with trefoiled lights. The nave, with a barrel vault of pointed form, is probably C13. Glynne saw a depressed chancel arch with imposts, possibly confirming this date. Barrel-vaulted S transept. Chancel with late medieval aisle, a wide, rendered four-centred arch. The arch into the tower chapel suggests aisle and tower may be of the same date. Restored in 1855 by *R. K. Penson*, who lengthened the nave by 14 ft to accommodate colliers, replacing an old W porch; hence the oddly lower roof-line of the W part of the nave. He also added the E.E. windows, some with his favourite cuspless plate tracery. Chancel arch of 1855. *Prothero & Phillot* of Cheltenham added the wagon roof and the florid straight-headed E window to the chancel aisle in 1899. – FURNISHINGS by *Penson*. – FONT. A good Norman piece, each side of the square bowl with a boldly carved vine branch. Plain PISCINA in the aisle. – STAINED GLASS. E window of 1890 by *Dixon*, Crucifixion. S – MONUMENTS. Woolford family, *c.* 1720. Raised sides, base with gadrooning. – Richard Fawley †1743. Bold tablet with engaged Corinthian columns and steep pediment containing winged putto mask. Reclining putti above, their feet on fluted vases. – Rebecka Williams †1764. Panelled pilasters, broken pediment with shield, skull and crossbones below, big consoles. – Constance Biddulph †1834. Tablet with drooping lily by *E. Gaffin*, spoilt by later lettering. – Charles Swann †1843. Shield-shaped with fat urn. Outside, some late C19 cast-iron MEMORIALS, made

at the local Coppet Hall ironworks. To the N, the small former
NATIONAL SCHOOL, 1860 by *E. M. Goodwin*, then of Laugh-
arne. Much rebuilt *c.* 1900 with tall dormered windows.

AMROTH GREEN, ¼ m. E. Once a large medieval house. Frag-
ments of boundary walls, and two parallel, barrel-vaulted
undercrofts.

AMROTH CASTLE, ¾ m. SE. Never a castle, and situated just
above the shoreline. The medieval house was originally called
Earwere. The earliest surviving part is the central porch with
altered corbelled parapet and four-centred door with a triplet
of corbels above, presumably for a lost oriel window. Probably
early C16, when Earwere was the home of the Elliots. The
house behind, seven bays long, is mid-C18 and was already
castellated, with a centre lunette on the top floor, a sophisti-
cated design for the date. Roof raised *c.* 1800, reproducing the
crenellations of the old house, which rise in the corners to
chimneys, but losing the lunette. Attached to the N, a small
CHAPEL of *c.* 1855, now gutted. Probably by *Goodwin*, added
when the house was used as a lunatic asylum. Inside, part of
a barrel vault to the rear of the porch, and an C18 stair with
bulbous turned balusters. In the present front reception room,
ceiling with plaster centrepiece with ships surrounding the
central rose; apparently set up to commemorate Nelson.

WALLED GARDEN to the S, with a little square battle-
mented C18 BELVEDERE to catch the sea views. In the W wall,
a series of arched niches, perhaps BEE BOLES. The house is
now holiday accommodation with caravans in the garden.

COLBY LODGE, ½ m. WNW. Built in 1803 reputedly by *Robert
George*, clerk of works to Nash at Ffynone (*see* Newchapel), for
the same patron, John Colby, who had coal-mining interests in
the valley below. A surprisingly inelegant stuccoed house, three
storeys and four bays, and only one room deep, with corridor
running along the rear. An elongated stair-light on the garden
front. Nothing of Nash's panache is apparent until one enters
the handsome dining room, which has a Corinthian screen at
one end (cf. Ffynone), the centre bay with plaster groining
behind. Crisp acanthus-leaf cornice. In the next room, Neo-
classical chimneypiece, perhaps late C18. The stair is graceful,
but cramps the entry. The lower rear wing may be older, remod-
elled as a service wing.

Fine gardens laid out by *Peter Chance* 1965–83, since 1979
managed by the National Trust and the present tenants. Near
the house, within the C19 walled kitchen garden, an octagonal
GAZEBO with pyramid roof by *Wyn Jones*, 1975. Inside, delight-
ful *trompe l'œil* painting, and signs of the zodiac in the ceiling,
executed by *A. Lincoln Taber*. Further down in the woodland
walk, two sets of heavy, late C19 iron GATES, formerly at Sion
House, Tenby (*see* p. 483). Beyond, an OBELISK to the memory
of Peter Chance, also by *Wyn Jones*, 1986.*

---

*Information supplied by Mr and Mrs Scourfield-Lewis.

MERRIXTON, 1½ m. WNW. On a steep hillside. A plain, early C18 house of three bays. Originally three storeys; upper floor removed 1885. The staircase has a heavily moulded string and delicate turned balusters. Gardens of similar date to the house: from a D-shaped stone-revetted pond, water tumbles steeply into a wilderness. Along the ridge beside the house is a circular stone base for a lost GAZEBO, giving splendid coastal views. Below, a square DOVECOTE (recently restored), of two storeys. The lower storey, with a vaulted roof, is a cartshed, though by tradition a Justice's lock-up.

CRAIG-Y-BORION, 2 m. NW. Stuccoed hip-roofed house of three bays and storeys. The early C19 home of *George Brown*, engineer and architect, and probably his work.

# ANGLE

<span style="float:right">8602</span>

Surviving medieval buildings amid a well-preserved strip-field system indicate an early and important coastal settlement, which had a sheltered bay and was surrounded by fertile land. The linear village was ambitiously redeveloped at the turn of the century after a brickworks was established *c.* 1880 by the philanthropic Mirehouse family of The Hall. Its CHIMNEY survives at WEST ANGLE BAY. A penchant for flat parapets gives the village almost the air of a set for a Western film, and one suspects that Richard Mirehouse acted as his own architect.

Milford Haven to the E is dominated by the chimneys and storage tanks of the OIL REFINERIES.

ST MARY. In the village centre, with pretty graveyard. Tapering late medieval embattled W tower with the usual barrel-vaulted base. Nave, N transept, chancel with N aisle. The S transept was demolished in the early C19. S porch added, dating from the extensive restoration of 1856 by *R. K. Penson.* The Dec E window was reproduced in 1856 at the insistence of the antiquarian James Allen, Dean of St Davids. Glynne admired Penson's arch-braced roofs, which have cusping over the collars. Chancel arch on short wall-posts with vinework capitals. – C19 FONT, presumably by *Penson*, copying the local Norman square scalloped type. – FURNISHINGS of 1856, including the PULPIT, with blind cusping and colonnettes. – Good quality STAINED GLASS.* – E window *c.* 1860 by *O'Connor*, Crucifixion in brilliant colours. Also by *O'Connor*, nave SE, a crowded Ascension, *c.* 1864, and chancel S, *c.* 1880, Good Shepherd. – Nave NW, 1860, and nave N, *c.* 1870, both by *Wailes.* – MONUMENTS. Damaged high-quality marble tablet to Brigadier-General Thomas Ferrers †1722. Rounded pediment, Corinthian pilasters with side scrolls, the heraldry surrounded by a riot of weaponry, well executed. – John Mirehouse †1823. Greek style.

*The attributions are by M. Harrison.

Outside to the s, three steps of the medieval CROSS, with
C19 crucifix.

Nearby the small C15 FISHERMEN'S CHAPEL of St
Anthony, with barrel vault of pointed form, above barrel-
vaulted ossuary. Square Perp E window. Inside, a small plain
PISCINA – Sentimental REREDOS of 1926 by *John Coates
Carter*. Crucified Christ with brightly painted backdrop of
toiling Angle villagers, framed by angels. – MONUMENT.
Much-worn medieval male effigy.

The houses remodelled by the Hall estate are easily distinguished
by their flat roofs and plain rendered fronts. Beginning at the
w end, Nos. 34–35, of *c*. 1905, are a rendered pair with flat
parapets, the outer bays projecting with an iron balustraded
balcony between. No. 45 is much earlier, C17 or C18, retaining
a broad gable chimney. TŶ CARREG is another parapet job;
is there earlier work behind? WHITEHALL, more ambitious,
has veranda flanked by little bay windows, all oversailed by a
stepped-up parapet. More early chimneys at Nos. 53 and 54,
and several more parapets further along. THE COURT is set
back with its gable facing the road. Two-bay cottage, a C19
reworking of earlier fabric: note the fine Pembrokeshire slate
roof, the slates laid in diminishing courses. Small wing to the
r. with tapering gable stack, containing a vast oven within,
probably C16. The three-storey GLOBE HOTEL, created from
a pair of cottages in 1904, gives an approximate date for the
exotic estate building programme. Battlemented, parapet;
upper storeys carried over the street on iron columns. w of the
church, small SCHOOL of 1862, by *John Cooper*. Steep roof with
bellcote, gabled house attached. Hidden behind the Post Office
the shell of a large building, locally known as the NUNNERY
or ALMSHOUSE. Rectangular, two storeys high with corner
stair-turret. Large window openings to the heated upper storey.

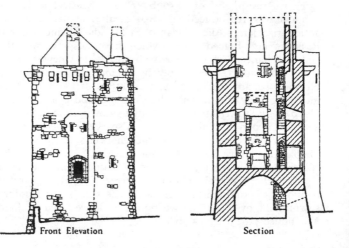

Front Elevation                        Section

Angle, The Old Rectory.

Probably a C15/C16 house with first-floor hall, a favoured build-
ing type in South Pembrokeshire. The VILLAGE HALL, 1913,
and No. 64 are built of rock-faced concrete blocks made at
Angle Brickworks.

OLD RECTORY, to the N, across the tidal creek. Extraordinary 51
appearance of a medieval tower house, as if it had strayed from
Ireland or Scotland. Restored 1999 by the Pembrokeshire
Coast National Park Authority and now open to the public.
Small, square roofless tower, three storeys high over a base-
ment with pointed vault. Its fortified character is immediately
apparent, as original entry is at first-floor level on the E side,
reached by a ladder (the basement entry is C19.) Well-dressed
doorway with curved segmental head. The recessed door, along
with the slots above, clearly indicates a drawbridge. Large
double corbels, which probably supported an external open
timber gallery at parapet level. Corner turret with broad stone
newel stair, serving all levels. The interior was well appointed,
each of the three upper rooms with a fireplace, the lower two
served by a circular chimney. Plenty of loop windows. A late

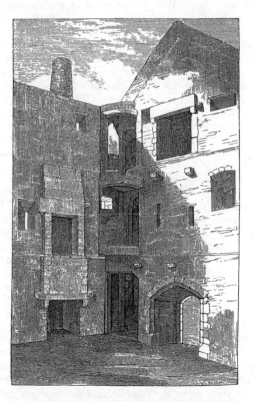

Angle, The Old Rectory. Interior. Engraving, 1888.

C14 or C15 date is likely. Fenton suggested that the house was the seat of the de Shirburns, who held land at Angle from 1278 and founded a chapel in 1447. (No doubt they were concerned about pirates using the Milford Haven. The site was once far more extensive, a moated square enclosure with the tidal inlet to the S; the moat has been filled up.) Fragments of buildings existed behind the farmhouse which now occupies the site.

To the N, a splendid medieval DOVECOTE, circular with a domical roof. This may be earlier than the tower, possibly C14.

THE HALL. John Mirehouse of Brownslade, Castlemartin (*see* p. 164), purchased the Hall estate for £29,000 shortly after 1800, and it became the main seat of the family after rebuilding in the 1830s. The façade of an older, C18 house remains as a three-bay, three-storey centre, with new, wide single-bay wings, running back. Across all this, a crenellated parapet. Many changes, especially *c.* 1900, when the qualities of Angle Brickworks were exhibited by small disfiguring extensions in all directions. Much-altered interior, except for the first-floor drawing room (in the r.-hand wing), with deeply coved ceiling.

THORNE ISLAND, 1 m. W. Prominently situated off the N headland of West Angle Bay, dominanted by the austere low-lying FORT, built 1852–4 under the supervision of *Lt.-Col. Victor*, C. E., as an outer defence to the Milford Haven, in conjunction with Dale, West Blockhouse, and Stack Rock forts, in the first phase of refortication. Designed as a battery of nine sixty-eight pound guns with barracks for sixty. Of local grey ashlar limestone, exterior windows inserted when converted to a hotel in 1932. Three ranges of brick-vaulted single-storey barracks and ancillary buildings to N, E and S, with the armoury at the W end of the S range, protected by a solid half-round bastion built out from the exterior wall. E- and S-facing parapets with apertures for small arms fire, and the entrance to the E, through a voussoired arch. The battery occupies the highest ground to the W, accessed by granite staircases.

CHAPEL BAY FORT, $\frac{1}{2}$ m. N. The fort and its ancillary structures occupy the whole of Chapel Bay. Invisible from the landward side, surrounded on three sides by a deep defensive ditch, and on the N side by the sea. The site was to provide a fortification to complement Stack Rock and South Hook forts, though the fort was not built until 1890. It is not only an important military survival, but also of great constructional interest, demonstrating the early use of structural shuttered concrete for some of the ancillary buildings, rather than the characteristic massive ashlar used for mid-C19 forts. Gun emplacements face the sea to the N; three date from 1903, intended for 6″ breach-loading guns. The W emplacement is the only survivor from the original battery of 1890, built for 10″ rifle muzzle guns. Concrete parapets, detonator stores below, shell-hoist mechanisms still intact. Access to the N emplacements is by concrete stairs, from a sunken passage to the rear. Behind the passage, sunken barracks: eight brick-vaulted rooms, with connecting doors and

fireplaces. At ground level to the s, single-storey stores, ablutions and cookhouse, the latter of shuttered concrete. To the E, master gunners' quarters. From this side the fort is accessed via a bridge over the deep moat. E of the fort, associated structures include a 12-pounder quick-firing battery of *c.* 1880, and a minewatchers' post (SM 8610 0355). Nearby, a well and pumphouse, and at SM 8617 0351, a submarine mining establishment, consisting of engine room, light emplacements and slipway.

POPTON FORT, $2\frac{1}{2}$ m. NE. This fort protects the inner mouth of the Milford Haven, in conjunction with Hubberston Fort. Built 1859–72, similar to Hubberston in basic layout, a defended barrack in the rear, and a casemated battery overlooking the Haven. Forty-five guns were originally planned, reduced to twenty in an open battery, and eleven in casemates. Further revisons produced six Moncrieff mountings with 7″ guns on the top of the casemates. Disused from 1903, but taken over in 1957 as the local headquarters of British Petroleum, who imported crude oil for their refinery at Llandarcy (Glamorgan) via a pipeline from their deep-water jetty at Popton Point (closed 1985). Now a field studies centre, preserved remarkably intact. The BARRACKS at the rear (E), designed for ten officers and 260 men, were planned as an irregular hexagon around a central court, with musketry bastions at the angles. NE entry, originally via a bridge. Local ashlar limestone; original pitched roofs lost. Batteries facing w and NW, the former a Moncrieff battery with casemate gun emplacements below, the latter an open battery; beneath both are underground arsenals. The massive masonry of the w battery is particularly impressive, with eleven casemate openings, all with flat voussoired arches of yellow granite.

EAST BLOCKHOUSE, I m. w. Scant remains of a small C16 fort established by Henry VIII. Three walls of a rectangular structure, the fourth fallen into the sea.

ROCKET CART HOUSE, $1\frac{1}{4}$ m. SE. Late C19 watch tower for shipping in the Milford Haven, also a repository for the rocket-fired life-saving apparatus. Vaguely Italianate three-storey tower, an odd feature in the landscape, looking like a church. Now a house.

THE DEVIL'S QUOIT, $1\frac{1}{2}$ m. SE. A Neolithic burial chamber. One of the three upright stones has fallen, the others still propping up the wedge-shaped capstone. Windblown sand hides any sign of surrounding cairn.

# BAYVIL/BEIFIL                                               *1040*

The church stands alone in a bracken-covered graveyard on the upland between Nevern and Moylgrove.

ST ANDREW. A rarity, an unaltered early C19 church, said to have   92 been built *c.* 1812, but probably of the 1830s, and by *David*

*Evans.* Carefully restored *c.* 1980 by *Roger Clive-Powell*, now in
the care of the Friends of Friendless Churches. A stone single
chamber. Pretty blue slate bellcote, the coping concave-curved.
Restored sash windows with Gothick glazing bars, the w door
inset in a shallow internal porch. Inside, everything remains
delightfully pre-Victorian, except for the plain roof boarding
of 1905. Slate floors, whitewashed walls, painted box pews and
high, three-decker PULPIT, and the simplest chancel RAILS. –
FONT. Late C12, square, cushion type. – MONUMENT. Mid-
C19 memorial to the last of the Lloyds of Cwmgloyne, by *James
Stone.*

## BEGELLY/BEGELI

*1107*

The scattered settlement grew as a result of coal-mining after the
early C19. Local collieries bearing high-quality anthracite were
connected to Saundersfoot harbour by a railway line as early as
1832 (*see* p. 448).

ST MARY. On a steep hillside, overlooking the flat, expansive
Kingsmoor Common. Dominant late medieval or C16 w tower.
Battered base and moulded string, battlements with plain
corner pinnacles. Barrel-vaulted ground storey. Nave with
transept and porch to s, chancel with N aisle. Striking Dec
chancel arch with broad waves, no capitals. Restored Dec
E window. Plain two-bay chancel arcade with round pier and
simple cap, a late C15 local characteristic (cf. St Florence).
Piercing the N wall is the stair to the rood loft, whose corbels
remain. Attractive restoration of 1887 by *E. M. Bruce Vaughan*,
his windows all Perp, some straight-headed. The quite
elaborate roofs also of 1887. – FONT. Apparently the Norman
one reworked. Square bowl. – FURNISHINGS by *Bruce
Vaughan*. – STAINED GLASS. Good E window of *c.* 1887 by
*Clayton & Bell*, Christ and the Virgin. – MONUMENTS.
Scattered C16–C17 bits. – Rev. J. Williams †1802. Careful
inscription.
Attractive stone-built Arts and Crafts LYCHGATE, also by
*Bruce Vaughan*, with hipped roof and four-centred archway.
Also his, the homely hip-roofed SCHOOLROOM to the w, of
local limestone with red brick detail.
ZION CALVINISTIC METHODIST CHAPEL, on the main road,
some 200 yds N of the church. Rebuilt 1866, the contractors,
and no doubt the designers, *Davies & Roberts*, i.e. David Davies
and Ezra Roberts of the Pembroke & Tenby Railway. Old-fash-
ioned long-wall front of three bays, windows and central door
all round-arched with emphatic dressed stone
surrounds, now painted. Interior however with pews stepped
up towards the rear, facing a gable-wall pulpit. The window
surrounds are similar to the nearby Kingsmoor Chapel (*see* Kil-
getty).
BEGELLY HOUSE. Large and square, on an eminent site just N
of the church, three storeys. Awkward mid-C19 refronting of a

house built *c.* 1750. Wide sashes, hipped roof with little pediment. Good C18 staircase inside with turned balusters.

CRAIG-YR-EOS, off Parsonage Lane. Formerly the rectory of 1842–4, by *William Owen.* Three storeys, hipped roof. Rev. Richard Buckby, rector here for forty-five years, was at variance with the Childs of Begelly House, and his large new rectory was intentionally competitive. Child responded by successfully prosecuting him for building across a right of way.

## BLAENFFOS 1837
### Castellan/Llanfihangel Penbedw

Straggling main-road village N of Crymych. On the l. the chapel on the r. the PRIMARY SCHOOL, a single, long range of 1876.

BLAENFFOS BAPTIST CHAPEL. 1856. Substantial, plain roughcast with two-storey pedimental front, and small-paned arched upper windows. Attractive interior with box pews and panelled, three-sided gallery on marbled timber columns. Panelled pulpit with turned corner posts, and big late C19 ORGAN behind. (cf. Tyrhos, Cilgerran and Penybryn chapels.)

CASTELLAN, ½ m. SE. A church of the Knights Hospitaller gave its name to the area, but was already derelict by the beginning of the C19. The site (SN 195 365), NE of Castellan Farm, is still identifiable.

## BLETHERSTON 0721

ST MARY. Deeply rural. Double aisle plan. The earliest fabric is the N aisle, including the chancel, but the medieval features indicate a late C15 or even C16 reworking, when the S aisle was added. Of this date, the crude W bellcote on the nave, carried on three triplets of corbels, and the chamfered round-headed surround of the blocked W door. Straight-headed Perp E windows. Restored 1886 by *E. H. Lingen Barker,* who rebuilt the S aisle, and added the simple Perp windows and odd half-timbered porch. Plain arcade of three bays, chamfered arches and piers, no capitals. Scissor-truss roofs of 1886, the chancel demarcated by a wagon roof. – FONT. Crude bowl, oddly pentagonal. – FURNISHINGS of 1886. – STAINED GLASS. E window, 1886 by *Alexander Gibbs,* Resurrection. – MONUMENTS. Lawrence Colby †1738. Deeply incised and careful lettering. – John Colby †1751. Shield above long inscription. – John Vaughan Colby †1919. Tall slate tablet with painted shield.

PENFFORDD CALVINISTIC METHODIST CHAPEL, ¾ m. NE. Built 1861 and renovated 1912. Simple gable front with porch, pointed windows to the long sides. Interior with raked pews.

LONGRIDGE, I m. SE. Early C18 rendered house, built for the Skyrme family. A double pile of two storeys and three bays, front fenestration altered. There was an attic storey. Early C18 staircase with twisted balusters and big moulded string.

2038                            BONCATH
                       Llanfihangel Penbedw

The village is C19; only the cottage on the crossroads was there in 1840. The BONCATH INN, opposite, is mid-C19, stone, three bays. To the N, PENTRE TERRACE is a stuccoed row of eleven estate cottages, of 1885 by *George Morgan*, for Mrs Saunders-Davies of Pentre and Cilwendeg. Half-hipped dormer gables to the larger centre and end houses, and hoodmoulded large windows. TY MAWR LODGE, beyond, is an early C19 lodge with three arched and hoodmoulded windows prettily disposed. On the l., and derelict, is the former STATION, of 1883–4, a hipped single-storey building with platform canopy, built for the Whitland & Cardigan Railway in its final push from Crymych to Cardigan, 1877–85, by the engineer *J. B. Walton*.*

St MICHAEL, by Penbedw Farm, some ½ m. NE. The parish church of Llanfihangel Penbedw, now miserably abandoned and overgrown. A plain short, gabled W tower, long nave and chancel. Some masonry may be medieval, but the plain pointed windows date from the restoration of 1859, by *J. C. Davies*. The wooden windows and perhaps the thin roof trusses date from repairs in 1907.

St CHRISTOPHILUS, Penrydd, by Dolalau Isaf, ¾ m. SE. The parish church of Penrydd, small, overgrown and abandoned. Nave, with bellcote each end, and a short chancel. Minimal Tudor detail from a rebuilding of 1841. Some work was done in 1911–12 by *David Davies* of Penrhiwllan.

FACHENDRE INDEPENDENT CHAPEL, ½ m. SE. 1879. Stuccoed plain gable front. Galleried interior with marbled iron columns, the fielded panels of the gallery front presumably reused.

CILRHUE, ½ m. N. The present mid-C18 house was probably built for Thomas Lloyd †1737, of Bronwydd, Cards., or his son James. Plain five-bay, two-storey roughcast front range, one room deep, with later service range to the l., and parallel rear range added in the early C19 around an existing stair projection. Inside, a mid-C18 central stair with pulvinated closed string and broad rail. The SW room has later C18 panelling.

WERNDDOFN, I m. SSW. Early C19 house, with no less than five Palladian tripartite windows in a three-bay stucco front with pedimental gable and lunette.

CILWENDEG. *See* Capel Colman.

* It apparently reuses designs from the Princetown Railway, Devon, by the G. W. R. engineer *W. G. Owen*.

# BOSHERSTON

9695

Attractive scattered village, with the church prominent in the centre.

ST MICHAEL AND ALL ANGELS. Small and cruciform, dwarfed 49 by the tapering and embattled C14 or C15 W tower. C13 nave and C14 transepts, all with pointed barrel vaults, like the tower base. The N transept is slightly larger. S porch, similarly vaulted, perhaps C15. S squint passage. Plain double PISCINA in the chancel and a Dec ogee-headed one in the S transept. Dec-looking lancet in the squint of the S transept. Restored in 1856 at the expense of Lord Cawdor of Stackpole Court, who employed *David Brandon*, as usual. E.E. windows of 1856, the E window with detached colonnettes inside. – FONT. Apparently a refashioning of the Norman one. Cushion-type square bowl with circular pedestal. – FURNISHINGS by *Brandon*. Late C19 painted metal COMMANDMENT PLAQUES. – FLOOR TILES in the chancel by *Minton*, including the Cawdor heraldry. – STAINED GLASS. Very good E window of 1872, by *Clayton & Bell*, Life of Christ in nine scenes. – W window (Resurrection) and squint (St Nicholas), both 1916 by *R.J. Newbery* – Transept windows, *c*. 1920, surely also by *Newbery*: SS Teilo and Govan to the S and SS Michael and David to the N. Typical elaborate canopy work. – MONUMENTS. Woman in recess under the S transept window, carved only above waist level, the praying hands clasping a phial-like object. Early C14. In a similar position in the other transept, a C14 woman, the head under a crudely cusped and crocketed canopy. Presumably the transepts were built with these monuments in mind. – William and Rees Freeman, 1800. Careful decorative tooling, an urn in the pediment and foliage below.

Outside, a good medieval CROSS, on three steps. The head and short shaft of the crucifix are of different stones and seem to belong to different structures. Weathered carved mask at the intersection of the arms, presumably the head of Christ. Probably C14.

STYLES, to the W of the church, has a pretty C19 front, slate-hung (a once-common practice, now all too rarely seen). The E part has a mighty tapering C16-looking gable chimney, such as are often found in this fertile coastal area. Further W, the OLD RECTORY, stuccoed and hipped, is early C19. Wide sashes and good fanlight. To the S, YE OLDE WORLDE CAFE, originally a pair of cottages, built 1834. Three bays each with casement windows.

ST GOVAN'S CHAPEL. 1¼ m. S. Of picture postcard familiarity, 2 but once seen, never forgotten. The little medieval chapel is perched above sealevel on a shelf amid precipitous cliffs, reached by a steep flight of rock-cut steps. Single chamber with W bellcote, roofed with a pointed stone barrel vault. STOUP. Stone BENCHES and ALTAR with a door by the latter leading to the CELL, gouged out of the cliffface. Dating is difficult,

but it is unlikely to antedate the C13. Below is the HOLY WELL, covered by a reconstructed vault. The history of Govan is vague, but it is believed that he was an Irish missionary, who died in 586.

HAROLD'S STONE. 1¼ m. N. An impressive BRONZE AGE STANDING STONE, about two metres high. The name perhaps derives from Gerald of Wales, who tells of King Harold setting up stones to commemorate his victory over the Welsh in 1063. Another STONE ½ m. NW and a further one beyond the Bosherston Lily Ponds at STACKPOLE WARREN: they are collectively known as the DEVIL'S QUOITS. Near the latter stone, a circular timber structure was excavated in 1977-9, possibly a Bronze Age HOUSE.

BOSHERSTON LILY PONDS. (*See* Stackpole Court, p. 461)

BOSHERSTON FORT. ⅓ m. E. An IRON AGE PROMONTORY FORT, upon a headland between two once-coastal inlets. The tip of the headland is cut off and defended by a long double bank and ditch system to the (landward) NW. Within the promontory, a ditchless third bank, forming a separate enclosure with lateral banks connecting to the main defences, possibly used for livestock. Further in, remains of a further bank, probably of an even earlier defensive system. Simple S entry.

9712

# BOULSTON
1½ m. S of Uzmaston

CHURCH. Remote waterside location, and accessible only by foot. Sadly now only a roofless shell. The graveyard touches the edge of the tidal Western Cleddau. The parish all lay within the Boulston estate, the church rebuilt for the Ackland family in 1843 and restored 1902. Nave with W bellcote, chancel with the shallow N and S projections so often found in the county. Simple Perp and Dec tracery of 1902. Abandoned after the last war. – MONUMENTS. Lewis Wogan †1702. Massive slab, crudely lettered. – Several fragments of Wogan tombs strewn around, some C17 and urgently deserving protection. The fittings and a miniature male effigy are now at Uzmaston church (see p. 490).

BOULSTON MANOR, ⅕ m. E. Also just above the shoreline. Much depleted ruins of the once-massive home of the locally powerful Wogans, who are recorded here in the C15. Earliest is the fragment of a late medieval FIRST-FLOOR HALL on the E side of the site, the barrel-vaulted undercroft broken at the W end, blocked mural stair. Above, only the E end wall and an oddly shallow C16 addition abutting it survive, the latter three storeys high and built to house a new stair. Inserted doorway with four-centred head, battlements. Traces only of buildings to the N and S. To the W, a towering fragment stands four storeys high with embrasures of huge windows, perhaps Jacobean, as is indicated by the diagonal chimney shafts. Remarkable series of COURTYARDS, the earliest enclosing the house to the E and W. A long and narrow courtyard

some 120 feet long was built to the S, abutting the earlier walls and house, with axial inner and outer gates to the river. Could this be a garden terrace? The gates are insertions, very likely of the early C17, the cambered outer gate particularly well-preserved, with stone-tiled gabled roof. Fenton (1810) noted that the gloomily sited house had been abandoned for 150 years.

BOULSTON HOUSE. Built 1798 for Dudley Ackland, a native of Philadelphia, who left after American Independence, hence perhaps the attractively colonial style of his house. Symmetrical garden front, facing the river, Palladian window each floor in centre, the outer bays projecting and hipped with arched windows. Bow-fronted first-floor balcony between on Doric columns; the ornate wooden canopy above it has sadly been removed, revealing the Venetian window behind. The outer bays continue back as wings, seven bays deep with entry on the W side. Much modernized inside.

BRAWDY/BREUDETH                                   *8524*

The parish spreads over a bleak plateau dominated by the hangars of R.A.F. BRAWDY, built 1944–5, enlarged since, and used as an army barracks since 1995. Nearby former U.S. NAVAL STATION of 1975, used for submarine tracking, closed 1995. The plateau is cut at the parish boundary by the deep valley of the Brandy Brook, running to the sea at Newgale, one of the three nucleated settlements. The others are Penycwm and Trefgarn Owen. The church stands isolated by BRAWDY FARM, a much altered four-bay house, with four hearths in 1670, but remodelled as a farmhouse in 1825.

ST DAVID. Long and low, and still with some medieval character. Nave and chancel with S porch and short parallel roofed SE aisle. Restored in 1882–4 by *E.H. Lingen Barker*, with new roofs, new windows, and fittings, for just £300. The nave with bellcote each end and the off-axis chancel may be later C13 or C14, from the narrow lancets on the N side of the chancel and S side of the nave (now into the aisle). But the two cusped two-light windows now reset in the aisle S wall (originally the W and E windows) look C15. E window of 1904–5 by *W.D. Caröe*. The aisle has no reliable dating detail, but a straight joint suggests two phases, C14 and C15. E end, predating the abutting big rough stone porch with plastered vault. Inside plastered walls and rough arches to the chancel and S aisle, plain boarded ceilings except in the chancel which has an attractive plain panelled roof of *c.* 1900. Rough corbelling along the inner wall of the aisle suggests a very uneven original roof. – FONT. C12 to C13, scalloped square bowl. – STAINED GLASS. E and W windows of 1904–5 by *Powell*, the E window with a flavour of Burne-Jones. – PULPIT. Plain, panelled, of the 1840s, brought from St Mary, Haverfordwest, in 1904. The vestry SCREEN and the prayer-desk are probably by *Caröe*,

in bleached oak. On the floor by the door, INSCRIBED STONE of C5 to C6, MACCATR. . FILI CATOMAG. . In the porch three more INSCRIBED STONES, C5 to C6, one moved from Castle Villa Camp, with .Q. QAGTE in Ogham, the other two smaller, one with VENDAGNI FILI V.NI almost completely eroded, and the name VEN.OGNI in Ogham, the third with BRIAC. FIL. in Latin, all C6.

PENYCWM INDEPENDENT CHAPEL, Penycwm. 1870, Gothic, stone, now a house.

RHYDYGELE CALVINISTIC METHODIST CHAPEL, on the lane to the church. 1821, small, half-hipped roof and centre door, now a house.

TREFGARN OWEN INDEPENDENT CHAPEL, Trefgarn Owen. 1833, thoroughly renovated 1903–6 by *D.E. Thomas*, only the outer form with half-hipped roof original. Stucco pilasters and window detail.

RICKESTON HALL, by the airfield fence. Early C19 stone three-storey four-bay house, built for Samuel Griffith †1824, quite plain, but the rear stair-tower, an old-fashioned feature, has one Gothick window and a roundel. Extensive farmyard buildings of the early C19 and 1885.

LLETHR, Penycwm. Plain four-bay, two-storey house, externally earlier C19, but a parallel rear wing is said to have an earlier C18 staircase. Derelict long lofted STABLE, probably late C18, with nogged brickwork in the pediment. Two bays added one end, dated 1851.

POYNTZ CASTLE, 1 m. w of Penycwm. Norman motte, with ditch, possibly built by Punchard or Pons, a tenant of Bishop de Leia 1176–90. A stone with an incised cross was found here, built into the now-demolished C17 farmhouse, but has since disappeared (Sian Rees).

BRANDY BROOK CAMP, SM 881 237. Circular Iron Age settlement on the hill above the brook, E of Eweston.

CASTLE VILLA CAMP, SM 881 276. 3 m. NNE. A prominent tree-clad, defended site, by the road, with three semicircular ramparts facing W.

BRAWDY PROMONTORY FORT, SM 862 239. ½ m. SW of Poyntz Castle, on the cliffs, facing W. Iron Age promontory fort.

# BRIDELL

*1742*

No village, just a scatter of houses along the main road S of Cardigan, and the converted SCHOOL of 1879. The main centre is now Penybryn (q.v.) to the N. Ruined cottages in the steep Cwmffrwd valley to the W indicate a more populated past.

ST DAVID. A small church, rebuilt 1887 by *H. Prothero* of Cheltenham. Only the massive mid-buttress of the W end suggests antiquity. Late Perp style windows replaced Gothic sashes of 1812, the E window with Prothero's thickly elaborate tracery (cf. Manordeifi). Plain interior; roof trusses of 1812 kept for lack of funds. – FITTINGS. Of 1887, panelled oak pulpit and

some high-backed STALLS, overscaled, given by the architect. – FONT. C12, small square bowl, beaded at the angles.

In the churchyard, INSCRIBED STONE with C5 or C6 inscription in Ogham: NETTASAGNI MAQI MUCOI BRECI, 'Nettasagnus son of the descendant of Brecos', the little encircled cross added later.

PLAS Y BRIDELL, $\frac{1}{4}$ m. N. Shapeless, gabled grey stone house of 1881–2 for *J. W. Bowen*, the plans apparently by the client, assisted by *J. Temple*, a London builder.

MAESYFELIN, 1 m. SW. Neat, square hipped villa of 1850 built for the Rev. J. P. George, rector and landowner. Cut Cilgerran stone to lower windows in recesses. The Ionic doorcase shows a Victorian thickening.

## BROAD HAVEN
### Walton West

8613

A fine sweep of sandy beach, the village now mostly a C20 sprawl. Older houses are tucked away inland. Like nearby Little Haven, this was a favourite retreat for the local gentry in the early C19, though the *Cambrian* newspaper in 1806 reported on the lack of speculation and of a hotel. A rail link with Haverfordwest suggested in 1853 came to nothing. Four years later, *W. H. Lindsey* of Haverfordwest was laying out plots. So was *Hans Price* of Weston-super-Mare, after 1865. Their efforts bore little fruit. *Lindsey* is presumably responsible for BROAD HAVEN HOUSE, built *c.* 1860 as a pair. Italianate and stuccoed, upper windows with odd eyebrow pediments. The best preserved of the late C19 housing is HEATHERMERE, built of rock-dressed masonry with pretty dormer windows. TRAFALGAR TERRACE consists of simple, stuccoed two-storey cottages. Simple stone-built SCHOOLROOM of 1890, enlarged 1894. Five bays long with big sashes.

HEPHZIBAH BAPTIST CHAPEL. Dated 1841. Gable-end entrance porch with round-headed windows above. Long side to the road with four tall arched sashes. Late C19 interior with gallery at the entrance end; panels with iron openwork. Small MANSE, added after 1841.

## BRYNBERIAN
### Nevern

1035

BRYNBERIAN INDEPENDENT CHAPEL. 1842–3. Substantial lateral façade in squared stone; two arched windows and arched outer doors, Gothick fanlights. The interior with three-sided gallery, pews and pulpit of 1882–4, the gallery front in long panels.

95

FELIN BRYNBERIAN, E of the village, N of the main road. Small, earlier C19 mill. Single storey and loft only, with later C19 overshot iron wheel. Malting kiln added in an outbuilding.

PENYLLYN, ¼ m. S. S of the main road. Remodelled *c.* 1988 by *Christopher Day* for himself, from a small two-storey house of Preseli stone. Day's interest in organic forms (cf. the Kindergarten, Nant-y-cwm Steiner School, Llanycefn) shows in the cairn-like chimneys and curving window openings. More experimental is the boat-shaped annexe, timber-framed on a boulder base.

PENRHIWLAS ISAF, ½ m. NE, by Tirnewydd. Early C19 lofted cottage, one of the best survivors, whitewashed stone with massive kitchen chimney and small parlour chimney. The loft is lit from tiny end windows.

BEDD YR AFANC (SN 106 346). Neolithic burial chamber on the boggy lower Preseli slopes, a remarkable double line of low stones which flanked a passage grave under a cairn. E entrance; small round W chamber.

The main road climbs the Preselis over Bwlchgwynt pass.
3, 11    STANDING STONES by the foot at Tafarn-y-bwlch (SN 081 337), and nearby at Waun Mawn (SN 080 339 and SN 084 340). To the W of the pass, CERRIG LADRON ROUND CAIRN (SN 066 321), and another further E along the 'Golden Road', the crest of the Preselis, at FOEL FEDDAU (SN 102 323). There are also STANDING STONES near the Cerrig Meibion Owen rocky outcrops: a pair W of the lane (SN 090 357) and one to the E (SN 090 354).

# BURTON

Scattered village with BURTON FERRY descending to the edge of the Haven estuary. The church is well inland, N of the upper part of the village.

ST MARY. A rewarding church. Set in a large sloping churchyard with an unusually broad, tapering W tower, slightly jettied over the nave roof. Thicker walls near the top, the lower stage barrel-vaulted, the date C14 or C15. Nave with E bellcote, N aisle, chancel with S aisle. Small added transepts, the S one with flattened barrel vault, the other with squint passage. Large, late medieval or C16 S porch. The heavily reworked, buttressed chancel aisle (St Andrew's Chapel) is reputed to be the earliest fabric – see the strange fenestration: six long S loops and a widely spaced, stepped triple E lancet without dressed masonry. Viewed from within, the serried tall loops with splayed whitewashed reveals are dramatic, almost modernist. They look E.E., but the battered walls of the chancel appear in fact to be the earlier work. Three-bay chancel aisle of steeply pointed plastered arches, cut through a thick wall. Corbels and part of the door belonging to the rood loft are visible. The N transept was nearly swallowed up in the aisle added during the 1867 restoration by *Thomas Talbot Bury*. Nave arcade of two bays; the thin circular pier, with bell capital and square abacus with scalloped corners, inspired by the chancel at Castlemartin (q.v.). Plain arches of two orders, the outer upon a mask of a

bishop. Bury had used the same source at Jeffreyston, com-
missioned as here by Dean Allen of St Davids, rector of Castle-
martin. The 1867 windows are lancets, but transept and E
windows have cusped Y-tracery and look a little earlier than
1867. The *Ecclesiologist* praised Bury for the 'downright way' of
bringing the tower stair into the nave, when the first floor of
the tower was fitted up as a vestry. – FONT. Norman, square
bowl, scalloped underneath. – FURNISHINGS by *Bury*. –
Amazing semicircular ORGAN LOFT of *c*. 1900 at the W end,
with delicate iron balustrade, on cast-iron columns with
Corinthian capitals, music-hall style. – STAINED GLASS. E
window by *Hardman*, 1867. Crucifixion in strong, clear
colours. – Chancel aisle E and N aisle W of similar date by
*Heaton, Butler & Bayne*. – MONUMENTS. Richard Wogan
†1541. Fine Tudor tomb-chest in the middle of the chancel, the
only one so sited in SW Wales, apart from the Edmund Tudor
tomb in the cathedral. Arcaded Bath stone sides with heraldry
and rebuses of Wogan's homes: a bull and tun for Boulston,
windmill sails and a tun for Milton. The dark limestone slab
with raguly cross in high relief is surely earlier, shaved down
to fit. – William Bowen †1686. Black marble slab with good let-
tering and big shield with leafy surround. – Owen Philipps †
1830. Tall tablet with crest. By the *Patent Works*, Westminster. –
Sir John Henry Scourfield †1876. By *Gaffin & Co*. Gothic sur-
round, shield below. – John Philipps Scourfield
†1878. Simple crucifix. – Augusta Scourfield †1880, Gothic. –
Gertrude Philipps Scourfield †1894. Brass. – Sir Owen
Philipps Scourfield †1921. Small Baroque tablet of alabaster.

Outside, four octagonal steps and the base of a medieval
CROSS, with C19 crucifix. To the S, OPEN BAPTISTERY of
uncertain date, mentioned in 1867, almost certainly a holy
well.

SARDIS BAPTIST CHAPEL, 2 m. NW. Dated 1896, probably by
*D. E. Thomas* of Haverfordwest. Front lobby with matching
doors and gabled centre window, paired windows above, all
round-arched. Dressed sandstone with red brick trimmings.
Gallery at the entrance end, unusually entered from a centrally
placed stair.

WILLIAMSTON HOUSE, 1 m. NNE. On the S side, the early C19
house of four bays and three storeys and a lower block.
Extended E, and the N wing rebuilt for Sir Owen Scourfield
in 1896, 'by a London architect'. This created a unified en-
trance front, the simple stuccoed Italianate detail rather old-
fashioned.

BEGGAR'S REACH, ⅓ m. NE. Three-bay hip-roofed house of
*c*. 1830, built as the rectory. Plain extensions of 1905 by *E. V.
Collier*. The small two-storey stable block to the N, although
much remodelled, consists of the higher end of a medieval
hall house. The service end was demolished during the work
of 1905. Screens passage with two blocked doorways –
one pointed and one round-arched – into the lost service
rooms.

BENTON CASTLE, $1\frac{1}{2}$ m. NE. Miniature C13 castle, with no known early history, best seen from the Cleddau, the whitewashed towers rising above the trees as in a fairy tale. Well placed to defend the tidal Cleddau. In ruins when painted by Sandby in 1779. Repairs were undertaken from the late C19 by the Scourfields of Williamston, who saw the castle as an obvious picturesque asset to their estate. Renovations to make the building habitable were begun in 1932 by the owner *E. L. Pegge*, civil engineer and archaeologist, completed after his death by his nephew, with the help of *J. A. Price*, County Architect. Roughly rectangular court, the N side with simple entry flanked by round towers of unequal size. The NW TOWER stands four storeys high with an added GARDEROBE TURRET, its roof tapering off below the parapet. The embattled parapet is polygonal, a late C14/C15 alteration. Massively thick walls. This tower was fairly complete before restoration, but the S W TOWER was much depleted. Also circular, but much lower.

*2336*

# BWLCHYGROES
### Clydey

Crossroads village on a high ridge S of Boncath. C19 GATEPIERS of a long-disused drive to Ffynone (*see* Newchapel).

BWLCHYGROES CALVINISTIC METHODIST CHAPEL. Dated 1832 and 1896. Of 1832, the lateral façade with two arched windows; of 1896, the hard grey cement, the porches, and interior without galleries.

*1396*

# CALDEY ISLAND
### $2\frac{1}{2}$ m. S of Tenby

Caldey Island is one of the lesser-known delights of Wales, although only a short boat-ride from Tenby. Its remarkable history of religious occupation from the early Christian period, to the establishment of a Benedictine abbey in the early C20, is reflected in the well-preserved medieval priory and the extraordinary abbey, built 1907–15, the surprisingly under-studied masterpiece of *John Coates Carter*.

This corner of south Pembrokeshire was an important centre of early Christianity. Caldey's origins as a religious community traditionally go back to the C6 when the island was a Celtic clas, then known as Ynys Pŷr, the island of Pyro, its first abbot, confirmed by the inscribed stone in the priory church. Pyro's successor was St Samson, founder of the monastery at Dol in Brittany, and his time at Caldey has been dated to 550–2.

In 1113 Caldey was granted to Robert FitzMartin, lord of Cemaes, who passed it to his mother, Geva, founder of the Tironensian abbey at St Dogmaels. Caldey never achieved great importance as a priory; only one monk is recorded in residence both in the late C12 and at the Dissolution. The remains date

largely from the C13–C14. Following the Dissolution, the island passed through many hands, and the late C16 historian George Owen noted that the fertile land was being intensively farmed for grain. Thomas Kynaston of Pembroke, who purchased it in 1798, built a castellated house (now demolished), using part of the old priory as service rooms, and laid out extensive gardens. Farming activity increased under James Hawksley, a noted breeder of livestock, owner from 1876. In 1897 the island was purchased by William Done Bushell, a senior master at Harrow School, who used Caldey as a holiday home, rescuing both the priory church and the medieval village church from their ruinous condition. It was Bushell who in 1906 eventually sold Caldey to Benjamin Fearnley Carlyle as a permanent home for his newly founded community of Anglican Benedictine monks.

The main settlement on the island, approximately 1 m. by $\frac{1}{2}$ m., is to the N, with the new abbey towering on a rocky bluff over the loose-knit group of whitewashed, red-tiled cottages. Just to the SE is the medieval island church, and to the SW stand the medieval priory and its church. To the S is the island lighthouse. Seventeen dwellings including the 'manor house' were recorded in 1771; the population of eighty-two in 1871 had declined to forty by 1971.

St David. The medieval island church. Short nave and short chancel. W porch. Massive thick walls suggest an early date. Repaired in 1838, after roofs and chancel S and E walls had collapsed. Crude round-arched W door of two plain orders with imposts – possibly early C13. Round-headed chancel arch also with imposts, much altered when reopened during restoration works of 1906–7 by *John Coates Carter*. He returned in 1923–5 to replace the wooden Gothick windows of 1838 with simple paired lancets. His, also, must be the incongruous pantiled roof. – ROOD with large carved figures, by *J. C. Hawes*. – Large FONT of 1906–7. By *Eric Gill*. Square Portland stone bowl with characteristic lettering on trefoil-section pedestal, the outer colonnettes with spiral twists. – STAINED GLASS. Nave N of 1924 by *Theodore Baily*, one of the monks, saints in attractively translucent colours. High-quality draughtsmanship. – Also by *Baily*, the chancel N window of 1922, Nativity and Mary Magdalen.

In the CHURCHYARD, several oak memorials of a Celtic cross type made to designs of *Coates Carter*.* – C13-style slab to Dame Margaret Egerton †1919, no doubt designed by *Carter*, as was the tall PREACHING CROSS of 1919, mounted on broad stone steps.

Oratory Chapel, $\frac{1}{4}$ m. NW. Squat circular tower of uncertain date and function, perhaps a lookout or a navigational aid for shipping. Upper chamber fitted up as a chapel by *J. C. Hawes* in 1906, soon after the arrival of the Benedictines. Plain interior.

---

* Such memorials in wood and stone were made to order in the abbey workshops and advertised for sale in the local press.

CALDEY PRIORY

45 Picturesquely situated ¼ m. sw of the abbey, immediately w of a
large pond. The small medieval priory complex consisted of the
church with three ranges around a small courtyard, converted
to domestic use in the late C16–C17, when Caldey was leased to
John Bradshaw of Presteigne. By the late C18, the priory was
being used as a farm, and a house had been formed from the
priory church. Thomas Kynaston's house of *c.* 1800 used the N
range of the priory buildings for service rooms (all now demol-
ished). What remains is the priory church, restored for religious
use 1897–9 by Bushell, and the E and W ranges both now derelict.

The PRIORY CHURCH, dedicated to St Illtyd, though heavily
restored, is C13, as shown by the roll-moulded inner face of the
restored E window, and by the trefoiled PISCINA. Long, narrow
nave and chancel. Simple windows of 1897–9; the inserted
C18 former openings are visible to the S. The N wall of the nave
was rebuilt some 5 ft S of its original line when it became a
farmhouse. Narrow W tower, battlemented and buttressed,

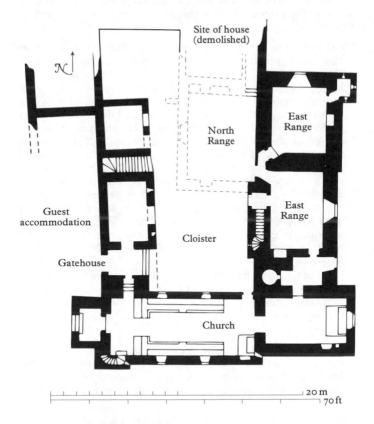

Caldey Priory, Caldey Island. Plan

with Dec w window of two trefoiled lights with quatrefoil. The leaning, oddly stunted spire is probably a C15 or C16 addition. Ground floor with barrel vault. Interior of 1897–9, including the charming cobbled floors. The chancel has a pointed barrel-vaulted roof; a later addition (*see* below), probably C16 or even C17. Simple FURNISHINGS, including the W GALLERY. Odd incised cement decoration in the chancel, depicting figures and symbols, of the 1890s, or later. – STAINED GLASS. Richly coloured figure of St Illtyd in the s wall of the nave, designed and made on the island in 1922 by *Theodore Baily*. – Fine large INSCRIBED STONE of the C5 or C6 with Ogham inscription translating as '[The stone] of Maglia – Dubracunas, son of. . . .' Dubracunas was associated with Illtyd and Samson, and is said to have consecrated Samson as abbot of Caldey in succession to Pyro. Latin inscription probably C9: ET SIGNO CRUCIS IN ILLAM FINGSI ROGO OMNIBUS AM MULAN-TIBUS IBI EXORENT PRO ANIMAE CATUOCONI ('and by the sign of the cross which I have fashioned on that stone, I ask all who walk there that they pray for the soul of Catuoconus'). Incised Latin crosses to face and side.

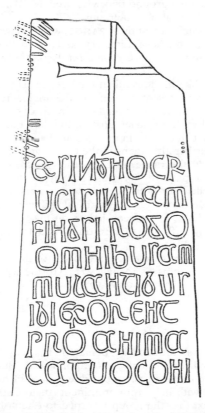

Caldey Priory, Caldey Island. Inscribed Ogham stone

The E flank probably began as a two-storeyed C13 range, the ground floor with an open arcade of three plain arches facing the cloister, their outline still visible in the stonework. To the S, alongside the chancel, was a barrel-vaulted passage, later blocked at both ends when a large oven and chimney were inserted. The N third of the range is C14, an almost self-contained first-floor hall house with deeply crenellated parapet and NE garderobe turret, also crenellated. The first-floor entry was to the W, now blocked. Barrel-vaulted undercroft. The upper room has a fine two-bay kingpost roof, with angle struts; sockets suggest that there were also arched braces. The building is related to other hall houses in the county (cf. Eastington and Lydstep). Its presence within the priory complex is unusual. There were probably C15 alterations which remodelled the older part as a single-storey building, with N–S barrel vault. The SW stair-turret of the C14 hall was removed and a ground-floor entry created. In the late C16 or C17 an upper floor was added to the S end, its stepped S gable over-sailing the chancel of the priory church, probably necessitating the construction of the barrel-vaulted roof. Windows of the C18–C19, when the ground floor was used as a dairy, and part of the upper floor as a schoolroom.

Incomplete footings only of the N RANGE, which may be C16–C17 rather than the medieval refectory, as is often thought. This range was used as service rooms for Kynaston's house (*see* above).

The W RANGE, like the E, is much remodelled. The tall isolated N W gable may represent the N end of the original range, which would have extended much further S. In the C15 the old range was replaced by the smaller existing building built further E, entered at first-floor level in its N gable, the flight of steps still surviving. Further alterations in the C16 created an impressive gatehouse S of the range, abutting the church, with pointed barrel-vaulted passage; for this, the upper floor-level was raised, corbelled out over the arch, with a small Perp window still in situ. On the W side, a cylindrical chimney corbelled out at first-floor level. The pigeon ledges on the courtyard eleva-tion, probably C18 or C19 insertions, add to the very pic-turesque ensemble.

To the E, a large medieval FISHPOND. To the N, a series of ponds, and the ruins of a small MILL. To the W, a plain late C19 three-sided FARM COURTYARD.

## CALDEY ABBEY

126   Caldey Abbey was founded by Benjamin Fearnley Carlyle, an Anglican Benedictine monk who approached Bushell, who offered him the island in 1900, but due to lack of funds it was not until 1906, with help from prominent Anglo-Catholics such as Lord Halifax, that the group returned to establish a perma-nent home.

Carlyle's community was the first revived monastic order within the Anglican church, and his recognition as abbot of the tiny group, in 1902 by Archbishop Temple, was a significant achievement of the Anglo-Catholic wing.

By the end of 1910, Caldey was described as 'the greatest phenomenon in the Anglican community at the present time', no longer a small and obscure Anglican brotherhood, but a large and flourishing Benedictine community of nearly forty members. However, in 1913 the community converted to Rome. Carlyle's love of fine things and unusual devotional practices led the *Church Times* to note the need for such groups to 'preserve the ideals of poverty unimpaired'. The community remained until 1928, but debts rose; the abbey was hastily completed to amended plans, and the island sold to the Cistercian monks of the abbey of Chimay, Belgium. A small group of Cistercian monks remain resident today, preserving the island from the excesses of tourism.

The abbey is the most ambitious and complete Arts and Crafts group in Wales, and the largest and most monumental project of *John Coates Carter*. The original plans were even more ambitious, for the present abbey was intended only as 'temporary' accommodation, which would be used as a boys' school, whose income would fund the building of a monastery on the NE headland. A crude perspective drawn in 1906 by *J. C. Hawes*, a community member, shows a Romanesque abbey church with twin-towered W front and massive S tower with broach spire, and cloistered monastery, none of which was ever started. Coates Carter's plans for the separate 'gatehouse', as the school was called, were exhibited at the Royal Academy in 1907: a quadrangle plan with chapel in the N range, and refectory and abbot's room in the W range.

Funds remained pitifully low, so the brethren were housed in a row of cottages near St David's church, built cheaply under Coates Carter's supervision in 1907 (the contractors, as eventually for the rest of the abbey, were *Davies & Griffiths* of Tenby). The short, single-storey row had flat-roofed dormers, with simple Voyseyan detail, the whitewashed roughcast walls and pantiled roofs setting the tone for the rest of the fabric. The accommodation soon became overcrowded, and the decision was reluctantly taken to build the abbey church not as part of the 'gatehouse', but as an extension to the E of the cottages. The cottages served as the S range until destroyed by fire in 1940 and demolished in 1951, leaving an unfortunate gap. The site was awkward; to accommodate even the smallest cloister meant pushing the N and W ranges out to the edge of the existing quarry face, and the ritual end of the church had to be to the W.

The style of the abbey is not easy to pin down. The dominating white roughcast and red-tiled roofs immediately suggest a Mediterranean influence, while the massive detail of the N range brings to mind the American architect H.H. Richardson, whose work was known in Britain from the 1888 monograph. The giant brick basement arches are particularly Richardsonian. The general delight in using towers and curved profiles is a legacy of

Coates Carter's former master, Seddon (cf. the Old College, at
Aberystwyth). The frequent use of shuttered concrete construc-
tion also reflects an interest of Seddon's. The work of Burges for
the Marquess of Bute in Cardiff may also have been an influ-
ence, (cf. the tall shafted chimneys of Castell Coch). Many ele-
ments are a standard part of the vocabulary of Arts and Crafts
architecture, such as the simple window openings with leaded
glazing, and, indeed, the whitewashed roughcast itself, but the
synthesis of all these ingredients at Caldey on a difficult site is
highly successful.

Substantial personal gifts in 1910 still did not allow for a start
on the 'gatehouse', and the money was used instead for further
additions to the aptly named 'cottage monastery'. A small and
plain chapter house and assembly area (statio) were added N of
the church in 1910, and in 1911 foundations were under way for
the W range with refectory, the octagonal kitchen to the N, and
to the S, linked by the apsidally ended Abbot's Chapel, the
luxurious Abbot's House, with its own enclosed garden. To the
NW was the detached St Martin's Tower, which originally con-
tained a clock. The three-storey N range with basement work-
shops, ground-floor washrooms at cloister level, cells above, and
with the library to the E was started in 1912. The whole cloister
was completed in 1913, except for the E range; this was to contain
the principal entrance and guest accommodation, and was dras-
tically reduced in scale before completion in 1915.

The original fittings in the abbey church, now lost, were of the
highest quality, paid for by patrons such as Athelstan Riley and
Lord Halifax. There was an enormous reredos by *F.C. Eden*, and
an altar of stones from sixty-one medieval British monasteries,
inscribed with the dates of their foundation, fitted together by a
local mason, *Sydney Davies* of Tenby, a hanging pyx by *J.N.
Comper*, while the silver and enamel monstrance was by *Henry
Wilson*. The altar furnishings were of silver and ebony, and in the
narthex were two altars to the Virgin and St Benedict, designed
by the American architect *Ralph Adams Cram*, a friend of Carlyle.
The carved oak abbot's chair in the sanctuary had a canopy with
Carlyle's arms. There were also fine fittings in Carlyle's private
chapel including an alabaster altar. Much was removed from the
abbey at the departure of the Benedictines in 1928; the altars and
reredos in the church were destroyed in the fire of 1940.

*Exterior*

This tour starts with the church at the SE corner and proceeds
clockwise.

ABBEY CHURCH (SS Mary and Samson). 1909–10. Small par-
allel range of 1910 containing the assembly area (statio) for the
monks and a small, apsidally ended chapter house. The church
was burnt out in 1940 and restored in 1951, the interior dras-
tically simplified. Whitewashed exterior, roughcast, Italian in
feel, with a Romanesque wheel window in the E (entrance)
gable above a sturdy round-arched door. Local grey limestone

is deliberately set against the render in random fashion. Simple unbroken roof-line with projecting s tower. Arched windows set high, two small ones for the narthex, three larger for the nave. The narrow lean-to s aisle below, containing tiny, plain side chapels, was added in 1951. Tapering tower, with simplified battlements. Paired belfry lights of limestone. Two high roundels light the chancel, sacristy with lower roof. The interior was austerely refitted in 1951.

The two-storey ABBOT'S HOUSE of 1911 to the SW, square in plan to hold the corner, balances the church. Facing E, a twin gabled composition, with plain crenellated porch set to the l. Round-arched entry flanked by low, tiled lean-to window bays. Canted corner bay, with overlapping hipped roof. Playful iron rainwater heads. On the s side, a bold composition of simple forms, a big rectangular bay window to the l, continued by skeletal timber glazing, softened by canted angles. On the corner, the fairy-tale ABBOT'S TOWER, built of pre-cast concrete. Absurdly tall, with an arched top window under conical copper roof. On the w side, the gables reappear with interesting asymmetries. The ABBOT'S CHAPEL ingeniously fills an angle, the diagonal line dictated by the steep quarry-face. Simple apsidal ends: a continuous white wall with stonework only for six small arched windows under the eaves. A round turret-porch echoing the Abbot's Tower carries the eye upwards to the taller Abbot's House. Conical copper roof, originally tiled. The five-bay REFECTORY, rectangular, with large red-tiled roof, has yet another round turret, to unite the different parts. It marks the mural pulpit of the upper floor refectory which is lit by big arched windows. Red-tile hoods, sill course and string course tie this range to the octagonal kitchen beyond. The basement arch in thin red brick is of the same form as those under the N front. In the short link to the kitchen are two big roughcast chimneys. A sloping roof is carried up to join the end roof of the main N range.

The KITCHEN anchors the principal corner, a dominant element in the long views. Octagonal, with laundry in the basement, the main kitchen storey emphasized by red-tile banding. The inspiration is the medieval kitchen at Glastonbury. The roof has two tiled stages with glazing between, the top has a copper-roofed spirelet. From the lower approach on the N, the sloping enclosed stair and the hipped scullery roof behind carry the eye upwards, and provide a diagonal accent. ST MARTIN'S TOWER, built 1910, assumes a sentinel role beyond the SW corner; a detached square-plan clock tower, with pyramidal roof swept out at the eaves, set diagonally to the main monastery. Ingenious concrete exterior stairs. Now without clock and chimney.

The N FRONT of the abbey, rising from a service courtyard, is designed to be seen from afar, a single entity carried on the great brick arches of the basement workshops: symbolizing the work of God being carried on the work of man. Above, roughcast with stone dressings. No overall symmetry, but

the strong horizontals of tile sill-bands and eaves maintain
overall unity. At basement level, an irregular sequence of
Richardsonian arches, the rock-faced stonework wilfully
massive. The spacing of five-plus-one arches leaves a gap on
the upper floors for a minor rhythm of narrow stair-lights near
the r. end. The first floor starts on the r. with six close-spaced,
very narrow arched loops followed by seven wide-spaced
narrow windows, then a pair of broader lights lighting the
kitchen access, the junction cleverly eased by a small corbelled
angle, disguising a change in level. In the upper floor, a more
even rhythm of arched windows. The dormers in the roof are
a later afterthought. Carefully crafted oak detail, the eaves with
curious turned pendants. In 2000–1, two pyramid-roofed
dormers, one each end, were restored in a general restoration
of the roofs by *Acanthus Holden Architects*.

At the NE corner, the LIBRARY, or scriptorium, a three-storey
gable front, with triple-arched basement, almost windowless
first floor, three arched windows in the gable. This was the
last part completed, in 1913, and would have been a link to a
complex of guest accommodation never built. The simple tall
rectangle with steep roof masks the join of the N and E fronts.
On the E front, a severe symmetrical group of three big arched
library windows.

The E ENTRANCE COURT, rarely used, was also a last design in
1913, after the intended guest wing was abandoned. To balance
the statio on the S, the N side has just a pergola of roughcast
columns on a low wall. Facing down this lawned court is the
single-storeyed entry, with brick arched doorway flanked by
red and white chequerwork, an Arts and Crafts motif. The
broad piers form part of a schematic triumphal arch, the top
stage outlined by a red-tiled band. On each side, beautifully
detailed little curved oriels, each with an arched stone window.

*Interior*

The CLOISTER surrounds a green lawn with whitewashed walls
and broad red brick half-round window arches; single-storeyed
on three sides, the N and most sunlit side rising to two storeys
under the big main roof. Here there is more formal symmetry,
the entrance doorway to the garth in massive stonework,
flanked by a broad window each side, while under the eaves,
simple two-light arched windows are evenly spaced. But the
dormers forsake regularity, and there is a delightful pyramid-
roofed NW projection for washbasins opposite the refectory
entrance. Within the cloister, simple tiled floors, leaded
windows and timbered roofs. In the E walk, some luscious deep
purple STAINED GLASS of the 1920s by *Theodore Baily*. From
the cloister E walk, a door with fine ironwork leads into the
STATIO, which has an arch-braced open roof with wind-
bracing. At the entry to the apsidally ended CHAPTER ROOM,
another fine doorway of massive stone blocks. In the SCRIP-
TORIUM, a STAINED-GLASS window by *Baily*.

From the w walk is the entrance to the REFECTORY, the finest surviving interior by Coates Carter. Impressive open timber roof with cambered tie-beams, raking struts and arch-braced collars. Also wind-bracing in two tiers. At the N end is the fireplace, a superb piece of Neo-medieval design in grey lime-stone with corbelled carved oak lintel and sloping hood. An arched recess contains the panelled PULPIT. In the sw angle, the passage access to the Abbot's House and then the ABBOT'S CHAPEL on the w. In the chapel, six early C20 STAINED-GLASS windows in conventional late Gothic style; maker unknown. Carved limestone arched PISCINA, wall panelling, and plas-tered vaulted ceiling above a stone cornice. The rich fittings were destroyed or dispersed. The ABBOT'S HOUSE has a gen-erous stair hall with oak staircase. The finest part is the ABBOT'S ROOM, right across the s front, an imposing room provided with intimate spaces in the window bays. Lavish fire-place, the oak lintel on limestone corbels. Finely detailed pan-elling, said to have been installed by men from Devon, so perhaps from the workshops of *Harry Hems* of Exeter. The sheer quality of construction is a joy to behold, as are small details, such as the bronze door handles in the shape of a crozier with an owl at the inner end. In one of the tiny w windows, roundel by *Baily*.

*Outlying Buildings*

The N half of the island is studded with whitewashed, red-roofed buildings, including the Post Office and cottages, all built 1910–13 by *Coates Carter*. They indicate Carlyle's desire to adver-tise the island as a peaceful retreat for visitors and permanent settlers (the hope was to attract some influential benefactors). The buildings match the abbey in the simple choice of materi-als, and some of the cottages display Coates Carter's masterly interior planning; the fittings, too, where they survive, are of high quality. What a shame that so many unsympathetic alterations have been made.

Immediately below the abbey the POST OFFICE of 1909–10, with clay-tiled gambrel roof, spreading over a veranda supported on timber struts, similar to H.H. Richardson's Old Colony Railway Station. End wall with giant-arched opening; dormer above with odd double-hipped roof. Just E are THE COTTAGES, an early C19 two-storey row, remodelled by *Coates Carter*, with whitewashed roughcast and pantile roofs. To the N ST JOSEPH AND ST PETER, a clever T-plan sash-windowed pair, sharing a broad Voyseyan chimney along the party wall. THE FORGE started life as an early C19 cottage, remodelled *c.* 1910 to form smithy and perfumery, the former originally entered via a giant Richardsonian archway to the r., now altered. Circular water tower to the rear, intended to have a tall conical roof. ST PHILOMENA, the island guest house, lies NW, just off the road leading down to the jetty. One of the earliest surviving buildings of the Benedictines, begun 1906 by *Hawes*,

and completed 1907 by *Coates Carter*. Here the elevations are of dressed limestone. Many Arts and Crafts ideas. The dining room projects to the centre with a full-height crenellated bay window. Single-storey w wing with severe round-headed lancets, the original guest bedrooms. Good detail inside: glazed screens, influenced by Baillie Scott, between entrance passage, drawing and dining rooms, inglenook fireplace and tiled chimney-breast with copper hood.

E of St Philomena, a large C19 LIMEKILN with opposed drawing-arches, probably much altered to make mortar for all the building work. TY GWYN, prominent on the NE headland, was built 1910–11 by Coates Carter for the steward of the island. Single-storeyed with a red-tiled, dormered roof and Richardson-style arched window to the s gable. Externally horribly rewindowed. Ingenious plan, with entry from the rear into a stair hall, the flue of the hall fireplace rising through the landing, the latter using borrowed light via a pair of large oculi. Main rooms along the front elevation; good fireplace to the drawing room, the greenish glazed tiles with Persian pattern. One of Coates Carter's most satisfying houses, deserving reinstatement. Finally, to the SE, TY MAIR is a simpler U-plan cottage, built for Abbot Carlyle's mother, of roughcast shuttered concrete and hollow concrete blocks. The rooms cleverly squeezed into a small area.*

100    CALDEY LIGHTHOUSE ½ m. s. Built 1828–9 for Trinity House to the designs of *Joseph Nelson*. Squat round tower of approximately 56 ft in height with tall lantern, refitted in the later C19. Flanking two-storey, hip-roofed houses at right angles added 1868–70 by *T. C. Harvey*, C.E.

On the NE cliffs, NANNA'S CAVE, where Upper Palaeolithic tools and later artefacts have been found. Similarly so at POTTER'S CAVE.

ST MARGARET'S ISLAND. Small and little-visited island w of Caldey: they are joined by a treacherous ridge of rock at very low tide. Traces of early religious activity mostly destroyed by C19 quarrying activity. When the naturalist John Ray visited in 1668 he noted a small chapel dedicated to St Margaret. The surviving ruins, later converted to quarrymen's cottages, comprise three ranges, open to the N. William Done Bushell in 1908 noted early features such as corbels and round chimneys, indicating a late medieval or C16 date. An early C19 sketch by Norris showed a traceried window in the s range.

9220                  CAMROSE/CAMROS

Small, deeply rural village, with the church tucked away to the w.

ST ISMAEL. Unexpectedly large, low-set in a sloping churchyard. Embattled w tower with broad polygonal stair-tower, skewed

---

*Phil Thomas, who has devoted years of study to Caldey, has provided invaluable assistance and encouragement.

out at the N E corner. Vaulted at ground level. Probably C15 or C16, an addition to the earlier fabric. Unusually long nave and chancel, C14. Dec PISCINA with ogee head and short stone BENCHES. Traces of the rood stair, blocking a lancet. In the s wall, a pair of blocked ogee-headed lancets. The two-bay s aisle has gone, leaving only the blocked archways and finely chamfered respond capital. Plain chancel arch, probably widened *c.* 1850, when the chancel was restored with fiddly scissor-truss roof and Y-tracery windows. The rest was restored expensively in 1884, by *J. P. Seddon*. Good oak roof, trefoil in section with kingposts (restored 2001 by *Wyn Jones* after a fire). Paired lancets. – Norman FONT, scalloped square bowl, tall cylindrical pedestal with rolls. – Seddon's oak furnishings include PULPIT and LECTERN. – PEWS with prominent butterfly joints. – STAINED GLASS. Nave NE, *c.* 1927 by *Kempe & Co.* – MONUMENTS. Emma Webb Bowen †1852. Neat limestone pedimented frame, dowel-like roundels in the entablature. By *T. Jones*.

Near the entrance, an attractive Arts and Crafts SCHOOL-ROOM, in memory of Katherine Lewis †1881. Gambrel roof of local stone tiles, wide windows, with stepped lights. Was *Coates Carter* (Seddon's partner at this time) involved? (cf. Caldey Island Post Office). W of the churchyard, the VICARAGE, *c.* 1830, roughcast, hipped, of that vicarage plan with entrance from rear, leaving the ground floor centre blank where one would expect a door.

LEBANON BAPTIST CHAPEL, 500 yds E. Dated 1876. Rubble stone and gable-fronted; windows with the pointed heads so fashionable in that decade. Gallery at the entrance end on timber columns. Pews with doors and attractive convex-fronted pulpit. Ceiling coved on the long sides with ribs and arch braces.

UNITED REFORMED CHAPEL, Keeston, 1½ m. WSW. Prominent in the centre of a small village. Rebuilt 1856. Half-hipped roof. Stuccoed entry end, the ground floor rusticated. Blind window either side of the door, two round-headed ones above light the gallery. Renovated 1881, the gallery at the entry end with bowed iron balustrade.

BETHEL UNITED REFORMED CHAPEL, Wolfsdale, 1 m. NNE. 1900 by *D. E. Thomas* of Haverfordwest. Giant arch with broad round-headed window. Local brown sandstone and yellow brick, typical of that date and architect. Interior galleried on three sides, the fronts with cast-iron palmette panels. Similar decoration in the enclosure around the big seat.

KEESTON CASTLE, a large earthwork to the W of the chapel, the enclosure double-banked on all sides but the S E. On the s side, a separate oval enclosure defended by a slight bank.

CAMROSE HOUSE, 500 yds S. Remarkably sophisticated for the region, a large but compact early to mid-C18 house of five bays and three storeys set on a basement. Attractive warm red sandstone with red brick. Steeply cambered windows with original sashes. Hipped roof, the starkly broad eaves altered. Good

contemporary stair with turned balusters, three to each tread. (cf. Great Westfield, Rosemarket). NW of the house a Norman MOTTE. E of the house, a SERVICE YARD with earlier C19 buildings on three sides, the principal one a hipped two-storey coach house and stable.

HOME FARM, $\frac{1}{2}$ m. SE, fine early to mid-C19 FARM BUILDINGS arranged around a courtyard, including a hipped two-storey barn with a large octagonal horse-engine house behind. The buildings are in poor condition.

CAMROSE MILL, 300 yds S. Small rubble-built mill in an idyllic setting. Early C19, on an older site. Converted to a house in 1988, retaining machinery and restored overshot wheel.

CLEDDAU LODGE, 1 m. SE. Early to mid-C19, hipped villa with trellis porch and Gothic stair light in an end wall.

EAST DUDWELL, 1 m. NW. Alongside the present farmhouse, a puzzlingly small building, having a massive round chimney at the gable-end. Pointed doorway. An outside kitchen or the remnant of a C16 house?

# CAPEL COLMAN

ST COLMAN. A rustic delight with echoes of rural Ireland, in its isolated but neatly walled churchyard. Rebuilt 1835–7 for Morgan Jones of Cilwendeg by *Daniel Davies* of Capel Colman, in a most cardboard Gothic. Miniature castellated tower, short nave with papery battlements of edge-on slate and corner pinnacles, the scheme repeated on the W porch. The interior originally had a three-decker pulpit on the S wall, but was tidied up in 1894–5 by *Richard Thomas* of Cardigan, who replaced the Gothick glazing and the box pews, but left the W GALLERY and coved plaster ceiling. – FONT. Possibly C13, circular bowl and shaft. – STAINED GLASS. E window of *c.* 1894. – MONUMENTS. Two by *D. Mainwaring* of Carmarthen, slightly Neo-Grec but crude in detail: Maria Jones †1823, and the family of Jacob Jones, *c.* 1833. – Rev. John Jones †1844, by *Lewis* of Cheltenham, with a rather better draped urn.

MAEN COLMAN, below the church on the track to Glanpwlldu, a 5-ft-high STANDING STONE with a C10 wheel-cross on the front and a crude, single-line Latin cross on the back. A small Latin cross is inscribed on the E side.

VICARAGE, N of the main road. 1892, by *Richard Thomas* of Cardigan. Stuccoed with half-hipped gables.

CILWENDEG. Rebuilt in the 1780s by Morgan Jones Sen. †1826, but expensively altered in the late 1830s for his nephew, also Morgan Jones †1840, probably by *Edward Haycock*. Further alterations 1884–5 for Fanny Saunders-Davies by *George Morgan*, whose coarse imprint dominates. Restored by *Dyfed County Architects' Department* in 1990.

The SE garden front in 1840 had a five-bay, three-storey main block with armorial centre pediment, low two-bay wings with parapets, the whole fronted with columned verandas and

wrought-iron balconies. At each end were greenhouses with pedimented frontals.

The detail, pedimented first-floor windows, channelled corner piers, are all by Morgan and dull. He enlarged the attic windows, and replaced the garden front loggia in heavily detailed Bath stone, enclosing the centre and changing the open columns each side from Ionic to a heavier Roman Doric. The greenhouses were replaced with clerestoried conservatories. Simpler NW entrance front, a solid square three bays, with large Bath stone *porte cochère* by Morgan. Interiors mostly late C19, ground-floor hall with pink marble fireplaces. The plain, narrow stone staircase, with iron rails rising off what was an axial passage, looks earlier C19.

Extensive OUTBUILDINGS, mostly of the 1830s. To the N, the hipped former LAUNDRY, roughcast and grey stone, with rusticated lunettes, roundels and quoins. Behind are the altered FARMHOUSE and one of the largest groups of FARM and ESTATE BUILDINGS in the county, mostly now in decay. Two main parallel ranges. The first, all apparently lofted cowhouses, and, at the top end, a two-bay section with big centre stack, the upper floor Morgan Jones' COUNTING HOUSE, 1832, proudly identified by an inscription. The range behind has lofted STABLES and big, early C19 high-door BARN with two arched entries. Remains of a later C19 horse-engine house behind. Derelict PIGEON HOUSE, dated 1835 a farmyard folly 87 of unparalleled oddity and undeniable grandeur, for chickens, turkeys and pigeons. Of 2 + 2 + 2 bays, the centre rising three apparent storeys, the end two, with high parapets striated with slate shelves, like a reversed rustication. The whole has a flavour of Vanbrugh, as all the openings are arched. Slate is used throughout, even for the high railings of the forecourt.

Across the top of the yard, a long, single-storey COW-SHED with many arched openings into enclosed yards, and four-bay, lofted CART-SHED.

In the undergrowth to the SW, the SHELL HOUSE, a 88 pretty, three-bay early C19 Gothic folly in rough white quartz with grey Cilgerran stone outer piers oddly banded like bookshelves. Odd, too, are the tiny traces of a roughcast of crushed brick and coal, which suggest that the piers were a reddish colour. Stepped quartz parapet with Cilgerran stone framing, and little quartz menhirs as cresting. The interior decoration in shell and bone is damaged, to be restored by the Temple Trust, 2004.

Below, and separate from the farmyard, a handsome, long COACH HOUSE and STABLE range, probably of the 1830s. Whitewashed, two storeys, the centre pedimented over an archway flanked by domestic-looking three-window bows with arched ground-floor windows, which actually light stables not drawing rooms. Low, two-bay coach houses each side link to pedimental-gabled end pavilions. There was a cupola on the main roof.

On the main road, two sets of paired LODGES of the 1830s.

The western pair, stuccoed, hipped and pilastered, perhaps by *Edward Haycock*. The eastern pair at Newchapel, probably earlier, have timber columned porches but were raised a storey in the early c20.

0403

# CAREW/CAERIW

A richly endowed parish: church, with rectory, charnel house and tithe barn, at CAREW CHERITON, ½ m. s, forming a significant and unusually intact group. Carew itself is a small, attractive village, with the outstanding CII CELTIC CROSS and the equally outstanding large medieval CASTLE, with Elizabethan prodigy-house river front. The Carew river was dammed here to form a large mill pond beside the castle, and, controlled by a rare tidal mill, it now provides a serene setting, endlessly quarried by artists and photographers.

23

## CAREW CASTLE

Whether viewed from the N across the mill pond, towards the lavishly windowed Elizabethan façade, or from the w, towards the mighty, early c14 drum towers, Carew Castle is a memorable sight. Though low-lying, it dominates the relatively flat surrounding land to the s. A walk around the exterior immediately confirms three phases of work. The medieval fortification was first transformed into a great early Tudor palace, with elaborately carved Bath stone windows replacing most of the medieval ones, on to which was then grafted a façade equal to the best prodigy houses of Elizabeth's reign though to date surprisingly under-studied.

Only in recent years (through an archaeological exploration from 1987 by Lampeter University) has it been conclusively proven that the site is ancient, probably Iron Age. A ridge of

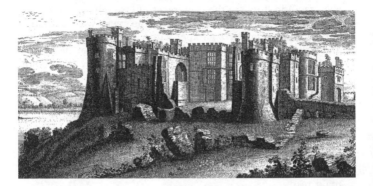

Carew Castle from the south east. Engraving by Samuel Buck, 1740

ground to the E of the present castle, now partly occupied by the
C16 walled garden, was cut off by five or six rock-cut ditches.*
The ditches were backfilled when a castle was begun *c.* 1100 by
Gerald of Windsor, who had married Nest, daughter of Rhys ap
Tewdwr. Of this date, there survives the Old Tower, the earliest
masonry structure, originally free-standing (cf. the Old Tower at
Manorbier). In the later C12 it was linked by a stone curtain wall
to small square towers; the N one survives as the Great Turret,
that to the S was enlarged later as the SE tower.

By the late C13 the castle was held by the Carews. Sir Nicholas
de Carew (†1311) probably remodelled the whole of the E
curtain, adding a hall block on its inner (W) side, and the Chapel
Tower to the E, alongside the Great Turret. The outer ward
was also walled around by now; traces of curtain foundations
were found on the N side (though nothing is visible today). Sir
Nicholas, or his son, Sir John (†1324), also built the present
western range, which consists of the Great Hall, occupying the
entire length between two mighty drum towers. The SE turret was
remodelled to form a matching tower, and almost certainly there
was a similar NE tower, destroyed in the C16. The completion of
the E and W ranges formed the roughly square inner ward as it
exists today.

In *c.* 1480 Sir Edmund Carew mortgaged the castle to Sir Rhys
ap Thomas, a powerful supporter of Henry Tudor. In 1507 a five-
day tournament was held at Carew Castle to celebrate Sir Rhys'
admission to the Order of the Garter. His grand remodelling
included an almost entire refenestration with straight-headed
Bath stone windows, and the small middle gatehouse, which
leads from the outer to the narrow middle ward. Rhys was suc-
ceeded by his grandson, Sir Rhys ap Gruffydd, who was executed
on a charge of treason in 1531. Carew then passed to the crown.

In 1558 Sir John Perrot, reputedly an illegitimate son of Henry
VIII, heir of Sir Thomas Perrot of Haroldston (*see* Haroldston
St Issels), was granted the governorship of Carew. He was a
bearer of Elizabeth's canopy of state at her coronation and an
increasingly powerful figure in the C16, until, as Lord Deputy of
Ireland, he was arrested for high treason in 1591 and died in the
Tower the following year. Perrot replaced the N range with the
splendid N front, complete with long gallery on the second floor,
all designed in the most up-to-date fashion of Robert Smythson
and his contemporaries. Moreover, Perrot relandscaped the outer
ward, altering and extending several of the buildings located here,
of which nothing is now visible. Excavation suggests that these
buildings were surprisingly elaborate; pink and grey slates, along
with decorative ridge tiles, have been found. An excavated
limekiln, datable to the C16, still half full of lime, may confirm
the old tradition that Perrot's work was left unfinished after his
sudden downfall, as does the inventory of contents made after

---

* Traces of a possible gate-passage were found, along with two postholes between
the W-most ditches, probably associated with the gate. Occupation of the site con-
tinued up to at least the C8.

Perrot's death, indicating a room stacked with glass, presumably waiting to go in the windows.

After Perrot's death, the castle reverted to the crown, which granted it briefly to Sir Thomas Perrot and then to the Earl of Essex, who occupied the castle for two years. By 1613 Sir John Carew had taken possession of his ancestral home, and the Carews continued in occupation until *c.* 1686. During the Civil War the castle was refortified, and the angular earthen ravelin is still clearly visible in front of the outer gatehouse. The s range with the kitchens was destroyed by the Parliamentarians. From the late C17 Carew was let to tenants, robbed of much of its dressed masonry, and the buildings of the outer ward disappeared. Some repairs (following a report by *W. D. Caröe c.* 1910) were undertaken, especially the replacement of decayed timber window lintels on the N front by iron girders, which saved the N front from collapse, though parts of the great bow windows had long gone. In 1983 the National Park Authority took the lease of the castle from the heirs of the Carews, and in conjunction with Cadw began a large programme of vital consolidation work, including the replacement of three of Perrot's windows.

The castle is wedge-shaped in plan. In the thicker part to the E, occupied by the outer ward, the sole upstanding remnant is the walled garden. The middle gatehouse leads to the long and narrow middle ward, into which projects the polygonally ended Chapel Tower. The inner ward is approximately square, with gatehouse, Lesser Hall, and chapel occupying the E range, and the Great Hall taking up the whole of the W range. Perrot's addition faces N over the mill pond. The castle is open to the s, the site of the destroyed service range; here, huge chunks of masonry can still be seen outside the curtain wall.

The walls are of local silvery Carboniferous limestone, still quarried nearby, the windows of both C16 remodellings, of Bath stone.

A tour should begin in the OUTER WARD, where the footings only of the OUTER GATEHOUSE survive. On the N side, the stone-revetted DITCH. The MIDDLE GATEHOUSE is of *c.* 1500, the grassed bank in front being the angular Civil War defence. The battlemented gatehouse is of two storeys, the upper jettied out on corbels. Segmentally vaulted passage with the projecting reveals of two gates, and on the N side, tiny square windows overlooking the ditch. The upper room was reached by an external stair and has both fireplace and garderobe.

Next, one faces the cliff-like three-storey E RANGE, which rises above a wall, built in the Civil War to give added protection to the inner gatehouse. The oldest parts here are the C12 core of SE TOWER and OLD TOWER, linked by the CURTAIN WALL and INNER GATEHOUSE, built in the later C13. The SE tower was originally square before it was extended s to form a large drum tower in the late C13 or early C14. The tower stands E of the curtain wall; in its N face is a doorway to a vaulted basement, which does not have access to the upper floors. N of

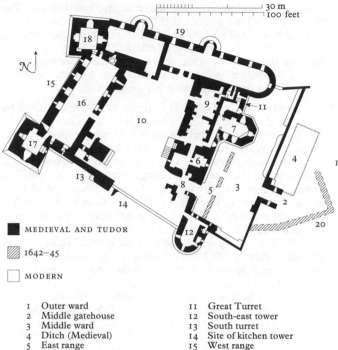

Carew Castle. Plan

|   |   |   |   |
|---|---|---|---|
| 1 | Outer ward | 11 | Great Turret |
| 2 | Middle gatehouse | 12 | South-east tower |
| 3 | Middle ward | 13 | South turret |
| 4 | Ditch (Medieval) | 14 | Site of kitchen tower |
| 5 | East range | 15 | West range |
| 6 | Old Tower | 16 | Great Hall |
| 7 | Chapel Tower | 17 | South-west tower |
| 8 | Inner gatehouse | 18 | North-west tower |
| 9 | Lesser Hall (undercroft below) | 19 | North range |
| 10 | Inner ward | 20 | Ravelin |

MEDIEVAL AND TUDOR

1642–45

MODERN

the gatehouse, the joints between the later work and the Old Tower are clearly visible, but the windows are largely Tudor, including the remains of a pretty oriel with quatrefoiled frieze below battlements. N of the Old Tower is the later C13 polygonal CHAPEL TOWER and the square C12 GREAT TURRET, and finally, the curved end of Sir John Perrot's N range.

The late C13 GATEHOUSE has a barrel-vaulted passage, with portcullis slot, and access into the Old Tower on the N side. The upper floor of the gatehouse has a ruined barrel-vaulted chamber, open to the SW, the damage probably caused during the Civil War. From the gatehouse, one enters the INNER WARD. Here one should first examine the W face of the E RANGE, built together with the E curtain wall in the later C13 by Sir Nicholas de Carew. Facing the inner ward is the LESSER HALL. Its exterior to the ward was completely refaced in the early C16. Straight-headed Bath stone windows, mostly robbed, mostly with three cusped lights and hoodmoulds; the

uppermost window over the entry to the hall has six. The northern two bays project slightly, representing the dais end of the Lesser Hall and its fireplace, which has a tall tapering chimney. At the low end of the hall, the OLD TOWER, remodelled in the late C13 with new floor levels, presumably for service rooms, and given a W extension to the same width as the hall. The circular chimney is probably C16.

The INTERIOR of the Lesser Hall range can be approached by a low door, which leads to a splendidly long, barrel-vaulted UNDERCROFT with relieving arches along the lateral walls. From here is access via a vice in the Chapel Tower to the hall itself. The main entrance is via low steps from the inner ward, with steps set back within the range itself up to the hall. The ceiling has gone. On the W side, a large fireplace robbed of its dressed stonework. The fireplace to the room above is a fine Tudor piece of work – clearly, in the early C16 this upper room was important. Straight-headed lintel, shafts, and well-carved cusped blind tracery above, flanking the arms of Henry Tudor. On the E side of the Lesser Hall a mural passage, repeated in the same position at ground- and second-floor levels. The GREAT TURRET is late C12, constructed as part of the original E curtain wall, lying N of the chapel. Its interior was subdivided to form latrines. Off the E side of this mural passage is the three-storey CHAPEL TOWER, added in the late C13, which contains a SE newel stair rising full-height. The ground-floor room, despite its proximity to the undercroft, was evidently significant; it has simple groin-vaulting (much robbed of its cut stone) and a fireplace. The CHAPEL is on the first floor, with two bays of groin-vaulting, and a fireplace on the N wall. Trefoiled PISCINA, and an arched E window minus its tracery. Large windows also to N and S, formerly with tracery, so once impressive. In the Great Turret to the N, a heated barrel-vaulted chamber complete with garderobe. The second-floor level of the E range is in varying stages of ruin, but there is an upper floor to the Chapel Tower, and to the rooms to the N, the layout corresponding to the floor below. The part of the E range to the S is very ruined. Above the gatehouse, a barrel-vaulted chamber, damaged probably during the Civil War, when the nearby kitchens were destroyed.

The late C12 SE TOWER was thoroughly remodelled for Sir Nicholas de Carew. Originally square in plan, it was extended S in the late C13 to give the appearance of a circular tower. Ground-floor chamber, barrel–vaulted and unheated, but with two garderobes on the E side. Above, accessed from the E range, a room now open to the sky, with fireplace and garderobe alongside. Above this, wall-walk and battlements, the latter rebuilt by Sir Rhys ap Thomas, along with the circular chimney. Practically nothing exists on the S side, due to the Civil War slighting. Footings survive of the S TURRET, which projected beyond the curtain, but the KITCHEN TOWER has completely gone.

The roofless W RANGE contains the GREAT HALL, built in the early C14 by the Carews, and remodelled in the early C16. The hall occupies the whole of the first floor. The grand two-storey porch was added in the early C16. A flight of stone steps leads to the arched doorway, which still has traces of its Bath stone mouldings: overhead, the well-carved arms of Henry, Prince Arthur (†1502) and Catherine of Aragon. The small upper room of the porch had quite large windows N and S. The undercroft has been almost totally destroyed, but there is clear evidence that it consisted of two parallel barrel vaults, which were supported on a line of central pillars. The hall, now roof-less, has three-light Tudor-arched windows on the E side, clearly of c. 1500, and at the N end, a big canted dais window, devoid of tracery. Fireplaces halfway along each long side, and moulded stone roof corbels. The SW TOWER is reached directly from the screens end of the hall at first-floor level, and by a mural stair to its second floor. Its ground-floor chamber, accessed from the undercroft, is barrel-vaulted, and has loops with big embrasures, like those in the undercroft. Both of the upper chambers in the SW tower have garderobes and fire-places, the upper fireplace with traces of C16 carving. All the windows enlarged in Bath stone. At the dais end of the Great Hall is the NW TOWER, the upper floor reached from a newel stair, which provides additional access to each floor. The inter-nal arrangements of both W towers are similar – so the hall had quite luxurious chambers at both ends. When the N RANGE was built by Sir John Perrot, a mural passage was created from the N side of the dais window to connect the Great Hall to the new rooms.

The N front is seven bays long, with two storeys of mullion-and-transom windows, set above a high basement. Here is Elizabethan architecture at its most confident, reflecting Perrot's court status. Best viewed from the public path across the mill pond, from where one appreciates its scale. In the penultimate bay from the W and the third bay from the E, the windows are in semicircular bays, with stepped bases. Girouard noted the tower-like nature of these bays, but 'with their char-acter changed from defensive bastions to circular lanterns of glass'. Although it is an old tradition that Perrot did not finish the range, evidence shows that at least some of the windows were glazed. Perrot's work probably involved the destruction of the NE tower, which is echoed in the bowed end of the N front. The plan is difficult to appreciate now, as the interior is a shell, but on the second floor of Perrot's range was a single long room, certainly a long gallery – and at approximately 160 ft, it was clearly intended to impress. On the first floor were two rooms, and there was a basement below. All the floors were of timber, as one would expect at this date, even in south Pembrokeshire.

CAREW MILL, ⅔ m. NW. Recorded in 1558, but its proximity to the castle would suggest a medieval foundation. Improvements

recorded in 1630. The large MILL POND is a medieval damming of the tidal creek. Water trapped on the high tide was released through the sluice to drive the wheel, as at Pembroke (*see* p. 338). The four-storey building, five bays long, is mid-C19 (the previous building rebuilt in 1792 after a fire), and though plain, is impressively large. The MACHINERY is intact. The two iron mill-wheels with timber paddles are set in sluices in the causeway. Inside, on the ground floor, mechanisms for levering the running stones and for lifting the sluice gates. On the first floor, six pairs of millstones, three driven by each wheel (the S wheel only restored), the grain cleaning machine, the flow dresser and the out roller. On the next floor are the grain bins, fed from the loft floor above. Open to the public under the care of the Pembrokeshire Coast National Park Authority.

The VILLAGE consists largely of PICTON TERRACE, two rows of low colour-washed cottages, dominated by the CAREW INN of *c.* 1850 at the W end. No. 1 is early C19. The next two, with broad chimneys, are earlier; a cambered arch revealed in the front of No. 3 is perhaps C17 or early C18. Further E, a large but forlorn free-standing conical chimney, the dwelling long lost. Probably late C15 or C16. CAREW BRIDGE crosses the estuary below, three round arches with breakwaters, mid/late C18, but no doubt replacing an earlier structure.

14 CROSS, standing 14 ft high, prominently sited beside the main road. Elaborately carved wheel-headed cross, inscribed as a memorial to Maredudd, who, with his brother Hywel, ruled the kingdom of Deheubarth and died in 1035: thus datable with unusual and most instructive precision. On the front (W), the sandstone head has a knotwork pattern with decorative panels carved in low relief to the neck and shaft, the latter of a harder stone. On the neck panels, T-frets with a key pattern in three squares below. Two large areas underneath, plaitwork above an irregular key pattern. Then two small panels, one inscribed MARGIT/EUT. RE/ X. ET G [uin]. FILIUS (The cross of Margiteut, king, son of Etguin). A different variety of plaitwork below with T-frets to the base. The sides of the shaft carved with plaitwork. The rear of the head has a combined outline and linear cross with panels of geometric triangles under. The shaft has four carved areas of fretwork, interlinked ovals, and plaitwork. The cross is closely related stylistically and in date to that at Nevern, both ranking among the most magnificent C11 monuments of their kind in Britain. The original position of the cross is uncertain; it has occupied the roadside location since 1822.

50 ST MARY, Carew Cheriton. Striking W tower of *c.* 1500, clearly owing its inspiration to the Bristol region, an exotic structure when compared to the standard local type. A fine composition in three stages, of squared limestone with moulded string-courses, angle buttresses, battlements (the pinnacles removed

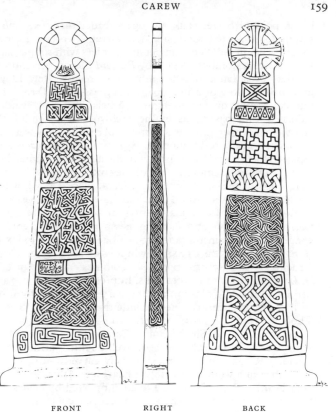

FRONT          RIGHT          BACK

1 m
3 ft

Carew Cross

in the early C19) and polygonal angle stair-turret. Belfry
windows with arched lights and rectangular hoodmoulds.
Lowest stage barrel-vaulted. The earliest fabric is the fine
chancel and N transept, traditionally and convincingly associ-
ated with Henry de Gower, bishop of St Davids 1328–47.
These have stepped buttresses. Late C15 nave arcades. Late
medieval/C16 S porch with STOUP and BENCHES, and pointed
barrel-vaulted roof. Splendid Dec chancel arch with four-petal
flowers in the hollows, a feature of de Gower's work at St
Davids (see p. 422). Broad outer waves and imposts with blank
shields. Transeptal arches with similar flowers. Presumably a S
transept was intended. The N and S chancel windows have
cusped intersecting tracery, carefully remade in 1893. Triple-
arched SEDILIA, the carving chiselled off. Dec PISCINA, and
another hidden behind pews in the transept. Small late C14/C15
chapel N of the chancel, long cleared and used as the vestry. It

has a pointed barrel vault, an ogee-headed PISCINA and a squint loop. Added rood loft stair-turret. Two-bay arcades, roughly chamfered arches on octagonal piers with simple caps. Destructive restoration 1836–8 by *Richard Barrett*, a Pembroke builder: in a letter of 1844, the next rector, Rev. Lloyd, mourned the loss of a fine open, 'compass-shaped' roof, the timbers resting on carved figure corbels, and a W window 'adorned with bas reliefs in the archivolt, representing the Nativity and other subjects'. Barrett's plaster ceilings were left untouched in the restoration of 1857 by *David Brandon*, who replaced the square Perp windows in the aisle with pointed Dec ones. *W. D. Caröe* removed some of the stucco in 1908. – FONT. 1844 copy of the old Norman square scalloped bowl, which has fooled many a visitor. The old base is in the vestry. – High-quality ALTAR and REREDOS of 1923 by *John Coates Carter*, Crucifixion and flanking gesso panels with golden-winged angels against a tapestry-like background. – PEWS by *Brandon*. – STAINED GLASS. E window of 1879 by *A. Gibbs*, Crucifixion and Resurrection. Wan colours. – N transept E by *A. L. Moore*, 1912. – FLOOR TILES. Impressive array of C15 and C16 inlaid heraldic tiles in the sanctuary, some reset from the castle early this century. They include the arms of Sir Rhys ap Thomas, †1525. – MONUMENTS. C14 effigy in an arched recess, said to be Sir Nicholas Carew †1311. Recumbent knight, legs awkwardly crossed. Well-detailed armour and shield. – Recumbent C14 priest, simply carved. – C14 miniature effigy of a woman (possibly a heart burial) under a small arch in the S chancel wall, the head supported by angels, the feet resting on a hound. The arched recesses containing these monuments suggest that the chancel was built to house specific founders' tombs. – In the N transept, Sir John and Dame Elizabeth Carew, large sandstone effigies on a chest, a little mutilated. Well-defined garments. Usual kneeling children below and tapering baluster-like pilasters with strapwork and Ionic capitals. Sir John, according to the inscription on the side, died in 1637. The IRON RAILINGS look early. – Margaret Beavan †1832. Weeping woman. – Hannah Bowen. 1845 by *J. Evan Thomas* of London. Weeping woman before sarcophagus; a similar design by Thomas is at Cilycwm, Carms. – Caroline Lowis †1871. Gothic and gabled. Signed by *J. Barrett* of Leicester. – George Llewhellin †1872. By *J. Phillips* of Pembroke Dock. Shield-shaped tablet with painted inset roundel.

To the NW, the sizeable C14 CHARNEL HOUSE, for the deposit of exhumed bones, with chapel above. Much the finest of the few examples in S Wales. Barrel-vaulted undercroft, the bone-holes visible, especially to the S. Above, a plain lancet to the N, and an E window with bits of Dec tracery, walled up to form a chimney when the building was converted to a school-room in the late C17. Inside, a plain STOUP, ALTAR NICHES and a PISCINA, with crocketed head rising to a finial. Reused collar-truss roof, perhaps C17.

Near the gates, a MOUNTING BLOCK and a short row of stables, originally ALMSHOUSES. The only old feature is a blocked pointed doorway without dressed stonework.

Towards the middle of CHERITON ROW, early C19, hidden behind a door, a communal BREAD OVEN. Former NATIONAL SCHOOL, immediately N, 1872 by *K. W. Ladd*. Simple Gothic in robustly dressed limestone.

S of the church, the former vicarage, now GROVE MANOR. Mostly rebuilt in 1836 by *Richard Barrett*. Two-storey bow window to the SW. The FORTIFIED RECTORY is an intriguing house of the late C15 or C16. Not enough survives for a definitive analysis. It was evidently a hall house with a tower porch. Fenton (1810) described it as of 'considerable antiquity, unroofed and in ruins', but it has since been restored. The tower stands three storeys high with a corbelled parapet and a four-centred doorway. The whole is less fortress-like than its counterpart at Angle (q.v.) but the original doorway may have been at first-floor level. Large stair-turret, the newel stair altered. Large hall, the arch-braced roof removed in the earlier C20. The stone well-stair to the rear looks C17. In the C19 extension to the E, part of an excellent early C18 mahogany staircase, spiral balusters and fluted newels with Corinthian capitals, removed from old Lawrenny Hall before its demolition (*see* p. 244). Also from there, some splendid early C18 panelled mahogany doors. Parts of a high embattled perimeter wall survive, also an arched gateway.

To the W, the late medieval or C16 TITHE BARN, large and rectangular with a stepped gable and a small C17 addition incorporating a dovecote. In the barn, a scarfed cruck roof (two pairs of principals), a rarity in Pembrokeshire. Now in domestic use.

WESLEYAN METHODIST CHAPEL, Carew. Dated 1852. Attractive rendered front with pedimental gable and rusticated ground floor. Round-arched windows to both storeys with intersecting glazing bars. Simple interior, no gallery.

WELSTON COURT, 1 m. SW. To a small, square stuccoed house of *c.* 1830, bow-fronted wings and pilastered porch were added in 1894 by *William Thomas*, borough surveyor. Covered iron balcony by *Macfarlane & Co*. Interior of 1894 with some crisp plasterwork.

HONEY'S PARK, ⅓ m. WNW. Dated 1687, but altered and rewindowed. Two storeys, single pile. The entry was in the end bay, backing on to the chimney, until the addition of a fourth bay beyond it.

MILTON MANOR, ⅓ m. WNW. A remodelling of 1869, by *K. W. Ladd*, removed the charm of a *c.* 1830 house, shown in photographs as an attractive stuccoed villa with hipped roof, bowed portico and a little pavilion each side. Ladd added the dormers, pitched roofs and Gothic detailing.

FORD, 1 m. WNW. To the W of the hip-roofed, early C19

farmhouse is the massively tall chimney said to be of an older house, the shaft bull-nosed against the prevailing wind.

FREESTONE HALL, 1¾ m. NNE. A three-storey, three-bay rough-cast house, a hipped roof replaced by a gabled one in early C20. But a 1768 date found on a roof timber marks the origin and may date the Chinese Chippendale staircase inside.

PARK, 1¾ m. NE. To the S of the house is PARK RATH, a circular IRON AGE DEFENDED FARMSTEAD. Interior enclosed by a single bank and ditch, also parts of an outer counterscarp bank, now altered. The S gap was probably the entrance.

SAGESTON HALL, ¾ m. ENE. Extended farmhouse with a C19 appearance, but surely concealing something much older, especially the three-bay N part. Good stone-built C19 FARM BUILDINGS, including three-storey MALTING LOFTS attached to the house, their brick-built interior kilns intact. In the garden wall, a small, late C19 stone-built GAZEBO with pyramidal roof.

## CASTLEBYTHE see PUNCHESTON

# CASTLEMARTIN

Small windswept village. At the W end, a circular stone-built POUND of 1780 for stray animals (creating one of the first round-abouts in the county). To the NW, an EARTHWORK with a large ringwork and bailey, the bank well preserved. The parish is dominated by the army range, established 1938.

ST MICHAEL AND ALL ANGELS. N of the village in a broad hollow. A rewarding church, largely C13, with tall C14 or C15 tower raised over the S transept. This originally had a saddle-back roof: the crude embattled parapet may be C16. All four storeys are vaulted (cf. Stackpole). On the S side, a pair of arched belfry windows rising into the parapet. Long nave with N aisle, chancel built on a sharply rising rock-face (the altar is reached up seven steps). N transept and both chancel aisles demolished. Traces of the transept E wall and a piscina are visible on the exterior. S transept and late medieval/C16 S porch have barrel vaults of pointed form. The four-bay arcade looks E.E. Plain stepped arches on piers chamfered to square bases and caps. Simple attached shafts supporting the outer arches. Glynne recorded lancets in the nave and 'altogether much that bespeaks the First Pointed period'. The arcade of two bays belonging to the lost N chancel aisle also appears to be C13, with slender round limestone piers (the E one monolithic). Bell-type capitals and odd square abaci with scalloped corners. The outer order of arches rest on corbels, crudely carved as masks. The other arcade has a central octagonal pier with simple capital, the abacus with angled lower corners. The S porch has corbels and doors of a former first floor; perhaps inserted. Glynne illustrates a lost W porch. Large STOUP. Entry to the tower was originally at first-floor level. A staircase from

the porch, against the S wall of the nave, provides access. Restoration in 1858 paid for by Lord Cawdor, by his preferred architect, *David Brandon*, introduced E.E. windows, new roofs and a new chancel arch with filleted moulding to the arch and plain jambs, curiously built up against the N arcade. – Good Norman FONT. Cushion type with little carved scallops below the rim, those at the corners enclosing a small scrolled leaf. An identical design at Hinton Blewitt, Som., suggests a West of England manufactory.– FURNISHINGS by *Brandon*, including the three-arched SEDILIA, unusually of wood. – FLOOR TILES by *Minton* in the chancel, some with the Cawdor arms. – STAINED GLASS. *Hardman* made two windows in 1850 and three in 1851. Only the S transept S 1850 survives. Crucifixion in bright colours. – Chancel S. Two good windows of *c.* 1860, perhaps by *Gibbs*? Nativity, and Christ with Mary Magdalene. – Chancel E, 1922 by *Heaton, Butler & Bayne*. Resurrection. – Three worn windows of saints, 1892 by *Joseph Bell & Son*.

CHURCHYARD CROSS, late C19. LYCHGATE of 1890 with elaborate cast-iron gates by *F. & A. Stephens* of Pembroke, the handle in the form of a welcoming hand.

Uphill, to the E, roofless, cottage-like OLD VICARAGE, a great mystery. Single storey and of several builds. Inside, built into the lateral walls, two arcades, both two bays long, the W one with circular pier and a square abacus with carved masks, similar to the chancel. The masonry seems to be reused, but not the arches, which are segmental and hardly medieval. If reused from the church, from what part? (cf. Manorbier for medieval remains in a similar position upslope of the church.) Used as a school in the early C19 and later as a cottage.

FLIMSTON CHAPEL, 2¼ m. SE. Bleak setting on the vast firing range. Tall, medieval single chamber with added late C15/C16 W turret with corbelled parapet and big pointed belfry windows. Small N chamber. Converted to a cartshed *c.* 1785, the blocked entries visible under the E window. Restored in 1903 to its original use by Col. and Lady Lambton of Brownslade, in memory of their three sons, all killed in the Boer War. The chamber is roofed with a barrel vault of pointed form. PISCINA, SEDILIA and STOUP, all plain. In the latter, a little bowl, unearthed near the site of Bulliber Chapel nearby. – Big limestone FONT, and FURNISHINGS of 1903. – STAINED GLASS. Seven windows of *c.* 1903 depicting saints. By *Heaton, Butler & Bayne*. – MONUMENTS. Tablet in memory of William, Alexander and Ronald Lambton by *Powell* of Whitefriars. Alabaster frame with some mosaic. Several brass plaques of the Lambtons.

Outside, a Celtic CROSS on four steps, erected 1909 by *Clarke* of Llandaff.

FLIMSTON, 2¼ m. SSE. Roofless shell near Flimston Chapel at the edge of the range. A long range of several builds, recorded from the C14, but of obscure history. At the N end, the earliest house, C14 or C15, a ground-floor hall with a cross wing to the

N containing a solar above undercrofts. An arch springing in the original W wall may indicate the entry to the hall. Only one of the vaulted undercrofts survives, possibly an alteration of the C16 or C17, when the upper floor level was altered. A four-centred doorway below may be of this date also. Lateral solar chimney, corbelled out, with tall circular shaft. The hall end was altered, probably also in the C16/C17, when the first floor was remodelled. Flanking the massive gable chimney to the S, a semi-octagonal projection; was it a medieval look-out, or a stair-turret to the new upper rooms? The ground floor of the turret was blocked in the C18, when the fireplace was enlarged, and a little vaulted first-floor room added alongside the chimney. The long E side was given C18 windows, regularly spaced, creating a front of four bays. In the C19 a dairy was added on the W side and a large service range to the S.

Extensive FARM BUILDINGS, some incorporating medieval masonry, especially the N range of the L-plan BARN to the E of the house, which has a massive battered gable and a narrow pointed S doorway. Odd sunken BYRE, built in a quarry pit, the floor and part of the walls cut out of the rock, evidently to keep the place cool.

FLIMSTON FORT, 3 m. SSE. Iron Age PROMONTORY FORT, the promontory guarded by a series of three banks and ditches. The outer bank creates an almost separate area (cf. Bosherston Fort). Much eroded.

PRICASTON, 1½ m. SSE. Much-depleted ruins, also on the R.A.C. range, urgently requiring conservation. Altered in the C19, but much remains of the earlier, probably C15 house. The entrance elevation is probably a C19 remodelling; a three-storey façade of seven bays. Single main range: hall, cross-passage with service rooms beyond, and solar above the latter. A perfectly preserved cross-passage has three arched doorways of dressed stone leading into the two barrel-vaulted service rooms. Masonry of high quality. The solar has a corbelled lateral chimney next to a trefoil-headed window. The hall area is much altered; the projecting stair-turret remains at the service end, the stairs replaced, but following the original winding path. The hall may have been originally at first-floor level, see the corbels and beam sockets. Backing on to the solar end is a much-ruined wing, altered in the C19, but retaining an earlier wall with tall chimneystack and base of a corbelled chimney.

BROWNSLADE, ¾ m. S. Demolished in 1976, when already a shell after enforced abandonment within the firing range. The house was built in 1782 for John Mirehouse, agent for the first Lord Cawdor, by Cawdor's protégé *William Thomas* (*see* Introduction).★

The impressive model FARMYARD survives to the W,

*53*

★ The design published in 1783 shows a refined villa with pavilion wings; the latter were not built.

arranged around a large courtyard; partly reusing a range of existing buildings, the small C17 house becoming the bailiff's house. Since 1945 this has been part of the army gunnery (and de-roofed). Mirehouse was notable for his planting campaigns to tame the strong salt-laden winds: 'the gardens which were doomed by friendly forbodings to eternal barrenness are so sheltered by thick plantations as to have made them among the most productive in the country' (Malkin). His prodigious achievements as a reclaimer and improver of land for farm use, draining huge tracts of the Castlemartin peninsula for the Stackpole estate, won him the Gold Medal of the Society for the Encouragement of Arts, Manufactures and Commerce in 1800.

LINNEY, 1½ m. SW. Faint traces of a deserted village, in decline by *c.* 1450 and extinct by *c.* 1800. There was a medieval hall house, demolished in 1976.

OLD RECTORY, ⅓ m. SW. 1840, by *John Large* of Pembroke. Faintly picturesque, with gables and tall chimneys in grey limestone, built for James Allen, later Dean of St Davids. Mahogany staircase within.

# CILGERRAN                                                    *1943*

Now a large village, but originally a medieval borough (cf. Newport) possibly incorporated by the Marshal family after 1223 (no charter is recorded). In 1867 there was still a borough government of portreeve, aldermen and burgesses, and some substantial medieval houses survived.

A single, long street, its breadth reflecting its market function. A few houses with Cilgerran grey slaty stone cut in long squared blocks, for the riverside was extensively quarried through the C19, with some ten QUARRIES along the gorge producing building stone, slates and slabs. The PENDRE INN, at the E end, with a gabled cross wing, could be late C17 or early C18. At the W end, CEMAES STREET continues W to the former SCHOOL, of 1845, much altered. Further out, the RECTORY of 1845–6, asymmetrical plan and scrolls at the gable, by *William Railton*, the Church Commissioners' architect. Cwm Plysgog, the attractive valley below the church, has smaller C19 houses and cottages.

ST LLAWDDOG. Rebuilt 1853–5 by *Benjamin Ferrey*, except for the C15 tower, which is quite plain, like Clydey, with single cusped bell-lights, two ornamented with tiny mask-like heads at the apex. Rough pointed vault inside. The medieval church with oak roof, fine chancel window and carved rood screen was demolished in 1836–7 for a very poor building by *Daniel Evans* which lasted only fifteen years. Of 1853, the nave, chancel and s aisle. Vestry and organ chamber added in the 1860s. The best example in the county of correct Ecclesiological Gothic but with no concession to locality. The detail is all English Dec, the display concentrated in the two E windows, textbook

examples of flowing tracery.* Side windows use the local
Cilgerran slate for jambs and mullions to unusual effect. Well-
proportioned interior, whitewashed, with grey Cilgerran stone
arcade, chancel arch and window reveals. Rafter roofs unin-
terrupted by trusses. – Of 1855, the ashlar PULPIT, carved by
*J.E. Thomas*, and FONT, ornately Perp, copied from St Mary
Magdalen, Oxford. – Encaustic TILES in the chancel. –
REREDOS of 1877 by *E.B. Ferrey*. – STAINED GLASS. The best
mid-C19 collection in the county, illustrating the change from
pictorial glass to the revival of the medieval practice of using
leading to outline the design. – E window by *Wailes*, 1854, with
three emotionally coloured panels in a rich setting. – S aisle E,
by *O'Connor*, 1854, with larger, more dramatic scenes, using
leading in the medieval way, as well as rich single-colour back-
grounds. – The two chancel side windows, 1854, by *J. G. Howe*
(attribution by Martin Harrison), take the four Evangelists
from post-Renaissance painting. – The three N two-light
windows, 1860, by *Ballantine* of Edinburgh, also derive from
oil painting but with a vibrant richness of colour. – In the S
aisle, two windows of 1970 by *Celtic Studios*. – MONUMENTS.
At the W end, John Lloyd of Cilrhue †1657, with swan-neck
pediment, the epitaph by the poet Catherine Philipps, the
'matchless Orinda'; Griffith Griffith †1822, by *D. Main-
waring*, white marble with a small sarcophagus; Abel A. Gower
of Castell Malgwyn †1837, Gothic white marble, by *T. Marsh*
of London; Admiral Sir Erasmus Gower †1814, with well-
carved draped urn; Margaret Owen of Rhiwsaison, of the 1730s
by *William Palmer*, Doric; Abel Gower of Glandovan †1788,
curved-fronted with scrolled abutments. – In the S aisle, Abel
A. Gower †1857, heavily Neo-Grecian.

In the churchyard, S of the church, an INSCRIBED STONE,
C5 or C6, TRENEGUSSI FILI MACUTRENI HIC IACIT,
'Trenegussus, son of Macutrenus, lies here', with Ogham
incisions down one side interpreted as I...MAQIN...N.
Nearby, a MEMORIAL of the 1870s to the Gower family and
Sir William Logan, pioneer of Canadian geology, in polished
grey granite, six ridge-backed slabs tethered to a centre plinth
like beached whales.

BABELL CALVINISTIC METHODIST CHAPEL, High Street.
1898. Grey limestone gable front with five stepped lancets.
Three-sided gallery on bulbous-headed columns, the gallery
front ornamented with blank fretwork panels over the columns.
PENUEL BAPTIST CHAPEL, Pendre. 1862, by *John Evans* of
Cilgerran. Gable front with open pedimental eaves and
arched windows. Gallery fronted in long panels on thin iron
columns. Vestry of 1908 by *W. Michael* of Newcastle Emlyn.
TYRHOS INDEPENDENT CHAPEL, Rhos Hill, 1 m. S. 1859.
Attractive, simple gable-fronted design, originally stuccoed.
Well-cut stone window arches and small-paned glazing.

*The aisle E window is a copy of Castle Ashby, taken from the frontispiece of
Parker's *Glossary of Architecture*.

Blaenffos and Penybryn Baptist chapels, 1856 and 1869, are similar. Attractive interior with grained woodwork, box pews and a three-sided panelled gallery on timber columns.

## CILGERRAN CASTLE

The dramatic ruins of a stone castle of the C13 stand on a clifftop   p. 168
site above the gorge of the river Teifi. Probably of Norman foundation, but the origins are obscure. Captured, with Cardigan, in 1165, by the Lord Rhys of Deheubarth, lost to William Marshal, first Earl of Pembroke, in 1204, recaptured by Llywelyn the Great in 1215. Finally, with Cardigan, taken by William Marshal II in 1223. The present castle is principally of the C13 and the work of three successive Marshal brothers, William II †1231, Gilbert †1241, and Walter †1245; and can be seen, both politically and architecturally, as an adjunct of Pembroke.

There were subsequent repairs, and the castle was apparently still habitable in the C16 when Henry VII appointed as custodian William Vaughan, a Merionethshire supporter. As a romantic ruin, it was painted by Wilson and Turner, but slate-quarrying in the 1860s caused the collapse of part of the outer ward curtain wall.

The castle may have begun as a C12 ringwork with a S entrance tower, enhanced in 1223 by the massive E tower, the first of the castle's two ROUND TOWERS. Shortly after 1223 came the enclosure of an outer ward to the S, beyond the rock-cut ditch  24 to the S, with a small gate-tower. Both earlier gates became unnecessary when new gatehouses were built, probably in the 1230s, up against the edge of the Cwm Plysgog gorge, at the sw corners of castle and outer ward. The second round tower replaces the C12 gate, the drawbridge site of which is visible on the S side of the ditch, and the outer ward gatehouse seems to have been blocked to become a mural tower.

Stengthening of the W and N clifftops may have followed in the later C13 and a canted-ended NE tower was added, perhaps in 1377. There was thus no separate keep, the two four-storey round towers both having residential functions (cf. the early C13 towers at Pembroke). The E TOWER has two-light windows into the courtyard on the first and second floors, but only the upper floor was heated. The W TOWER had a first-floor entry from a wooden stair. A spiral stair from the basement and the ground floor door are later C14. Hooded fireplaces on first and second floors.

The CURTAIN WALL survives to near original height between the towers. Close to the E tower, a sally-port leads into the ditch, with another from the ditch through the outer wall. A short stretch of curtain wall runs W to the largely demolished INNER GATEHOUSE, from which an inner round arch survives. The adjoining wall shows that the gatehouse was three-storeyed, with a vaulted first-floor room, possibly a chapel (see the arched recess, possibly a piscina). A wall-

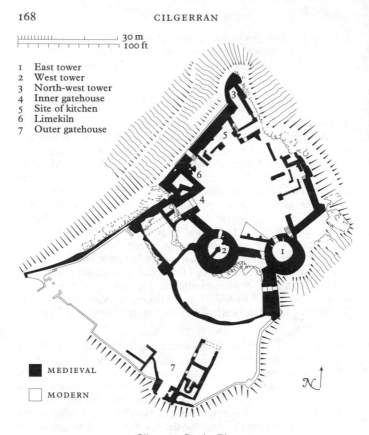

1  East tower
2  West tower
3  North-west tower
4  Inner gatehouse
5  Site of kitchen
6  Limekiln
7  Outer gatehouse

MEDIEVAL

MODERN

Cilgerran Castle. Plan

passage connected the gatehouse to the w tower. A curtain of
impressive height runs NE from the E tower to the edge of the
gorge, with latrine shafts at the end. Minimal walling along the
N edge of the gorge, and basement only of the D-plan NW
tower, probably later C14. The W wall back to the gatehouse,
above the precipitous Cwm Plysgog, survives to wall-walk
level, always much lower than the more vulnerable front wall.
Another sally-port is pierced through. Against these rear walls
foundations of buildings, perhaps hall (N) and kitchen (W),
where a limekiln base also survives.

From the OUTER WARD are visible the rock-cut ditch with
remains of the late medieval bridge to the gatehouse. Of the
curving outer curtain, a massive stretch of wall remains, with
sally-port, attached to the E tower. Foundations of the first
gatehouse remain opposite the w tower, with later medieval
three-room building adjoining. The second gatehouse stood
near the present ticket office; excavation established that it had
a portcullis.

GLANDOVAN/GLANDYFAN, 1 m. s. A later C17 gentry house, 75
built for a branch of the Vaughans of Corsygedol, Meri-
onethshire. Owned by the Stedmans of Strata Florida in the
later C17 and by the Gowers from the early C18 to the C20. No
major alterations after 1808, when the Gowers moved to
Castell Malgwyn. The best example in SW Wales of the Renais-
sance formal plan (cf. Plas y Wern, Llanarth, Ceredigion).
Double pile, with tall hipped valley roof and axial three-shaft
chimneys, which may correspond to the hearth tax assessment
of 1670. Two storeys with basement, five-bay plain roughcast
front of small timber cross-windows. Paired brackets to the
eaves, the front door and columned porch are an early C19
refurbishment. At the rear, a hipped stair-tower with hand-
some, if crude, open-well stair with turned balusters, newel 76
pendants and finials, and reached by a broad centre passage.
The four main rooms are relatively plain, the plastered beams
with simple mouldings in the front rooms, and in two upstairs
rooms.
    STABLE COURT. Two long ranges, the earlier to the N, pos-
sibly late C18, with an attractive earlier C19 bell-tower. Earlier
C19 plain Gothic LODGE and handsome rusticated stone
gatepiers with cast-iron urns.
RHOSYGILWEN, 1½ m. s. Rebuilt 1885–7 by *George Morgan*
for the Rev. Robert Colby. Cilgerran stone with Bath stone
dressings. Jacobean, with three varied gables, big mullion-
and-transom windows, and Northern Renaissance detail to the
entrance. The brick chimneys were rebuilt more simply after
a fire in 1985, and a corner of the garden front has been left a
shell. Heavy timber staircase with stained-glass stair window.
WELSH WILDLIFE CENTRE, 1½ m. NW. 1993–4, by *Niall Phillips* 133
*Architects* of Bristol, won after a limited competition. Job archi-
tects *Peter Roberts* and *Chris Mart*. An education centre for the
Dyfed Wildlife Trust and visitor centre for the Teifi marshes,
large, but sited in a dry valley to reduce impact. From the
marshes only the sloping roof appears over the bank. The S
front is a dramatic curving curtain of glass over a stone base-
ment, with overhanging curved roof. The glass box contains
exhibition area and shop; the upper floor is cantilevered out
over two-thirds of the space as an eating area, giving full impact
to the glass walls and roof. The marriage of the simply detailed
timber rear with glass curtain walling works well visually
because of the deep overhang of the roof. There remains the
risk of an unadaptable interior only divisible by screens.
*See* also Castell Malgwyn, Manordeifi.

# CILGWYN
### Nevern

ST MARY. Single-chamber church, closed 1999, and deterio-
rating. Largely rebuilt by *E. H. Lingen Barker* in 1883. Steep
roof, once with a timber W bellcote, plain lancets and three-

light E window. A datestone of 1786 built into the porch. – FONT. Plain and damaged, shallow square medieval bowl, on a base of 1883. – MONUMENT to Thomas James of Gellifawr †1774. Rustic, black-and-white painted, with charming winged cherub head at the foot.

In the churchyard, a high-walled GRAVE ENCLOSURE of the James family of Gellifawr, with memorial to Thomas James †1801.

CAERSALEM BAPTIST CHAPEL. 1841, altered 1915 and 1948. Stucco gable front with arched windows. A carved slate clock face in the centre stands for ever at 10.42, giving a little margin before the eleventh hour should come. Across the road, an outdoor baptistery.

GELLIFAWR, I m. SW. The big stone, three-bay front range with battered chimneys was built in 1860 for David Davies of Castle Green, Cardigan. Remnants of an early C18 house (of the James family) survive behind. Three-sided mid-to-later C19 farm-court, the longest range lofted and with an internal water wheel.

PENTRE IFAN BURIAL CHAMBER. *See* Nevern.

0421               CLARBESTON

Church amid scattered farms in a deeply rural setting. The main population is at CLARBESTON ROAD, a halt of the Carmarthen–Haverfordwest railway.

ST MARTIN. Rebuilt in 1841, according to the datestone, to plans by a local man, *David Rosser.* Nave, chancel and battlemented W tower. How closely does this reflect the plan of the old church? Much restored in 1894 by *Kempson & Fowler*, who added Bath stone tracery, Dec in the chancel. – Large octagonal FONT of *c.* 1860, removed from St Mary's Tenby after 1887. – FURNISHINGS of 1894.

CARMEL BAPTIST CHAPEL, ½ m. NE. Dated 1872. Rock-faced sandstone with tall window each side of the entry, all round-arched. Rewarding interior, galleried on three sides upon timber posts, the front panels grained to imitate different woods.

2535             CLYDEY/CLYDAI

The church stands alone on the side of the Cneifa valley. Above is the OLD VICARAGE, 1878, by *Stephen Lewis* of Haverfordwest, stuccoed, with a trefoiled attic dormer. Large parish, with scattered farms. Tegryn, Bwlchygroes (q.v.), Llwyndrain and Star are the village settlements.

ST CLYDAI. A unique dedication, to one of the twenty-four daughters of Brychan Brycheiniog, the Irish ruler of Brecon whose progeny fill the calendar of Welsh saints. Simple C15 W

tower, (cf. Cilgerran), vaulted within, and the floor lower than that in the nave. Nave, chancel and S aisle were rebuilt to the original plan in 1888–9 with heavy-handed insensitivity, by *Middleton & Son* of Cheltenham. The steep roof-pitches over-whelm the original tower, and the tracery in early Dec style is harsh, quite unrelated to what was there before. The tower was given a steep, slated pyramid roof, removed 1973. Nave and aisle are of the same size, divided by a four-bay Bath stone arcade; the chancel is exceptionally short. – Notable C12 FONT, cushion type with ornament in raised lines around the edges of the half-round faces. – By the door, a C13 STOUP under a pointed arch. Three-sided front with two carved heads. – INSCRIBED STONES. Three C5 to early C6 stones. DOB[I]TUC FILIUS EVOLENG[I] overlaid by a Celtic cross, possibly C10, and eroded Ogham strokes on the l. side, possibly reading D[O]V[A]TUCEAS. The second is inscribed ETTERN – FILI VICTOR, and has ETTERN . . . TOR in Oghams, (top missing). The last reads SOLINI FILIUS VENDONI, but has no Oghams.

CASTELL CRYCHYDD, Llwyndrain (SN 261 347). Medieval motte to the E of an oblong enclosure.

LANCYCH. *See* Abercych.

## COEDCANLAS
2 m. NNW of Lawrenny

<span style="float:right">0108</span>

ST MARY. Now a shell. Said to have been rebuilt in 1718, by Sir Arthur Owen of Orielton, after sixty years in ruins. Repaired *c.* 1830 by Sir John Owen. In ruins again by 1879. Nave and chancel, no features surviving.

COEDCANLAS, 1 m. NW. A house of antiquity held by the Percevals from at least 1362 then by the Butlers, who remod-elled it in the C16. It had ten hearths in 1670 but was reduced in size when Sir Arthur Owen of Orielton 'rebuilt' the house in 1718. The wooded surroundings and fields fronting the Cleddau estuary offered, in Fenton's view, 'as delightful a situation for a great man's residence as any in this county'.

N front of three storeys facing the road, the lower floor partly subterranean. Five irregular bays, with stone steps to the off-centre door, at first-floor level, set within a C19 trellised porch. To the l. of the porch two late C16 blocked mullioned windows, each of two lights with quarter-round mouldings. These are set between the levels of the present upper floors; their level corresponds with three storeys of large, late C16 mullion-and-transom windows of Bath stone in the W gable, revealed in 1999, blocked when the chimney was inserted, probably in the C18. At the SW corner a strip of wall corbelled out at first-floor level suggests a stair and possibly the existence of a former wing. Lateral N chimney; massive projecting E chimney. The more formal S front, remodelled in the early C19, is of

three bays and storeys. Slate-hanging, removed in 1999, revealed more blocked windows and confirmed that the house originally had a hall at first-floor level. Pointed central door; offset above are traces of the former main entry, originally reached via a stair. Perhaps the basement was barrel-vaulted. Little early detail left inside. The roof trusses are dated 1811, presumably the date of the central staircase. On the s side, single-storey farm ranges, enclosing a yard.

GARDEN REMAINS. To the N, across the road, the so-called OLD GARDEN contains a D-shaped, moated enclosure within a broad ditch, and traces of earthworks with possible water features beyond. Below the enclosed yard to the s, and sloping towards the estuary, remains of a fine polygonal garden, with roughly central former pond and connecting stream. Local tradition calls this the HOP GARDEN. Among other features, aerial photographs clearly show nearest the house, though not in alignment, the gardens laid out c. 1700 by Sir Arthur Owen. A rectangular walled garden, possibly with SE gazebo, and an inner (presumably dwarf) wall. Against this, long ridges, said to be associated with hop-growing, and against the w side, six square compartments, presumably for vegetables. The layout compares to one at Ashurst House, Highgate, London, known from an engraving.

# COSHESTON

Large linear village, the church at its higher w end, with delightful views over the estuary.

St MICHAEL AND ALL ANGELS. A picturesquely spreading church. Nave, N aisle, chancel with N aisle, s transept and s porch. Restored in 1831 by *George Gwyther* of Pembroke, rebuilt, approximately to the old plan, in 1885 by *S.W. Williams* of Rhayader. From the old church, the little battlemented turret, corbelled out on the w side, clearly a late medieval or C16 addition, until 1980 capped by a spirelet. As at East Williamston, an external belfry stair follows the gable. Inside, the only old-fabric is a low N squint passage and the remains of another on the s side. Rich High Victorian interior, all of 1885, old-fashioned by then. The incumbent and patron T. G. Cree was High Church. E.E. arcades on round piers, hoodmoulds in the nave with big swirly foliage stops. Heavily ornamented chancel arch with rood beam. The arches are of polychrome stone, unfortunately painted over. Arch-braced nave roof on short wall-posts with carved corbels and capitals. Panelled chancel wagon roof with floral bosses. Grouped lancets. – FONT, based on the Norman one at Lamphey, but taller and polychromatic. It stands in a w end baptistery with brightly tiled floor and dado. – Overdone carved stone REREDOS of 1895. – FURNISHINGS mostly by *Williams*. Timber PULPIT with cusped panels. They have water-colour Apostles, dated 1890–91. – Late C19 painted METAL

PLAQUES depicting incense-burning angels. – STAINED
GLASS. All in the chancel, *c.* 1885. By *Lavers, Barraud & West-lake*, according to M. Harrison. – MONUMENTS. The S transept
is a rare survivor in the county of a family chapel, with C18 and
C19 memorials to the Roch family of Paskeston, all modest.
Outside, only the square socket stone of the CROSS.

Linear VILLAGE, many simple C19 cottages and farmhouses set
in long medieval burgages. At the W end, the SCHOOL of 1859,
planned by *Prichard & Seddon*, built more simply by *Hugh Hoare* of Lawrenny. In the late C19 OLD RECTORY, vaults of
the medieval or C16 predecessor. The simple CARPENTER'S
ARMS was built in 1857 by *James Leach*, a local carpenter, for
himself. HILL HOUSE of the mid-C19 has a pretty three-bay
front with wide tripartite sashes, lozenge-paned. Further E, the
tiny FUNERAL CAR TENEMENT used to house the village
hearse, dated 1895. Finally, the BREWERY INN: early C19 front
concealing an earlier building. Pretty glazing of paired lights
with triangular heads within rectangular openings.

THE HALL, ½ m N. Rebuilt (as Woodfield) for Orlando Harries
Williams of Gloucestershire possibly by *William James* of
Stone, Glos., in the 1840s. In 1867 enlarged and remodelled
for Henry Wedgwood (of the Etruria family and a cousin of
the Allens of nearby Cresselly), probably by *F. R. Kempson*, in
restrained but eclectic Gothic. Two storeys, but with varied
roof-heights and steep dormers on an irregular plan. Rendered
walls and many tall chimneystacks (mostly now missing) are
relieved by brick and sandstone polychromy. Inside, a good
teak staircase with chunky balusters. A wing was demolished
in early C20.

PASKESTON HALL, 1¼ m. E. On a hillside platform with grounds
(now overgrown) beneath the terrace. Much rebuilt *c.* 1850 for
the Roch family, it seems by *John Cooper*, as a large-scaled two-storey villa with a broad shallow bow on the garden front. Old-fashioned, though Victorian in feel. The interior is subservient
to the staircase hall, full-height and circular. The winding teak
staircase with spindly twisted balusters was made by the local
carpenter *James Leach*, but ambition outpaced ability. The C18
house, of three bays with full-height central porch, survives as
the rear wing.

## CRESSELLY HOUSE <span>0606</span>
### 2 m. W of Jeffreyston

A new house built 1769–71 for John Bartlett Allen. Designed as
a villa, a rarity in this area; one has to look as far E as Penrice
in Gower to find another (albeit finer), of 1776. The archi-tect is unknown, but *William Thomas* of London (a native
of Pembroke) might be suggested; his published plans of
Brownslade, Castlemartin, show similarities. Built of local
stone, never rendered. Restrained five-bay, three-storey
entrance front sited close against the road. The central three

bays break forward slightly; recessed lower windows in the outer bays, within simple blind arches. Each floor is articulated by a smooth projecting band, that to the first floor running through the sills. The garden front is dominated by a broad full-height canted bay, the outer bays here having Venetian windows on the ground floor set within blind arches (one altered later). Pavilioned wings are known to have been built, rebuilt in 1869 in two full storeys, and of three bays. On the garden front, canted bays on the ground floor match the dimensions of the centrepiece, balustraded above. The architects for the additions were *Clark & Holland* of Portsmouth, estate architects to the Earl of Portsmouth, father of Lady Allen of Cresselly.

Alterations in 1815–16 by *William Hoare* of Lawrenny make reconstructing the original plan difficult. The staircase may have risen from the central three-bay hall, now reduced by the extension of the dining room into its l. side. The present toplit stair is in a square well to the r. of the hall. Wrought-iron balusters made by *William Moss* of Carmarthen. The old drawing room is in the centre of the garden front, taking in the central bay. The silk wall panels in Adamesque style are Edwardian, but the late Rococo decorative ceiling is of 1771 and charming, with delicate vine tendrils radiating from a centrepiece. In the bay, a cartouche with crossed musical instruments and open score. Perhaps Bristol work. The border with twined roses may be Edwardian. Chimneypiece of coloured marble with floral carved central panel. The room to the w was fitted out as a library in 1816, the shelving perhaps by *William Owen* (payments recorded to him at this date). Plaster floral swag above the fireplace. To the E of the drawing room, a small panelled study. The 1869 work provided a new drawing room and billiard room at the w end, and service rooms at the E. In the new secondary staircase, part of a Chinese Chippendale balustrade of 1769.

*Clark & Holland*'s best work is the series of GATES and LODGES which created park drives from the four points of the compass, to disguise the fact that the house is right beside a main road: crested gatepiers and big single wooden gates. L-plan lodges with bay windows.

# CRESSWELL QUAY
1 m. w of Cresselly

Idyllic small group, set deep in the tree-clad tidal reach of the Cresswell river, tributary to the Cleddau. Despite its present-day tranquillity, Cresswell Quay was originally the centre of the Pembrokeshire coal industry; coal was sent from here in *c.* 1280 to build Aberystwyth castle. The valuable anthracite was carted from small local pits to the quays, and shipped off in barges downstream for transfer to sea-going vessels at Lawrenny and elsewhere. Three quays are marked on a map of 1755, each owned

by the principal local landowners, including the Allens of Cres-
selly. Trade declined by the early C19; with the increase of mining
at Saundersfoot and further afield, small local collieries were
uneconomical, and trade continued in Cresswell Quay only for
local supply.

Much remains of early industrial activity. Two QUAYS survive.
The one forming the present public house car park seems to have
been reserved for general goods. Footings of the other remain
immediately downriver. On the N side of the water at the foot of
the wood is the stone wall of the huge mid-C18 COAL FOLD, over
an acre in extent, belonging originally to the Barlows of Slebech,
where stocks of coal and timber were stored prior to export. The
ruined former counting house is by the riverside entrance. The
creeper-clad CRESSELLY ARMS has an C18 core, remodelled in
the late C19, with an added l. wing. CRESSWELL HOUSE, stuc-
coed, two storeys and five bays, was built c. 1750, apparently as
a manager's house. Just SE, THE MANSE, a stuccoed three-bay
house with hoodmoulded windows, an 1885 reworking of an
earlier house, most likely by *K. W. Ladd* for the ministers of Pisgah
Baptist Chapel (*see* below). Just beyond, a large barrel-vaulted
WELL of uncertain date. To the N, on the road to Cresselly, some
good, unaltered C19 cottages, including KILN COTTAGE.

CRESSWELL CASTLE, ¼ m. N. Extensive ruins on the w bank,
partly consolidated. A chapel belonging to Haverfordwest
Priory existed here before the Dissolution. The later owners
were the Barlows of Slebech. William Barlow (†1636), who
settled at Cresswell, was High Sheriff in 1612. The large rec-
tangular courtyard with four corner towers gives the impres-
sion of a fortified house, but there is no evidence of standing
medieval remains. The 'castle' probably dates from the time of
William Barlow (perhaps with some earlier masonry); a minia-
ture imitator of romantic early C17 sham castles such as
Lulworth, Dorset (1608), Ruperra, Glamorgan (1626),
although built to a courtyard plan, rather than a single house.

The two-storey round corner turrets, linked by the castel-
lated walls, are simply garderobe towers, except the ruined
SE tower, which was a dovecote. Within the courtyard are
remains of three ranges, N and S ones against the curtain wall.
The rectangular S building, very ruined, has a massive inserted
C18 fireplace. The ruined N building may have C16 origins as
it is abutted by the C17 NE tower. The most prominent build-
ing is the large and clearly later two-storey gabled E range,
probably C18, the last part inhabited before abandonment
c. 1800.

To the E of Cresswell Castle, BUBBLETON BRIDGE, dated 1763
on a cutwater, single-arched. Upstream, an attractive group,
CRESSWELL MILL, a later C18 whitewashed, three-bay
cottage, with taller hip-roofed mill beyond, retaining much of
the machinery. Well restored in 2000.

PISGAH BAPTIST CHAPEL, ⅛ m. S. A smaller building, of 1821
by *John Upton*, local carpenter, was enlarged and refitted 1877

by *K. W. Ladd*. Plain gabled front, with tall round-arched windows on the long sides. Gallery at the entrance end.

Opposite the chapel, Nos. 1–4 PISGAH COTTAGES, two C19 pairs, both single-storey.

## CRINOW
### 1 m. E of Narberth

*1214*

ST TEILO. Tiny. Nave and chancel of uncertain date. W bellcote. Restored 1894, the date of the simple windows and FURNISHINGS. – MONUMENTS. Richard Mathias †1763. Carefully attempted lettering, some misaligned. – Eaton family, 1833 by *Reeves* of Bath, plain.

In the NW corner of the CHURCHYARD, a small Celtic cross MEMORIAL to Blanche Allen †1907, by *G. E. Halliday* of Llandaff.

PARC GLAS, 200 yds E. Early C19, stuccoed, five bays long and single pile, with hipped roof (shorn of the eaves). Portal with fluted stone Doric columns. Perhaps by *James Hughes* of Narberth. The three-bay rear wing was the old C18 house, refitted to contain a large oval entrance hall, with cantilevered stair and plaster ceiling rose with radiating spears. The drawing room (in the front range) has a screen of Ionic columns with full entablature. Good plasterwork, especially the lunettes above the doors.

## CROESGOCH
### Llanrhian

*8230*

A main-road village, with the ARTRAMONT ARMS, named after the Co. Wexford estate of General Le Hunte, the early C19 landowner.

CROESGOCH BAPTIST CHAPEL. Rebuilt in 1858. Attractively painted Gothick gable front with long pointed windows and small-paned glazing (all plastic now), a more heavily Victorian traceried rose in the gable. Perhaps by *Joshua Morris* of Newport. The handsome interior has a three-sided gallery on painted timber columns with bases at pew level, a feature of Morris' chapels. Pews still of the box type and grained.

TRENEWYDD FAWR, 1 m. ESE. Unusually extensive later C19 farm buildings around a large grassed court. Single-storey cow-houses, one large lofted range and a long cart-shed.

TREARCHED. A pretty vernacular LODGE on the main road, half-hipped and with grouted roof, probably C19, for all its apparent age. Mid-C18 farmhouse; three-bay front with C19 tripartite sashes. Inside, an earlier stair and fielded-panel doors.

MESUR Y DORTH STONE, by the main road ½ m. E of Croesgoch. Inscribed stone, C7 to C9, a ring cross with stem.

# CRUNWERE

*1810*

The old village has disappeared, having migrated s to the A477, the turnpike road completed by *Thomas Telford* in 1839.

St Elidyr. Isolated, in the lee of the hill. A smaller church was replaced by the present cruciform one in 1847 by *Thomas Jones* of Haverfordwest, retaining the c15 low embattled w tower with battered base and rectangular belfry-lights. Ground-floor barrel-vaulted. Odd raised quoins to the 1847 work. Plain interior, restored 1878 by *Thomas David* of Laugharne, who added the s porch, with patterned doorway of moulded cement, using a machinery cog as a mould. Lancets of 1878. – Early c19 FONT with octagonal bowl and tall pedestal. – Carved PULPIT of 1878 of Bath stone. – Late c19 marble COMMANDMENT TABLETS. – STAINED GLASS. Well-coloured e window by *Wailes*, *c.* 1878. Crucifixion. – MONUMENTS. Thomas Davies †1706. Crudely lettered. – Anne Morgan †1826. Pediment and lozenge-shaped finials. – On the outside wall of the s transept, MEMORIAL to Rev. John Harries †1727, rector of New Radnor, who 'in the year of Trial 1691, was deprived of all that he could not keep with a good conscience'.

Zoar Baptist Chapel, 1 m. sw. (Disused). Dated 1854. Simple gabled front with two arched windows, side porch. Unexpected interior, the seating rising in steep steps. High-backed PEWS and pulpit with box pews of 1842, brought in 1869 from Molleston Chapel (*see* Templeton). Note the gouging of the wall behind the pulpit, evidently for a stout minister.

# CRYMYCH

*1833*

The Whitland & Cardigan Railway arrived here in 1875. Single main street, with two plain stucco chapels, Seion Baptist Chapel, 1900–1, and Antioch Calvinistic Methodist Chapel, 1875 and 1927. At the n end, the Crymych Arms, the only building pre-dating the railway, and a plain, half-hipped Market Hall, 1913–15 by *L. Lewis* of Cardigan. To the r., down Station Road, the former STATION, 1875 by *J. W. Szlumper*, stone with yellow brick, and stone GOODS SHED, reused as part of a small industrial estate, 1990, with two modest industrial units, well designed with green-stained plank cladding on concrete plinths.

Ysgol Preseli, to the s. Comprehensive school of 1953–7 by *Lt.-Col. Walter Barrett*, the County Architect. Modern in its assembly of flat-roofed blocks clad in yellow brick with windows in bands. Prominent four-storey classroom tower. To its w, single-storey interconnecting dining hall, assembly hall and gymnasium, building up neatly from a low changing-room cluster. s entrance court enclosed on the e by a two-storey science and craft block, the main entry very understated.

12 FOEL DRIGARN, 2 m. W (SN 158 336). Very large Iron Age
   hillfort on a Preseli crag, of three distinct enclosures walled in
   drystone, the topmost, and presumably the earliest, enclosing
   three massive Bronze Age cairns, the largest in the region.
   Within the fort, seventy-seven platforms for houses have been
   detected in the top part, and a further sixty-three in the NE
   addition. Excavations in 1899 suggested a major settlement
   into Roman times. The ridge of the Preselis running E was of
   major importance from the Bronze Age to the Iron Age, with
   numerous house sites, field walls and cairns. CARN MEINI
   further W, a natural rocky crag, is the probable source of the
   bluestones used at Stonehenge. At the W end, SN 140 326, a
   collapsed CHAMBERED TOMB. CARN ALW (SN 139 338) is
   an Iron Age hillfort on the NW side of a natural outcrop, the
   W side defended by jagged upright stones, *chevaux de frise*. No
   sign of houses within, but outlines of round huts in the area,
   together with enclosures and piles of cleared field stones, which
   may be Iron Age. BEDD ARTHUR, W of Carn Meini, SN 130
   325, is a curious and unexplained oval of thirteen small stand-
   ing stones, beautifully sited on the bare ridge.
   CASTELL DYFFRYN MAWR, 1 m. NW (SN 175 351). Eroded
   Norman motte.

*8005*                          DALE

   Coastal village facing E into the sheltered Dale Roads at the W
   end of Milford Haven, protected by the St Ann's Head penin-
   sula. The church and Dale Castle are some ¼ m. W of the village
   in the valley that cuts off the peninsula from the Marloes ridge
   to the N. On the E end of the ridge, overlooking the Haven, a
   large stone WINDMILL tower of *c.* 1800, almost the last in the
   county. The flat NW upland overlooking Marloes Sands is the site
   of a large disused Second World War airfield.

   ST JAMES THE GREAT. Nave, chancel and thin battlemented W
   tower, all grey roughcast. The tower looks C15, plain battered
   walls and corbelled parapet. It has square-headed small cusped
   bell-lights and some small trefoiled lancets. The base is stone-
   vaulted. The rest was rebuilt in 1761 and extensively restored
   in 1890 by *F.R. Kempson*, and all the bland detail is his. Some
   further work in 1903. Boarded panelled roofs within and fur-
   nishings of 1890, except the fine white marble FONT of 1761.
   This is a big oval bowl with inset band and octagonal baluster
   pedestal, and is said to come from Italy. Charmingly crude
   timber ogee font cover, presumably earlier C19. – STAINED
   GLASS. E window of 1894 by *A. Savell & Co.* of London,
   conventional Ascension with four Saints, on clear ground. –
   MONUMENTS. Mary Paynter †1815, grey limestone reeded
   surround to a marble panel, with painted arms below; Henry
   Lloyd-Philipps †1826, Neo-Grec in slate and two colours of
   marble.

The village is divided in two by the marshy valley.

On the S side on a late C18 scale, the GRIFFIN INN and RICHMOND HOUSE, a narrow three-storey pair. EATON HALL completes the terrace, presumably originally of the same date but thoroughly remodelled *c*. 1900 to a plain six-bay, three-storey front with broad timber enclosed porch. Around the corner, No. 2 SOUTH STREET, actually two houses of the late C18, the left side three-storeyed with early C19 small-paned shop windows. Opposite, pink-washed READING ROOM, converted in 1892 from a house. Further out, COLDSTREAM LODGE, yellow-washed and with early C19 four-bay front; it has a mid-to-later C18 stair. Beyond the council houses, in the cemetery, WAR MEMORIAL, 1923, one of the white marble soldiers by *Jones* of Llanybydder usually found in the Teifi valley (cf. Aberbanc, Cribyn, Llangeitho, Cered.).

N of the marsh, from the seafront, first BROOK COTTAGE, a roughcast row of C19 cottages with two gabled bays and a hipped bay. Above is BROOK HOUSE, a complicated yellow-washed house of several periods. The massive W stack at the rear may be earlier than the mid-C18 date suggested by a shell-headed niche inside this range. The central staircase in the rear range and the shorter block with the drawing room that obscures the older front are earlier C19, and an early C20 big square bay adds a final front layer. Just W, ALLENBROOK, converted about 1916 from a row of houses that included the Vicarage in the four E bays, and three two-bay houses to the same height. The oak roof trusses suggest that the vicarage was mid-C18, and blocked windows show that it was three-storeyed. The rest is probably late C18, to a larger scale than usual, but confused by the early C20 work which aimlessly scatters bays and a porch. Further W, the OLD POST HOUSE, set back above the road, the regular three-bay front probably late C18, but the big external chimneystack looks older. Inside, a Chinese Chippendale stair. Further W, by the churchyard, WALLED GARDEN to Dale Castle, with a NW entry with a broken pediment that although heavily roughcast looks earlier C18. The horns of the pediment shelter a little ashlar pedestal.

DALE CASTLE. Castellated house that originated in a medieval castle, of which virtually nothing remains. What is there is eminently picturesque in everything but the house itself, which may be early C18 but heavily remodelled in the early C20. Viewed from across the valley are layers of red sandstone terrace walls, with creeper-clad accents and a castellated gateway facing W towards a mysterious featureless thin stone tower that proves to be a water-tank. SW of the house on the S side of the entrance court is some creeper-clad walling that is all that remains of the medieval castle, reduced to just part of the terrace and forecourt walls in about 1910.

The medieval history is obscure. The de Vale family were here from the C12 to the C14, but a view of 1810 shows what may have been a late medieval tower house SW of the main house. What survives below terrace level is the basement with

a single broad stone or rubble vault. There was a later domes-
tic wing to the w of the tower, of which only part of the front
wall survives, undateable.

The main house as seen in the 1810 view was a big square
mansion with corner domed turrets, possibly early C18. The
Allens of Gelliswick owned Dale from 1705 and John Allen
married a Stepney in the earlier C18, which may have provided
funds for rebuilding. In 1776 Dale passed to the Lloyds of
Mabws, Cered., now Lloyd-Philipps. By the late C19 the house
was a plain battlemented two-storey block with sash windows,
but its present appearance derives from a remodelling
between 1905 and 1911 by the owner, Rhodri Lloyd-Philipps,
presumably aided by his agent, the architect *H.J.P. Thomas* of
Haverfordwest. The exterior was elaborated without flair, the
walls brown roughcast, with cement hoodmoulds and cappings
to the battlements and turrets. The main new features are a big
canted bay on the s front and Tudorish porch on the w, also
an existing NW service range was enlarged with some Tudor-
ish detail on the E side. The interiors are redone also; Neo-
Georgian door-cases. Little decorative work of before 1905,
except the drawing-room marble fireplace, Neo-Grec going
early Victorian. The picturesque forecourt wall with the embat-
tled gateway is earlier C19, not in the 1810 view.

FORTIFICATIONS. The Dale peninsula guards the entrance to
Milford Haven, strategically important enough for Thomas
Cromwell to have a fort built at West Blockhouse Point *c.* 1540,
of which nothing remains. While the defence of the Haven
was discussed in the C18, the issue really reopened with
the Napoleonic War naval dockyard, first at Milford then at
Pembroke Dock. The massive expenditure was in response to
the perceived threat from Louis Napoleon, later Napoleon III,
after 1848 (*see* Introduction). Dale Fort and West Blockhouse
Fort are part of the first phase of the so-called Palmerston
Forts, proposed in 1850 and built 1852–7, to defend the Haven
entry. They are thus contemporary with Thorne Island across
the water at Angle, and the first phase of the Stack Rock island
fort, (qq.v.).

DALE FORT, Dale Point. Built in 1853–7 as a heavy gun emplace-
ment to cover, with Thorne Island and West Blockhouse forts,
the entrance to the Haven. *Lt. Col. Victor* of the Royal Engi-
neers may have been the designer. Planned as a battery with
seven 68-lb guns and two 32-lb guns, and barracks for seventy.
The gun platform, on the headland, is a terrace cut into the
rock, superbly fronted, like all the forts, in grey limestone with
massive granite copings. Within the fort are two barrack-blocks
in line, one for officers, one for other ranks, single-storey to
the inside, two-storey to the sea, limestone with flat roofs
behind parapets, the detail as elsewhere minimal but excellent.
Fireproof interiors, the ground floors with brick quadripartite
vaults, the upper floors with parallel brick vaults on iron
girders. The conservatories along the court are early C20. On
the landward end the headland is isolated by a wall and ditch

running up from the fortified gateway to a gun emplacement on the top and then steeply down to the sea again. The wall is grey limestone, buttressed inside, and pierced with musketry loops. The emplacement on the summit allows for fire down the length of the outer ditch. On a platform cut into the cliff above the courtyard, a circular concrete pit built for the experimental Pneumatic Dynamite Gun of 1893, an enormous, fifty-foot fifteen-inch smooth-bore tube designed so that inherently unstable dynamite might be fired safely without flash.

WEST BLOCKHOUSE FORT. Built in 1853–7 with Dale Fort and Thorne Island Fort, though smaller than both of those, and also said to have been built under *Lt. Col. Victor*, Royal Engineers. Essentially the same purpose, a cliff-face terrace for six 68-lb guns with barracks for forty-three artillerymen and defenders. Of all the Haven forts, West Blockhouse survives the least altered, thanks to a careful restoration in 1986 for the Landmark Trust, by *Andrew Thomas* of *Thomas Jones Associates*, Builth Wells.

The whole site is cut back into the cliff with fine grey limestone revetment walls and granite cantilever steps down to the first floor of the barrack block and on down to the platform level. The barrack block is basically L-plan but chamfered at the angle to present three faces to the sea, the lower storey high and battered with tiny windows, the upper floor slightly more generously windowed with band and parapet to the flat roof, the parapet pierced with musketry loops. It is the detail of military engineering that impresses, the minimal projection of quoins, the curved upsweep of the sill sides to avoid water-holding right angles and the half-round cap-house on the flat roof that tops the winding stair. The interior is fireproof with brick-vaulted basement and transverse brick arches on girders above. There were two barrack rooms on the upper floor, one and a magazine below.

The seaward platform for the heavy guns has a low wall superbly coped in massive granite slabs. The fort, like the others, was never attacked, and its smooth-bore armament was obsolete in face of the new rifled cannon almost as soon as it was completed. During the Boer War concrete emplacements with underground magazines were built on the ridge above the fort, for three six-inch guns and two 9.2-lb guns. Rearmed in the Second World War.

PROMONTORY FORTS. Several headland forts of the Iron Age. On DALE POINT there is evidence of early Bronze Age occupation and later Bronze Age defences of timber palisades and a stone-revetted bank. In the Iron Age these were replaced by the present bank, stone-faced on both sides, some masonry still visible. Beyond the ditch a lesser bank. The entry was in the middle, excavation revealing massive holes for the gate timbers. The exact extent is uncertain, obscured by the Victorian works at Dale Fort (see above). At GREAT CASTLE HEAD, $\frac{1}{2}$ m. w of Dale, a triangular Iron Age fort defended on the land side by a double system of banks and ditches with a third, lesser bank,

inserted in places to the N. Much eroded central entrance and small interior.

ST ANN'S HEAD. The S tip of the peninsula and the site of Henry Tudor's landing in 1485 on the route to Bosworth Field. Long tradition says that Henry VII built a chapel here in commemoration. George Owen in the late C16 describes the chapel as a ruin, with a tower resembling a windmill – might it also have acted as a beacon? A tower survived until 1800, sketched by Norris as a D-shaped tower with traces of a building attached (possibly the chapel). The evidence is confused as in 1713 Joseph Allen was granted a lease to erect a light to keep ships off Linney Head and mark the Haven entrance. Allen's tower was separate from the older tower, as Norris and Warwick Smith show both equipped with coal braziers, the two in line acting as a leading light. In 1800 both were replaced by Trinity House with new low and high towers, designed by *Captain Huddart*, of which the high tower survives as THE OLD LIGHTHOUSE, battered, stuccoed and circular, capped now with a C20 observation box. The present ST ANN'S HEAD LIGHTHOUSE was built in 1844 for Trinity House by *James Walker*, a short octagonal stucco tower with typical lattice-glazed lantern. The builder was *William Owen*. Some early C20 Trinity House terraced houses adjoin, and, further back, ST ANN'S TERRACE, early C20 single-storey houses running down to an earlier group of the 1850s, also built for Trinity House. VERONICA COTTAGE is a simple double-fronted cottage, the well-cut limestone caps of the chimneys showing a touch of class, and HEADLAND HOUSE with the group of three single-storey cottages behind, a stuccoed C19 Tudor group with gables and mullion windows, rather altered.

DALE CAMP, 1 m. N. Large derelict Second World War complex of some fifty-nine structures, first occupied by the RAF and then by the Navy from 1943. The RAF buildings are of conventional rendered brick, but the naval buildings have concrete wall posts and infill of hollow terracotta blocks. The survival of the buildings is astonishing and highly evocative, including a fine complex of interlinked barrack/ablution blocks and even the chapel, now roofless. In the barracks some lively cartoons of fighter planes.

## DINAS

*0038*

A long sequence of terraces and houses, mostly later C19, along the main road. Some display the hard green Preseli dolerite quarried in the area, and many still have small-paned sashes, though of the 1870s. Dinas houses were largely built by returning sea-captains, and greater wealth shows in grey limestone dressings and, occasionally, slate hoodmoulds. At Brynhenllan, an older settlement, an altered row of single-storey cottages in the centre. At Pwllgwaelod, to the W, a typical coastal LIMEKILN, and, set back, CWM DEWI, a pretty, vernacular pair: a small whitewashed

farmhouse with low upper floor and a single-storey cottage, early C19.

St Brynach, Cwm yr Eglwys. By the beach, the remains of the old medieval church, damaged by storm in 1851 and all but swept away in the great storm of October 1859. Massive low w wall with shallow pointed arch and a sturdy stone double bell-cote probably C15. There was a nave, chancel and s transept.

St Brynach, Dinas Cross. 1860–1, by *R. K. Penson*. Low, brown stone nave and chancel with swept roofs and a slated bell-turret, the detail harsh, especially the E window tracery. The porch, gabled unusually E–W, is the best feature. It contains a dismantled C13 FONT, square and scalloped. Inside, open timber roofs and octagonal C19 FONT. Sanctuary oak panelling of 1963. – PULPIT. 1911, carved by the rector's niece, *F. Alderson*. Gothic panels, lumpish form. – STAINED GLASS. By *Abbott & Co.*, Lancaster, 1913. Nave s, brash Modernist window, *c.* 1985.

Brynhenllan Calvinistic Methodist Chapel, Brynhenllan. Disused chapel of 1842. Tall long-wall front in grey roughcast with two big arched windows, outer doors and gallery lights. High and atmospheric interior, grained box pews following the line of the deep, five-sided gallery above, the gallery on marbled columns. Behind the pulpit, an open pediment on elongated piers. The pulpit is later.

Gedeon Independent Chapel, Dinas Cross. 1830. Attractive, simple lateral front with bracketed eaves, two big cambered-headed windows and plain outer doors. The interior, one of the best in the county of its date, is quite charmingly crowded with painted-grained, five-sided gallery and box pews. Panelled front with square railings above; simple panelling also to the pulpit.

Tabor Baptist Chapel, Bwlchmawr. 1842, possibly by *Daniel Evans* of Cardigan. An early gable front with arched windows, open pedimental eaves and an oval plaque. Inside, gallery on slim marbled columns, curved at the corners, canted in towards the pulpit. Plaster ceiling roundel, slightly domed, (cf. Bethania Baptist Chapel, Cardigan, and Tabernacle Independent Chapel, Fishguard). Box pews. Pulpit perhaps of 1882. Large window behind the pulpit, the Good Shepherd, early C20 and very conventional.

Hescwm Mill, Aberbach. Complete water mill, set back from the coast, carefully restored from 1995. A small, half-hipped rubble-stone building with overshot wheel and big holding pond behind. Surviving machinery may be that recorded in 1859: a pit-wheel driving two stones. A second wheel pit powered a saw bench.

Fishguard Bay Caravan Park. Amid the caravans a surprisingly intact naval battery site of 1942 with observation tower. Two bungalows were once 6″ gun emplacements, and on the cliff edge is a searchlight emplacement and generator house. Another searchlight post has fallen off the edge. The site

is similar to Soldier's Rock, St Ishmaels.

STANDING STONES. The LADY STONE (SN 008 387) stands in a field N of the main road, behind Mercury Garage. TY MEINI STONE (SM 996 376), also by the main road, W of the village.

# EAST WILLIAMSTON
1 m. SE of Jeffreyston

Small clustered village, a little spoilt by later C20 development.

ST ELIDYR. Small, narrow and plain. Nave and chancel only, under a single roof. Much restored in 1889. Simple wooden windows. Battlemented W bell-turret C16 or C17, crudely corbelled out. Wide openings with segmentally headed lintels. As at Cosheston, access to the belfry is from outside, via a flight of steps alongside the gable. Simple interior. Early photographs show a round-headed chancel arch, possibly of the C13. Early C13 FONT. Circular bowl, terminating in an octagon with the elaboration of pointed arches under the rim: unexpectedly large and all held together by an old iron band.

# EGLWYSWRW
On the Fishguard to Cardigan road. In the compact village, the SERJEANTS ARMS, a large coaching inn said to date from 1650, though the long whitewashed and bay-windowed front with slate pent roof looks C18. Site of a magistrates sessions, the court house added on the E end in the C19. Mid-C19 whitewashed stable block opposite, and early C19 coach-house adjoining. Behind, the YOUNG FARMERS' CLUB was an early C19 chapel with one Gothick central window and a hipped roof. Could this be the 'church chapel' of 1800 built for reformed services, like those at Nevern and Newport (q.v.) for G. Bowen of Llwyngwair, Nevern. E of the church, CORLLAN, a small lofted stone cottage, is dated 1726. At the W edge of the village, on an outcrop N of the main road, a Norman RINGWORK CASTLE, steeply embanked to the W and S.

ST CHRISTIOLUS. Almost all of 1881–3 by *Middleton & Son*, keeping the walls of the church of 1829. For £650 Middleton achieved a nave and chancel with big W rose window, W bell-cote, and timbered S porch. Bath stone is supplanted wherever possible by dressings in sandstone, perhaps Pwntan from Cardiganshire. Lean-to W vestry with stepped parapet and imitation stone dressings, 1930. In the porch, two broken bits of C15 tracery. Inside, the roofs are the best feature: five-sided rafter roof in the nave, ribbed and panelled in the chancel. Heavy corbelled chancel arch. – Plain medieval square FONT, possibly C14. – Conventional timber PULPIT, STALLS and READING DESK. Iron and brass ALTAR RAILS with tiny metal leaves.

BERLLAN, 1½ m. NW. Three-storey, hipped square house,

probably rebuilt *c.* 1820 by *David Evans* for the Rev. David Griffith, vicar of Nevern. Three understated roughcast three-bay façades, the principal one marked by a fanlight and consoled doorcase, an exceptional rarity.

COURT, 1 m. NNW. Moated site w of the present farmyard. The medieval manor house of Eglwyswrw, held by the Cantington family from 1199 through the medieval period. The house was ruinous by 1594.

# FELINDRE FARCHOG
## Nevern

Roadside village in the Nevern valley.

CANA INDEPENDENT CHAPEL. 1856–7. Stone gable front of a North Pembrokeshire type associated with *Joshua Morris* of Newport. Two long arched windows with Gothick glazing bars. Gable altered. Inside, box pews and panel-fronted galleries on marbled timber columns. Opposite is YR HEN GAPEL, 1810, the original chapel, altered inside as a schoolroom. Low cottage-like façade, three sash windows, the centre one set higher for the pulpit, and two outer doors.

COLLEGE. Dated 1852, a manorial courthouse for the barony of Cemaes, built for Sir Thomas Lloyd of Bronwydd as part of his enthusiasm for things medieval. Probably by *R. K. Penson* (cf. Bronwydd, Llangynllo, Cered. and Newport Castle). Tudor Gothic with steep gable of the courtroom to the l. of the entrance tower, and cottage to the r. On the tower, a datestone of 1624 from the schoolroom on the site built for the historian George Owen of Henllys. The courtroom has banded slates and two reset (upside-down) C17 ashlar mullion-and-transom windows.

Opposite, a circular C19 cattle POUND and a pair of plain estate cottages of *c.* 1860. Just N, the overgrown remains of a small, early C19 Gothic LODGE to Cwmgloyne (*see* below).

PARC YR EFAIL. A small housing scheme of 1998 by *Harold Metcalfe Partnership* of Carmarthen, with sash windows in the local vernacular, well-mannered and well-grouped. Roughcast over timber frame; the chimneys are dummy, but welcome.

CWMGLOYNE, ½ m. NE, a C17 gentry house of the Lloyd family, had a three-sided court, now reduced to an L-plan farmhouse and outbuildings. C18 closed-string staircase.

HENLLYS, ½ m. ENE was the C16 house of the historian George Owen; the foundations of the original house have been uncovered to the E of the present house of *c.* 1850.

Castell Henllys and Meline church. *See* Meline.

# FISHGUARD/ABERGWAUN

Fishguard town is on a clifftop. The old harbour, now Lower Fishguard, or Lower Town, is to the E at the mouth of the Gwaun. The more recent Fishguard Harbour is at Goodwick, to the W (q.v.). The name is Norse, and there was a coastal port in the

Middle Ages, but nothing remains. In the later C18 Lieutenant Samuel Fenton developed the herring-fishing industry that really created the town. The fish then called herring were sardine and appeared in huge shoals in the Irish Sea for some fifty years. Fishguard became the third largest town in the county, but the shoals vanished about 1790, never to return. Richard Fenton, the Pembrokeshire historian and Samuel's nephew, built his country house in the Gwaun valley behind the port. But Lower Fishguard was mostly cottages, the larger houses being in the upper town.

ST MARY. Rebuilt 1855–7 to the designs of an amateur, *Thomas Clark* of the wealthy Wiltshire clothier family from Trowbridge who offered his services free in 1847 to an impoverished parish. Far from Ecclesiological, this is an engineer's building wearing Romanesque detail uncertainly. A broad nave, apsed chancel and apsed SE vestry, with minimal round-arched detail, the dressings in yellow terracotta chosen for economy and (mistakenly, it seems) suitability to coastal air. The W doorway alone shows some elaboration.

Inside, a single broad nave spanning 40 ft, with deep arch-braced trusses carried down low on corbels. Paired windows are gathered in Gothic arches, and the chancel arch is also Gothic, though the apse windows have Norman column-shafts. Old-fashioned big W gallery. In the N wall, a tiny two-light medieval window, salvaged, it is said, from a lost medieval chapel of Llanfartin, near Fishguard. – SCREEN and STALLS. 1919. – STAINED GLASS. Much of the 1920s, conventional in style with gloomy colouring. – Nave S second and third by *R.J. Newbery*, 1920 and 1921, and possibly nave N fifth, *c.* 1925, and NW 1930. – Nave N third and fourth by *Powell*, 1920. – Three chancel windows by *Burlison & Grylls*, 1921, decent but dull. *Celtic Studios*, nave N second, 1954, and S fourth, and the roundel in the porch, 1970. – Real vigour comes in the dramatic scarlet of *John Petts'* E window, 1986, 'I am with you always', and in his triple W window, 1989, 'Peace, be still', in swirling blues, the movement all in the leading.

In the churchyard to the NW, an INCISED STONE oddly mixing Celtic and Gothic forms. Roughly incised Latin cross, with trilobe ends, randomly surrounded by small knotwork patterns. Also an inscription, 'David Medd', who was vicar in 1535. On the r. edge, in the rounded lettering of the front, apparently IHC XPC AN DI MDI or 'Jesus Christ Anno Domini 1501'. On the l. edge, a more conventionally Gothic inscription DNE MISERERE DD ME.

HOLY NAME (R.C.), West Street. 1916. Whitewashed roughcast, almost styleless, a big roundel over three arched windows. Open roof trusses and a S transept with organ gallery. Stone-columned altar and rails. – STAINED GLASS. In the nave N, two mid-C20 windows, one signed *Clarke*, of Dublin. – In the E end, a fine roundel of *c.* 1970 with Christ figure in rich reds and blues.

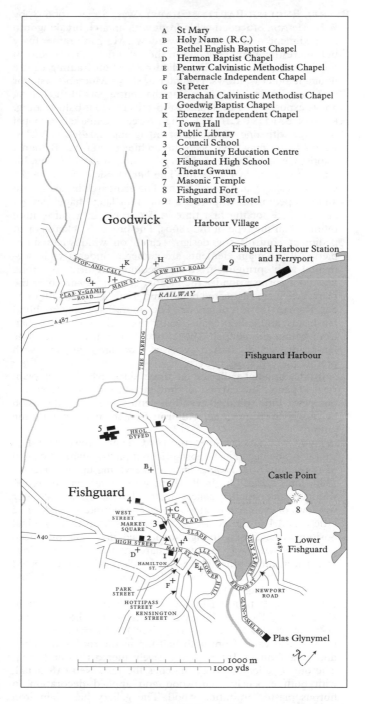

A    St Mary
B    Holy Name (R.C.)
C    Bethel English Baptist Chapel
D    Hermon Baptist Chapel
E    Pentwr Calvinistic Methodist Chapel
F    Tabernacle Independent Chapel
G    St Peter
H    Berachah Calvinistic Methodist Chapel
J    Goedwig Baptist Chapel
K    Ebenezer Independent Chapel
1    Town Hall
2    Public Library
3    Council School
4    Community Education Centre
5    Fishguard High School
6    Theatr Gwaun
7    Masonic Temple
8    Fishguard Fort
9    Fishguard Bay Hotel

Goodwick

Harbour Village

Fishguard Harbour Station and Ferryport

STOP-AND-CALL

NEW HILL ROAD

QUAY ROAD

PLAS-Y-GAMIL ROAD

MAIN ST.

RAILWAY

A 487

"THE PARROG"

Fishguard Harbour

HEOL DYFED

Castle Point

Fishguard

WEST STREET

MARKET SQUARE

PENSLADE

SLADE

A 40

HIGH STREET

MAIN ST.

MILL TER.

LOWER HILL

QUAY STREET

A 487

Lower Fishguard

HAMILTON ST.

PARK STREET

HOTTIPASS STREET

KENSINGTON STREET

LOWER BRIDGE ST.

NEWPORT ROAD

GLYN-Y-MEL RD.

Plas Glynymel

1000 m
1000 yds

Fishguard and Goodwick

BETHEL ENGLISH BAPTIST CHAPEL, West Street. 1906–8, by
*J. H. Morgan*. Stuccoed gable front with an arch breaking into
the pediment, over two arched windows. Morgan's rather fussy
but interesting manner shows in the extra detail: recessions in
the vertical plane, and channelled rustication framing centre
door and outer windows. The interior shows Morgan's taste for
more longitudinal élan in raising the centre part of the ceiling
above exposed trusses. Gallery top-rails of squat balustrading.

HERMON BAPTIST CHAPEL, High Street. Remarkable chapel
of 1832, with one of the most intriguing façades in Wales.
*Daniel Evans* may have been the architect – (cf. his Bethania
Baptist Chapel, Cardigan, of 1847) – though *David Evans*, his
father, practised in Fishguard. The late classical vigour to the
design speaks of an original talent. The giant arch breaking into
an open pediment, so potent a model for later chapel design,
appears here for the first time in Wales, but in a guise more
refined than the type of the 1860s. The broad, bracketed open
pediment controls the design, seated on windowless outer
piers. All the main elements are gathered under a wide seg-
mental arch springing from the pediment returns. A strong
first-floor cornice divides the façade, broken forward over the
piers, which are rusticated below, and frame a loggia with four-
bay Roman Doric colonnade. The doors have elegant blind
fan-heads, and gallery stairs neatly rise each end, rather than
from within the chapel. Above, two windows with the same
fan-heads, set in arched recesses, and an oval vent with
prettily pierced cross pattern.

Inside, original galleries on three sides, panelled in plain
vertical panels and carried on timber columns raised above the
box pews. Fine spiralled acanthus centre rose. Extended 1906
by *George Morgan & Son*, with iron-fronted gallery behind the
pulpit.

PENTWR CALVINISTIC METHODIST CHAPEL, Tower Hill. The
lateral façade began as a substantial but plain roughcast chapel
of 1824, but *D. E. Thomas* livened everything up in stucco in
1889, for £1,200. Originally there were larger centre arched
windows and smaller gallery lights. Thomas made all four
windows of even size to give a more concentrated façade. The
little roundel in the centre and the doors keep their original
positions, the doors, though, concealed in a pair of stucco
porches linked by a veranda. Square interior, all the fittings
of 1889, in pitch pine. Three-sided gallery with long pierced
cast-iron panels, and pulpit with arched panels and balus-
trading each side.

TABERNACLE INDEPENDENT CHAPEL, Park Street. Built in
1844–5, for £800, possibly by *Daniel Evans* (see the blank fans
over the windows, cf. Hermon, above). Otherwise, this is a
plain, broad gable front with half-hip to the roof and arched
door with fanlight. Interior expensively altered 1915 and 1924.
The organ gallery of 1924 matches the rest. Neo-C18 detail,
with both expensive hardwood and applied decoration in
fibrous plaster, imitating wood. The gallery has plain iron

columns, mid-to-later C19, but what date is the shallow curved centre? Coved ceiling of 1845 with pretty plaster rose, by *Thomas Rees*, plaster ornate fluting to the cove of 1924. Fine pulpit, half-round with six columns; pews with classicizing bench-ends, both early C20.

TOWN HALL, Market Square. Plain early C19, two-storey rough-cast, of 2+1+2 bays with pediment, hipped roof and timber lantern. Altered 1950, when ground-floor shops were replaced by windows and a pedimented entrance. Late C19 or early C20 covered hall behind, with a painted board of 1836 listing market tolls. Two iron columns within the ground floor, pre-sumably an open market originally. Long, open rear courtyard with remnants of lean-to roofs for market stalls.

PUBLIC LIBRARY, High Street. Behind a stone outbuilding, an economical flat-roofed library of the 1970s. The outbuilding became the entrance lobby, and the side wall has been treated in the manner of H. H. Richardson, rendered above a stone base. The giant round arch of the entry has a Romanesque solidity, despite not resting on a column or pier, and is bal-anced by just a single narrow, arched window with exposed jambs and exaggerated radiating voussoirs in cement. – STAINED GLASS. Small fish-like panel by *Amber Hiscott* of Swansea, 1992.

COUNCIL SCHOOL, West Street. 1907–8, by *D. E. Thomas* of Haverfordwest. Gable-fronted stucco block with squared-off detail and Arts and Crafts lettering.

COMMUNITY EDUCATION CENTRE, Lota Park. The former County School of 1902, by *L. Bankes Price* of Lampeter. Plain stuccoed front between gables (cf. County School Aberaeron, Cered.).

FISHGUARD HIGH SCHOOL / YSGOL UWCHRADD ABER-GWAUN, Heol Dyfed. 1954, by *Lt.-Col. Walter Barrett*, County Architect. On a bleak hilltop site, a bleak group of red brick flat-roofed buildings with curtain glazing, strung together informally, without cohesion. Long, two-storey spine block of classrooms; corridor blocks across each end with spurs off. The hall runs forward from the r. side of the front range, with big brick stage tower dominating a mean entrance façade. Joyless interiors.

THEATR GWAUN, West Street. Former Temperance Hall of 1881, plain, stuccoed. Cinema from 1926, refitted as a theatre in 1994.

MASONIC TEMPLE, West Street. 1924–5, by *H. J. P. Thomas* of Haverfordwest. Chapel-like stucco front with a large Edwardian lunette window.

FISHGUARD FORT. On Castle Point, the promontory NE of the Lower Town. Built 1781–5 as a gun battery after the town had been bombarded by an American–French privateer in 1779. The Master-General of Ordnance agreed unwillingly to provide eight guns if the inhabitants would build the platforms and storehouses, and furnish the powder. Fan-shaped

platform, with ditch in front and wall behind. Not manned until 1794, when three invalid artillerymen were sent to train local volunteers. There were only three rounds of ammunition and some blanks when Colonel Tate's three French ships entered the harbour on 22 February 1797 – just enough, fortunately, to persuade the cautious Tate to land elsewhere, at Carreg Wastad, Llanwnda. With matching courage, the defenders were ordered to spike the guns at  the fort and abandon the town, but the invasion force was overcome before the order could be carried out. The Reverend J. T. Williams wrote to the Secretary at War on 3 March: 'for God's sake, if you choose to let the fort stand, take away the Cannon which can never be of any service to us, but may be cursedly mischievous in the hands of the Enemy'. Abandoned after 1815. The two brick-vaulted chambers that remain were part of the storehouse and garrison room.

PERAMBULATION

The centre of the town is the triangular MARKET SQUARE in front of the Town Hall (q.v.). Mixed stuccoed façades of the C19, perhaps fronting older buildings. Two C18 inns whitewashed, now stripped back to stone. The ROYAL OAK, of three bays, has upper windows breaking into the roof. The similar FARMERS ARMS, has a large kitchen chimney of farmhouse type. BARCLAYS BANK is late C19 stucco with cornice and parapet. Opposite some three-storey earlier C19 buildings and No. 20, BOOTS, with a semicircular lunette in a pediment. From here, three roads lead out: Main Street, going E towards the lower town and Cardigan, High Street, S towards Haverfordwest, and West Street, W towards Goodwick.

In MAIN STREET, on the N side, the parish church (see above), followed by No. 1, a late C19 draper's shop, and then Nos. 3 and 5, the most urbane pair in the town, of about 1800. Three storeys, No. 3 with handsome rusticated stucco front and a very individual open-pedimented Ionic doorcase, the capitals wiry as if of wrought iron. No. 5 is lower, with the upper floor an attic, and a more conventional Ionic doorcase. No. 7, COMPTON HOUSE, drops to two storeys, stuccoed, three bays, with nice eight-panel door and fanlight. A plaque of 1823 on the rear. Inside, triple-arched screen between front and back on raised timber columns. Nos. 9 and 11 are three-storey again, No. 9 with parapet, much altered, No. 11 with nogged brick cornice, early C19. On the S side, E of Hamilton Street, the three-storey Nos. 16–18, two-storey thereafter. No. 23, SAIL COTTAGE, is older, rubble stone with small windows and a top floor sail maker's loft, dated 1786 on a roof truss. Main Street is continued E along the crest as TOWER HILL, with HILL TERRACE at r. angles above the steep descent to Lower Fishguard. On Tower Hill, opposite Pentwr Chapel (see above), TOWERSIDE, TOWER HOUSE and PENTOWER, originally one house, remodelled and extended by *Sir Evan Davies Jones*,

engineer, to his own designs in 1909. Partly pebbledashed, with three conical-roofed turrets, the extension rendered. – On the other side ARDWYN, three-bay mid-C19, with eroded wrought-iron railings, and COURT HOUSE, early to mid-C19, the door with elliptical fanlight in the side wall.

HAMILTON STREET runs s off Main Street. On the E, Nos. 11–13, mid-C19, four-bay, stuccoed, with paired doors in a nice stucco corniced doorcase. Further up, the former NATIONAL SCHOOL, a prominent stone Gothic building dated 1886, across an alley from the school-teacher's house of 1857, much altered. Behind is the original school of 1857, a stone range with eccentric detail; see the brick chimneys and the odd heads to the paired arched windows. Opposite, at the entrance to PARCYSHWT car park, a mid- to later C19 stone WAREHOUSE. Off Hamilton Street, PARK STREET, with the Tabernacle Chapel (q.v.) on the r., and early to mid-C19 houses opposite. In KENSINGTON STREET and HOTTIPASS STREET, smaller C19 stuccoed terrace houses.

Returning to the MARKET SQUARE, HIGH STREET starts narrow, with altered three-storey, early C19 houses on the l. Above Hermon Chapel (q.v.), a single-storey cottage, now ST JOHN'S NURSING DIVISION, associated uncertainly with the original Baptist Chapel of 1776. Beyond, the street is two-storeyed. The best building is BENNETTS TAVERN, a wine-merchant's established in 1823, with a late Georgian shopfront of two small-paned bowed windows in a pilastered frame. Further up, the Library (q.v.). Among terraced houses on both sides No. 41 stands out, early C19, pink stucco, with pedimental centre gable, lunette window, and pedimented doorcase. Nos. 43–49 are an earlier C19 row – see the stone chimneys – but altered. Further up, on the r., LLYS MAIR, the former rectory, c. 1830, for the Rev. Samuel Fenton. Square, with pyramid roof and two-storey, three-bay front spoilt by concrete tiles and a ground-floor extension of the 1930s.

Returning again to the centre, WEST STREET curves away narrowly, with the stuccoed later C19 OLD POST OFFICE on the l. On the r., SEAWAYS BOOKSHOP, earlier C19, two-storey, and Nos. 5–7, a heavy double-gabled, mid-C19 house with columned porch. In THE SLADE, a lane running steeply down a cwm to the estuary edge, No. 1 a mid-C19 hipped-roofed cottage, then a later C19 terraced row. At the foot, two well-preserved LIMEKILNS. On the crest of the valley, PENSLADE has early C20 villas, one pair with cheerful little ogee domes. WEST STREET continues towards Goodwick. Plain terraces give way to late C19 gabled houses with oriel windows, nearly all altered. On the l., the R.C. church, then Heol Dyfed leading up to the High School, and on the r., Theatr Gwaun and the Masonic Temple (qq.v.), before the hairpin descent to Goodwick.

LOWER FISHGUARD is more picturesque than architecturally notable. The quay and houses are all on the E of the Gwaun. On the w, a mid-C19, four-storey stone WAREHOUSE with

hipped roof. Single-arched BRIDGE of 1875. BRIDGE STREET
and NEWPORT ROAD are traffic-clogged and narrow, with
early to mid-C19 two-storey houses. The most prominent, No.
1 GLYNYMEL ROAD, mid-C19, faces down Bridge Street with
sharp bargeboarded gables. THE QUAY was rebuilt by Samuel
Fenton in the 1780s. Long, curving stone quayside with small
two-storey houses. Just behind, a Gothic MISSION CHURCH
of the 1870s, now a house. Glynymel Road runs s up to Plas
Glynymel with more cottage houses. Behind GLANABER, on
the r., a small WOOLLEN MILL of 1875. Further down, on the
r., the former WORKSHOP WALES GALLERY, 1991–2, built
for the artist John Cleal, by *Alex Barry* of *Cedric Mitchell Archi-
tects*, Carmarthen. A neat design in vertically ribbed, stained
timber. Art gallery and house together, the gallery windows
carried up through the eaves. Well-managed interior with small
spaces created by axial walls, not in line, carried up full-height.
Facing down the lane, CLEALS, a pretty estate cottage of the
earlier C19, with Gothic windows and a bellcote, at the
entrance to Plas Glynymel. Beyond, the former WALLED
GARDEN, altered.

PLAS GLYNYMEL, house of Richard Fenton, the Pembrokeshire
historian, was built in 1799 as an Arcadian idyll in miniature.
Like Thomas Johnes of Hafod, Cered., Fenton was a Roman-
tic child of the Enlightenment, seeking to lay the gentle touch
of taste upon the savage beauty of wild places. Both justified
their enterprise as contributing to the relief of the local popu-
lation: in the case of Fishguard, those left destitute by the
failure of the fishing. The gorge of the Gwaun was ideally pic-
turesque, even if the site had to be created by blasting of the
rock-face, and the foundations taken down 30 to 50 ft to find
bedrock. The gardens were planted with exotic trees; Mexican
aloes, Himalayan bamboos, figs and oranges grew outside, and
Fenton grew one of the first Australian eucalyptus trees in
Wales. There was even wine made from grapes on terraces
above the house. No trace remains, though, of the green-
houses and hot houses, nor does the small indentation in the
rock-face quite match the hermit's cave of contemporary
description.

The house may well have been designed by Fenton and is
amateur by comparison with the precisely contemporary
houses of John Nash. Now of rubble stone, but originally
roughcast or stuccoed. Three-bay front of exceptional height,
because the basement service rooms are at ground level, with
three storeys above. Deep-eaved hipped roof with Greek
cornice in timber. Double stone stair, with delicate wrought-
iron rail up to the front door, in a columned porch with pilaster
responds. Above, a simplified Venetian window, and then a big,
oval attic light, with plain sashes to the sides. The entrance hall
has a columned screen in front of the stair, which looks as if
it was designed to rise in two flights although the r.-hand flight
is absent. Oddly rustic stair rail; possibly the double rise never

existed. An axial passage links broad, elliptical-arched double
doorways, that to the N with two doors to dining room and
study, that to the S with double door to a single long drawing
room. Only the dining room has plasterwork of any elabora-
tion, a leaf cornice and a nice shallow-curved recess on the N
wall. S room altered, probably after 1905.

## FORD *see* WOLFSCASTLE

## FRESHWATER EAST
1½ m. S of Lamphey                                                    *0198*

An impressive S-facing sweep of golden sands backed by exten-
sive dunes, which were developed from the 1890s by tourists and
local town shopkeepers for holiday chalets. Most have been
altered or replaced by the more ubiquitous bungalow. Intact
survivals include WAVECREST, timber-framed and clad in cor-
rugated iron, with ornamental bargeboards. The date appears to
be of *c.* 1920.

PORTCLEW, ¼ m. NW. Stuccoed, three storeys and bays,
    described as the modern house of Lewis Parry in Lewis's,
    *Topographical Dictionary*, 1833; the stable range is dated 1827.
    But the entrance front conceals the early C18 front of a pre-
    vious five-bay house. The early C19 remodelling enlarged
    the rear, forming a double pile, under a generously eaved
    hipped roof. Large semi-octagonal porch. Pair of WALLED
    GARDENS. *William Owen's* involvement is likely.
PORTCLEW CHAPEL, ¾ m. E. Very ruined and overgrown remains
    of a small medieval chapel.

## FREYSTROP

Barely a village at all, just a scattering of houses along the road.   *9611*

ST JUSTINIAN. Set in a deep secluded hollow. Rebuilt 1874 by
    *E. H. Lingen Barker*, preserving only a crude squint passage.
    Nave, chancel, N transept and S porch. The FONT is Norman,
    the square bowl scalloped underneath: circular pedestal with
    the unusual addition of an extra detached shaft in each corner.
    Bath stone REREDOS with inset coloured tiles, of 1874, as are
    the FURNISHINGS. – MONUMENTS. Caesar Mathias †1762.
    Pediment breaking over the tablet. – Alice Mathias †1802. Side
    scrolls and urn. By *Tyley* of Bristol.
BLACKFRIARS. Former rectory. 1907, by *H.J.P. Thomas*.
    Rendered, hipped roof and bay window.
CLARESTON. 1m. SW. Mid-C18 three bay double pile house of
    the Roch family (a freestanding stone in the garden is dated
    'G. R. 1755'), much altered and enlarged. The former entrance
    front was rebuilt *c.* 1830 to create a very showy S garden front
    under a balustraded parapet, conspicuous upon approach.
    Clearly the work of *William Owen*. As built, two generous

single-storey bows supported semicircular balconies, ornately iron-fronted and topped with splendid ogee half-domes with ribs terminating in coronet-like finials. The bows remain, but the shades of Brighton Pavilion have gone. Owen also put a single-storey extension against the gable-end to form an entrance front, dominated by a large Doric porch with wreathed entablature. Owen's interior shows ingenuity and drama. Access to the new rooms is via a tiny centrally-placed semicircular vestibule, half-domed above; mahogany doors curved at an almost impossible angle. The stair, straight ahead, is of Cotswold stone, sweeping tightly around each turn up to attic level, with iron S-shaped balustrading: above, a shallow compartmented dome, just as at Hillborough House, Haverfordwest (p. 222). Further alterations to the rear, perhaps Owen's, and beyond, a fine front range to the farmyard, clearly by Owen, the central carriage arch flanked by two blind arches beneath a pediment with clock, and an octagonal ogee-topped bell turret above. The drive meets the road through wrought-iron gates (no doubt by *Marychurch* of Haverfordwest), once part of a gracious segmental screen, now half-missing.

# GLANDWR
### Llanfyrnach

*1928*

Village in the upper Taf valley.

GLANDWR INDEPENDENT CHAPEL. A substantial chapel of 1836, with long-wall front and typical half-hipped roof, but stuccoed and remodelled in 1876, by *John Humphrey* of Morriston. Of 1876, the two heavy stone porches and the Florentine window tracery. The broad, almost square, interior has a gallery typical of Humphrey, with fretted detail and band of continuous pierced ironwork. Pews laid out to a continuous curve.

In the graveyard, an INSCRIBED STONE with Celtic cross.

# GLANRHYD
### Llantood

*1442*

A small cluster of houses between Llantood and Nevern, with chapel and an altered SCHOOL of 1879.

GLANRHYD CALVINISTIC METHODIST CHAPEL. Set back in a railed forecourt. Dated 1870, gable treated as an open pediment (cf. Pontyglasier). Brown stone banded in grey Cilgerran slate, the colours alternated over the arched openings. Long arched windows and a small centre pair. Inside, three-sided panelled gallery on turned wooden columns with bases raised above the pews, which suggest *Joshua Morris* of Newport as designer.

# GOODWICK/WDIG

Goodwick was just a few cottages on the slope above the marsh p. 187 before the coming of the railway. The North Pembrokeshire and Fishguard Railway, an extension of the line that had been built to serve the slate quarries at Rosebush, arrived in 1895. Financially exhausted, it was taken over by the Great Western Railway, which built a shorter new line from Clarbeston Road in 1899.

St Peter. 1910–11, by *E. M. Bruce Vaughan* of Cardiff. A church of some sophistication and unusual expense, £6,400, well set on the hillside with dominant SE tower. Rock-faced, coursed grey-brown stone said to come from Ireland, with limestone dressings. The detail is late Gothic, after Bodley, with the main decorative elements the big seven-light E window and the top stage of the sheer tower, with panelling around the bell-lights. The W end was never completed. Inside, ribbed boarded roofs and S arcade with dying mouldings, the Bath stone painted over. – Elaborate SEDILIA and PISCINA. – The wood and stone carving is by *W. Clarke* of Llandaff, including FONT, PULPIT and STALLS. – REREDOS and PANELLING, 1947, by *E.A. Roiser* of Cheltenham. – STAINED GLASS. Dull E window by *C. C. Powell*, *c.* 1930. – One N window of *c.* 1924 by *R. J. Newbery*.

Berachah Calvinistic Methodist Chapel, New Hill. 1906–7 by the *Rev. William Jones* of Ton Pentre, Glamorgan. Elaborate pedimented winged front with grey ashlar dressings. The Venetian window above the door with roundel each side shows some originality, but the whole is somewhat fussy. It cost £1,700. Inside, the gallery on three sides with long panels and canted angles.

Goedwig Baptist Chapel, Main Street. 1870–3. Plain stone gable front.

Ebenezer Independent Chapel, Stop-and-Call. 1929 by *T. G. Price* of Llandeilo. Pink stucco, mildly Gothic.

## FISHGUARD HARBOUR

Begun in 1893 by the Fishguard and Rosslare Railways and Harbours Co. to compete with the Great Western Railway Irish ferry terminus at Neyland. The project was taken over by the G.W.R. in 1899. The promoters hoped not only to win the Irish traffic, but also to wrest the Atlantic passenger trade from Liverpool. But Cunard liners stopped at Fishguard only from 1909 to 1914. The works began under *J. T. Mann*, 1893–9, and were completed by 1906, under *J. C. Inglis*, G.W.R. chief engineer. The cost was over £500,000. A platform had to be blasted out of the sheer cliffs for the quay, and a 2,500 ft breakwater built out into the bay. The terminus was four railway platforms under a twenty-one-bay steel and timber roof, which survives, though with only one platform in use. At the N end, MARINE

OFFICES, with typical late C19 G.W.R. detail. There were extensive covered cattle pens w of the station for the Irish cattle trade, and two stone marine workshops to the N. The modern ferry port added glass and metal structures with gull-wing roofs, 1992.

<center>PERAMBULATION</center>

The village is terraced on the hillside w of the railway line. s of the railway bridge is the disused clapboard STATION of 1895. ROSSLYN just above the bridge is a charming clapboard house built as a railway engineer's office *c.* 1899. Five bays and two storeys, with first-floor entrance. On Quay Road, running N, the corrugated-iron GOODWICK INSTITUTE, built as the Working Men's Club, *c.* 1900. After some late C19 villas, notably PENRHYN, the FISHGUARD BAY HOTEL, the largest hotel in the region, indicative of early C20 aspirations. Part of an earlier C18 house may be incorporated in the many-gabled N range opened as a hotel in 1887. The massive main range was added 1900–10, by *Jenkinson & White* of London, elephantine, painted stucco, four storeys, with taller entrance tower across the SE angle, and an iron two-storey balcony on the s front. The best rooms are in the early C20 part: a big stone staircase up from the hall, with wrought-iron rails, and lounge and billiard room in sequence facing s, with hardwood curved pedimented overmantels and dado panelling. The grounds were laid out over several acres of cliff by *Treseders* of Truro.

NEW HILL ROAD runs past Berachah Chapel up to the HARBOUR VILLAGE, 112 houses on the cliff top built for harbour employees by the G.W.R., 1902–8, to designs of their resident engineer, *G. L. Gibson*. The bleak and windswept site was described as 'probably one of the most salubrious spots to be found anywhere'. There were thirteen different designs, in the roughcast vernacular mode of the Garden Village movement. Not a house in the village is in original condition, demonstrating how much damage cumulative alteration can do. Below the road, just before the village, Neo-Georgian hipped-roofed ships' officers' houses. A lane runs w up to PENRHIW, a four-square, mid-C19 farmhouse with two parallel half-hipped roofs and two-bay front clad in colour-washed slates.

Returning to the centre, MAIN STREET runs s. Late C19 or early C20 shops with oriel windows to the upper floors. The LIBRARY was the Sessions House, of 1911 by *Arthur Thomas*, roughcast and gabled, free Arts and Crafts style. Upstairs, former courtroom with arch-braced roof trusses. Further on, the parish church (*see* above), in Plas y Gamil Road, and a HOUSING ESTATE in ST DAVID'S ROAD, of *c.* 1908 for the Great Western Railway, small groups at r. angles to the road, with steep, red-tiled hipped roofs and oriels under the eaves. Well handled, though the walls are of concrete block imitating

rock-faced stone. DYFFRYN, at the end of the road, was
recorded from the early C17, but what remains is externally
earlier C19, two-storeyed and modest. Below the railway, on the
main road, RAILWAY TERRACE, a row of nine cottages with
dormer gables, presumably post 1895, though they look earlier.
Further out, in the valley to the l. of the main road, THE DRIM,
earlier C19, three bays, outshut rear and miniature rear court
of outhouses, one side with brick arches. In the grounds, an
early C19 COACH HOUSE and STABLE, and ruinous older build-
ings, including a former house with massive chimney, perhaps
late C17.

THE PARROG, the Goodwick foreshore, where the French
invasion force surrendered to Lord Cawdor in spring 1797, was
landscaped in 1994–5, and a VISITOR CENTRE and SAIL
TRAINING CENTRE were built in 1996–7, by *Tim Colquhoun*
of *Preseli Pembrokeshire District Council*. A broad stone-clad
cylinder, like a Scots *broch*. Toplit exhibition space, linked
by a turf-roofed passage to a low, curving glass-fronted visitor
centre, with curved roof. The sail training centre is similar.
Both have echoes of the visitor centre at Castell Henllys,
Meline (q.v.), without the subtlety of that design. At the E end
of the Parrog, small colourwashed COTTAGES, a reminder of
the pre-railway era.

GARN WEN BURIAL CHAMBERS (SM 948 390), behind Harbour
village, three cromlechs in line with massive capstones and very
low sidestones.

# GRANSTON/TREOPERT

The church sits well in a rectangular churchyard surrounded
by trees above the road. Nearby, GRANSTON HALL, mid-C19,
hipped, with unusual paired sashes to the four-bay E front, and
tripartite narrow sashes to the N entrance front. To the S, the
parish rolls down to the Western Cleddau at Llangloffan. To the
NW, a narrow wooded valley runs down to the sea at ABERBACH.
On the footpath, GARN BARCHUD and ABERBACH COTTAGE,
good examples of the single-storey whitewashed stone cottages
of the area, with massive chimney-breast and half-lofted interior,
probably early C19. Behind the beach, an earlier C19 LIMEKILN.
Aberbach and the larger beach at ABERMAWR to the S were
chosen by *I. K. Brunel* as the port for ferries to Ireland at the end
of his Great Western Railway, after he had been denied Fishguard
by the Navy. Work began 1848–51, but all was abandoned in
favour of pushing the line S from Clunderwen to Neyland. The
cottage N of the beach was the telegraph hut for the submarine
telegraph to Ireland of 1883.

ST CATHERINE. Rebuilt in 1877–8 by *E. H. Lingen Barker*. Nave,
chancel, N transept and N porch, W bellcote. Dec tracery and
bi-colour voussoirs. Rebuilt squint. Simple plastered interior
with open-back pews. – FONT. C14, plain octagonal. – MONU-

MENT. Slate plaque to Henry John of Llangloffan †1745.

TREGWYNT, ½ m. NW. One of the oldest north Pembrokeshire
house sites, recorded from the C14, and owned by the Harries
family for some six centuries – apart from a break in the
mid C19 – until 1986. A plain two-storey house in roughcast
coloured yellow ochre. Earlier C18, six-window E entrance front
with narrow sashes (cf. Priskilly Forest, Mathry). Late C18 or
early C19 rear range on the site of an earlier stair-tower. Across
the N end, a big plain, late C18 ballroom, hipped, with five long
windows raised over a low basement. Here Mrs Harries enter-
tained the local gentry on the night of the French invasion, 22
February 1797. Inside, the front range has low rooms and an
oak roof, the rear roof is pine. On each floor fluted arches with
keystones, originally to the rear stair. The present stair hall is
to the r., early C19 detail. The stair itself seems a hybrid, with
thick ramped rail earlier than the close-spaced square balus-
ters. To r. of entrance gates, former HOUND KENNELS,
ruinous but to an early C19 model design.

TREGWYNT MILL, ¼ m. N. Hipped and whitewashed corn mill,
dated 1819 on a roof truss, converted to a woollenmill in the
later C19, and still in use. Unusually, the water wheel is within
the building (cf. Castle Mill, Newport).

See also Llangloffan.

## GRASSHOLM ISLAND

5909    Uninhabited and scarcely visited, and best known as a bird
sanctuary, this small island lies 11 m. or so W of the Marloes
peninsula. On the W side, traces of a former settlement in the
form of low footings.

## GUMFRESTON
1001            1½ m. W of Tenby

The houses surrounding the church shown in an early C19 water-
colour by Charles Norris have disappeared, except for the ruin
of a cottage with a large gable chimney to the W, described as
'ancient' when used as a school in 1845.

ST LAWRENCE. Highly picturesque, in a sloping wooded site, an
essential sightseeing trip for all Victorian visitors to Tenby.
Mellow fabric of complex history. Nave, chancel with S chapel,
W porch and tall, tapering late C15 or C16 tower uphill on the
N side, its barrel-vaulted lower chamber used as a chapel. On
the N side of the nave, an odd little semicircular projection,
most probably to house a lost tomb. Plain, slightly pointed
chancel arch with imposts, possibly C13. In the chancel,
fragmentary Dec PISCINA. The tiny S chapel, late C14 or C15,
unusually, has a vault with crude diagonal ribs. Square window
with trefoiled lights. The porch has a pointed rubble vault
(perhaps intended to form the base of a tower), a wide octago-

nal STOUP, and a plain niche above the inner door. The tower vault is of ashlar, perhaps later than the porch. In the tower chapel a four-centred altar recess and lamp corbel. C16/C17 mullioned windows in the nave. Careful restoration in 1869 by *T. G. Jackson*, an early work in his career. Jackson buttressed the leaning s wall and added the roofs, the attractive nave roof with arch-braces and crown-posts. – FONT. Medieval square bowl with chamfered corners; base with waterholding mouldings of *c.* 1200. – Oak FURNISHINGS by *Jackson*, the PULPIT with cusped open panels and Caen stone base. – WALL PAINTING. Very faint traces of a medieval saint on the N wall of the nave, possibly St Lawrence with his grid-iron. – Decorative GLASS in the chancel of 1869, by *Powell & Sons*. – MONUMENTS. John Williams †1693. Large floor slab with marginal inscription and worn incised work. – Henry Williams †1696. Similar, but with shield in relief. – Edwards family, 1809. Good lettering. – Late C19 BRASS to the Hall family.

Outside, to the N, the shaft of the CHURCHYARD CROSS and, to the S, steps lead to the HOLY WELLS, a meeting of three springs, two of them chalybeate. Their existence suggests that the site is ancient.

OLD RECTORY, to the E. Almost as large as the church. Stuccoed, with half-hipped roofs, the windows hoodmoulded. 1873 by *W. Newton Dunn* of London and Tenby.

GUMFRESTON FARM, 300 yds N. Large, rendered four-bay farmhouse with tall gabled porch. A sketch of 1822 shows mullioned windows and a broad tapering gable chimney.

# HAKIN
## Milford Haven

Older than Milford, Hakin was a cluster of cottages on the W bank of Hubberston Pill, mostly cleared for the docks in the late C19. The crest of the hill was built up from *c.* 1900, with larger villas overlooking the sea, and expanded in the mid-C20, to join Hubberston. WESTAWAY, No. 21 Westaway Drive, of 1904, is a pretty Arts and Crafts house in white roughcast with a play of slate-hung gables and small-paned sashes.

HAKIN WESLEYAN CHAPEL, on the hill above the port. Stuccoed and hipped, first built *c.* 1803–5, remodelled later and in 1900. Early/mid-C19 rear gallery with big fielded panels.

REHOBOTH CALVINISTIC METHODIST CHAPEL, Hill Street. 1840, roughcast gable front with an outsize stucco circular plaque. Plain ungalleried interior.

NATIONAL SCHOOL (former). Upper Hill Street. 1855–6, by *W. H. Lindsey*, angular Gothic with side bellcote. Altered in 1875 with larger windows.

THE DOCKS. *See* Milford, p. 292.

## HAROLDSTON ST ISSELS

*9614*

ST ISSEL. Delightful setting, on the bank of the Western Cleddau. Circular churchyard. Small and much restored. In ruins in the C16 when purchased by Sir John Perrot. Rebuilt in the late C17, the date of the walls and presumably the w bellcote. Much work in 1894 by *E. H. Lingen Barker*. – FONT. Square bowl, probably a retooling of the Norman one. – FURNISHINGS of 1894. – MONUMENT. Rev. David Allen †1855. Pediment.

FERN HILL, ¾ m. SE. Low C18 farmhouse with a grander three-bay block added in the 1820s, for Sir Henry Mathias. C19 WALLED GARDEN and remains of an ICE-HOUSE.

HAROLDSTON, ½ m. NW. On a commanding site, looking N-wards across the valley to Haverfordwest. Very ruined fragments of the expansive home of the influential Perrots from the late C13. A small tower-like house remains, possibly late medieval, with stair-turret surviving to third-floor level. Basement with flattened stone vault, garderobe above. Surrounded by walled enclosures. Between the two N courtyards the undercroft survives of a long range covered with a crude pointed barrel vault. Footings of a rectangular building near the road, possibly the gatehouse. In the late C16, Owen wrote that the place was 'ornamented with groves and otherwise boasted of every luxury and fashionable life'. The GARDENS must have been important. On the E side, an L-plan stone-revetted TERRACE, with steps at each end. On the w side remains of a SUNKEN GARDEN. To the N, a TERRACE, with more earthworks visible below. Sir Thomas Perrot was Gentleman of the Bedchamber to Henry VIII, his heir, Sir John, was Queen Elizabeth's Lord Deputy in Ireland and rebuilt the castles at Carew and Laugharne.

## HAROLDSTON WEST
1 m. N of Broad Haven

*8615*

ST MADOC OF FERNS. Small church, set in a secluded hollow with splendid coastal views. Almost completely rebuilt in 1883–5 by *E. H. Lingen Barker*, dull and carefully correct E.E., with Dec E and w windows, and N porch. Chancel arch on corbelled wall-posts. The building replaced a 'barnlike' old church of nave and chancel with big sash windows and a makeshift roof of salvaged ships' timbers, derelict by 1882. Earlier schemes for ambitious rebuilding by *K. W. Ladd* in 1868 were rejected by the Incorporated Church Building Society – FONT. Norman square bowl, scalloped underneath. – Poor REREDOS of 1899 with a towering canopy. – FURNISHINGS of 1883–5, including a fussy Bath stone PULPIT.

At UPPER LODGE, ¾ m. SSW, are two STANDING STONES, half buried in the hedgerow. A third is embedded in the hedge.

They all formed part of a Bronze Age STONE CIRCLE. HAROLD'S STONE, $\frac{1}{3}$ m. N, is probably associated. At BLACK POINT, $\frac{1}{2}$ m. W, an Iron Age PROMONTORY FORT.

# HASGUARD

8509

2 m. W of Walwyn's Castle

ST PETER. Next to a farm, set in a raised churchyard. Sadly derelict, the fittings removed. Red rubble sandstone walls, still preserving some pre-C19 lime render. Nave, chancel and S porch. Broad buttress-like W bellcote with twin arched openings and flat top, a local type (cf. e.g. Talbenny), probably C15 or C16. Plain rounded chancel arch, perhaps C13; the massive walls of the long nave also look early. Late medieval porch with pointed barrel vault and stone benches. Curious blocked doorway to the former rood loft, with a cinquefoiled head and big rose-like flowers crudely carved around the frame. Presumably a Perp insertion. Corbels of the former rood still in situ. The rest of the simple detail belongs to the restoration of 1874 by *D. E. Thomas* of Haverfordwest, when the chancel was rebuilt in rock-faced masonry. To be conserved as a ruin.

# HAVERFORDWEST/HWLLFFORDD

9515

p. 218

From at least the C16, Haverfordwest rather than Pembroke was regarded as the county town, conveniently located in the centre of the county at the highest navigable point of the Western Cleddau. Approaching from the E, the town rises from the river bank, dominated by the massive shell of the castle on its rocky knoll, and the towers of the three medieval parish churches all visible.

There is no evidence of pre-Norman settlement. The castle is first recorded *c.* 1110, founded by Tancred or Tancard, a Fleming. Henry I encouraged Flemish settlers to Pembrokeshire, Giraldus Cambrensis tells us, as a defence against 'unquiet Welshmen'. Evidence for the growth of the town is provided by a grant of six burgages to the nearby Commandery of Slebech, by Tancred's son Richard, 'a great and mighty man' according to Giraldus (who visited the town in 1188). A Sunday market and annual fair were granted in 1207 by Richard's son Robert, probable founder of the Augustinian priory, to which he gave the three town churches. No other town in Wales has three medieval parishes. The town was held by William Marshal and his sons, 1213–41, and prospered, despite a Welsh attack in 1220 by Llewelyn the Great, which 'burnt all the town up to the castle gate'. Surviving C13 deeds suggest a lively property market. By the mid-C13 the central area around St Mary's was fully developed and deeds refer to High Street, Dew Street and Goat Street. The guildhouse stood E of the church until demolished in the mid-C19.

Archaeological evidence suggests that the burgage plots of

Dew Street overlay field strips, the street formed from the head-land providing the main route from the market to the open fields at Portfield to the w. Other expanding areas included Bridge Street, connecting Castleton, the area around the castle, to the river crossing and the quays. A friary was established here before 1246 but moved E of Bridge Street after 1256. By 1324 it is esti-mated that there were up to 360 burgage plots, which by 1379 had increased to 422. But the plague of 1359 halved the popula-tion and as late as 1474 167 whole or parts of burgages were unoccupied. In 1479 a charter of incorporation established a mayor, sheriff, and two bailiffs; further administrative changes in 1500 helped to boost the economy.

A C13 murage grant indicates that some defences were built, but probably only Castleton had a stone wall, although gates existed for the outer areas (South Gate at the upper end of Market Street and West Gate at the lower end of Dew Street). Leland refers to a 'wallid town' and also to one of the churches lying 'without the towne in (the) suburbe'.

In the C16 Haverfordwest emerged as the pre-eminent town in Pembrokeshire with its own MP, and was described in 1577 as the 'best buylt, the most civill and quickest occupied town in South Wales'. The borough was granted its own court of great session and its unofficial status as county town was confirmed by its shire buildings: the county gaol received a charter in 1610, the county poorhouse was established in 1614, although the new Shire Hall did not come until 1835 and the guildhall remained out of repair until rebuilt c. 1760.

Many of the houses were stone-built by the late C15, as at Tenby, but late C19 photographs show a large number of fine timber jettied houses; a group on High Street is still intact (*see* p. 220).

In the C18 the town became an increasingly fashionable place for the local gentry. William Pitt the elder visited the town in 1736, but found the steepness of the streets a struggle: 'he liked the place because it had the appearance of trade, but said it was a devil of a town to walk in'. By 1748 an assembly room had been built, and a bowling green set up within the castle precinct. A new gaol was built at the castle, and a lavish new market hall was created in 1825 (now demolished). Among the more substantial new houses for the local gentry was Foley House in Goat Street, designed for Richard Foley by *John Nash*. But it was in the early C19 that major improvements were made, following the passing of the 1835 Municipal Reform Act. Municipal status accelerated a scheme for a grand new entry to the town including a new bridge. The development was promoted, part-financed and exe-cuted by the influential County Surveyor, *William Owen*. The new bridge was aligned with the foot of High Street, whose approach was flanked by the stuccoed three-storey terraces of Victoria Place. The Neoclassical Shire Hall (also by *Owen*) provided an appropriately civic note to the steeply sloping High Street. Many properties were remodelled or rebuilt within the old town, but

Haverfordwest, view of town from the east.
Engraving by Samuel Buck, 1740

despite C19 sash windows and stucco, thick walls and steep roofs indicate earlier fabric.

The decline of Haverfordwest as a port began with the arrival of the railway at Cartlett, just to the E of town, in 1853, though providing impetus for growth to the SW, in the Portfield area. Today's trend towards suburban shopping has had a damaging effect on the town centre, as has the relocation of the market in the 1980s to the riverside, between the two bridges. More unfortunate has been a series of road improvements over the last forty years, creating something of an eastern bypass, but too close to the town centre, carving an ugly division between the town and Prendergast (q.v.), and destroying many older buildings in the process.

## HAVERFORDWEST CASTLE p. 205

The castle is an impressive sight when viewed from the E, towering over the town on a steep rocky outcrop, with its cliff-like S and E curtain walls. The lofty pointed windows, now blocked, clearly once lit chambers of a grand scale. Yet behind the curtain wall is a more or less empty shell, and of the outer ward, virtually nothing survives. Much was destroyed by the building of the County Gaol within the castle confines from 1780, and the subsequent clearance of most of the prison quarters in 1963–7.

The castle founded by Tancred, soon after the first Flemish settlement of the county in 1108, was seized by King John in 1210 and given to William Marshal Earl of Pembroke. Remains of a rectangular NE tower, strategically sited to overlook the Cleddau crossing, may date from Robert FitzTancred's time (cf. late C12 rectangular towers at Carew and Manorbier). In the later C13 a succession of brief owners included Queen Eleanor, who held the

castle from 1289 to her death the next year. Large sums were spent on 'the Queen's castle at Haverford', and the impressive S and E ranges of the inner ward are almost certainly of the late C13. A new stable and new tower are recorded in 1387, and repairs took place after an attack by Glyndŵr's forces in 1405. In 1577, however, the castle was described as 'utterlie decayed' and the 'fine hall' was no longer habitable. By the time of the Civil War the castle offered no real defence, though in 1648 it was ordered to be slighted. Inevitably, it was plundered by local stonemasons and a survey of 1653 mentions 'old stone walls . . . being good quarries'.

In 1780 the County Gaol was built within the inner ward, against the S wall; briefly it held captives from the attempted French invasion at Fishguard in 1797. The Governor's House (now the town museum) was built to the E, on the site of the inner gate. It destroyed most of the surviving medieval fabric. Extensions were made in 1816, but in 1820 a new, much larger prison was built in the outer ward, designed by *J. P. Pritchett* of York, who was born in the county. In 1878 the prison closed, and up to 1963 the buildings were occupied by the Pembrokeshire Constabulary. The castle was acquired in 1963 by Pembrokeshire County Council, who converted the gaol into the County Records Office, and removed all of the C18 gaol buildings from within the inner ward.

The plan of the castle is not immediately apparent, due to the loss of the large OUTER WARD. This was roughly rectangular, with the INNER WARD to the SE, the dividing line of the INNER GATE marked by the PRISON GOVERNOR'S HOUSE of *c.* 1780, battlemented, of three bays and two storeys, with pointed windows, and bowed centre bay containing the entry, deliberately Gothic for the setting. This has survived rather better than the former COUNTY GAOL, now the County Records Office. Hip-roofed, three storeys, and thirteen bays long, built of local brown sandstone, the windows with flared keystones. The central observatory tower has been shorn off. Central parapeted porch of ashlar limestone with round-arched entry. Originally this was flanked by the curtain walls of the exercise yards; the r. half has been demolished, and the l. flank rebuilt for accommodation after 1963, with a strange millstone-like window inserted. Strange, too, the blocking of the windows and the substitution of fibrous openwork panels. The conversion was carried out by *Gilbert Ray*, County Architect. The only surviving medieval feature of the outer ward is the base of a rectangular TOWER to the NW.

Now to the INNER WARD. The main survivals here are the outer walls of the S and E ranges, the former containing the hall, demarcated by the two huge pointed first-floor windows of eroding local Nolton sandstone. The tracery has long gone, but the wave-moulded surrounds remain, perhaps confirming the date of *c.* 1290. The hall stood on a vaulted undercroft, but together with the inner wall of the range, the vaulting has all

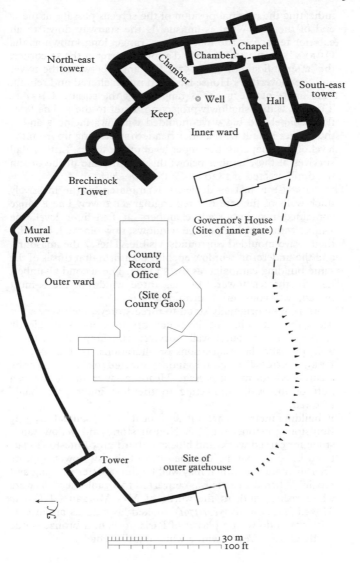

North-east
tower

Chamber

Chamber

Chapel

South-east
tower

Well

Keep

Hall

Inner ward

Brechinock
Tower

Governor's House
(Site of inner gate)

Mural
tower

County
Record
Office

Outer ward

(Site of
County Gaol)

Tower

Site of
outer gatehouse

N

30 m
100 ft

Haverfordwest Castle. Plan

gone. The undercroft was lit by unusually generous windows
set in big embrasures; only when one walks around the exte-
rior of the range does one appreciate how high-set the under-
croft level is. Base of a fireplace in the centre of the inner wall
footings. Note the crease in the masonry across the first-floor
windows, indicating the roof level of the 1780 gaol.
The contemporary round SW TOWER contains a small chamber
on each of the three levels, and a stair from hall level,

indicating the original position of the screens passage at the W end of the hall. What is unusual is the stairway down to an exterior terrace at the foot of the S range, long known as the QUEEN'S ARBOUR, which had a round turret at the SE corner, the latter still standing in 1577. The angle between the tower and the Governor's House has been much altered and rebuilt.

At the angle of the E and S ranges was the square CHAPEL TOWER, with a shallowly projecting turret to the E. The first-floor chapel had big wave-moulded windows facing E and S, the former rebuilt with a brick head. Stair leading up from the level of the chapel to the upper level of the tower. Little detail survives of the chamber below; this was the site of the prison treadmill erected *c.* 1820 by *Sir William Cubitt*.

The E RANGE is just as depleted, terminated by the massively thick walls of the late C12 rectangular NE tower. The E range contained two important chambers at first-floor level, the S-most with three big pointed windows, now blocked, but with their wave-moulded surrounds visible. These, the masonry, and the undercroft window openings confirm that this is of the same building campaign as the S range. The second chamber, next to the NE tower, also has three windows, the N-most paired, with voussoired surrounds.

The NE TOWER originally stood to three storeys, with very stout walls; the butt joints of the later work to N and S are clearly visible. Only the outer walls survive, with fireplaces to the N wall, probably later insertions or alterations. To the NW, the BRECHINOCK TOWER is round, connected to the NE tower by a corbelled-out mural passage. Heading SW from the tower, a butt of the wall connecting to the lost inner gate, badly restored.

The building materials are a mix of local brown sandstone, grey Boulston gritstone, purplish Nolton stone and yellow sandstone for carved work, and blocks of hard grey limestone scattered in rough bands. The masonry of the SW tower appears finer in character, which may well be due to later refacing and repairs. When the castle was converted to a gaol, the walls were whitewashed, and, in the words of Mrs Morgan (*A Tour to Milford Haven in the year 1791*), looked 'as bald as an antique bust would do with a plaster of Paris nose, or a bronze statue of the Grecian Venus with a white handkerchief'.

p. 208　　　　　　　HAVERFORDWEST PRIORY

Reached off Quay Street, and situated immediately on the W bank of the Western Cleddau. The best view is from the bypass on the opposite side of the river. Much depleted, the chief, finger-like remains are the NW angle of the N transept, the SW corner of the S transept, and the W end of the nave: otherwise, only footings are left. For centuries after the Dissolution, the priory was an open quarry for local builders. In 1981 the Guild of Freemen of Haverfordwest acquired the site, and passed it to Cadw, who carried out an excellent programme of excavation

Haverfordwest Priory from the south-east.
Engraving by Samuel Buck, 1740

and consolidation. Thanks to this work, the priory now is easy to interpret, the plan consisting of a cruciform church, with cloister to the SW.

The Augustinian priory was founded shortly before 1210, probably by Robert FitzTancred. A patent of 1381 confirms an earlier, undated grant of properties to the priory by Robert, before he was removed as lord in 1210, including the three town churches, no doubt the original endowment. While conveniently close to the town quay, as a building site the plot granted by Fitz-Tancred was far from accommodating: a steep river bank giving way to marshland prone to tidal flooding. Building was achieved by cutting into the rock and forming a large platform just above flood level. Remaining detail is datable to the early C13, and excavation has revealed that the original plan was established from the outset. Extensive later changes included the insertion of a square tower – probably in the C15 – unusually placed at the E end of the nave. Slight footings remain, and evidence for the raising of the walls can be seen in the surviving masonry. The church is modest, c. 150 ft. (c. 50 metres) E–W. Only the prior and two canons were in residence when the priory was dissolved in 1536. The site was purchased by Roger and Thomas Barlow, brothers of the bishop of St Davids, but because of its inconvenience, it was simply left to the elements. The Buck view in 1740 shows the church in nearly the present ruinous condition, except that the N wall of the chancel was still standing.

The cruciform layout of the PRIORY CHURCH is revealed by the recent consolidation works, which have raised the floor levels by some 150 mm over the fragile original tiled floors in transepts and chancel, the stone edgings reflecting the original diagonal patterning. In the nave, modern flagstones reflect as far as possible the original flagged floor beneath. Some footings, particularly in the chancel, were raised, the junction

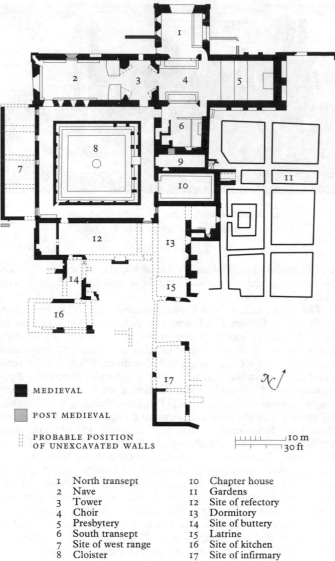

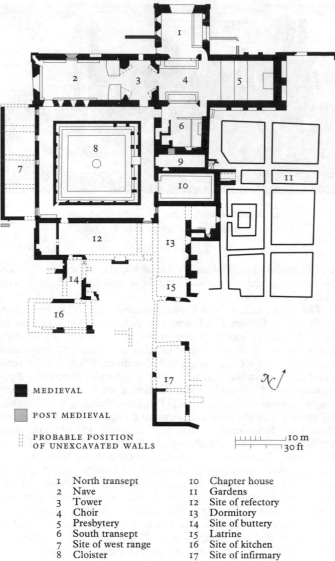
MEDIEVAL

POST MEDIEVAL

PROBABLE POSITION
OF UNEXCAVATED WALLS

⊢⊢⊢⊢⊢⊢ 10 m
⊢⊢⊢⊢⊢⊢ 30 ft

| | | | |
|---|---|---|---|
| 1 | North transept | 10 | Chapter house |
| 2 | Nave | 11 | Gardens |
| 3 | Tower | 12 | Site of refectory |
| 4 | Choir | 13 | Dormitory |
| 5 | Presbytery | 14 | Site of buttery |
| 6 | South transept | 15 | Latrine |
| 7 | Site of west range | 16 | Site of kitchen |
| 8 | Cloister | 17 | Site of infirmary |
| 9 | Sacristy | | |

Haverfordwest Priory. Plan

between old and new masonry demarcated by slips of red tile. Of the NAVE, only the sw corner stands, along with the chamfered jamb of the w window. As the w end is built into sloping ground, entry was to the N; the N door is blocked by a later garden boundary. The remains of the stone benches are clear

to see. At the E end of the nave, the footings of corner piers for the inserted TOWER. Large remains of the collapsed W arch were excavated. Of the transepts, the S TRANSEPT is the more intact, its windows set high above the level of the cloister buildings, except to the E, where there were three windows above an altar recess. PISCINA and AUMBRY, much robbed. On the W side, the remains of a mural stair, leading to the dormitory to the S. The N wall of the N TRANSEPT survives to show the stumps of a triple window, and an external niche each side. In the W wall, a pair of tall lancets, robbed of their dressed stone. Traces of a Bath stone string course at sill level. The CHANCEL is very depleted, the recent works preserve the position of the three altar steps. Tiled floors were found in the chancel and transepts, laid diagonally in a pattern of green and buff plain slip tiles; these date from the late C15 or C16, and overlay an earlier tiled floor.

The CLAUSTRAL RANGES lie largely unexcavated, except for the SACRISTY and the CHAPTER HOUSE. The sacristy lay S of the S transept, in the E range of the cloister: a narrow room with a door each end, originally covered by a barrel vault, of which some of the springing remains. This may have originated as the slype passage connecting cloister and riverside. Both doors were blocked when converted to the sacristy. A door to the transept is now blocked by later masonry. The next chamber to the S was the chapter house, a plain rectangular room, of which only footings survive, and a little of the fine door surround with roll moulding with deep hollows. Remodelled in the C15, with added rib vault; one extraordinary corbel head was excavated, depicting seven human faces with shared eyes. Towards the E end, the plinth of a tomb, its smashed effigy found among the post-Dissolution fill, included the head of a C13 knight, perhaps one of the FitzTancreds.* Further footings and heaps of spoil indicate a long E range projecting well S of the cloister, presumably with dormitory at first-floor level. The S and W ranges have not been excavated. To the W, an inner wall survives of a range that had four doorways opening into the cloister. Of the CLOISTER itself, full excavation revealed that the walks were covered by pent roofs, and laid with green and buff tiles. Between garth and walks ran a sizeable drain, spanned at intervals by bridges which supported the buttresses of the arcades. The cloister was rebuilt in the C15, but all the dressed stone has since been removed. Carved fragments of the C13 cloister, reused for footings, are of high quality, including fine abaci decorated with friezes of animals, and shafted piers.

Excavations revealed an extensive and very rare medieval GARDEN, between the priory and the river, a grid of raised beds revetted with low stone walls, restored and replanted by Cadw.

Traces of the PRECINCT WALL survive to the W.

*On display at the Castle Museum.

CHURCHES AND CHAPELS

ST MARTIN, Church Street. Close to the castle, and said to
be the oldest of the town's three churches. Thin, tapering
NW tower with corbelled parapet: a C15 date is likely. Its
position – as at the earlier tower at St Mary (*see* below) –
is unusual in the county. The big splayed buttress is dated
1857. *C. E. Giles* of London replaced the spire in 1870, in
local grey limestone ashlar with chunky Forest stone string
courses. The old spire, probably C16, some 15 ft lower,
had replaced a saddleback roof. The rest is C14 with some
C16 work, heavily restored by Giles, 1862–5. Nave and chancel,
both long, S aisle with earlier porch to the W, N chancel aisle
S door flanked by Dec trefoiled niches. Fine tall Dec chancel
arch with small filleted and keeled rolls; the capitals lost
when *Thomas Rowlands* inserted a ceiling in 1840. Good
trefoiled PISCINA with crocketed ogee surround, ballflowers
in the hollows. Triple SEDILIA, ogee arches on hexagonal
colonnettes, also Dec. The simple two-bay S arcade is by
Giles. Square pier, the capital with volutes. In the E respond,
a narrow SQUINT with a four-centred head, and below, a
little carved PISCINA or STOUP. This work looks early C16,
likewise the flattened Tudor arch in the S wall of the chancel
and the (restored) Perp E window flanked by crude niches.
Giles' windows are Geometrical. Dec work in the porch,
chiefly the two trefoiled niches. Giles added the N chancel aisle
and the roofs, scissor trusses in the chancel and arched braces
in the nave with curving struts. – FONT. Much restored. Low
square bowl with angled corners, octagonal pedestal. – Large
Bath stone PULPIT of the 1860s with blank quatrefoils. –
Gothic SCREEN in the porch, 1903 by *H.J.P. Thomas*. –
STAINED GLASS. E window *c.* 1880, Christ with SS Martin and
David. – S aisle E, 1921, by *Morris & Co.*, the figures after
designs by *Burne-Jones*, four lights depicting St Mary Magda-
lene, the Virgin, Christ and St John, set against a rich blue
ground. – Chancel S by *C.E.G. Gray*, 1893.* – Aisle SE by
*Heaton, Butler & Bayne*, 1909. – W window, 1988 by *Celtic
Studies*. – 1960s SCULPTURE of the Virgin and Child, by
*Stephen Sykes*, who worked at Coventry Cathedral. Concrete
slab with portraits encircled by glass shards. – C13 or C14
COFFIN LID with elaborate floriated Latin cross. – MONU-
MENTS. Thomas Lloyd †1722. Good small tablet of veined
marble, well lettered. Open pediment with shield above. – Rev.
James Rees †1835 and Frances Thompson †1842, both by *J.
Thomas* and plain.

30, 31  ST MARY. Imposingly set, closing the memorable vista of the
steep High Street, St Mary contains an uncommonly high
amount of excellent early C13 work. The plan consists of nave
with N aisle, chancel with N aisle, porches, and NW tower.

* The chancel was given elaborate painted decoration by *C.E.G. Gray* in 1895, since
whitewashed.

Among much Perp detail, several C13 exterior clues, especially the W window, a triple lancet, the colonnettes inside with bell-type caps. More striking and also more problematic is the large plate-traceried E window, of three lights with quatrefoils in three roundels. The simplified exterior detail suggests Victorian restoration (repairs were made in 1844), but the inner face is certainly E.E. (*see* below). More eccentric are the windows below the clerestory on the S side. In the chancel, the windows lack arches over the two lights and foiled circles, while in the nave are more conventional Geometric windows, two lights with cinquefoiled circles, the latter divided by straight mullions from solid spandrels. These windows are shown as existing on a lithograph of 1860, and appear to be faithful reproductions of the C13 originals. Finally, of the same date, the low NW tower. Trefoiled lancets in the belfry, low corbelled parapet and low, crudely added angle buttresses. The timber and lead spire was demolished in 1802, chiefly to please Lady Kensington, who was afraid that it would fall on to her house. Several attempts to replace it followed. *William Owen* made a model for reinstating it in the 1830s. In 1860 *W. H. Lindsey* proposed to demolish the whole tower and build a big Perp one with angle buttresses rising to tall pinnacles. *C. E. Giles* proposed a rebuilding, complete with large belfry lancets and a broach spire with bands of polychromy. Mercifully, ambition always exceeded funding.

A major programme of works took place *c.* 1500: on the E side, the old gable is visible, raised when a clerestory was added to nave and chancel, topped by battlements. Generous panel-tracery windows here and in the N aisle, which was enlarged at this time. On the S side of the nave, bold gargoyles. The plain porch may also be of this date, earlier than the date of its sundial, 1656.

The E.E. N door whets the appetite for the INTERIOR. Deep rolls, some with fillets and caps carved with fleurs-de-lys and also a small beast. Hoodmould on male and female heads. The magnificent early C13 arcades are unparalleled in SW Wales. The work belongs to the 'West Country School' identified by Harold Brakspear.* Here in far west Wales, the nave of Wells Cathedral, begun *c.* 1180, can be identified as the chief source of inspiration. The quality of both design and sculpture is higher than the work at Llandaff; indeed, it is nearly as high as at Wells itself. The stone was almost certainly imported from France. Four-bay nave arcade, with lavishly carved capitals and hoods on headstops, just as at Wells. The piers are broadly Greek cross on plan with triple shafts in the cardinal directions, the middle shafts filleted. Deep hollows and single filleted shafts between, the latter with continuous capitals, like the diagonals of the piers at Wells. At Wells, however, the treatment at capital level is more complex, the intermediate shafts having square abaci, and not circular ones as here. The central

31

* *Archaeologia*, vol. 31 (1931).

pier marks a subtle departure: the plan is hexagonal and has no strong cardinal accents. It has ringed shafts on N and S, shafts paired on the E and W faces. The thin filleted shafts accompanying them create the illusion of triple shafts. Filleted shafts in the diagonals. The arches are of three orders, each distinguished by deep rolls, some with fillets. The plinths are encased in later masonry. Outstanding and memorable carved stiff-leaf capitals: as at Wells, there are other subjects too, some similarly profane (and plastered over, probably in the C17, until rediscovered in the early C19). Starting with the nave W pier, amid much stiff-leaf, a mask with protruding tongue next to a leering grotesque beast, and also intertwined beasts with a single head. On the next pier a pig playing a fiddle, an ape playing a harp, and a man with toothache. In addition, a winged beast, its tail terminating in splendid foliage. In the third pier, the lamb biting the serpent's head is shown twice.

The chancel arcade is of two bays, the pier with plain detached shafts and filleted ones between; the plain ones painted black (in the C19?) to imitate Purbeck marble. Similar capitals to the nave, including a figure with a pitcher, representing the thirsty soul. The E arch dates from the extension of the chancel aisle *c.*1500, see the surround of the blocked C13 window above. The carving is of much lower quality, capitals with stylized foliage and flowers. The interior face of the E window is E.E., the arches with deep multiple rolls, the colonnettes with rings, and the outer shafts filleted. The splendid early C13 chancel arch is triple-shafted with outer pairs of filleted shafts, rich stiff-leaf capitals with masks facing N and S. In the arch, a complex series of small-scale rolls. C13 window surrounds in nave and chancel, their (restored) tracery suggesting a mid- to later C13 date, and so slightly later than the arcades. E.E. trefoiled PISCINA. The blocked S opening in the chancel perhaps was the sedilia.

Rich Tudor roofs, especially in the nave and aisle, added with the early C16 clerestory. Nave roof of shallow pitch, with big carved bosses at the intersections of heavily moulded beams. Large spandrels carved with foliage (some with painted texts) upon an assortment of carved head corbels. (According to a plaque, the lean-to aisle roof was repaired in 1745.) Also in the C16, the tower was given a surprisingly impressive lierne vault.

The church was restored in 1844 by *Thomas Rowlands*, much of whose work, including a gallery, has long been removed. *W. H. Lindsey* began some work in 1860 (*see* below, the East Walk), but died in 1863. *C.E. Giles*, then working on St Martin's church (*see* above), took over, and his is the vigorous S porch with its angle buttresses and doorway with colonnettes. Next came *Ewan Christian*, between 1881 and 1889, who largely restored the roofs, especially that in the chancel, retaining the Tudor carved figural corbels. The nave was discreetly restored 1903–5 by *W.D. Caröe*, who repaired the roof, clerestory windows and arcade. At the reopening service, the

mayor allegedly grumbled that much had been spent, but no improvement could be seen.

FURNISHINGS. Splendidly elaborate free-standing STOUP, presumably Perp. Pedestal with colonnettes, the square bowl with cusping on each side. – Of a similar date, two carved 66 BENCH ENDS. The best-preserved one depicts St Michael triumphing over Satan. Splendidly free carving. The other bench end, mutilated, shows a weapon-brandishing figure and is terminated by a huge lion. – Elaborately carved PEWS and PULPIT of 1905, by *Caröe*, as is the VESTRY SCREEN in an Arts and Crafts style, erected in 1925 under the tower arch, and the ROLL OF HONOUR, 1920. – Oak STALLS of 1889 by *Christian*. – STAINED GLASS. E window of 1893, a magnificent work by *C. E. Kempe* depicting the life of Christ in six scenes. – Plenty by the firm of *Kempe & Co.* Nave SE, Christ and Mary Magdalene, 1910. Nave S, 1913, Crucifixion, and another window of 1917, with saints. Typically crowded W window with Old Testament prophets and saints, 1919. In the N porch, four windows depicting the Evangelists, SW chancel window of 1929, SS Teilo and Justinian. – Chancel S, second from E, *c.* 1843, highly coloured, third, 1955 by *Powell*. – Nave S (penultimate from E), 1864 by *Wailes*, miracles of healing.

An impressive array of MONUMENTS. Earliest is a much-defaced effigy of late medieval date, evidently a pilgrim, with shoulder bag with three scalloped shells for St James of Compostela. – William Walter †1614. A muddle, the slab set on its side within a crudely rusticated recess. – James Scourfield †1614. Simple, with shield below inscription. – Tomason Howell †1617. Small, inscription around the edge. – William Meyler †1622. Tall tablet with a skull in the shaped top. – Hugh Knethell | 1624. Small. – Sage Davids | 1654. Good brass in carved stone frame. Very good lettering; the husband within rusticated arches at prayer, and a shield. – John Conseil †1678. Tablet with frame and scrolled pediment. – Jane Fowler †1687. Plain. – Elizabeth Browne †1699. Ionic pilasters and broken segmental pediment containing a large winged cherub head. – Jane Bowen †1701. Swan-neck pediment, crude. – Mary Mathias †1723. Large white marble tablet, scrolled sides, shield and cherub head, good quality. – Bowen family, before 1731. Long inscription. – Thomas Skyrme †1731. Tall, with acanthus leaves in the cornice and leafy consoles. – Elinor Philipps †1733. Large, veined marble tablet. Scrolls, well-cut lettering and ball finials. The urn is lacking. Signed by *Thomas Burnell* of London. – Elizabeth Smythe †1733. Bold lettering with carving in relief below. – Sir John Philipps of Picton 71 Castle †1736, one of the Commissioners for Fifty New Churches in London. Arrestingly large and well-executed tablet signed by *Christopher Horsnaile* of London, one of James Gibbs' principal masons. Beautifully veined marble with freestanding Composite columns carrying a broken segmental pediment with large playful reclining putti, one holding a ring, the other wrapped in drapery. More putti each side of the

columns, in lively poses, one clutching his temple as if in dis-
belief. Skilfully lettered inscription with a fine marble bust
above, the only such funeral bust in the country. Above the
pediment, a tall shield. – Sir John Philipps †1764. Tall, with
Corinthian columns and broken pediment. Crisp inscription
with shield above. – Hessy Jones †1771. Oval tablet. – Richard
Wright †1800. Oval, with shield. – George Parry †1821. White
marble with urn and fluted sides. Signed by *Porter* of London.
– Thomas Tucker †1822. Moulded sides. By *W. Rowlands*
of Haverfordwest. – Richard Philipps, Lord Milford, †1823.
Over-large and lacking cohesion: thin Corinthian columns
topped by fluted urns. Huge shield with draped peer's robes
and coronet. By *J. Phillips* of Haverfordwest. – Sir Henry
Mathias †1823. Sarcophagus type, with tapering colonnettes
each side. By *Reeves & Son.* – Thomas White. Simple tablet
by *Caröe*, 1925. – Under the arcade, a flat stone to Sir John
Pryce †1761, eccentric thrice-married baronet of Newtown,
Montgomery.*

In the small CHURCHYARD, the EAST WALK, bounded by
crenellated walls and railings, by *Lindsey*, 1860, with a Gothic
archway opening off the street. The N entry to the churchyard
is the doorway to the demolished medieval CHARNEL HOUSE.
Shafts with small filleted rolls, C14.

ST THOMAS, off Market Street. On a hilltop site, the highest
point in town. The church is set in a huge Dickensian grave-
yard, approached by the dark, narrow CHURCH LANE. Tall,
slender late medieval W tower with battlements: the Perp W
window looks early C19, but the belfry windows (two lights
with a quatrefoil) look original (cf. Johnston). Roughly coursed
ashlar on the W side, and polygonal stair-turret. Heraldic stone
over the W door, formerly within a large stone W porch. Barrel-
vaulted lower storey. The remaining fabric is largely C19;
replacing a C17 rebuild; the very thick part of the S wall may
be medieval. Long and narrow nave, N aisle and chancel with
N vestry. Restoration by *E. M. Goodwin*, then still of London,
1853–5. Foundations of a long-lost N aisle were found, and the
aisle rebuilt by *E. H. Lingen Barker* in 1881. The lean-to aisle
with its Dec. windows rising to dormers, porch and chimneyed
two-storey vestry looks like a school with attached house.
Arcade of seven bays, hoodmoulds with carved foliage stops.
Chancel arch on corbelled wall-posts with big capitals of
heavily carved foliage and fruit. – FONT. By *Goodwin*. White
marble. – PULPIT of 1881, skeleton-like with marble colon-
nettes. – Good carved REREDOS of c. 1920 by *John Coates
Carter*. Triptych with outer shutters, uncoloured figures and
texts. – STAINED GLASS. E window of 1881 by *Mayer & Co.*,
Crucifixion. – Nave S, c. 1868, Crucifixion, by *Cox & Sons*,
strong colours. – MONUMENTS. – Large slab with a floriated
Latin cross in relief, the arms terminating in fleurs-de-lys,

---

*His third wife only consented to marriage on condition he removed the embalmed
bodies of her two predecessors from the bedroom.

defaced portrait above. The inscription reads: RICARD LE
PAVMER GIT ICI DEV DE SAALME EIT MERCI. AMEN. Late C13
or C14. – John Bernardiston and family, *c.* 1734. Large undu-
lating marble tablet, scrolled sides and painted shield above.
Draperies frame the whole, falling over the putti heads below.
– Owen †1724 and Elinor Phillips †1748. Good, side scrolls
terminating in leafy capitals, broken pediment with vase.
Signed by *Thomas Beard* of London. – Elizabeth Eliot
†1780. A well-carved classical piece. Scrolls with swags. Semi-
circular carved scene with mourning woman. – Among many
minor memorials of the earlier C19: William Jordan and family,
*c.* 1802. Garlanded cartouche with painted heraldry. – Owen
Phillips † 1846. Lozenge-shaped tablet in pedimented frame,
by *J. Phillips*. – John Lort and family, 1848. Large draped
urn, shield below. By *H. Phillips* of Haverfordwest. – Richard
Phillips †1860. By *T. Gaffin*. Scroll type. – Peregrine Lort
Phillips †1861. By *Bedford*, scroll type. – Chambers family,
1852–72. Large and free-standing, of veined marble on a Bath
stone base. Praying female, her arms resting on a plinth,
inscription on the tall pedestal. Signed by *Sanders* of New
Road, London.

ST DAVID AND ST PATRICK (R.C.), Dew Street. Simple gabled
Gothic, 1872 by *Richard Williams* of Carmarthen. Interior
refurbished in 1905. Nave and small sacristry with triple-
shafted arch, rear gallery. Large N annexe 1960.

TABERNACLE CONGREGATIONAL CHAPEL, City Road. One of 115
the most individual and attractive classical chapels in south
west Wales, the result of an enlarging and remodelling
in 1874 of the 1774 predecessor, by *Lawrence & Goodman* of
Newport. Stuccoed and coloured, the middle projecting as a
half-drum with Ionic columns on high bases. Arched doors on
the ground floor into the open vestibule. Outer bays with ter-
minating antae above rustication which runs up to the top of
the bases. Parapet rising to a large inscription tablet. Detail and
design are handled with great flourish. The big interior of 1874 116
is splendid, divided into nave and aisles of five bays by tall iron
columns with Corinthian capitals supporting segmental
arches, decorative plaster roundels in the spandrels. Between
the columns run the galleries, the unusual iron balustrading
of a robust vine pattern. The 'nave' has an elliptically coved
plaster ceiling, unexpectedly coffered. Rear apsidal recess with
cabled ribs in the ceiling, a far-removed glance at the biblical
tabernacle (i.e. a tent in the wilderness), and a row of arched
lights. Pulpit with some ironwork. Tabernacle was founded
by Calvinistic Methodists, after preaching visits both by
Howell Harris and, in 1768, by George Whitefield. The C18
chapel had a pedimented façade and similar plan to the present
one, including a plainer barrel-vaulted ceiling. Simple 1874
STAINED GLASS in the apse, some with lily and vine, others
with texts. – Lobby window of 1920, a war memorial in brown
hues, unusually representational.

    To the N, the handsome stuccoed SCHOOLROOM of 1864.

Five bays long, the ends projecting, with steep pedimental gables containing delicate stucco decoration. Round-headed windows, paired in the rusticated wings, and bold bracketed entablature. Who was the architect? Attractive iron GATES of *c.* 1835, perhaps cast at the *Marychurch Foundry.*

117  BETHESDA BAPTIST CHAPEL, Barn Street. 1878, a considerable work by *George Morgan.* Looming Italian Romanesque façade of limestone with Bath stone detail, the wide middle bay rising sharply to a corbelled gable to startling effect. Large wheel window over paired shafted doorways with chevron and heavy carved capitals. Three-sided gallery inside with bow-fronted iron balustrade. Shallow rear apse with a row of lancets high up, the whole framed by a zigzag arch. Broad pulpit with arcaded front, steeply gabled surround behind, a dramatic background for any preacher. *E. Powell* of Abergavenny undertook the stone carving. – STAINED GLASS of 1878 by *Cox & Son,* brightly coloured in the apse.

To one side, the SCHOOLROOMS, also of 1878, squeezed into a narrow site, front gable with stepped lancets, matching the blind ones in the gable of the chapel. The excellent cast-iron RAILINGS are by *W.A. Baker* of Newport.

WESLEYAN CHAPEL (now a warehouse), Perrots Road. 1818, enlarged in 1835 and embellished with simple classical detail when *D. E. Thomas* refitted the interior in 1880. Rendered front with parapet, narrow central bay slightly advanced. Terminating giant Tuscan pilasters. Round-arched windows on both levels. Inside, the three-sided gallery stood on wooden Ionic columns. *Thomas* added the long stone SCHOOLROOM to the N in 1874. VESTRIES, rebuilt 1911 by *Henry Budgen* of Cardiff. The cause was founded in 1763, the date of Wesley's first of fourteen visits to the town, and a chapel was built in 1772. Wesley preached at the opening and called it the neatest chapel in Wales.

EBENEZER CALVINISTIC METHODIST CHAPEL, lower down Perrots Road, near Swan Square. The grand four-bay classical front dating from 1886, by *D. E. Thomas,* is a big two-storey SCHOOLROOM. The chapel behind it was built in 1817 and enlarged in 1844. Rendered front, the lower storey rusticated, the upper with Tuscan pilasters, paired at the ends. Panelled parapet, containing a small central pediment. The sides of the schoolroom are similarly treated, but the chapel is plain. Simple interior of 1889 (also by *Thomas*), rear gallery with bowed iron front.

ALBANY UNITED REFORMED CHAPEL, Hill Street. A very early cause, said to date from 1638, if so, then the earliest Independent cause in Wales. Dates of 1655, 1842 and 1891. 1842 is the most relevant, when *William Owen* built a large new chapel to face Hill Street, (the original entrance faced St Thomas' Green). Gable-fronted with simple pointed windows, the stepped gable removed 1965. The gallery, running along three sides, was replaced in 1873 by *D. E. Thomas*: panels of ironwork and iron columns with simple foliage caps. Other fittings of

1891 by *Thomas*, as is the massively classical wooden surround behind the pulpit, of 1904; with pilasters and pediment. Simple Arts and Crafts SCHOOLROOM, 1908, along one side of the forecourt, again by *Thomas*.*

HILL PARK BAPTIST CHAPEL, *see* Prendergast.

## PUBLIC BUILDINGS

SHIRE HALL, High Street. 1835 by *William Owen*. Handsome classical façade expressing renewed civic pride. Five bays, two storeys, and stuccoed, the centre three bays with pediment and giant Ionic pilasters, round-arched ground-floor openings. Inside, the courtroom is semicircular and toplit, through the coffered barrel ceiling, the fine plaster cornice with Greek detail. Giant Ionic pilasters along the rear wall. In front, fine railings, also designed by *Owen*, possibly from the local *Marychurch Foundry*; openwork posts with Greek fret.

COUNTY HALL, Freeman's Way. The old county offices of 1964–7 by *Geens, Cross & Kellaway* of Bournemouth, were demolished in 2000, perhaps a regrettable loss, as it was one of the few buildings in the county that embraced post-war Brutalism. Superseded in 1998–9 by massive new offices to the w, strung out along the river front; 24 bays in all, with central and end bowed projections with conical roofs, reminiscent of an overblown Regency villa, accentuated by painted render and slate. Designed by *Tim Colquhoun* of the *Pembrokeshire County Council Architect's Department*.

COUNTY LIBRARY, Dew Street. 1967–9 by *Gilbert Ray*, County Architect. Flat-roofed three-storey main block with glazed ground floor, the upper floors of reconstituted stone framed by rusticated brick piers. Large central abstract panel resembling shelves of books, by *David Tinker*. Single-storey range to l. with the entrance and a fortress-like screen-wall in front of a circular exhibition hall.

PEMBROKESHIRE COLLEGE, Merlin's Bridge. 1988–90 by *Alex Gordon Partnership*. Complex of two-storey buildings in yellow brick with deep-eaved roofs and blue-painted metalwork, planned as wings radiating from a taller pyramid-roofed square entrance hall. Inside, the hall with much exposed steelwork, rather cluttered.

## PERAMBULATIONS

*1. High Street and the South Side of Town*     p. 218

A logical start is made at the WAR MEMORIAL on the w side of SALUTATION SQUARE, a carved dragon of Forest stone on a high pedestal with bronze plaques. 1921 by *Oswald Milne and Paul Phipps*. More impressive when it stood in the centre of

---

*The Moravian Chapel, St Thomas' Green of 1773, altered 1853, was demolished in 1961. The organ of 1829 is in Bethlehem Chapel, Spittal. It was the last Moravian Chapel in Wales.

BRIDGEND
SQUARE

HOLLOWAY

OLD BRIDGE

SWAN
SQ.

CITY ROAD

VICTORIA
PLACE

SALUTATION
SQUARE

5+    +1    Castle

CHURCH
ST    QUEEN
SQUARE

SPRING
GARDENS

+6    MARINERS
SQUARE    CASTLE
SQUARE

DARK STREET

NEW
BRIDGE

+2    HIGH STREET

II

HILL LANE

GOAT ST

3
+

4
+

9
+

DEW STREET

BARN STREET

MARKET STREET

HILL ST

ST
THOMAS'
GREEN

Western Cleddau

QUAY STREET

PICTON PLACE

BRIDGE STREET

NORTH STREET

+7

8

10

N↑

1   St Martin
2   St Mary
3   St Thomas
4   St David and St Patrick (R.C.)
5   Tabernacle Congregationalist Chapel
6   Bethesda Baptist Chapel
7   Former Wesleyan Chapel
8   Ebenezer Calvinistic Methodist Chapel
9   Albany United Reformed Chapel
10  Priory
11  Foley House

0.5 mile
0.8 km

Haverfordwest

Salutation Square, which since *c.* 1960 has been filled by a busy
roundabout. The town is entered via PICTON PLACE, with the
C19 three-storey COUNTY HOTEL, of 4 + 4 bays, turning the
corner. Plain but for the porch on Tuscan columns. Opposite,
the impressive former MASONIC HALL, which has a noble
pedimented façade with giant Corinthian columns. 1870–1 by
*Szlumper & Aldwinckle*, and utterly different from their usual
proficient Gothic. On the N side of Picton Place the terrace is

harshly interrupted by a small 1960s supermarket, just a con-
crete, monolithic two-storey block. After this mixed start, an
excellent prospect of the centre of town lies ahead, with houses
climbing each side of the street, terminated by St Mary's
Church within a forked junction. The view is framed by the
terraces and bridge which formed a new entrance to the town,
created 1832–9 by the skilful local architect and entrepreneur,
*William Owen*. The NEW BRIDGE, completed in 1834, is of
dressed grey limestone, three elliptical arches, the parapets
stepped up above the cutwaters. Along the river front to the N,
the injudiciously placed NEW MARKET, a varied but undis-
tinguished low-rise development of the 1980s, strung between
old and new bridges, punctuated by two octagonal towers.
Little real use is made of the river front. Ahead are Owen's two
terraces in VICTORIA PLACE, 1839, both three storeys and
stuccoed. That to the N side is plain, but the S terrace is lively
and taller, the intermediate bays framed by giant plain pilaster
strips. Parapets and marginally glazed sash windows. Towards
the centre, additions for LLOYDS BANK in 1893 by *D. E.
Thomas & Son*. Ground-floor rustication, scrolled dormers,
and a big, segmentally pedimented portal.
From here, a variety of routes can be taken: the tour starts with
QUAY STREET to the S, followed by HIGH STREET to the W,
its wide mouth created from the demolition of houses in 1837.

First, QUAY STREET. T. O. LLEWELLIN & CO. on the r. side
was originally the Pembrokeshire and Haverfordwest Savings
Bank, built 1861–2 by *T. G. Jenkins*. Italianate and stuccoed,
four bays and two storeys, centre bays advanced and pedi-
mented. TUSSIE MUSSIES is probably C17, with a steeply
pitched roof and large chimneystack to the rear end. Opposite,
WILTON HOUSE, 1856, five bays. Good plaster ceilings, and
staircase with cast-iron balustrades. Beside it stood Clibborn
House, demolished in the 1950s, the Jacobean staircase the
best in the county. No. 14 has a surprisingly massive medieval
arched barrel vault at ground-floor level, within the present
restaurant. No. 15 looks C18, with a simple stuccoed two-storey
front, six bays long. Opposite, the POST OFFICE of 1934–6,
Bath stone and redolent of the pride that institution used to
take in its buildings. Two storeys and five bays, with pedi-
mented portal on Doric columns, and single-storey wings.
Further on, the OLD WOOLMARKET, an early C19 warehouse,
three storeys and bays with half-hipped roof. At r. angles, a
five-bay former warehouse facing the QUAY, dated 1777,
according to the inscribed stone, built by *J. Argust*, who also
rebuilt the quay itself. (On the opposite side, traces of former
medieval vaulted buildings.) The BRISTOL TRADER looks
C18, the detail all C19. Two storeys and five irregular bays,
with steeply pitched roof. Further S, more WAREHOUSES,
including a vast seven-bay, four-storey warehouse, surely C18,
with mansard roof.
Now up HIGH STREET. The cottage-like OLD THREE CROWNS

on the l. of two storeys and five irregular bays, is probably C18 but with later detail, a contrast to the classical SHIRE HALL (q.v.) of 1835 by William Owen. Opposite, No. 48, formerly the Pembrokeshire County Club, 1877 by *D. E. Thomas*, stuccoed Tudor with an oriel window over the entrance. From here, a fine view up High Street, bordered for its full length by a mixture of buildings, mainly three-storeyed with C19 detail, but with earlier cores. Nos. 44 and 46 are an early C18 pair with narrow sashes. No. 44 has a stair with simple turned balusters. Nos. 40 and 42 also form an early C18 pair, five and three bays, under a broad hipped roof on modillions. On the s side is No. 43 (MUNT'S JEWELLERS), its two-storey gable facing the street immediately suggesting late medieval origins, confirmed by the corbelled first-floor chimney facing HILL LANE and, inside, by the barrel-vaulted cellar within the rear block. Shopfront of *c.* 1900 with a fine bracketed-out clock above, of *c.* 1880. Next is the MIDLAND BANK, in a watered-down, stuccoed classical style by *D. E. Thomas*, 1900. Uphill, a short run of mid-C19-looking, two-bay stuccoed shops, but No. 35 retains a fine dog-leg stair of *c.* 1700, rising through all three storeys, with spiral-twist balusters. No. 38 is of three narrow bays and storeys, with No. 36 stepped down below, stuccoed, with early C19 detail including pedimented doorcases on Ionic columns. BARCLAYS BANK is another refronting, *c.* 1920 by *D. F. Ingleton* of Haverfordwest. Stuccoed, with attractively simple detail. No. 26 is of *c.* 1840; on the first floor, tripartite sashes set in segmentally headed recesses. No. 24 has plain later C19 detail but an early C19 staircase and late C18 rear wing with Venetian window. No. 22 is C18, three storeys and bays, with segmentally headed sashes, the glazing C19. Early C19 pedimented doorcase. Mid-C18 dog-leg staircase with turned balusters.

Opposite, the prominent bulk of the former grocery premises of ELLIS & CO., built 1876–7 by *D. E. Thomas*. Ten bays and four storeys, paired bays separated by plain giant pilaster strips, an effective way to liven up a monolithic façade. Central entry to yard behind. No. 15 hides some high-quality early detail. At first-floor level, the stone mullions of a large five-light window, also a magnificent carved fireplace with carved shields within quatrefoils along the overmantel. The heraldry suggests that the house belonged to the Owen family, who had built up an extensive estate between 1550 and 1570. Another heraldic fireplace is dated 1614.\*

Nos. 9, 12 and 13 are among the oldest buildings on the High Street; the only known timber-framed survivals in town, probably C16. Each is of three storeys and a single bay, the upper two with their first floors jettied out. The detail is all C19, a late C19 photograph showing quite elaborate jettied façades, the timber framing now hidden behind render. No. 9 has a small barrel-vaulted cellar. Nos. 5–7 are late C19, three bays and

---

\*George Owen noted armorial glass in the town house of Morgan Voyle.

storeys of buff-coloured brick with a little polychromy, good
unaltered shopfronts with tapering Corinthian pilasters. No. 8
at the junction with St Mary's Street was the former Post
Office. 1879–80 by *D. E. Thomas*. Four-storey, six-bay façade
in a freely handled stuccoed Italianate style. Nos. 2, 4 and 6,
now a shop, are a striking arrangement of three narrow houses
stepped down from No. 2, three bays and storeys, to No. 6,
two bays and two storeys, plus attic. Narrow C18 window open-
ings, but earlier origins visible inside. Each house has a
medieval barrel-vaulted undercroft, of pointed form to Nos. 2
and 4, segmental to No. 6 (the latter possibly post-medieval).
In No. 2, good features of *c.* 1700, include a full-height
dog-leg staircase with twisted balusters, the top balustrade with
shaped slat balusters. Ground-floor rear room with a good pair
of cupboards, the doors with round-headed panels separated
by fluted pilasters. On the first floor, a fine panelled room with
moulded chimneypiece.

The corner building of High Street and Market Street was
demolished in 1952, but its C13 undercroft was preserved,
and can be seen from the street. Impressive quadripartite
vaults with plain chamfered ribs on two round columns with
simple caps. Immediately to the se, the broken end of a
medieval barrel-vaulted cellar. Market Street rises even more
steeply than High Street, with a mixture of C18 houses and C19
shops. Commerce House of 1869 has an imposing stuccoed
façade of nine bays and four storeys, the parapet rising above
the centre five bays, terminating in scrolls. Round-arched
windows, attractive iron balcony. Designed by an engineer,
*Thomas Randle*. On the parapet, a statue of Exportation, a
woman sitting at a spinning wheel, surrounded by bales ready
for export, added in 1894 by *Butcher & Axtell* of London, sculp-
tors. Importation at the other end of the parapet has gone.
Opposite, the old established butchers' shop of W. Roch
James, early C19, three stuccoed bays and storeys. Its late C19
shopfront is one of the few survivors in town. Slate-hung gable-
end. Kent House to the r. is C18, refronted in the C19. Three
generous bays, two storeys plus attic. Early C19 Doric pedi-
mented doorcase. Good simple railings with urn finials.
Careful early C19 detail inside, a generous staircase rising
around a large rear stair hall. Opposite, No. 18 of three storeys
and one bay has a good Edwardian shopfront: end pilasters
with trophies. The Georges, opposite, established in 1803,
is low and narrow, three bays wide. Simple stuccoed detail. In
the same row, Nos. 28 and 30 look C18 (see the deep brack-
eted eaves), altered in the later C19. No. 28 has a shopfront
with fluted Ionic columns, at No. 30 the columns are unfluted,
with pronounced entasis. Next, Hamilton House, early
C19, three bays and storeys, plain pilastered doorcase. The
Palace Cinema on the corner of Market Street and Hill
Street was built as the corn market in 1847 by *William Owen*.
Two storeys and seven bays to Hill Street, divided by broad

piers, with stuccoed detail of 1912, when converted to a cinema. Round-headed doorways, some with iron radiating fanlights. Marginal-glazed sashes above.

Proceeding S, one enters the main early C19 suburb. In BUSH ROW, the exception is WILLESDEN HOUSE, mid-C18, five bays and three storeys, stuccoed. ST THOMAS' GREEN to the W is the site of St Thomas' annual fair. Now, inevitably, given over for car parking. Facing the green, the former INFIRMARY, 1873 by *D. E. Thomas*, three storeys, 3 + 3 + 3 bays, the outer bays gabled, balancing wings each side. The top storey of the central block added 1897–9, also by *Thomas*. On the N side of St Thomas' Green, the rear of Albany Chapel (q.v.), with Nos. 12–14, an attractive row of C18 cottages, Nos. 13 and 14 with simple dormers. The mortared roof of No. 14 is a once-common roof repair in windy SW Wales.

HILL STREET, to the N, has some graceful three-storeyed terraced houses, set behind iron-railed gardens. No. 1 is of three storeys, with a pedimented doorcase set on oddly detailed Ionic columns. COLLEGE HOUSE (for several years a Baptist college) is of four bays, including a glazed-in former cart-entry. Railings with spear and trophy finials. No. 91 has a full-height canted bay window and a pedimented doorcase on Doric pilasters, as does No. 89. To the N, a good terrace of two-bay houses of *c.* 1830. Opposite is THE DRAGON, three storeys and bays with plain, early C19 detail. Moving E, on the r.-hand side, HILLBOROUGH HOUSE, early C19 by *William Owen*, five bays, with Tuscan porch.* Fine staircase in rounded well with circular upper landing which has a domical ceiling. Nos. 12 and 14 on the same side, with Tuscan double doorcase. No. 23 with its tall, close-set sashes, looks C18; with early C19 detail, including fluting on the sashes. As Hill Street approaches the historic heart of the town, the scale becomes smaller. No. 13 and the PEMBROKE YEOMAN have simple C19 detail, but the broad roof-pitch suggests an C18 date or earlier.

Across Market Street, GOAT STREET runs steeply downhill, the lowest houses built up on a high terrace. From the top of the street, good rural views above the chimneypots. Like Hill Street, Goat Street was a fashionable C18 and early C19 residential area, also with stuccoed houses, but with a greater variety of scale. MORE HOUSE on the r. has six wide bays with dormers above the modillioned eaves. Probably late C18. No. 18, opposite, is a two-storey double-pile house of the early C18, the deeds dating back to 1732. C19 detail outside, including an attractive pedimented doorcase, presumably installed in 1807, when alterations are recorded. Good early C19 detail inside, including a staircase, which has reeded balusters, and fluted fireplace surrounds. In a first-floor room, a small round-arched cupboard survives from the original house. No. 7 (WILLIAMSTON HOUSE) has a wide front of five bays and

---

* Originally, there was a bay window over the porch, since clumsily replaced.

three storeys, set behind an iron-railed forecourt. Large pedimented doorcase on Doric half-columns. Nos. 8 and 10 are a large, stuccoed three-storey pair, probably later C18, No. 8 with a late pedimented doorcase on Doric half-columns – No. 9 is more humble in scale, with a wide, two-storeyed canted bay window of timber, with early C19 detail, such as sunken panels. No. 11, of two bays, has similar detail; doorcase with Ionic columns. After this, the two whitewashed gable-ends of the former stable ranges of *Nash*'s FOLEY HOUSE (*see* below), which stands opposite. Set on a high terrace, a row of the late C18 to early C19, mostly three-storeyed. Around a sharp r. angle HILL LANE, with a short stuccoed row. No. 33 and EMLYN HOUSE have pedimented doorcases on Ionic columns. Further down is a splendid octagonal GAZEBO of red brick, probably of *c.* 1840, rescued from dereliction *c.* 1990.

## 2. The North Side of Town

A start is best made back in High Street, at the entrance of DARK STREET, a narrow little street flanked by looming buildings, especially the backs of those facing St Mary's Street. In the rear of SWALES, a late medieval pointed door at basement level, with voussoirs, and a tapering projecting chimney. One flight of a C17 staircase. SUMMERVILLE HOUSE and SOMERSET HOUSE are a good early C19 pair, three storeys and stuccoed. No. 12 is a pretty two-storey cottage with later C19 pilastered shopfront. Dark Street suddenly empties out into MARINERS SQUARE, where the Mariners Hotel was established as an inn in 1625. The present five-bay building is of early C19 appearance. Porch on stone Ionic columns. Stuccoed detail against early C20 roughcast. Built against the side of Bethesda Chapel (q.v.), Nos. 16 and 17, with steeply pitched roof and, to the rear, a large lateral chimney, possibly C17. Ahead in BARN STREET, SPRING GARDENS, an unexpectedly imposing terrace of seven large two-storeyed, stuccoed houses with battlemented parapets and mansard roofs. Under construction in 1839, probably by *William Owen*, for William Rees, solicitor, a key promoter of the great improvements of the 1830s. Nos. 8 and 8a, Rees' own house, has a splendid two-storey veranda of wrought iron. The town's Marychurch Foundry was at its peak at this time: but the upper panels are different, in a *Coalbrookdale* pattern, of similar date to the house. In the large grounds behind, a sadly derelict small rockwork grotto on a mound. Further up Barn Street, the VOLUNTARY-CONTROLLED SCHOOL, built as a 'model' school (i.e. for teacher training) 1848–9 by *Thomas Rowlands*. Large and austere, set on a high terrace. Local sandstone with ashlar detail, seven bays and two storeys, odd shouldered windows with later glazing. Lower three-bay matching wings project, the end bays gabled with tall, paired trefoiled lancets. Further s again, the well preserved PERROTS ALMSHOUSES, *c.* 1846–66, the first houses at the top end by *W. H. Lindsey*,

the later houses matching in style. Very long row of two-storey stone cottages, stepped down the hill in five sections. Ground-floor windows with labels, upper windows below wide dormer gables. Back down Barn Street, Nos. 1–4 SPRING GARDENS is a pleasant, small stuccoed terrace of the early to mid-C19, with marginal-paned sash windows in full-height panel-like recesses.

Going W up CITY ROAD, past Tabernacle Chapel (q.v.), some good early C19 stuccoed houses climb the hill: for example, No. 24, three bays and storeys, set behind a deep iron-railed garden. CHURCH STREET runs E alongside St Martin's Church (q.v.) into QUEEN SQUARE, redeveloped 1972 (*Preseli District Council Architects Department*). The N side was given a short Neo-Georgian terrace *c.* 1975 by *Beaumont E. Minter*. NORTH STREET has CASTLE TERRACE, a well-preserved row of three-storey, two-bay stuccoed houses on a stone-faced terrace, with railings with anthemion finials. Dated 1832 at both ends on iron plaques; presumably by *William Owen*. A good period piece. ROCK HOUSE to the E is of *c.* 1700, three wide bays, two storeys plus attic. Projecting end chimneys and a steep roof on deep bracketed eaves, the façade remodelled in the late C19. C18 detail inside includes the panelled hall, with a reset arched cupboard. Simple, early C19 stuccoed houses in HOLLOWAY, terminated by GLOUCESTER TERRACE, a lesser terrace of *c.* 1840, two bays wide, three storeys high, with plain corniced doorcases arranged in pairs. Presumably by *Thomas Rowlands*, recorded as landlord in 1855. To the NE is the OLD BRIDGE over the Cleddau, rebuilt in 1726 at the expense of Sir John Philipps of Picton Castle. Repaired in 1829, and widened on the downstream side 1847–8 by *W. Rowlands*, stonemason and father of Thomas. Three shallow segmental arches and cutwaters. Fine large plaque to the upstream side, set in a tomb-like frame of ashlar limestone. To the NE in BRIDGEND SQUARE, now a traffic-congested roundabout, No. 16, with straightforward three-bay front with C19 detail. Inside some massive beams survive, and in the rear wing, a large fireplace with stone cambered head, served by a projecting, tapering chimney.

Going SE from Swan Square, BRIDGE STREET is one of the main shopping streets, with little of interest until one reaches CASTLE SQUARE and the CASTLE HOTEL, four storeys and three bays. Probably C18, though the present height and the large sash windows date from an early C19 remodelling. A three-storey block with a castellated parapet was replaced by WOOLWORTHS, *c.* 1955, which has a slightly apologetic, simple rendered façade.

HERMON'S HILL, off Goat Street. Home of *William Owen*, who extensively remodelled the earlier house. The hip-roofed garden front, perched high up overlooking the river, is of three storeys and bays, with a full-height, central canted bay window. Much more jolly is the smaller, three-bay range facing the

street, the entrance squeezed between two big bows rising
through both storeys; all on a charmingly miniature scale, but
intended to impress.

FOLEY HOUSE, Goat Street. Built *c.* 1790 for a leading local  84
attorney, Richard Foley, by *John Nash*. Foley was a younger
son of Ridgeway, Llawhaden, where Nash probably also
worked for his brother. The house is externally well preserved,
except for the unfortunate coat of dry-dash render applied by
Pembrokeshire County Council in the late 1950s, when it was
converted to offices. In plan, almost identical to Priory House,
Cardigan, completed by Nash some two years earlier, but
the façades here are classical, anticipating the symmetry of
Ffynone (*see* Newchapel). Two-storey s entrance front, five
bays long, the centre three slightly projecting and pedimented.
Round-headed niches flanking the entry, and round-headed
sashes beyond. The use of a broad string between the storeys,
deep bracketed eaves, and basement service rooms clearly
owes a debt to Sir Robert Taylor, in whose office Nash was first
employed. The basement is hidden behind the raised terrace,
the house itself set back beyond matching quadrant walls. That
to the l. joins the house to the plain two-bay service range,
which is treated as part of the adjoining terrace (cf. Priory
House, Cardigan). Further l., an altered carriage arch to the
original stables, dated 1794. The narrow E end of the house
is more dramatically Taylorian, pedimented and of three storeys
due to the slope. Broad, canted bay window, with (blocked)
lunettes for the basement, tall sashes for the drawing room,
and round-arched French windows to the balcony level above,
which has latticed iron balustrading. The garden front (N) now
overlooks the car park, but commands fine views over the town.
On a high basement with lunettes, the central three ground-
floor windows set within blind arched recesses (cf. Ffynone).
The plan reflects Taylor's and Nash's love of novel-shaped rooms.
The stair hall is immediately entered from the front door, with
the stair running l. within an apsidally ended well, occupying
a good quarter of the house. Cantilevered stone stair rising in
two flights, with scrolled wrought-iron balustrade. In the
ceiling immediately behind the front door, a simple plaster
roundel, with corner fluting, within a square panel. Behind the
hall, the dining room occupies the three W bays of the house.
Simple plaster cornice with floral frieze. White marble fireplace
(the only survivor) with corner roundels. The drawing room
on the E side is lit by the broad curved bay window; acanthus
cornice. Clever planning upstairs too. From the landing, a
spinal passage to the E, terminated by an archway before a
small lobby to the bedrooms.

AVALLENAU, Merlin's Bridge. A squarish villa by *William Owen*
of 1845–6, four-bay front, the awkwardness concealed by a
two-bay central Doric portico. Five-bay side with single-bay
centre pediment. Inside, a generous stair in a semicircular hall
and fine mahogany doors from Owen's workshops.

# HAYSCASTLE/CAS-LAI

The church stands alone E of Hayscastle Farm. Between the two, a Norman MOTTE, still distinct, though tree-covered.

ST DAVID. Of medieval origin, but nothing datable survives. Plain nave and chancel with bellcote, cheaply restored 1861–3. The brick Gothic windows are probably old-fashioned rather than earlier C19. Repaired 1927–8 by *D.F. Ingleton*. Bare interior with plain roof, one truss dated 1811. The chancel arch only 5 ft wide is inserted, the church was originally single-cell. – FONT. C13, scalloped, but retooled. – PULPIT and E window STAINED GLASS both of 1928.

NODDFA BAPTIST CHAPEL, Newton. 1924, old-fashioned stone gable front with a centre arch and arched windows.

LLANEDREN, ¼ m. N of Walterston Farm (SM 894 283). The former parish church of St Edrens, a small parish of some half-dozen scattered farms. As isolated as any church in the county, and now a house. Prominent on bare high ground, in an ancient circular Celtic churchyard, a bald work of 1846 by *Joseph Jenkins* of Haverfordwest. W tower, nave and chancel, the tower with flat corbelled parapet, showing early recognition of Pembrokeshire precedent, though the buttresses do not.

# HENRY'S MOAT/CASTELL HENRI

ST BRYNACH. Rebuilt heavily in 1884–5 by *E.H. Lingen Barker*, for £400, so that it appears entirely Victorian. Nave with central N porch and bellcote, chancel and S transept. Barker kept nave and transept walls but everything else is his. The gable crosses are white terracotta from Torrington. Plain but attractive interior with plastered arches to the chancel, S transept and from both chancel and transept into the SE vestry. Medieval chancel arch; the arches into the vestry are based on the remnant of a large squint. Two rood loft corbels on the nave E wall. – FONT. C12, cushion-shaped, on original round shaft and moulded base. – STAINED GLASS. E window of 1909, the Resurrection. C16 style, by *Wippell* of Exeter.

E of the church, an eroded Norman MOTTE.

SILOH CALVINISTIC METHODIST CHAPEL, Tufton. Dated 1842 and 1900, plain stucco with end porch and two arched windows on the side wall.

BUDLOY STANDING STONE (SN 064 286). 7-ft-high standing stone.

DYFFRYN STONE CIRCLE, 1½ m. ENE. (SN 059 285). The scattered remains of a 65-ft-diameter stone circle around a mound, thirteen stones remaining.

BERNARDS WELL MOUNTAIN (SN 056 292). On the SE slope, Iron Age round-hut sites, enclosures, and field system.

# HERBRANDSTON

Attractive village centre surrounded by indifferent C20 housing.

ST MARY. Tucked away E of the village green. Nave, chancel, and N and S porches. W tower added probably in the C15, with battered base below a chamfered string course. Lowered before 1740, a map of that date showing the battlements barely higher than the nave roof. These have been replaced by a simple half-hipped roof. Vaulted base. N porch (vestry) also with pointed barrel vault. Wide, shallow recesses each side of the chancel, similar to e.g. Johnston, each of these projections retaining a medieval lancet. Original Perp E window of three lights, a rare survival locally. Attractively restored in 1904 by *C. Ford Whitcombe* of Worcester, who added (or replaced) the square Perp windows. Homely interior. In the nave, carved stone CORBELS (king and bishop), the only survival of the medieval roof. – FONT. The square bowl is a replacement, but the scalloped underside and circular pedestal are Norman. – PEWS, COMMUNION RAIL and richly carved PULPIT, all oak and of 1904. Black and white marble tiles in the chancel. – Wooden ALTAR and REREDOS, 1927 by *J. Coates Carter*. ROOD of 1952 by *Francis Stephens* of London. – STAINED GLASS. All in the chancel. Two windows of 1992 by *Geoffrey Robinson* of *Bell & Son* of Bristol; Annunciation, and a figure of Christ in richly varied colours. – Two windows of 1957, by *Powell* of Whitefriars, Virgin with Child, John the Baptist. – MONUMENTS. Slab with incised floriated cross, worn face in relief above. Late C13 or early C14. – Mary Holcombe †1745. Crude, fluted vase finial. – Rev. William Roch †1858. Scroll type.

RECTORY, just S of the church. *John Cooper* remodelled an earlier house in 1839. Three-bay front, the middle projecting. Tudor hoodmoulds and curly bargeboards. Vast roof structure.

PRIMARY SCHOOL, ½ m. NNW. 1935, by *Owain Thomas*, County Architect. Low and symmetrical, nine bays long, the outer three on each side canted forwards butterfly-fashion – cleverly adapted to a sharp bend of the main road, and a model of its kind. Red brick, the sash windows, alas, altered.

SOUTH HOOK FORT, 2 m. S. One of the several forts built 1850–70 to protect the Milford Haven against possible French threat. Planned as a twenty-gun open battery with a defensible barrack S, carrying guns on the roof, to the rear. Begun 1859 and completed in 1865; the plans changed to provide two separate batteries protected by earthworks with guns mounted in embrasures, all connected by a covered way running along the rear. Large, two-storey D-plan barracks, protected by a two-storey counterscarp gallery and musketry galleries. E and W batteries, the latter replaced by gun emplacements between *c.* 1890 and 1905. Sold in 1936, turned into a country club, but all now derelict, the batteries altered when the Esso refinery was built.

# HODGESTON

Unspoilt little village clustered around the church, amid fertile countryside.

46, 47  PARISH CHURCH (dedication unknown). In the care of the Friends of Friendless Churches. Nave, chancel, C19 S porch and pencil-like tapering W tower, with the usual corbelled parapet, but without battlements. The stair-turret clasps the N side like a chimney. The two lower stages have pointed barrel vaults. C15? The nave and chancel are of similar lengths, the former probably C13, with a pointed barrel vault. The chancel is Dec, traditionally ascribed to the time of Bishop de Gower (1328–47). Its masonry is uncommonly good, with a string below the windows. Excellent surviving Dec work inside, especially the triple-arched SEDILIA with ogee-arched canopies rising to bold leafy finials, the trefoiled arches with ballflower ornament. Similarly treated double PISCINA, with four-petal flowers accompanying the ballflowers and better-preserved finials. Steps and corbels of the former rood loft. Remains of a stone cornice, with carved flowers of the ball and four-petalled types. All the C14 carving is of high quality, but reasons for such fine work in this small church are unclear. Repairs followed a visit by the Cambrian Archaeological Society to the dilapidated church in 1851. By 1856 *David Brandon* had completed a new Dec E window and an over-elaborate arch-braced roof. Brandon's 'dandy Gothic roof' was scathingly condemned in *The Gentleman's Magazine* in 1856 since it necessitated some destruction of the Dec cornice, and had no local context. The Dec N and S windows in the chancel are late C19 reproductions, when the nave was restored. – Good FONT of the square Norman type with incised linear pattern and crosses on the E and W faces. – Heraldic TILES by *Minton* in the chancel, including the arms of Rector Thomas, incumbent during restoration.

To the NW, visible from the road, is an overgrown but intact square MOATED SITE, with the earthwork of the surrounding moat.

# HUBBERSTON

The small scatter of houses near the church, overwhelmed by post-war Milford council housing, is now one with Hakin.

ST DAVID. Horribly obscured by a C20 shopping parade, but a most rewarding small medieval church, probably of the C15, with small W tower, nave and chancel, remarkably all three stone-vaulted. The tracery, transepts and symmetrically arranged N porch and N vestry are of 1929–31 by *J. B. Fletcher* of Cardiff, sympathetically done. Perp chancel windows. The interior is plastered. Fine late medieval triple SEDILIA, with nicely rustic mask carvings on the octagonal piers, which

otherwise have no capitals and support heavily moulded pointed arches. – FONT. C13, square scalloped bowl on a round shaft. – Pretty SCREEN, with pulpit and reading desk incorporated into the side bays, presumably 1929–31. Faded STAINED GLASS of *c.* 1881 in the E window, and two windows of 1958 and 1980 by *Celtic Studios.*

One extraordinary survival remains from the period of Charles Greville's creation of the new town at Milford. In Picton Road are the ruins of Greville's OBSERVATORY of *c.* 1805, possibly by *William Jernegan,* intended as the nucleus of a 'College of King George III', but abandoned on Greville's death in 1809. A very early example of an observatory dome with slit openings (an advance, for example, from the Richmond Observatory built for George III in the 1760s), all achieved in masonry, much of which has fallen. The observatory is octagonal and two-storey, with very modest single-storey wings. Off Picton Road, on the approach to Fort Hubberston, TELEGRAPH COTTAGE, originally three symmetrically arranged cottages built in 1855 as part of the telegraph system along the Haven.

FORT HUBBERSTON. Derelict and vandalized, Fort Hubberston remains perhaps the most impressive of the vastly expensive forts built to defend the Haven following the 1859 Royal Commission on the defences of the country. The original design was for a heavily armoured twelve-gun battery on the cliff above the water, with a further ten-gun open-air battery on top and another ten-gun earthen battery to the E, the whole defended by a fortified barrack complex on the hill behind. Work began in 1860 and was complete by 1865, at a cost of £87,894, though the armament was changed to eleven, eight and seven guns at the different sites. The later C19 history of the fort was of continual alteration to face ever more powerful artillery. Never attacked, it was abandoned in 1908, though used in both the First and Second World Wars for troop accommodation. Subsequent removal of the staircases (to make safe) and vandalism have severely damaged the barracks, but the massive limestone outer walls survive intact.

Roughly triangular site, with the parabolic curve of the barrack block at the apex, fortified on the exterior, facing over a dry moat, originally with a drawbridge to the main entry, dated 1863. High limestone walls from the barracks to the cliff edge, enclosing a considerable area, with the massive limestone main battery curving at the SW angle and the simpler earthen battery to the S, both with complex magazines tunnelled into the hillside.

The barracks are of rock-faced grey limestone, with flat concrete roofs, and high parapet pierced with gun-ports and musket-slots. They surround a triangular parade ground, while the parabolic curved range contains the main entry, barrack rooms and the officers' quarters (at the apex) in a series of twenty-one tall brick vaults, each containing two storeys. Each vault had a large room on each floor, heated by ducted warm

air, the upper rooms reached by an external gallery. From the apex a fortified passage crosses the dry moat to brick-vaulted musketry galleries behind the stone revetment of the opposite bank. The lower ends of the parabola-shape project as bastions, with a two-storey cross range between containing wash-houses and service rooms below and a hospital above, the roof flat with a defensive parapet.

The lower gun batteries are equally impressive, though the open batteries to the s are mostly overgrown. There were three groups of gun emplacements and four sunk traverses containing the underground magazines, protected by some 12 ft of mass concrete under earth cladding. Monumental casemates at the sw, twelve superbly built brick-vaulted chambers, eleven for guns with openings framed in granite, the twelfth an artillery store. The rear has massive stone corbels for the York stone gallery that formerly served the open-air battery on top. The platform was covered *c.* 1870 in mass concrete, with eight 10-ft pits for Moncrieff disappearing-guns, though the pits were partly infilled about 1893. Oddly, there was only access by foot to the gun emplacements from within the fort. Wheeled traffic could enter only via the big foritified gateway at the end of the sw battery. The magazines built into the hill behind the casemates have complex access arrangements to provide security from accidental fire and from blast.

St Botolph's, 1 m. N. A big plain three-storey house in unpainted stucco, five bays to the front and six to the side, originally of two storeys. Built for the Elliot family in 1800, the upper floor added *c.* 1830 for A. J. Stokes, possibly by *William Owen*. Later C19 columned porches and side wing. Interior subdivided.

9600

# HUNDLETON

C19 and modern houses around a triangular green. Off to the w, the grey limestone PRIMARY SCHOOL, 1872 by *K. W. Ladd*, extended later, and the church. The parish slopes N-wards to the Haven, with LIMEKILNS surviving at Fleet Farm and Goldborough Pill. The hamlet of BENTLASS, once a ferry crossing to Pembroke Dock, has a stone waterside WAREHOUSE of the mid-C19. The s part of the parish was mostly part of the Orielton estate (*see* below). Several farmhouses have a massive square outside chimney, a south Pembrokeshire feature from the C17 to the mid-C18. The best is BROWNSLATE, early C18, with the chimney on the service wing, and a good selection of farm buildings, including a C19 barn with pierced brick lozenges. A small outbuilding NE of the house has a rough-vaulted basement, which could be C16. YERBESTON, near St Petrox, dated 1793 on the farmhouse, has the stack on the earlier service wing, and LOWER CASTLETON has one on the farmhouse, otherwise early C19.

ST DAVID. 1933, by *W. Ellery Anderson* of Cheltenham, replacing a corrugated iron church. An interesting design in brick with arched narrow windows and Roman tiles, i.e. in the Italian early Romanesque style in vogue at that date. Plain white interior with broad roof trusses, simple and effective. No chancel division. – S side STAINED GLASS of the 1970s by *Celtic Studios*. – E window of 1948.

GILEAD CALVINISTIC METHODIST CHAPEL, Maiden Wells. 1876, probably by *K. W. Ladd*. Plain, but the attractive little previous chapel of 1845 survives opposite. Lateral façade, two big arched windows with interlaced glazing bars.

ORIELTON, I m. S. One of the principal country houses of the county. The present house externally dates from 1810, when remodelled by the spendthrift John Lord, who was unexpectedly left the estate by the young sixth baronet, Sir Hugh Owen. He had bankrupted it by 1841. Plain painted stucco exterior, three storeys and basement, quite extraordinarily featureless, both the E entrance front, shortened from thirteen bays to the present eight in the 1870s and the eleven-bay garden front. Just angle pilasters, sill courses and cornice with low parapet for relief: the pilasters and cornice have been simplified. The cambered-headed sash windows on the upper floor may be an echo of the brick and stone house of the 1730s (described at the time as being 'like Llanforda', Oswestry, a house of 1715 attributed to Francis Smith of Warwick). The entrance front, with its two-bay central Doric porch, had until the 1870s a second porch and a tent veranda between. The four-bay S end has crude arcading on two floors, possibly simplified, with half-round piers and first-floor tripartite windows with broad fanlights. The ground floor has blank openings and a tall door with fanlight. Two C18 armorial downpipes and C20 Owen arms.

Inside, evidence of the earlier house survives only in the basement service rooms on the entrance side, one plaster ceiling with simple roundels, some heavy beams, and some fielded panelled shutters and doors. Spectacular central stair hall, a cantilevered open-well stone stair rising full height with French Empire iron balustrade and good plasterwork, suggesting work in the 1820s. Spine passage behind the enfilade of three principal rooms on the garden front. The main rooms have Neo-Grecian acanthus cornices, trailing centre roses and marble fireplaces. The centre room, three bays, has double doors each end and a coved cornice. There is said to have been an internal orangery at the S end, but if so, it has been subdivided.

Below the house, an early C19 STABLE COURT, hipped, two-storey, three-bay centrepiece with ogee-capped lantern, and single-storey ranges. To the NE, four-acre WALLED GARDEN, roughly octagonal, with ORIELTON GARDENS, an early C19 estate house, hipped, two-storey, three-bay, outside to the NE. A further large walled garden well to the S of the house was called the American Garden, apparently planted with

American pines in the C19. Adjoining is a remarkable three-storey BANQUETING TOWER of *c.* 1730, in red brick with Bath stone dressings, presumably similar to the mansion as rebuilt then, and notable also for the early use of brick. Ground floor with carriageway through, the upper floors red brick with brick and Bath stone corners, Bath stone windows, a little crude, with flat voussoir heads, and a high brick parapet.

Around the estate, an extensive collection of lodges and farms, mostly late C18 to early C19. By the main drive, NORTH LODGE, Gothick and two-storey with canted ends. Opposite, in a big walled garden, BRICK HALL, earlier C18 painted brick front of five bays, on a small scale. Further w on the same road, WEST LODGE, early C19 Gothic, with double windows and comic double eyebrow stucco surrounds. One of a row of three octagonal chimneys survives. The ruinous GAMEKEEPER'S COTTAGE, opposite the banqueting tower, was identical. Further w, IMAGES LODGE, hipped, with hoodmoulds. Lead putti on the gatepiers are said to come, like those on Pembroke clock tower, from the 1730s house. ROSE LODGE, NE of the estate, is identical. WEST ORIELTON LODGE, behind West Orielton Farm, hoodmoulded with a pedimental porch on brick piers, presumably altered; it had octagonal chimneys. EAST LODGE, at East Orielton Farm, was more classical, stucco with inset arched windows, but is almost unrecognizable.

Of the three estate farms, HOME FARM, by the walled garden, is all altered. EAST ORIELTON has extensive C19 farm buildings, the farmhouse and buildings attached now converted to a multicoloured terrace. WEST ORIELTON, with mid-C19 N front to the house, and older s range, has two yards of C19 outbuildings, the E yard incorporating an exceptionally large round DOVECOTE, with some 1,500 brick nesting boxes inside. The use of brick suggests an C18 date.

CORSTON, 2 m. sw. Plain, whitewashed three-storey, five-window house with semicircular timber columned porch. Probably built for Abraham Leach, who moved here in 1779. The interior detail, reeded pilasters and plain staircase, offset at one end, suggest the early 1800s. Bay windows were later pushed out each side of the porch.

*0598*
# JAMESTON
1 m. NW of Manorbier

Once one of south Pembrokeshire's best-preserved villages. Several cottages had round and square chimneys of the C16, all surviving until shortly after the Second World War, when local authority housing was built, and the main road straightened. Of chief importance now is the rather self-important GREEN GROVE, the three-bay front stuccoed with unusual raised panels – early C19? The projecting gable chimney suggests earlier fabric, probably C18. Porch of *c.* 1900 with cast-iron columns, and

splendid iron railings in front. Old maps suggest a square moated site. Big gable chimneystacks at both PLOUGH COTTAGE and the SWAN LAKE INN. Finally, TUDOR LODGE, an attractively Gothick three-bay house of early C19 appearance, with arched windows and rounded chimneys. The odd proportions suggest a remodelling.

# JEFFREYSTON

Good village, clustered around the church, whose hilltop site is visible for miles around. Mostly C19 cottages and farmhouses: e.g. ROSE VILLA, three bays with attached lower kitchen. JEFFREYSTON HOUSE, W of the church, has a three-storey C18 stuccoed front of five unequal bays and two long rear wings. Early C19 tall iron railings in a semicircle, the posts with urn finials, brick piers. Imposing for a village house.

SS JEFFREY AND OSWALD. The original churchyard is roughly circular. Of the old church, part of the N transept, the twinned (C14?) S chapel and parallel transept and S porch survive. Commanding, slim and embattled W tower, C14 or C15. Sir Stephen Glynne remarked on the 'curious effect' of the three-gabled S elevation. Chapel, S transept, porch and tower all have pointed barrel vaults. The nave and chancel were rebuilt with added N aisle in 1868 by *T. Talbot Bury* (cf. Burton). Solid and unfussy work, but not overly muscular: lancets and a three-bay arcade of unchamfered dressed limestone arches on round piers, the outer order on blocky corbels. The piers were inspired by one in the chancel of Castlemartin church, as at Burton. – FONT. C12. Large square bowl, scalloped underneath. – Ornate late C19 REREDOS with marble colonnettes and traceried panels containing alabaster. – FURNISHINGS largely by *Talbot Bury*. – STAINED GLASS. E chancel, S and N transept, all 1868 by *Heaton, Butler & Bayne*. – Nave S, 1904 by *R.J. Newbery*. – Squint window of 1972 by *John Hall*, SS Christopher and Francis. – In the porch, a C6–C8 CROSS-SLAB with incised ring-cross and slightly splayed intersecting arms. – MONUMENTS. Edwards family, 1794. Plain, square and well lettered. – In the chancel, several to the Allens of Cresselly. John Bartlett Allen †1803. Sarcophagus type with painted brass shield above. – Gertrude Allen †1825. By *Wood* of Bristol, large urn finial. – John Hensleigh Allen †1843. Gothic, crocketed gable with pinnacles. – John Young †1858. By *Lander* of London. – Seymour Philipps Allen †1864. Gothic, supported by a carved angel. – Penelope and William Keates, 1869. Also by *Lander*, broad draped urn. – Christabel Lloyd †1996. Small oval, finely lettered. By *Ieuan Rees*.

In the churchyard, C14 PREACHING CROSS, a tall tapering shaft, the upper section repaired 2001.

RECTORY, ¼ m. W. 1892, by *William Newton Dunn*. Extended and given red tile-hanging in 1902 by *George Morgan & Son*. On

the roadside to the E is a small stone crudely carved as a WAYSIDE CROSS.

PRIMITIVE METHODIST CHAPEL (former), Cresselly, 1½ m. W. 1893, by *K. McAlpin*. Gabled front with traceried window. Side porch. Well converted to a house in 1991.

# JOHNSTON

Busy village, strung out along the main road with the church in the centre.

ST PETER. A single Perp build or more likely remodelling, little altered. Pencil-slim tapering W tower, the battlements skilfully added to a plain corbelled parapet, presumably during the conservative restoration of 1893 by *Kempson & Fowler*. Perp tracery in the belfry, quatrefoils over trefoiled lights. Cruciform plan, the tiny transepts with flattened stone vaults, like the base of the tower. The chancel with shallow projections each side, (cf. Herbrandston). The E window has panel tracery, which is repeated on a diminutive scale in the transepts. Other windows with straight heads. Delightfully coherent interior. Chancel arch chamfered all the way down to broach stops. Square squint window on either side, each with two arched lights. Corbels of the rood loft. PISCINA, also a tiny one in the S transept. SEDILIA, the pair of plain chamfered arches upon a circular column. Roofs of 1893, skinny arch-braces in the chancel. – Norman FONT, square scalloped bowl on a circular pedestal. – Oak PEWS and PULPIT of 1908, made by *Hems & Sons*. – MONUMENT. Slab incised with an elaborate floriated cross, set in the sanctuary step. C15?

JOHNSTON HALL, just S of the church. An ancient and formerly aristocratic seat, but now offering little. The buildings now lie around three sides of a courtyard, open to the S, the E range a barn, save at the S end. Here is the only old survival – a C16 GATEHOUSE from the time of the Butlers. Single room above, under a gabled roof, no ornament. The passage has a shallow stone vault. External stone stair to the upper room, fitted up in the late C19 as a study. Opposite the barn, a low, two-storey double pile, with awkwardly adjoining cross-wing. Inside some C18 features from when the house was owned by the Edwardes family, Lords Kensington (sold 1835). The former principal bedchamber has an early C18 moulded wooden cornice and wooden chimneypiece with lugged panels above. A small closet (not adjacent) has big-fielded panelling and a pedimented overmantel. In 1873 the house was purchased by Richard Carrow (founder of the formerly adjacent brickworks), who employed *E. H. Lingen Barker* to modernize (fussy bay windows etc.). GATES – a fine wrought-iron pair, with overthrow topped by a crest of crossed battleaxes, apparently early C18, but of unknown provenance. In the woods to the E, a subterranean stone WATER CISTERN with vaulted roof.

## JORDANSTON/TREWRDAN 9132

The church and Jordanston Hall stand alone. LLANGWARREN BRIDGE, to the S, is a small four-arch structure, probably C18. JORDANSTON HOUSE to the E was the rectory, 1888 by *D. E. Thomas*, plain stucco, hipped.

ST CWRDA. A plain little church with thin embattled tower, nave and chancel, all apparently rebuilt in 1863 for Sir J. J. Hamilton. (Plaques record a rebuilding in 1797, and a tower restoration in 1881.) S vestry 1909 by *Hugh Thomas*. Illiterate chancel arch, in Bath stone. Modern cement render contrasts poorly. – Plain oak FITTINGS of 1863. – C13 circular scalloped FONT. – E window STAINED GLASS by *Celtic Studios*, 1949. – MONUMENTS. In the chancel, Jenkin Vaughan †1675, nice plaque with Jacobean tapering pilasters and swan-neck pediment. – Adjoining, Gwynne Vaughan †1808, marble with draped urn, and Gwynn Gill Vaughan †1837, by *E. Physick*, draped urn and oak wreath. Greek but with a Victorian fullness. – FLOOR SLAB to Thomas Mathias of Llangwarren †1617, a rarity in the area, with shield and border inscription.

JORDANSTON HALL, W of the church. A much modernized long stuccoed front with eaves cornice, of two storeys, six bays, with further two-bay service range to the l. and a hipped wing projecting at the r. Four l. bays have narrower windows; indicating a core of the earlier C18, or earlier, (a house of five hearths was assessed here in 1670). Held by the Vaughan family from the mid-C17 to 1837. Lewis Vaughan †1755, High Sheriff in 1717, was probably the main builder.

LLANGWARREN, 1m. SE. Late C19, plain hipped house in two parallel ranges, the rear one longer, a recasting of something earlier; the Mathias family (also of Lamphey Court) are recorded here from the C16. By the house, a C5 or C6 INSCRIBED STONE, marked DOVAGNI TIGERNACI DOBAGNI, found 1896. In the farmyard, an early GRAIN SILO, of the 1920s, of very thin reinforced-concrete blocks, spalling badly.

CASTELL HENDRE WEN, ½ m. N. Circular hillfort with NW entry.

## KILGETTY 1207
### 2 m. N of Saundersfoot

Scattered settlement, with the expansive Kingsmoor Common to the W.

KILGETTY FARM, 1 m. NE. Formerly Kilgetty House, now mostly demolished and most notable for the fragments of the GARDENS. The estate, first mentioned in the C16, passed to the Philipps family of Picton in 1706. John, second son of Sir John Philipps, enlarged and altered the house 1725–6 and began a garden on the hilltop site, still unfinished when he succeeded

unexpectedly to Picton in 1743. The site, confirmed by aerial photographs, is shown on a plan by John Butcher in 1743. A perspective of similar date shows a house of three bays and storeys with a bowed railed forecourt, flanked by long ranges. In front was a symmetrical series of walled gardens, the set nearest the house with a large central fountain. The main axis was closed by the now-ruined BELVEDERE (*see* below), with D-shaped pond in front, now filled in. All rather old-fashioned for the period. The upper gardens (i.e. those nearest the house) were laid out as geometrical parterres, each with a statue. Other statues flanked the central avenue. The house was mostly demolished in the C19, when the ranges became farmhouse and stables. The bowed wall of the forecourt still stands, along with parts of the walled enclosures. The thoroughly sophisticated belvedere was originally of three storeys, apsidal, with square stair-turret to the rear. The front had a Tuscan ashlar arcade on the ground floor, mostly fallen. Who was the architect? Could it have been *John James* who built the belvedere at Picton in 1728 for Sir John's father? To the NW, ruins of several ancillary buildings and a large DEER PARK, still used in 1818.

KINGSMOOR PRIMITIVE METHODIST CHAPEL (former), ⅔ m. SW. Built *c.* 1870. Simple Gothic, dressed limestone surrounds against render, the front with thin buttresses. Interior stripped. Probably by *Davies & Roberts* (cf. Zion, Begelly, and Bethesda, St Issells).

# LAMBSTON

3 m. NW of Haverfordwest

ST ISMAEL. Windswept and bleak, set in a circular churchyard next to a farm. Small and much restored. Nave with w bellcote, chancel. Simple whitewashed interior, the only medieval features the corbels of the rood loft and a trefoiled N lancet. Early C19 raised BENCHES to the rear of the nave, set against a high wainscot. *F. Wehnert* re-roofed the nave in 1869, arch-braces with angle struts. A scheme by no less an architect than *Temple Moore* in 1894 for internal decoration was not realized. *H.J.P. Thomas* added the chancel roof in 1912. *John Coates Carter* produced plans for a restoration in 1923, but nothing was done. – The best feature is the large Norman FONT, the typical square bowl scalloped underneath. – Carved oak PULPIT, a memorial of the 1914–18 war.

FRIENDS' BURIAL GROUND, ⅔ m. SE. According to a plaque, established by the Quakers in 1661. Small square walled enclosure, much overgrown. Some C19 MONUMENTS and a C17 plaque on the wall, sadly broken.

EAST HOOK, ⅔ m. E. C18 house, three storeys, five bays. Simple C19 external detail with Doric porch. Inside, a Chinese Chippendale staircase of the later C18.

# LAMPETER VELFREY/LLANBEDR EFELFFRE <small>1514</small>

Linear village set deep in a wooded valley, with the church at the
E end.

ST PETER. Double-nave plan, N transept and S porch with
tall moulded doorway, the latter resulting from *Prichard &
Seddon*'s restoration of 1860–6, as do the elaborate open Gothic
bellcote and Dec windows. Some of the exterior detail was
reinstated in the restoration of 1998–9 by *Wyn Jones*. As at
Llanddewi Velfrey (q.v.), the patron was Richard Lewis of
Henllan, Bishop of Llandaff. The N aisle (nave) is the earlier,
the exact date uncertain. Very crude, blocked two-light S
window, probably C17, and on the N side, a damaged Perp
window originally with two trefoiled lights; probably reset.
The unusually monumental arcade is of five lofty chamfered
arches on round piers with simple caps. Long considered
E.E. (Glynne), due to the cushion-like nature of the bases and
abaci. But a later date must not be ruled out; cf. later medieval
round piers and cushion detailing at, e.g. St Florence and
Begelly. Two arches removed in 1839 by *John Davies* of
Narberth were reinstated by *Prichard & Seddon*. Roofs of the
1860s, arch-braces in the N aisle and scissor trusses in the S. –
FONT. Much-restored square Norman bowl. – Teak PULPIT
with deep shaped panels. – PEWS with big pegged joints and
CHOIR STALLS with open tracery. All of 1860–6. – Pretty,
painted metal COMMANDMENT PLAQUES, presumably of
the same date. – STAINED GLASS. Very good three-light E
window of 1860 by *Clayton & Bell*, depicting the Transfigura-
tion in predominating reds. – S aisle E by *Belham & Co.*, 1881.
Resurrection and Ascension, confidently composed. W
window, installed 1901, by *R. J. Newbery*. Faithful servant with
SS Peter and David. A large piece of work for that artist. – N
aisle NE, *c.* 1877. – MONUMENTS. Jacobean chest-tomb with
carved shields and strapwork, traces of the original paintwork
survive. On the side, an incised date of 1611. – Lewis John
†1696, Baroque, with Ionic pilasters and broken pediment
with vinework scrolls and reclining cherubs. – Elizabeth
Lewis †1793. Shaped tablet. – Catherine Philipps †1805.
Sarcophagus-shaped tablet in wide frame. – Richard Willy and
family, 1819. Bold lettering, fluted pilasters, and urn above,
with painted shield.

   CHURCHYARD CROSS, three steps and octagonal base; the
crucifix is a replacement. To the W, the small Gothic CHURCH
ROOM of 1875, by *George Jones* of Aberystwyth.

VICARAGE. Stuccoed, three bays and three storeys, with off-
centre bay window. A remodelling of the late C18 vicarage in
1852, by *James Wilson* of Bath, for Richard Lewis. The porch
and wing have been demolished.

GLANRHYD BAPTIST CHAPEL, 1½ m. S. 1902 remodelling of
1835 fabric. Simple gabled front with an arched window each

side of the door. Interior of 1902 with rear gallery and char-
acteristic detail, probably by *J. H. Morgan.*

Bryn Sion Congregational Chapel, ½ m. w. Built in
1879 by *John James* of Narberth in simplified Romanesque.
Rock-faced limestone with Bath stone dressings. Romanesque
gable, and porch with colonnettes. The interior is unexpec-
tedly urban. Three-sided gallery on iron columns, and plaster
ceiling with timber ribs. Organ chamber behind the pulpit,
1923 by *J. Howard Morgan.*

Carvan Congregational Chapel, 2 m. e. Dated 1797, but
a rebuild of 1835. Rendered lateral front with arched windows
and outer doors. Hipped roof. Inside is the three-sided gallery
of 1835 (an iron column is dated), the front with fielded panels.
Work in 1873, by *Rev. Thomas Thomas* of Swansea, included
the seating, pulpit, and overhauling of the gallery, providing
interior gallery stairs in place of exterior stone steps.

0100

# LAMPHEY/LLANDYFAI

St Faith and St Tyfei. In the village centre, dominated by
the tall, tapering late medieval embattled tower. Cruciform
church, nearly all rebuilt 1870–1 by *Ewan Christian.* Two
medieval lancets in the chancel, the n one looks E.E., with a
continuous roll moulding and trefoiled head, the s one c14 or
later, with hollow chamfer. Barrel-vaulted s porch, probably
c15. Inside, c14 piscina, partly blocked squint and an odd
quarter-round s transept arch. The rest all by *Christian,*
a standard job with tall plate-traceried windows, and arch-
braced roofs in nave and chancel. High chancel arch on corbels
with painted inscription above. Carved stone reredos with
mosaic-filled panels. – The Norman font is among the best
in the county, the square bowl decorated with well-carved
six-petal flowers in roundels. Pedestal with two tiers of cable
mouldings. – stained glass. Three-light e window of 1871
by *Lavers & Barraud,* Crucifixion. – Chancel s, 1871. – w
window of *c.* 1880, – Monuments. Ann Merchant †1761.
Veined marble, neatly lettered. – John Williams and family,
1773. Fluted base with paired winged cherub heads. –
Margaret Parry and family, 1794. Pilasters and broken pedi-
ment with cartouche. – Harry Kemm and family, 1819. Large
urn. – James Thomas and family, 1865. Scrolled parchment
type, by *King* of Bath. – Charles Mathias †1865. Gothic frame.

Opposite the simple lychgate, a tall medieval slab with
incised cross, the arms with rounded projections halfway
along.

Pockets of the much-developed village suggest that it once
was quite Picturesque, due to its development by Charles
Mathias of Llangwarren. He bought the manor in 1821, and built
Lamphey Court (*see* below), a temple-fronted house overlooking
an Arcadian landscape with the Gothic ruins of the nearby
Bishop's Palace (*see* p. 240).

First, beginning at the E end, is the C17 LOWER FARM: square lateral chimney and Victorian dormers. LAMPHEY HOUSE is early C19, stuccoed and formal, with a good fanlight. To the W, now in a garden, the isolated base and cylindrical shaft of a late medieval lateral chimney of a long-vanished house. COURT HOUSE to the W has a C19 white-washed front of four bays. S of the church, the hip-roofed OLD SCHOOL HOUSE, three bays with Gothick windows, perhaps *c.* 1830. The single-storey CHURCH ROOM continues the Picturesque note, even though it is dated 1897; door and windows with ogee heads. The iron windows with intersecting glazing were reused. Designed by *G. C. Churchward*. Opposite, THE VENISON, early C19 with later dormers. LAMPHEY HALL, in the centre of the village, has an island-like front garden enclosed by railings. Four bays long and stuccoed, the core *c.* 1820, but concealed by large-scale alterations in 1896, when it became the vicarage. To the W, THE LODGE of *c.* 1830, stuccoed and single-storey, with Gothick windows.

NORTH DOWN, 1 m. NW. Good, early C19 COACH HOUSE, five bays long, the centre bay wider and pedimented.

LAMPHEY COURT HOTEL, ½ m. N. Nestling in the trees, one of the best surviving Greek Revival houses in south west Wales, begun *c.* 1821 by Charles Mathias, and dated 1823 in the roof. By *Charles Fowler*, architect of the Covent Garden Market, 1828. The handsome stuccoed façade, seven bays long, has a bold tetrastyle portico with unfluted Ionic columns. Inside, a centrally placed open-well staircase with iron balustrade, and plaster cornices in the main rooms with anthemion decoration (much repeated in the now-dispersed furniture), the style suggesting that *William Owen* fitted up the interior. The drive crossed a bridge with ornamental ponds below. Fowler's grander landscape scheme was not used. Neat limestone service buildings set back by the house, rationally planned.

## LAMPHEY PALACE
½ m. N.

4
pp. 240,
241

Gerald of Wales recounts that during the thwarting of a Welsh siege of Pembroke, the bishop of St Davids lived 'hard by' the town; almost certainly a reference to Lamphey. Surrounded by fertile farmland, Lamphey seems to have been a favourite country residence of the bishops of St Davids. Between the early C13 and mid-C14 no fewer than three ranges were built, each one larger and more splendid than its predecessor.

The palace had two courtyards, with the main complex to the SE, at the centre of which is the earliest surviving part, the early C13 OLD HALL. Adjoining to the W, the larger and finer WESTERN HALL perhaps by Bishop Richard Carew (1256–80). The long range to the E, with its distinctive arcaded parapet, is attributed to Henry de Gower (1328–47), on the basis of his similar work at St Davids: the quality of the stonework at Lamphey is admittedly much poorer; however, the lancets in the

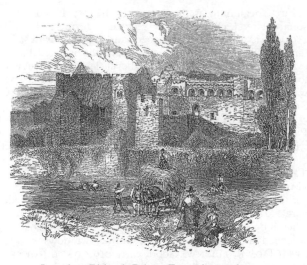

Lamphey, Bishop's Palace. Engraving, early C19

undercroft are undeniably Dec. Much remodelling early in the
C16, possibly by Bishop Robert de Sherborne (1505–8). Leland
informs us that Edward Vaughan, bishop 1509–22, was respon-
sible for building the CHAPEL (immediately N of the Old Hall)
and the great BARN to the N. An inventory of 1536 mentions
twenty-seven rooms. The palace was surrendered to the Crown
in 1546 and granted to Richard Devereux, whose heirs, the earls
of Essex, held it until the Civil War. Lamphey was garrisoned for
Parliament, providing Pembroke with stores. In 1683 the Owens
of Orielton purchased the estate, and did little more than convert
the palace to farm buildings. The manor was bought in 1821 by
Charles Mathias of Llangwarren, who turned the palace into a
secluded walled garden, carefully maintaining the ruined build-
ings. The palace came under Ministry of Works care in 1925 and
is now maintained by Cadw.

A tour may conveniently begin with the ruined OLD HALL, of
the early C13, at the centre of the complex. Enough survives
to indicate a rectangular first-floor hall with a timber-ceiled
undercroft. Early C16 remodelling raised the roof level,
inserted larger windows and a new fireplace, served by a coni-
cally shaped chimney. Perhaps its function as a hall was lost
later in the century when the larger and grander battlemented
WESTERN HALL was built; a latrine block was added to the
SW of the Old Hall, which may have been made into service
rooms. The first-floor entry of the newer hall is clear to
see; the doorway has a capital with chunkily carved stiff-leaf.
Small, conical lateral chimney jettied forward on odd, pendant-
shaped carved corbels – a C16 alteration? The plan is odd; the
fireplace is in the centre of the N wall, rather than towards one

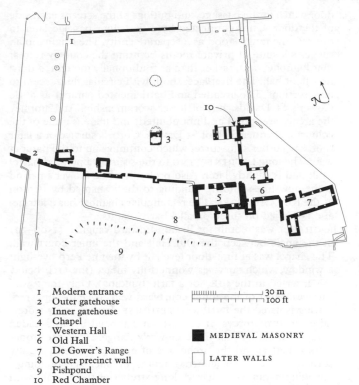

1 Modern entrance
2 Outer gatehouse
3 Inner gatehouse
4 Chapel
5 Western Hall
6 Old Hall
7 De Gower's Range
8 Outer precinct wall
9 Fishpond
10 Red Chamber

|||||||| _____ 30 m
|_____| 100 ft

■ MEDIEVAL MASONRY

☐ LATER WALLS

Lamphey, Bishop's Palace. Plan

end, as one might expect, and opposite is a tiny projecting chamber, engulfed in a later latrine-turret. Inside, the main surviving detail is the PAINTED DECORATION, probably C13, in the heads of the S windows and in the SW corner. Red ochre on a rich cream background, imitating blocks of ashlar. In the window splays the blocks contain five-petalled flowers. Also visible are traces of a border containing festoons in red paint. Much Tudor remodelling, see the surviving hoodmoulded SE windows: the shafts of their C13 predecessors survive, the leafy capitals of high quality. The barely discernible row of stone barrel vaults in the undercroft must be an insertion, probably also C16. The gables, also, are later.

DE GOWER'S RANGE to the E is long and narrow, resting on a vast, rugged barrel vault, of pointed form. Its vertical ribs have been robbed, but some of the Dec lancets survive. The hall above is now a single chamber; but the emergence of the first-floor entry well towards the centre of the upper storey suggests that formerly there were two chambers each side of a passage. This seems to be confirmed by a small window opposite the

door which lit the passage, and putlogs of the screens each side of the door. Until connected by a first-floor passage later in the C16, the range stood as a separate entity. The original plan suggests a suite of private rooms befitting the country retreat that Lamphey was, rather than as traditionally thought, a third first-floor hall. The fireplaces, both with circular flues, seem to be insertions. The arcaded and battlemented parapet as at de Gower's St Davids, but of lesser workmanship. At Lamphey the arches are round and not pointed, and there is none of the colourful chequerwork of St Davids. Corbels survive of a later roof. s w corner stair-turret which continues up to the parapet walk. The long LATRINE WING to the s sits on a pointed barrel vault and is slightly later. Also probably of de Gower's period is the now free-standing building to the N, named by Fenton as the RED CHAMBER. The rectangular chamber has a latrine, and is carried on three parallel barrel vaults.

62   The CHAPEL was rebuilt for Bishop Edward Vaughan (1509–22) in the angle between the Old Hall and the inner court wall. The chapel was at first-floor level, lit by the fine Perp five-light E window, which survives wonderfully intact (the arch below was inserted in the C18, for a farm building). Only the E wall survives. Most of the inner courtyard walls have disappeared, leaving isolated the INNER GATEHOUSE. Earlier lower storey, raised to two storeys in the C16, and topped by an arcaded parapet, imitating that of de Gower's Range. Here, the stone-work is better, and the arches are of pointed form. In the s w corner of the outer court, remains of ancillary buildings, including a vaulted cellar. A long stretch of the N wall, with regularly spaced loops, is the surviving rear wall of Bishop Vaughan's massive BARN. The ruined OUTER GATEHOUSE lies to the sw; part of it became a dovecote, possibly in the C18.

The boggy valley to the NE contains a series of medieval FISH-PONDS. First the 'servatoria' or holding ponds, four stone-lined small ponds stepped up to two top ponds side by side behind a stone dam with centre sluice. The stream is chan-nelled separately to the w. Then in the woods above are prob-ably the four 'vivaria' or breeding ponds mentioned in 1326, now boggy depressions.

At UPPER LAMPHEY PARK, 1m. NE, a small rectangular building of medieval date, now two storeys, originally three. Was this a hunting lodge for Lamphey Palace? Both storeys are heated, the upper fireplace with a hood on moulded corbels. Blocked doorway at both levels, possibly suggesting the exis-tence of an attached first-floor hall. The sw stair-tower is an addition. Buck's print indicates a tall, tower-like building, with a large and lower structure attached, occupying the site of the present barn, which is largely a C19 rebuild. The walls of the DEER PARK to the sw are still discernible. LOWER LAMPHEY PARK, just s, is a broad, hip-roofed early C19 house, once slate-hung, rescued from dereliction c. 1990.

# LANDSHIPPING

1½ m. NW of Martletwy

LANDSHIPPING QUAY alongside the Cleddau estuary was reconstructed in 1801 for Sir Hugh Owen of Orielton, whose colliery at Landshipping was one of the most productive of the day. Coal was probably being mined here from the C16, but most of the surrounding collieries had closed by 1870. In 1844, a colliery disaster killed 40 workers.

NEW LANDSHIPPING, ½ m. NNE. Ruined shell of a substantial house rebuilt in 1837 by *William Owen* for the Owens of Orielton. Two big full-height castellated bows, the right one of three storeys as it refaces the end of an earlier C18 house, the new work oriented to face across the water to Picton Castle and Slebech, which it mimics.

GREAT HOUSE, 1 m. The big C17 house of the Owens of Orielton (taxed in 1670 at 20 hearths) has entirely vanished but its relict garden is remarkable, especially as shown in aerial photographs. Fenton (1810) relates that it was a favourite residence of Sir William Owen (†1781, aged 84) 'where the venerable baronet lived much, in a style of hospitality but little known and practiced these days'. Thereafter abandoned. A very early brick garden enclosure of *c.* 1700 is all that is upstanding now. That this enclosed a courtyard or pleasure garden is evident from the large, regularly spaced openings between brick piers along its SW face, giving views over the main garden and beyond. Below, shallow terraces at right angles step down to flatter ground, where aerial views show a complex layout of ridge and furrow beds, a dotted grid pattern representing orchards and a large and deep (but now dry) rectangular tank. At the lower end of this, ruined stonework amid brambles may be the remains of the 'water follye' being constructed here in 1697 by *Mr Hancock* for Sir Arthur Owen, who was at the same time laying out the fine gardens at Coedcanlas (see p. 172). Beyond this, a wilderness with informal ponds in a tiny valley. A few ancient oaks survive only randomly from a broad avenue leading W to the water.

# LAWRENNY

Attractive loose-knit village, the church to the W, set against a wooded backdrop.

ST CARADOG. Mellow, spreading fabric, dominated by the tall and graceful battlemented W tower of limestone blocks. Short corner pinnacles (cf. Begelly), well-moulded string courses, and W window, all indicating a late Perp date. Between nave and chancel, a sanctus bellcote with arched openings. Cruciform plan; the nave and chancel earliest, the C13 chancel arch round and without ornament. In the chancel (restored) E.E. trefoiled lancets, one partly blocked by the later squint passage to the N transept. Shorter S transept with small squint window.

Restoration of 1886, to plans of 1876 by *T.G. Jackson*, much simplified when carried out by Mrs Lort-Phillips of Lawrenny Castle. During the work, the E.E. double SEDILIA with blunt trefoiled arches and the PISCINA were uncovered. The Dec windows date from *c.* 1860; *Jackson*'s are of lancet form. S porch, dated 1896. Restored 1999 by *Frans Nicholas*, when the wise decision to lime-render the walls was taken. – FONT. Retooled square Norman bowl. – Tame PULPIT set on a high Bath stone base, both articulated with blank Gothic panels. By *Jackson*, as are the PEWS and STALLS. – STAINED GLASS. N transept, 1909, by *A. L. Moore*. – E window after 1926, Resurrection. – MONUMENTS. In the squint passage, set within a Dec-looking cusped canopy, mutilated upper half of a recumbent knight. – Lewis Barlow †1681. Small and accomplished Baroque design, with well-lettered oval tablet, framed by a curtained canopy, the draperies pulled open by nude putti. Segmental pediment with shield. Probably from Bristol. – Guiliemus Jones †1698. Pediment with tall urn, cherub faces below long Latin inscription. – Abraham Warr †1753. Veined marble, large crossbones. – Hugh Barlow †1809. Large white free-standing marble sarcophagus on a grey veined marble base. Nearby are two tall Neoclassical VASES of flawless alabaster, presumably associated with the tomb; Lewis saw them here in 1833.

LAWRENNY CASTLE, SW of the church. The fine Queen Anne pilastered four-storey cube of the Barlows, called Lawrenny Hall, was abandoned in the early C19.* In 1856 it was replaced by a large mock castle of grey limestone blocks by *Henry Ashton* for G. Lort-Phillips, M.P. In the 1930s *Clough Williams-Ellis* failed to find a solution for modern living. Demolished 1950.

GARRON, ½m. N of church on a short arm of the estuary. Three-bay two-storey farmhouse concealing an early C18 interior with panelled room in large fielded panels and a curved shelf recess.

# LETTERSTON/TRELETERT

Straggling village on the A40 S of Fishguard, the older part W of the main road.

ST GILES. For all its uniform plainness, the product of three campaigns: a cheap nave and chancel of 1844–5 by *Thomas Rowlands* of Haverfordwest, completely re-done in 1881 by *E. H. Lingen Barker*, and extended, in matching style, by one bay to the W in 1926 by *J. Coates Carter*, with new porch and bellcote. Plain lancets and traceried end windows, the character all of 1881. Close-spaced roof trusses to the nave, boarded chancel roof. Medieval foliate cross slab reused by Carter as a PISCINA. Pitch-pine W gallery of 1926. – Early C15

---

*Fittings of the C18 house survive at the Fortified Rectory, Carew Cheriton q.v.

MEMORIAL of a lady, with only the head on a pillow in relief.

SARON BAPTIST CHAPEL, on the village street. 1869, possibly by *Joshua Morris* of Newport. Attractive stone front with bracketed gable, small-paned arched windows. The big windows match those at Llangloffan with a dove shape created by cusping. Galleries on raised timber columns, cf. Bethlehem, Newport, and Mount Pleasant, Solva. Long horizontal panels to the gallery fronts.

EMBANKED CIRCLE. The only example in the county of a Bronze Age circle of stones surrounded by a bank (like Meini Gwyr, Efailwen, Carms.) was found under a round barrow near Letterston but destroyed in the 1960s (Sian Rees).

## LITTLE HAVEN
### 1 m. N E of Talbenny

*8512*

Charming village in a deep inlet, overlooking St Bride's Bay. A noted bathing place for local gentry in the early C19, encouraged by Rowland Laugharne of Orlandon, St Brides, who built a house here in *c.* 1800. A sketch of 1841 shows the core of the village in place. Following the sale of the Bristol-based Goldwyer family estate in 1865, plans for building plots were drawn up by *Hans F. Price* of Weston-super-Mare, but if any development resulted, it was piecemeal.

Grandest of all is BRIDGE HOUSE, right in the village centre, dating from the early C19. Stuccoed and hipped, porch with crudely articulated Ionic pilasters. The houses along POINT ROAD are shown on the 1841 sketch, the SWAN INN since extended and given bay windows. Also shown are the cottages at the beginning of ST BRIDE'S ROAD. OLD POLICE COTTAGE is associated with the lock-up, built in 1850 by *William Owen*, then County Surveyor. Now utterly spoilt. Late C19 three-storey terrace houses, here and in GROVE PLACE. Perhaps by *Price*? MANOR HOUSE, off Grove Place, early C19, three storeys and bays, with coach house and service wing, originally an inn. Up the hill, PENDYFFRYN HOUSE in the late C19 seaside style, with bay windows and carved bargeboards. Finally, at the top, the weighty HAVEN FORT HOTEL, of *c.* 1870, built as The Havens for the Goldwyer family. Heavy Gothic style in bold rock-faced masonry, L-plan, with pointed windows and corbelled gable facing the sea. Small service block, joined by a tall screen wall. By *Price*?

## LITTLE NEWCASTLE/CASNEWYDD BACH

*9728*

A nucleated village around a triangular green. The new castle was a C12 fort built by Adam de Rupe or de Roche, of which all trace has gone.

St Peter. Small church with very short nave, w bellcote, chancel, n vestry and n porch, almost entirely rebuilt in 1875–6 by *E. H. Lingen Barker*. A parallel n nave, added in 1842–3, was demolished by Barker, whose n wall is halfway across its site. Barker kept only part of the nave w and s walls, adding a new chancel; and his typical steep-pitched roofs and trilobe-headed lancets with bi-colour voussoirs. Interior with open timber roofs. The solid pine screen to the lean-to vestry is unusual. – FONT. C12, small scalloped square bowl with chamfered angles. – MEMORIAL. Anne Symmons †1805. Black-painted pedimented surround to a well-lettered oval plaque. – STAINED GLASS. A good C20 set. e window of 1966 by *Roy Lewis*, Christ and St Peter, two strongly delineated figures on a deep blue ground, a fine work. – The five nave single-light windows of 1995–6 were commissioned from the Swansea Institute, which adventurously selected designs by *Caroline Loveys*, then recently graduated. Mother and Child, and Baptism on the n, Crucifixion, Resurrection and Ascension on the s, each a single hieratic floating figure with lines of the drapery carried outward in the leading. Muted colours.

# LLANDDEWI VELFREY/LLANDDEWI EFELFFRE

The main village grew in the C19 along the A40, ¾ m. n of the church.

St David. Lonely church in a valley down a long track. Broad, high nave of uncertain date, chancel with n aisle, s porch. According to the datestone, chancel was rebuilt in 1757. Crude and archaic C16 two-bay arcade: Tudor arches on a round pier, the capital with cable moulding. Relieving arches supported on a corbel with masks. The lancets and Dec e window belong to the restoration of 1861, by *Prichard & Seddon*, and the tall w bellcote was added in 1891, by *G. E. Halliday*. All this work was instigated by Richard Lewis of Henllan (*see* below), bishop of Llandaff – hence the use of his diocesan architects. Roofs of 1861, arch-braces with cusping in the chancel, short kingposts with struts in the nave. – FONT. Much-repaired square bowl, probably Norman. – PULPIT by *Halliday*, with blank carved tracery. Also his are the CHOIR STALLS. – 1861 PEWS with big pegged joints. – Late C19 brass COMMANDMENT PLAQUES in Gothic frames. – STAINED GLASS. e window, *c.* 1860, probably by *Clayton & Bell*, life of Christ. – Aisle e, 1874 by *O'Connor & Taylor*. – By *R. J. Newbery* aisle nw and nave se, both *c.* 1920. – Two w windows *c.* 1932, by *Shrigley & Hunt*. – MONUMENTS. Elizabeth Thomas † 1729. Crudely inscribed. – Elinor Lewis †1816. Large and well executed, by the firm of *James Smith* of London, Smith himself having died in 1815. A winged angel leads the dying girl to heaven, a swirling cloud bears triumphant putti. Also by *Smith*, David Lewis †1816,

reading woman before a draped urn. Both monuments erected 1818. – Elizabeth Lewis †1837. By *C. Smith*, of London, sarcophagus flanked by drooping foliage. – Richard Lewis, bishop of Llandaff, †1905. Alabaster tablet in colourful mosaic frame.

OLD VICARAGE, ¼ m. E. An old house remodelled and enlarged in 1831, by *James Hughes* of Narberth, the three-bay front concealed behind large Edwardian bay windows.

FFYNNON BAPTIST CHAPEL, ¾ m. NW. 1832. Four-square and plain, the render replacing whitewash. The three-bay façade, with windows on both storeys, central door and hipped roof, is like many of the farmhouses in which Nonconformists met until they could afford to raise a chapel. Its large size indicates the early grip of Nonconformity in eastern Pembrokeshire, the cause here founded in 1723. Original three-sided gallery on iron columns with fielded panels. Later pews and pulpit, the latter set against the back wall.

BETHEL CONGREGATIONAL CHAPEL, 1 m. NE. Dated 1849. Rendered and gablefronted. Paired arched windows over a sentry-box porch of 1912. Interior with box pews. Later gallery along three sides, of 1877.

HENLLAN, ⅔ m. WNW. Demolished 1957. Italianate stuccocd house of 1854, rebuilt for J. L. G. P. Lewis, brother of the bishop, to plans by *Wilson & Fuller* of Bath.

TREWERN, 1½ m. NE. Broad double-pile house, rendered and re-sashed in the late C19, built *c.* 1824, but incorporating earlier fabric. Five bays and three storeys with continuous parapet. Three-bay Doric porch, originally with balustrade. Nine-bay rear elevation, facing a large pond, with big full-height bow each end (cf. Slebech). Tall, round-headed central stair window The lost balustrading and the bows are reminiscent of the work of *William Owen* of Haverfordwest. Inside, a large entrance hall leads to the stair, rising handsomely within a rectangular well with apsidal ends.

QUAKER BURIAL GROUND nearby, established in thc 1660s.

FRON, 1½ m. ENE. Mid-C18 double-pile house. Three bays and two storeys; a central gable with lunette.

PLAS CRWN, ½ m. ENE. Small, late C19 house with castellated fake corner towers and little wings, all ruined. STABLE/BARN RANGE, thirteen bay, but utilitarian. Parallel COW-SHED heightened in red brick, with little Diocletian windows.

PANTEG, ⅔ m. E. At the end of a long wooded drive. Plain but handsome, rendered and colourwashed double-pile house of five bays and two storeys, set on a high basement, the entrance originally on the other side. Big chimneystacks. Lower three-bay wing to r. possibly older. An outbuilding with the initials of John Hensleigh is dated 1744, a convincing date for the house itself. The Hensleighs from Devon purchased Panteg from the Stepneys of Prendergast in 1619.

Fine unaltered interior. DRAWING ROOM enlarged to include the original entrance hall with big-fielded panels. Narrow triple panels between the windows. Chimney-breast

with tall fluted Ionic pilasters. Its adjoining room in the front
(s) range, the DINING ROOM, has similar panelling, the
pilasters with well-carved Corinthian capitals, suggesting that
this may have been the drawing room originally. The STAIR-
CASE, in the centre of the rear range, is of outstanding quality
for the area. Two flights, with turned and fluted balusters, three
to each tread, and fluted newels. Fine carved foliage tread
ends, and thick ramped handrails, the details very similar to
Great House, Laugharne. Parallel secondary staircase rising to
the attic, with turned balusters. The kitchen to the NE has a
massive chimney-breast and a fine dresser, full-height with
central shelves flanked by tall cupboards, not contemporary.
At the opposite end of the rear range, small wainscoted room,
fireplace wall with plain fluted pilasters. Yet more panelling to
the first-floor front bedrooms, again with pilastered fireplace
walls. In the NE bedroom, now hidden fragmentary survival of
painted, *trompe-l'œil* panel work (rather finer quality than the
other work). Repairs were undertaken in 1813 by *James Hughes*
of Narberth: by then Panteg was the dower house of the Allens
of Cresselly.

Although the s side is the principal front, the present
entrance is from the N in a cramped position alongside the
present stair.

WAUNDDWRGI, 1½ m. SE. Well-preserved, early C18 farmhouse,
two storeys and three bays; taller two-bay block to the l. dated
1776 in the roof.

LLANDDEWI GAER, ¼ m. N. Massive IRON AGE PROMONTORY
FORT, defended by natural slopes on s and E sides. On the
other sides, three curving banks and ditches, the middle bank
and ditch later. The strong defences are *c.* 52 metres wide in
total, while the interior is only 61 square metres in extent.
Entry on the E side.

At BRYN FARM, 1½ m. NNE, part of a ROMAN ROAD was exca-
vated in 1993.

## LLANDEILO *see* LLANGOLMAN

8526

## LLANDELOY

Llandeloy village is mostly C20, expanded with the airfield at
Brawdy. The other nucleated settlement is at Treffynnon, with
a small CALVINISTIC METHODIST CHAPEL of 1867. Of the
scattered farms, CAERWEN and TREFANER have rear stair pro-
jections – a C18 feature, but here C19. TYLLWYD has a screen
wall to the drive with a coach house each end and walled-garden
entry in the centre, the three entrances charmingly framed in
sandstone, crudely classical, dated 1844 and 1848. HENDRE is of
1881, by *D. E. Thomas*.

ST TEILO or ST ELOI. Now in the care of the Friends of Friend-
less Churches. Rebuilt from ruin in 1926–7 by *J. Coates Carter*,
and in a region of churches battered with alien tracery, a
beacon of Arts and Crafts sensitivity. Nave, W bellcote, chancel

and S transept. The long and low proportions with lengthened chancel, are emphasized with a single ridge-line. Roofs sweep down over a rood stair on the N and very low on the chancel S side. N doorway roughly arched, the windows simply stone-lintelled in the nave; inside, exposed stone. The cluttered and tunnelled effect is delightful, achieved by low roofs, rough stone arches, and fittings that obstruct rather than open up the views. The roofs have cambered tie-beams to keep the eye low, and the low chancel arch is filled by an exceptional ROOD SCREEN. The loft is accessible via a rood stair reached by a wall-tunnel which allows the minister to appear like a jack-in-the-box in a little pulpit squeezed in front of the screen. There is a toy-like charm, though the late Gothic detail of the screen is fine, with close-spaced uprights and panelled loft front. From the transept, an angled way through to the chancel, ill-defined space derived from the surviving ruins. Much odder is the low chancel aisle under the outshut roof, complicating the spatial effect at the junction with the transept. The chancel is simply flagged, and stepped up to a curtained altar with painted timber REREDOS, also by *Carter*. – FONT. C13 or C15, tapering octagonal bowl, splayed in at the base, and on a round shaft. – STAINED GLASS. The E and S transept windows presumably of 1926–7, dull. – Nave S window *c*. 1938, showing Llandeloy and Llanreithan churches.

CROES HENDRE GALLERY, 1½ m. W. The former National School, of 1849–51 by *Joseph Jenkins* of Haverfordwest. Careful Tudor (cf. Llanrhian), with stone-mullioned windows, and bellcote porch.

FELIN WEN, 2 m. W. Small two-storey water mill with iron wheel and machinery, dated 1842.

## LLANDISSILIO/LLANDYSILIO

Main-road village on the Carmarthenshire border.

ST TYSILIO. An odd shape, the nave broad and square, the older chancel set to one side with a little parallel vestry. The nave of 1838–40, apparently by *John Cooper* of Slebech, was described by Lewis in 1844 as 'a very plain building with few characteristics of a church'. Possibly it replaced a double nave. In decay by the 1890s, restored by *H. A. Prothero* of Cheltenham in 1899–1900, with Perp windows, new porch and vestry. In the chancel S, small lancet and cambered-headed two-light window, medieval but restored.

Inside, the nave ceiling is bare, with sloping sides, the chancel has good detail of 1899, open roof, two arches through to the vestry, and wrought-iron RAILS. – MONUMENT. John Mathias of Cilau †1765, grey and white marble pedimented plaque. – ORGAN. Earlier C19 domestic organ in panelled case, said to have been brought from Milford Haven in the 1950s. INSCRIBED STONES. Set into the nave S wall a massive stone inscribed CLUTORICI FILI PAULINI MARINILATIO

(Clutorix, son of Paulinus Marinus of Latio), C6. Another has EVOLENG- FIL- LITOGENI HIC IACIT. The Irish 'g' may indicate a slightly later date. Another is inscribed RIAT. Also, towards the SW corner, an eroded stone inscribed with a C9–C10 Maltese cross formed of five circles within a circle.

PISGAH INDEPENDENT CHAPEL, on the main road. 1901–2 by *J. Howard Morgan*. Gable front in unpainted stucco, two-storey, with main arch, and piers, with channelled rustication below sunk panels. Inside, a raised centre to the roof gives a longitudinal axis. Timber three-sided gallery with shaped flat balusters to the upper panels.

BLAENCONIN BAPTIST CHAPEL, S of the village, on the main road. 1933–5, by *Henry Ellis* of Swansea. A stone gable front with Gothic windows, conventional galleried interior. The last major chapel in the county, but without any of the interest in new form shown by J.H. Morgan (*see* his Sardis, Stepaside).

CASTELL GWYN, ½ m. W (SN 110217). Large Iron Age HILL-FORT above the Eastern Cleddau, with circular embanked centre, open to the W, and double bank to the S, within a roughly square enclosure with double bank that curves out to the S.

## LLANFAIR NANT Y GOF *see* TRECWN

*1637*

## LLANFAIR NANT GWYN

No village. The church stands at the head of the drive to Pantyderi (*see* below), off the Eglwyswrw to Boncath road.

ST MARY. Small and characterful church, rebuilt 1855–7 by *R. J. Withers*, in a style more acutely angular than his later works. Steeply pitched roofs, timber bell-turret crowned by a thin slated spire. The thin roof trusses appear outside in the gable shoulders. The interior keeps this attenuated quality, the chancel arch dying sharply into a corbel with a recessed carved head. – Simple Gothic timber RAILS and PULPIT: the rails an exemplar of High Victorian woodwork stripped of decorative inessentials. – The FONT plays with solid geometry, round, the stem splayed to octagonal. – STAINED GLASS. Fine E window, 1857, in C14 style, strongly linear drawing, an early work by *Alfred Bell*, working for *N. W. Lavers*. Armorial glass in the chancel S, Evangelist symbols in the two W windows also by *Bell* for Lavers. – TILES. Encaustic tile floor with Bowen arms. – MONUMENTS. At the W end, three reset marble plaques: W. M. Williams †1820, signed *Daniel Mainwaring*, Elizabeth Bowen †1820 and James Bowen †1788.

EBENEZER BAPTIST CHAPEL, Ffynnonwen, 1½ m. N. 1870. Grey Cilgerran stone gable front, with large depressed-arched centre window, traceried in three plain lights but with two circles, like close-set eyes. Three-sided gallery inside, with curved corners and panels of heavy applied fretwork.

PANTYDERI, just E of the church. Plain three-storey, five-bay stuccoed house, of the Bowen family from 1745, but probably rebuilt in the early C19.

Pyramid-roofed LODGE on the main road, to the N.

# LLANFIHANGEL PENBEDW *see* BONCATH

# LLANFYRNACH

2231

Church and Norman MOTTE stand on the hillside, above the modern village beside the disused Whitland to Cardigan railway. Below the church, the OLD RECTORY, 1849, by *William Railton*. Three bays, stone, with projected centre gable and arched doorway, the sashes still small-paned. From the C18 the only notable lead mine in the county was in the valley to the NE. Near the site, BRICK ROW, a much-altered, later C19 row of twelve back-to-back cottages, built for the mine-workers.

ST BRYNACH. Rebuilt 1842, with enthusiastic if unarchaeological Tudor Gothic detail, in the local slaty stone. The architect is unknown, perhaps *John Phillips* of Tavernspite. Broad, squat W tower, short nave and very short chancel. The tower is substantial, with stepped buttresses, parapet and pinnacles. Bell-stage lights and large W window are false, the three-light Tudor tracery applied in slate within chamfered recesses, without openings but for some apologetic slits. The tower top hides a valley roof, and external and internal levels do not match. The rest of the church is even more amply buttressed, the angle buttresses capped with big triangular slate pediments. Nave and chancel E gables carry curious slate finials: the nave a plump cross, the chancel a stepped obelisk, like a Christmas tree. Timber leaded windows, square with hood-moulds or four-centred. Plain interior with later boarded roofs and pews, but the simple painted-grained PULPIT and READING DESK original. – FONT. Late medieval octagonal bowl, coved beneath. – STAINED GLASS. E window, the Good Shepherd, *c.* 1900, dreadful.

LLANFYRNACH SILVER-LEAD MINE, NE of the village. Begun in the 1750s, with intermittent working until abandoned at the end of the C18. Reopened *c.* 1840, it saw a short heyday 1878–88, with average yields of some 300 tons of lead, before drainage problems closed the mine in 1890. A round stack remains next to the boiler house of No. 2 engine shaft (SN 2254 3148), probably *c.* 1850. Ruins of the Cornish engine house of No. 1 engine shaft (SN 2248 3165), 1860. Also traceable are: the C19 water-wheel pit by No. 1 engine shaft, parts of the loading platform and ore hoppers, dressing floors, buddles and leats.

GLOGUE, $\frac{1}{2}$ m. N. Slate-quarrying settlement with a terrace of houses by the dismantled railway. The quarry was one of the largest in the county, producing roofing slates and slabs.

Exploitation probably began in the C17, but dates mostly from the 1840s, declining in the late 1870s, though not closed until 1926.

HERMON BAPTIST CHAPEL, Hermon, ¾ m. NW. 1835. Half-hipped roof, and entry in the gable-end, an early example. Interior altered 1883.

LLWYNYRHWRDD INDEPENDENT CHAPEL, 1 m. NNE. Surprisingly large chapel of 1874. Severe front in cut Cilgerran stone with giant rusticated centre arch and outer quoins. Long arched windows in the side bays, centre with double doors and triple window, all arched. Broad interior, the galleries with long horizontal panels and curved angles.

9032                    LLANGLOFFAN
                          Granston

A picturesque cluster of chapel and two farms. LLANGLOFFAN FARM has a former horse-engine house, with canted walls. PONT LLANGLOFFAN below, a low, rough stone bridge of two arches over the Western Cleddau.

LLANGLOFFAN BAPTIST CHAPEL. 1862–3, possibly by *Joshua Morris* of Newport. Handsome unpainted stucco front with deep-eaved open pedimental gable on channelled piers, derived from Hermon Chapel, Fishguard. A wide elliptical arch breaks into the gable over bold raised lettering in a big oval pattern. Long outer arched windows, with Y-tracery (cf. Saron Chapel, Letterston); echoed in the fanlight. Over the door, an arched triplet. Three-sided gallery with long panels, on timber columns.

1126                    LLANGOLMAN

The Eastern Cleddau is crossed at PONT HYWEL, a twin-arched bridge with cutwaters, dated 1747, but heavily restored. The former parish church of Llandeilo Llwydiarth, w of Llangolman, has disappeared but for foundations by Llandeilo Isaf farm (nave and chancel, with s door). There was a holy well to the NE, the waters of which were drunk from the skull of St Teilo, now in Llandaff Cathedral.

ST COLMAN. A small Victorian lancet Gothic church all in dark Preseli stone. Nave and chancel with w bellcote and s porch. Repairs recorded in 1866 for £450 and in 1899 for £300. Nothing ancient seems to have survived, except a well-carved but eroded plaque in local slate to Stephen Lewis †1728.

LLANDILO INDEPENDENT CHAPEL, 1 m. w. Dated 1882 and 1931. Plain gable front, with two small arched windows and an arched door, probably 1882, likewise the interior. Three-sided gallery with boarded front.

PENRHOS COTTAGE, 1½ m. SW. Roadside lofted cottage, restored

and open to the public, with thatched roof, a reminder that thatch, once very common even in slate areas like this, has wholly vanished.

# LLANGWM

9909

Attractively compact village, on the W bank of the Cleddau estuary. A fishing village in the C19, noted for its robust fisherwomen.

ST JEROME. Much restored, but with some good Dec work intact. Chancel and long nave. Large N transept of the C14, small S transept with barrel-vaulted roof, C14 or C15. Restored in 1840 by *William Lewis*, of Haverfordwest; his work replaced 1879–82 by *E. H. Lingen Barker*, who added the Dec windows and the S porch. But the E window of the N transept is genuinely Dec; of two lights with ogee-shaped trefoils and quatrefoil above. The splendid N transept is entered through a two-bay arcade of moulded arches on an octagonal pier, its N wall occupied by fine large TOMBS (*see* below). On the E wall a fine PISCINA. Rounded bowl with large blank shields, set on a pedestal. Shields along the edge of the niche. Cusped canopy above, with more shields, rising to a tall pinnacle. Dec work of this quality is rarely encountered in the area.* – FONT. Square Norman bowl, chamfered to circular pedestal. – FITTINGS by *Lingen Barker*, including the Bath stone PULPIT, with coloured marble colonnettes. – STAINED GLASS. E window of 1908. – INSCRIBED STONES. Small slab with inscribed Latin cross, the arms contained within a circle, simple cusping. Another slab, head only, a similar pattern, but the cusping creating a more pronounced quatrefoil. Both probably C9. – MONUMENTS. Two C14 effigies in the N chapel, traditionally of the Roch family, presumably the builders of the transept. Both set in large ogee-headed, cusped and crocketed recesses in the N wall, with pinnacles. Carved fronts with quatrefoil panels, some with shields. Knight with sword and shield, crossed feet resting on a lion. Mailwork around the neck. The other figure, much worn with simple drapery in loose folds, may be the female effigy which Fenton saw in the chancel.

WESLEYAN METHODIST CHAPEL. 1897, by *D. E. Thomas*. Brown sandstone, yellow brick detail. Gallery at the gable end, the bow-fronted iron balustrade of palmette design. Ceiling coved along the long sides, incorporating arch-braces.

GALILEE BAPTIST CHAPEL, $\frac{1}{8}$ m. S. Dated 1904, by *George Morgan & Son*. Slightly Beaux-Arts, with small Diocletian window under the gable. Entry flanked by stubby colonnettes, under a segmental arch with pronounced voussoirs. Narrow windows in a row above the entry. Interior with gallery at the

---

*Good enough to be one of the few Welsh exemplars noted by Thomas Rickman in his 1817 *Attempt to discriminate the Styles of English Architecture*.

entrance end. Attractive roof, unceiled with wavy struts along the centre. Typical of the firm at that date.

EAST HOOK, 1½ m. N. The exterior detail looks C18, but there is an earlier core within the S part, an L-shaped range with rear stair-wing and narrow sashes. Long, whitewashed additions to the N, probably C17, which involved thickening the gable chimney. Stair of *c.* 1700 with shaped slat balusters; simple panelling to stair passage. In the added projecting W wing, drawing room with big fielded panels and cupboard recess. Immediately W, at an angle, part of the ruined earlier house. Simple C19 farm buildings, including pig-sties with handsome cast-iron doors.

GREAT NASH, 1 m. NW. Described by Fenton as ruined, but once one of 'the most fashionable form of mansions in this county of its date' (i.e. *c.* 1700), cubic in plan. Little now remains. Fine circular DOVECOTE in the farmyard, perhaps medieval.

ASHDALE, ½ m. SW. Early C18, five bays, two storeys. George Lort Phillips, according to Lewis, made extensive alterations before 1840, possibly including a now demolished N wing.

8127

# LLANHOWELL/LLANHYWEL

Isolated church, apart from the former VICARAGE, mostly of 1900–3 by *D. E. Thomas* of Haverfordwest.

ST HYWEL. Possibly C14, small, much restored in 1889–95, when the S wall was rebuilt and the windows attractively replaced in purple Caerbwdy stone. Reroofed by *E. V. Collier* in 1909, with graded small slates. Nave and chancel with small N transept and broad NE squint passage. Arched W bellcote, from a lower roof. Whitewashed plastered walls and low arches to the chancel and N transept. Rough corbels over the chancel arch for a rood beam. Small recess in each side wall of the N chapel, and another in the squint which is perhaps C15 (cf. Whitchurch). – FONT. Square, C12, scalloped bowl on a circular shaft. – ORGAN. Early C19 chamber organ in a mahogany case, brought from Plymouth in 1975. – INSCRIBED STONE. At the W end, a C5 or C6 stone found at Upper Carnhedryn Farm, inscribed RINACI NOMENA.

TREGLEMAIS FAWR, 1 m. N. A manor of the bishops of St Davids, recorded from 1332. Now a substantial late C18 or early C19 farmhouse. Whitewashed stone with a big arched porch, typical of Dewisland farmhouses as is the S end wall hung with slates against the gales. The big sashes with brick heads each side of the porch are later, but the irregularly spaced bays suggest several phases.

LECHA CROMLECH (SM 811 271). Capstone of a Neolithic burial chamber.

# LLANLLAWER

The church is up a steep hill from Llanychaer. In the field nearby, a medieval HOLY WELL, in a roughly vaulted chamber.

St David. Small church in hard Preseli stone, by *R. J. Withers*, 1858–60, derelict. Nave and chancel in one. Steep single roof and harsh plate tracery of Bath stone. – INCISED STONES. On the outside s wall, a small cross-inscribed stone. On the vestry lintel a cross in an oval, an unintentional fish shape. The gateway has two rough stones with incised Latin crosses, C7 to C9.

COURT. A plain but well-preserved gentry house of *c.* 1800–12, built for John Gwynne. Five-bay stucco front with bracketed eaves and hipped roof; the doorway with Ionic porch is in the fourth bay. Interior with good simple detail, all early C19. Extensive outbuildings, a lofted coach house just N, and a long range beyond with hipped two-storey mill, later C19. A tiny roofless Gothic LODGE by Llanychaer Bridge.

PARC-Y-MEIRW STANDING STONES, $\frac{1}{2}$ m. E (SM 998 359). In the hedge-bank on the s side of the lane, the only stone row in the region. Prehistoric alignment of seven – perhaps originally eight – standing roughly SW to NE, suggesting an astronomical purpose.

# LLANREITHAN                                    9835

The church stands by Llanreithan farmyard on high ground around the source of the Solva river.

St Rheithan or Rhidian. Disused. Rebuilt in 1862 by *R.K. Penson*. Small; nave, chancel and w bellcote, steep-roofed, with some plate tracery, more decent than characterful.* Nothing, else obviously medieval apart from the gloss-painted C12 FONT, square tapered to round, the rim scalloped. Open timber roofs, plastered walls. In the altar, a medieval cross-shaped STONE.

LLANREITHAN, just w of the church. Substantial earlier C19, three-bay house, slate-hung with large sashes under a hipped roof, probably built for Elizabeth John †1834.

BLAENLLYN CALVINISTIC METHODIST CHAPEL, 1 m. NE. Rebuilt in 1879 by *D. E. Thomas*; painted stucco with pilasters and centre arch. Stretched proportions.

# LLANRHIAN/LLANRIAN                              8131

Coastal parish NE of St Davids with a compact village centre. E of the village, LLANRHIAN MILL, dated 1827, small and half-hipped with a later C19 iron overshot wheel. TRENEVED FARM,

*A foundation stone dated 1473, found in the restoration, has vanished.

to the E, is earlier C19, three-bay, with broad end stacks and large
sashes. The OLD VICARAGE, further E, 1880–3 by *K. W. Ladd* of
Pembroke Dock, is rendered and gaunt.

ST RHIAN. Rebuilt in 1836 by *Daniel Evans* of Cardigan except
for the short W tower, a rarity in North Pembrokeshire. Unlike
the towers of South Pembrokeshire, it is square, with no batter.
Plain arrow-slit bell-openings. The attractive crowstepped
gable with obelisk finials is of 1836. Evans' church has nave
and transepts of equal length, with crude stepped battlements
and obelisks on the transepts, and replaces a double-naved
church with round columns. The chancel, though, was
recorded as derelict in 1844, and may have been rebuilt later
in the C19. Attractive stone Perp tracery was added by *Seddon
& Coates Carter*, in 1891, replacing wooden windows. Rough
stone vault to the tower. Broad nave and transepts with pan-
elled lower walls, the panelling formed from the old box pews.
Simple Perp chancel SCREEN of 1891, also the fine PEWS, with
little octagonal colonnettes in the bench ends. – PULPIT of
1906 to match, by *E. G. Thomas* of St Davids. – FONT. Late
medieval decagonal bowl with upside-down shields, one with
the arms of Sir Rhys ap Thomas †1525. – MONUMENTS. Some
plain marble plaques to the Harries family of Cruglas and
Trevaccoon. – John Harries of Cruglas †1797, signed *H. Wood*
of Bristol.

LLANRHIAN SCHOOL, at the crossroads SW of the church.
Built as the National School in 1851, by *Joseph Jenkins* of
Haverfordwest. Unusually elaborate Tudor Gothic in stone,
with house to the l. and two-bay school to the r., the doorway
between carried up to a bellcote.

MANOR HOUSE, immediately behind the church, dated 1769,
the S front low and irregular, slate-hung and whitewashed.
The rear kitchen wing has a massive banded stone chimney.
Extensive farm buildings, the best an early C19 lofted stable.
Entrances inside a big centre arch.

TREVACCOON, ½ m. SW. Handsome small country house of
c. 1805, built for Samuel Harries, with touches of fashionable
Greek detail, rare in this area. Roughcast, two-storey, three-
bay N front with widely spaced sashes and a broad hipped roof
of grouted slates. The eaves cornice has Greek mutules, and
the porch on the E end wall has baseless Doric columns with
fluted necks. Long axial corridor to the W end stair, the narrow
entrance hall with plaster vaulting in two bays, and the stair
hall with long arched stair-light. Behind, an earlier house sur-
vives facing on to the narrow S service court, with earlier C18
roof trusses.

*See* also Porthgain and Abereiddy.

# LLANSTADWELL

Simple houses, strung along the N side of the Milford Haven. A
densely populated area, with Neyland to the E, an oil refinery to
the W, and Pembroke Dock across the water.

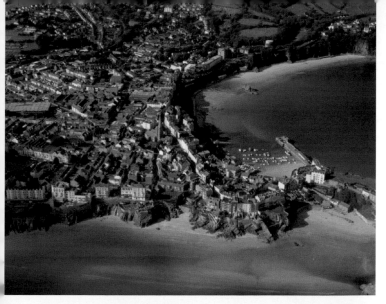

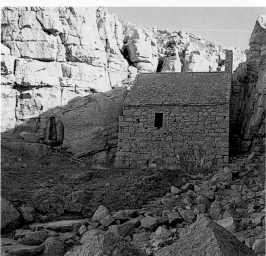

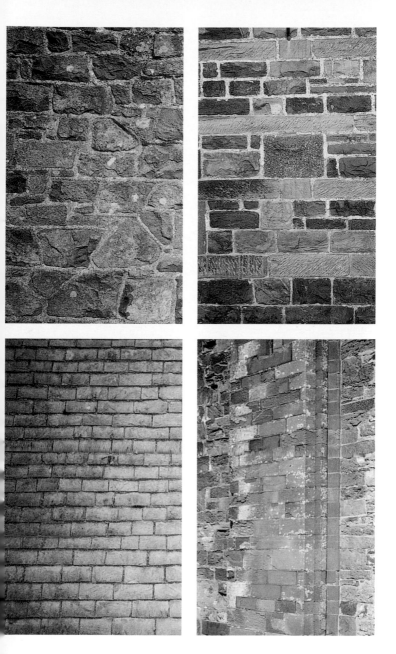

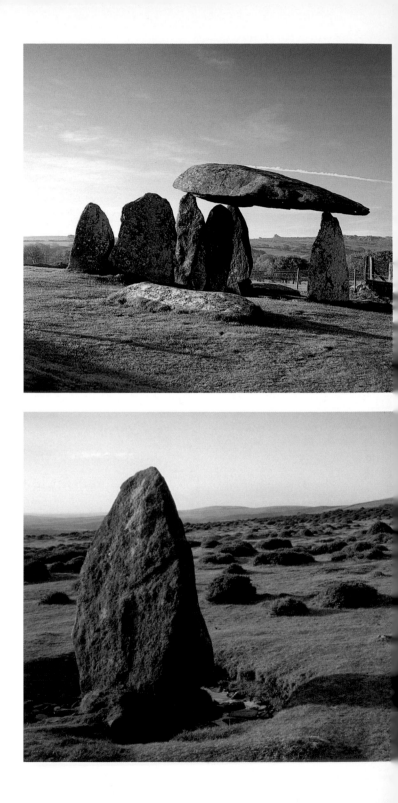

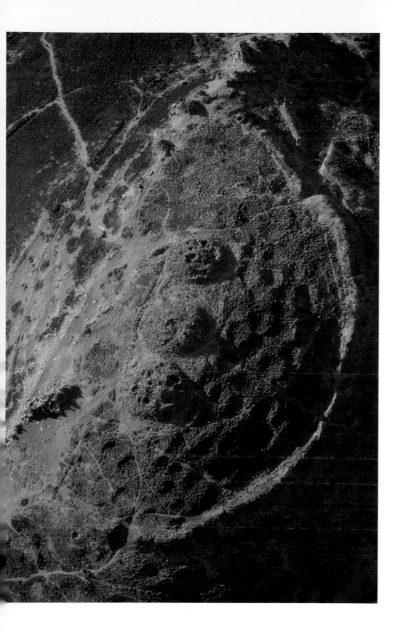

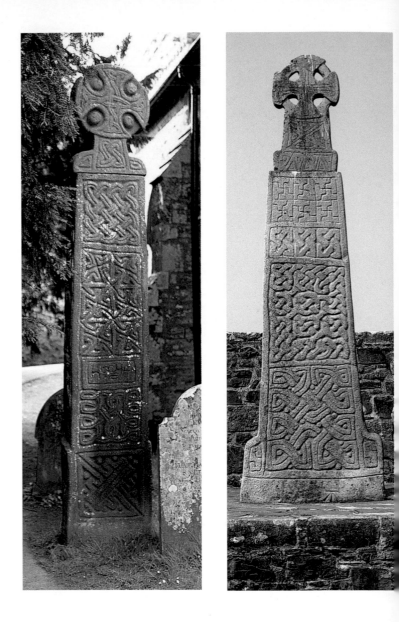

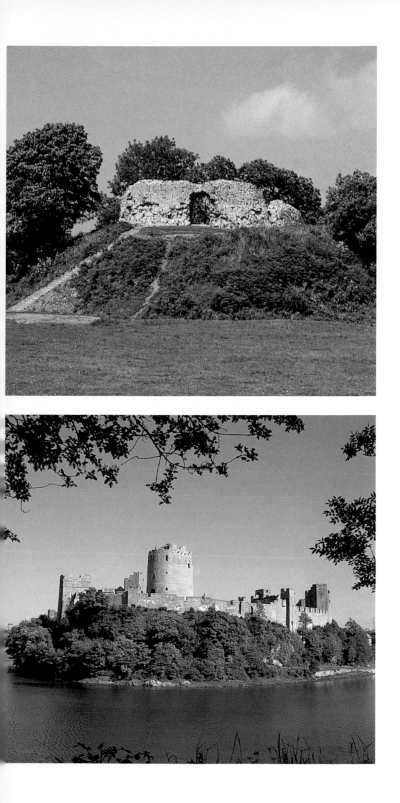

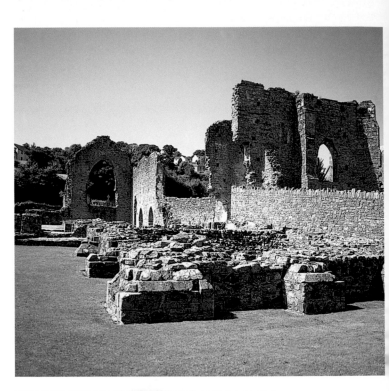

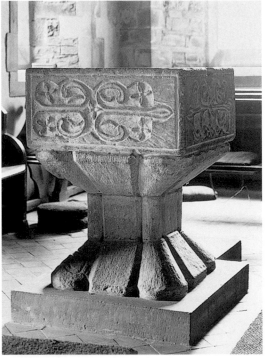

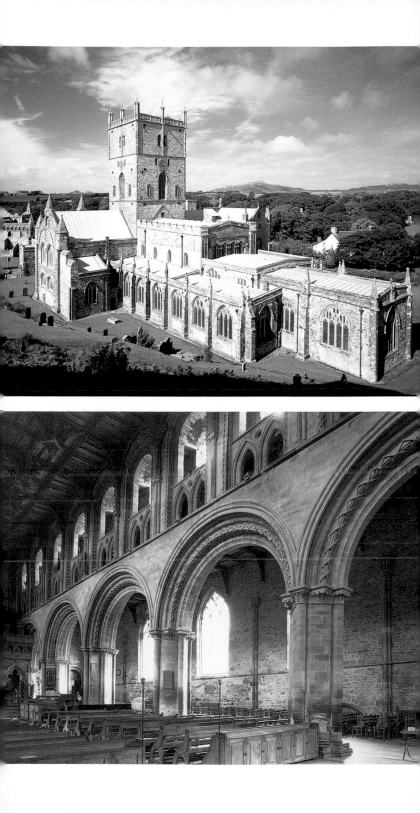

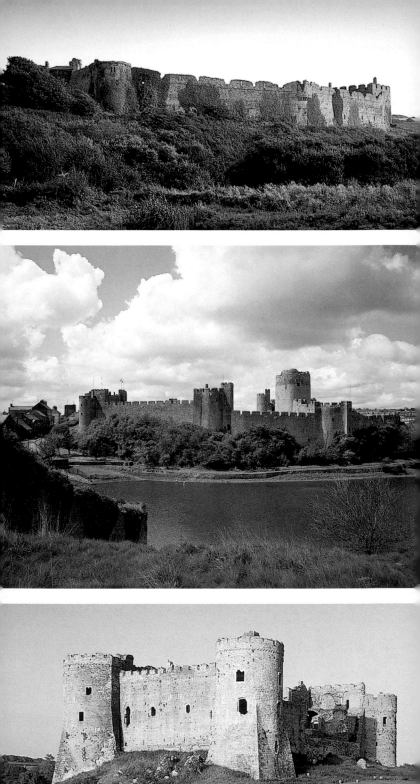

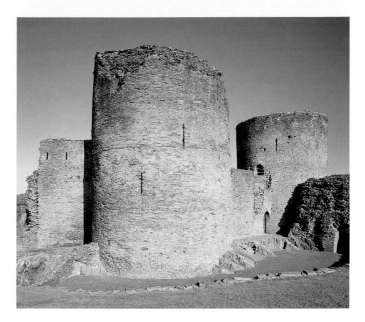

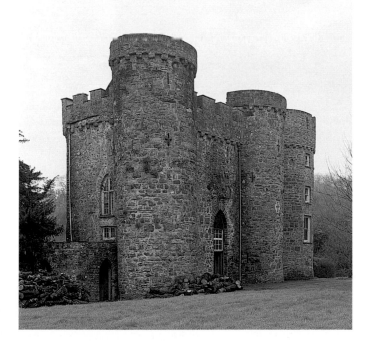

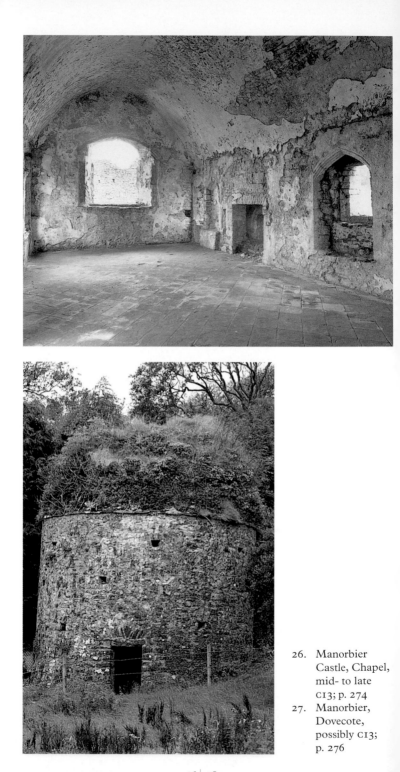

26. Manorbier
Castle, Chapel,
mid- to late
c13; p. 274
27. Manorbier,
Dovecote,
possibly c13;
p. 276

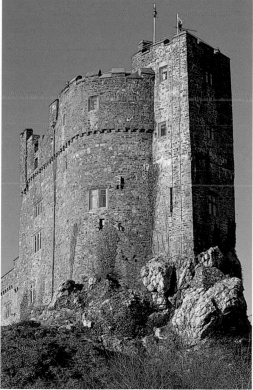

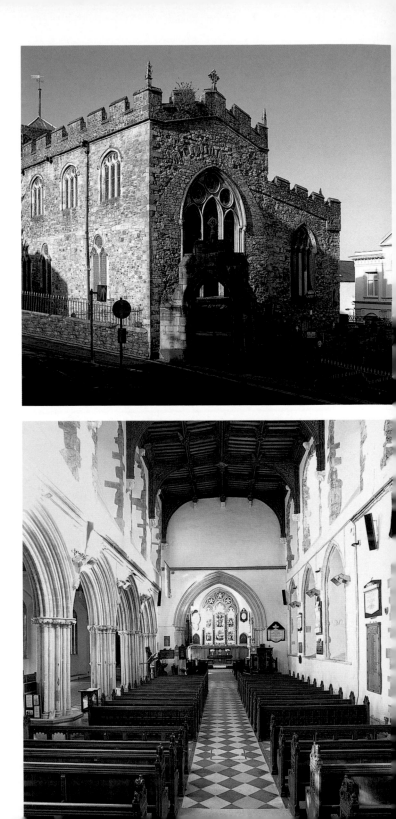

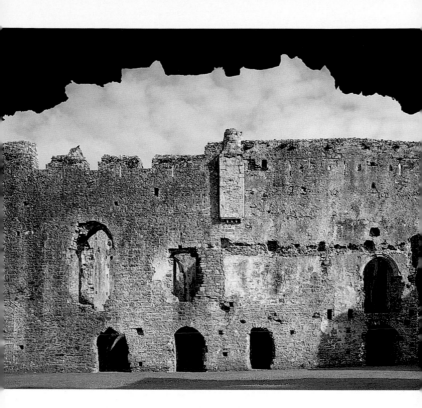

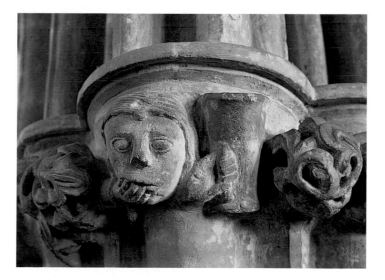

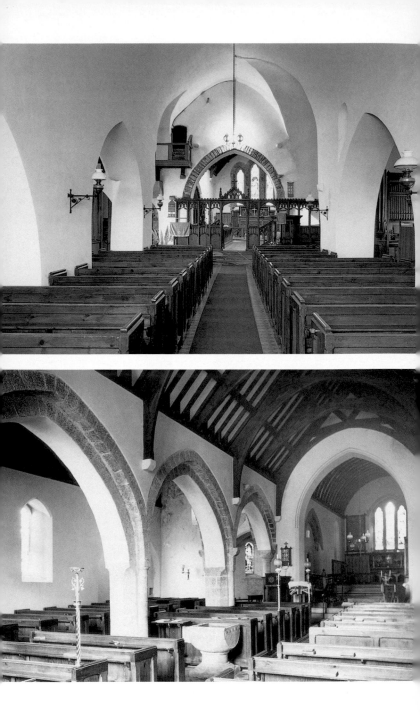

34. Manorbier, St James, barrel vaults, C13 to C15; p. 275
35. Castlemartin, St Michael, nave, C13; p. 162

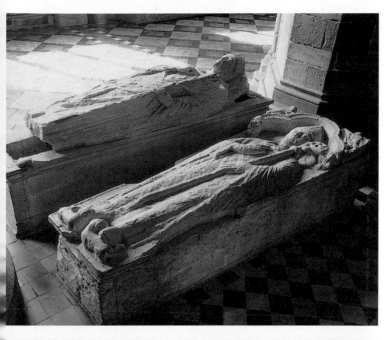

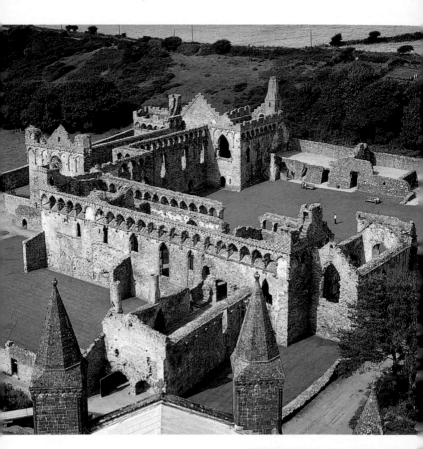

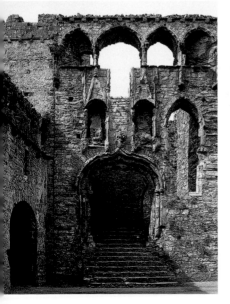

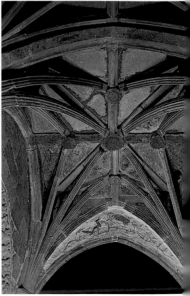

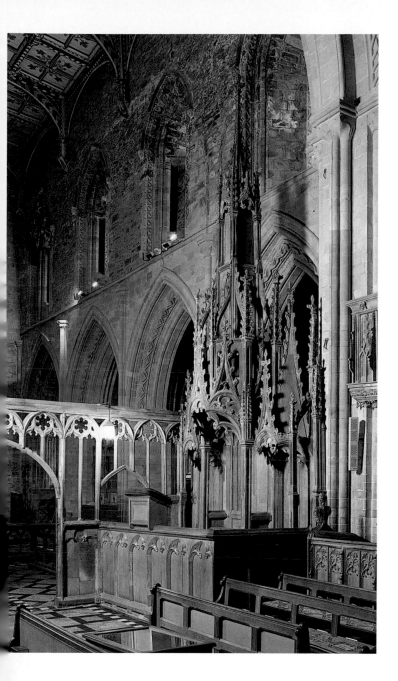

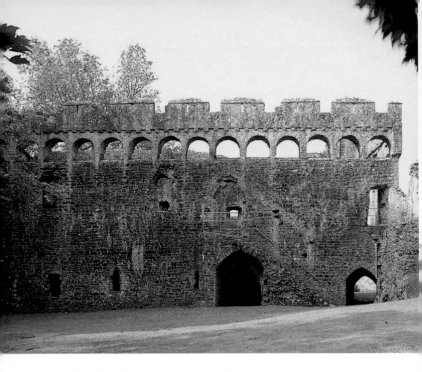

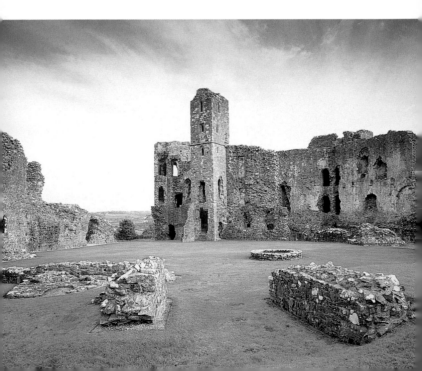

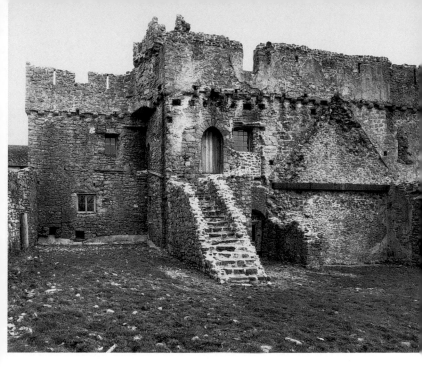

44. Rhoscrowther, Eastington, late C14; p. 374
45. Caldey Island, Caldey Priory, west range, C15; p. 140

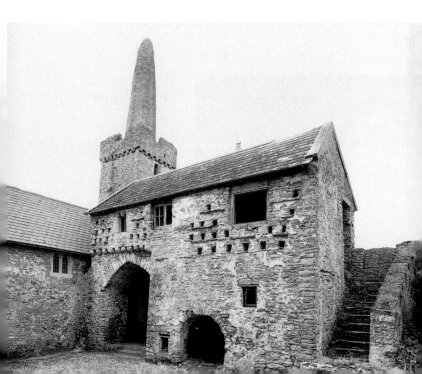

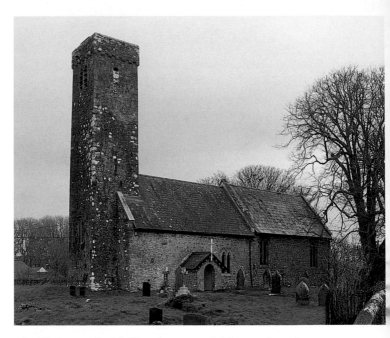

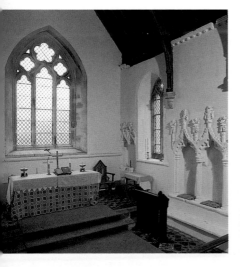

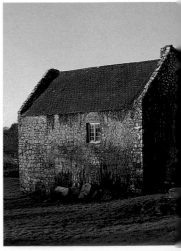

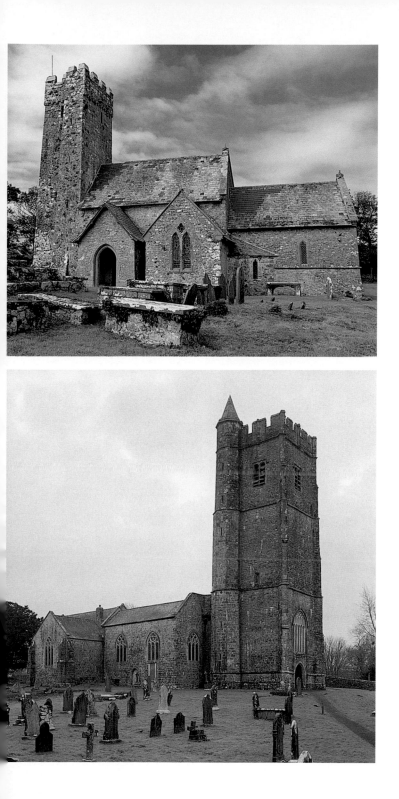

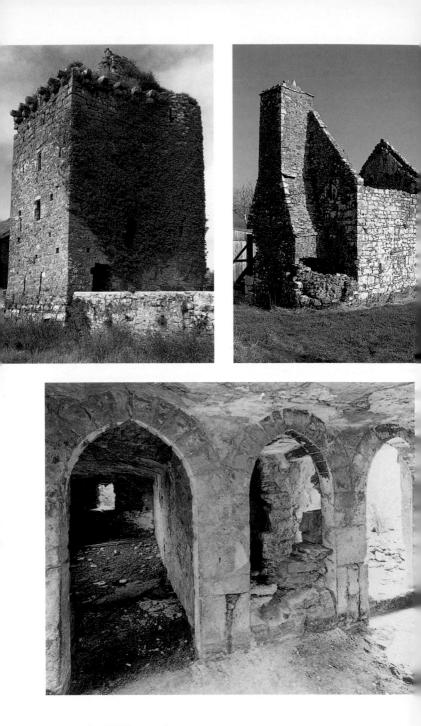

51. Angle, Old Rectory, late C14 or C15; p. 125
52. Penally, Carswell, late C14 or C15; p. 355
53. Castlemartin, Pricaston, cross passage, C15; p. 164

51 52 | 54
53 | 55

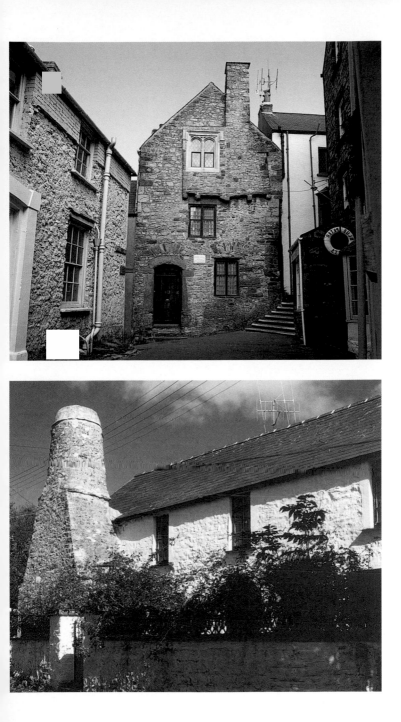

54. Tenby, Tudor Merchant's House, late C15; p. 474
55. St Florence, Old Chimneys, early C16; p. 440

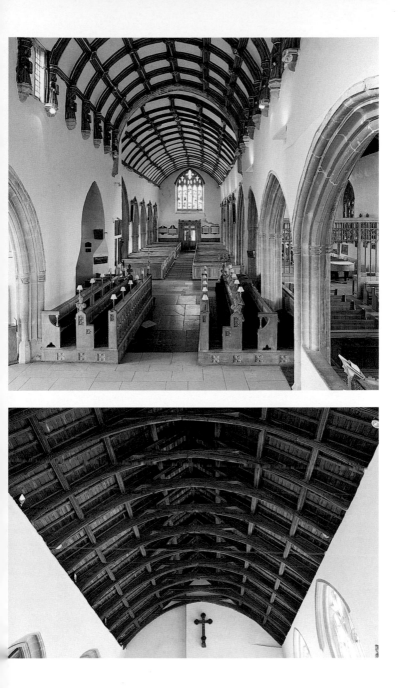

56. Tenby, St Mary from east, mostly C15, C14 tower with C15 spire;
    p. 469
57. Tenby, St Mary, interior, C15; p. 469
58. Tenby, St Mary, south aisle roof, late C15; p. 471

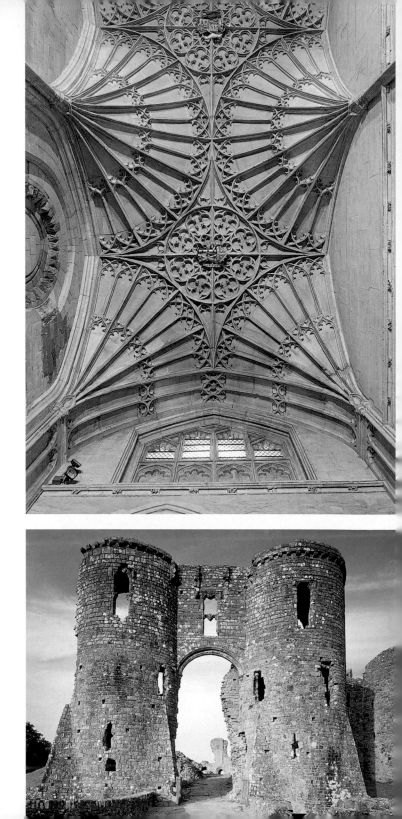

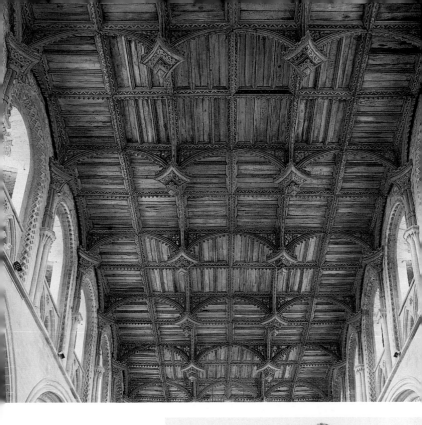

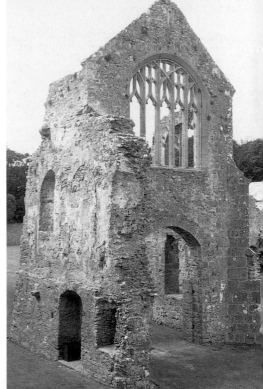

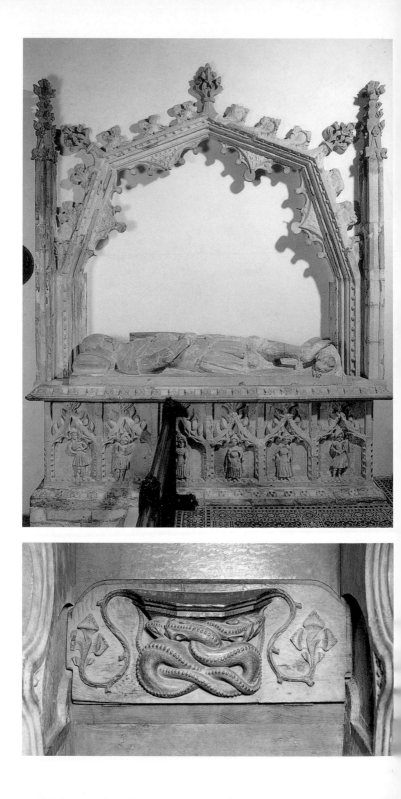

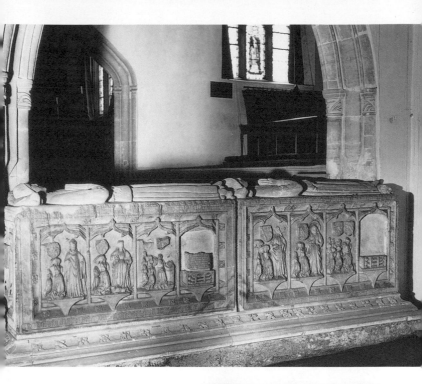

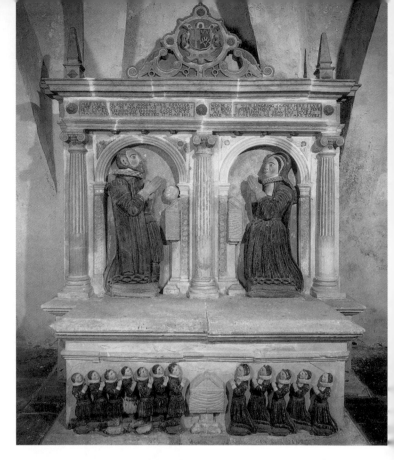

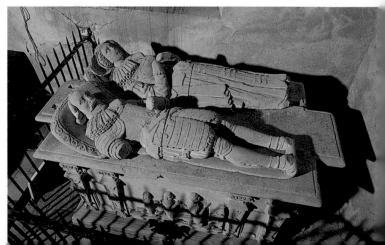

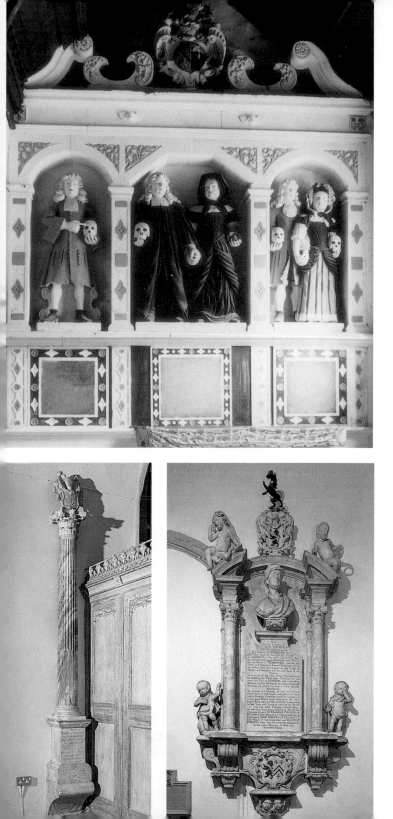

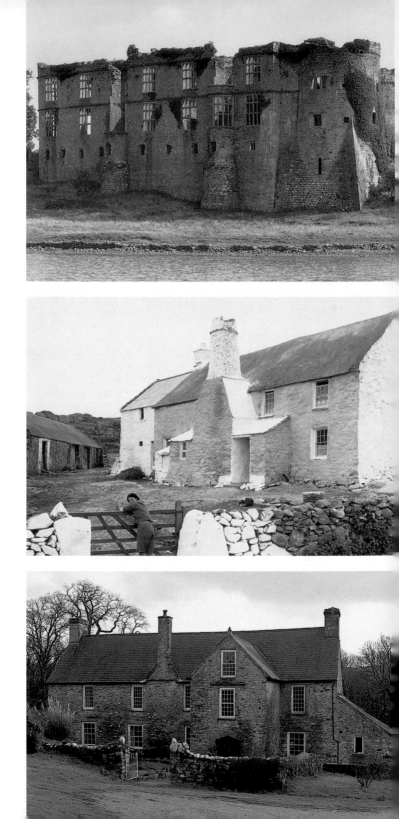

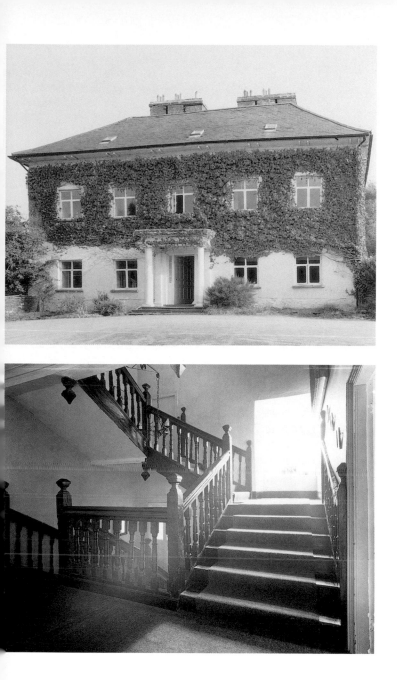

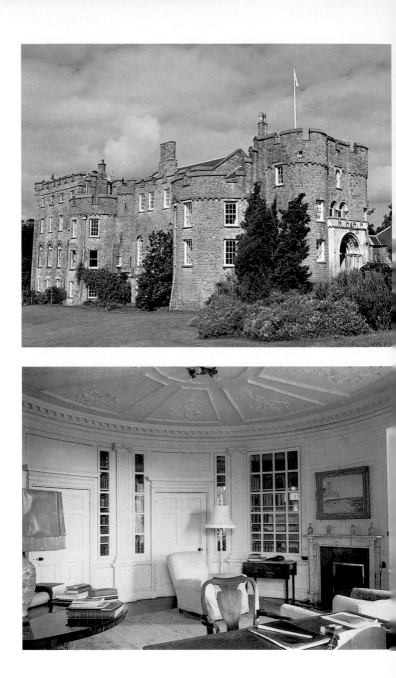

77. Picton Castle, c.1300, remodelled early to mid-C18; p. 360
78. Picton Castle, library, mid-C18; p. 362

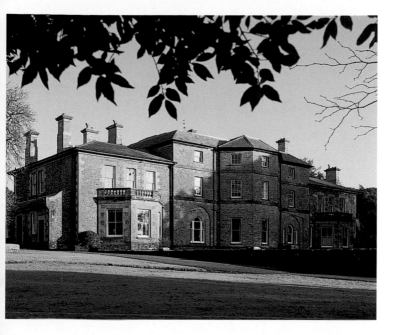

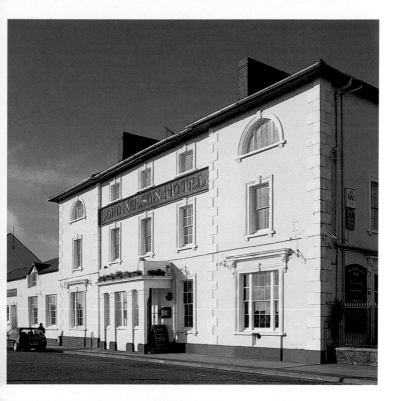

85. Stackpole Court, Eight-arch Bridge, by James Cockshutt, 1796–7; p. 463
86. Solva, limekilns, c18; p. 454

87. Capel Colman, Cilwendeg, pigeon house, 1835; p. 151
88. Capel Colman, Cilwendeg, shell house, *c.*1835; p. 151

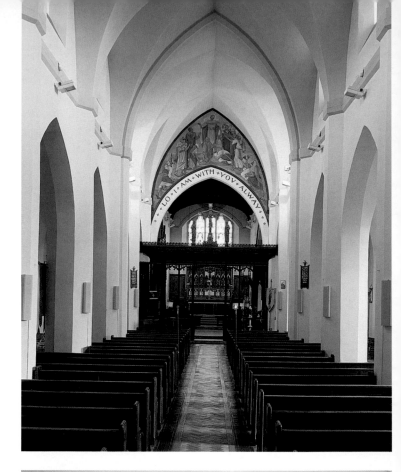

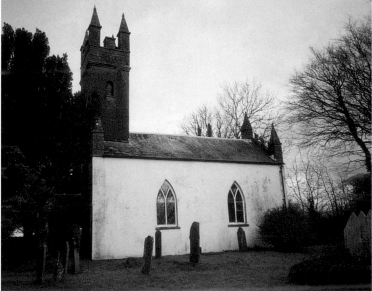

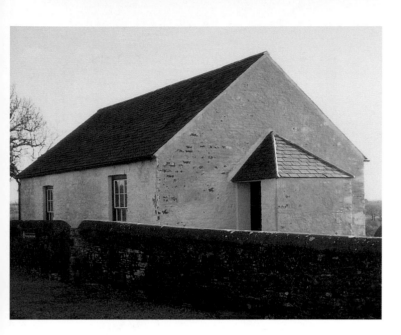

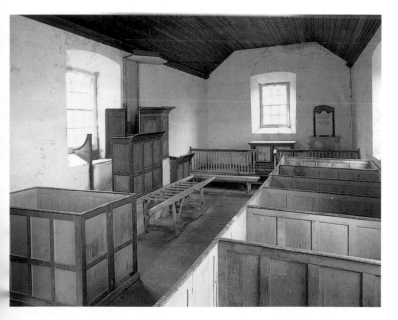

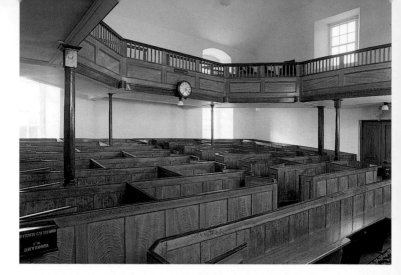

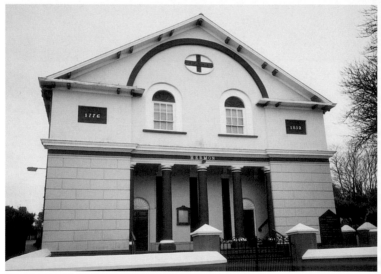

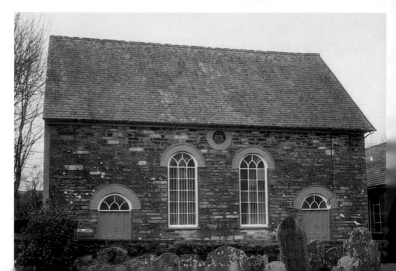

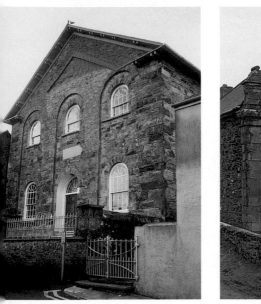
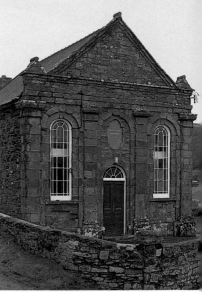

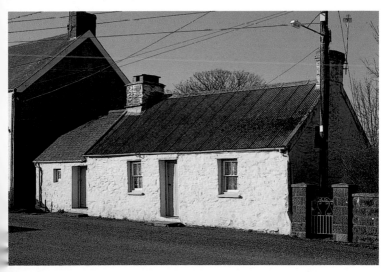

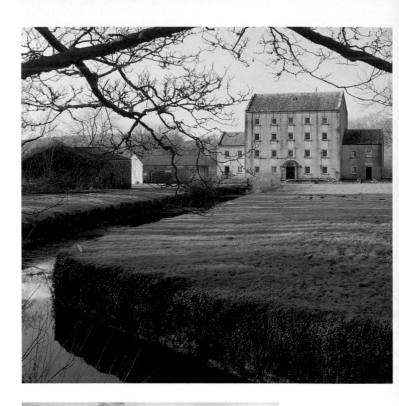

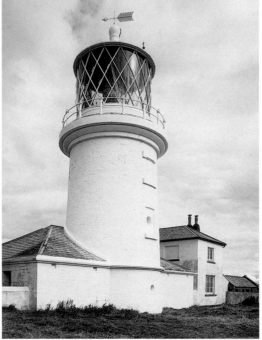

99. Minwear,
Blackpool Mill,
by George
Brown, c.1813;
p. 295
100. Caldey Island,
Caldey
Lighthouse, by
Joseph Nelson,
1828–9; p. 148
101. Stepaside,
Kilgetty
Ironworks,
casting house,
1848; p. 465
102. Penally, Kiln
Park limekilns,
c.1865; p. 354

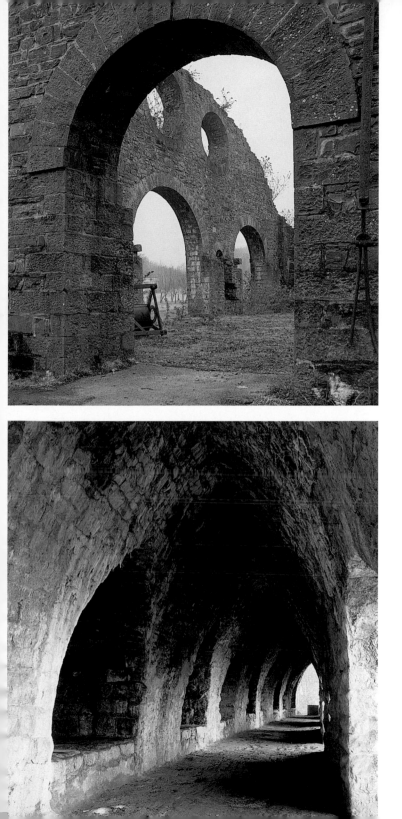

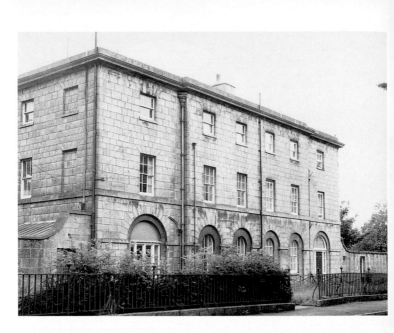

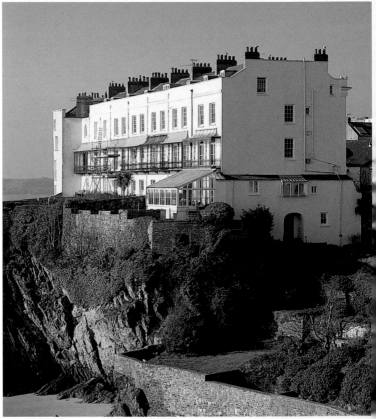

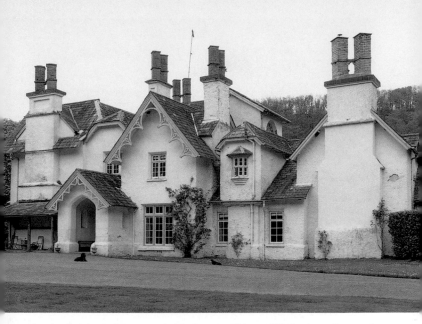

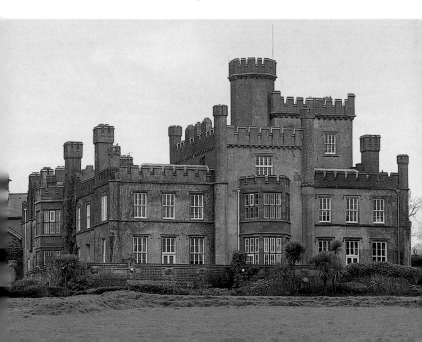

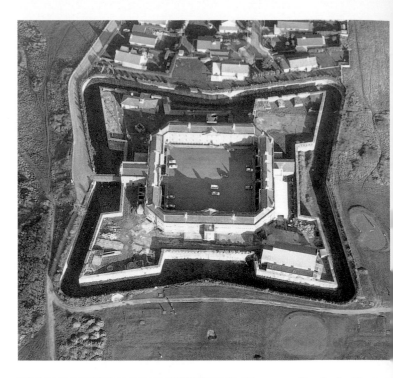

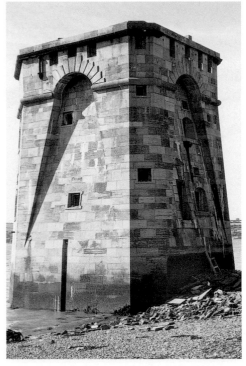

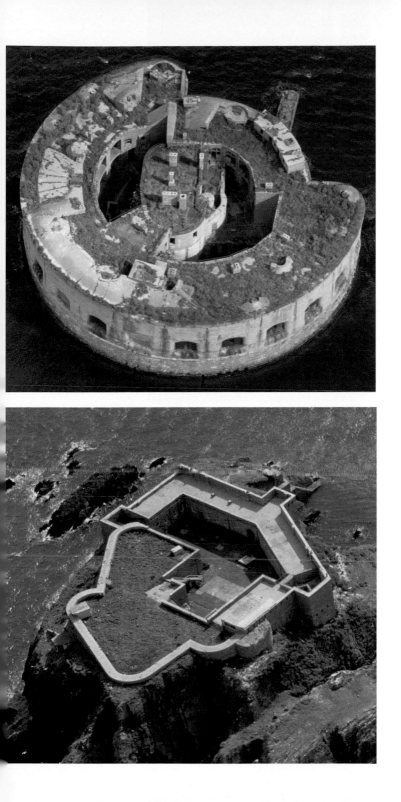

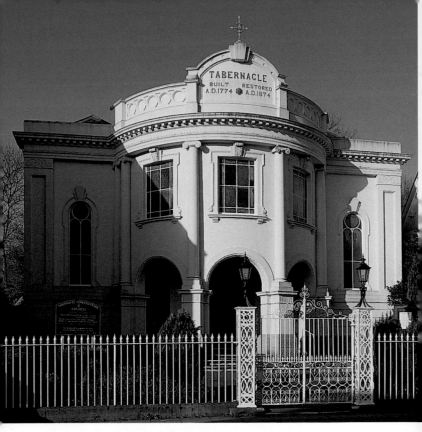

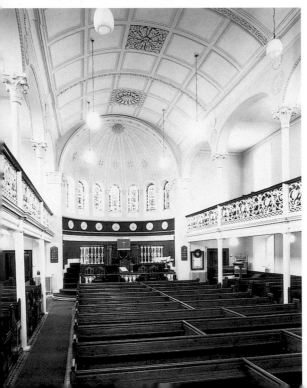

115. Haverfordwest
     Tabernacle
     Congregational
     Chapel,
     remodelled
     1874 by
     Lawrence &
     Goodman;
     p. 215
116. Haverfordwest
     Tabernacle,
     Congregational
     Chapel,
     interior; p. 215

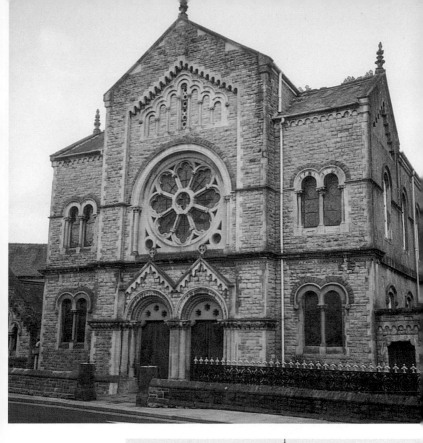

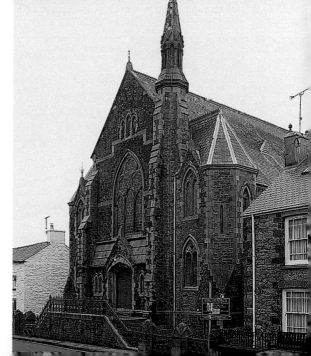

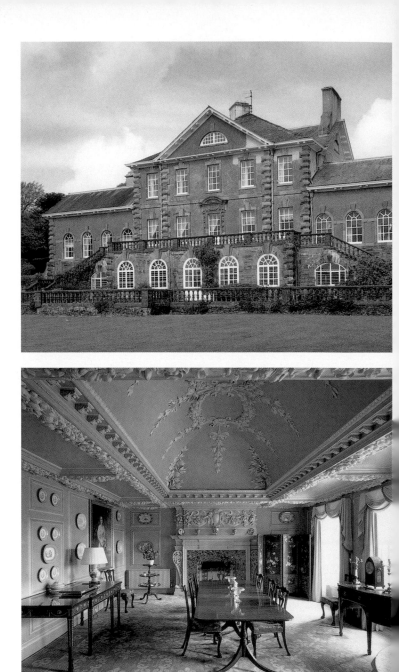

119. Newchapel, Ffynone, by John Nash, 1792–5; remodelled by F. Inigo
Thomas, 1902–7; p. 313
120. Newchapel, Ffynone, dining room, by F. Inigo Thomas, 1902–7; p. 315
121. Newchapel, Ffynone, music room, by F. Inigo Thomas, 1902–7; p. 314

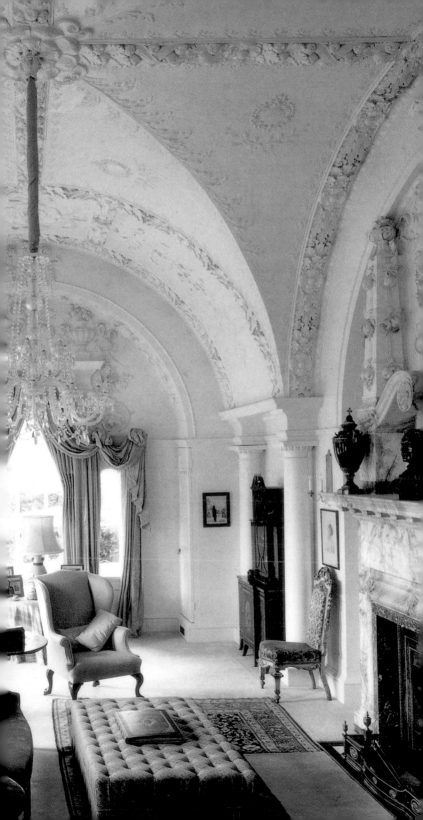

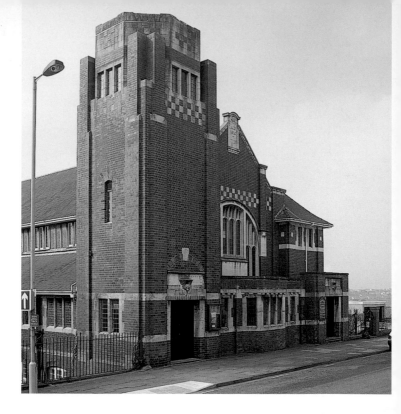

122. Milford, Tabernacle Independent Chapel, by D. E. Thomas & Son, 1909–10; p. 291
123. Milford, Tabernacle Independent Chapel, interior; p. 291
124. Tenby, St Mary, stained glass by Karl Parsons, *c.* 1920; p. 471
125. Stackpole, lychgate, by Christopher Hatton Turnor, 1898; p. 459

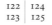

| 122 | 124 |
| 123 | 125 |

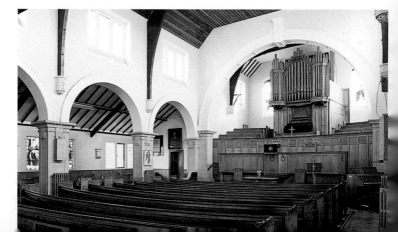

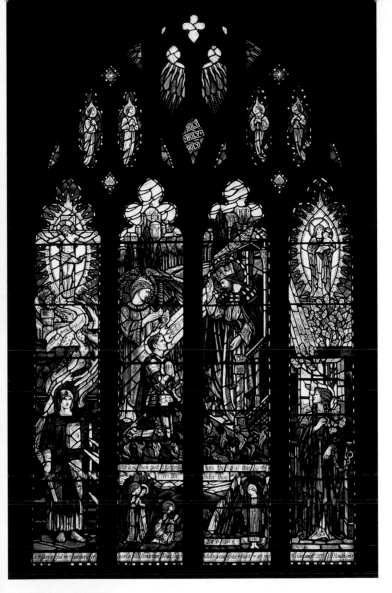

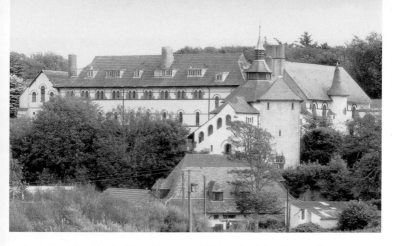

126. Caldey Island, The Post Office and Abbey, by John Coates Carter, 1907–15; pp. 138, 147
127. Caldey Island, The Abbey, north front by John Coates Carter, 1907–15; p. 148
128. Tenby, War Memorial, by J. Howard Morgan, 1923; p. 484
129. Fishguard, St Mary, East window, by John Petts, 1986; p. 186

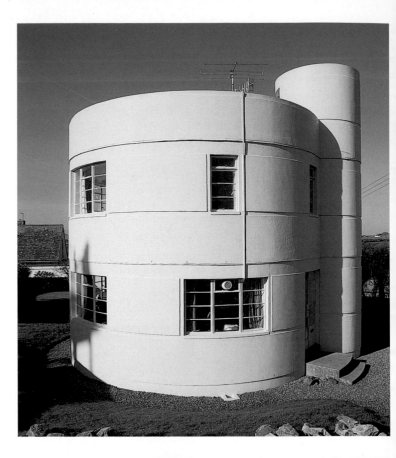

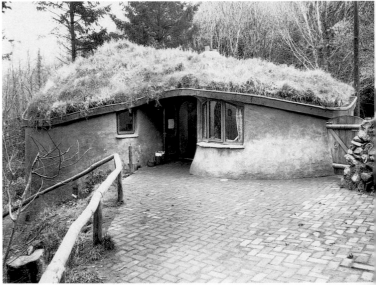

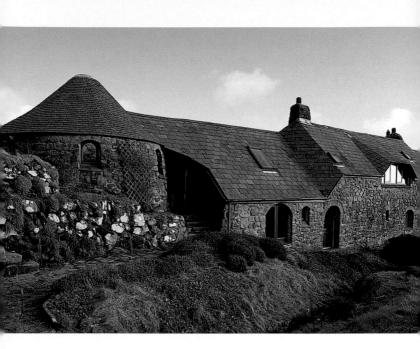

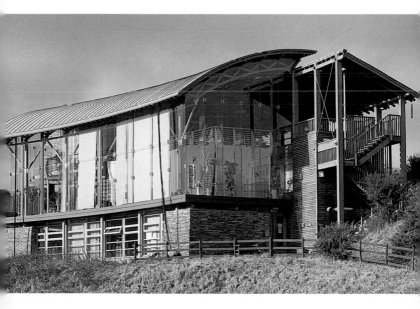

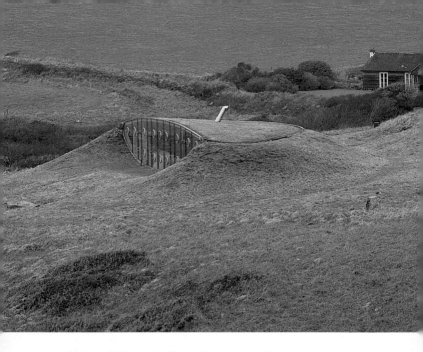

134.  Nolton, Malator, by Future Systems, 1998; p. 327
135.  St Davids, Tourist Information Centre, by Peter Roberts, 2001; p. 425

ST TUDWAL. Barely above the water's edge. Broad w tower, tapering and embattled, with a rough string course about halfway up: perhaps, C15, restored by *Coates Carter* in 1924. The lowest storey vaulted. Cruciform church, heavily restored. Earliest is the nave and chancel; masonry inside suggests the N transept is later. The s transept was added in 1863, the date of the very old-fashioned Y-tracery windows. In 1876 new roofs were added, and floors and walls were raised, the old N squint passage nearly filled in by the new floor level. Nave and transepts, have arch-braced roofs, simple, but skilfully handled at the crossing. The chancel was restored and the s porch added in 1888. – FONT. Square bowl, perhaps the Norman one pared down. – Splendid BOX PEWS, but possibly as late as 1863. In the s transept, carved BENCH ENDS, perhaps C17. Narrow in proportion, depicting musical instruments and singing birds among vinework. – Tall but unremarkable oak PULPIT of 1917, by the *Bromsgrove Guild*. – STAINED GLASS. E window 1921, by *Kempe & Co.*, Nativity – MONUMENTS. Mary Mathias †1849. Sarcophagus-shaped. – Thomas Jackson †1881. – John Sutton †1896. Both by *J. Phillips*.

HEPHZIBAH BAPTIST CHAPEL, Little Honeyborough, 1 m. NNW. Built 1840–1, but remodelled in 1904 by *T. W. Evans* of Neyland, repositioning the entrance to the gable-end: a late example of such a change. Stuccoed. Interior of 1904 with hammerbeam roof, and gallery at the entrance end with painted front.

GLENOWEN, ½ m. N, at Mascle Bridge. A three-bay, two-storey villa, almost square, overwhelmed by its huge, almost pyramidal hipped roof on broad eaves, pierced by a pair of large-scaled triangular bay windows on the seaward side. The design must owe something to the original owner, a sea captain, who died in 1854 with the house part-built.

SCOVESTON FORT, ¼ m. NW. Visible only as a mound in the field. The first to be built of the chain of C19 forts around Pembroke Dock, and the only landward fort protecting the naval dockyard. The line was proposed in 1860, Scoveston was built from 1861 to 1868 under *Lieutenant Gordon* (of Khartoum) of the Royal Engineers, and cost £45,462. On a low mound with panoramic views. The fort is an earthwork, with a moat some 36 ft deep. Originally, there were to be thirty-two guns on ramparts, with a 128-man garrison, but like many of the other forts, no permanent garrison was based there, and its only real use was during the First World War, when it served as a garrison preparing troops for the battlefield. Hexagonal moated enclosure, entered via a vaulted passage on the s side, originally reached by a wooden bridge. Two barrack blocks of finely dressed limestone: arcaded fronts with brick infill containing the openings. The N block is built into the perimeter of the site, the other into an earth revetment, to protect it against shell fire. Finally sold in 1932, now derelict.

WATERSTON, 1 m. NW. A small hamlet, now dominated by huge oil refinery storage tanks.

# LLANSTINAN

*9533*

Nothing but a cottage near the church down a track in fields E of the A40 near Scleddau, the modern village.

ST JUSTINIAN. A possible Celtic church site, the churchyard rounded and embanked. Small and low: nave, chancel, S transept and W bellcote. Still with sash windows in the nave and a Gothick sash in the slate-hung S transept. C19 work without archaeological pretension. A recent rebuilding is recorded in 1836, and the need for repairs in 1849 and 1855. *F. Wehnert* renewed roof and fittings in 1869 and there was work by *H. J. P. Thomas* in 1906–7. Inside, the whitewashed walls are unscraped, with pointed arches to chancel, squint and vaulted S transept.

SION BAPTIST CHAPEL, Scleddau. 1859. Small half-hipped chapel with gable entry. Characterful interior with tightly packed three-sided galleries, on timber posts. Fretwork panels to the pulpit.

HILL FORTS. Iron Age hillforts on the hilltop S of the church (SM 952 335) and at CASTELL DRAENEN NE of Scleddau (SM 949 345).

# LLANTOOD/LLANTWD

*1541*

No village; just the church by Llantood Farm standing on exposed upland between Cardigan and Newport.

ST ILLTYD. A bleak rebuilding of 1876–84 by *David Davies* of Penrhiwllan replacing a church of 1820. Lancets and a bellcote. Buttresses were added for structural reasons in 1890, by *George Morgan*. Two small mask-like heads, probably C13, and a STOUP in pitted conglomerate stone in the porch. FONT, in similar conglomerate, small and square, presumably C13. – On the W wall, FLOOR SLAB with incised foliated cross, possibly C14. – On the S wall, MEMORIAL to John Bowen of Tredefaid †1829, white marble columns. – In the vestry, C18 slate slabs to the Lewes and Bowen families of Tredefaid.

RHYDGARNWEN, ½ m. N. Asymmetrical villa of grey Cilgerran stone with ornate bargeboards and half-hipped gable. Built *c.* 1890 for J. P. M. George, probably by *George Morgan*, who added the stables in 1892.

PANTYGRWNDY, 1½ m. N. Mid-C19 hipped square villa, whitewashed. Large windows, original sashes replaced. Extensive four-sided FARMYARD, with deep lean-to cart-shed of eight bays against a N embankment.

TREDEFAID, 1½ m. NE. A gentry house from the C17, the scale that of a farmhouse, roughcast with half-hipped porch. NW corner room with heavy beams and scratch-moulded joists, C17. Entrance passage and stair were added behind the original fireplace. The staircase dated 1698 has gone.

PENRALLTDDU, 1 m. WNW. Substantial stone Victorian farm-

house, gabled and bargeboarded, built in 1861 for J.W. Bowen. The outbuildings include the former farmhouse of 1826, with reset datestones of 1803 and 1773.

CASTELL FELINGANOL, ¾ m. W (SN 163 422). Promontory fort with ruined rampart 300 ft long (RCAHMW), overlooking the deep Cwm Ffrwd.

CASTELL PENYRALLT, 300 yds NE of the church (SN 157 420). Motte 8 ft high and 30 ft wide, bailey roughly circular with 10 ft ditch (RCAHMW).

*See* also Glanrhyd.

# LLANWNDA

<span style="float:right">9339</span>

An archetypal north Pembrokeshire landscape, the hamlet dwarfed by rocky outcrops, the ground sloping N with spectacular views out to sea. CARTREF, E of the church, has a traditional cemented slate roof. Some single-storey cottages, eg. the pair restored by the artist *John Piper* on the SE side of Gawn Fawr. Otherwise, there are isolated farms. TREHOWEL, the best, is L-plan, colourwashed and slate-hung, probably mid- to later C18. Occupied as the headquarters of the French invading force in 1797. TRENEWYDD, to the W, has an early C19 sash-windowed front, and quite elaborate plasterwork to the entrance hall and stair. PENYSGWARNE, to the SW, of the 1830s, hipped roof and columned porch. CAERLEM, N of Garn Fawr, *c.* 1820, sashed and colourwashed, three bays. At Cilau, to the E, a village group: several farmyards with farmhouses and cottages close together. BWTHYN CILAU was restored from ruin 1992–4 by *Joan Hague* assisted by her son-in-law, *Steve Mantell*. It is one of a handful of restorations respectful of the traditions of the region. Remarkable interior with full-height living room, the end-wall overmantel a half round red-and-white-striped lighthouse tower, a reference to Douglas Hague, author of the major study of British lighthouses. On Carreg Wastad point, MEMORIAL, 1897, above the site of the 1797 landing.

ST GWYNDAF. The best of the simple medieval churches of north Pembrokeshire. Low and rough-hewn, two bellcotes, short lean-to aisles overlapping the chancel arch, big, rough stone-vaulted S porch. Nave restored 1881 by *E. H. Lingen Barker*, relatively carefully; the chancel was almost wholly rebuilt by *Ewan Christian* in 1880. Fragments of medieval stonework in the chancel side windows and N aisle look Perp. Colourwashed plastered interior with low arches to the chancel and cut through to the aisles, both sides of the chancel arch, those to the E regularized in 1880. The nave roof has some late medieval tie-beam trusses with arched braces to kingposts, one beam with a carved tonsured head. The N aisle is stone vaulted, like the porch. – FONT. Plain and square, possibly C12, on a circular shaft. Set on a platform some 6 ft square, faced by stone benches around the walls. – Outside, reset

INSCRIBED STONES, the one under the S aisle E window with crude human face.

In the churchyard, three high-walled, earlier C19 private GRAVEYARDS, cf. Cilgwyn.

HARMONY BAPTIST CHAPEL, 2 m. WSW. 1913. Stucco with giant centre arch and two-storey elevations.

STRUMBLE HEAD LIGHTHOUSE, Ynys Meicel. On a bare island linked to the mainland by a footbridge, a 55-ft whitewashed round tower of 1906–8, with latticed glazing to the light, and a cluster of flat-roofed accommodation and storage buildings in front.

HENNER BOARD SCHOOL, ½ m. S. 1874–6, by *D. E. Thomas*. Stone, the gabled roofs prominent and unwelcoming on a lonely crag.

The parish is particularly rich in prehistoric monuments, especially around Garn Fawr.

TALYGAER CORBELLED HUT, Pwll Deri, 2 m. W. Small, circular chamber (6 ft in diameter) of rough boulders with low corbelled roof.

GARN WNDA BURIAL CHAMBER, 300 yds S of Talygaer. Neolithic, the massive capstone supported by a single stone on one side, the chamber partly hollowed from the rock beneath.

DINAS MAWR FORT, Pwll Deri, 2 m. W. Iron Age clifftop fort dramatically set on a near-island promontory.

GARN FAWR and GARN FECHAN HILLFORTS, Garn Fawr, 2 m. W. Two Iron Age hillforts separated by a lower saddle. Garn Fawr is the larger, a rough inner square with drystone

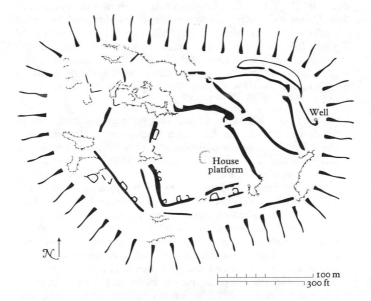

Llanwnda, Garn Fawr Iron Age hillfort

walls, one rampart to the W and two to the E, the outermost embanked with ditch and counterscarp. Three gateways through from the E. Garn Fechan, 300 metres to the E, is smaller, with drystone wall between natural outcrops.

GARN GILFACH BURIAL CHAMBER, Garn Gilfach, 2 m. WSW. A similar Neolithic tomb to Garn Wnda, the capstone partly resting on the ground, and the chamber hollowed under.

INCISED CROSS STONE, Cemetery Crossroads, SE of the village. Boulder at the roadside with inscribed cross.

# LLANYCEFN                                                    0923

The village is a half-dozen houses, mostly early C20. The OLD VICARAGE is of 1891 by *Ernest Collier* of Carmarthen, brown and grey stone.

ST NON. Small, in hard Preseli stone with grey Forest of Dean dressings, heavily restored in 1904 by *Ernest Collier*, without a spark of the new century. Nave and chancel, W bellcote and S porch. The battered nave S wall may be medieval but most of the rest is of 1904. Before there were sash windows instead of lancets, a brick bellcote, and a W door with fanlight. Inside, low medieval chancel arch, rood-loft door and squint. – STAINED GLASS. E window of 1906.

NANT-Y-CWM STEINER SCHOOL, 1 m. NE. The former 131 Llanycefn Board School of 1875–6, a stone single range with off-centre porch, and windows framed in grey limestone. Altered *c.* 1982 by *Christopher Day* for the Steiner School, with a volunteer workforce. A loft floor was inserted and a new rear wing built, to minimum cost, and self-evidently to amateur craft skills. To the front, the Victorian windows have been lowered and two dormers of interesting shape added, presaging the transformation inside. Here, the bare spaces of the C19 are subdivided into small and irregular rooms, the r. angles of walls and ceilings softened or lost altogether with roughly worked plaster. Door-heads are polygonal and asymmetrical. Colour washes of watery tones complement the tactile quality of the surface renders, reminiscent of Christmas grottoes, but intimate and child-centred, and they have worn better than conventional smooth finishes spoilt by the first handprint.

The KINDERGARTEN of 1989, also by *Christopher Day*, was built from new on the edge of thick woodland across the road. Here the ideas latent in the school, and explained in Day's *Places of the Soul* (1990), are given proper freedom. Rudolph Steiner in the early C20 had taken a stand against the mechanistic values and aesthetics of Modernism, noting the dichotomy between complex and curvaceous forms of natural objects and rectilinear forms designed by man. Day follows Steiner, but also borrows from the organic structures built by tribal societies, and from the C20 ecological movement, with its emphasis on natural materials to create a building intended to be actively healing to the spirit. The Kindergarten sits low

to the earth, especially on the road side, with pink-washed rendered walls battered outwards under an undulating green turf roof. Windows are curved or polygonal-headed, tiny to the road, but generous where function requires. A tightly articulated plan takes the child from a N end entry sheltered between out-curving walls, into a short corridor curving into a small, subtly lit central space of roughly triangular shape. Curved bench and coat-pegs to one corner. Four doors lead off, two to circular classrooms, to S and E, each rough-plastered, with niche-like refuges and play spaces, and shallow-domed ceiling. Both classrooms have main windows looking out into tree-tops. On the W, against the road, are storeroom, washroom and staff room. The hand-crafted, rough but tactile quality of these interiors recalls the more radical Arts and Crafts houses. The child-scaled detail – seen in the basins and benches, the varied niches, the doorways, and even the narrow wicket-gate off the lane – has a charm and a seriousness of commitment so appropriate that it comes as a shock to realize its rarity.

## LLANYCHAER/LLANYCHÂR

9835

The village is by PONT LLANYCHAER, a three-arched bridge over the Gwaun. The BRIDGEND INN has a late C19 iron water wheel. The church is in a wooded valley, about ¾ m. S. There was a slate quarry at Cronllwyn, S of the village (SM 985 353), from the earlier C19 to 1868.

ST DAVID. Rebuilt in 1876 by *Edwin Dolby* of Abingdon. Well crafted, walls of green Preseli stone and grey limestone, with ashlar dressings. Nave with W bellcote, S transept, and chancel. Lancet windows, a triplet at the E end. Pleasant interior with scissor-rafter roofs, and plain unmoulded chancel and transept

Llanychaer, Church of St David, pre-restoration

arches. The s wall of the chancel opens to a small lean-to under a timber lintel, based on the odd choir recesses of the region, cf. Nevern. – Encaustic tile REREDOS. – Small medieval FONT, retooled, square with chamfered base and two arch-headed sunk panels each side. – STAINED GLASS. E window and W lancet (St David), 1909 by *Heaton, Butler & Bayne*.

GLANDWR BAPTIST CHAPEL, ¼ m. SE. 1894, designed by the minister, the *Rev. J. L. Morris*. Small stone chapel with two arched windows and centre porch. Old-fashioned small-paned windows with Gothick intersections.

GARN, ½ m. SE. Much restored late C16 hall house with massive side-wall external chimney with conical shaft, a rarity outside Dewisland (cf. e.g. Rhosson, St Davids). Open hall with three massive and crude collar-trusses, the only one in the region, and a monumentally deep fireplace. Pointed doorway to the rebuilt upper end, which may have been a parlour or service rooms, and a lower end room beyond the entrance passage. The plan of the hall is extraordinarily skewed with barely a right angle, and complicated by a lateral outshut each side, possibly bed recesses. This is the only intact example in the county of a C16 ground floor hall still open to the roof, though it is assumed that there were others (cf. Thorne Cottage, St Twynnells).

## LLANYCHLLWYDOG *see* PONTFAEN

## LLAWHADEN/LLANHUDAIN                    *0117*

Linear village, dominated by the ruined castle, the church almost hidden to the E, deep in the river valley. Little evidence remains of the borough established in the C13 by Bishop Thomas Bek. A royal licence for weekly markets and annual fairs was given in 1281, and a hospice founded, of which some remnants survive. By 1326, 174 tenement plots were in occupation and Llawhaden was the richest estate of St Davids.

### LLAWHADEN CASTLE                       p. 264

Commanding position, astride a high motte, with early C15 gate-house visible from afar. Llawhaden had long belonged to the bishops of St Davids and the castle was perhaps begun in the C12. Gerald of Wales mentions it in 1175, seventeen years before its capture by the Welsh. Control was regained in the early C13 and the earliest masonry is of this date. Thomas Bek, bishop from 1280, and Keeper of the King's Wardrobe, remodelled the castle as a splendid manorial residence, with a huge new hall block on the NE side. A large and luxuriant southern range of apartments was added in the 1380s, attributed to Bishop Adam de Houghton, with an extraordinary tower-like porch. Glyndwr's rebellion probably led to the building of the gatehouse early in the C15. For much of the C15 the castle was abandoned, and after some work by Bishop Edward Vaughan (1509–22), the lead was

removed by Bishop Barlow. Licence was given to demolish in 1616, and, though impressive from the outside, the castle is little more than an empty shell. Placed under the Ministry of Works in 1931, it is now maintained by Cadw.

The steep RINGWORK was perhaps adapted from an IRON AGE FORT. The earliest masonry dates from the early C13, including the footings of the ROUND TOWER to the SW, small in diameter, but with immensely thick walls. Of the same date the base of a smaller tower to the NE, indicating that the early C13 castle had round towers linked by a curtain wall. The NE side is chiefly taken up by Bek's great HALL, begun after 1280. The vast hall (24 × 7 metres) was at first-floor level. Large

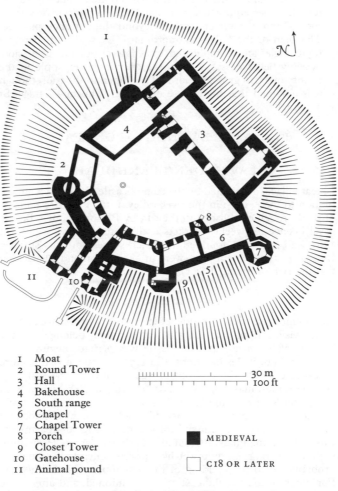

| | |
|---|---|
| 1 | Moat |
| 2 | Round Tower |
| 3 | Hall |
| 4 | Bakehouse |
| 5 | South range |
| 6 | Chapel |
| 7 | Chapel Tower |
| 8 | Porch |
| 9 | Closet Tower |
| 10 | Gatehouse |
| 11 | Animal pound |

30 m
100 ft

MEDIEVAL

C18 OR LATER

Llawhaden Castle. Plan

cross-wings at each end, projecting towards the ditch, pre-
sumably contained service (w) and private rooms (e). Both hall
and wings have the remains of large barrel-vaulted undercrofts,
with internal newel stairs; in the main undercroft a trefoiled
lancet, and fine triple-chamfered doorway with big bulbous
stops at different heights. To the w, footings of a large BAKE-
HOUSE. The s RANGE is proven to date from the time of Bishop    43
Adam de Houghton, c. 1380, when *John Fawle* was 'master of
our works'. Fawle was constable of Llawhaden, and master
mason for St Mary's Chapel at St Davids. The three ruined
barrel-vaulted undercrofts may belong to an earlier structure,
built against the curtain wall. The large range, with its two dis-
tinctive polygonal towers along the curtain wall, contained
apartments, with the CHAPEL, indicated by three large cinque-
foiled lancets of purple Caerbwdy stone, in the eastern third
of the first floor.

The three-storey CHAPEL TOWER is quite complete. All of
the chambers have latrines, and the topmost has a groin-vaulted
roof. Extraordinary five-storey PORCH to the chapel; now
nearly free standing, and towering above the rest of the castle.
Doorway with deep label, worn king and queen headstops. The
shafts of a quadripartite vault survive at first-floor level, also a
well-moulded inner doorway. Of the adjacent apartments, little
survives but enough remains to speak of great luxury. Above
the undercrofts were two sets of rooms to both floors, each
having a large heated room. The uppermost windows have
wide embrasures, with seats. The CLOSET TOWER, placed cen-
trally, provided each room with a little vaulted chamber and a
latrine, situated in the dividing spine wall. (Cf. Amberley
Castle (West Sussex) for the bishop of Chichester.)

The handsome GATEHOUSE retains some earlier masonry
behind, including part of the C13 curtain wall. The design is
similar to that of Carmarthen, erected c. 1410, and so may be
close in date. Two D-plan towers with spurs flank the tall seg-
mental arch; the arch is flanked by bands of purple Caerbwdy
stone, and alternating voussoirs are of the same material. Large
square-headed Perp windows above, with cross-loops below.
As at Carmarthen, the middle had machicolations, but only
the carved-head corbels survive. Parts of large barrel-vaulted
rooms remain at all three levels. Attached to the gatehouse is
a large oval ANIMAL POUND, perhaps C18.

ST AIDAN. Delightful setting, on the bank of the Eastern
Cleddau, with the castle high above. Medieval nave and
chancel, s chancel aisle and w porch. Extraordinary s tower,
incorporating an earlier, much smaller one, the latter part-
projecting and acting almost as a buttress. Both are embattled;
the older tapering one is diminutive compared with its sub-
stantial successor of c. 1500, which stands on a battered base.
The N transept has been lost. The two-bay arcade of the
chancel aisle has crudely chamfered four-centred arches on a
round pier, simple cap with cable moulding. It is late C15 or

C16 (cf. Llanddewi Velfrey). The W respond has a crudely carved mask and beast with one-and-a-half faces, and the relieving arches are supported on a mask corbel. Everything else speaks of a dreary restoration in 1862, by *J. G. Sturge* of Bristol, a surveyor. Plate-tracery windows in the nave, part of a two-light labelled Perp window in the chancel. Thin arch-braced roofs. – FONT. Norman square bowl, scalloped underneath. – Plain FURNISHINGS of 1862. – MONUMENTS. Much-worn effigy of a priest in the chancel, perhaps C14. – Rev. Evan Owen †1662, chancellor of St Davids and son of the historian George Owen. Beautifully lettered small oval plaque (in Latin) with splendidly carved cartouche-like surround. The curly top has swags of drapery flanking a cherub's head, female figures each side, and laughing cherub below, with heraldry. – Rev. William Evans †1796, who translated Rev. Rhys Prichard's poems into English. Simple pilaster strips and pediment. – John Furlong †1818. Pediment with winged cherub head.

Outside, in the E wall, an eroding INCISED CROSS, C6–C9. In the SW corner of the cemetery, a walled enclosure with crude obelisk finials, presumably for the Skyrmes of Llawhaden House. A monument of 1713 survives, but the structure looks older. Adjoining, a part-railed area with two tablets let into the wall, both with good pilastered surrounds. Both are early C19 memorials to the Foley family of Ridgeway, who claimed descent from John Fawle, constable of Llawhaden in the late C14.

BETHESDA CONGREGATIONAL CHAPEL, 1 m. ENE. 1848, altered in 1871 by *Rev. Thomas Thomas*. Small gabled front, tall arched windows in the outer bays, with moulded surrounds. Gallery on three sides, presumably 1871. Box pews of 1848.

The OLD MILL (now a house), near the church. Three bays, with half-hipped roof. Boldly executed stone doorcase with open pediment and date 1765. BRIDGE much repaired in 1809 by *James Rees* of Nevern. Three segmental arches, wider in the centre. The arches are probably contemporary with the rebuilding of the mill: Buck's print of Llawhaden shows a medieval bridge with six pointed arches.

LLAWHADEN HOUSE, in the village centre. Gutted by fire in May 2000, the interior tragically all lost. Home of the Skyrme family from the early C17. Picturesque rambling plan with C16 nucleus, the windows all sashed. Low two-storey E front, rendered, with irregular gabled projections, including a C17 porch l. of centre with truncated corbelled chimney on its N wall. The present shape is shown in Buck's print. The long rear service wing is earliest, with barrel-vaulted room at the W end lit by an early C15 cross-loop (salvaged from the gatehouse of Llawhaden Castle). Blocked dormer windows with painted panes on the S wall. Set in the W wall, an early medieval INSCRIBED STONE, long illegible. Good C18 GATEPIERS with trophy finials. Extensive FARM BUILDINGS. Small C18 outhouse W of the house, incorporating a tracery fragment,

perhaps C14, reused from the castle. C17 or C18 square DOVE-
COTE with pyramidal roof and external dove-holes. Com-
bined cow-house and cart-shed, the latter with three elliptical
arches, one dated 1820, with the initials of Francis Skyrme.
Large WALLED GARDEN across the road. Datestone of 1691
(formerly over the entrance), stating that the whole took only
ten weeks to complete. The names of the masons, *Thomas
Matthews*, *R. S. Evans* and *H. V. Ferrier*, are recorded. On its E
wall, a ruined GAZEBO, and to the S, an overgrown CISTERN
HOUSE. To the E was a large rectangular mill pond, now grassed
over as the village green.

Behind the modern village hall, remains of the HOSPICE,
founded in 1287 by Bek. Large rectangular chamber, roofed
with tall pointed barrel vault. A piscina-like recess suggests this
was the chapel. Probably later than 1287. Archaeological evi-
dence indicates an earlier, larger structure on the site.

DORNEY WOOD, ⅓ m. NW. Formerly the vicarage. 1878. Stolidly
Gothic: labelled windows and half-hipped roofs, typical of its
architect, *W. Newton Dunn*.

PENLLWYN HOUSE, 1 m. ENE. Mid-C19, three storeys and bays,
hipped roof. Porch on thin Ionic columns. Lower wing.

VAYNOR, 1½ m. E. Substantial early C18 house of two storeys,
dated 1707 over the door, with the initials of William Skyrme.
Six very irregular bays long, and with fine carved Bath stone
portal in the centre. with fluted Corinthian pilasters, and the
arms of the Skyrme family in the broken segmental pediment.
Single-pile plan; good, early C18 staircase with dog-gate and
turned balusters. The principal rooms are on the first floor, one
with panelling.

   VAYNOR GAER, to the SW, large, oval enclosure: a much-
altered double bank and ditch.

RIDGEWAY, 1 m. S. Prominently sited. Late C18, square three-
storey house with hipped roof. Lower, slightly later wings with
the ground-floor windows in elliptically headed recesses. The
wings are by *John Nash*, built for the Foley family, for whom
Nash also designed Foley House, Haverfordwest. The main (E)
entry is directly underneath the staircase as at Nash's Glan-
wysc (Powys) and the plan of the stair – two sweeping flights,
with a return flight to the gallery – is also similar. The
balustrade must be later, likewise the clumsy canted porch.
Large, intricately glazed iron Diocletian window above, light-
ing the stair. In the centre of the late C18 house, a good Chinese   82
Chippendale staircase.

HOLGAN CAMP, ½ m. NE. Iron Age promontory fort, with double
bank-and-ditch system to the W. Archaeological evidence of
earlier occupation, which indicated the fort as part of a group
of periodically used enclosures, settled and embanked in the
first century B.C. and in use in the first centuries A.D.

GELLI BRIDGE, 1½ m. NE, winds pleasantly over the river. Two
unequal arches, probably early C19. The BAPTIST CHAPEL
nearby is dated 1861, but its plain gabled front and galleried
interior are of 1893, by *George Morgan & Son*.

# LLYSYFRAN

Village just SE of the Llysyfran reservoir, a few houses on the lane
to the church, which is hidden at the foot of a steeply sloping
churchyard. Slight remains of a MOTTE N of the church.

ST MEILYR. Small; nave and chancel with W bellcote, much
rebuilt in the C19, though the main recorded restoration, 1869
by F. Wehnert, cost only £150. Plain interior with minimal roof
trusses. Low, crudely rounded, plastered chancel arch. In the
S wall near the W end a curious curved chamber, 5 ft deep, 6 ft
wide, apparently medieval, though with C19 trefoil window. –
Medieval FONT, nine-sided bowl on a round shaft with roll-
mould and spur feet.

CAPEL GWASTAD, Gwastad. Stucco half-hipped chapel pre-
sumably of the 1830s, to long-wall plan, nicely altered in the
1890s to give three long arched windows and a porch in the
fourth bay, with pulpit on the end wall. No galleries.

LLYSYFRAN RESERVOIR. Created 1968–72 to supply water to
south Pembrokeshire and the oil industry, by damming the
Afon Syfynwy, a Cleddau tributary. The 200-acre reservoir
is contained by a concrete dam 147 ft high. Roughcast and
slate VISITOR CENTRE, 1989–90, by *Alex Gordon Partnership*,
like a golf clubhouse with a hipped two-storey centrepiece.
Laminated curved trusses inside.

# LOVESTON

Tiny unspoilt hamlet. Three farms, N and W of the church, the
mid-C19 GREAT LOVESTON FARM with slate-hung front.
Anthracite was mined from the C16; the Loveston Pit disaster
killed seven men in 1936.

ST LEONARD. Much Perp detail. Nave and chancel, S porch.
Tiny matching transepts, both with pointed barrel-vaulted
roofs and big, early C19 window openings. Dramatically
tapering W tower, the stair-turret rising proudly above the bat-
tlements. Perp straight-headed E window, of three lights.
Rugged colourwashed interior. Alas, the early C19 box pews,
double-decker pulpit and late C17 communion rail were
removed in the 1970s. Perp chancel arch, flanked by square
squint openings, suggesting the main body of the church is of
a single campaign (cf. Johnston). Plain pointed PISCINA.
Minor repairs in 1914 by *F. R. Kempson*. – FONT. Norman
square bowl with corner scallops and little chevrons between,
circular pedestal. – MONUMENTS. Large tablet of *c.* 1630 in
the chancel, framed by engaged Corinthian columns on
consoles, the panel and shields with curly carved surrounds.
The lost painted inscription may have commemorated a
branch of the Adams family of Paterchurch, Pembroke Dock,
then seated here. – Henry Leach †1787. Veined white marble,
triangular pediment over clear inscription.
    Ruined CATTLE POUND in the hedge to the N.

# LUDCHURCH/YR EGLWYS LWYD          *1410*

Scattered roadside village, with the church to the N.

St Elidyr. On a cliff-like site, nearly surrounded by a long-disused, water-filled limestone quarry containing some good LIMEKILNS. Tall, tapering C15/C16 W tower, embattled, the stair-turret rising above. Lower stage barrel-vaulted. Nave and chancel with long S aisle, a C16 addition. N porch. Simple, straight-headed late Perp aisle windows. Restored 1892–3 by *Kempson & Fowler*, adding the other Perp windows and the wagon roofs. *J. P. Seddon* had produced plans for a more drastic restoration in 1875, but nothing was executed. Rewarding interior with arcades of chamfered Tudor arches, three bays long in the nave, and two in the chancel. Round piers, simple caps with shields, plus a crude mask in the nave, and a flower in the chancel. Pointed chamfered chancel arch with simple imposts. C19 wagon roofs. Good STOUP, the bowl carved with a simple mask, flanked by flowers. A simpler stoup in the aisle, indicating a blocked S door. – FONT. Plain, square chamfered bowl, possibly the Norman one. – FITTINGS of 1892–3.

In the graveyard, large upright MEMORIAL to William Baugh Allen †1922, designed by a 'London architect', using a fireplace from Allen's house. Originally inset with beautiful blue-green peacock-feather tiles by *William de Morgan*.

TALL TREES, ⅓ m. N. Former vicarage of 1868 by *Foster & Wood* of Bristol. Large, irregular, pared-down Gothic of the muscular Victorian type. Red and green sandstone mixed with silver limestone and Bath stone bands. Mullion-and-transom windows, some cusped. Two-bay garden front with gable. Large stair hall inside.

WESTERTON, ⅓ m. NW. Apparently a C19 three-bay farmhouse; but two massive lateral chimneys on the back wall, suggesting the C16. Corbelling indicates large fireplaces on first as well as ground floor; possibly a storey has been removed. In the cellar, a mullioned window, now blocked.

# LYDSTEP          *0898*
2 m. W of Penally

Small roadside village with splendid coastal views. The cliffs were quarried in the C19 for the manufacture of fireplace surrounds and gravestones. The fine-flecked limestone shines up well when polished. The cottages and farm buildings with bright red pantiled roofs are the results of remodelling *c.* 1912 by *Baillie Scott & Beresford* for Lord St Davids of Lydstep House.

PALACE. A ruin, recently consolidated. A medieval undefended first-floor hall of considerable size. Rectangular, with three undercrofts, two with longitudinal barrel vaults, the third with transverse barrel vault. The much-depleted first floor had hall and chamber, with latrine attached to the hall. Entry was at first-floor level on the W (long) side, with no internal stair. No

sign of an original wall fireplace in the hall, so probably ori-
ginally heated by an open hearth; and indicating an early, pos-
sibly C13 date. Altered windows. Steeply gabled roof; on the
long side wall, corbelled base of the hall chimney. According
to local tradition, a palace belonging to St Davids. Fragments
of red Caerbwdy stone among the masonry might support such
a connection. Or was it one of the houses in the area 'built on
arches' (i.e. vaults), constructed perhaps for the merchants of
nearby Tenby, which are mentioned by Fenton?

WEST LODGE, prominent in the village centre. Built in 1912
in Arts and Crafts style, by *M. H. Baillie Scott & E. Beresford*
for Lord St Davids. Native stone, with red tiled roof. Road
elevation with stepped tapering chimney between gable and
outshut. The service end is cranked, creating an intimate
entrance front. Bold corner chimney, balanced by the gabled
stairwell; beyond it the roof sweeps over the porch. Barge-
boards were substituted for the intended copings and the
house was not colourwashed as planned. In their *Houses and
Gardens* (1933), where the building is illustrated, the architects
lamented that the client 'considered an umbrella better than
a mackintosh', resulting in the 'flimsy picturesque associated
with a cuckoo clock'. The Arts and Crafts style found little
favour in the county; in 1912 the *Tenby Observer*, recorded
that West Lodge had 'evoked severe criticism' for its uncon-
ventional design.

LYDSTEP HOUSE, ¼ m. E. Now a clubhouse for a large caravan
park. Delightful setting, with breathtaking views across to
Caldey Island. Plain exterior: a long, low façade, given large
cross-wings with wide bay windows in 1894, for Lord St
Davids. Inside, the robustly eclectic Arts and Crafts details,
reputedly instigated by Lady St Davids, surely suggest *Baillie
Scott & Beresford* were involved. The staircase rises around a
generous, panelled well, with slat balusters and cut-out hearts.
At the top, tall cupboards with painted panels depicting figures
and landscapes. Heavily carved timber chimneypieces, the one
in the present bar with large hood, incorporating a cupboard
with coloured glass panes and beaten copper hinges.

On the cliff to the w, a small SUMMER-HOUSE, built for
Lady St Davids.

MAENCLOCHOG

A substantial village with the church across the top of a triangu-
lar green. A further green space at the lower end flanked by the
slate-hung, whitewashed CASTLE HOTEL, three bays, mid-C19.
N of the church, the SCHOOL of 1878.

ST MARY. An absurdly thin, square w tower remains from the
church of *c.* 1806 built for Barrington Pryce of Temple Druid.
The rest re-done without flair by *Middleton & Son* in 1880–1.
Single-roofed nave and chancel with s transept, and added N
vestry. Interior with a plain chancel arch, seven-sided, open

rafter nave roof, and panelled chancel roof, all 1880. –
STAINED GLASS. E window of *c.* 1950, conventional figures
on clear glass. – MEMORIAL. Nicely rustic slate oval to H.
Bulkeley of Temple Druid †1821. – At the W end, two C5–C6
INSCRIBED STONES of three removed from the lost church of
Llandeilo Llwydiarth (*see* Llangolman); the third is at Cenarth,
Carms. They relate to the same family. The taller stone reads
ANDAGELLI IACIT FILI CAVET-, with an Ogham inscription
on the l. angle [A]NDAGELLI MACU CAV . . . , and has a C7 to
C9 inscribed Latin cross with three-pronged terminals. The
other stone (presumably a brother) is inscribed, COIMAGNI
FILI CAVETI, while the stone at Cenarth commemorates
Curcagnus, son of Andagellus.

YR HEN GAPEL (INDEPENDENT CHAPEL), 1904–5 by *D. E.
Thomas & Son* of Haverfordwest. Closed 1999. An enter-
taining free Edwardian stucco façade, barely related to the
building behind. Centre gable, recessed between side bays with
parapets, over a first-floor row of pilasters slicing a broad,
curved window. This is over a much thicker pilastrade framing
the two doors under a flat, heavy hood.

TABERNACLE INDEPENDENT CHAPEL, below the Castle
Hotel. 1884, by *John Humphrey* of Morriston. Stuccoed gable
front of some originality. Excessively long slit windows, like a
pair of thermometers uniting the two floors. Eleven openings
in all, but only two admit much light. Inside, three-sided
gallery with continuous band of pierced cast iron.

HOREB BAPTIST CHAPEL, I m. NW. 1885, by *George Morgan.*
Rock-faced stone, severe and large with roundel tracery in the
main window and fanlight, and bargeboards joined in a curve
across the gable.

TEMPLE DRUID, ¾ m. E. The present three bay stuccoed house
was formed *c.* 1830 from a part of a lost and inadequately
documented house of 1795–6 by *John Nash,* built for Henry
Bulkeley. This house was dismantled in 1824, when among
the sale items were an 'elegant geometrical stone stair with
mahogany balustrade branching from the centre of the hall to
each end of the gallery'. The sitting room in the present house
has a big apsidal recess with curved cupboard doors, and a
coved ceiling, which certainly look like work by Nash, but the
room is smaller than any recorded in the original house.* The
name Temple Druid comes from a big cromlech destroyed to
build the farmyard, according to Fenton. The farmyard on the
cliff above is carried on stone vaults, partly collapsed, and
fronted to the road by a row of three whitewashed cottages.

STANDING STONES. A pair N of the village, NE of Ty-newydd
(SN 082 279), one E of these, W of Galchen Fach (SN 087 278),
and one E of Prysg Farm opposite Temple Druid (SN 096 271).
*See* also Rosebush.

---

* Nash's house had a stone-paved entrance hall, 27-ft principal room each side, eight
bedrooms, three dressing rooms and an attic storey, suggesting something larger
than his Llanerchaeron, Cered.

## MANORBIER/MAENORBŶR

A rewarding place, with castle, dramatically set astride a rocky spur between the village and the beach, and a fascinating medieval church on the steep opposite side of the valley. The village itself is mostly C19.

Manorbier was the birthplace of the author and ecclesiastic Gerald de Barri, better known as Giraldus Cambrensis, or Gerald of Wales (*c.* 1146–1223). Manorbier was prosperous in Gerald's time. He described the castle as 'excellently well defended by turrets and bulwarks, situated on the summit of a hill extending on the western side towards the sea, having on the northern and southern sides a fine big fish pond under its walls and a beautiful orchard on the same side, enclosed on one side by a vineyard and on the other by a wood remarkable for the height of its hazel trees'. He goes on to mention the large lake and mill s of the castle; the former is silted up, but the latter may be the predecessor of the present ruined building (*see* Perambulation, below). Gerald concluded that in all of Wales, 'Manorbier is the most pleasant place by far'. Enough remains to appreciate his sentiment.

21

### MANORBIER CASTLE

Despite the precipitous curtain walls, the castle has no military history of note. It is first mentioned in 1146, when it was occupied by the de Barri family, who held the castle peacefully until the late C14. In 1403 it was owned by Sir John Cornwall. After 1475 the castle was Crown property. It was acquired by the present owners, the Philipps of Picton, *c.* 1630. Judging by the surviving buildings, the castle was used for a mixture of farm buildings and cottages from the C16. Nothing came of the plans made in 1829 by *Daniel Robertson* of Oxford to convert the hall block into a shooting box for Richard Philipps, Lord Milford. In 1865 Sir Thomas Phillips of Middle Hill, Worcs, planned to roof the entire inner ward for his vast library, choosing a Pem-

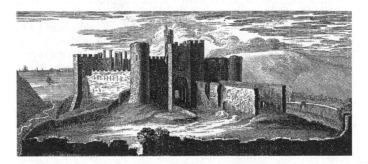

Manorbier Castle from the south east.
Engraving by Samuel Buck, 1740

brokeshire site to suggest an unwarranted ancestral link with the
Philipps family of Picton. In 1880 the medieval enthusiast *J. R.
Cobb* took a lease of the Castle, erecting the present house in the
inner ward. Cobb floored the North and Round towers, and the
gatehouse, which was also roofed, but his restoration work does
not detract from the quaint clutter in the inner ward.

The INNER WARD is rectangular with entry on the E side. At the
opposite end is the hall block, with the chapel to the S. Little
remains of the medieval buildings along the S side. The OLD
TOWER and the HALL are probably of Giraldus' period. The
crudely built, square Old Tower adjoins the present gatehouse
on its N side, and probably defended an earlier gate. The rec-
tangular hall block to the W is has a double-height hall entered
at first-floor level from a (replaced) exterior stair. Below is a
basement of three parallel barrel-vaulted chambers (one inac-
cessible), and a crudely built, interior stone spiral stair. The
hall fireplace, on the E side, has a cylindrical chimney, a later
(C16?) feature. The dividing wall between the hall and the
apartments has fallen. The apartments occupied the northern
third of the range; a plain hooded fireplace survives on the
top storey, with cylindrical flue. The stone CURTAIN WALL

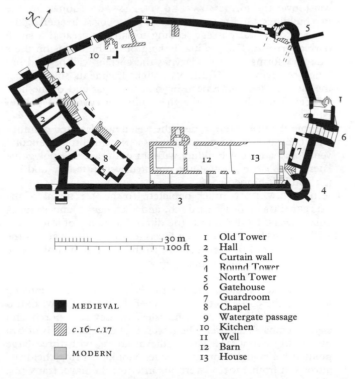

| | 1 | Old Tower |
| | 2 | Hall |
| | 3 | Curtain wall |
| | 4 | Round Tower |
| | 5 | North Tower |
| | 6 | Gatehouse |
| MEDIEVAL | 7 | Guardroom |
| | 8 | Chapel |
| *c.*16–*c.*17 | 9 | Watergate passage |
| | 10 | Kitchen |
| MODERN | 11 | Well |
| | 12 | Barn |
| | 13 | House |

Manorbier Castle. Plan

connecting the hall and the Old Tower is probably of *c.* 1230, heightened at a later period, preserving the original rampart walk. This heightening added an extra storey to the Old Tower. On the E (entrance) side, two curtain towers, the ROUND TOWER contemporary with the curtain wall is the better preserved, standing to four storeys. Mural stair within, and a domed roof. The masonry of the semicircular, three-storey NORTH TOWER is slightly later.

The mid-C13 GATEHOUSE had a drawbridge over the ditch, protected by two portcullises. Two chambers above the passage, barrel-vaulted on the first floor, and heated on the top floor. To the S, parallel with the curtain, the low, vaulted rectangular GUARDROOM. The CHAPEL in the SE corner of the ward is mid-or later C13, set at a slight angle to the hall. Barrel-vaulted undercroft, with some E.E. trefoiled lancets. The chapel, reached by an exterior stair, is also barrel-vaulted, long and lofty. The large windows (robbed of their tracery), have remains of angle shafts with stiff-leaf capitals, signs of a design of considerable quality. Single SEDILE. Fragmentary PAINTED DECORATION: part of a human figure can just be seen on the W wall in red. Inserted fireplaces on both levels, probably of the C16. Slightly later chambers were squeezed between the hall and the chapel, within the SW corner of the ward, over the former WATERGATE PASSAGE connecting the two buildings. On the N side, a good pair of ogee-headed lights; to the S, a mural passage leading to latrines created a small dark courtyard. The gradual linking of the buildings on the S side now forms the boundary, as the curtain wall beyond has long been removed. To the NW, slight fragments suggest that the kitchens may have been beyond the solar end of the hall. A deep WELL here. To the N, within the curtain, a pair of latrines.

From the C16 and C17, near the well a now isolated chimney with conical flue, a long roofless BARN, with little triangular vents, and adjacent building with an odd, tapering polygonal lateral flue. *Cobb*'s house was unobtrusively fitted in, and has a broad half-hipped roof.

The OUTER WARD is much depleted. To the N, remains of the POSTERN GATE near the ditch, and rectangular and semicircular towers. To the S, near the ditch, fragments of a tower.

Civil War EARTHWORK, a stone-faced terrace running across the ridge in front of the castle ditch. To the NE, the shell of a large BARN with triangular vents.

ST JAMES. Remarkable site on the steep valley side, looking across to the castle to the N and over the sea to the W. Extraordinary rambling plan with aisles, transepts, S porch and slender embattled tower. The tower, N of the chancel, is of two builds: C13 below and late medieval above, with three large pointed belfry-lights on the N side. Monkton Priory held the advowson from 1301. Cavernous interior: the nave, transepts, aisles and porch all with pointed barrel vaults – an extreme

example in an area lacking in good building timber. The long nave is partly Norman with a former plastered round-headed window to the s. Pointed barrel vault added in the C13, when the nave was lengthened to the w. In the C14, the oddly mis-aligned chancel was rebuilt and the transepts added. The narrower N transept was lengthened in the C14, and given a barrel vault with plain parallel ribs. Squint to the s. The aisles (very narrow and tunnel-like on the N side) were both added in the C15, with plain three-bay arcades gouged out of the nave walls. The s aisle is almost equal in size to the nave. Bellcote and paired Perp lights in the N aisle, and a mural rood stair. Finally came the vaulted, late C15 porch, the door with shallow mouldings. Restorations by *Richard Barrett*, in 1843, and by *J. P. Harrison* in 1848 (w triple lancet). A more evident programme of 1865–8 by *F. Wehnert* provided the E.E. windows and the arch-braced roof in the chancel. N transept converted to a chapel in 1958 by *Caroe & Partners*; simple SCREEN with tall turned wooden balusters.

FURNISHINGS. – FONTS. Heavily retooled Norman bowl with scallops. The smaller octagonal bowl is presumably late medieval. – The church is justly noted for the survival of the C15 ROOD LOFT with ribbed coving, moved to the N aisle in 1868; a rare survival in Pembrokeshire. It fell apart during Wehnert's restoration, leaving only the upper part usable. Corbels of the rood loft clearly visible. First-floor access to the tower is via a complex arrangement of C20 wooden galleries which incorporate a length of the rood loft cornice. – Handsome oak REREDOS designed by *J. Fergusson Barclay* (*see* Holyland, Pembroke) and carved in 1906 by his mother, a local lady. Five stepped bays, with vinework cornice – FURNISHINGS by *Wehnert*, all of good quality. Perp style CHANCEL SCREEN, carved timber PULPIT and STALLS, COMMUNION RAIL with bold open cusping. – FONT COVER and heavily carved SETTLE also by *Mrs Barclay*. – Traces of late medieval PAINTED DECORATION on the vaulted ceiling of the porch, a geometric pattern, each panel with a wheel surrounded by floral motifs. – Small Early Christian CARVED STONE in the porch, a cross with splayed terminals. – Large ROYAL ARMS, 1702. – STAINED GLASS. E window s transept and chancel s, 1902 by *Joseph Bell*. – N aisle centre, 1915 by *Kempe & Co.* – N aisle NW, N transept, chancel SE and w window, all by *Powell*, 1919–26. – MONUMENTS. – In the chancel, well-preserved early C14 effigy of a de Barri of Manorbier Castle. Chain-mail, with sword, and shield carved with the de Barri arms – a rarity: the folds of surcoat and details of spurs well defined. Formerly in the N transept. – Maria Williams †1782. Fine lettering, skull within curved top. – Lewhelling family, 1809. Well lettered. – Augusta Lloyd †1828. By *Williams* of St Florence, plain. – Thomas Millard †1866. Pediment.

CHURCHYARD CROSS: three steps and a piece of the shaft.

RUINS uphill to the S; possibly of a grange established after Sir John de Barri granted Manorbier Church to Monkton Priory in 1301. Among them, CHURCH HILL COTTAGE, small and rectangular, interior covered with a pointed barrel vault. Rehabilitated as a school *c.* 1840: presumably the date of the little round chimneystacks. To its S fragments of at least four other ancient buildings. To the NE is SHUTE COTTAGE, a pretty, whitewashed single-storey cottage with small pointed windows and octagonal chimney. Early C19 appearance, but the cottage is roofed with a barrel vault – medieval work?

The VILLAGE lies NE of the church, a huddle of C19 and C20 houses, with high limestone garden walls bounding the narrow winding roads. It was popular with late C19 tourists, and much of Manorbier dates from this period. In the centre, a surprise: the VILLAGE HALL of 1908, by *W. A. S. Benson* of London, who had retired here. Local limestone, in simple but effective classical Arts and Crafts style. Each elevation has a small Venetian window with colonnettes; those on the sides lie under a gable, and are flanked by buttress and tapering chimney, a local reference. Benson also added the cylindrical chimney to the rear of CASTLE CORNER HOUSE, opposite; imitating those in the castle. Moving E, FERNLEY LODGE is gabled and late C19, with an Edwardian porch. This looks over the tiny, early C19 WARLOW'S COTTAGE, with hipped roof and central chimney. The small, simple BIER HOUSE was built in 1900, to house the funeral bier. It stands within a large, late C18 or C19 circular ANIMAL POUND. Further E the former VICARAGE, 1865 by *Wehnert*. Plain Gothic, of local limestone, gabled, with shouldered front chimneystack.

S of the castle, *c.* 250 yds from the village, the ruined MILL, probably on the same site as the medieval building. The stream which fed the mill pond has been re-routed. Fine medieval circular DOVECOTE, with domical corbelled roof. The marshy ground between dovecote and castle is the site of the medieval FISHPONDS, mentioned by Giraldus.

LONG PARK, NW of the village. 1936 by *T. Alwyn Lloyd*. Simple rendered house in the style of Voysey, with splendid views out to sea.

SUNNY HILL, 1¼ m. N. Hip-roofed, nine bays, chiefly C18 to early C19. The three E bays are late C18, timber-framed and weatherboarded, Colonial-style; said to have been built for a Jamaican merchant. Late C18 interior detail, including the upper flight of a staircase with Chinese Chippendale balustrade.

NORCHARD, 1½ m. NE. The seat of the Marychurch family from the C14 until the late C18. Large and handsome, late C17 farmhouse of 1-3-1 bays, the end ones projecting, with round windows in the gables. The front is a C19 refacing. Chimneys with diagonally set flues on the whitewashed E side. The core of the house is pre-C17. On the E side a barrel-vaulted chamber. On the W side two small barrel-vaulted rooms. Were they a

separate building, or the opposite end of a large hall house? Pointed rear doorway blocked by a C17 stone stair. The late C19 staircase incorporates some late C18 Chinese Chippendale detail. To the S, C17 gateway with battlements; to the E, a small mill (much rebuilt in the C19) with large pond.

HILL FARM, ½ m. SE. C18 farmhouse, three bays. Older lower wing to the E, with huge lateral chimney.

WEST MOOR, 1½ m. WNW. Three-bay, double-pile farmhouse, 1812; the rear may be older. Pedimented doorcase with thin Tuscan columns.

KING'S QUOIT, ¼ m. SW. Low Neolithic BURIAL CHAMBER on the edge of the cliff. Large capstone supported by two uprights (the third has fallen away); one side is supported by the cliff itself.

# MANORDEIFI

<div style="text-align: right">*2243*</div>

No village around the old church. Carreg Wen, around the new church, is mostly C20. The main centres are Abercych and Newchapel.

MANORDEIFI OLD CHURCH. St David, but possibly originally St Llawddog. In the care of the Friends of Friendless Churches. Isolated against the hillside by the Teifi flood-meadows. Repaired 1847, 1905 and 1968–73. Chancel, nave with bellcote and W porch. Medieval core – see the late C14 or C15 window on the chancel S wall – but the delight of Manordeifi is that it remains untouched by Victorian ecclesiology. Big W porch, enlarged to shelter the Lewis of Clynfyw monument of 1789. The N wall was rebuilt in 1847. All the windows are sashes, pointed in the nave, but arched at the E end, with Gothick glazing bars, remarkably old-fashioned for 1847. The W end is particularly picturesque. Rough and massive W bellcote, medieval, with front slot for the bell-rope, flanked by equally rough corner buttresses. Inside, a medieval vault under the bellcote, and then the luminous white and grey interior of plastered walls and slate floors. – Fine array of BOX PEWS, all different in their panelling. At the W end, the Ffynone and Castell Malgwyn pews, higher, with thin fluted columns; the E end pews for Clynfyw and Pentre have fireplaces. – Panelled PULPIT, presumably the remains of a three-decker, originally on the N wall. Attractively simple open-back BENCHES. – Altar on three-sided slate platform with boldly quatrefoiled timber RAILS, presumably 1840s. – FONT. Fine square bowl with fluted chamfered base, C12 or C13; the rough quatrefoil band may be later C14. Pattern of opposed half-circles on part of the E side, probably the original design, unfinished. – MONUMENTS (from E–W), Jacob Morgans of Vaynor †1712, Rev. J. Blackwell †1840, by *Denman* of London. – Leoline Davies of Clynfyw †1747 and wife. David Davies of Pentre †1829, with small urn. Susanna Davies of Pentre †1823, heavy Neo-Grecian; Capt. C. Colby of Ffynone, killed

by a tiger in 1852, marble urn inscribed 'Rawal Pinde', and tro-
phies, by *E. Physick*. Also H. O. Colby † 1831, Neo-Grecian.

In the CHURCHYARD, eight iron-railed enclosures, mostly
C19. The Colby enclosure E of the church has a particularly
ornate overthrow, and the Saunders-Davies enclosure to the S
has the oddity of urns being cast in perspective to follow the
slope. E of the church, a big arch-headed stone monument of
the type mainly found in SW Ceredigion, the plaque to Lt. Grif-
fiths of Vaynor †1797.

ST DAVID, Carreg Wen. The new church of Manordeifi, 1898,
by *Prothero & Phillot* of Cheltenham. Grey Cilgerran stone.
Not large, nave, chancel and thin, octagonal W bellcote, but
expensively and fussily traceried in Bath stone. Good fittings,
including the ornate FONT and PULPIT from the private chapel
at Pentre, Newchapel, demolished in the 1970s. This was a
memorial of 1879 to A. H. Saunders-Davies of Pentre by *J. P.
St Aubyn*. The fittings, High Victorian in their geological rich-
ness, are showpieces in pink alabaster and marble, with inset
panels of mosaic, columns of green serpentine, and balls of
onyx and marble – Also from Pentre, the Gothic ORGAN. –
Fancy iron and copper RAILS, 1899, with entwined leaves. –
Painted timber REREDOS, 1921–3 by *Martin Travers*, with relief
figures in a Renaissance to Baroque frame, the detail blurred,
like stage decoration. – STAINED GLASS. 1898–1900 by *A. L.
Moore* (chancel); good C15-style W window of 1898.

CILFOWYR BAPTIST CHAPEL, ½ m. W. 1877–9, by *C. J. Davies*
of Cenarth. Broad front with strong open-pedimental gable,
cf. Y Graig Chapel, Newcastle Emlyn, Carms. Gallery with
arched panels, on Gothic iron columns by *Macfarlane* of
Glasgow. Pulpit with sweeping curved stairs and fretwork
panels.

MANORDEIFI OLD RECTORY, ¼ m. SE of the old church. Square
three-bay house with deep hipped roof, Regency in feeling
though built in the early 1840s. Plans of 1838 by *William Owen*
of Haverfordwest were simplified in execution. In 1847 *John
Joseph* of Cardigan resited entrance and staircase, and added
a kitchen wing.

CASTELL MALGWYN, by Llechryd Bridge, in Cilgerran parish.
Built for Sir Benjamin Hammet, Taunton entrepreneur and
London banker, who in the 1790s took over the Penygored
tin-plate works here. Named from a reputed castle site about
a mile away. The house is substantial but plain, hipped, five-
bay, three-storey, and originally roughcast. One fine marble
fireplace and the broad proportions of the hall and stair survive
inside. A wing with a belvedere tower, proposed in 1867
by *William Burn*, was not built. Behind the house the small
Morgenau valley was landscaped as a romantic walk with
bridges and rock-cut paths by *Charles Price* of Llechryd, the
only recorded Welsh professional landscaper, and his only
known work though he claimed forty years' experience in an
advertisement.

Hammet died in 1802; the works were demolished and the

estate was sold to the Gowers of Glandovan (*see* Cilgerran). On the site A. L. Gower built the STABLE COURT *c.* 1842, a strenous display of local slate, with pyramid-roofed entrance tower. The Jacobean LODGE with massive rusticated GATEPIERS was added in 1845 by *Ambrose Poynter*. Both lodge and piers have lost strapwork decoration, and a centre pier has been removed.

Just S of the gates, CASTELL MALGWYN BRIDGE, 1799, an elegant single span over the dried-up remnant of the canal that powered the works. Cast-iron keystone plaques with Hammet's crest, name and date. Little else survives. The industry used ores imported to Cilgerran by ship. Another cast-iron plaque, of 1800, on HAMMET BRIDGE, to the SW, commemorating Hammet's new road to Cilgerran. MOUNT PLEASANT, on the corner of that road, is a Gower estate house of *c.* 1845, with timber mullioned windows and three little gables, picturesque, though with traditional big chimney and outshut rear.

On the supposed castle site to the E, CASTELL MALGWYN FARM, a model farm built for Hammet *c.* 1800, and called 'a noble farmyard' by Fenton in 1810. Much battered and altered, but the remains of an interesting plan. The S end was half-oval, with large archway under a low-roofed tower flanked by curving stalls and stables. The archway opens ineffectually to the S on to steep steps down to a C19 farmhouse, but to the N an axial drive runs between mirrored L-plan ranges of barns to a N entry with stone archway. Nearby is a red brick walled garden of *c.* 1800, with the remains of hot houses, and a lonely fountain in a field, formerly a flower garden.

CLYNFYW. *See* Abercych.

FFYNONE. *See* Newchapel.

PENTRE. *See* Newchapel.

## MANOROWEN/MANARNAWEN                    9336

On the main road from Fishguard to St Davids, the country house and farm one side, the church and walled garden the other.

ST MARY. Prettily set by the old Manorowen walled garden and opposite the new house. Rebuilt in 1872, by *Foster & Wood* of Bristol, though the crude bi-colour brick detail and the odd bellcote pediment look less than one would expect for this firm. Porch added 1925. C17 plaque to Mary Painter on the E end. Plain whitewashed interior. Small unmoulded FONT bowl, too small for the column shaft, though both are medieval. – STAINED GLASS. Two nave N war memorials, 1918, and E window, Crucifixion, 1922, all by *Powell*. – MEMORIALS. Oval plaque to Capt. James Howell †1833. – On the S wall, later C19 plaque to Richard Fenton †1821, the historian of Pembrokeshire; he deserved better.

MANOROWEN. Country house rebuilt in the 1820s for Richard Bowen and enlarged later in the C19 for Dr Moses Griffith.

Plain, rendered E front of five bays and two storeys. The origi-
nal three bays probably to the r., with a full-height bow on the
N end wall, and two matching bays added to the S. Tripartite
ground-floor sashes, the heavy cement cornices probably late
C19. To the S, mid-C19 FARM COURT, behind an early C19 lofted
stable and coach-house range. Across the road, the WALLED
GARDEN, and on the rock outcrop at the corner, looking out
to Fishguard Bay, a pyramid-roofed GAZEBO, with nogged
brick cornice, probably later C18. The gazebo was mistaken for
a fort by the French invading force in 1797.

# MARLOES

Loosely knit coastal village, surrounded by large fertile fields,
with the church at the centre.

ST PETER. Rugged fabric. Much rebuilt 1875–7 to the plans of
*Charles Buckeridge*, taken on by *Pearson* after Buckeridge died.
Nave, bellcote, transepts of equal size, both with squints, C14
chancel, covered with a pointed stone barrel vault. The Dec E
window seen by Glynne in 1856 has gone, as has a chapel N of
the nave. The present Dec windows are of 1877, of attractively
dark purple Caerbwdy sandstone. – Norman FONT, square
bowl with chamfered corners and scalloped underside, round
pedestal. To counter the growing Baptist cause in Marloes, an
OPEN BAPTISTERY was included at the W end of the nave. –
FURNISHINGS of 1875–7. – Carved C17 wooden PANEL, from
a chest, now fixed to the wall, with grotesque masks
and figures. – STAINED GLASS. Nave S, 1990 by *John
Petts*. Effective leading. – MONUMENTS. Martha Allen †1734.
Slate tablet with incised winged cherub head. – William Allen
†1758. Coloured marbles, large, elliptical arch with keystone.
– Richard Davies †1756. Cloud-borne trumpeting angels
above, well carved. – Anne Davies †1775. Convex oval tablet
with surround. – Margaret Allen †1778. Steep apex, cartouche
below.

MORIAH BAPTIST CHAPEL. Dated 1892, the architect *D. E.
Thomas*. Sandstone with yellow brick detail. Twin gabled
porches with lobby between, big arched window with
simple timber tracery. Gallery on half-fluted iron columns with
Corinthian caps.

To the S, between church and chapel, the CLOCK TOWER of 1904,
in memory of the fourth Baron Kensington, was erected under
the supervision of Kensington's estate agent, *John Fergusson*,
by the County Liberal Association. Short, tapering sandstone
tower with low boarded clock stage and pyramidal roof.
Further S, the VILLAGE HALL, originally a Wesleyan Chapel,
1837. Long-wall façade with central porch, a sash window each
side with brick arched head.

PHILBEACH, ½ m. SE. Attached to the lower end of the plain C19
farmhouse is the nucleus of the earlier dwelling. A lateral
chimney with conical shaft suggests a C16 date.

Musselwick, $\frac{2}{3}$ m. N. Substantial late C18 or C19 farmhouse of two storeys, the front wall slate-hung. Four bays long under a single roof, the service end on the l. Rear outshuts, with tiny chimneystacks. C19 FARM BUILDINGS, and a small fragment of the previous house, with C16 four-centred doorway.

Gateholm Island, $1\frac{1}{2}$ m. sw. Just off-shore, accessible by a narrow neck of land at low tide. Deserted early settlement on a long, narrow site. Footings of at least a hundred buildings, enclosed by a (turf-covered) stone bank on two sides. On the E side buildings N of the track were laid out on a linear pattern, while those to the s and w were arranged around courtyards. Excavation revealed C3–C4 artefacts and also material of the C11–C13, most of the settlement being of the latter date; its history is unknown.

Watery Bay Fort, $1\frac{1}{2}$ m. wsw. A fine Iron Age PROMONTORY FORT, with a series of triple banks and ditches defending the landward side.

Deer Park Fort, 2 m. w. A large Iron Age PROMONTORY FORT, connected by a narrow neck of land to the w tip of the Marloes peninsula. This natural defence was protected by a single bank, the slope outside scarped for greater strength. Entry to the s with an L-shaped inner bank. Another entrance *c*. 75 yds to the N is possibly the original. The promontory was walled as a deer park at an unknown date. In the wall by the toilets a cross-inscribed STONE.

# MARTLETWY

*0310*

Deeply rural village, amid a maze of narrow lanes.

St Marcellus. Nave, chancel and long N aisle, the latter with w bellcote. Much rebuilt 1848–50 by *Hugh Hoare* of Lawrenny. s porch, C16 or C17, round-arched doorway with crudely carved sundial in one of its massive voussoirs. The interior heavily restored 1896–7 by *E.V. Collier*, with new roofs and plate tracery. Crude inserted two-bay nave arcade with vast circular pier. Four-centred arch between aisle and chancel, suggesting a late C15/C16 lengthening of the aisle. In the chancel, narrow lancet with rough seat, presumably a sedile. Undecorated round-headed chancel arch, probably C13. – Norman FONT, square bowl with panelled sides. The huge late Norman base with waterleaf corner volutes was rediscovered in 1897. – ALTAR TABLE in the aisle, late C19 and dramatically scorched. Rescued from the bombed St Paul, Bow Common, London; previously at Yerbeston. – MONUMENT (chancel NW). Part of a slab, with upper portion of a tonsured priest in high relief, the head resting on a cushion and the hands, carved in outline, raised in benediction. Worn inscription to Sir Philip Resi or Rees. Probably later C14.

Baptist Chapel, at the s end of the village. 1864 by *K.W. Ladd*. Large and gaunt. Rendered gable front to the road, but porch to one side. Interior with end gallery.

HOREB CONGREGATIONAL CHAPEL, $\frac{1}{2}$ m. NE. Dated 1844.
Plain gabled front with sash windows above the door, but
pointing the way towards the trend for gable-entry chapels.
Pointed side windows with wooden glazing. Gallery at the
entry end.

91 BURNETT'S HILL (former Calvinistic Methodist Chapel),
1 m. w. A rare survival, built 1813, wholly in the vernacular
tradition. In a pitiful state until 2001, when restored by the
Pembrokeshire Coast National Park Authority for a local trust.
Despite a remodelling of *c.* 1850, which turned the interior
seating to face the E end, the chapel remains entirely without
pretension. Colourwashed front with sash windows, echoing
those cottages in which the early Calvinists met before they
could afford a building of their own. Unspoilt interior with
woodwork of various C19 dates – the earliest, the simple raised
rear benches. Unusual railed dais at the pulpit end with
benches for the elders.

GLEBE HOUSE, formerly the rectory. Square, with broad eaves
and hipped roof. 1884, the only known domestic work of *John
Romilly Allen* of London, engineer and noted Welsh antiquary
of local descent. He was responsible for Baron de Reuter's
Persian railway scheme. An engineer's design; large windows
oddly placed to one side, lighting the main rooms from each
compass point, neat and efficient central-lobby plan.

CHURCH SCHOOL (former), just E of the church. 1854, by *T. E.
Owen* of Portsmouth, and well preserved. Long, symmetrical
schoolroom with matching lateral chimneys and end porches.
Tall sashes break the eaves line. Simple house opposite. An
advanced design for the area, looking forward to later board
schools. Well converted to a restaurant.

MATHRY/MATHRI

The village looks Continental, clustered around the church on a
prominent hilltop surrounded by large fields. The bishops of St
Davids were the main landowners here from the Middle Ages.
The parish was called the Golden Prebend from its rich grain
crops. HIGH ROOST, the former vicarage, 1827–30 by *William
Owen*, roughcast, hip-roofed, with toplit staircase. SCHOOL of
1870, with the bishopric arms on the lintels. Some houses with
the grouted roofs once typical of the area.

HOLY MARTYRS (the seven boys rescued from the Tywi at
Llandeilo by St Teilo). Wholly rebuilt in 1868–9, by *R. K.
Penson*. Unusually severe for him, but appropriate for the bare
hilltop site with a High Victorian solid geometry. Grey stone;
nave and canted apsed chancel, S aisle with transept gable, and
sturdy SW tower sadly left unfinished, capped with a pyramid
roof (a slated spire was intended). Plain lancets, triplets at the
W end and in the S transept. Tall vestry chimney, with battered
base and side-vented top. White walls and two-bay S arcade of
grey stone: a light and simple interior. Penson's open nave roof

was boarded over in 1905 and his fittings have gone, but the apse roof is original, in plaster panels with moulded beams. – STAINED GLASS. E window, 1921, signed *H. G. Hiller.* – In the porch, INSCRIBED STONE, C5 or C6. Two more with ring crosses in the S W corner of the churchyard wall, C7 to C9, from neighbouring farms.

CARNACHENWEN, ¾ m. NW. A complex vernacular house recorded from the C15, held by the Perkin family until 1657, and then by the Tuckers of Sealyham, St Dogwells. The lessees during the C18 were the Rogers family of Goodwick, whom Fenton describes as smugglers. Long two-storey front of two bays each side of a far-projecting porch; the latter is large enough to have been the *ystafell fwrdd*, the room that had the board or table where farm-workers came to eat. The main entry was just to the l., now a window. At the l. end, a date of 1743 on an unusual corbelled-roofed smoke chamber annexed to the very deep W end fireplace. Rear wing dated 1776. Sash windows throughout, mostly early C19. Rear stair with thick C18 rail.

PRISKILLY FOREST, 2 m. SE. A bishopric estate leased to the Harries family at least from the late C18. Early C18 five-window roughcast S front, with narrow eight-pane sashes, (cf. Tregwynt, Granston). Original eighteen-pane sash on the r. end wall. Later C18 two-bay hipped wing. Hipped, four-bay parallel N range with mutuled eaves and long sashes, *c.* 1820, perhaps the improvements made by John Hill Harries, referred to in 1853.

ABERCASTLE/ABERCASTELL, 2 m. NW. Small, picturesque coastal hamlet by a small cove. Colourwashed cottages, mostly altered. ABERCASTLE MILL is late C18 or early C19; low double-fronted house, grouted slate roof, the former mill at r. angles. Early C19 circular LIMEKILN on the beach.

CASTLEMORRIS/CASMORYS, 1½ m. E. Small village with altered cottages on the S side of a green. PENCNWC is a long farmhouse, early and later C19, rendered, the older part to the r. Unusually large MILL building in the corner of the farmyard, basement and two storeys, L-plan, with iron water wheel. 1874 scratched on a doorway arch stone.

CARREG SAMSON BURIAL CHAMBER, Longhouse Farm, near Abercastle (SM 848 335.) Both scale and site make this one of the most spectacular Neolithic burial chambers of the region. Oval chamber surrounded by six uprights, of which only three carry the massive capstone. This is of conglomerate, as are three of the side stones. A passage grave; the lost NW entrance passage was established from excavation.

TREWALLTER BURIAL CHAMBER, 1 m. W (SM 858 317). Massive capstone mostly on the ground, with one collapsed side stone.

IRON AGE FORTS, along the coastal cliffs: on the promontory at Penmorfa (SM 872 347), W of Abermawr; on Ynys y Castell, at the entry to Abercastle harbour (SM 851 339); and at Castell Coch, W of Longhouse (SM 840 338).

*1138*    MELINE

No village, the church is on the lane S of Castell Henllys Iron Age fort (*see* below).

113  ST DOGFAEL. Characterful small sandstone church by *R. J. Withers*, 1864–5. Built for Sir Thomas Lloyd of Bronwydd, Cered., medievalizing Lord Marcher of Cemaes (*see* Felindre Farchog and Newport Castle). An object lesson in High Victorian solid geometry and minimal extraneous detail. Single apse-ended slate roof over both nave and chancel, the eaves stepped up a little for the chancel. S porch with simple cross-gable but N vestry roof swept down from the main roof with fine battered chimney. Sheer walling with flush tracery. Two-light Dec windows; small cusped lancets around the canted apse. The W wall is anchored by a broad sloping plinth with emphatic horizontal line; a minimal bellcote is half-sunk into the gable apex. Surprisingly ornate W rose window of five cinquefoils.* In the N wall, reused frame of a carved pointed DOORWAY, said to be C13, but possibly rustic late medieval. Crude continuous roll mouldings; hoodmould with grotesque headstops. Inside, open nave roof with complex trusses and wind-bracing, pointed ashlar chancel arch, closed polygonal chancel roof with plaster panels. Very Victorian gradation in the chancel: five steps from W to E. – High Victorian FITTINGS: octagonal FONT with moulded ring; pitch-pine PEWS, STALLS, PULPIT and ALTAR RAILS, all simple but original carpentry designs, emphasizing structure over decoration. – Big stone REREDOS with TILE PANELS, using the best five-colour tiles. – Above, STAINED-GLASS single-light E window of 1865 by *Lavers & Barraud*, a lovely design in blues, purples and red.

CASTELL HENLLYS. Three large thatched round-houses on a well-defended spur above the Nyfer valley, part of the recon-structed Iron Age hillfort. The site, approached steeply from below to a W entrance, is naturally defended on three sides, with double bank and ditch to the weaker N side. There was stone reinforcement at the W entry, with extra banks and ditches outside. The tops of the steep slopes were embanked, and there were timber palisades. Excavations from 1980 to 1989 by Professor Harold Mytum established the layout. Post-holes within the enclosure gave the basic outlines for the recon-structed buildings, built from *c.* 1980, with advice from *Dr Peter Reynolds* (originator of the Butser Ancient Farm Project, Hants). The largest round-house, (10 metres in diameter), has an inner ring of posts with linking wall-plate to carry the long timbers from low outer wattle-and-daub walls to the apex. The next two are smaller and have no inner ring. Everything is conjectural apart from the postholes, but the solutions are well thought out. The use of thatch dictates the roof-pitch,

---

*It may be the window made for Bronwydd, the Lloyd seat at Llangynllo, Cered., designed by *R. K. Penson* in 1853 but removed soon after.

although the extreme length of rafter necessary raises the question of how available such timbers would have been. The reconstruction includes granaries, based on sets of four post-holes, pottery kiln, iron-smelting furnace and palisade. Just N was a separate settlement, built in the C1 or C2 A.D. after the fort was abandoned. A defence of close-set upright stones below the bank is probably an earlier outwork.

CASTELL HENLLYS VISITOR CENTRE, in the valley below the hillfort. 1993–4 by *Peter Roberts* of *Niall Phillips Architects* of Bristol, (also architect of the Welsh Wildlife Centre, Cilgerran, and the Treginnis Isaf Farm conversion, St Davids). The brief asked for an environmentally sensitive design, of minimal impact, using natural and local materials. The architecture fulfils this without recourse to 'heritage' reference. A large single-pitch grassed roof covers a slightly curved building. Paired pine poles, stripped of bark and stained blue-grey, raised on cast plinths, carry floor and roof. The framing between is smartly horizontal, thin battens of pale oak between dark-stained rough boards or flush panels of yellow lime-washed plaster. Yellow is also the colour of doors and windows. The entrance front faces over a meadow to the river and has a raised veranda under a metal-sheet monopitch roof. Its pitch opposes that of the main roof, which overshoots it to protect a row of roof-lights. Simple, well laid out interior: entrance hall to the l. of a single main teaching room, which opens on to the veranda with library space at the far end. An oak-panelled spine wall divides off rear service and staff rooms. The paired posts within define a roof-lit route through the teaching space to the library area. Internal walls are clad with rough-sawn stained pine boards. The tactile quality of materials impresses; the poles have a bleached driftwood quality, contrasting with the rough-sawn boards and the mellow oak framing. Well-handled landscaping of the outdoor teaching space, with large boulders, oak-baulk footways and stepping stones.

PENYBENGLOG, $\frac{1}{2}$ m. S. A gentry house recorded in the same family from 1342 to 1756. G. W. Griffith, historian, rebuilt the house in 1623, and it had six hearths in 1670, but the present house is more probably early C18. Rendered, two storeys and attic, five bays, one bay obscured by a wing dated 1828. Three C19 gabled attic windows. Some early C18 first-floor sashes and a heavy door with diagonal cross pattern and fielded panels. S end wall was rebuilt in 1946. In the end of the NW wing the reset front door of 1623, ovolo-moulded oak frame with carved initials and date in the lintel. The interior was derelict before the 1940s and a panelled room has been lost. Remaining are some two-panel C18 doors, an ovolo-moulded beam, perhaps C17 and, in a rear stair-tower, an earlier C18 staircase with turned balusters and closed string with pulvinated frieze.

GLANDUAD FAWR, $\frac{1}{4}$ m. W of the church. Earlier C18 five-bay house, originally similar to Penybenglog but all altered outside. The staircase with pulvinated closed string is very similar and

the panelled ground-floor room is said to resemble the one lost from there.

HILLFORTS. CASTELL LLWYD (SN 113 376), S of Penybenglog, and another further SE (SN 119 373), both on promontories above the gorge of the Nanhyfer, and both with double defences on the weaker N or NE sides. CASTELL MAWR (SN 119 378), on the hilltop N of these two, is a big circular camp, double-banked, with a single bank crossing the centre.

*See* also Felindre Farchog.

## MIDDLE MILL/FELINGANOL
### Whitchurch

*8025*

On the Solva river. Quarries on the W bank produced the green Middle Mill granite.

MIDDLE MILL BAPTIST CHAPEL. One of the early Baptist chapels of the area, the dates 1756, 1799, 1833, 1883 and 1920 showing how often a rural cause could renew its building. The shell dates from 1833: lateral façade, two pointed windows and outer doors. The hard stucco detail is of 1883, the canted bay containing the pulpit, in the centre of the façade, is of 1920. Three-sided gallery on bulbous columns with panelled front, probably 1883. Outside is the baptismal total-immersion pool.

Below the chapel, a much-restored CORN-MILL, earlier C19 with later C19 iron overshot wheel behind. Rough rubble-stone BRIDGE of three round arches, one over the mill leat.

KINGHERIOT, up the hill to the E, is a big mid-C19 rubble-stone farmhouse, still with Georgian twelve-pane sashes. In the yard, a little lofted OUTBUILDING typical of the region, with grouted slates, single cart-shed and single stable door; two loft-lights under the low eaves with dove-holes between.

TREMAENHIR, 1 m. E. Substantial stone farmhouse, three bays with sashes and brick heads, i.e. earlier C19. Slate-hung rear stair-tower, old-fashioned by then, with a long twenty-four-pane window. Lofted STABLE with grouted slate roof. Two STANDING STONES, one on the other side of the road, the other in the bank E of the farm buildings.

## MILFORD

*9006*
*p. 288*

Milford, also known as Milford Haven, taking its name from the waterway, was born of the marriage of the diplomat Sir William Hamilton to an heiress of the Barlow family. The estate included the land between Castle Pill and Hubberston Pill, then encumbered by nothing more than a derelict medieval chapel and two farms. Hamilton asked his nephew, Charles Greville, to oversee his Pembrokeshire estates, with the maritime prospects of a port on so sheltered a waterway uppermost in his mind. In 1790 the Milford Haven Harbour Act was passed, and by 1792–3 the first

plans for the new town were made. Greville secured as first settlers the crews and their families from the American Southern Whaling Fleet, driven from Nantucket by the War of Independence. Around fifty Americans arrived in 1792, a fraction of the numbers originally intended.

Charles Greville consulted the Swansea architect *William Jernegan* in 1792–3, who probably designed the straightforward plan of three parallel streets, though the actual building of much of the town seems to have been entrusted to *Jean-Louis Barrallier*, a naval ship-builder from Toulon, possibly to plans adapted from Jernegan's designs.* *Griffith Watkins* of Haverfordwest was also involved. The shipyard was established as a private yard by Charles Greville and leased to the Navy in 1796, to build three warships. This curious decision, to build so far away from the usual naval centres, may have been due to the pressure of wartime needs, but as the lease was maintained even after the 1801 peace, when the warships were incomplete, the influence of Admiral Nelson must be assumed. The triumphal visit of Nelson with Sir William and Lady Hamilton in 1802 was clearly arranged to promote the project. In 1809 the Navy Board embarked on dockyard buildings to a grand Neoclassical scheme, which would have stretched in a great curving range, some fifty-nine bays long, along the steep slope between the front street and the waterway. The Board did not then even own the yard, and negotiations to buy it that year failed with the death of Greville, as his heir R. F. Greville asked for too much money. The dockyard was moved to Pembroke Dock 1812–14.

The naval dockyard had been a lifeline for the new town. The American whalers were too few in the period 1793–6 to build a new whaling base, though the first houses of the front street were being built and facilities created for equipping whaling ships. After 1797 the first group were joined by others, under Benjamin Rotch, who had traded from Dunkirk for ten years. The enterprise did not grow into a full-blown whaling port, due in part to lack of support from London, suspicious that the Americans were merely using Milford as a means of importing whale-oil without paying duty. The easing of relations with the United States, prompted many of the whalers to rejoin the American fleets in New Bedford, Mass. The death of Greville and the loss of the dockyard ended the first phase of development. His successors, R. F. Greville to 1824, and Col. R. F. Greville to 1867, sought prosperity for the town in transatlantic trade, but the docks were not large enough. The decision of Brunel to develop the port at Neyland in 1852, and the consequent delay in bringing the railway to the town made this plan still-born. In 1857 Col. Greville bridged the two waterways E and W of the town and built a pier for larger boats at Newton Noyes. Grandiose plans in 1856–7 for a new extension to the town on the Rath, S and SE of the church, by successively *W. H. Lindsey* and *Frederick Wehnert*,

---

* Barrallier and his son Charles sign many of the early leases as agents for Greville.

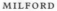

|   |                             |    |                      |
|---|-----------------------------|----|----------------------|
| 1 | St Katharine                | 7  | Wesleyan Chapel      |
| 2 | St Thomas à Becket          | 8  | Town Hall            |
| 3 | Pill Priory                 | 9  | Milford Haven Museum |
| 4 | Baptist Chapel              | 10 | Torch Theatre        |
| 5 | Friends' Meeting House      | 11 | Central School       |
| 6 | Tabernacle Independent Chapel | 12 | Former Council School |

Milford

came to nothing, and the Greville estate was finally sold. Large-scale docks were not finally built until 1874–82.

The one industry that succeeded in Milford was fishing, less grandiose, but more adapted to the realities, and it was the fishing boats that kept the docks prosperous in the first half of the C20. Over-fishing, though, already a problem between the wars, ended the industry by the late 1950s. In 1957 a strategic decision was taken to develop the Haven for large oil-tankers. This initiated a new start, with oil-refining changing enormously the face of the waterway, though it had less effect on the town itself. The prin-

cipal installations were storage tanks or refineries: for Esso at Gelliswick Bay, w of Hubberston, for Amoco just inland, and for Gulf at Waterston, e of the town. On the opposite shore were Texaco at Rhoscrowther, BP at Fort Popton, and the oil-burning Pembroke Power Station at Pwllcrochan. With time, the attraction of the Haven as a deep anchorage for very large tankers declined as the tankers themselves grew too large. The oil industry was in decline, by the 1990s returning the town to high unemployment. Tourism, as elsewhere, has become a touchstone, despite the visual damage of the oil era, and old installations are being tidied up with grants from the European Community. Since 1990 the docks have been cleared of the fish-sheds, and the area has been remodelled as a yachting marina and tourist attraction.

## CHURCHES AND CHAPELS

St Katharine. Built 1802–8 for Charles Greville, the architect most probably the French shipwright *Jean-Louis Barrallier* (*see* above), or his son *Charles Barrallier,* as suggested by a surviving letter. Despite an unprepossessing exterior, this is a remarkable Georgian Gothic design; French elements are not obvious. Thinly detailed exterior, with big w tower. Thick grey roughcast replacing original stucco. This was coloured yellow, presumably to match the Bath stone parapet. Sir Richard Colt Hoare thought the building on the whole chaste and elegant, though with 'too much yellow without, and too much white within'. *F. Wehnert's* restoration of 1866–7 inserted harsh stone tracery in all the windows.

The interior, aisled with clerestory, is wholly vaulted in plaster with elegantly crisp lines. There is a masterly handling of line, reminiscent of the stripped Gothic of the 1930s. The octagonal piers rise without mouldings continuing as a chamfered shaft to carry the nave vault, with the rear faces sliding into the aisle vault. The nave, originally of four bays, with simple chancel arch and shallow apse, was extended e by two bays in 1906–7, when a new chancel was built, by *Wood & Gaskell* of Milford. The tower has similar plaster vaulting to the ground-floor porch and the first floor, which opens as a gallery to the nave.

In the porch, a porphyry Egyptian urn, intended by Greville as the font for the new church, and a piece of the mainmast of *L'Orient*, the French flagship at the Battle of the Nile.*

Chancel screen of 1919 by *J. Coates Carter*. Delicate, with big coved top and three rood figures. – reredos. 1925 by *Coates Carter*, carved wood in a baldly squared frame. – The other fittings are mostly post 1900: brass lectern 1903,

---

*Bishop Burgess rejected the 'pagan' urn, disliking Greville's desire to play on the cult of Nelson, already by 1808 erroneously said to have laid the foundation stone in 1802.

FONT 1904, PULPIT 1913, and ALTAR RAILS *c.* 1914, in the style of *W. D. Caröe*. – Some curious fragments brought in from other churches, mostly C19, including the FONT COVER and two iron SCREENS. Most interesting are the pair of tall canopied clergy STALLS of about 1840, and the less correct but very fancy three-seater canopied SEDILIA of about 1830; these were bought in 1918 'on the East Coast', but are clearly from a church of some status. – STAINED GLASS. E window of *c.* 1910. One N aisle window by *John Petts*, 1987, with symbols of teaching. – WALL PAINTING. Over the chancel arch, brightly coloured fresco of the Ascension, 1932, by *Sister Marabel* of the Anglican convent at Wantage.

ST THOMAS À BECKET, The Rath, Pill. A small medieval church, said to have been dedicated to St Catherine. Ruinous by the late C18, just the two rough stone vaults of nave and chancel survived. Simply restored in 1930–1 by *H. J. P. Thomas* of Haverfordwest, with leaded windows and new W wall.

PILL PRIORY, Lower Priory (St Mary and St Budoc). The little-known ruins of a small priory of the Order of Tiron, founded *c.* 1200 by Adam de Roche, and dependent on St Dogmaels Abbey, set in the valley at the head of Hubberston Pill. The wide chancel arch of the church survives, together with the base of the E wall of the crossing tower. Rough stone without mouldings, a window over the arch into the chancel and the marks of the chancel gable. Old engravings show an upper stage with two lancets. The probable date is C13. The S transept S wall remains, linked to the adjoining house, which has two parallel rough vaults to the ground floor, possibly the undercroft of the dormitory. Another rough stone vault survives a little way S in the rear part of the PRIORY INN. Probably part of a range running N–S, across the line of the vault. A medieval lancet is partly visible in a gable over the roof of the front range.

BAPTIST CHAPEL, North Road. 1878–9, by *George Morgan*, Gothic, and expensive at £2,425. Tall gabled front divided by pinnacles, with paired doors and a big traceried window, Bath stone tracery of High Victorian solidity. The fine interior has big arched roof trusses and four-sided gallery on pierced cast-iron panels. Gothic pulpit and great seat. Alongside, the SCHOOL by *J. Howard Morgan*, 1926, with pretty candlesnuffer side-turret. The main window has lost its mullions.

FRIENDS' MEETING HOUSE, Priory Street. Built in 1811 for the American whaling families invited by Charles Greville to found the new town of Milford. The plans, of 1808, are by *Griffith Watkins* of Haverfordwest. Small, with hipped roof and two-window front, the windows large cambered-headed sashes, to give a luminous interior. This is divided into two by a movable screen, each half entered directly from the two doors in the porch. In the meeting-room a raised dais, with fielded panelling, centre steps up, and a bench each side of the steps. Plain panelled back and seat on the dais. Some of the original open-back benches survive. The other half has wall panelling and a fireplace.

In the graveyard, some simple initialled headstones of the

American families.

TABERNACLE INDEPENDENT CHAPEL, Charles Street.
1909–10 by *D. E. Thomas & Son* of Haverfordwest. Quite unlike   122,
anything else the firm ever did, apparently a first work of *Owain*   123
*Thomas*. A big tower unbalances an otherwise symmetrical
front, fashionable red brick is used with chequerwork of Bath
stone, and a little late C17 detail. Memorable, squared-off tower
designed in flat planes, cut back in stages to a pillbox octagon
cap over unmoulded mullioned windows. The group, with the
subsidiary buildings and the contemporary iron railings, stands
complete, at £6,100 the costliest chapel in SW Wales. Inside,
classical arcades on ashlar piers, but the boarded roof deeply
braced from Gothic corbels. Curving pews face a panelled dais
with projecting pulpit. Raking choir gallery with handsome
classical organ case. Another raking gallery over the entrance
lobby. – STAINED GLASS. In the aisles, fairly conventional, post
1945, some by *John Hall* of Bristol.

WESLEYAN CHAPEL, Priory Road. 1901–2, by *John Wills* of
Derby, prolific chapel architect. Gothic, large and externally
unadventurous. Tracery from the gable window lost. The old-
fashioned interior is still in the acid High Victorian manner,
with open roof trusses and gallery fronts in pitch pine, with
much well-detailed chamfering and notching.

### PUBLIC BUILDINGS

TOWN HALL, Hamilton Terrace. 1937–9 by *T. V. Williams*, the
borough surveyor. Neo-Georgian in pink brick with hipped
roof and copper lantern.

MILFORD HAVEN MUSEUM, The Docks. Former Customs
House, built *c.* 1794, one of the first buildings of Greville's
new town. Formerly stuccoed, and once handsome, but now
stripped of all detail. Pedimented three-storey centre and six-
bay wings, the ground floor arcaded and the centre bays
grouped vertically. Probably by *William Jernegan*.

TORCH THEATRE, St Peter's Road. 1970, by *Beaumont Minter*.
The lozenge-shaped stage tower, sheer yellow brick with
metal cladding to the top, is all too visible, on the fine site
above Hubberston Pill. Associated buildings in brown and
yellow brick with monopitch roofs, harshly and cheaply
detailed. Cramped entrance but some interesting play of levels
inside.

COMPREHENSIVE SCHOOL, Steynton Road. 1962–4 by *Lt. Col.
W. Barrett*, the county architect. Extensive complex in red brick
with flat roofs, the school hall the dominant block.

FORMER CENTRAL SCHOOL, Prioryville. 1929–35. Restored
1992–3. Low yellow brick, Neo-Georgian with simplified Mod-
ernist details. Centre with hipped roof and cupola balanced by
hipped pavilions.

FORMER COUNCIL SCHOOL, North Road. 1900–1 by *Wood &
Gaskell* of Milford. Three-gabled and slightly 'artsy' in detail,
the flint chequerwork in the outer gables remarkably out of
place in west Wales. Recessed centre gable with little curved

pediment. There was a cupola.

WAR MEMORIAL, Hamilton Terrace. 1923, designed by *J. P. Morgan*. Three white marble statues, one for each of the armed services, made in Italy to models by *E. Jones*, of Llanybydder.

MILFORD DOCKS. The tidal anchorage in Hubberston Pill, with quays on the Milford and Hakin sides, included the quay where Greville's Customs House was built. Slips for the naval dockyard of 1809 were further E under the cliffs. The plan to enclose Hubberston Pill was initiated by Col. Greville in 1864, to designs by *Sir Charles Fox* and *J. Morton Toler*. Work faltered, and restarted in 1874, with Toler as engineer, but financial and structural problems brought a halt in 1879. Under Samuel Lake, entrepreneur, the dock was deepened for larger ships, and an entrance lock completed, before Lake's Milford enterprises, which included the railway, ship-building, and a steelworks, collapsed in 1882. Finally, the work was completed 1886–9 under the engineer *A. M. Rendel*. Rendel abandoned the entrance lock, changed one part-completed dry dock into an entrance lock, and enlarged a second dry dock. Though the docks were equipped for transatlantic ships, few called, and by 1900 the fishing trade was dominant. Just within the gates, a single-storey OFFICE range, of *c.* 1875, now a restaurant. To the E, the late C18 former Customs House, now the MUSEUM (*see* above). The long area of land to the E, cleared in the late 1980s, was formerly covered by the brick fish-quay buildings, of *c.* 1900. MARTHA'S VINEYARD restaurant, 1990, by *Pembroke Design*, is a playfully Postmodern pavilion in dark brick with a split pedimental gable over each façade and arched windows. At the E end of the marina, COSALT, fishery company offices of 1907 by *C. L. Blethyn* of Milford. Beyond is the SMOKEHOUSE, of *c.* 1900, with steeply raking louvred roof. New blocks of offices and flats, in a warehouse style, 2002, by *Frans Nicholas* of Haverfordwest. On the W side of the docks, a long range of limestone dock WAREHOUSES, of the 1870s perhaps, and the entrance LOCK and DRY DOCK, the capstans and bollards dated 1888.

PERAMBULATION

The three parallel streets of Greville's town are Hamilton Terrace (which had the larger three-storey houses), facing over the Haven, Charles Street behind, and finally Robert Street, with progressively smaller houses. The original designs, drawn in miniature on the side of the leases of *c.* 1797–1810, give little or no detail. The houses were probably stuccoed or roughcast, with sash windows, only occasionally on the front street varied by arched recesses. Subsequent alterations have left scarcely any in original state, but inside several Hamilton Terrace houses, identical thin balustered staircases and elliptical arches between front and rear rooms, show a common date, and possibly a common architect or builder.

HAMILTON TERRACE runs as a splendid broad promenade

from the church w-ward. At the E end, HAMILTON HOUSE, stripped of chimneys, but the only surviving example with the arched recesses that appear on early leases. Its gardens are now the public park. Beyond, the MASONIC HALL, 1880–2 by *Henry Lovegrove* of London. A stuccoed and pedimented chapel-like façade, then a gap before the main terraces. The largest three-bay houses are in the centre, mostly modified with Victorian or later stucco. No. 25 stands out with parapet and tented balcony, all the detail of 1991 but copied from old photographs. This was the house of Benjamin Rotch, the leading financier and entrepreneur of the American whalers, and was built 1801–2. It became the Milford Bank in 1804. Opposite, MARINE GARDENS, halfway down the cliff-slope, is the minimal remnant of the unachieved Royal Dockyard of 1809–10. The plan was magnificent. Five ship-building slips and a wharf were to be dug into the foreshore, while above, on a great terrace reached by a double ramp, was to be a very long Neoclassical range of stores. Only the smithy and store, and an entrance gatehouse, were built, at the W end, together with some seven bays of the sheds, and only some barely recognizable fragments survive.* Such an accomplished Neoclassical design may have come from the Admiralty, but the motif in the store blocks of a two-storey arcade with lunette upper windows, over a basement, is reminiscent of the Customs House and the hotel at Milford. Back on Hamilton Terrace, Nos. 15–16, BARCLAYS BANK, rebuilt from an original pair in 1872. In the next block, MIDLAND BANK, of *c.* 1925, low and neatly Neo-Georgian, and No. 8, a tall Georgian front, but of 1908, and built as the Post Office, originally red brick and Bath stone, since painted over. The LORD NELSON HOTEL, 1795 1800, originally the New Inn, but renamed after Lord Nelson's 1802 visit, is the finest individual building, intended by Greville for the Irish mail traffic. A sophisticated Neoclassical design, presumably by *Jernegan*. Three storeys, 1+3+1 bays, under a deep-eaved hipped roof. The outer bays project slightly, and there are lunette windows to the attic. The present stucco is probably mid-C19. The interior is altered, though the staircase is original. The stable court to the l. was altered in the 1850s; originally it had a tall wall with two blank arches each side of the gate. This part of Hamilton Terrace, closest to the cliff edge, is supported on a massive stone-arched retaining wall, possibly mid-C19.

VICTORIA ROAD continues W down to the Docks. No. 8, slate-hung and detached, was built *c.* 1795 for Daniel Starbuck, one of the American whalers. At the foot of the hill, mid-C19 WAREHOUSE, three-gabled with heavy granite dressings. Beyond, and ill-sited opposite Victoria Bridge, a remarkable

---

*The plans show a three-storey, seven-bay centre with pediment and cupola, two four-bay, three-storey hipped end pavilions, all identified on the plan as storehouses and offices, separated by twenty-two-bay, single-storey ranges, identified as sheds. At each end were to be a detached single-storey, three-bay building, one a smithy, and then another three-storey, four-bay store.

MEMORIAL of 1822, in *Mrs Coade*'s patent stone, put up by R. F. Greville to commemorate George IV's accidental visit to the town, a long text under a pretty nautical relief. Hubberston Pill was first bridged by Col. Greville in 1857; the present bridge is of 1998.

CHARLES STREET. Here, late C19 to C20 buildings of progressively lower quality, have replaced the originals. Small fragments of R.F. Greville's MARKET of 1811 survive in the outer walls of the cinema. Right at the E end of Charles Street, opposite and E of Tabernacle Chapel, are some two-bay and three-bay houses of *c.* 1800, much altered. To the E of Priory Street, PRIORY LODGE, built *c.* 1797 for Samuel Starbuck Jun., is a small, late Georgian country house, of three bays with only an open-pediment doorcase for distinction, much altered.

At the E end of Hamilton Terrace, THE RATH curves around the headland. MURRAY CRESCENT HOUSE is the only built fragment of *F. Wehnert*'s 1857 new town, and all the stucco detail is lost. It was to have been part of a quadrant facing SW; crescents and terraces in a lush Bayswater Italianate were to have extended right up to Castle Pill. Today C20 houses curve round into PILL, where there is little of interest save, to the NE, some picturesque C19 cottages on CELLAR HILL, and a LIMEKILN just off the road to Black Bridge. On the E side of Castle Pill, the small remnants of the CASTLE HALL estate.

CASTLE HALL, E of Castle Pill. The house was demolished by the Admiralty in 1937, and the grounds are derelict. A villa of *c.* 1770–80 built for John Zephaniah Holwell, governor of Bengal, and survivor of the 'Black Hole of Calcutta'. Enlarged with single-storey conservatory wings after 1804 for Benjamin Rotch, the American whaler; sold after his bankruptcy to R. F. Greville in 1819. Col. Greville spectacularly remodelled the house in an exotic Italianate in 1855–6.* The remaining outbuildings are modest, but the grounds have relics of a romantic garden, probably made for Benjamin Rotch. Facing on to the lake is a terrace raised on a three-by-two-bay stone vault with triple arcade to the front. Adjoining is a big, roofless lean-to hot house, perhaps the 'capital conservatory' mentioned in the 1818 sale document, or the three pineries of different temperatures where Rotch grew some 250–300 pineapples a year. Octagonal mid-C19 LODGE by the Home Farm on the Neyland road.

# MINWEAR

1½ m. N of Martletwy

The church has an idyllic setting, adjoining a farm.

ST WOMAR. Nave, chancel, tiny barrel-vaulted S transept probably added in the C14, N aisle. Small C16 or C17 W tower with corbelled parapet: entered by a first-floor doorway (cf. Cosheston). A striking interior: the plain chancel arch stands

---

* The house had a great arcaded portico and two campanile towers by *W. H. Lindsey*.

on square piers with a lower arch each side, that to the N
sharing an octagonal pier with the aisle arcade. Above are two
triangular-headed openings of uncertain date. They achieved
their present form in the 1870 restoration, but their differing
sizes surely reflect earlier openings. Two-bay chancel arcade
of plain elliptical arches on a very crude round pier, prob-
ably as late as the C16. Nave arcade of only one bay. *John
Cooper* prepared plans for restoration in 1836, but nothing
occurred until the patron and local squire, Baron de Rutzen,
had finished his new church at Slebech in 1844. In order to fill
this *folie de grandeur* with a congregation, he unroofed Minwear
(as, too, Newton North), and reused the windows in a new
lodge. In 1861 the Court of Arches ordered reinstatement. In
1870 work began under *K. W. Ladd*, an architect not used to
dealing with churches, as his strange and alien oculi in the nave
indicate. – Good medieval FONT, a circular bowl with defaced
masks above crude leafy bosses. – Simple FURNISHINGS of
1870. The LECTERN of 1904 contains work from the 1840s
pulpit at Slebech. – MONUMENTS. Thomas Davies †1715.
Clear inscription.

THE SISTERS' HOUSES, ½ m. NW. In the woods, close to the
banks of the Eastern Cleddau, are a number of ruins, dating
from the C15–C17; possibly those of a 'respectable mansion'
mentioned by Fenton, which belonged to the Barlows of
Slebech. An impressively large, rectangular CORN BARN at the
centre, with porch and closely spaced loops. COWHOUSE to the
N. A group to the W with small CORN BARN, a two-storey
HOUSE with lateral chimney, and another with a gable
chimney. Immediately to the W stand the much-depleted
remains of a first-floor HALL HOUSE with tall, shouldered
lateral chimney. Near this, a strange barrel-vaulted structure,
its end walls lost. The name of the site is probably corrupted
from mention of a 'systerne house' in 1546 – probably a cistern
or pool, supplying a mill.

BLACKPOOL MILL, 1½ m. NE. Built *c.* 1813, by the engineer
*George Brown* of Amroth. Tall and imposing main block of four    99
storeys and five bays with lower, balancing two-bay wings.
Brown probably also built the handsome adjacent BRIDGE over
the Eastern Cleddau; it is of impressive single-arch span with
pilaster strips. The carved stone EAGLES at the entrance to the
mill were formerly at Eagle Lodge, on one of the drives to
Slebech Park. An important early iron forge recorded nearby
in 1635 had ceased production in 1806.

## MONINGTON/EGLWYS WYTHWR

A small parish near Moylgrove. No village centre but a small      *1344*
cluster around the altered MILL at Rhydyfantwn. PLAS
LAWRENCE, s of the church, is a derelict early C19 farmhouse
built for the James family. GLANDWR, s of Pantsaeson, is dated
1790, the front still not symmetrical to allow for the large kitchen

chimney, and the upper windows small.

ST NICHOLAS. Isolated small church of 1860 by *R.J. Withers*, neatly built in tooled grey stone, nave, chancel and bellcote, the vestry with a handsome chimney, stepped in and topped with a hipped stone cap. The care in detail shows too in the w projection carrying the bellcote. Simple interior with open timber roofs and octagonal C19 FONT. A roughly circular churchyard with a C19 BIER HOUSE.

PLAS PANTSAESON. A large stucco classical villa of 1836, built for J.T.W. James, five bays, the centre advanced with paired Ionic pilasters, blocking course and scrolled shield. A big Doric porch with paired columns and triglyph cornice shelters a broad front door. The style and plan suggest *William Owen* of Haverfordwest. Similar five-bay side and three-bay rear, presumably including later extensions. Inside, a broad hall to off-set stone cantilever staircase. Estate FARMHOUSE dated 1752, but probably C19, pedimented seven-bay COACH-HOUSE and STABLE, dated 1779 and two long ranges of outbuildings linked by an arched gateway, the w range with seven elliptical arched openings probably *c.* 1840, the s range simpler, dated 1764 but possibly remodelled in C19.

# MONKTON

9710 MONKTON PRIORY (St Nicholas). Dramatically set on a hilltop. The parish church incorporates the remains of a Benedictine priory dependent on the monastery of Séez; founded *c.* 1098, acquired by St Albans in 1443. After the Dissolution the C13 nave was retained as the parish church, and was restored in 1879–85 by *John Prichard*. The C14 chancel, which had survived as a shell, was restored to Prichard's plans by *Parry Moses* of Cardiff in 1887–95, retaining the medieval N chapel and fragments of associated buildings.

First, the medieval remains. Tall nave and lower chancel, both very long. Originally cruciform; the N transept has vanished, a tall slender tower, probably C15, stands over the s transept. Above the E window a splendid Dec exterior niche, with ogee head and ballflower; a broken statuette within. C15 s porch; its outer door reuses early C13 trumpet capitals on keeled shafts. The date of the nave is suggested by the mid-C13 s doorway, round-arched with heavy continuous roll-mouldings, cf. St Mary Pembroke. Inside, the impression is of a long dark tunnel, as porch, nave and transept have pointed barrel vaults with only a tiny N nave lancet. The vaults appear to be an addition; two blocked round-headed windows on the massively buttressed N side were discovered in 1890, hidden by an inner wall thickening, which was probably added to support the vault.

N of the chancel a short passage leads to a chapel, possibly for the Prior, with plain pointed PISCINA. Corbels and evidence for a staircase and upper doorway indicate a west gallery.

The staircase was within a barrel-vaulted structure built against a blocked arch on the N side of the chancel; remains of the vault survive, with springing for a parallel vault, now incorporated in the C19 vestry. The chamber above opened to the chapel gallery and had a squint looking into the sanctuary. Buck's 1740 print of Pembroke indicates other buildings N of the church, but all that remains is rough walls on the N side of the nave, with a blocked ground-floor door and another above.

Now for the Victorian work. E.E. windows in the nave. Big E.E. chancel arch of 1887 with over-thick filleted shafts and bold foliage caps. Attractive chancel roof, moulded arch-braces and purlins. – Massive FONT of 1882, round bowl with foliage underneath. Mounted on the C13 square base with eight colonnettes. – Oak PEWS and PULPIT by *Prichard*. – Sumptuous but over scaled CHOIR STALLS of 1911 by *G. E. Halliday*, the canopies with detailed carved tracery. – Fine brass LAMP STANDARDS in the nave, *c.* 1882, with branching lights. In the chancel, CORONAE of 1885. – WALL PAINTINGS in the chancel, by *C. E. G. Gray* of Cambridge, 1895–6, of poor quality, and the scheme only partly surviving. – STAINED GLASS. A set of three in the chapel by *Percy Bacon*, *c.* 1920. Old Testament figures with Solomon to the E: prominent symbols of the Freemasons, who paid for the windows. Kempe-style. – E window by *Herbert Davis*, after 1902. Life of Christ. Also by *Davis*, two chancel S windows of 1905–6, Good Shepherd/Light of the World, and Christ in the House of Mary and Martha. – MONUMENTS. C14 priest, much defaced. Another fragment of a recumbent figure in the chancel. – Early C16 canopied tomb, devoid of its inset brasses. Very well-carved piece, the chest with panels of cusping, spiral-twist columns above and good leafy cresting – Sir Francis Meyrick †1603. Big chest, seven large kneeling children, with billowing skirts on the front, and shields each end. A surviving portion, of delicately carved alabaster, shows that the upper part must have been a fine piece of work. – Sir John Owen † 1612. Large wall-tomb, the chest with carved panels. Paired Ionic columns above with shared capitals, and carved pedimented shield overhead, the heraldry flanked by fig-leafed supporters. – Sir Hugh Owen †1670. Leafy pilasters and scrolls, segmental pediment with large mourning putti. – Catherine Humphreys †1790. Tapering tablet with urn. – Hugh Owen †1809. By *John Bacon the Younger* of London. Weeping female in front of a sarcophagus and broken columns, long inscription. – Charlotte Owen †1829. Panelled sides with anthemion finials, draped urn.

VICARAGE, just NE. Plain. 1893 by *George Morgan & Son* of Carmarthen, not rising to the fine setting. To the N, portions of the medieval walling. The commanding views led Cromwell to set up his cannons here in the siege of Pembroke, 1648, and later inspired one of Richard Wilson's most famous paintings.

PRIORY FARM, to the W of the church. Heavily modernized. Possibly the medieval prior's house despite its distance from

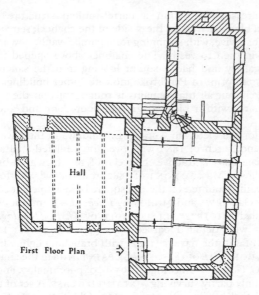

Hall

First Floor Plan

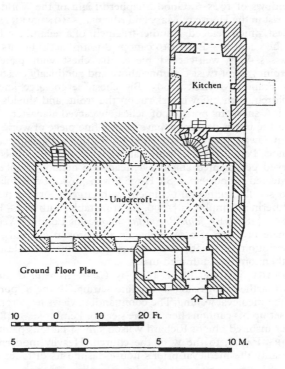

Kitchen

Undercroft

Ground Floor Plan.

| 10 | 0 | 10 | 20 Ft. |

| 5 | 0 | 5 | 10 M. |

Monkton Old Hall. Ground and first-floor plans

the cloister, although lack of datable detail suggests the house could well be post-Dissolution. L-shaped, the N range with a barrel-vaulted undercroft. Access was originally at first-floor level in the NE angle; the staircase, according to Fenton, had 'very curious pillers'. Fragments of a corbelled parapet and a lateral chimney with conical shaft survive. To the E, the remains of a rectangular medieval BARN with two high-pointed entries, and, to the NW, a broad circular DOVECOTE.

MONKTON OLD HALL, 150 yds S E of the church. A tall medieval building, apparently the original hospitium, or guesthouse, of the priory. Much the finest of South Pembrokeshire's many inhabited stone-vaulted houses. Probably begun in the C14. Detail is sparse, and several restorations make dating difficult. After the Dissolution the building became divided into tenements and by the mid-C19 was a roofless shell. In 1879 *J. R. Cobb* (cf. Manorbier) began a large-scale restoration for himself, adding the arch-braced hall roof. Renovations after 1933 including leaded windows. Carefully restored from 1979 by *Leonard Beddall-Smith* of Cardigan for the Landmark Trust.

The first-floor hall sits on a C14 barrel-vaulted undercroft. The undercroft is heated and has splendidly preserved quadri-partite vaulting in three bays. Above, the nearly square hall occupies roughly the western half of this length, originally served by the broad N lateral chimney with later cylindrical shaft. At the E end is a later wing at r. angles, the N part with barrel-vaulted undercroft and internal newel stair. Kitchen chimney on the gable with massive tapering square stack. The S end of this wing is a shallow projecting porch, its upper storey slightly jettied above a high-pointed blind arch which bears no relation to the interior. Behind it at basement level two small barrel-vaulted rooms. The cross-passage above is reached via a blocked pointed door on the W face of the porch. All this is puzzling, suggesting extensive late medieval alterations. The original main entry to the hall was to the S, reached by a flight of steps (removed *c.* 1950), with a separate entry below

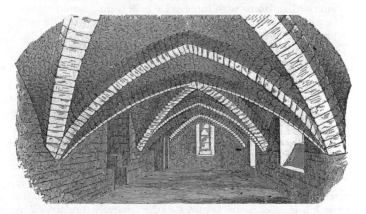

Monkton Old Hall. Fourteenth-century undercroft. Engraving, 1888

to the undercroft. A NE wing, presumably the solar wing, its blocked doors visible in hall and undercroft, was rebuilt *c.* 1880 and demolished in 1980. Inside, the hall has a tall relieving arch at the screens end with a chamfered, elliptically headed doorway and part of a four-centred one alongside. Little squint loops above. The crude hooded fireplace may be C14. It came from another part of the building, but may originally have been in the hall.

## MORFIL *see* PUNCHESTON

## MOUNTON *see* TEMPLETON

## MOYLGROVE/TREWYDDEL

[1245] Parish of bare coastal upland, but with quite a sizeable village in the deep valley of the Ceibwr stream. The houses mostly C19 altered; by the bridge a half-hipped former MILL. The church stands with the later C19 VICARAGE on the hillside E of the village.

ST ANDREW. Rebuilt in 1866 by *R. J. Withers*, incorporating the walls of the previous church of 1814. On a small scale, quite a complex design with S transept, and short W octagonal spirelet. Plate tracery with two-light windows, the foiling of the top roundels varied, and the gabled S doorcase has ashlar introduced into the apex with a blank trefoil. Inside, open timber roofs, the W window deep-set in the arch carrying the spirelet, fittings of 1866, Gothic ashlar REREDOS flanked by encaustic tiles, heavy High Victorian FONT, square with roundel panels, on a ring-shafted circular stem. A plain square C12 or C13 FONT survives also. Timber PULPIT, STALLS and RAILS. – STAINED GLASS. E window of *c.* 1870. On the W wall a reset 1679 datestone.

BETHEL INDEPENDENT CHAPEL. Lateral façade of the earlier C19, heavily overhauled in unpainted stucco *c.* 1900, but the interior handsome with three-sided gallery on painted wooden columns, the fronts in long panels. Painted pews, and the walls lined as ashlar.

TABERNACLE BAPTIST CHAPEL. 1894–5 unpainted stucco; gable front with arched windows, quite large though it cost only £400.

At CEIBWR, a small cove, with remains of a LIMEKILN.

TREPRYSG, Cwm Bach, ½ m S. Earlier C18 small gentry house of five narrow bays, the windows all replaced, but fielded panelling and bolection-moulded doorcases within.

## MYNACHLOGDDU

[1430] The name, 'black monastery', was already recorded in 1291, referring to a chapel or grange of St Dogmaels Abbey. The parish church is isolated some 1½ m. SW of the relatively modern village

around the chapel.

St Dogmael. In a circular enclosure down by a tributary of the Eastern Cleddau. Attractive two-nave church, the N nave with bellcote possibly C14, restored in 1877 by *E. H. Lingen Barker*; the s nave perhaps C15, mostly rebuilt in 1888–9 by *C. R. Baker King*. King had a nice touch – simple flush ogee heads to the windows and rough stonework of a more Arts and Crafts sensitivity than the Victorian norm. In the N nave, flat-headed windows with arched lights, a late medieval type, but mostly renewed. Inside, a low plastered arcade, very much in the local manner. N roof with heavy collars and some wind-bracing, the s roof with simpler collar trusses. – Medieval square FONT with chamfered corners. – MONUMENT. B. Jones †1900. A standard bronze plaque to the City of London Imperial Volunteers, signed *F. Wheeler*.

Bethel Baptist Chapel. Stone gable-fronted chapel of 1875–7 with two long windows and a small pair over the door, all arched. Squared Preseli dolerite (something of a feat to work), with grey slaty stone for the arches. The façade clearly by the same hand as the chapels at Pontyglasier and Glanrhyd. Panelled galleries on fluted iron columns, by *T. Thomas* of Cardigan. On the platform and pulpit attractive fretwork panels in Jacobean style. Ornate and fleshy plaster rose in a boarded ceiling. The former chapel of 1821, now the schoolroom, is adjacent; roughcast long-wall façade with three sash windows, the middle one taller, marking the pulpit position.

Gors Fawr Stone Circle, $\frac{1}{2}$ m. sw of the village (SN 135 294). On the flat moor backed by the jagged crest of Carn Meini, the Preseli ridge whence came some of the Stonehenge bluestones. An atmospheric site, though the sixteen stones are small, disposed around a 72-ft rough circle. Dated to around 3,000 B.C. They are probably part of a larger group – see the two taller stones some distance off to the NE. It has been suggested that these are a midsummer indicator, aligned not on the Preselis behind but on Foel Drych, the hill to the E.

Waun Lwyd standing stones, NE of the village, (SN 158 312). A pair of stones N of Foel Drych.

Glyn Saithmaen standing stones, 2 m. w. The name means 'the valley of seven stones', and there are several, of which the best are the GATE STONE, by the road sw of Glyn Saithmaen Farm (SN 111 303), and the CERRIG MEIBION ARTHUR, the 'stones of the sons of Arthur', on the moor NE of the farm (SN 118 310), a pair of stones some 30 ft apart.

# NARBERTH/ARBERTH

One of the places where the king of Dyfed held court according [1014] to the medieval *Mabinogion*. A Norman castle is mentioned in 1116. The lordship by 1413 stretched from Canaston in the w as far E as St Clears. In 1652, Captain Richard Castle, a dissenter

and Parliamentarian, began a weekly market which grew rapidly, was stopped in 1676 after objections from Tenby, but permanently re-established in 1688. By the late c18 Narberth had become an important post-town, situated on the Haverfordwest–Carmarthen turnpike road; the town's several hostelries were founded in this era.

The early c19 saw a near rebuilding of the town, including the De Rutzen Arms in 1833, a large hotel with a covered market behind, for the lord of the manor, Baron de Rutzen of Slebech (*see* p. 450). The local builder/architect *James Hughes*, who died young in 1832, was building houses in Church Street for J. H. Allen of Cresselly in 1812, and rebuilt much of the church in 1829. He specialized in three-bay, stuccoed, hipped-roofed villas, of which there are several scattered in and around the town. The railway came to the outskirts in 1866, but brought little growth. Even today the town has not grown much beyond its triangular core and is still a small and inviting town.

NARBERTH CASTLE. Standing on the escarpment overlooking the valley. A single-ward castle much depleted. First recorded in 1116, burnt in 1215 by Llywelyn the Great and again by him in 1220. Repaired for William Marshal II, destroyed in 1256 by Llywelyn the Last, rebuilt but burnt again in 1299. The present castle looks late c13. Rectangular in plan with corner quarter-engaged drum towers. The gatehouse to the N has disappeared. Three of the three-storey towers survive in varying states. That to the SE is the worst. An aumbry in the first-floor window reveal shows the location of the chapel. There is more of the SW tower, with fragments of a first-floor lancet. The NW tower has portions of two garderobes in the angle with the curtain. Between the E towers, a barrel-vaulted cellar, which, according to the 1539 survey, lay under the great chamber. One wall of the hall range remains. Traces of the curtain to the W, with a semicircular bastion and a circular fragment to the NW, perhaps of the fourth tower. The castle was in decay when it reverted to the crown in 1531, but it continued to be inhabited up to 1677.

CHURCHES AND CHAPELS

ST ANDREW. On the SW corner of the town, on a gentle slope. Of the old church, only the thin, late medieval N tower survives, tapering and embattled, along with the windowless N nave wall. The chancel rebuilt in 1829 by *James Hughes* with N chancel aisle, but everything grandly rebuilt, by *T. G. Jackson*, in 1881. Good crisp tracery (curvilinear to the E) and closely spaced triple-stepped buttresses. Short octagonal turret SE of the nave, with bristly crocketed spirelet: decidedly striking when viewed from the SE approach to the town.

Dark, barn-like nave with massive wagon roof of kingpost construction: simpler version in the chancel. The surprising feature is the very high tripartite chancel arch, on stone

columns, the side arches angled to the w. Moulded caps. Hoodmould with naturalistic stops, crisply carved. The chancel is grand in effect. Jackson has made the best use of the space with a single-bay arcade each side, then the walls reduce to the width of the sanctuary. FURNISHINGS mostly by *Jackson*: – FONT. Simple octagonal bowl on bulging pedestal. – Nicely polychromatic PULPIT built into the s arcade. It stands on grey Forest of Dean columns, and has bands of purple Caerbwdy sandstone and some carved vinework of Corsham stone. – Triple-arched SEDILIA, cusped arches with ivy and maple leaf carving in the spandrels. – Small wooden LECTERN. Simple PEWS and CHOIR STALLS. – Bright REREDOS of 1927 by *John Coates Carter*: painted floral panels, wooden figures of the Annunciation above with flanking candlestick-bearing angels. – Also by *Carter* the half-glazed oak TOWER SCREEN. – STAINED GLASS. Good Samaritan, 1927 by *William Morris Studios*, Westminster. Hard-edged Arts and Crafts style and the next one SS Christopher and Michael, *c.* 1920, more like the better known *Morris & Co.* – E window of *c.* 1900, Crucifixion. – MONUMENTS. George Devonald †1805. Tall oval tablet, clumsy fluted urn. – Charles Hassall †1814. Reeded surround, urn, signed by *Tyleys* of Bristol. – Anne Prichard †1819. Inset draped tablet, urn over cornice. – Maurice Bateman †1824, by *Tyleys*. Sarcophagus over tablet, fluted sides, shield below. – John Smith †1828, by *D. Mainwaring* of Carmarthen. Urn within shallow segmental pediment, side torches. – Emma Lord †1847. Plain, by *King* of Bath. – Catherine Davies †1849. Draped urn above cornice, by the *Patent Marble Works*, Westminster. – William Lloyd †1862. Scrolled tablet with drooping palm branch, by *King*.

CHURCH OF THE IMMACULATE CONCEPTION (R C), Church Street. Formerly the National School, built 1869 by *T. David* of Laugharne, and converted 1981. Bellcote with stepped top.

BETHESDA BAPTIST CHAPEL, High Street. Down a narrow passage behind late C19 iron gates. Dated 1889. By a local builder, *James Williams*, in the manner of George Morgan. Tall, Romanesque gabled limestone front, the central bay slightly advanced with a big wheel window. Paired round-arched windows, doorway with fleuron and dogtooth ornament. Three-sided gallery with iron balustrade, coved plaster ceiling with timber ribs. ORGAN recess and wide PULPIT with upper arcading added by *George Morgan & Son* in 1906.

TABERNACLE UNITED REFORMED CHAPEL, Tabernacle Lane. Built 1858 by *John James* of Narberth, replacing the plain old chapel of 1818 to the E, which was remodelled *c.* 1860 as a schoolroom. Good three-bay pedimented front, stuccoed, with giant Tuscan pilasters. Tall, round-arched windows. Three-sided gallery with panelled painted front on fat iron columns with simple Corinthian capitals. High pews with doors. Box-like later organ recess.

## PUBLIC BUILDINGS

TOWN HALL, High Street. Island site. Built *c.* 1835 as a gaol with magistrates' room over, perhaps by *William Owen* as County Surveyor. Brown local sandstone gabled front with first-floor entry. Square, two-stage stuccoed turret of *c.* 1880, with steep slated and sprocketed roof, giving the whole a somewhat Swiss appearance. Stuccoed upper storey added 1912 by *George Thomas* of Templeton. Refurbished 1991 by *Wyn Jones* of Haverfordwest.

COURT HOUSE, Market Street. Erected 1864 by *Charles Reeves* of London, surveyor of County Courts. Italianate. Four by three bays, three storeys. Grey limestone with Bath dressings, rusticated ground floor. Round-arched windows above segmental ones, the latter with flared triple keystones, a sober and distinguished design.

QUEEN'S HALL, High Street. Rebuilt 1994 by *Ken Morgan* of Narberth. Low-key, tall roughcast front with sash windows and dormers.

MASONIC HALL, Station Road. A Wesleyan chapel until 1965. By *J. Preece James* of Tenby, 1905. Grey rock-faced limestone with Bath dressings. L-plan, with odd three-stage tower and a tall, slender spirelet, now lopped.

LIBRARY, St James Street. Dated 1905, a conversion of a Wesleyan chapel of 1883 into a Petty Sessions House. Three-bay single-storey front with centre gabled porch. The straight-headed windows, with colonnettes and labels with leafy stops, appear to be of the earlier date.

INTERMEDIATE SCHOOLS (former), Station Road. 1896 by *J. M. Thomas* of Narberth. Long, symmetrical single-storey front of silvery limestone with buff brick dressings. Gabled wings, triplet windows. Converted into industrial units in 1990.

RAILWAY STATION, ¾ m. E. 1878 by *J. W. Szlumper*. Plain stuccoed. Half-hipped, roof canopy on cast-iron columns, brackets with quatrefoils.

### PERAMBULATION

The bottom of MARKET STREET starts with the DE RUTZEN ARMS, dated 1833, a large hotel formerly with covered market to the rear. Stuccoed front of seven bays and three storeys. Four symmetrical bays to the r.: the outer bays with first-floor windows under blind arches. The upper part to the l. has the main market entrance, with tall pilaster strips dividing the bays. Flanking plain three-storey houses. All by *Thomas Rowlands* of Haverfordwest, who took the job after the sudden death of *James Hughes*. Uphill, past the Court House of 1864 (q.v.) to the triangular MARKET SQUARE, with the WAR MEMORIAL by *D. F. Ingleton*, 1923: a pale granite octagonal base and tall cross. On the w side of the square, a good stuccoed urban group. No. 5 with close-set Georgian sashes. BACK LANE,

behind the E side, leads past C19 MALTING LOFTS. A detour W
along PICTON PLACE leads to ROCK HOUSE, home of the
Narberth architect *J. M. Thomas*, built by him *c.* 1875. The basic
three-bay house displays every skill Thomas could muster: poly-
chrome brick voussoirs, squared sandstone walls, windows of
all kinds, and fretted bargeboards above with an elaborate
chimneystack. Ahead is the TOWN HALL (*see* above) on an
island site and HIGH STREET, consisting mostly of early C19
houses, some given shopfronts and a certain stuccoed grandeur
early in the C20 (e.g. No. 25, No. 15). The NATIONAL WEST-
MINSTER BANK has a little stuccoed frontispiece added
in 1904 by the bank's surveyor, *C. H. Brodie*. No. 34 has
another Edwardian façade: ground-floor bay windows with
fancy sashes, sandwiching a gabled porch. Next, the gates to
the Baptist Chapel (*see* above). No. 15 opposite has a wide
shopfront of *c.* 1900, the timber cornice on leafy consoles. Near
the top of the street, stucco gives way to some taller mid-C19
houses of a coursed brown stone similar to the Town Hall.
Above, two small two-bay cottages, the lower with a miniature,
late C19 former shopfront, heavily restored. The three-storey
HILL HOUSE commands the end of the street, its late C18 date
indicated by the small window openings; glazing and other
detail lost.

Opposite, the COUNTY PRIMARY SCHOOL (1872 by
*J. M. Thomas*). To the E, NORTHFIELD ROAD leads past
BLOOMFIELD TERRACE. No. 2 is a pretty stone three-bay
cottage of *c.* 1840, pointed narrow windows with Gothic
glazing.

SPRING GARDENS leads E, past a gaunt red brick warehouse of
*c.* 1910, to ST JAMES STREET. At its start, the LANDSKER
CROSS, designed 1995 by *Howard Bowcott*, split in two to
depict the imaginary divide between Norman and Welsh Pem-
brokeshire. Simplified Celtic wheel-head cross, built of thin
strips of Blaenau Ffestiniog slate. In ST JAMES STREET past
modernized C19 terraced cottages is Narberth's best town
house, LLWYN-ONN *c.* 1830. Simple stuccoed three-storey
front with good pilastered pedimented portal and intricate
radiating fanlight. Opposite, No. 7 has an early C19 wooden
pedimented portal with fluted pilasters. Below is the tall BAR-
CLAYS BANK, of 1915, by *J. Howard Morgan*. Six narrow bays
with higher projecting end bays; centre windows squeezed
between giant pilasters. Finally, LONDON HOUSE, with two
good late C19 shopfronts: the upper has consoles with lion
masks.

PLAS, off Church Street. A mid-C16 house, built for John
Vaughan †1582, now much reduced. Rescued from derelic-
tion in 1997. The present rear was the original entrance front. It
retains a lateral chimney and remains of a first-floor, three-
light mullion window with label. The upper storey was
removed during a C19 remodelling, when the existing simple

four-bay front was created. Gable chimneys: the upper is massive and projecting, the lower corbelled out. There was a courtyard and gatehouse (*see* Buck's 1740 view of Narberth Castle).

SODSTON MANOR, 1¼ m. N. Small, box-like Italianate house of *c.* 1850. Stuccoed, with high panelled parapets, and corner pilaster strips.

SODSTON HOUSE, 1¼ m. N. Three-bay hipped-roof house of *c.* 1820, one of the local group of houses possibly by *James Hughes*, the upper storey slate-hung. Open pedimented portal on Tuscan columns. Inside, a dog-leg stair of four flights with turned balusters. To the N, a good mid-C19 symmetrical COACH-HOUSE. Wide, gabled centre bay with cambered entry; windows with radiating iron glazing.

BLACKALDERN, ¾ m. E. Early C19, four-bay stuccoed front range, hip-roofed, with later massive polygonal bay window, set off-centre. Some contemporary plasterwork and fireplaces inside.

ALLENSBANK, ¾ m. S. Built as the Union Workhouse in 1838, a standard *George Wilkinson* design, erected by *William Owen*. Centre triplet of gables with big cruciform loops. Rear additions 1868–75.

THE VALLEY, 1 m. W. Until 1902 this was the rectory. It began as a three-bay hipped house, designed 1829 by *James Hughes*. Later C19 top storey and ground-floor bay windows. Side entrance with open pediment and Tuscan columns.

*0103*

# NASH

2 m. NE of Pembroke

Secluded setting, just a farm, with the church opposite.

ST MARY. Long, narrow single chamber, later N vestry. Rebuilt 1842 by *George Gwyther* of Pembroke. Some of the walls were originally slate-hung. The tall mullioned windows are late C19. The interior is a well-preserved pre-Ecclesiological survivor, retaining BOX PEWS, double-decker PULPIT and W GALLERY, the front with turned wooden balusters. – FONT. Probably a heavy retooling of the Norman one: the usual square scalloped type. – MONUMENT. Thomas Davies †1741. Small tablet, but unusually treated, as if a fielded wooden panel. Crisp inscription with heraldry above.

LOWER NASH FARM, just SW. Good farm buildings, including a mid-C19 CORN MILL with overshot wheel.

NASH RECTORY, ¼ m. S. Three bays with wide sashes, stuccoed. 1838, by *George Gwyther*.

*0840*

# NEVERN/NANHYFER

A large parish with several rewarding houses. The village is an ancient settlement in the wooded valley of the Nyfer or

Nanhyfer, where according to the *Mabinogion*, King Arthur hunted the magical wild boar, the *twrch trwyth*. There were Irish settlers from the C5; in the C11 Meilyr Brydydd refers to the people of Nevern as *Gwyddyl diefyl duon*: 'black Irish devils'. During the C12 control shifted between the Welsh and the Fitz-Martins, Norman lords of Cemaes (*see* Newport). There may have been a tiny Norman borough here, but by 1200 the Fitz-Martins' new castle and town at Newport had replaced Nevern, which was in the hands of the Lord Rhys.

The village is attractively loose-knit. S of the bridge, the early C19 pink stucco LLWYNGWAIR LODGE, the much-extended rubble-stone TREWERN ARMS, and a pair of C19 cottages. To the N, the village hall, the CHURCH HALL, of 1908, by *L. Lewis* of Cardigan: simple Voyseyan roughcast with raking buttresses, and the church. On the lane running W, the VICARAGE, late Georgian three-bay with Doric-columned porch, and IVY COTTAGE, a good example of the single-storey lofted cottage of the region, with massive kitchen chimney, probably early C19.

ST BRYNACH. A site of great antiquity, where Saint Brynach may have settled his monastery in the earlier C6. The churchyard is set against the hill with ancient yew trees, including the famous 'bleeding yew', a relatively recent phenomenon. A large church with broad and squat W tower, aisleless nave and slightly leaning long chancel, perhaps C14 in origin. Dating is complicated by *R. J. Withers'* restoration of 1864, which replaced all the windows in an elegant ogee, late C14 style – but on how much evidence? The nave has a N lean-to chapel, and the chancel has small lean-to projections each side; a local feature for which there is not a convincing explanation. The remarkable lofted S chapel, with winding stair in a W turret leading to a priest's room in the roof, looks C15, and an early C19 engraving shows Perp tracery. Big S porch by *Withers*. The massive character of the tower suggests an early date but the small bell lights are C15 (and cf. the similar tower at Newport with early to mid-C15 heraldic evidence). Oddly crude flat-headed W window of four even lights; it looks C19. Old STONES, reset: on the S chapel, a corbel with carved face, and a cross over the buttress. On the N side, a consecration cross on the E wall of the lean-to chapel, and in the sill of the second chancel N window, a broken stone – possibly Romano-British – with lettering.

An amply Victorian interior, with well-designed roofs, the chancel roof to a trilobe profile, and Bath stone tower and chancel arches, nicely moulded. The tower is not vaulted. Bath stone segmental arches to the N chapel and above the two-bay arcade to the S chapel. C19 arcade in grey Forest of Dean stone, with an octagonal pier. The S, or Trewern, chapel, quite exceptionally in the region, has a low two-bay rib vault largely renewed in Bath stone. The pitted grey stone on S and W walls is apparently original, matching the crude conical corbels. A low C15 W door gives access to the winding stair to the loft, lit

only from a small C19 E quatrefoil. The lean-to N, or Glasdir, chapel is C19 in character, except for a cusped-headed PISCINA. A second PISCINA adjoins in the nave NE corner: ogee-headed, late C14. Two shallow chancel recesses with broad Tudor arches, also in pitted grey stone presumably original C15. – FONT. C12: square shallow bowl tapered below to a round shaft, on a base that inverts the form of the bowl. – FITTINGS. By *Withers*, and good of their type, with a High Victorian taste for form over intricate detail. – PULPIT. Smooth ashlar with red sandstone angle shafts. – FONT. Octagonal, on a fat cluster of ringed shafts. – REREDOS. With three inlaid marble panels and encaustic TILE panels each side. – Pitch-pine tower SCREEN, PEWS, STALLS and COMMUNION RAILS. – Two brass CHANDELIERS. – STAINED GLASS. E window of *c.* 1879, in a well-mannered C15 style. – Chancel S window of 1864 by *Lavers & Barraud*. Much hotter High Victorian colours. – Late Gothic-style glass, of *c.* 1905, in the S chancel recess, possibly by *R. J. Newbery*, and weary Arts and Crafts glass in the chancel N window, of *c.* 1940 by *E. L. Armitage*. – MEMORIALS. Three matching painted slabs with attractive rustic lettering: to William Warren of Trewern †1710, Katherine Warren †1720, and George Lloyd of Cwmgloyne †1731. – Marble plaque with a draped urn to George Bowen †1810. – Another draped urn to Edward Warren Jones of Trewern †1829, signed *Daniel Mainwaring*. – INSCRIBED STONES, two in S chapel window sills. C6 stone inscribed MAGLOCUN FILI CLUTOR, in Ogham strokes. Interlaced cross of a thin, inelegant two-cord design, so dated late, to the C10.*

The CHURCHYARD has tall gate piers and wrought-iron gate of 1823. The new churchyard across the road has a cast-iron gate dated 1810.

In the old churchyard, two important early MONUMENTS. Just E of the porch, the C5 VITALIANUS STONE, inscribed VITALIANI EMERETO, with VITALIAN in Ogham strokes. – By the S chapel, the NEVERN CROSS. One of the outstanding Celtic crosses of Wales, possibly by the same hand as the Carew Cross (*see* p. 158), which is dated to 1033–5 by the inscription. Like those at Carew and Penally, the cross-head is of the Anglian type, with curving arms, and like Carew, but unlike Penally, the ornament is in panels, front and back, and to both sides of the massive shaft. The panel patterns, cut into the hard dolerite, are a mixture of plaitwork and key patterns, with two inscription panels: H.AEN.H, or perhaps H.AN.EH, to the front, and DNS, perhaps Dominus, behind.

NEVERN BRIDGE. A well-made, double-arched bridge with cut sandstone voussoirs, the N arch broader, and a tall cutwater between. Late C18 or early C19.

* A stone, possibly inscribed IOHANNES, recorded by Edward Lhuyd in 1693, and noted in 1896, as well as a pillar stone with a Greek cross on a stem, sketched in 1861: both now missing.

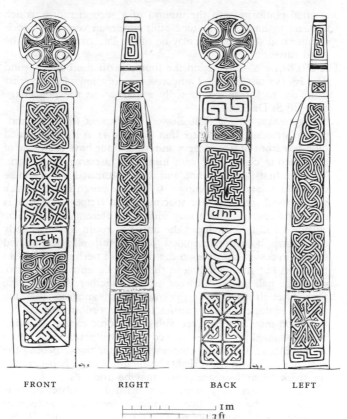

FRONT          RIGHT          BACK          LEFT

1 m
3 ft

Nevern, Nevern Cross

VILLAGE HALL. One of the earliest chapel buildings of the
   region, built in 1799 by George Bowen of Llwyngwair as a
   'Church Chapel', like the one in Newport (*see* p. 322), for
   reformed services, still within the Anglican church. A
   Methodist chapel after 1811, it became the board school in
   1876. Hipped rectangular structure in banded stone with large
   Gothick pointed windows, the façade obscured by an added
   wing of 1894.
NEVERN CASTLE, ¼ m. W. An ancient site, apparently an Iron
   Age hillfort used by the Welsh in the C9 and C10, possibly an
   important seat of the *cantref* of Cemaes. Robert FitzMartin
   from Devon seized the area *c.* 1105 and established a Norman
   castle here. The castle changed hands during the C12 and was
   dismantled by Hywel son of Lord Rhys in 1195. Nevern is prin-
   cipally a Norman motte of the early C12 with banks running
   out to the E and S, and bailey to the SE. E of the bailey, at the
   edge of the site over the gorge, a deep rock-cut ditch cuts off

a small platform with the mound of a second motte, which appears to have had a stone-built tower on top. This much smaller and stronger fort may be of the late C12, built for the Lord Rhys.

The PILGRIM'S, CROSS, on the footpath off the bend beyond The Ivy (SN 081 400). A Latin cross roughly hewn in high relief from the rock-face. Supposedly a marker on the pilgrimage route to St Davids.

LLWYNGWAIR, 1 m. W. The Bowen family seat from the mid-C16, in succession to Pentre Ifan (*see* below). A long, stuccoed nine-bay front of two storeys and attic. Four bays each side of a projecting centre bay with lunette in a narrow pediment, Venetian first-floor window, and inset columned porch. These details look late C18 to early C19, but the porch bay has thick sloping walls and the bay spacing of the ranges each side is not quite regular which may indicate different periods. The entrance hall now includes the four-bay room to the E; early C18 heavy bolection-moulded panels and elliptical-arched serving recesses, the one on the front wall perhaps a lost C17 fireplace, but the panelling in the entrance end is early C20, when the hall and room were thrown together. To the W the floor level drops with a thick wall, that suggests that the porch and upper bays are earlier. In the first room an early C18 bolection-moulded fireplace with crude Ionic capitals, floating over elongated pine cones, moved from Bridget Bevan's house at Laugharne. Cramped staircase in a stair-tower behind the entrance hall, with short flights branching from a half-landing; the thick rail and square newels may be mid-C18.

On the old driveway to the E, a delightful two-storey LODGE, probably of the 1840s, like a Staffordshire china mantelpiece ornament. A whitewashed roughcast cylinder with little Gothic windows and hoodmoulds, overhanging octagonal roof and round chimney. The drive continues past derelict hipped and pedimented COACH-HOUSE and STABLE (fine original internal fittings), early C19, to PONT NEWYDD, an estate bridge of *c.* 1800 in well-cut ashlar, with main arch between full-height cutwaters; small flood arches each side.

LLWYNYGORAS, ½ m. SE. Exceptionally for the region, a house reliably dated to the late C16. The date of 1578 scratched on the fireplace beam is confirmed by George Owen's statement of *c.* 1608, that the house had been built some thirty years past for Thomas George Bowen, a great-grandson of Sir James ab Owen of Pentre Ifan. A modest, cruciform house, originally roughcast, the front arm with storeyed porch, the rear containing the staircase. All four gables apparently had chimneys but three have gone. Later windows. Late C16 ogee-moulded oak E doorway within the porch. Inside, the original partitions have disappeared. Principal four-bay ground-floor room, with heavy chamfered beams and exposed joists. In the S two bays, the former parlour end, the joists have scratch-moulded enrichment. Rough joists at the N end, and a massive fireplace

beam. N of the entrance an unexpectedly elegant drawing room of *c.* 1840, with heavy moulded cornice and some Neo-Grecian ornament. The stairs open off the W side of the hall, enclosed with thin C18 square newels and moulded rail; the room behind has heavy beams, some reused.

BERRY HILL, 1 m. NE of Newport Bridge. Small country house of 1810, built for the Bowens of Llwyngwair. Typical deep-eaved, hipped late Georgian villa, of two storeys and three bays. The stonework, recently limewashed, originally showed some of the contrasting banding typical of the Cardigan area. Added S porch. Well preserved Regency interiors, with W end staircase, behind a pointed window.

PENTRE IFAN BARN, 1½ m. SE. By the small C19 Pentre Ifan farmhouse, a large lofted barn, converted to a youth hostel in 1990. Probably the remnant of the mansion of Sir James ab Owen †1518, ancestor of the Bowens of Llwyngwair. The big through-way with Tudor-arched entry in rough grey stones suggests a gatehouse range, though no trace of a separate mansion has been found. The stone frames of the other openings – a pedestrian entry just next to the main one, another door and some windows – are more massive than domestic. A fine three-light oak-mullion window was found in 1990 but destroyed. Corbels (lost in the conversion) suggest that there was a very low ground floor under a single first-floor room, and there is evidence of external steps to the upper floor. The roof survives, dated to the early C16. A fine ten-bay array of oak collar trusses, with cambered collars and rounded spurs to the feet of the principal rafters. The butt purlins are not found elsewhere in the county. There was a chimney at the W, now gone, but presumably not original. Some smoke blackening towards the W end.                                                        74

TREWERN, 1 m. S. One of the best-surviving gentry houses in the region, called 'the mansion house' of William Warren by Owen in 1603. Remodelled in the early C18, but the moulded beams suggest that essentially the house is late C16 to early C17. Rubble-stone, asymmetrical five-bay front, with a storeyed porch in the fourth bay, and C18 sash windows. Oak door frame with ogee and ovolo mouldings in the porch. Inside, a three-room plan with lateral hall fireplace. The mouldings of the front door are repeated in three doorways, and the beams are ovolo-moulded. W end kitchen with similar beams, E end parlour with the beams plastered. Upstairs, early C18 bolection-moulded doorcases and fielded panels, and in the attic, the remnant of an C18 stair with fluted column newels.   10

PENTRE IFAN BURIAL CHAMBER, 2 m. SE (SN 099 370). The finest of the Megalithic monuments of the region, a burial chamber of extraordinary – and presumably accidental – elegance, as the pointed capstone would have been under the earth of the covering mound. The capstone on three uprights covered a sunken chamber with portal at the S framed by pairs of stones, making a semicircular forecourt. The size of the fixed portal stone suggests that the chamber was sealed after a single

use. Owen, in the early C17, recorded four side-stones, but no trace remains of the two on the E. (*See* p. 26.)

TRELLYFFAINT BURIAL CHAMBER, 2 m. N (SN 082 425). Neolithic chambered tomb, with what may be a smaller chamber to one side. Both are of the portal dolmen type, with one principal opening. The main chamber has a capstone over the back part, on which have been found thirty-five cup-shaped marks, possibly evidence of Bronze Age reuse, but also called random natural indents. STANDING STONE nearby (SN 083 423).

LLECH-Y-DRIBEDD BURIAL CHAMBER, 2 m. NE, off the track S of Penlan Farm (SN 101 432). Neolithic burial chamber of particular massiveness. Immensely thick capstone on three uprights. Despite the name, 'tripod stone', a fourth stone lies alongside, and was apparently standing in 1693. Possibly a portal dolmen, with the entry to the SE.

2239

# NEWCHAPEL/CAPEL NEWYDD
## Manordeifi

Village on the ridge S of the Teifi. Along the road, the FFYNONE ARMS, mid-C19, of grey Cilgerran stone, TALFAN and ARFRYN, a pair of bargeboarded estate cottages, and the chapel, from which the village is named. Opposite, a stuccoed former COURT-HOUSE, of 1908.

CAPEL NEWYDD. Calvinistic Methodist chapel of 1848, the successor to an early Methodist chapel of 1763. Stuccoed long-wall front with two big arched windows, spoilt by new glazing. Unaltered interior: grained box pews and gallery fronts simply panelled over a bracket cornice. A later balustrade over the vestibules connects the gallery ends behind the low-fronted pulpit.

MANORDEIFI SCHOOL. 1873 by *K. W. Ladd* of Pembroke Dock. Main schoolroom and house under a single long roof. The house rear gable and infants' schoolroom gable asymmetrically balance the N front – an unostentatious but careful design.

PENTRE, ½ m. NW. The remains of a country house, the front range demolished in the 1970s, the range behind given a utilitarian new façade. Recorded from the earlier C18, but rebuilt about 1830 for Dr David Davies, who married the Saunders family heiress. Davies consulted *C. R. Cockerell*, but nothing came of plans made in 1824–5. The lost E front looked early C19, five-bay, with double-hipped roof, parapet and columned porch. After 1863 it was remodelled for some £5,000 for Col. A. H. Saunders-Davies by *J. P. St Aubyn*, who also designed a Gothic memorial chapel to his memory in 1878. This chapel has also gone – a sad loss, as it had an exceptionally rich interior, with stencilling and stained glass by *Clayton & Bell*. The pulpit and font are in Manordeifi new church, and some of the

glass is at the County Museum. The main surviving part is the
rear service wing running W, with some heavy ashlar dormers
of 1863.

To the W of the house, a sizeable early C19 FARMHOUSE of
six bays, hipped, with lower windows in arched recesses.
Detached and at r. angles to the W, a similar three-bay farm
cottage; W again, the rarity of a fine four-sided FARM COURT-
YARD, early to later C19. The E range, mostly two-storey, and
the pyramid-roofed dove-tower next to a coach-house are all
earlier C19, as is the W range with triple-arched coach-house
and barn. Elsewhere, later C19 triangular window-heads e.g. to
the single-storey stable and cart-shed and long N cow-shed
range. In the centre, a later C19 pyramid-roofed building,
perhaps a pump-house.

The NORTH LODGE, by the old main drive, is altered, but
the rusticated Cilgerran stone gatepiers survive: earlier C19.                    119

FFYNONE, 1½ m. SE. A small country house by *John Nash* of        p. 314
1792–5, built for John Colby, but so thoroughly remodelled
1902–7 by *F. Inigo Thomas* for John Vaughan Colby, that we see
Nash through Edwardian eyes. Ffynone is the first of Nash's
early houses to experiment with the compact square plan, with
pyramid roof, bracketed pediments on all four fronts, and
matching 1-3-1 elevations. The arches framing the centre three
ground-floor windows were the only relief to the plain stucco.
On the E side Nash's oddly graceless paired windows remain
in the pediment, overlooking the plain service court. Extensive
repairs by *William Hoare* in 1828 suggest that the house was
badly built. The fine Greek enclosed loggia in Grinshill sand-
stone added to the N entrance front, not mentioned in the
accounts, must date from *c.* 1830 and can be attributed to
*Edward Haycock* (cf. his Clytha Park, Monmouthshire). *Inigo
Thomas* remodelled the house with great panache. He added
stone dressings to the openings and massive rock-faced quoins,
all in grey limestone, well set against unpainted roughcast.
Lunettes replaced Nash's window in three of the pediments.
Thomas, a skilled garden designer, made the S front the centre
of a great terraced composition excavated out of the slope with
four-bay arched-window wings fronting a terrace over an
arcaded basement. This opens on to a lower terrace terminat-
ing in curved exedrae with exuberantly massive rusticated piers
and urns. The entrance forecourt has similar gatepiers and the
W garden is terraced to a curved end, giving an Edwardian
setting to each façade. All the garden masonry is of turned and
moulded Cilgerran slate, of admirable quality.

INTERIOR. The entrance is now through the loggia of
*c.* 1830. A square lobby with charming Gothic plaster vault
(used also in two bays to the r. over a basement stair) leads
into Nash's entrance hall, octagonal with niches in the diago-
nals, umbrella vault and arches with big wheel fanlights N and
S. The small rectangular inner hall in the centre of the house
has a fluted oval ceiling, a broad l. arch opening to the stair
and doors to the SW dining room and NW drawing room. As

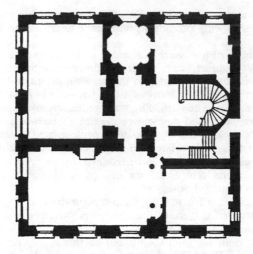

Ffynone, near Newchapel/Capel Newydd.
Original ground-floor plan

in Nash's contemporary villas at Llanerchaeron, Cered. and
Llysnewydd, Carms., the apsed stair hall only comes into view
after two small and subtly lit spaces have drawn the visitor to
the centre of the house. The main rooms do not communicate
with each other, in contrast to his later and grander villas in
England. The cantilevered stone stair (by *William Drewett* of
Bristol) curves elegantly with delicate iron railings, a curved
door to the service wing at mid-height and a window above.
The NE morning room, always relatively plain, was extended
by the entrance front addition of *c.* 1830 and given an extra
doorway from the entrance hall. The drawing room is the least
altered Nash interior, simple cornices and fireplace. The dining
room, now library, was much enriched by Thomas, but keeps
Nash's fine Corinthian end with quadrant corners and pair of
columns (with access to kitchen and service stair concealed
behind the l. one). The plain SE room now serves as ante-room
to Thomas's new dining room.

Upstairs, Nash's work survives extensively. The staircase
landing runs into a central rectangular lobby, the detail
repeated from the one below, but simplified. This gives access
to the bedrooms at the corners, either directly, or, on the S, via
a plaster-vaulted, apsidal-ended passage. The bedrooms are
plain, but there is some interesting spatial play in the small
dressing rooms between, that on the S apse-ended, that on the
N octagonal with corner niches, and the one on the W with
elliptical recess on one side and a little vaulted entrance space.

In the basement, service rooms and centre passage with
plastered vaults, presumably of Nash's time.

So to the work of 1902–7. The new wings each contain a
single reception room reached by steps down from Nash's floor

level: to the w, the ballroom, now the music room, to the E, 121
the dining room. They are exceptional examples of Edwardian
opulence, scholarly but free interpretations of English decora-
tion from Wren to William Kent, and superbly executed. The
ballroom has a mighty cross-vaulted tunnel roof, embellished
with thick floral bands, the end walls garlanded after Grinling
Gibbons. Most emblematic of this English Baroque taste is the
huge N wall fireplace, with outsize swan-necked pediment
and obelisks each side. The dining room has a fine deep-coved
vault surrounded by panels, framed in thickly encrusted fruit-
and-flower plasterwork in late C17 style, and an Ionic screen
to the w end lobby. In the library, curved pedimented (i.e.
earlier C18-style) doorcases and overmantel, sitting well with
Nash's columns, and, indeed, a fine timber fireplace by *Joseph
Ramsden* of Edinburgh, 1824, with nautical reliefs; this was
imported as part of the restoration from 1988 for Earl and
Countess Lloyd George of Dwyfor, which saved the house.
The interiors have been dramatically coloured to a scheme by
*Enriqueta Crouch* with Countess Lloyd George: yellow for the
drawing room, lilac for the music room, and terracotta for the
dining room.

The SERVICE BLOCK and STABLE COURT to the E are a
single utilitarian range, perhaps altered since Nash, as they
were recorded as much decayed in 1827. Timber clock turret,
rusticated with a little Gothic frieze under the dome. Detached
to the N, an octagonal later C19 GAME LARDER.

HOME FARM to w, presumably of Nash's time, but now
much altered. Big double-arched, half-hipped open barn with
sweeping side and rear roofs; a curious high wall with dove-
holes and lean-tos. Below the house to the s, WALLED
GARDENS, the earlier part late C18, lozenge-shaped and brick-
walled. Later stone walls link to the mid-C19 GARDEN HOUSE,
and an octagonal Gothick SUMMER-HOUSE.

In the valley below, the remains of a picturesque landscape
with a drive around an artificial lake created by damming
the Dulas. By the lake, PONT NEWYDD, a bargeboarded,
stone picturesque cottage of the C19. The hills to the s have
three stands of timber planted to enhance the view, but much
of the valley has been forested with conifers. Around the
Cwm Ffynone waterfall, w of the lake, some specimen tree
planting survives.

CLYNFYW, 1 m. E. *See* Abercych.

CILWENDEG. For the mansion, *see* Capel Colman. Just w of
Newchapel, an early C19 pair of stucco LODGES with timber
porticoes. Originally single-storey, raised by a floor in the
earlier C20.

# NEW MOAT/MOT

A T-shaped village, the upper part with the early C20 RECTORY
and two large farms. UPPER MOAT FARM has an exceptionally

long range of mid- to later C19 stone farm buildings. The road s has a Norman MOTTE, one of the chain along the s side of the Preselis. The church stands to the w. THE MOTE, seat of the powerful Scourfield family from the C13, was demolished in 1926. It was Neoclassical, of the 1830s, possibly by *Edward Haycock*. The park, the remains of a stable-yard, and a large walled garden survive, also, s of the church, a nice Neoclassical stuccoed LODGE like those at Cilwendeg, Capel Colman.

ST NICHOLAS. Thin, late medieval tower, the northernmost of this s Pembrokeshire type. Restored in 2002 by *Frans Nicholas*. Battered base, corbelled battlements, NW stair turret pushing the openings off centre. Crude C19 bell-lights. Inside, vaulted base, with Tudor-arched stair door. Nave, chancel and narrow N aisle, restored 1884–6 by *Archibald Ritchie*, who replaced everything except the walls. His are the ogee-traceried E window, bargeboards and shallow gable over the s door. Arcade and chancel arch rebuilt in Bath stone. – FONT. C12 square, scalloped bowl, tapered below. – MONUMENTS. William Scourfield †1621. Fine early C17 tomb: arcaded chest with fluted pilasters, three arches above on Ionic columns, central tablet with strapwork. – W.H. Scourfield, M.P. †1843. Neo-Grecian tablet, by *Patent Works*, Westminster.

Beneath the chancel, the rarity of a stone barrel-vaulted CRYPT, entered from a passage under the N aisle. It contains lead COFFINS of C18 and C19 Scourfields, with fine coats of arms and velvet hangings. Also the bones of a greyhound, a breed bound up with family mythology.

## NEWPORT/TREFDRAETH

The town is attractively set on the lower slopes of Carn Ingli, with the fishing port a little distance away at the Parrog, where the Nanhyfer estuary meets the sea. The houses are chiefly of the C19, with the hard colourful stone of the Preselis exposed in the later C19 fronts, where earlier it would have been rendered or whitewashed.

Newport began as a planned town of the earlier C13, the chief town of a small Norman Marcher lordship, the barony of Cemaes held by the FitzMartins. Their seat at Nevern was lost to the Lord Rhys in 1191, and William FitzMartin may have decided to move to Newport shortly after. The first castle, probably the EARTH-WORK near the estuary, was sacked by Llewelyn the Great in 1215. The surviving stone castle above the main street may date from after a sack by Llewelyn the Last in 1257; earthworks indicate it may be built on the site of an earlier ringwork. Cemaes was never a wealthy barony. The FitzMartin estates passed to the lords Audley in 1324–5 and thereafter the barons were not resident. Rentals dwindled from the late C14 and many of the burgage plots were never built upon. Castle and town were damaged in Owain Glyndŵr's rising of 1403–5. Fenton called the town 'a straggling place, meanly built, with many chasms in

the street to fill up, a mere skeleton of the town it once was'. The post-medieval history is of a small coastal town with some fishing and a little ship-building. The young men in the C19 left to find work as mariners – as the gravestones relate.

ST MARY. A typical Norman dedication, ignoring the local saint, St Curig, whose name survived in the annual fair. An uncommonly substantial W tower, like Nevern Church, suggests an early date, but the detail points to the C15: flat-headed, two-light bell-openings, big five-step buttresses, double-chamfer moulding to the W door. The NE buttress adjoining a flat, low buttress suggests earlier work incorporated. A small ogee niche on the NW buttress and carved head further up may be repositioned C14 pieces. Chevron coat of arms on pairs of shields over slot windows on the N and W sides, and on the stops to the W door, arms of the Touchet family, lords Audley from 1401. The likely builder is James, Lord Audley, royal justiciar in South Wales from 1423.

Victorian W window part of a rebuilding in 1878–9 by *Middleton & Son*. Foundations of the old nave and transepts, and perhaps some walling, were reused, but the chancel was lengthened. The twin-gabled transepts which had been altered in 1834–5 were restored with much higher roofs, brash Dec tracery to the windows, and an elaborate N porch. Inside, chamfered medieval tower arch with attractive timber screen of 1878. In the tower arch, an ogee-headed STOUP, matching the niche on the tower buttress. In the nave, exposed stonework under big open timber roofs. No aisles, but two-bay ashlar arcades cross the transepts, each transept valley carried robustly on two beams, one above the other, with timber framing between. Elaborately carved chancel arch, carried on corbelled shafts. On its E side, a tiny CARVED HEAD found outside the porch in the 1870s. – FONT. A massive C12 square scalloped bowl on an original squat column base. – COFFIN LID. In the tower vestry, late C13, foliated cross on long shaft, a finely carved female face above. – FITTINGS. Chancel stalls, panelling and rails of the 1960s, by *Alban Caroe*. – STAINED GLASS. E window, 1911, by *A. O. Hemming*. – Chancel, two lancets of 1879, by *Heaton, Butler & Bayne*, incorporating, on the N, two Flemish medallions, one dated 1631, and on the S, a much-restored medieval Nativity panel, said improbably to be Austrian and C14. – Four other lancets with matching canopywork, two, SS Luke and Mary, of 1911 by *Hemming*, Good Shepherd of 1939, and Light of the World, 1985, the progressive loss of quality painful to see. – MEMORIAL. In the chancel, Art Nouveau portrait roundel in metal of Evelyn Alderson, signed *Molock*, 1902.

In the churchyard, small INSCRIBED STONE C7 to C9, with incised ring cross. Numerous C19 slate MEMORIALS to mariners.

BETHLEHEM BAPTIST CHAPEL, Upper West Street. 1855, by *Joshua Morris* of Newport. A large roughcast chapel in minimal

Gothic, façade under a broad Tudor arch, with outer piers carried up to castellated tops. Two very large, small-paned pointed windows with Gothick glazing bars, and centre door with matching fanlight. The porch combines attenuated classical columns with fretted bargeboards. Light and simple interior in the late Georgian tradition. Three-sided panelled gallery on thin marbled columns, painted-grained pews; classical plaster ceiling roses.

Forecourt walls, with the date 1855 in the ironwork of the gates, stone piers with egg finials.

96  EBENESER INDEPENDENT CHAPEL, Lower St Mary Street. 1844–5, by *David Salmon* of Newport. In the narrow street, an overwhelming front in brown Cardiganshire sandstone, raised behind a small forecourt. Bold minimal classical elements: bracketed verges returned as an open pediment. Three tall, arched recesses enclosing small-paned arched windows on two levels. The door has iron fanlight tracery. Fine interior with painted-grained woodwork, box pews and panelled three-sided gallery on timber columns. C20 pulpit.

TABERNACLE CALVINISTIC METHODIST CHAPEL, Long Street. Of 1837, though dated 1815, thoroughly remodelled 1904. Originally a lateral façade with arched windows and outer doors (revealed by removal of stucco), the l. door covered by a schoolroom of 1904. Interior realigned to face the end wall.

YSGOL BRO INGLI, Long Street. 1991 by *Dyfed County Council Architects*, County Architect *Roy Howell*. Neatly planned primary school. Small internal courtyard, with glazed walls to the surrounding corridor and much internal glazing through to the classrooms. Assembly hall with full-height glazing divided by thin metal piers.

### NEWPORT CASTLE

Set on the hillside immediately above the main street, a picturesque mixture of medieval and Victorian, for the major surviving element, the N gatehouse, was in 1859–60 incorporated into a house for Sir Thomas Lloyd of Bronwydd, Cards., by *R. K. Penson*. This was part of the romantic medievalism that Lloyd espoused at Bronwydd, bolstered by the genuine Norman title of Lord Marcher of Cemaes, which the Lloyds had acquired in the mid-C18. Newport Castle, the historic seat of the barony, was rebuilt largely for symbolic reasons, and, as so much had already been spent at Bronwydd, relatively economically – which is part of the charm. The estate was massively indebted when Sir Thomas died in 1876.

As seen from the town below, the twin-towered gatehouse is the single prominent structure, Victorian in its centre and E tower, only the W tower substantially medieval. One wing of the Victorian house projects to the r. with half-timbered oriel

and dormer. A broken curtain wall runs w to a ruinous NW tower, the so-called Hunter's Hall. These are the N and NW elements of an irregular square, with the more fragmentary SW and SE towers apparent from inside the ward.

The castle probably dates from after the 1257 sack by Llywelyn the Last; other dates are conjectural. A refortification was ordered in 1370, and accounts exist for repairs in 1395 and 1398, the latter including a new drawbridge. In 1408 it was reported to have been 'destroyed by the invasion of the king's rebels' in Owain Glyndŵr's uprising.

The GATEHOUSE towers were both round with high spurred bases, but of the E tower only the base is original. The W tower rises with progressively inset stages to a corbel table under a high polygonal parapet. Masonry of top stage and parapet is of much thinner stones, possibly a late medieval addition, and the parapet has been raised in the C19 in mock ruin. The former centre gate-passage is lost; replaced by C19 masonry with windows on three floors and battlements. The square E tower is also C19 – possibly of the 1880s, (there is a straight joint to the centre block). – Narrow lancets and a mock-ruined corbelled parapet, picturesquely higher on the NW. From within the ward, the Victorian house obscures the medieval work. It is hardly a mansion: a pleasant, plain two-storey stone front with steep roof, small gable in the centre and big round-shafted chimneys, the W chimney built on to the medieval curtain wall. To the E a roughly built addition of the 1880s, with lean-to roof against the NE wall. Inside, oddly ill-planned, C19 interiors, nothing special – but the basement is substantially medieval, as are the walls of the W tower.

The curtain wall, rebuilt in the C19, connects to the NW TOWER, the HUNTER'S HALL; much ruined, though the three-storey W side and curved NW angle are still intact, partly refaced in the C19. Some parapet corbelling survives. On the E side, the ground floor has corbelling for a ribbed vault, possibly the undercroft of a great hall, of which the fireplace survives above. Little survives of the W curtain wall and SW, or kitchen, tower, where a semi-basement chamber seems to have been built from the rubble; restored 1871, nothing obviously medieval. The S curtain is lost. At the SE corner, basement of the large S TOWER, diagonally placed, with square spurred base, and rounded angles above. A fragment of a NW stair-turret survives, with reused carved medieval keystone. Pointed NE door with ashlar double-chamfered arch. The interior is D-shaped, with large and small embrasures in the wall at ground- and first-floor levels. Garderobe chutes to a basement latrine tank on the E side, but no evidence of fireplaces.

The intriguing building just N of the S tower has a rib-vaulted UNDERCROFT, square, with centre ashlar octagonal pillar and eight wall-shafts, made mostly of thin coursed stones, presumably intended for plastering. Its function is unclear. The

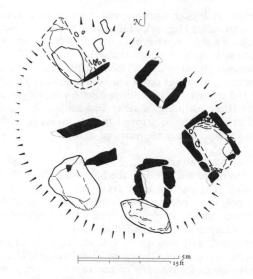

Newport, Cerrig y Gof. Chambered tombs

centre pier is broached at the base and has a chamfered cap, suggesting the late C13 or early C14. Quadripartite rib vaulting, the ribs square in section and also of thin stones.

CARREG COETAN ARTHUR, behind Cromlech House, Penybont (SN 060 393). Fine Neolithic chambered tomb with massive capstone over rectangular chamber. Of the four uprights, only two support the capstone. Excavated in 1979 and 1980; a radiocarbon date of 3500 B.C. was given.

CERRIG Y GOF, 1 m. W at Cwm Rhigian, s of main road (SN 037 389). Very unusual grouping of five small Neolithic chambered tombs in a rough circle, the open ends facing outwards. The capstones are dislodged, and one has gone. The SE chamber is the most complete, with four side-stones.

CARN INGLI HILLFORT (SN 063 373). On the rocky summit of Carn Ingli, behind Newport, a very large Iron Age enclosure with stone walls in the gaps between the natural rock outcrops. The most extensive walling was E and W of the saddle, much eroded. Four successive enclosures, possibly beginning in Neolithic times, and later adaptation. Numerous entrances. Twenty-five huts were found within the fort, soil-filled enclosures – both within, at the N end, and without, to the W and S – and numerous drystone round-house footings outside to the NE and SW.

CARN FFOI HILLFORT, 1 m. SW, E of Ffordd Bedd Morus (SN 049 379). Small Iron Age hillfort on one of the lower promontories of the Carn Ingli range. A single rampart links three natural outcrops with entrances to the NW and SE.

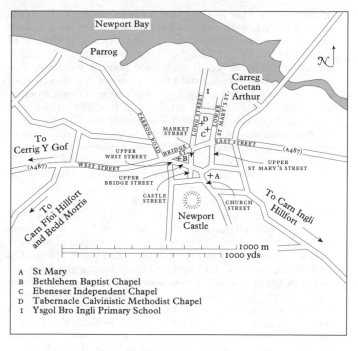

Newport Bay

Parrog

Carreg
Coetan
Arthur

N

PARROG ROAD

LONG STREET

LOWER
ST MARY'S ST.

MARKET
STREET

I

D
C

To
Cerrig Y Gof

UPPER
WEST STREET

BRIDGE
ST.

B

EAST STREET

(A487)

UPPER
ST MARY'S STREET

(A487)

WEST STREET

UPPER
BRIDGE STREET

A

To
Carn Ffoi Hillfort
and Bedd Morris

CASTLE
STREET

CHURCH
STREET

To Carn Ingli
Hillfort

Newport
Castle

1000 m
1000 yds

A   St Mary
B   Bethlehem Baptist Chapel
C   Ebeneser Independent Chapel
D   Tabernacle Calvinistic Methodist Chapel
I    Ysgol Bro Ingli Primary School

Newport

BEDD MORRIS, 2m. SW (SN 038 366). By the roadside, a large
standing stone, the boundary mark between Newport and
Llanychllwydog parishes, date uncertain.

PERAMBULATION

The Norman grid plan shows in the two parallel streets running
downhill from castle and church: Market Street and Long Street
aligned on the castle, Upper and Lower St Mary Streets to the
E, running down from just E of the church. Possibly a single E–W
road passed below the church and castle, along the present
ragged line of minor streets (Goat Street, Church Street, Upper
Bridge Street and Upper West Street); the present main road
below (East Street, Bridge Street, West Street) being later. The
two merge at the beginning of West Street. Nothing obviously
earlier than the late C18 survives, and much is of the late C19,
generally two-storey, in an attractive mixture of stucco, roughcast
and stone.

From the principal crossroads, MARKET STREET runs S. No. 3,
on the W, has attractive earlier C19 bow windows. Otherwise,
the street is mostly later C19, PORTH Y CASTELL at the top
has a late Victorian mix of stone, yellow brick window-heads
and slate hoods. CASTLE STREET continues S towards the
castle, Nos. 1 and 2, on the l., a pair of single-storey cottages,

probably early C19. In CHURCH STREET, to the l., LLUEST, stone with red brick window-heads, dated 1770 on a corner and 1714 on a reset stone by the door. Behind, at the top of UPPER ST MARY STREET, the CHURCH CHAPEL, 1802, half-hipped with lateral façade and three pointed windows. Two original doors blocked. Built by members of the church congregation, as a 'meeting-house . . . for hearing Divine Worship according to the doctrinal articles and homilies of the now established Church of England' – a form of words that sufficed to allow co-existence with the Methodists at least until the 1811 split over the ordination of Methodist ministers. Others were built at Nevern, Eglwyswrw and St Dogmaels. In Upper St Mary Street, stone one- and two-storey houses, of the C19, the smaller windows and rougher stonework indicating those of earlier date. In LOWER ST MARY STREET, across East Street, Ebeneser Chapel (*see* above) on the l., and on the r., the OLD SCHOOL. Schoolhouse of 1874, severe and gabled, school remodelled 1910, with the more cheerful small-paned windows of that date. Adapted in 1995 as offices and Youth Hostel. On East Street, going E, LLYS MEDDYG, a substantial later C19 house in green dolerite, the sashes still Georgian, the added ashlar porch crashingly Victorian. An excursion NE down PENYBONT leads to CROMLECH HOUSE, earlier C19, with a lunette window in the pediment, and, behind, the Coetan Arthur cromlech (*see* above). The IRON BRIDGE over the Nyfer was of 1895, replaced in 2000. By the footpath on the N bank of the estuary, in Nevern parish, a large circular LIMEKILN.

Back on EAST STREET, IVY HOUSE (Cnapan Restaurant), on the N, is earlier C19, painted roughcast, with panelled doorcase and fanlight, the porch with the etiolated, debased classical columns popular all over the region. CARNINGLI, further W, on the S side, has another rustic Regency doorcase, though everything else is altered. The former SESSIONS HOUSE next door, 1900, probably by *Arthur Thomas*, has a stucco front with unexpected late C17 detail, mullion-and-transom windows breaking the eaves under stucco pediments. Next, the LLWYNGWAIR ARMS, a dignified three-storey stone front of the 1830s, with false pointing to disguise the irregular Preseli stone. Going N from the crossroads, LONG STREET has at the top, on the l., ANGEL HOUSE, earlier C19, also three-storey, stuccoed. Further down, on the r., BANK TERRACE, an attractive seven-bay row of the 1860s or 1870s, still surprisingly Georgian, with small-paned sashes, the pale brown brick window-heads giving away the late date. Further down, on the l., THE WHITE HOUSE, a well-restored single-storey cottage with big stone end stack, probably early C19, with the Primary School (*see* above) on the r.

To the W of the crossroads, in BRIDGE STREET, the CASTLE HOTEL (the former Commercial Hotel) on the r. *c.* 1880, hard green dolerite and brick window-heads, with an ashlar porch

like that on Llysmeddyg. Beyond Upper West Street, Bridge
Street becomes WEST STREET. WESTLEIGH, on the l., is early
CI9, double-fronted with a centre pedimental gable and
lunette. Further out, ABERTAWE HOUSE, a big double-gabled
stucco villa of *c.* 1900, and the large plain MEMORIAL HALL
of 1924 where a medieval pottery KILN was found and is pre-
served in the basement. COTHAM LODGE, in a walled garden
beyond, was a dower house of the Bowens of Llwyngwair (*see*
Nevern). Early to mid-CI9, white roughcast with late CI9
veranda. Attractive banded-stone stable block to the E, lofted
and with a big chimney, once a house?

Returning past Westleigh up UPPER WEST STREET, VICTORIA
LODGE, of *c.* 1840–50, has the best of the rustic classical
porches of the town, open-pedimented with thin columns
and sub-classical acanthus blocks above. Neat minor details:
slate plinth and patterned cobble paving. MAJOR HOUSE has
another porch with bulbous columns, and frilly bargeboards
in the pediment. After the mill brook the street is UPPER
BRIDGE STREET. On the l., a large-bayed Victorian villa, and
YR HEN FELIN, a small, late CI9 woollen mill converted for
himself by *Kenneth Bayes*, 1989, with *Christopher Day* and
*Julian Bishop*. AROSFA, beyond, is a smaller, late Georgian
stone house of three bays. Massive kitchen chimney on the
rear roof. MILL LANE runs uphill from Bethlehem Chapel
to CASTLE MILL, by the castle drive, late CI8 or early CI9,
derelict, with the unusual feature of an internal wheel pit.

PARROG ROAD runs N from West Street to the sea. NEWPORT
POTTERY is in a mid-CI9 stone warehouse, probably built
for the grain trade. Beyond, some substantial later CI9 houses
supposedly built by returning mariners. Nos. 1–2 SPRING
HILL have the heavy fielded-panelled doors and Georgian
small-paned glazing that show the conservatism of the
Newport carpenters. At THE PARROG, PARROG HOUSE
surprises by its scale: three storeys and attic, early to mid-CI9,
stone. Was it always two houses? The pedimented double
porch is restored, but the two arched doorways seem original.
The BOAT CLUB by the water is a much-altered earlier CI9
warehouse. Remains of LIMEKILNS behind the harbour wall,
and two picturesque stone, single-storey buildings, apparently
stores, but perhaps once cottages. At the far end of a long row
of CI9 to C20 seafront houses, the former LIFEBOAT HOUSE
of 1884.

LLWYNGWAIR MILL, ¾ m. E. An unusually large corn mill,
stone, half-hipped, with a big iron-rimmed wheel dated 1843,
made by *Moss & Sons*, Carmarthen.

MOUNTAIN WEST. The hillside S and SW of the town, scattered
with small houses and cottages, mostly mid- to later CI9. W of
Ffordd Bedd Morus (SN 045 384), a spectacular early CI9
CATTLE POUND, a circular high bank of stone and earth, with
single narrow entry.

GELLI OLAU, I m. W. The former rectory. A puzzling house, its
pedimental lunette typical of *c.* 1800. Rear additions of 1871

by *E.M. Goodwin*. Between service range and house at first-floor level a small, late medieval segmental-pointed door-head on rough corbels.

ABERFFOREST, 1½ m. w. Small coastal inlet with well-preserved circular LIMEKILN on the beach.

# NEWTON NORTH
*0613*                2½ m. NE of Martletwy

Ruined church, reached across the fields, alone in a little dell.

CHURCH. Deliberately unroofed after the building of Slebech church in 1844 (see p. 450). Ivy-shrouded, leaning W tower, probably C15, with battered base below a string course. Lower storey barrel-vaulted. Small nave with Tudor windows inserted into earlier fabric. The chancel is later than the nave. Tall, plain pointed chancel arch. Tiny S transept with mural stair, to the rood loft. Stone benches along the walls of both nave and chancel.

CASTELL COCH, ½ m. NE. Hidden in trees at the edge of Canaston Wood is the remarkable shell of a massively built, rectangular medieval house within a square moated enclosure. The RCAHM tentatively suggests a first-floor hall, indicated by surviving lateral entries to both storeys. Large internal newel stair, which, like the massive first-floor windows, has been robbed of all dressed stone. Cross wall between hall and the lower E chamber, clearly an insertion, its fireplaces ignoring the former levels. The large windows appear late medieval or C16 additions, so the fabric could be C15. Called New House, until Fenton discovered its original name (Castell Coch); all was abandoned before his arrival shortly after 1800.

# NEYLAND
*9605*

The decision by Isambard Kingdom Brunel to bring the South Wales Railway to Neyland, to facilitate Irish – and ultimately international – trade, transformed Neyland from a small and obscure fishing village on the edge of the Milford Haven, into an important railway town. The line was opened in 1856. The town grew as a bustling railway terminus, with a thriving steamship route to Waterford and Cork, just across the water from Pembroke Dockyard. *W.H. Lindsey* of Haverfordwest laid out the town as it exists today, from *c.* 1855 onwards. A new town sited further N, at Honeyborough, had earlier been projected by a local solicitor, George Parry. Plots were advertised at 'Parryville' in 1855, but by then Brunel had decided to re-route his line S-ward, to terminate closer to the water. Fifty years of prosperity ended with the transfer of the Irish traffic to Fishguard in 1906. Greater hardship followed with the closure of Pembroke Dockyard in 1926. The sad story does not end here: Neyland terminus closed

in 1964, and the river ferry crossing ended with the opening of the Cleddau Bridge in 1975.*

St Clement, St Clement's Road. Despite rapid development of the town, it was not until 1899 that the Anglicans had their own place of worship, whereas the Nonconformists had raised four chapels by 1864. The church, of iron, was designed by *M. L. Nichols* and erected by Messrs *Wilson & Co.* for £450. This survives as the Church Hall, re-erected after it partly blew down in 1928. Latin cross plan, with little transepts off the chancel, and pointed windows. The w end had a spirelet. In the 1920s *John Coates Carter* made plans for a new church, but present church dates from 1928–30, by *Ellery Anderson*. It is in his recognizable style with roughcast walls and red pantiled roof. w bellcote, set below the ridge. Cool and airy interior, nave and chancel in one, s aisle with provision for a N aisle. Attractive swirly leading in the windows. Oak FURNISHINGS.

Presbyterian Chapel, High Street. Dated 1861, by *Lindsey*. Thickly rendered front, with rusticated angles, oddly rising to pinnacles. Entry under a tall rusticated arch, inscription in the tympanum. Broad interior, with a gallery at the entrance end, the pulpit end altered *c.* 1950.

United Reformed Chapel, High Street. 1864, by *K. W. Ladd*. Simple Gothic, a triplet over paired doors, flanked by buttresses. Sandstone with Bath and limestone detail. Gallery at the entrance end, the panels with cusping. Pulpit with colonnettes. Skinny scissor-truss roof.

Bethesda Baptist Chapel, High Street. A very hamfisted design of 1903, by *S. Wilson Edwards* of Swansea. Big projecting stair-towers with pyramidal roofs (originally more like spirelets). Tall triple lancets lighting the chapel, over a lobby sandwiched between the towers. Render, with harsh red brick trim. The gallery runs around three sides, its pierced-metal bowed front with an attractive fern leaf design, probably by *Macfarlane* of Glasgow. Ribbed ceiling on a cove, the middle bay open like a tunnel vault. Behind is the old chapel of 1863, now the schoolroom with old-fashioned lateral front. Within, the gallery survives, with wooden trellis-work front.

Wesleyan Chapel, High Street. Rebuilt in 1877 by *K. W. Ladd*. Simplified Romanesque. Sandstone rubble, three bays divided by silver limestone strips. Triplet in the middle, paired windows each side, round-arched. Interior altered 1893–7 by *Habershon & Fawckner*, who added the gallery at the entrance end, and the rear SCHOOLROOMS, the upper one opening to a gallery over the pulpit.

Perambulation. The long HIGH STREET curves gently down towards the river, with shops, all the chapels, and simple stuccoed terraces. More terraces along LAWRENNY STREET, off the N side, and the parallel CAMBRIAN ROAD, also by *Lindsey*. Below this, and also facing the water, RAILWAY

*The help of Mr Simon Hancock is gratefully acknowledged.

TERRACE, *c.* 1860, among the first of the new houses. These are slightly Italianate, the only houses in the town of a distinguishable style. Along the upper portion two blocks of semidetached houses, stuccoed, with broad eaves, and a short terrace of six, the end houses projecting, with low-pitched gables. Nos. 1–15 are at r. angles, following the road downhill, each pair imitating a three-bay house, but with shared blind windows above each pair of entries. Presumably by *Lindsey*. Much detail lost. Further downhill, facing the water, the site of the large SOUTH WALES HOTEL, built 1857–8, by *William Owen* of Haverfordwest, sadly demolished in 1970. STATION HOUSE is of a similar date, three bays with broad eaves. S again, in PICTON ROAD a three-storey terrace of 1859; then GREAT EASTERN TERRACE, a smaller terrace. Above this is NEYLAND TERRACE, Nos. 1–4 surviving intact, with basements and railed forecourts. To the SW of Picton Road, FIELDS COTTAGES – one storey only. Some straight terraces on the NW side of town, including CHARLES STREET, which has some three-bay houses.

8618

# NOLTON

Loosely strung village along the road leading down to Nolton Haven.

ST MADOC. Set in a circular churchyard, towards the N end of the village. Nave, and chancel; S porch with vaulted roof divided into panels by hollow-chamfered ribs, probably early C16 (cf. Roch). The chancel, unusually, is wider than the nave on the N side, and evidently was of greater length. Alterations of *c.* 1700, left N and S walls projecting raggedly until tidied up in 1789. Much rebuilt in routine mode 1876–7 by *E. H. Lingen Barker*, who added a vestry N of the nave. Lancet windows. Inside, crudely carved corbel on the N side of the nave, with three human faces, one bearded. To one side animals, perhaps a hunting scene. What date can this be? Stone brackets on the altar wall, one carrying what appears to be the original PISCINA, repositioned after the alteration of the E end. – FONT. Norman square bowl with scallops. – FURNISHINGS of 1876–7. – MONUMENTS. In the porch, a very eroded military effigy with shield, standing upright, long used as a gatepost hence the two sockets. Perhaps C13 or C14. – John Grant †1804. Small brass plaque. – Rev. Moses Grant †1810. By *J. Phillips* of Haverfordwest, missing its urn.

In the churchyard, the SCHOOLROOM of 1810, the main part of three bays. The master's accommodation was underneath the schoolroom itself, the latter with pointed windows. Alterations in the 1890s by *D. E. Thomas*.

THE RECTORY. An instructively deceptive building. From the front, an early C19 house with an added gabled wing (by *T. P. Reynolds* in 1886). Inside, three barrel-vaulted rooms on the ground floor from a medieval house, with traces of a stairwell

in the rear room. Fenton informs us that the building 'was formerly approached by a gateway opening into a quadrangle, walls five feet thick and cement as hard as a rock'.

NOLTON CHAPEL, Nolton Haven, ¾ m. NW. An unexpected 97 temple-fronted chapel of 1858, of fast-eroding Nolton sandstone, built for the Congregationalists. Tuscan pilasters, tall windows in arched recesses. Inside, a gallery at the entrance end. Pews and pulpit of 1907, the latter incorporating some ironwork.

Standing near the cliff edge, 1¼ m. NNW, the stone and red brick chimney of TREFRAN CLIFF COLLIERY, the mine sunk in 1899, closed in 1905 – the western end of the south Wales coalfield.

MALATOR, 1 m. S. Built in 1998 as a small weekend home for 134 the Labour M.P. Bob Marshall Andrews, by the adventurous *Future Systems* (job architect *Jan Kaplicky*). The sensitive coastal location and the planning policy of the Pembrokeshire Coast National Park Authority called for a radical solution. By excavating into the sloping ground, and providing a rough turfed roof, the house appears as a low hillock with a metal flue rising from the grass. From the front (facing the road), a V-shaped glazed entrance, with views through the living area to the sea. The seaward elevation is entirely of glass. Open plan with central living area, the kitchen and bathroom towards each end, these rooms within free-standing pear-shaped pods. Steel-framed construction, the roof supported on a steel ring-beam.

## PEMBROKE/PENFRO

9801
p. 336

Pembroke is a mighty natural fortress, situated on a high limestone ridge at the head of a tidal creek. Leland, in the 1530s, observed that the town 'standith on a veri maine rokki ground'. It is one of the best examples of a Norman plantation town in south Wales, estalished as a defensive port to secure the Milford Haven waterway. Finds in the Wogan Cave underneath the castle date back to the Mesolithic period.

Following the 1093 conquest of Dyfed by Roger de Montgomery, Earl of Shrewsbury, Pembroke was granted to his son, Arnulf. Gerald of Wales records that Arnulf threw 'a slender fortress of stakes and turf' across the neck of the natural ridge. Henry I confiscated Pembroke in 1102, but granted a borough charter encouraging civil settlement at the castle gate. In 1138 Pembroke became the caput of an earldom and county palatinate corresponding to the southern half of present-day Pembrokeshire; it was to retain its semi-autonomous status until the Act of Union. The early masonry castle dates largely from the time of William Marshal, Earl of Pembroke 1189–1219, and it was he or his successors who enclosed the town with walls, confirming its long, narrow layout 'without any cross streets', an oddity noted by the Elizabethan George Owen. The plan remains

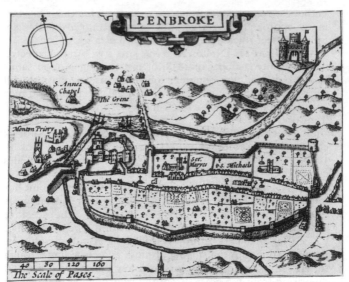

Map of Pembroke by John Speed, 1611

essentially the same today. Behind the two main rows of houses were long burgage plots, sloping down to the walls, still clearly defined on Speed's map of 1611; the walls and many of the plots remain discernible.

Although clearly of great military importance, medieval Pembroke was not very prosperous – 20 of the 200 or so burgages had been abandoned by *c.* 1400, and by 1480, 44 were in decay. This is in striking contrast to the booming port of Tenby, which, although of equal size, paid over twice as much as Pembroke in the lay subsidy of 1543. Leland saw a ruinous eastern suburb almost as large as the town itself. Speed in 1610 noted that he had found 'more houses without inhabitants than I ever saw in any one city throughout my survey'. By the late C16 only sixty-four householders are recorded. The 1648 siege ended the town's military history; during the long struggle against Cromwell's men, much property was destroyed. An improvement of fortune came in the early C18. Defoe saw a bustling port, 'the most flourishing town of all South Wales', dealing in wool, grain, fish and coal, and a new town hall was planned, though not built.*

Pembroke prospered as a market town especially after the construction of Pembroke Dock (q.v.) some 2 miles to the NW, and the opening of the dockyard in 1814. Much rebuilding from *c.* 1800 gave the town its present late Georgian appearance.

---

*An unsigned engraving dating from *c.* 1740 shows a seven-bay structure on open arcades, with rusticated window surrounds and a hipped roof surmounted by a clock.

In the later C19 suburbs expanded; the Green and the area E of the town grew after the Pembroke & Tenby Railway was completed in 1863. The major new suburb to the S, ORANGE GARDENS (originally Orange Town), had streets laid out on a grid plan, to house dockyard workers. Most of the terraces are single-storey, some cottages only two bays wide. The C20 has seen little visual change, but the geography of the town has created an intractable through-traffic problem.

PEMBROKE CASTLE

22
p. 331

Pembroke Castle is sited on a high ridge between two tidal inlets, its curtain walls mostly intact. The great strength of the C13 stone buildings ensured that it stood firm against every attack by the Welsh. The castle today looks surprisingly complete, although this is due to an energetic restoration by its early C20 owners. It was founded by Roger de Montgomery, earl of Shrewsbury, following the death of the local prince Rhys ap Tewdwr in 1093, and granted to Shrewsbury's son Arnulf, also founder of the Benedictine priory at Monkton, across the water.

The initial defences were of timber. The rectangular Norman Hall has the earliest masonry, probably begun by Earl Richard 'Strongbow' de Clare in the late C12. But it was Earl William Marshal, at Pembroke from 1204, who was probably responsible for most of the early masonry now visible, including the massive circular keep, and the curtain walls of the inner ward.

Pembroke was granted to William de Valence, half-brother of Henry III, in 1247, and he too initiated an ambitious construction programme. The large outer ward was walled in stone, complete with cylindrical guard towers and Great Gatehouse. The C14 was, in contrast, a period of decline, with a series of absentee landlords, during which lead was stripped from the roofs. However, the castle was equipped for the French invasion scares of 1377 and 1405, and later in the C15 became the seat of Jasper Tudor, whose nephew, the future Henry VII, was reputedly born in the tower that now bears his name.

It was not until the Civil War that Pembroke saw its first

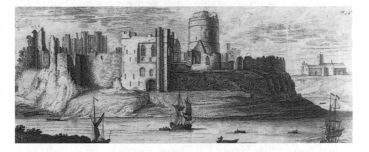

View of Pembroke Castle from the north-west.
Engraving by Samuel Buck, 1740

major siege, when, alone among Welsh towns, it declared for Parliament. At the close of the first Civil War, the garrison suddenly changed sides, and it was not until Cromwell arrived in person that Pembroke capitulated. Parts of the castle fabric date from this period, but the entire w front was eventually slighted, and the fronts of the towers and the barbican were blown up. The castle then became a convenient quarry, and the subject of landscape painters in search of the picturesque. The antiquarian J. R. Cobb purchased the castle in 1879, and spent four years on restoration and excavation works. In 1928 Major-General Sir Ivor Philipps of nearby Cosheston Hall bought the castle and, up until the Second World War, carried out a vast programme of restoration, reinstating the slighted towers on the w side, and restoring the gatehouse, so that all now looks convincingly complete, except for the slightly bogus round chimneys. Internally, the restoration work is much more obvious, due to the insertion of concrete floors in the outer ward towers and gatehouse, and the conjectural reinstatement of hooded fireplaces. Opinion is divided as to the merit of this approach, but one should at least applaud the endeavour. Today the castle remains in the hands of its rescuers' successors, and is open to the public.

The place to start a tour is at the GREAT GATEHOUSE on the s side, facing town, begun by William de Valence after 1247. It is fronted by the low walls of the D-shaped barbican. The gatehouse is an impressively broad three-storey block, flanked by round towers, the BYGATE TOWER abutting the entry, and the BARBICAN TOWER to the e, not forming part of the block itself, but covering the oblique entrance approach at this point. The gatehouse represents a step on the way towards the 'keep-gatehouses' of the late C13, although not defensible against the outer ward. The front of the Bygate Tower was reinstated in the 1930s. Small round-arched entry, with a pair of portcullis slots. The inner passage has entrances into the guardrooms each side, and beyond, entrances to the stairs leading to the upper floors; these stairs are carried up semicircular turrets flanking the rear side of the gate. Three large chambers in both upper storeys. The Barbican Tower has a domically vaulted roof. There is no constable's hall, perhaps because Willam de Valence himself was frequently present to occupy the chief apartments.

22 The OUTER WARD is vast, with four cylindrical guard towers, those to the se connected to the Great Gatehouse by vaulted mural passages in the curtain walls. The towers are all of three storeys, all but the WESTGATE TOWER much reconstructed before the Second World War. The HENRY VII TOWER is reputedly the birthplace of that monarch. The thickening of the wall-walk between this and the Westgate Tower took place during the Civil War, and a flight of steps was provided to the first floor of the Henry VII Tower, together with an odd little corbelled-out porch, giving access to latrines. The MONKTON TOWER, on the w side of the ward, is the most intact, with

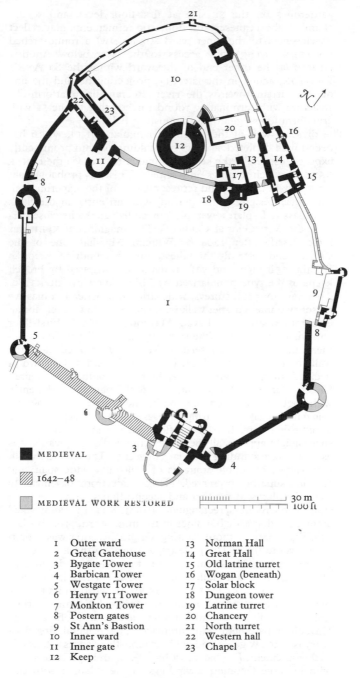

MEDIEVAL

1642–48

MEDIEVAL WORK RESTORED

|              |                  |
|--------------|------------------|
| 1 Outer ward | 13 Norman Hall |
| 2 Great Gatehouse | 14 Great Hall |
| 3 Bygate Tower | 15 Old latrine turret |
| 4 Barbican Tower | 16 Wogan (beneath) |
| 5 Westgate Tower | 17 Solar block |
| 6 Henry VII Tower | 18 Dungeon tower |
| 7 Monkton Tower | 19 Latrine turret |
| 8 Postern gates | 20 Chancery |
| 9 St Ann's Bastion | 21 North turret |
| 10 Inner ward | 22 Western hall |
| 11 Inner gate | 23 Chapel |
| 12 Keep | |

Pembroke Castle. Plan

garderobes on the SE side at first-floor level, and square chamber above; these extra domestic refinements may reflect its closeness to the inner ward. To its NW, a round-arched POSTERN GATE, giving access to the river below. Another postern at the other end of the ward within the ST ANN'S BASTION, added in the late C13, projecting beyond the line of the curtain towards the river. Rectangular platform-like structure with terminating round turrets, that to the SE with cruciform loops, guarding the postern below.

The dividing wall of the roughly triangular INNER WARD has been much depleted, leaving the buildings within prominently exposed, especially the keep. Original entry was via the INNER GATE, of which footings only remain. This was probably built very early in the C13, and represents one of the 'experimental' gatehouse designs of the period, with an entry in the flank of a massive D-plan tower. No portcullis (unlike its close parallel, the West Gate at Caldicot). The magnificent KEEP was built shortly after 1204 by William Marshal, one of the earliest, and certainly the tallest, among cylindrical keeps in Britain (75 ft high, and 50 ft in diameter), inspired by French keeps of the type popularized by Philip Augustus after 1180. There are four full storeys, with attic floor beneath a massive masonry dome. Parapet walk with sockets below, surely for an elaborate hoard, (cf. Laval, Mayenne, France). First-floor entry is on the N side (the steps are late medieval); the basement entry is a later insertion. Massively battered base, the walls here nearly 20 ft thick. Loop windows, but also two of decided domestic appearance high up, both large paired lancets of imported oolitic limestone, the pair above the entry with dogtooth ornament and mask. The other is less elaborate, also with a mask. Fine string courses divide the keep into three diminishing tiers. Inside, the floors are missing, so that the sheer height appears all the more acute; looking upwards, it is as if one were standing in a giant dovecote. The domical vault, constructed of rubble stone, is of amazingly wide span, and remains superbly preserved. Newel stair from basement to roof. Fireplaces to the first and second floors.

To the NE, the roofless, rectangular NORMAN HALL, sandwiched among the domestic buildings in the inner ward, probably late C12. Two storeys without vaulting. Originally, entry was at first-floor level to the S. The large triple lancet to the E is a crude C20 restoration. The latrine turret to the SE is an addition. Parallel to the Norman Hall, abutting the N curtain, is the taller and grander GREAT HALL of c. 1300. Attached to its E is the OLD LATRINE TURRET, part of the original Norman curtain wall. The hall is of two storeys, again, a roofless shell. Unvaulted basement with fireplace. The original first-floor entry is at the W gable-end, with ground-floor access alongside to the basement. The hall must have been an impressive space, with its large Geometric windows to the N, some with surviving bits of tracery (roundels over two lights), with ballflower decoration. Shafted inner frames, with a little surviving stiff-

leaf. The roof corbels remain intact. Battlemented parapets jettied out at two levels, on cut-stone corbel tables. At the E end a small chamber, with large E window, and large latrine off to the NE.

Access from basement, via a partly rock-cut newel stair, leads down to the WOGAN, an astonishingly big natural limestone cave below the inner ward, opening on to the river. The mouth of the cave was largely walled up early in the C13; the dating is suggested by a two-light E.E. window, which looks strangely at odds with the surrounding natural architecture. No doubt the space was used for storage, and probably also as a boathouse. Flint tools found here suggest that the Wogan was first occupied in the Mesolithic period.

Between the Norman Hall and keep lies a group of mixed dates. Against the S side of the Norman Hall, a small square SOLAR BLOCK; lateral chimney with circular shaft, and a gabled oriel window, both probably late C15 additions. S E of this, the three-storey circular DUNGEON TOWER, doubtless contemporary with the outer ward towers (i.e. after 1247), and similar in layout. First floor reached by a flight of steps, with dungeon at basement level. Attached to it to the N a later LATRINE TURRET: both were built along the line of the Norman curtain wall, dividing inner and outer wards. At a r. angle to the Norman Hall, on its W side, the rectangular CHANCERY, a single-storey rectangular shell, recorded in 1331.

Along the NW boundary of the inner ward, the Norman curtain wall is intact, running along the cliff edge. The square N TURRET is probably early C13. Tight against the SW corner of the ward is the WESTERN HALL, just inside the inner gate, a single-storey, narrow barrel-vaulted chamber, a C13 or C14 addition to the curtain wall (see the butt joint and the awk-wardly abutting vault). Garderobe and fireplace. Alongside, and of the same date, scant remains of a rectangular E–W building, possibly the CHAPEL; a blocked W door is visible. The internal dividing wall is later.

THE TOWN                                        p. 336

ST MARY, Main Street. But for the lofty battlemented tower, one could almost miss the church, although large, because the S side is concealed by houses on the street front. The broad tower N of the chancel appears C14. Its ground-floor chamber is elaborated by a groined vault with wide flat ribs. Nave, chancel, N aisle, small S transept, and elongated S porch, the latter running up to the street between houses. The N transept has long gone, and an odd half-vault belongs to another lost part. The nave and chancel seem to date from the early-mid C13, *see* the S doorway, round-arched, with continuous deep roll mouldings, (cf. Monkton Priory, p. 296). The older part of the porch (it was lengthened in 1937) may be of the same date; it has a barrel-vaulted roof. Round-headed windows were revealed in 1876 in the S wall of the nave, but covered up again.

The barrel-vaulted aisle is an addition of the late C14 or C15: arcade of four unadorned arches. The tower is later than the chancel, *see* the N wall thickened on a corbel table. Heavily restored 1876–9, by *J. L. Pearson*, to more modest plans than those proposed by the late *Buckeridge*. Pearson added Geometrical tracery, a new tall chancel arch and new roofs. All a little stark (fundraising had been a problem). W porch 1926, transept fitted up as a Lady Chapel in 1946. – FONT. Norman. Square scalloped bowl, circular pedestal with cable mouldings. – Large and good Bath stone REREDOS of 1893, by *Pearson*, carved by *N. Hitch*: Christ in Glory, symbols of the Evangelists, angels in flanking niches, whose tracery was copied from a piece of alabaster tomb-chest of *c.* 1500, discovered during the renovations. – PEWS and carved oak PULPIT by *Pearson*. – STALLS by *K. McAlpin*, stolidly Gothic, though as late as 1910. – STAINED GLASS. Much for *Kempe & Co*. enthusiasts. E window of 1907, the last work of Kempe before his death, representing the Crucifixion. – Two S chancel windows and others in the nave, of 1909–18, depict Welsh saints and historical figures. – Transept. Suffer the Little Childern, 1898. Unusually colourful. – Two W windows by *Clayton & Bell* of *c.* 1879 (Evangelists). Strongly coloured, in instructive contrast to the Kempe work. – MONUMENTS. Fragment of an alabaster chest *c.* 1500, of fine quality (cf. the White tombs in Tenby). Two bays of the chest front, with shield-bearing angels in very ornate niches. Much repaired figures above. Reused as an early C17 memorial. – John Merike †1606. Small tablet, flanking term figures with Ionic capitals. Big shield above. – Robert Seafort †1670. Tiny, curly gable. – Francis Parry, mayor of Pembroke, †1688. Fine brass with vivid account of his funeral, which coincided with a 'deluge of Neptune's flowing tide'. Stone frame with scrolled sides and a broken pediment with recumbent putti, prominent hourglass. – William Goodacre. C17, with cartouche above, and angular cherub heads. – Edward Byam †1768. Wreathed oval inscription. – Charlotte Adams †1814. Torches each side. By *Harris* of Dublin. – Samuel Ferrior †1815. Plain, by *Reeves*. – Alexander Adams †1814, signed by *Richard Westmacott, Jun*. Sword and unfurled flag above the inscription. – Sir Francis Meyrick †1932. Said to be designed by the Tenby artist, *Herbert Allen*. Shield with knightly attributes.

ST MICHAEL, St Michael's Square. Fenton saw a Norman cruciform church, with a stunted crossing tower, the whole having 'no tendency to ornament of any kind'. Little save a small N chapel survives of this, apart from the scar of the S transept barrel vault against the tower wall. Drastic remodelling in 1831, by *Thomas Rowlands* who created a wide nave, demolished the transepts and chancel, relocating the latter N of the tower, and built a S porch. During this orgy of destruction much of the tower collapsed. Rowlands' drawings show quite a handsome Regency church. The cheerfully confident tower has polygonal shafts, battlements and big Perp belfry windows. But

much of the rest was swept away in 1887 by *E. H. Lingen Barker*, who tried in vain to bring Victorian propriety to the interior, dividing the nave with a four-bay arcade, and lengthening the chancel westward. The arcade has round piers with moulded caps. Neither architect touched the little medieval N chapel (vestry), which has a pointed barrel vault. – FONT. 1887 copy of the Norman one at Lamphey, i.e. the square scalloped type. – REREDOS of 1932, by *Ellery Anderson*, with painted wooden figures. – Wrought-iron SCREEN, by *Lingen Barker*, as are the FITTINGS and the semicircular Bath stone PULPIT on squat black marble pillars. – STAINED GLASS. E window of 1887, by *Cox & Co.*, oddly salmon-tinted Last Supper. – Plenty by *Kempe & Co.*, including the aisle W, a war memorial, unusually highly coloured; aisle centre, 1922, and a set of three in the nave, *c.* 1920. – MONUMENTS. The best are in the former N chapel. Dr John Powell †1734. Large and well detailed, with fluted Corinthian pilasters of veined marble, segmental pediment with cartouche and scrolls. Gadrooning below, the tablet supported on a cheerful cherub's head. – David Mackenzie †1781. Coloured marbles, urn. – Dudley Ackland †1795. Draped urn on heraldic pedestal. – Charles and Letitia Philipps. By *J. King* of Bath, 1864. Tablet with drooping palm-frond.

WESTGATE CALVINISTIC METHODIST CHAPEL, Westgate Hill. 1866, by *K. W. Ladd*. Simple Venetian Gothic style in grey native limestone with sandstone and red brick dressings. The façade has a polygonal stair-turret: a clever solution to a steeply sloping site. Triplet over the entrance. Interior with rear gallery, the dramatic pulpit end with the former organ recess behind four bays of giant Corinthian pilasters supporting a full entablature, now obscured by the pipe organ set in front.

MOUNT PLEASANT BAPTIST CHAPEL, East Back. Enlargement of 1877 by *Rev. Thomas Thomas* of Swansea. Gothic buttressed façade of limestone with Bath stone dressings, very broad and rather lifeless. Large traceried windows to both storeys. The odd proportions may have been dictated by the previous chapel, built in 1860 by *John Cooper*. Inside, the gallery of 1877 runs around the three walls, with attractive panels of pierced ironwork. Large plaster surround behind the pulpit with ogee head. Good railings in front (signed by *Coalbrookdale*). Polygonal limestone piers.

TABERNACLE UNITED REFORMED CHAPEL, Main Street. 1867, also by *Thomas*; here he had a free hand and a deeper purse. Wildly undisciplined Gothic front with buttressed turret to one side, capped by a slender spire, and a gabled stair-turret on the other side: everything that makes chapel architecture so fascinating to enthusiasts and so confounding to purists. Large traceried window above twin doors. After this, the interior is conventional with three-sided gallery and coved ceiling.

Gabled MANSE to the l., with segmental bow window: also by *Thomas*.

114 WESLEYAN CHAPEL (former), St Michael's Square. Strikingly set on its island site. 1872, by *K. W. Ladd*, his only known venture into the classical style, actually a bastard Italianate, but characteristically unconventional with most of the detail Gothic. Stuccoed and pedimented façade with giant arch, rusticated corner piers and three-quarter Corinthian columns of sandstone. Large traceried window over the entry, plate-traceried windows in the outer bays. The interior has been gutted.

TOWN HALL, Main Street. Plain. Begun in 1819, five unequal bays long, two storeys high. The ground floor is of well-tooled limestone ashlar with blind round arches, which until 1909 led into the open market. Rendered upper storey with tall sashes and the town arms. The date 1887 refers to large rear extensions, now demolished. Modernized inside. The first floor housed the council chamber, originally reached from an exter-

1  Castle
2  St Mary
3  St Michael
4  Westgate Calvinistic Methodist Chapel
5  Mount Pleasant Baptist Chapel
6  Tabernacle United Reformed Chapel
7  Former Wesleyan Chapel
8  Town Hall
9  Barnard's Tower

0.5 mile
1 kilometre

Pembroke

nal stair. New large meeting room to the rear by *Clare Julien*, 1993.

## PERAMBULATIONS

### 1. The Town Walls

Although much depleted and rebuilt, enough survives to define clearly the medieval town boundary, as shown by Speed. There were three gates and six towers set at intervals. Very little of the gates remain, but four of the towers survive in varying states of repair. No documentary evidence survives, but it is likely that the defences are the work of William Marshal, in the first years of the C13. A brief tour may begin at the bottom of DARK LANE, where the old North Gate stood until 1820. A watercolour by J. C. Buckler shows a twin-towered gate with single archway. Moving E, along MILLPOND WALK, much of the wall is later and stands downslope of the original. A square projection to the E is also post-medieval and of uncertain function. Further on, a good stretch of wall with loops and the remains of a semicircular tower with a battered base. From here, visible across the mill pond is the former WORKHOUSE of 1838; the triplet of gables in the centre is a hallmark of *George Wilkinson* of Oxford (additions of 1902 by *Lingen Barker* included an infirmary). A short distance E, BARNARD'S TOWER, an impressive three-storey circular tower linked to the wall by a short spur. Entry at first-floor level, defended by a bridge pit, gate and portcullis, its slots clearly visible. The upper vaulted room is heated, and well lit by a pair of lancets to the N. With its latrine, this was a self-contained unit, defending the weaker end of town, and also guarding an important well. The wall (inaccessible) now continues s. Following BLACK HORSE WALK, Main Street is reached. E of the filling station stood the East Gate, demolished before 1780, when the Rev. J. Pridden noted that the mayor had used the stone to enclose his potato field. This was the most impressive gate, located at the weakest approach to town. Leland observed that it had before it 'a compasid tour not rofid in the entering whereof is a portcolys ex solido ferro'. This brings to mind the early C14 barbican gate in Tenby. The southern stretch of wall is reached at GOOSES LANE. First the footing of a rectangular tower, then the base of a circular tower, topped by a two-storey octagonal GAZEBO of the late C18 (originally of brick, now unfortunately pebble-dashed). Beyond, a C19 LIMEKILN, and westwards, the base of another circular tower. Following the PARADE, only fragments of the wall survive. Of the medieval West Gate, the springing of an arch is visible, abutting the charming medieval houses. Speed indicates a gate with two arches. To the W, beyond the castle, a short length of wall, long gone, linked the Northgate Tower to the North Gate.

## 2. The Town

A tour begins at WESTGATE HILL. Nos. 8–11, immediately oppo-
site the castle, is the best surviving group of medieval town
houses in West Wales. No. 11 is largely a C19 rebuild, little more
than a simple cottage, as is its neighbour, with its picturesque
outshut. No. 9 sits astride a barrel-vaulted undercroft, and is
probably C15. The little cross-wing is later, probably C16,
its upper floor jettied out on corbels. The blocked lower door,
with elliptical head, once led to the undercroft. To the rear, a
broad lateral chimney, the shaft of D-section. Above towers the
altered No. 8, which retains a short length of a corbel table and
a chamfered pointed door. To one side, a high blocked cam-
bered archway is left marooned, due to extensive lowering of
the road. These stone buildings are a misleading start, for the
rest of the town is late C18/C19 in appearance, and stuccoed.
No. 6 (formerly the vicarage to St Mary's) has a late C18 façade
of three storeys and bays, with later bay windows. Some fielded
panelling inside, accompanying a fine late C18 staircase with
broad turned balusters. The tall No. 3 has a good, simple early
C19 timber doorcase with bracketed cornice. The rear wing
(now flats) is medieval, the ground storey with long pointed
barrel vault. Opposite, the very plain DRILL HALL, 1913, by
H.J.P. Thomas. Simple entrance buildings of limestone with
central arched entry. The tall CASTLEGATE HOTEL, along
with its neighbour (originally one house), dates from c. 1800.
The main front room is treated in an Adam manner, the plaster
cornice with anthemion and swag detail. Good timber
chimneypiece with Ionic pilasters. The cellars, however, belong
to a late medieval or C16 house. The long cellar to the rear has
barrel vaults at two levels. Four-centred door to the w wall with
corbels from a former chimney visible in the long axial passage
alongside. The front cellar has a C16 window opening off
the passage, the timber mullions set diagonally. Further E, the
three-storey LION HOTEL was rebuilt or remodelled in 1856.
Central porch with bay window above, crowned by a splendid
recumbent lion.
The short DARK LANE leads N to the MILL POND, where the
site of the mill is now a paved area. A tidal mill and dam were
almost certainly begun here in 1326. The big four-storey mill,
designed c. 1820 by George Brown of Amroth, burnt down in
1956. The ROYAL GEORGE HOTEL dates from c. 1780, three
plain storeys and bays. Inside, a staircase of Chinese Chip-
pendale type.
Returning s to MAIN STREET, backing on to St Mary's church
is BRICK HOUSE, a good, early C18 three-storey brick façade,
the tall first-floor sashes with cambered heads and keystones,
but colourwashed, with lamentably brutal shopfront. Next, the
stuccoed CLOCK HOUSE. The square portion, with quoins
and small arched windows, mildly Italianate, is of c. 1845.
Lower flanking wings of 1899, when the tower was given a
drum and clock stage, crowned by a cast-iron coronet. The C18

lead cherubs came from Orielton (*see* p. 231). Opposite, the
C18 KINGS ARMS HOTEL, its plain four-bay front much
rewindowed. Inside, a good, late C18 Chinese Chippendale
staircase, rising to the full height around a well, with great
effect. The ghastly supermarket building opposite is a terrible
imposition of the 1960s, its bland white front too long at eight
bays, with suspended bay windows on the upper floor. Much
of Main Street consists of early C19 stuccoed tall façades, some
with a little late C19 detail, many with altered shopfronts. Nos.
57–59 are a group of altered C18 cottages. In No. 59, yet
another Chinese Chippendale staircase, awkwardly inserted.
The former TSB BANK of *c.* 1880 is solidly Gothic, built of
native limestone ashlar, unmistakably by *K. W. Ladd.* At this
point, the shops cease and the street becomes largely domes-
tic. On the N side, ORIELTON TERRACE, attractively sited on
CHAIN BACK, a raised bank. The first three houses are of two
storeys, with parapets and ground-floor canted bay windows.
The oddly shouldered window openings, recalling some of the
hotels along Tenby's Esplanade, might be the work of *F.
Wehnert*, active in Pembroke in 1867. Then a taller group, Nos.
72 and 74, mid-C19, with original glazing, each different.
On the S side, behind the YORK TAVERN, and visible from
NEW WAY, a steep path leading downhill, the so-called
OLD CHAPEL. Small rectangular building of two storeys, the
lower with stone barrel vault and fireplace, the upper mostly a
C19 rebuild. Four-centred doorway. Possibly a C16 house in
origin. Wesley preached here in the 1760s. The former
NATIONAL SCHOOLROOM is dated 1861, still Tudor, with
labelled windows and a top-heavy bellcote on the gabled street
front.

Main Street near this point becomes briefly split by HAMILTON
 TERRACE (Speed shows an island of houses in 1610). The
 W end is neatly terminated by a stuccoed two-storey pair
 of *c.* 1810, MELBOURNE HOUSE and HAMILTON HOUSE,
 sharing a wide pedimental gable. Tall sash windows. Five bays
 long, the centre with a niche. Melbourne House has a N
 entrance with fanlight. Opposite, Nos. 86 and 88 are early C19,
 a three-storey pair, with Doric porches. The E end is more strik-
 ingly finished with the former WESLEYAN CHAPEL (*see*
 above). The crowning glory of Pembroke's domestic architec- 81
 ture is No. 111, Main Street, a big-windowed refronting of
 *c.* 1840 of an early C18 house, three storeys and bays. Later
 portico, with thin Tuscan-style columns. Probably built for
 Dr John Powell, whose monument is across the road in St
 Michael's church. The interior is an unexpectedly fine survival
 of the early C18. The VESTIBULE has panelling, a simple chim-
 neypiece and a heavily moulded plaster cornice. Behind, a
 very broad dog-leg staircase, with a triplet of twisted balusters to
 each tread. Coved ceiling above, but with early C19 elabora-
 tion. The DRAWING ROOM (ground floor r.) has raised and
 fielded panelling, the chimney wall with tall fluted pilasters

flanking a panel painted as an overmantel, depicting a seascape with classical ruins. Similar details in the room above. Opposite, across the street, in a gable wall facing the car park in front of St Michael's church, a pair of arches, which seem to have been associated with a former vault of a medieval building runing back from the street front.

BUSH HOUSE, ½ m. N. Dated 1903, replacing an C18 house, burnt down in 1866. Built for Sir Thomas Meyrick by *George Morgan & Son* of Carmarthen, the plans signed by *J. Howard Morgan*. Now a nursing home. As the Meyrick family figured prominently in local affairs from the early C18, the choice of a local firm of architects associated with chapel-building may have been a political gesture – but it was an unfortunate choice. The style chosen was a mercantile mix of Tudor and Baroque, exactly as in the firm's contemporary Barclay's Bank, Carmarthen. The gaunt proportions of the house and its disparate parts indicate indecision, *see* the angle between the garden and entrance fronts, poorly defined by a tall corner chimney and a bisected crowstepped gable. Lifeless entrance front of four bays, all gabled except the r., which contains a rectangular bay window; wide round-arched entry to the l. Oddly disparate garden front. Large entrance hall with complex stair and galleries, the timberwork heavily detailed. Large window with heraldic glass by *T. Camm* of Smethwick. Partly octagonal drawing room in the angle between the two main façades, with typically heavy detail. The service wing of the old house, of nine bays, with a central Gibbs surround door, survives as a façade to the l. of the new house.

HOLYLAND HOUSE, ¾ m. NE. Stuccoed and hipped two-storey house, largely of *c.* 1800, with a broad bow to the l. end of the garden front, oddly asymmetrical. Seat of the Adams family from the C16. A small barrel-vaulted chamber survives to the rear of the older house. References in 1829 to a new drawing room, dining room and library seem to refer to refurbishment, as a map of 1814 shows the present shape of the house. Plain staircase. Heavy chimneypiece on the first floor, carved *c.* 1910 by a family member, *Hermione Barclay*. It depicts a hunting scene. *James Wilson* of Bath produced plans in 1844 for a Tudor remodelling, skilfully making sense of the ungainly shape of the house, but nothing was executed.

Stable block to the N, seven bays long, the central three pedimented. Dated 1824, with the initials of George Alexander Adams.

UNDERDOWN, ½ m. SE. Small symmetrical house of *c.* 1800, stuccoed; pilaster strips with incised Greek key decoration. Remodelled and extended *c.* 1880, and now a hotel.

# PEMBROKE DOCK/DOC PENFRO

Pembroke Dock was a new foundation, created out of the twin decisions in 1809–10 to establish a royal dockyard on Milford

Haven, and not to purchase the existing dockyard at Milford, where ships were already being built for the Admiralty. The choice of an empty site – then called Pater – may have been due to more than the quarrel over price with R.F. Greville (*see* Milford). The site at Pater was unencumbered, already partly owned by the Board of Ordnance (which had begun a fort there in 1758), and had ample room for expansion. *John Rennie* advised on the first plan in 1812, and by late in 1814 the dockyard wall was begun, the first two ships were building, and the first four houses in Front Street were up. Smaller than the other royal dockyards, Pembroke Dock was always something of an anomaly. Run largely by civilians, it was primarily a constructing site, with no facilities for fitting out before the 1870s and none for repairs, victualling or armament. Hence it had a larger number of building slips – thirteen finally – than other yards, but smaller store-houses and less dockyard accommodation. The yard employed some 2,000 men in 1890, small as compared with the 5,500 employed at Chatham and at Devonport, but the largest single workforce in Wales.

The town began haphazardly, the Admiralty reserving land s of the dockyard for streets that were never fully developed, while house building began to the E, behind Front Street. A formal grid pattern was established relatively early, apparently by the landowners, the Meyrick family, and possibly by their surveyor *George Gwyther*. The grid of regular two-storey houses covered the lower slope from the dockyard to the station by the 1880s. On the upper slope to the s, from High Street to Pennar, development spread ribbon-fashion from the 1830s, with single-storey houses. These, more formal than the rural Welsh *croglofft* cottage, and akin to the urban cottages of NE England, are a distinctive feature of Pembroke Dock, and of this part of south Pembrokeshire. The defence of the dockyard meant that the town always had more resident military than naval personnel, housed in the defensible barracks and the hut encampment on Llanion Hill, replaced by permanent barracks 1899–1906. The dockyard, for all its unpropitious siting, weathered technical and political change from 1814 to 1926, and was improved with some of the earliest wide-span iron shipbuilding sheds from 1845. It adapted timber shipbuilding technology to building iron-clads in the 1860s, and so narrowly escaped the axe that fell on Deptford and Woolwich in 1864. Early photographs show an array of whale-back roofs of the ship-sheds lined along the N shore, the yard behind stacked with timber, with larger buildings for the smithy, foundry, saw mill and storehouses. The yard declined in the early C20, as it was not capable of building the very large battleships of the *Dreadnought* era; the last warship was launched in 1917, and the dockyard closed in 1926. The clearance of the great ship-sheds happened early, the major workshops following after 1930, when the R.A.F. established a seaplane base on the site. The period since 1980 has been particularly unhappy for the last dockyard buildings, lying derelict, while most of the building slips have been filled in for new port facilities. Since the late 1990s,

however, a change of heart towards conservation has begun a
limited restoration programme, coupled with a recognition
of both the architectural and technological interest of the
buildings.

The town itself, with its grid of two-storey houses on broad
streets, survived remarkably unchanged until the 1960s, but the
later C20 saw drastic alterations. Where unity depended on a few
features (windows, door and exterior cladding), their replace-
ment in alien materials devastates, and in Pembroke Dock,
original examples are now exceptional. It is a pity, as for all
the modesty of its domestic architecture, the town has a spa-
ciousness quite outside the normal. The situation is changing for
the better since 2001 with the injection of money for restoration
through a well-funded Townscape Heritage Initiative.

## CHURCHES AND CHAPELS

ST JOHN, Bush Street. The first new church in SW Wales built to
Ecclesiological principles, 1845–8 by *J. P. Harrison*, and inter-
esting, too, in looking to local sources: typical south Pem-
brokeshire unbuttressed tower in a transeptal position, triple
gables from Tenby, details from Castlemartin, all in grey Pem-
brokeshire limestone, lancet style. The tower was reputedly not
completed as intended, building work not being supervised by
Harrison. Dark but dignified interior with open timber roofs
and plain chamfered arcades. – Rich FITTINGS of 1879 by
*Wilson, Willcox & Wilson* of Bath. PULPIT on squat marble
shafts; open iron SCREEN on a low stone wall, carved STALLS
and encaustic TILES on the E wall. – Plain massive FONT. –
Lady Chapel fittings of 1919–20 by *J. Coates Carter*. Two Perp-
style SCREENS, and oak triptych REREDOS. – STAINED GLASS.
E window by *Herbert Davis*, 1898, richly coloured. – An exten-
sive series by *Kempe & Co.*, mostly of 1910–20: in Lady Chapel,
and S and N aisles (one in the S aisle pre-1907). The WAR
MEMORIAL outside, 1921, probably by *J. Coates Carter*, was
vandalized in the 1990s, and has lost its red sandstone Calvary.
SUNDAY SCHOOL, 1883 by *K. McAlpin*, lancet style to match
the church.
ST PATRICK, Treowen Hill, Pennar. 1893–5 by *Nicholson & Son*
of Hereford. Simple Dec style with bellcote, ogee tracery, nave,
aisles and chancel under a single roof, but the E end raised
impressively. Organ of *c.* 1846 from St John's Church.
ST TEILO, London Road, Llanion. 1903, improbably by *J.
Coates Carter*. A small, utilitarian stone building with red brick
lancets.
SS MARY AND PATRICK (R.C.), Meyrick Street. The first C19
R.C. church in SW Wales, 1847, probably by *Joseph Jenkins*,
altered 1862 by *John Cooper*. Grey rubble-stone gable front
with rough octagonal corner piers – probably originally ren-
dered. Two blocked lancets suggest that the present windows
date from 1862. Thin open timber roof, W gallery. – STAINED
GLASS. E window, 1929 by *Paul Woodroffe*. Attractive conven-

tional glass, St David and a child, whose nakedness a later hand has tried to clothe. – One s window, *c.* 1980.

BETHANY BAPTIST CHAPEL, High Street. 1877 by *George Morgan.* An economical version of his standard Romanesque: cement render and Bath stone details. Extended 1904–6 by *Morgan & Son,* new galleries all around with curvaceous, pierced cast-iron front. Well-preserved rear schoolrooms with glazed partitions.

BETHEL BAPTIST CHAPEL, Meyrick Street. 1873–5 by *Hans Price* of Weston-super-Mare. A formidably mixed design, the pedimental centrepiece with Neo-Grecian ornament, broken by two long arched windows over a deep, Romanesque arched doorway, and clasped by single-storey lobbies, also more Romanesque than classical. Interior of unaltered High Victorian character, aisled in effect by carrying an angular wood arcade on the upper of two orders of thin iron columns, the lower carrying the galleries, with attractively stencilled panels.

ST ANDREW'S PRESBYTERIAN CHAPEL, Bush Street. 1865–6 by *K. W. Ladd.* A strong design, twin pyramid-roofed towers framing a gable, grey limestone banded in brick. The round-arched paired doors and stepped triplet above are nicely picked out with bi-colour heads and pointed hoods, in a North Italian Gothic manner. Interior with deep arch-braces to the roof (which subsided and was rescued *c.* 1880 by *K. McAlpin*) and three-sided gallery with inset trefoil-patterned panels of cast iron. – STAINED GLASS. Big three-light end window of 1882, the Prodigal Son, made by a London firm. Unexpected in a Nonconformist setting.

TRINITY UNITED REFORMED CHAPEL, Meyrick Street. 1851–? by *John Road.* A dull rendered exterior, pedimental gable, the windows once as on Zion (*see* below), but only the heads unaltered, 1889 porch. Characterful interior, with plaster ceiling roses, Gothic panels to gallery fronts on painted timber columns, and an elliptical-arched recess behind the pulpit.

ZION FREE CHURCH, Meyrick Street. Built as the Tabernacle Wesleyan Chapel, 1846–8, probably by *John Road.* Still the largest chapel w of Swansea. A high and broad classical front, painted stucco, of five bays, the centre three with raised pediment (apparently an alteration of 1857). Arched small-paned windows and three arched doors. The scale still impresses despite some loss of detail (to be restored in 2004: the ground floor was rusticated, first-floor pilasters were Ionic, the main three windows had architraves). Inside, plaster ceiling with two large roses and many smaller ones. GALLERIES all around with long horizontal panels, on painted timber columns. The focal PULPIT stands high on painted columns with curving timber stairs each side, and veneered front panels. Restoration 1986–90 has enhanced the interior, which, despite the apparent unity, was extended back with organ gallery 1865–7, by *K. W. Ladd,* altered in 1882, with new pews and entrance lobby, and again in 1911.

PUBLIC BUILDINGS

COUNCIL OFFICES, Llanion. *See* under Dockyard and Military Buildings, below.

PATER HALL, Dimond Street. 1957, in yellow brick and cast stone, Neo-Georgian. On the site of the 1844 Temperance Hall.

RAILWAY STATION, Apsley Terrace. 1870–1, by *Szlumper & Aldwinckle*, for the Pembroke to Tenby line, similar to the station at Tenby. Picturesque Gothic with half-hipped gables and a big half-hipped porch off-centre between. Platform canopies added 1902.

ALBION SQUARE C.P. SCHOOL, Albion Square. 1877, by *K. W. Ladd*. Quite large, grey limestone, single-storey, Gothic with bargeboards. Extended in matching style in 1896.

CORONATION SCHOOL, Meyrick Street. 1901–4 by *Morgan & Son* of Carmarthen. Tightly composed urban Board School for 900 pupils, a type unusual in the region. Tall, two-storey, in grey rock-faced stone with Bath stone dressings. Freely detailed with recessed centre and gabled wings, the inner angles with quasi stair-turrets, though the stairs are elsewhere, and the big upper windows under gables.

PENNAR PRIMARY SCHOOL, Owen Street. 1956, by *Lt.-Col. W. Barrett*. Red brick, single storey, with hall at r. angles. The predecessor Board School survives nearby on Treowen Hill, 1873, extended in 1901 by *G. Morgan*.

MARKET, Melville Street. Built by the Admiralty in 1826, a square surrounded by rubble-stone outside walls, with ashlar central gateways and blank lunettes. The sloping site produces odd effects: the gateways are square, whereas the string courses each side run with the slope. The façade of Tenby Market (1829) is very similar. Originally open, with lean-to stalls and a central two-storey corn market, poorly treated since passing into local authority hands in 1880. Five large iron roofs of 1884 (by *K. W. Ladd*) loom over the s front, three altered after bomb damage, and the market hall they cover is bleak. To be restored 2003 by *Acanthus Holden Architects*.

CEMETERY, London Road. 1869 by *K. W. Ladd*. Stone lodge and two small chapels.

CLEDDAU BRIDGE, Pembroke Ferry. 1965–75. A fatal collapse in 1970 accounts for the long building period. Slim and high above the water, six concrete piers carrying an elegantly profiled box-section bridge, an enhancement to the waterway.

DOCKYARD AND MILITARY BUILDINGS

The dockyard is a walled enclosure of some 80 acres, broadly laid out according to plans of 1815, presumably based on *John Rennie*'s report, but drawn up by *Edward Holl*, architect to the Navy Board. The early plan was for a row of shipbuilding slips and a dry dock along the shore, backed by a single line of buildings (storehouses, offices, kilns, mould-loft and pitch house)

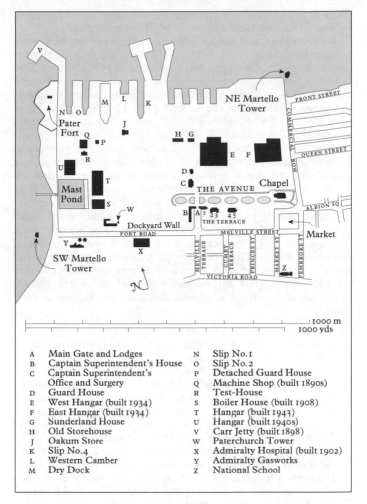

Pembroke Dockyard. Plan showing the original functions of the
surviving nineteenth-century buildings

| A | Main Gate and Lodges | N | Slip No.1 |
| B | Captain Superintendent's House | O | Slip No.2 |
| C | Captain Superintendent's | P | Detached Guard House |
| | Office and Surgery | Q | Machine Shop (built 1890s) |
| D | Guard House | R | Test-House |
| E | West Hangar (built 1934) | S | Boiler House (built 1908) |
| F | East Hangar (built 1934) | T | Hangar (built 1943) |
| G | Sunderland House | U | Hangar (built 1940s) |
| H | Old Storehouse | V | Carr Jetty (built 1898) |
| J | Oakum Store | W | Paterchurch Tower |
| K | Slip No.4 | X | Admiralty Hospital (built 1902) |
| L | Western Camber | Y | Admiralty Gasworks |
| M | Dry Dock | Z | National School |

then, behind, a very large area for timber storage (some 2,500
trees were needed for a ship the size of H.M.S. *Victory*), and
finally, just within the dockyard gates, the houses for the com-
missioner and principal officers. These were largely built by 1825,
to Holl's designs. A regular grid of seven streets was planned
outside the gates, with market at the w and chapel at the e. In
the event, the chapel was built within the walls, and the seven
streets were never completed, but the broad outlines were fol-
lowed. Buildings were added along the formal avenue from the
dockyard gates in the 1840s. The dockyard area was extended in

1844 at the sw and w to include the old tower of Paterchurch, two new building slips and the newly built mast pond.

Between 1845 and 1860 the major elements of the yard were modernized, built or remodelled. The roofing over of slips in timber began in the 1830s, but it was the 1845 roofs, over Nos. 8 and 9 slips, that broke new ground: the first long-span iron roofs in a British dockyard, spanning 80 ft, designed by *Fox, Henderson & Co.*, later engineers for the Crystal Palace. Three iron roofs by *Fox, Henderson & Co.*, and two by the other main contractor, *George Baker & Son*, have been identified among the thirteen roofs at Pembroke Dock, all now gone. Architecturally, little of significance was built after 1860, the deep-water jetty of 1898 being the major new work, most of the other work comprising additions to existing workshops.

After 1926 the ship-sheds went, and much was modified for the RAF after 1930. The foundry, smithy, saw mill and mould-loft were cleared by 1942, the fire-engine house shortly after. Decline after 1957, accelerated after 1980; the new storehouse, loan-tool store, RAF officers' mess, airmen's quarters, and most of the building slips went. The restoration plan drawn up in 2000 has at last turned the tide, and the works already achieved, all by *Acanthus Holden Architects*, are models of their kind.*

A 12-ft WALL surrounds the site, of 1832 and 1844, breached on the E for the railway in 1864, and regrettably breached again at the SE corner for an access road. The main entrance GATES and LODGES, 1817 by *E. Holl*, are on the long s side, the piers broken in 1993 and badly rebuilt. Originally, they carried anchors and a chain with lamp slung between. The lodges, or guard houses, lie within, colonnaded in grey limestone, attached to the houses to E and w. These are No. 1 THE TERRACE, 1817–18 by *E. Holl*, the main part the house of the Fleet Surgeon, the end bay the Police Station, and, to the w, the former CAPTAIN SUPERINTENDENT's HOUSE, of 1832–4, latterly a hotel. Each is a four-bay, three-storey, grey limestone house with arcaded ground floor, cornices and parapets. The hotel has a long rear wing of stables and coach house.

103   Beyond No. 1, Nos. 2–3 The Terrace, 1817–18 by *Holl*, houses for the Master Shipwright and the Clerk of the Cheque, 1 + 4 + 1 bays, similar, but with big arched doorways in the end bays. The outstanding interest of Nos. 1–3 is Holl's use of structural cast iron. Nos. 2–3 have iron floor beams and trimmers, with sand infill, and four small hipped roofs. These have cast-iron tie-beam trusses, with raking struts and a wrought-iron centre bolted rod. The complexity of jointing at the roof hips and small scale of the roofs suggest something experimental. No. 1, restored 2001, with composite trusses of cast iron and timber, the timber ties in compression. It also has iron floors and a single-hipped roof. Otherwise, the interior detail is simple,

* Information on the restorations and recent discoveries given by *Peter Holden* of *Acanthus Holden Architects*.

cornice mouldings based on the Greek mutule, panelled doors
and shutters. No. 2 has handsome serpentine cast-iron balus-
ters to the garden steps. Behind are COACH HOUSES, with their
own access lane inside the dockyard wall. The HOTEL, for all
that it copies No. 1, appears to have no structural ironwork.
The interior is altered. Nos. 4–5 The Terrace, 1877, were added
for the Constructor and Chief Engineer, in a heavy Victorian
version of the Holl original, tooled stone, the upper floor taller
and with cambered-headed windows.

The AVENUE was laid out with oval beds, 1844 by *William Edye*,
Master Shipwright, but is overgrown and rubble-strewn, over-
looked by the wreck of the CHAPEL, of 1830–1 by *G. L. Taylor*,
Holl's successor. This is a spartan classical design, related to
the more economical designs for the Church Commissioners,
with emblematic portico under a square tower with dome,
the mouldings severe and Greek. Pilasters, three stepped
doors and three blank panels to the portico. Five arched side
windows with iron glazing bars. The use of stone for a very
few mouldings and courses is carefully considered. The
interior was galleried at the W, with coffered plaster ceiling,
but was gutted for a motor museum. Restoration began in
2002, and it is hoped to save some of the massive timber trusses
of 50 ft span, the tie-beams of scarfed sections reinforced with
iron straps.

Flanking the avenue, running in from the entrance gates, on
the l. CAPTAIN-SUPERINTENDENT'S OFFICE AND SURGERY,
1847 by *Fox, Henderson & Co.*, engineers, but architecturally
capable as well. Severe grey stone front of 1+4+1 bays with
cornice and parapet. Military-looking iron railings guard the
basement areas. Stone staircase within. Restoration in 2000
revealed a very fine iron roof, a composite of wrought and cast
iron, the compression struts in shape of a tree. Also found were
very extensive cellars. Next door is an earlier office building,
of *c.* 1840, known as the GUARD HOUSE, with hipped roof,
1+3+1 bays; the rock-faced stonework already looks Victorian,
but the columns of the deep veranda echo the 1817 entrance
lodges, the depth a tribute to concealed ironwork. Restored
2002, the roof here was plain timber. Opposite, to the E, two
massive HANGARS, 1934, built for Sunderland flying boats.
Reinforced-concrete piers, ridge-and-furrow roofs and full-
height sliding doors.

SUNDERLAND HOUSE, further on, on the W side, was the
first office building, of 1822 by *Edward Holl*. Originally four
bays, the W three added in the 1880s to match, a rhythm
of 1 + 2 + 1 + 2 + 1 bays with arcaded ground floor, lime-
stone and granite dressings, plain cornice and parapet. This
also has an iron roof structure, to be restored in 2003. The
detail is matched by the OLD STOREHOUSE, also of 1822 by
*Holl*. Low nine-window front, 3 + 3 + 3 bays with centre
pediment, architecturally staid (though formerly enlivened by
a tall domed clock tower), and small compared with Holl's

great quadrangle at Sheerness, or storehouses at Chatham, Portsmouth or Plymouth. The exterior of rubble with granite dressings suggests that the building was stuccoed. The interest is the fireproof interior: iron columns carrying stone-flagged floors on fish-bellied iron beams and joists, stone stairs, iron doors and windows, and iron roof trusses. The technology was well tried by the 1820s, but this is the outstanding example in Wales.

The matching new storehouse of 1857 behind, and hip-roofed loan-tool store of *c.* 1840 to the NW, have gone in recent years, followed by the C20 RAF buildings, the red brick former NAAFI building of 1935 to the SW, and the eight blocks of Neo-Georgian AIRMEN'S QUARTERS, 1933–5.

The present division of the dockyard fences off the W end as the Royal Naval area, reached from the naval entrance at the SW corner of the dockyard. Within the naval area, former OAKUM STORE, 1856, grey stone, two-storey and T-plan on the upper floor, the ground floor rectangular with lean-to wings. N of this are the last remaining building slips, limestone ashlar with granite copings and stepped sides. SLIP No. 4 was built in the 1820s, lengthened seawards before 1858 and landwards before 1891. The WESTERN CAMBER, to the W, built by 1832, is a square tidal basin, formerly with slip No. 3 running off to the S, but infilled by 1891. Next, the DRY DOCK, magnificently constructed with high steps, or 'altars', alternating chutes and flights of steps down, and a floating caisson for the gate, all part of a remodelling of 1857–61. To the E, within the naval area, SLIPS Nos. 1 and 2, of *c.* 1845, i.e. additions after the first phase. Slip No. 2 had until 1993 a remaining aisle of the iron SHIPBUILDING SHED of 1847, by *George Baker & Son* of Lambeth, cast-iron piers and arched trusses.

Behind the DRY DOCK, the site of the pitch house, demolished 1977, and some smaller buildings. Behind is the former DETACHED GUARD HOUSE of *c.* 1850, with a cast-iron veranda (derelict), a MACHINE SHOP of the 1890s, with red brick dressings, and a small stone TEST-HOUSE of the 1880s. Further back, the twin-gabled BOILER HOUSE, dated 1908, and the MAST POND, a big square tidal pool, for soaking elm for masts, 1843–4, by *Capt. T. R. Mould.* NE of the pond, a reclad HANGAR of 1943, smaller than the 1934 hangars, and a still later HANGAR N of the pond with sawtooth roof. At the NW angle of the dockyard, CARR JETTY of 1898, the deep-water mooring that replaced Hobbs Point for finishing warships.

PATER FORT. Just W of the dockyard, one stone-faced SW embankment and one section of W wall remain from a fort, begun in 1758–9 but never completed. Gradually encroached by the dockyard, only a small gun platform was left by the mid-C19. Dismantled in 1903.

PATERCHURCH TOWER, just within the N wall of the dockyard, N of Fort Road. A stone tower probably of the late C14 or early C15. An exceptional relic, which seems to have been domestic. Oriented N–S, with three superimposed vaulted rooms, the

undercroft with crude rib vaulting, both the upper rooms with plastered tunnel vaults, more acutely pointed in the uppermost. Fireplace in the corner of the first-floor room. Winding stair in a NE stair-tower, externally roughly rounded to octagonal. The undercroft, with corbelling over the S door and a pointed N door, hints at a through passage – perhaps the tower was a gatehouse? There are vestiges of a gable on the N wall, but maps show the ruins of the Paterchurch mansion well to the SW of the tower, so function and relation remain unclear. First recorded in 1422 when John Adams married the heiress, Elen de Paterchurch.

Outside the dockyard, S of Fort Road, is the much-altered Admiralty HOSPITAL of 1902, and ruins of the Admiralty GASWORKS of 1855.

OTHER NAVAL AND MILITARY BUILDINGS

SW AND NE GUN TOWERS. At opposite corners of the dockyard, 108 below the high-tide line, two island forts of 1848–51, built to command the outside length of the dockyard wall. A development from the Napoleonic War Martello towers of the English south coast, these are gun platforms mounted over small barrack rooms, with basement stores and magazines. Superbly constructed in grey limestone ashlar, the battered walls rising from the water to a parapet over a bold round-nosed string course, their elemental geometry gives them a picturesque quality. They were too small and too vulnerable to seaborne attack to be a satisfactory defence, and were disarmed by 1882. The broad NE tower, reached from Front Street, well restored in 1994 and open to the public, is the larger and the more dramatic: trefoil-shaped to seaward, two-storeyed, built to carry three 32-lb guns. The smaller SW tower, at the end of Fort Road, is an irregular octagon, three-storeyed, and carried a single 32-lb gun.

DEFENSIBLE BARRACKS, Barrack Hill. 1842–5, by *Captain* 107 *Farris* of the Royal Engineers. A remarkable attempt to answer two problems: the accommodation of the Royal Marines allocated to defend the dockyard, and the provision of an elevated gun platform to protect the dockyard from naval bombardment and land attack. In defensive terms, extraordinarily old-fashioned, the last fort in Europe built to the plan associated with Vauban in the C17: the 'square bastion trace', with acute-angled bastions commanding the lengths of the dry moats. The outer walls of the barrack square, pierced with musketry loops, have a formidable appearance, but the barrack square must have been indefensible to naval bombardment. Nevertheless, Pembroke Dock is left with the finest Georgian-style square in Wales. The barrack square is enclosed by four regular two-storey terraces in grey limestone, linked by arches in the chamfered corners, the centres pedimented except on the S side, all sash-windowed. The sides have single doors to the W and E for barrack blocks, several to the S for the officers' quarters and

mess. Handsome iron railings embossed VR to the basements.
The exterior is another story, grim and lined with small square
gun-loops, in rows. The barracks stand on the defensive plat-
form with corner pointed bastions, or ravelins, above a mighty
ditch of ashlar-faced banks and counterscarps. The gatehouse
on the N projects to the edge of the ditch, pedimented, with
gun-ports over the access drawbridge. Inside the barracks, cast
iron is used for massive floor beams and joists, but curiously
not for the roof structure.

LLANION BARRACKS, Llanion Hill. A temporary hut encamp-
ment which lasted nearly fifty years, first set up in the 1850s
during the Crimean War. Some more permanent outlying
buildings survive, along Pier Road: the former GUN SHEDS,
grey stone, single-storey, and Nos. 1–6 HAVEN WORKSHOPS,
now single-storey, which were later C19, two-storey stables. On
the N side of the hill, on the footpath, the MAIN MAGAZINE,
1860, and CARTRIDGE MAGAZINE, 1875, built into the hillside,
fire-proof, brick-vaulted and protected in walled enclosures.
Mass concrete was used for the cartridge magazine, though
the vaulting was brick. On the crown of the hill, the former
OFFICERS' MESS of the permanent barracks, built 1904–6,
with the COMMANDANT'S HOUSE to the l. Hard red brick
with suburban detailing, the buildings hardly do justice to the
superb site. Used as council offices in the late C20, proposed
2003 as the Pembrokeshire Coast National Park headquarters.
The GUARDROOM pub with its long veranda is the most attrac-
tive of the remaining buildings; the three BARRACK BLOCKS of
1899–1905 have lost all detail in conversion to flats.

PENNAR BARRACKS, on the hill, low, red brick buildings, derelict
by the 1990s, built in connection with a 'submarine mining
depot' established at Pennar Point in 1875, to store mines for
the defence of the Haven. From the depot below some small
stone buildings remain.

THE TOWN

The plan of the town is a grid to the E of the dockyard. Build-
ing started in Front Street on 14 May 1814, but the pattern only
filled out slowly before 1850. Bush Street and Meyrick Street,
now the main streets, were largely undeveloped in 1848; the E
and SE sectors were built up only in the 1890s. The Admiralty
planned seven streets S of the dockyard, but only five were built.
Single-storey cottages in rows covered the upper slopes, from
High Street in the 1820s, up to Pennar and Military Road by
the 1850s. The first Front Street houses were double-fronted,
smaller-windowed than the later houses which have large twelve-
and sixteen-paned sashes. These were almost all two-bay and
two-storey, some with basements. A few single-storey double-
fronted houses intruded into the lower town (Charlton Place,
Wellington Street). Occasional three-bay houses appeared, in
Prospect Place in the 1850s, and in Cumby Terrace (originally
called Officers' Row) in the Admiralty section. In the centre the

only three-storey buildings, of the 1850s, on Bush Street and Meyrick Street, are in late Georgian style, stucco with parapets. The pattern remains, but in the late C20 most of the minor details have been lost. Only in the post-1850 quarter of the town (Prospect Place, Church Street, Laws Street and Gwyther Street) can a few unaltered houses be found.

FRONT STREET overlooks the NE Martello tower (*see* above). At the E end, the last of the private shipyards, with a mid-C19 DRY DOCK. MEYRICK STREET runs S. Nos. 17–21 on the E side were a unified row of mid-C19 three-storey houses with centre pediment. No. 10 was a late C19 bank. Zion Free Church (*see* above) remains the main accent, with the contemporary chapel houses at Nos. 14 and 16. DIMOND STREET, the main commercial street, is uneventful. On the N side, No. 33, built as the MECHANICS' INSTITUTE in 1862–3 by *K.W. Ladd*, stucco and arcaded, all the detail stripped off. No. 35, LLOYDS BANK, has a stucco front of *c.* 1850–60 with parapet and some detail of 1913, when the bank moved in. At the E end, WATER STREET runs N; Nos. 22–30, on the W, had some character, stuccoed with parapets, but the detail is gone. No. 20 is later C19, distinctive for an architectural handling of the façade, the upper floors in sunk vertical panels. At the N end, in the middle of a roundabout, late C19 pyramid-roofed PUMP-HOUSE.

S of Dimond Street. In BUSH STREET, Nos. 50–66 and the two corner houses to Laws Street were a rare unified group, of the 1850s: three-storey with parapets, mostly restored in 2002. The upper ends of GWYTHER STREET and LAWS STREET, of *c.* 1850–60, CHURCH STREET of *c.* 1850 and the E end of PROSPECT PLACE have a scattering of houses with original detail, and with the eyes half closed, some of the unity may be recaptured. In Church Street, the VICARAGE, 1858 by *Joseph Clarke* of Pembroke Dock, is in limestone, like the church, the big bay window of 1878 by *K.W. Ladd*.

The W end of Bush Street was redeveloped *c.* 1900, as was PARK STREET to the N. In Park Street, PENFRO PLACE, 1991 by *Pembroke Design*, courtyard flats incorporating some gable features from the 1899 infirmary by *Morgan & Son* which was previously on the site. At the W end of Bush Street, the MASONIC HALL, 1903–5 by *Morgan & Son*, mullioned windows and free detail, the octagonal rear roof striking. In ALBION SQUARE, CENTENARY MEMORIAL, a 1914 ornamental lampstand, but the enclosure of the square was lost with the demolition of the big Gothic Congregational Chapel (1865 by *R. C. Sutton*) on the N side, and Albion House on the E. The school (*see* above) and former CO-OP STORES, 1893 by *H. C. Reid*, in red brick and stone, fill the S side. In CHARLTON PLACE, to the S, some single-storey houses, and on the W, walls of the former Admiralty reservoirs, of *c.* 1840. The streets to the W, S of the market and dockyard, were laid out by the Admiralty in the 1820s and built up by 1850, but the houses are all altered.

In VICTORIA ROAD, to the S, facing Barrack Hill, VICTORIA HOUSE, the Victoria Hotel of *c.* 1835, altered *c.* 1905, and to its l., the former NATIONAL SCHOOL, 1843–5 by *William Edye*, master shipwright at the dockyard. Hipped and stuccoed originally, with six pointed windows, the smaller piece to the r. is the master's house, added 1847–8. From Victoria Road, BELLEVUE TERRACE, with former Royal Artillery married soldiers' quarters, *c.* 1893, on the w, runs up to High Street. Single-storey terraces, of the 1820s to the 1860s and perhaps later, line HIGH STREET, MILTON TERRACE, NORTH STREET and, further up, on the Pennar ridge, MILITARY ROAD. Unfortunately, barely one remains unaltered. A smaller variant, with only one window and door, can be seen in Military Road and in BEACH ROAD, Llanreath.

The E part of the town is mostly later C19 or C20. HOBBS POINT, to the w of Llanion Hill, was from 1832 to 1848 the terminus of the Irish mail-coaches from London, hence the name on the turnpike road milestones. Passengers sailed to Waterford from here, and London Road and Pier Road were laid out for access. The PIER and SLIPWAY are of 1830–4, by *Capt. Fanshawe*. PIER HOUSE, 1835–6, was the Royal Mail Hotel. Roughcast with hipped roofs; it looks of the 1860s, but the profile is visible in views of the 1830s. LONDON ROAD runs E to the roundabout s of the Cleddau Bridge. Off the roundabout, CALL CENTRE, 2001, by *Pembroke Design*, striking curved roof and much glass. LLANION COTTAGES, s of the roundabout, are two rows of mid-C19 cottages, once formally paired, but the detail all gone. Further s, across the railway, some ruined stonework of LLANION HOUSE, a C17 to C18 seat of the Meyricks. N of the roundabout, a long single-storey terrace on WATERLOO ROAD, and a few more altered single-storey houses under the bridge at PEMBROKE FERRY.

# PENALLY/PENALUN

Penally was the birthplace of St Teilo in the C6. Archaeological evidence points to an important Early Christian site in the area of Trefloyne, to the NW. The vaulted medieval hall houses at Whitewell and Carswell (*see* below) attest to days when Tenby was a rich port and the fertile Ritec valley was navigable. From the 1840s the place developed as a fashionable, picturesque seaside village, still recognizable today. Despite much C20 development, the village retains an attractive charm. Splendid views out to sea and towards Tenby.

ST NICHOLAS. The site of a *clas*, or Celtic monastery, from which remarkable carved crosses survive, blending Celtic, Northumbrian and Scandinavian styles. The present church, on a steeply sloping site on the village green, is largely of the C13 and C14. Unusually narrow nave, long chancel with squint passages, slightly irregular transepts. S porch. Slim embattled

CI5 W tower. The whole of the interior is stone-vaulted: the native tradition taken to its extreme. Whatever painted decoration existed was removed during the 1851 restoration by *David Brandon*, his first of many restorations in the area. Wall paintings of medieval armoured figures were seen when the old plaster was removed. Lancets. – FONT. Late Norman scalloped square bowl. – STAINED GLASS. Good E window of 1851, by *Wailes*, Crucifixion. – NW window of nave by *A.L . Moore*. – The others stem from an interior refitting by *Jones & Willis* in 1884. – The PENALLY CROSS. In the N transept, superb, monolithic early CIO wheel-head cross, standing some 7 ft (2 metres) high. An elegant combination of Celtic and Northumbrian styles. Shaft and head both edged with cable mouldings. The front of the shaft looks uniform, but has three types of carving: a single vine scroll at the top, of Northumbrian character, plaitwork in the middle, and angular knotwork at the bottom. The rear face has vertical bands of knotwork and plaitwork. The head is similarly patterned on both faces, the central boss decorated with a four-lobed knot. Formerly outside the W door. – Splayed shaft of another CROSS, probably of similar date, the front with Northumbrian-derived decoration: key pattern, vine scroll and confronted animals. Plaitwork to the rear, including a ribbon-animal of Scandinavian form, with a long curving head, apparently biting the neck of a serpent. – Another piece of CIO SHAFT in the vestry, with knotwork and key patterns in low relief. – Built into the outside of the N transept, a plain INCISED CROSS. – MONUMENTS. William de Naunton and his wife, Isemay, *c.* 1300. Sandstone slab set in recess with small and well-preserved heads of a lighter stone. Incised Latin cross, the arms terminating in fleurs-de-lys. Marginal inscription in French. – Lawrence Cook †1792, and children. Erected after 1854 by *Tyleys* of Bristol. Weeping woman with sarcophagus, long and informative inscription. – Thomas Dunn †1832. Simple moulded frame and urn. 37

### PERAMBULATION

A tour may begin at the S side of the village with GILTAR LODGE, built as the Railway Hotel. Hipped roof, full-height gabled porch upon Doric columns with railway-style fretted canopy. Moving N, PENALLY COURT FARM below the church is a gabled, dressed-limestone house dated 1858. Picturesque in outline, but with robust detail. Corbelled gables, bay windows (triangular to the rear), and corner porch with fat Doric column. FERN HOUSE next door, stark Italianate of the 1850s, has a three-bay stuccoed front with corniced windows, but full-height side-porch with frilly bargeboard and hood-moulded window. Off a lane running behind the church, THE COTTAGE, an early CI9 stuccoed and hipped villa with veranda. Slightly below to the N, PENALLY ABBEY HOTEL, rambling Tudor Gothic, probably mid-CI9. Irregular triple-gabled front loosely dressed up with variegated bargeboards

and wide ogee-headed casements (inside, a cheerful mix of classical and Gothic detail). In the grounds to the N an enigma, ST DEINIOL'S CHAPEL. It resembles the local type of rectangular, vaulted first-floor hall house with entries to each storey. Restored and much prettified *c.* 1850, when it was made into a fashionable fernery: the brick double barrel vault was inserted and the openings were restored, so that nothing datable remains. Ruins behind, with C15 or C16 looking conical chimney. High above, up the adjacent lane, PENALLY MANOR, a commanding seaside-Gothic house of 1839, built by *James Harrison* for Captain Wells. Two-storeyed and stuccoed, with clustered chimneys and corner polygonal shafts with tall ball finials. Attractive taut, triple-gabled entrance front. First-floor wooden canted bay windows with loops above frilly bargeboards and cusped ogee-arched doorway, almost Moorish in effect. Similarly treated cart-house: four-centred entry with huge dressed stone voussoirs. Back on the main thoroughfare, THE OLD VICARAGE to the S is a two-storeyed, stuccoed hipped house, its three centre bays dating from *c.* 1822. Graceful doorcase under elliptical arch with those attenuated, plain wooden columns so popular in Regency Tenby. Opposite is the small VILLAGE SCHOOL of 1873. Local stone with bellcote, polychromatic relieving arches of limestone and sandstone. WAYSIDE, further N, is a painted brick Swiss chalet, begun 1929 for a local artist, E.J. Head, who taught Augustus John. Low hips, wide eaves and shutters with heart motifs. KENYSTYLE, further downhill, was a small development of flat-roofed concrete bungalows of *c.* 1926 by *E. Glover Thomas* of Tenby. Modern in concept, but plain in style. Three survive. Finally, the PADDOCK INN at the N end of the village is a C16 or C17 two-storey house with square lateral chimney and early outshut porch.

FOUR WINDS, ½ m. NE. In the grounds of the house a roofless conical TOWER, probably a late medieval beacon. The pointed C15 door-head was inserted in 1903, taken from a demolished house in Tenby.

102 KILN PARK, ½ m. NE. At the edge of the caravan park is an impressively large bank of twelve LIMEKILNS with pointed openings, behind a screen wall which has round arches alternating with Diocletian windows. Vaulted continuous passageway between, over the former tramline. Probably of *c.* 1865; one of the most striking industrial monuments in the county. Less elaborate block of seven to the E.

WHITEWELL, 2 m. W. Scant ruins of a late C14/early C15 rectangular first-floor hall house, entered from both floors, as at Carswell and West Tarr. E wall with traces of a lateral fireplace.

TREFLOYNE, 2 m. NW. Trefloyne was the seat of the Catholic Bowen family from the early C16, when a large double courtyard house was built. It was slighted by Parliamentarians in 1644, and 'suffered greatly', but was taxed with eight hearths in 1670. In ruins by 1800. The existing farmyard clearly represents three sides of a courtyard, the W range retaining the

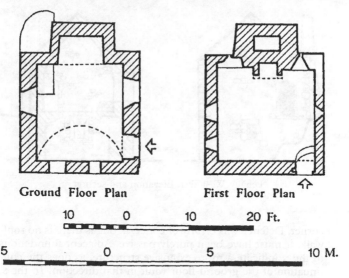

Ground Floor Plan        First Floor Plan

10        0        10        20 Ft.

5        0        5        10 M.

Penally, Carswell. Ground-floor and first-floor plans

base of a three-light mullioned window, internal corbels and several blocked openings. Small, early C19 farmhouse, now the rear wing of a vaguely picturesque house of 1853 with steep gables and tall casements. Some features reused from the C16 house, chiefly a chamfered pointed doorway (retooled) with diagonal stops, and various chamfered lintels. Uphill to the N, the shell of a square C16 DOVECOTE.

PALMERS LAKE, 2½ m. NW. Much rebuilt lateral-chimney farmhouse, probably early C17. Tapering square chimney, huge semicircular oven with a roughly corbelled gable.

CARSWELL, 2¾ m. NW. Small and roofless rectangular hall house of the late C14/early C15 with barrel-vaulted undercroft. Huge projecting square gable chimney heating both floors. Separate entries to each floor, no internal stair. Upper steps visible inside the first-floor doorway on the E gable, which was probably reached by a ladder. Small first-floor fireplace with corbelled hood. In the care of Cadw. Just on the opposite side of the yard, another rectangular building, much rebuilt in the C19 but retaining a slightly pointed undercroft; either an ancillary building or, more likely, another house. 52

WEST TARR, 3 m. NW. Tiny rectangular hall house of the late C14/C15 (uninhabited), built into the slope E of the present farmhouse. It consists of two vaulted chambers, the lower rounded, the upper pointed in cross-section. Originally, a lateral chimney heated the first floor, until it was replaced by an entrance, at a comparatively recent date. First-floor entry to S gable with pointed head, presumably reached by a ladder, as at Carswell, though there is an internal stair to the NW p. 352

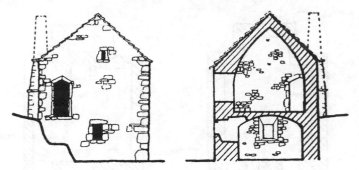

Penally, West Tarr. Elevation and section

corner. Defence was clearly of concern, but as there is no roof-walk, it must have been purely passive. Adjacent foundations to the N indicate a more extensive structure, as does the continuation of the ground-floor vault in that direction. To the S, a roofless building of similar dimensions, but without vaults or a visible chimney. Two square recesses inside. Other small outbuildings scattered around seem to have much earlier origins than their deceptively C19 appearance would admit. To the NW, a circular C19 LIMEKILN.

## PENRYDD *see* BONCATH

*1742*
## PENYBRYN
### Bridell

Crossroads settlement on the Tenby road S of Cardigan.

PENYBRYN BAPTIST CHAPEL. Gable-fronted chapel of 1869, similar to Tyrhos Chapel, Cilgerran. Banded brown and grey stone two-storey front with arched window- and door-heads in grey Cilgerran stone. Small-paned windows; only the wavy bargeboards give away the late date, and there are still bow pews inside. Gallery front in long panels, on fluted iron columns marked *T. Thomas*, Cardigan.

*0313*
## PICTON CASTLE
### 5 m. SE of Haverfordwest

Among the most important historic houses of Wales, home to the most influential family in the county, and still in the possession of the descendants of Sir John Wogan, 'lord of Pykton' in 1302. The original small medieval castle is of a type more akin to certain Irish castles; indeed, Sir John Wogan, its builder, was justiciar of Ireland 1295–1313. The outward appearance of Picton is

that of a castle a child would draw, battlemented, with round corner towers, but civilized by C18 sash windows and a large, battlemented four-storey block added to the W after 1791. Despite several remodellings and additions, the original plan is fossilized within, the Great Hall still dominant. No Victorian tried to remedievalize Picton, though a young and enthusiastic *Thomas Rowlands* added a Neo-Norman E porch in 1827, the style also chosen for the stable block to the SE. The lush parkland setting is broad and fine, located on the rolling banks of the Eastern Cleddau: indeed, the best view of the castle was always considered to be from the river itself, which until the C19 was the chief mode of local transport.

The last Wogan died in 1420, and after 1469 Picton passed to Sir Thomas Philipps of Cilsant, through his marriage to the heiress Jane Dwnn. Little work, if anything, was carried out during this period. In August 1684, when the Duke of Beaufort visited Picton, his secretary Thomas Dineley recorded that they were 'nobly entertained at a dinner by Sir Erasmus Philipps' in the great medieval open hall. In 1697 Sir John Philipps, fourth baronet, raised the entrance to its present level by creating a balustraded causeway from higher ground to the E, shown on the Buck engraving of 1740 (replaced by the present entrance court in 1827), thus entering the castle at the same level as the principal rooms. An architect named *Hancock* is recorded at Picton in 1697, making alterations for Sir John – presumably he was responsible for the causeway. Either at this date, or certainly before 1740, an extra storey was added over the hall, presumably removing the medieval open roof, and sash windows were added throughout, except to the hall. When exactly these works were carried out is unclear, but Sir John Philipps wrote to his sister Katherine in 1713 referring to repairs, and between 1715 and 1730 internal works were undertaken, including the provision of new wainscot and ceilings. The fourth baronet, 'Good' Sir John, M.P. (†1737), was prominent in promoting Anglican reform, and was a leading member of the SPCK from its foundation, his brother-in-law being the cleric and educational reformer Griffith Jones. Deeply cultured and well-connected (his niece was Sir Robert Walpole's wife), he was appointed one of the Commissioners for building fifty new churches in London; no doubt this accounts for his commissioning no less a figure than *John James* in 1728 to design a belvedere tower at the end of the avenue leading from the front door (*see* below).

The family continued as influential patrons of leading architects and sculptors: Sir John's son, Sir Erasmus, went on the Grand Tour, and the monument he erected to his father in St Mary's Haverfordwest was by the London sculptor *Christopher Horsnaile*. His brother, Sir John, sixth baronet, M.P. and privy councillor, was also a man of sophisticated taste (cf. Kilgetty), and between 1749 and 1752 he set about an extensive and lavish internal remodelling, refitting the Great Hall and chapel, and improving all of the principal apartments, adding plasterwork and panelling of the finest quality. Happily, these rooms survive,

and it is this phase of activity that gives the real flavour to the interior. No architect is recorded. Given the family links with the London commissioners and the patronage of John James, perhaps one of the London surveyors was involved. A letter from *James Gibbs* to Sir John in 1752 is recorded, but its contents are not known. Gibbs was by then too old, but could have given advice (he worked at Stanwell Place, Middlesex, for Sir John's uncle, Richard, governor of Nova Scotia). Much of the internal joinery was supervised by *James Rich*, a London carpenter, while five excellent chimneypieces were carved by the fashionable *Sir Henry Cheere*.

The sixth baronet died in 1764, succeeded by his son, Sir Richard, M.P. for Pembrokeshire 1765–70 and 1786–1812, and created Lord Milford in 1776. Picton was now too small for this increasingly important family, and in 1791 Lord Milford began a major extension to the W, demolishing the medieval solar tower and adding a tall four-storey block. Lord Milford preferred Picton to London, and made a point of employing local artisans. Almost certainly, the architect was *Griffith Watkins* of Haverfordwest, who was used extensively on the Picton estate, designing Lord Milford's Tenby town house in 1810. The new range is plain, except for its battlements; its size was intended to impress, particularly when viewed from the river, but its stark regularity contrasts with the picturesque outline of the medieval castle. Rev. J. Evans in 1803 noted of Picton that 'it is always disgusting to the eye of taste to observe ancient and modern architecture blended together in the same edifice', while Fenton in 1810 lamented that Lord Milford had not 'better assimilated the external of his improvements to the ancient part of the structure'. The new range provided a spacious new drawing and dining room, and new bedrooms and dressing rooms above. The C18 stair between the W towers was removed at ground level, and replaced by a grander stair in the new block. Lord Milford died in 1823, Picton passing to his cousin Richard Grant Philipps, who set about more improvements in 1827, this time to the exterior. Again, a local architect was sought, this time *Thomas Rowlands* of Haverfordwest, aged only twenty-three. A large Neo-Norman porch was added, the latter a confident piece of work; this and the grand new stable courtyard to the SE ensured that Picton was up to date in architectural fashion, epitomized in Wales by the contemporary Neo-Norman Penrhyn Castle, Gwynedd. A broad new raised entrance court was created with low crenellated walls and sweeping steps down to ground level each side. Rowlands also remodelled the L-plan service range, off the NE corner of the castle. Sir Charles Philipps, who inherited in 1875, proposed extending the W block to the N and W, the plans drawn by *George Robinson* of Swansea. Had it been executed, this would have swamped the early castle. Instead, *Trollope & Sons* of Pimlico, with whom *T. P. Reynolds* of Haverfordwest was associated, were engaged 1884–97 to enlarge the service block, also connecting it to the castle by a low link corridor.

In 1934 fire destroyed the decorated plaster ceiling of the hall,

and gutted the rooms above. Repairs were carried out by *Sir Reginald Blomfield & Son*. Following wartime occupation, the castle was in a poor state. *Claude Phillimore & Aubrey Jenkins* of London proposed demolishing the w block and reinstating the semicircular w tower, but instead remedial works were carried out, completed by *Donald Insall* in 1962. These included skilfully replacing worm-eaten beams without disturbing the plasterwork, but followed fashion in removing the render, being replaced in 2003 for the Picton Castle Trust by *Michael Garner*.

## The Medieval Castle

The evidence for the medieval castle will be considered first, before describing the building as it is today. The castle of *c.* 1300 had a simple but sophisticated plan, a large rectangular keep containing a great hall above an undercroft, with four round corner towers (smaller to the w) and E gate-tower protected by flanking D-towers. These elements are reminiscent in miniature of the great late C13 Edwardian Marcher castles, Beaumaris in particular. What is lacking is an inner courtyard, and any traces of outer defences, including curtain walls or a moat. An encircling wall shown in a sketch of 1684 by Thomas Dineley lacks a defensive character, and looks C16 or C17. The design is closer to some Irish castles than anything in England or Wales. Ferns Castle in Leinster, for example, would have been well known to Wogan, who owned vast Irish estates; this had a keep tower surrounded by four round towers, and was built by Sir John's patron, William de Valence, Earl of Pembroke. Locally, the compact plan can be compared with the much less significant Upton Castle (*see* p. 488), but at Upton the defensive nature was emphasized by a first-floor

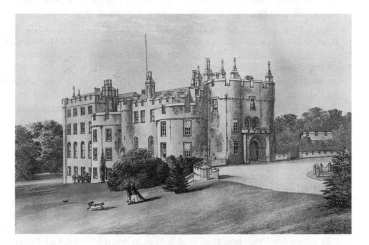

Picton Castle. Later C19 engraving

entry. At Picton the entry was at undercroft level – as clearly shown in the Dineley sketch of 1684.

The original entry, now directly below the present entrance, led to a central passage (subdivided by a later wall) protected by a portcullis, of which one slot survives. On the flanking walls, large cross-loops each side command the entrance from the guardroom chambers, each accessed via a pointed doorway, chamfered with angle stops. Similar, larger doorways led into the undercrofts of the E towers. From the NE tower a stair led to the screens passage at the E end of the hall. The doorways from the E tower undercrofts to the main undercroft are however secondary. Thus, originally, the main undercroft was only accessed from above, via the full-height vice to the NE corner, which also gave on to the screens passage. Was there a grander entry to the hall from the undercroft? The springing survives of a pointed arch which may have heralded a stair leading directly from the entry up to the screens passage. The alterations at ground-floor level make all this puzzling. The existence of a screens passage is confirmed by the survival of two former doorways with pointed arches in the E wall of the hall (blocked in the C18 remodelling), which must have led to service rooms; they flank two niches, also with pointed arches.

Before the C18 alterations the hall had windows with pointed heads. The Buck engraving of 1740 shows them with Perp tracery. Early access from the hall to the upper chambers of the W towers is only now apparent in the form of a small vice at the junction of SW tower and hall block: perhaps additional stairs were lost with the demolition of the solar tower.

77
P. 359
## Exterior

Now for the present appearance of the castle, which is mostly rendered and limewashed, in correct medieval tradition, icing-like, giving the S front in particular an attractive uniformity. A tour is best started at the main entrance, the E PORCH added in 1827 by *Rowlands*. The porch is set between the D-turrets of the E tower, Neo-Norman, crisply and confidently executed in ashlar. Doorway of three orders, double-chevron and scalloped, on shafts with scalloped caps; hood on head-masks. Above, a pair of large round-arched windows with matching detail regrettably replacing the C18 Venetian window of the chapel. The tower rises to three storeys, with battlements, but before the driveway was raised in 1697, level with the principal floor of the castle, its appearance would have been more forbidding. The 1697 balustraded causeway – a sophisticated piece of work for this area – disappeared in 1827 when Rowlands formed a broad raised semicircular carriage sweep, bounded by low crenellated walls, with stairways sweeping down to the garden. On the S FRONT, the odd contrast between old castle and the late C18 block is best appreciated, the latter also battlemented, four bays and storeys with underscaled

corner towers. The first-floor windows belonging to the dining room were given Neo-Norman heads after 1884, above plate-glass sashes. Otherwise, the whole elevation is unified by sash windows. The SW and SE TOWERS both rise to three storeys, with battered bases. The hall range between is slightly higher, due to the addition of the extra floor in the early C18. The hall itself is lighted by two tall round-arched sashes, inserted in the mid-C18, replacing the medieval windows depicted in the Buck engraving. The N FRONT is a near mirror image, the windows of the W block likewise Normanized, but without the carved detail. Both NE and NW TOWERS have slightly battered bases, and the pointed relieving arches of the medieval hall windows are visible in the exposed stonework (which is to be rendered). The SERVICE RANGE near the NE corner, rebuilt as a two-storey L-plan range in 1827 by *Rowlands*, had Neo-Norman detail to match the porch, but was swamped in an overblown enlargement of 1884–97 by *Trollope & Sons* of Pimlico, overseen by *T. P. Reynolds*. The battlemented centre bays rise to three storeys facing the entrance court, with a taller round turret, and narrow slit-like windows. The link corridor between service range and castle was also added at this time. The new work does no favours to the castle, being stark and dominant.

*Interior*

The best start is made via the inserted door of the NE UNDER-CROFT, which has a fine rib-vaulted roof, and a blocked vice to hall level. The door into the MAIN UNDERCROFT is a later insertion (*see* above); this could only be entered from above, via the full height stair in the NW corner. The undercroft is a magnificent medieval survival, a spine wall dividing two rows of three cross-ribbed vaults. The SE UNDERCROFT also has a rib vault. From here, access is preserved into the original ENTRANCE PASSAGE, flanked each side by a small guard room, with big cross-loops in the dividing walls, and the channel of the portcullis, masked by later alterations. Originally, both tower undercrofts were reached via the passage, through the larger of the paired pointed doorways, which have angle stops. Ahead of the entry, the springing of an arch suggests that a staircase lay beyond, probably to the screens passage at the E end of the hall. The other two undercrofts have been modernized.

From this level the GREAT HALL is now approached by the main undercroft stair. This magnificent mid-C18 Palladian interior is the centrepiece of the remodelling of the interior for Sir John Philipps, for which *Gibbs* may have been consulted. The room rises two storeys, lit by tall round-arched sash windows, the flat plaster ceiling on a Doric frieze added by *Blomfield* after the fire of 1934. E GALLERY on fluted Doric columns, the balustrading broken forward to the centre. Like the rest of the accomplished Georgian joinery in the house, by

*James Rich*, a London carpenter. Fine organ of 1750 by J.*Snetz-ler Sen.* originally in the chapel. Impressively wide pedimented W doorcase, again on fluted Doric columns, originally leading to the solar tower, before its replacement by the W block. Big, Portland stone chimneypiece by *Sir Henry Cheere*. Terms with bearded faces entwined with ivy, the centre panel depicting a delightful scene of cherubs unsuccessfully shearing sheep, flanked by pastoral scenes. Black and white marble floor, relaid in 1884. Two medieval pointed doors in the E wall of the former screens passage remain (*see* above). E, and reached from the gallery, is the narrow CHAPEL, fitted out by *Rich* in 1752. 'Handsomely wainscotted with mahogany', according to Fenton, painted since. The chapel is of two bays, the C19 ceiling divided by an elliptical arch. Good high BOX PEWS with fielded panels facing each other, the W set copies when the chapel was restored in 2002. COMMUNION RAIL with bulbous balusters. Unfortunate paired E Neo-Norman windows added 1827 by Rowlands, replacing the C18 Venetian window. The chapel then was embellished in 1897 with stencilled patterns and texts by *C.E.G. Gray* of Cambridge, since wallpapered over. Also added then was strongly coloured STAINED GLASS by *Alexander Gibbs* (Mary and Martha, and the Resurrection), out of character.

Now for the main reception rooms, within the corner towers. Within the SE tower, the circular LIBRARY, beautifully fitted out in the 1750s; a charmingly intimate space. Plaster ceiling with radiating compartments filled with foliage. The walls are lined with curved glazed shelving, framed by Ionic pilasters which are the fronts to secret shelves. Fine inlaid wooden floor, the pattern radiating from a centre star. The quality of the joinery is also evident in the curved panelled doors. Early C19 chimney-piece replacing that by Cheere now in the SE bedroom. The NE room is plain and modernized by *Insall*. The NW chamber was altered in 1983, when a new staircase was made to the first floor. Within the SW tower, the DRAWING ROOM, another room of remarkable quality. Delicately plastered ceiling, the compartments containing four profiles of English poets, and dentil cornice. Walls with big panels enriched with egg-and-dart. Overdoors with bold acanthus detail. Fine fireplace by *Cheere* of reddish veined marble with white marble relief, the centre panel an enjoyable scene of infants kindling a fire. Pedimented overmantel with inserted late C18 landscape painting.

Now to the first floor. The SE BEDROOM had become a breakfast room by 1810, and *Cheere*'s small chimneypiece was imported from the library at this date. Red and white marble with tablet of a sow protecting her litter from a wolf. Early C19 cornice. The W bedrooms are reached from the staircase of 1983. Originally two matching bedrooms of 1725–30, the SW one the better preserved, still with bed set in a deep pilastered and groin-vaulted recess and panelled walls. The NW BEDROOM lost its bed recess when the 1983 stair was inserted and panelled. The upper flight of a mid-C18 stair survives,

leading to the rooms over the Great Hall. Plain bedrooms with spine corridor, reconstructed after the 1930s fire.

Now for the W BLOCK of 1791. The new accommodation provided two large reception rooms and a new stair hall above a high basement, with bedrooms on the two upper floors. No attempt was made to create an entry on this side of the castle.

The STAIR HALL across the E end of the new block is reached by a short passage between the W towers. The hall has a centre plaster groined vault, with timber stairs rising to the r. in two flights, handsomely proportioned with bulbous balusters and reeded rail. Two sumptuous moulded and panelled mahogany doors, of the 1820s from *William Owen*'s workshop, open into the two parallel rooms, dining room to the S and drawing room to the N, though their roles may originally have been reversed. The two are of quite different character, the one Georgian, the other Regency. The DINING ROOM has plaster-panelled walls with oval portrait frames above the doors and a consoled cornice, old-fashioned, like work of at least two decades earlier, highlighting *Griffith Watkins*'s provincial background. The DRAWING ROOM was refashioned in the 1820s, the ceiling with an attractive vine and acanthus border and large sinuous cen-trepiece. Both rooms have fine reset chimneypieces by *Cheere*, in the dining room a masterpiece possibly from the demolished solar room: snow-white marble with centre tablet of putti in hats ice-skating and strings of deeply-undercut sea-shells, and in the drawing room a fireplace with three inset pietra dura tablets of figures in Turkish dress against black backgrounds, probably N Italian and perhaps acquired there by Sir Erasmus Philipps.

## Grounds

The long wooded main DRIVEWAY is from the N. Paired LODGES of 1827, by *Thomas Rowlands*, stuccoed cubes with simple Neo-Norman detail and battlements. Round-arched windows with Gothick glazing. Fine sweep of iron railings. The W drive-way has a plain 1850s LODGE by *W.H. Lindsey* and passes the WALLED GARDEN, probably of 1827, stone and brick walls, but later C19 railings on the E side with heavy detail. Of all the improvements made by *Rowlands* the most impressive was the STABLE BLOCK, on rising ground 100yds SE of the castle, clearly designed to be seen from the front door. Big, fortress-like Neo-Norman rectangular courtyard – with formal two-storey W front (originally containing accommodation); roughcast, with small arched windows, arched entry flanked by projecting bays, and a squat octagonal clock tower with ogee dome. Groin-vaulted entrance passage on fat shafts with cushion caps. Within, the courtyard is approximately 40 × 60 metres, but appears all the larger because the two-storey central block of the E range has splayed stair-turrets each side.

This block contains round-headed coach entries in three bays; single-storey S and N ranges have cart-sheds and stables. At time of writing urgent conservation is required. The Georgian stables had been in two long low opposed pedimented ranges flanking the 1697 causeway.

About 600 yards E of the front door (formerly up a long lime avenue) are the sad remains of the BELVEDERE set on a raised mound. It was by *John James*, though the drawings he sent in 1728 to Sir John Philipps were according to his son's diary, 'not entirely followed'. No proper view survives of the building called by the antiquary John Carter in 1805 'a pavilion in the Italian style'. It seems to have disappeared in the 1820s, probably because the mound subsided, and Rowlands' stable block became the substitute eye-catcher. The ground between undulates and, with the mound summit just below the sight-line, the belvedere would have been completely visible but invisibly supported. Through the MOUND runs a large stone-arched tunnel with niches, presumably for statues (though there were none when Mrs Morgan walked through shivering with fashionable Gothic horror in 1791). The roof has collapsed midway, pointing to the fate of James's tower above.

PICTON HOME FARM, ¼ m. W. A rare and mostly intact survival of a model farm, built 1827 for Sir Richard Grant Philipps by *Thomas Rowlands*. Plain functional, ranges around a large courtyard, originally with dovecote in the centre. The S range has the three-bay hipped farmhouse, turning its back on the yard. Mirrored two-storey, hip-roofed E and W ranges, each with six cart entries towards the N end. The rear of the N range, thirteen bays long, is symmetrical, the intermediate bays with giant blind arches. The tall centre archway was the original main entry. In disrepair.*

In Rhos village, a TERRACE of four estate houses by *W.H. Lindsey*, of the 1850s with paired arched windows, the end houses advanced and gabled.

0234

# PONTFAEN

The parish lies S of the Gwaun river but the village is N of the double-arched PICTON MILL BRIDGE, which marks the boundary with Llanychllwydog parish. The DYFFRYN ARMS is dated 1845 but looks later, three bays, the centre gabled. SYCAMORES, just E, is late C19, Preseli stone with red brick. TY GWYN, ¼ m. W, earlier C19, has a canted three-sided front, like a tollhouse, but set back from the road. Up the hill to the S of the bridge, the church, Pontfaen house and the Old Vicarage.

ST BRYNACH. Small and much restored, the short nave and chancel with their battered wall bases may be medieval, and possibly also the N transept with a broad squint passage.

* The help of Michael Garner and David Pryse Lloyd with Picton Castle is gratefully acknowledged.

Ruined in 1861, it was repaired by *J. C. Davies*; the cusped Bath stone windows may be his. The present character derives from work of 1898–1909, for Percy Arden of Pontfaen, by *Morgan & Son* who in 1905–7 added the S porch (replaced in 1985) and N W vestry, parallel to the nave, lowered the floors, and replaced the roofs and fittings. Ornate roof trusses on hammer-beams. The squint passage from the N transept has cambered arches and a C19 roof. – FONT. Medieval whitewashed square bowl chamfered at angles. PULPIT, LECTERN and READING DESK of 1907 also, unusually, seven Stations of the Cross, a Madonna della Sedilia painting brought from Italy in 1902 and a set of finely worked vestments, now displayed under glass. Wrought-iron and brass altar RAILS. – STAINED GLASS. All by *Heaton, Butler & Bayne*, 1898–1904.

In the churchyard two CROSS-INSCRIBED STONES, Latin crosses, one with roundel at centre.

JABES BAPTIST CHAPEL, ½ m. E of Dyffryn Arms. Rebuilt 1904, by *J. H. Morgan* of Carmarthen. Stucco. The centre recess, a tall bald rectangle, encloses a broad arched upper window with sunburst rustication, and the broad porch below has a typically Edwardian curved cornice with flat wings.

PONTFAEN. Next to the church. A gentry house of the Vaughan and Laugharne families from the C15 to 1823, assessed at five hearths in 1670. Remodelled in the mid-C19, for the Gowers of Castell Malgwyn. An early C18 hipped cross-wing at the S end, a main range running N and a gabled cross-wing at the N end. The external detail, stucco with timber mullion and transom windows, is all C19 or C20 replacement. The E front has a large gable to the N cross-wing to the r. and three smaller gables, while the rear has both cross-wings projecting, and the main entry is here, in the angle to the N wing. Inside, some chamfered beams and oak roof trusses in the S end, the N end all mid-C19 including the stair.

Attractive whitewashed L-plan COACH-HOUSE and STABLES yard to the S, probably of 1845.

THE OLD VICARAGE. ¼ m. S. 1903, by *Morgan & Son*, hipped rendered three-bay front with a fashionably Arts and Crafts curved cornice on stubby columns to the porch, and small panes to the windows.

COTTAGES. The Gwaun valley has a number of very small farm-houses of the Pembrokeshire type, double-fronted with big chimney to the kitchen end and smaller to the tiny parlour, over which was the sleeping loft. CWM LLAN on the roadside 1 m. W, LLETHR up the slope just further W and CILRHEDYN BRIDGE FARM, further on again, just W of Cilrhedyn Bridge are all of this type, while DANYCOED, 1 m. E, is more of a tiny pattern-book design, hipped with triangular heads to the two windows.

TY CWRDD BACH, 1 m. N on the Dinas road. 1974 by *Christopher Day,* formed from the shell of a small chapel. One of the first turf-roofed houses in Britain, the original rectangle sub-verted to something rooted in the landscape of stone and turf.

Rubble walls under a green roof that sweeps down low at the back, animated by cairn-like rubble chimneys. The front window are modifications of the original, the angled heads a characteristic Day softening of line. The new windows seemingly randomly set in the side walls are designed to light the rooms within subtly, light and surface texture contributing to the sense of well-being at which Day feels architecture should aim.

132  FFALD Y BRENIN, Sychbant. $1\frac{1}{2}$ m. ENE. A Christian retreat centre, on the site of outbuildings at Sychbant farm, 1985–8, by *Christopher Day*, showing the care for organic form and harmony with site characteristic of the architect. The main building follows the edge of a quarry-like rock face, the roofs slope N to S in a gentle undulation punctuated by three short chimneys shaped like cairns. Day avoids hard angles: roofs join with a slope to avoid a gable step, sweep down to gather in the E porch, and flow over the largest window on the W front. Windows are small, with curved brick heads, especially small on the W face, so that the wall appears an extension of the rock below. The E side backs on to a stepped terrace cut from the rock, and has larger windows, stepped with the line of the slope. The porch stone walls curve to give an organic flow. At the N end, Day has added a circular chapel, which, though small, becomes the point from which the whole range depends, the conical roof coming unexpectedly into view at many points. This chapel best expresses Day's feeling for materials, stone roughly laid, walls splayed out at the base to meet the bedrock, and the eaves uneven, echoed in the coursing of the slates. Inside, a pure whitewashed shallow-domed space with bedrock rising through the floor and no furnishings but whitewashed wall-benches. In the main range, Day varies the spaces so that the rectangular envelope is always subverted: a diagonal passage, a corridor kinked around a lavatory, kitchens or sleeping platforms set in extrusions from rooms, to give privacy or separation. Wall finishes are rough and whitewashed, splayed out to meet floors and rounded at angles, windows are subtly placed, bringing light to hidden corners, and woodwork is simple but delightful, the thumb-latches carved as fish-and-loaf or trumpet-and-harp.

An L-shaped single-storey building was added by *Day* in 1990–1, below the first range.

CILCIFFETH, $\frac{1}{2}$ m. WSW. Once a major house of the Lloyd family from the C14 to 1631, the mansion is long demolished, but a rough vaulted undercroft some 35 ft long in the garden gives a hint of the scale, and a C17 carved stone with fluting set in the corner of the present farmhouse hints at the quality. The farmhouse, though modest, is late C17, with a lateral fireplace and an oak moulded doorcase upstairs, perhaps reset and originally external.

LLANYCHLLWYDOG, 1 m. W. The former parish church of St David has been converted to a house. Of 1862, by *R. J. Withers*, small, nave and chancel with S porch and W bellcote. Obvi-

ously economical, but with Withers' nicely sharp geometrical forms, the bellcote with sloping sides, the chancel three-sided. In the churchyard, two C5 or C6 INSCRIBED STONES, said to mark the grave of St Llwydog, one with outline around a cross with roundel centre.

## PONTYGLASIER
### Whitechurch/Eglwyswen

*1436*

Small hamlet N W of Crymych, N of the Preselis.

BETHABARA BAPTIST CHAPEL. 1872, attractive gable-façade in Cilgerran stone with darker grey stone arches. The long windows still have the small panes and Gothick tracery of the Georgian tradition. Interior with three-sided gallery on wooden columns raised above the pews suggesting that it may have been designed by *Joshua Morris* of Newport. The roundel had a painted 'eleventh-hour' clock face (*see* Cilgwyn), now gone.

CROSSWELL HOUSE, at Crosswell, 1 m. W, is a good example of the earlier C19 vernacular of the region, three-bay, whitewashed stone with small-paned sash windows. It was the Cwmgloyn Arms, on the main road to Haverfordwest.

## PORTHGAIN
### Llanrhian

*8132*

The rock-bound harbour was a centre of intense industrial activity from *c.* 1837 to 1926, connected successively with slate, brick, and roadstone, each exploiting the combination of a wedge of granite intruding into slate sediments. This gave a good quality brick clay around the edges of the granite.

Prior to the building of the harbour occasional boats landed limestone for the LIMEKILNS: a circular one stands behind the harbour and a square one inland S of the village. Slate and granite quarrying on the cliff top began in 1837 and by 1860 a horse-drawn tramway connected this working with the one at Abereiddy (q.v.), under the same company from 1855. By 1860 two terraces of single-storey cottages had been built, one on the cliff top has gone but PORTHGAIN ROW in the village survives. Five low double-fronted houses originally with sleeping-lofts; a two-storey house at the far end is ruined, as is the former mill. Production of slate ended in the late C19, the Abereiddy quarry and tramway were abandoned. Granite was quarried in a small way, but bricks, made from *c.* 1884, became the prime export until 1918. TY MAWR, the large stone central building, was the machinery shed, of the 1890s, reroofed in 1996. On the N engine-house, the stump of a chimney. There was a larger chimney for a Hoffmann kiln on a parallel brick-making shed to the E, now gone. By 1887 the cliff top had a

tramway system with stationary engines for hauling material out of the ever deepening pit. About 1900 granite for roadstone became important, with a second quarry further w. In 1902–4 the HARBOUR was much enlarged, the quay backed by the towering brick HOPPERS built to hold the various grades of roadstone. The first quarry pit was by now so deep that a level tunnel could be cut through to connect it to the quayside. In 1909 steam replaced horses on the tramway and a brick ENGINE SHED survives on the cliff top, as do ruined brick store buildings at Pen Clegwr. The harbour, tiny as it is, received some twenty ships a day, but after 1918 remoteness and lack of rail access brought decline. Despite modifying the harbour for larger ships in 1930, it closed in 1931.

On the headlands each side are tall whitewashed conical stone navigation BEACONS of *c.* 1870.

# PRENDERGAST

An ancient suburb E of Haverfordwest, submerged by C20 housing. Prendergast House, the vanished seat of the influential Stepney family, was in ruins by the late C18, following their move to Llanelli.

ST DAVID. Tall tapering late medieval tower at the w end of the N aisle, no battlements. The ground storey is barrel vaulted. Above the tower door, a reused piece of panel tracery, the result of an alteration of 1910. Otherwise, the church is the result of a lavish and good-quality rebuilding by *Foster & Wood* of Bristol between 1866 and 1868. The cost was not enormous at £1700 for such a large church, probably because John Foster was the brother of the vicar, Rev. Francis Foster and provided his services free of charge. Broad nave, chancel, s porch and full-length N aisle. The roof-line of the aisle is broken at the same line as the chancel, adding variety in the way that Pugin advocated. Geometric and plate tracery. Impressively spacious interior. Three-bay arcade in the nave, octagonal piers, with moulded caps. In the chancel, the two-bay arcade has a round pier. The piers have alternate bands of painted ashlar and grey sandstone. Tall chancel arch with dogtooth detail, upon stumpy triplets of colonnettes. Good varied roofs, that in the nave with wind-braces and arch-braces on big fluted corbels; wagon roof in the chancel, the ribs given bold blocky mouldings. In the aisle, crown-posts in the main part with scissor trusses at the E end. – FONT. Norman square scalloped bowl, painted. – REREDOS in memory of John Foster, erected 1894, and designed by *Wood*. Inlaid marble panels, niche each side with figures of St David and St Chad, added in 1926. – FURNISHINGS by *Foster & Wood*, including a big rounded Bath stone PULPIT, carved with emblems of the Evangelists. Plenty of STAINED GLASS. E window of 1887 depicting the Crucifixion by *Burlison & Grylls*, the subdued yellows and blues clearly indicating the move away from High Victorian strong colora-

tion. – Large w window of 1889 by *A. L. Moore*, Suffer Little Children. Rich colours, poor modelling. – Chancel SE, *c.* 1896, Christ and Mary Magdalene. – Chancel SW, *c.* 1898, Feed my Sheep. – Nave SE, Mary and Martha, 1881 by *Bell & Son*: luscious colours. Next, Adoration, 1940 by *C. Powell*, and an unsigned window of *c.* 1941 (Road to Emmaus). Tower window, 1909, St David, by *Powell & Son*: also by that firm, aisle NW, *c.* 1928, Holy Family, and the next window, *c.* 1925, Resurrection. Also in the aisle, SS Mary and Cecilia of *c.* 1988, and E, the happy warrior *c.* 1920. – MONUMENTS. A good late C17 tablet treated with folds of draperies has an illegible inscription. – Dame Mary Philipps †1722. Side scrolls, heraldic cartouche above. – Catherine Philipps. The date cannot be deciphered, but extremely similar to the above monument. – Elizabeth Evans †1789. Reeded sides, urn missing. By *Phillips* of Cartlett. – Mary Ann Beezard †1821. Urn. – Col. Francis Williams †1830. Signed by *Reeves & Son*. Greek, with oversized urn. – David Morgan Lloyd †1868. Scroll type.

PENRHIWILLAN. Formerly the rectory of 1869, by *Foster & Wood*. Large house of rubble stone with ashlar dressings in domestic Gothic style. Garden front with paired gables.

CHURCH HALL. In the main street of Prendergast. 1884, also by *Foster & Wood*. Two uneven gables to the street front, the central door blocked, the materials again of rubble stone.

HILL PARK BAPTIST CHAPEL. At the foot of Prendergast Hill. Opened in 1858 to serve the Welsh-speaking north Pembrokeshire families who had settled in the town. *James Rowlands*, tax collector and architect, designed the first meeting house. His chapel (now the vestry) has a simple two-storeyed pedimental gable end facing the road. Originally there was a colonnade along the ground floor with covered steps up each side of the building to the chapel itself, which, unusually, was on the first floor. In 1888–91, *George Morgan* built the larger successor adjacent, the side wall of which faces the road. The standard blind arcading over two storeys of windows shows none of the invention that he brought to his gabled façades. The interior is galleried along three sides, incorporating some ironwork. Services in Welsh only ceased in 1880, so the need to enlarge soon after is linguistically revealing.

PRIMARY SCHOOL. 1876 by *T.P. Reynolds*. Impressively long range, the single-storey central block flanked with two-storey gabled L-plan blocks and further gabled single-storey wings with stepped lancets. Shorn of much original detail.

SCOTCHWELL ½ m. SE. Early C18 house of six bays, partly enveloped in very large, but plain extensions dated 1887, by *Alfred Guy* of London.

GLANAFON ½ m N. Remodelling of an older house in *c.* 1840, almost certainly by *William Owen*, for J.H. Peel. The projecting chimney at the r. end indicates the earlier structure. Stuccoed, four wide bays and two storeys; hipped roof. Broad band between the storeys, typical of Owen. Entry at the second bay

from the l. via a Doric porch. Well-stair with stick balusters, toplit by a fine octagonal lantern. In the drawing room, a black marble fireplace with primitive Doric columns.

COTTESMORE, 1½ m N. Ingenious renaming of an old farm-house, called Cotts, when rebuilt as a large country seat for Edward Massey in 1841. The architect must have been *William Owen*. Three storeys and five bays, stuccoed and hipped, with a big string course between the upper storeys. Full-length five-bay flat-roofed veranda along the front, on eight Bath stone Doric columns, that appear to have been reused from elsewhere (see several socket holes). Around the front door, some good heraldic glass panels contemporary with the house. Cantilevered stone staircase rising around a square well with cast-iron balusters, incorporating elongated anthemions. Extraordinarily large ceiling roses in the NW and SE rooms, the latter with a white marble fireplace. Behind the house, a small square GRANARY, presumably C18, with steeply hipped roof, and open ground floor, since blocked in. Stuccoed C19 STABLE block, with access to stables from within a pedimented broad-arched cerntrepiece.

PRENDERGAST MILL, 1m. N, by the Western Cleddau. Ruins of a cotton mill of *c.* 1786, described as having 1,512 spindles in 1805, the largest such mill in Wales. It became a paper mill by 1816 and closed *c.* 1900. The façades of a three-bay office build-ing which was pedimented, and six-bay mill, all originally of three storeys, survive, in finely laid red brick.

## PRINCE'S GATE
### 2 m. SE of Narberth

*1312*

ST CATHERINE. Tiny roadside mission church. The nave with its W bellcote was built 1888 by *F.R. Kempson*, the chancel added in 1909 by *E.V. Collier*. Squared red sandstone, red brick around the lancets – not an unattractive combination. Modern FURNISHINGS.

CILRHIW, ½ m. NE. Small L-shaped house, stuccoed with hipped roofs. Begun around 1826 for Lancelot Baugh Allen, Master of Dulwich College. Square block added to the broad side of the house *c.* 1850.

## PUNCHESTON/CASMAEL

*0029*

Nucleated village, dominated by the 1,000-ft bare slopes of Mynydd Cilciffeth to the N and Mynydd Castlebythe to the E. Two single-storey cottages by the main junction, TY NEWYDD and WHITE HART, both earlier C19. N of the village street the two chapels and the church, and just E, CASMAEL, a Norman fortified enclosure with earth and stone curving banks.

ST MARY. Small stone single-roofed church with W bellcote and S porch, recorded in 1338. Nothing externally medieval now,

mostly of 1895, when restored for £375 by *E. V. Collier* with new windows and a very plain interior. Bolted pine roof trusses, with bracing to mark the chancel arch. – FONT. Medieval square bowl, chamfered below. – STAINED GLASS. E window, the Last Supper; chancel S, St David; and W window, St Mary, all of 1906–8 by *Heaton, Butler & Bayne*, muddy colours.

BETHEL CALVINISTIC METHODIST CHAPEL. 1891, rendered gable front.

SMYRNA BAPTIST CHAPEL. Roughcast and cement gable front, dated 1871 and 1928.

STANDING STONES. Several around the village, one N of the houses at the W end, another on the E side of the road running N, and a third on the slopes of Mynydd Cilciffeth, at Fagwr Fran. On the summit of Mynydd Cilciffeth are ROUND BARROWS.

SUMMERTON IRON AGE FORT. 1 m. WNW of Puncheston, (SM 990 302). On the summit of a small hill, a double ring circular enclosure with entry from the W.

CASTLEBYTHE/CASFUWCH, ½ m. E. Small village around another Norman MOTTE, part of the chain along the S side of the Preselis. The parish was small and the CHURCH opposite the motte has been demolished to the base of the walls. It was neatly rebuilt by *Edwin Dolby* of Abingdon in 1875 to designs illustrated in the *Church Builder* of 1868. E of the village is a large Iron Age FORT with double bank to the W.

MORVIL/MORFIL, 2 m. NE. Formerly a tiny parish squeezed between Cilciffeth and Morvil mountains. The church by the farmyard of Morfil Farm is derelict. Small, nave and chancel only, mostly of 1885 by *E. H. Lingen Barker*, with his typical two-tone window heads to the lancets. SW of the porch a small INSCRIBED STONE with ring cross.

# PWLLCROCHAN

<span style="float:right">9202</span>

On the slope to the S of Milford Haven. Only a pair of houses and the SCHOOL, 1861, with bellcote and hoodmoulded windows, near the church. LAMBEETH farmhouse, 1 m. SE, has a large external stone stack, early C18.

ST MARY. Converted to a house in 1994. The dedication stone of 1342 on the N transept, recording the rebuilding by Ralph Beneger, priest, is unique in Wales. Possibly reset, as the tracery of N transept and adjoining squint is Perp and looks C15. Nave and chancel, N transept, N and S porches, and small, typical south Pembrokeshire tower with charming stone recessed broach spire, in the position of the S transept. Restorations 1865 and 1897. The roofs are all C19, as is most of the tracery, also the N porch. The door within, unmoulded, is medieval. Plain whitewashed interior, with vaulted S transept under the tower. Two recesses in the chancel S wall, one formerly with a carved effigy said to be Ralph Beneger. The font and monuments have been transferred to Rhoscrowther.

HOLLY BUSH, $\frac{1}{4}$m. N. Overgrown shell of a miniature three-bay, two-storey later C18 house, of inexplicable sophistication, perhaps a curate's house built for a rich patron. Canted centre bay, the door in a Gibbs surround of red brick, diminutive false windows with brick keystones, and a stone band between floors.

PEMBROKE POWER STATION. Demolished 1999–2000, removing a short-lived landmark. When built 1963–72, on reclaimed mudflats at West Pennar, it was the largest oil-fired power station in Europe, with 2,000 MW output. Completed just before oil prices rose, however, it was never economical. The 713-ft (220-metre) concrete stack, 72 ft across at the base, was the highest point in south Pembrokeshire.

7023        RAMSEY ISLAND/YNYS DEWI
                    St Davids

The largest island of the northern group, across Ramsey Sound from St Justinians. A property of the bishops of St Davids until 1904, Ramsey is said to have had two medieval chapels, but no traces survive. The FARMHOUSE on the E side is early C19, three-bay, altered in 1963. Its enclosed courtyard of farm buildings is later C19, altered in the 1930s.

SOUTH BISHOP LIGHTHOUSE, on the largest of the Bishops and Clerks, the string of rocky islets to the w. 1836–7, by *James Walker*, similar to St Ann's Lighthouse, Dale. Built by *William Owen*. Stuccoed tapered tower with corbelled cornice under the cast-iron latticed lantern. Uninhabited now. The former keeper's house and oil store are adjacent.

0804            REDBERTH

Tiny village packed around the little church.

ST MARY. Rebuilt in 1841 by *George Brown*, engineer. At the reopening, Bishop Thirlwall chose to break new ground by preaching in Welsh (which he had just learnt). Alas, few in this English-speaking area would have understood a word. Nave, chancel, and curious toy-fort battlemented three-stage bell-turret at the w end, incorporating some Perp window dressings. Lancets. Refreshingly unaltered interior retaining the original BOX PEWS, their sides with pointed panels. Similarly treated raised PULPIT with attached reading desk. Arch-braced roof of 1913 by *F. R. Kempson*. – FONT. Norman square sandstone bowl on a circular pedestal. Carved crosses, flowers and scrollwork, possibly retooled. – STAINED GLASS. E window of 1926, by *Jones & Willis*, Good Shepherd.

# REYNALTON                    0908

Lewis' *Topographical Dictionary* records a village with 'every appearance of antiquity', the decaying cottages with circular chimneys; nothing of this is apparent now. Little evidence, too, of the C19, when this was a small colliery village.

ST JAMES. On a hillock, hidden behind a chestnut tree. Small, late medieval single chamber, with S transept and very squat battlemented W tower of the C15 with lower gabled stair-turret. Ground floor of the tower barrel-vaulted. S door and transeptal arch both four-centred. In the transept the lower part of a stone stair to the former rood loft, from which a corbel survives. – Small FONT, possibly Norman, though the square bowl is much cut down. – Late C19 FURNISHINGS.

# RHOSCROWTHER                    9002

A strange and unhappy village mostly evacuated in 1996–7 after an explosion in the nearby OIL REFINERY. The village setting, on a S-facing slope, protected from the Haven, is unusually attractive, the oil refinery largely concealed behind the crest. Below the church HILTON FARMHOUSE, with one of the best local examples of the big square outside chimney, C17 or early C18. The oil company has demolished the large Vicarage and most of the other houses.

ST DECUMAN. Disused. A large and rewarding medieval church, restored 1852 and again in 1869–70 by *F. Wehnert*, who re-roofed it and replaced much of the tracery. Repaired almost invisibly in 1910 by *W. D. Caröe*. Nave and chancel slightly angled, C13 to early C14, with N transept, SE chapel and tower over the S transept added in the late C14. N porch, and small vestry in an unusual SW position, both medieval but of uncertain dates. Sanctus bellcote on the nave. Fine south Pembrokeshire tower with corbelled parapet and C18 obelisk finials. The SW vestry is much altered; Caröe thought it might have been a small oratory. The N porch is large, almost matching the transept, stone-vaulted with rounded arch. The two armorial bosses are said to come from Angle church. Plain pointed door within, matching the blocked S door. Charming miniature carving of the Risen Christ reset above, late medieval. Plastered interior, with low arches to the rough-vaulted transepts. Surprisingly fine carved step into the N transept, the reused base of a C15 altar tomb. Chancel tomb recess, cinquefoil, cusped and crocketed with damaged side shafts, late C14 or early C15. Two-bay arcade to the SE chapel, with octagonal centre pier, and in the chapel, two tomb recesses, one with carved C14 female EFFIGY and an ogee-arched piscina. – FONTS. In the church, a small whitewashed, scalloped square font; in the porch, a much larger scalloped font from Pwllcrochan. Both C12 to C13. – MONUMENT. On the nave N wall,

F. Powell of Greenhill †1716. Baroque pilastered marble plaque, moved from Pwllcrochan. – STAINED GLASS. E window of 1878. – SE chapel E window by *Celtic Studios*, *c.* 1960. – One S window signed *H. Hughes*, 1880.

In the churchyard, former NATIONAL SCHOOL, 1851. Picturesque Tudor, with fish-scale slates and deep eaves, the windows with iron patterned glazing bars. Also the eroded stump of a CHURCHYARD CROSS.

44  EASTINGTON, ¼ m. NW. Remarkable late C14 tower house, on first appearance a compact and complete example of the south Pembrokeshire medieval stone house, with characteristic raised hall. The outside stone stairs possibly replace an original wooden structure. The rectangular hall is raised over a vaulted undercroft, with a small first-floor vaulted parlour and latrine in a wing behind, also over a vaulted undercroft. A stair-turret in the angle between gives access from the hall to an embattled wall-walk, so defence was an obvious requirement. The puzzle is the mark of a substantial gabled building on the W side: this poses the problem that the remains are either the cross-wing to a now-vanished hall on the model of Monkton (p. 296), or that the building is a self-contained hall-unit like Lydstep (p. 269) with a later block added. Eastington belonged to the Perrots in the C15. It was a gentry house in the C18, and the long, mid-C18 nine-bay farmhouse attached has a certain formality, with centre break and heavily rusticated front door surround. The scale indicates an ambition perhaps not fully realized. It belonged to the Meares family, who built Plas Llansteffan, Carms. in 1788.

HENTLAND, ½ m. ENE. Below the C19 farmhouse are the remains of Henllan, once a gentry house of the White family from

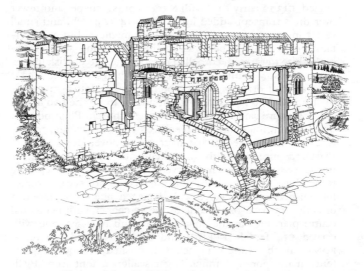

Rhoscrowther, Eastington. Reconstruction drawing

*c.* 1545 until 1677. A substantial stone range is now a barn, with blocked upper windows and end stacks, possibly C17. In front are earthworks of formal gardens and a once-elaborate large red brick garden archway, with a plaque read in 1891 as dated 171(?), now hidden by ivy. A very early use of brick (cf. Landshipping). In the field beyond a closely planted circular grove of ancient sweet chestnuts.

## ROBESTON WATHEN
<span style="float:right">*0815*</span>

CHURCH. In the centre of the hilltop village. Dominant C14 or C15 tapering embattled W tower. The rest practically rebuilt 1841–3 by *Joseph Jenkins*, and again, rather fussily, in 1876 by *T. G. Jackson.* A sketch of 1684 by Thomas Dineley indicates that the old plan was adhered to. Nave, chancel, N aisle and small S transept. Ribbed wagon roofs (kingposts in nave and aisle), arcade with smooth round piers (cf. Narberth). Tall shafted chancel arch with rood beam. Jackson's differently shaped windows (chiefly Perp in style) add to the visual restlessness. – Big, bold tub FONT by *Jackson,* in grey local limestone with fish-scale decoration. Its predecessor is late C18, with baluster-type pedestal: a rarity. – Small REREDOS in the transept, painted plaster, winged angels flanking the Crucifix, by *Joan Fulleylove* (daughter of the Victorian artist John Fulleylove), 1934. – Attractive FURNISHINGS by *Jackson,* including an oak pepperpot PULPIT, the upper panels with openwork carving. – STAINED GLASS. E window 1876, by *Ward & Hughes.* – Aisle NW, *c.* 1918, by *Kempe & Co.*

NATIONAL SCHOOLROOM (former), S of the A40. Dated 1872; bargeboarded gable incorporating bracketed bell-canopy.

ROBESTON HOUSE, SE of the church. Built *c.* 1820 possibly by *James Hughes.* Three bays, with hipped roof, the stucco removed. The rear wing is earlier, with Gothick windows. Red brick WALLED GARDEN.

## ROBESTON WEST
<span style="float:right">*8809*</span>

ST ANDREW. Raised churchyard, picturesque rural setting. A rewarding church. Broad tapering tower on the N side of the nave without battlements, C14 or C15. Nave with W bellcote, chancel with N aisle, N porch, the two latter abutting the tower and clearly later. The earliest fabric is the barrel-vaulted nave. Massively thick battered walls. Later chancel with shallow S projection which may relate to a lost S transept (see also the masonry below the S window of the nave). Spacious N aisle off the chancel, datable to *c.* 1500. Perp straight-headed windows. Arcade of two bays on an octagonal pier with simple cap. Perp chancel arch, simply chamfered, with imposts, probably part of a remodelling when the aisle was added. Corbels of the former chancel roof and also of the rood. The barrel-vaulted

porch also possibly *c.* 1500, with ogee-headed STOUP and stone benches. The ground floor of the tower is unusually covered with a simple ribbed barrel vault. Restored in 1863 by *W. H. Lindsey* with E.E. tracery of the simplest kind. Restored again, sensitively, by *D. E. Thomas* in 1908. – FONT. Square bowl with little corner scallops underneath, Norman. – PEWS by *Lindsey*. – Very simple oak REREDOS, 1925 by *John Coates Carter*. – STAINED GLASS. E window, *c.* 1900. – MONUMENTS. Sadly broken and worn C14 woman, with flowing outer mantle, her hands clasped. – Martha Roch † 1753. Tall, tapering white marble tablet with painted heraldry in the pediment, early C19, by *H. Woolcott* of Tenby. – John Evans † 1759. Pedimented. – Joshua Roch † 1829. Large urn, also by *Woolcott*.

ROBESTON HALL, NW of the church. Burnt in 1921, and demolished. The house was C18, with earlier parts. The ruined BARN, ICE-HOUSE and part of the WALLED GARDEN survive.

*8821*

# ROCH/Y GARN

There was no village at Roch, just the castle on its rock, the church and two farms. But from the 1950s bungalows filled the ground between the main road and the castle, a terrible waste of one of the dramatic sites of the county. The isolation of the castle is now only to be appreciated from the road to Cuffern. To the NW of Cuffern mountain, overlooking a steep valley, is SLADE IRON AGE FORT (SM 891 226), a semicircular enclosure with double bank to the S, and entry to the SW.

ST DAVID. Supposedly founded by Adam de Roche *c.* 1200, but with nothing visible of so early a date. Externally unremarkable, low nave and chancel with S porch, heavily restored 1858–9 by *R. K. Penson*, with coarse tracery. Vestry added in 1904 by *D. E. Thomas*. Penson's bellcote was removed in 1968. On the S side, the blocked remains of two C15 arches which divided nave and chancel from an aisle removed in 1799. The very Victorian-looking porch conceals a C15 panelled stone vault, as at Nolton, Tudor-arched, four by four panels, the ribs hollow-moulded. Inside, C19 open roofs, a chancel arch raised in 1798, and a plain, possibly C13, FONT: shallow square bowl chamfered to a ring. – PULPIT, 1918, in the style of *W. D. Caröe*, grey Forest of Dean stone, classical motifs. – In the chancel, fittings of 1859, thin iron altar RAILS, enamelled metal Decalogue boards, and the E window glass. – STAINED GLASS. In the E and SW, patterned windows with heavily stamped quarries, 1860 by *Powell*. – Viscount St Davids gave four windows by *Morris & Co.*, 1913–20, long after Morris and Burne-Jones, which show both the decline in quality and how much better than average their glass could still be. The figures in the W window of *c.* 1920, and the N Nativity window, 1917, still have the languor of Burne-Jones, and his rich depth of colour. The other N window, Suffer the little children, of 1913, is stiffer,

while the chancel s window of *c.* 1920, Christ and a Boy Scout (copied from a painting owned by the donor), is quite horrible. One s window of 1985 by *Celtic Studios.* – MONUMENTS. In a s wall niche, Rev. John Grant, 1790, in *Mrs Coade*'s artificial stone, a delicately cast female figure and classical pedestal, finely inscribed. – In the nave NE corner, John Stokes of Roch Castle †1770, and his wife †1800. Marble with urn, slightly gauche. – On the N side, Sarah Meredith †1820. Shield plaque by *W. Williams* of St Florence. – Early C20 alabaster plaques to the family of Lord St Davids.

ROCH CASTLE. A commanding presence on a craggy outcrop, 29 visible for miles around. Late C13, probably built for one of the descendants of Adam de Rupe or de Roche. Traces of an earlier earthwork castle in the grounds, and of an embanked bailey. The tower was made habitable for Sir J. W. Philipps, later Viscount St Davids, by *D. E. Thomas*, 1902–5, with further work *c.* 1910 and after 1918, the last by *D. F. Ingleton*. The castle is a single keep, square, but with curved SW and angled SE walls joining a slightly projecting s tower. This rises sheer to the battlements without corbelling; the rest has a deep corbelled parapet, more or less uniform at the corbels but varied at battlement level, stepping up to NW and NE angle turrets. The E side is rougher, the SE wall with a projection at the junction with the E wall and projecting stones which suggest that a curtain wall may have been intended or removed. Small two- and three-light stone mullion windows, C20, carefully done, apart from one harsh plate-traceried SE window which looks C19. An added range set much lower to the N does not intrude. Before reconstruction the interior had a basement which may have been a barrack, with straight stair up to the main first-floor room accessible by an outside ladder or wooden stair. A

Roch Castle. Engraving, 1888

small vaulted oratory in the front s projection. Both the main room and the room above had fireplaces.

CUFFERN, 1 m. E. Once a plain seven-bay, three-storey stuccoed house, said to have been built in 1770 for John Rees Stokes, but much altered since, the parapet removed after a fire in 1899, the stucco stripped and the interior gutted in the C20.

HILTON. Early C19, but late C19 in character, hipped, with two-storey bay windows. Below the house, HILTON MILL, an unusually large mill of 1851, basement and two storeys, five bays with stone window heads and broad elliptical-arched front door. Undershot iron wheel. Converted to flats.

SOUTHWOOD, 1½ m. W. Large farmhouse of 1822, with a cemented plain front, once slate-hung, of five bays, facing over one of north Pembrokeshire's best surviving FARMYARDS. Cement-grouted roofs to stone buildings, none especially large, ranging from the small outside kitchen by the house to the farm ranges around the L-plan yard. Some incorporate medieval carved stones. The short E arm has a coach house, with pigsties along the end wall. The long, narrow yard below the house has a lofted barn, cowhouses, and stables, the lower range dated 1854, and the cart-entry at the top of the l. range dated 1822. Particularly attractive is the complex of stone-walled enclosures uniting the group: curving entrance walls, walled garden W of the house, fold-yards in the farmyard, the house front yard, an enclosure by the outside kitchen, and the pig-sties. By the outside kitchen an arched entry opens into a short stone-vaulted chamber with bread oven on the rear wall, the triangular vault more akin to limekilns than older types, so probably not an ancient survival.

# ROSEBUSH
### Maenclochog

0729

On the side of the Preselis in open moorland, Rosebush was, albeit briefly, the most important Pembrokeshire slate quarry, developed on an industrial scale from 1870 by Edward Cropper, of Swaylands, Kent, a retired Manchester businessman. Cropper spent £22,000 up to 1879 building at his own expense the Maenclochog RAILWAY from Clunderwen, 1872–7 (T. Macdougall-Smith, engineer). In the village, he built the TAFARN SINC, 1877, originally the Precelly Hotel, a two-storey railway hotel of corrugated zinc, and the TERRACE, 1874, by Macdougall-Smith, a row of quarrymen's cottages on the track to the quarry. These are low, two-storey, with tiny upper windows, and were of one room per floor (twenty-six originally, now twelve). The larger first house, the OLD POST OFFICE, was the manager's. In the quarry, the processing MILL survives, roofless under the towering terraces. The returns never matched the investment; the market collapsed in 1876–7. Cropper died in 1879, and the railway closed in 1882. Mrs Cropper married Col. John Owen, local landowner, and tried to market the windswept

village as a holiday resort. Col. Owen disliked the visitors: 'not one word can be said in favour of them . . . a pint of beer is perhaps the only harvest of the town through which they pass'. The railway was restarted twice, reaching Fishguard in 1896, but the quarry was never reopened.

FOEL CWMCERWYN, 2 m. NE. The 'very summit of the Andes of this county' (Fenton), at 1,760 ft, with four Bronze Age cairns. Fenton's description of his excavation of one in 1806, that yielded a funerary urn in a stone-lined circular cist, is a delightful account of Georgian amateur archaeology.

## ROSEMARKET/RHOSFARCED

9508

A sizeable village, unusually laid out along two long parallel streets.

ST ISMAEL. Nave with N porch and N transept, chancel. W bell-cote. Two-light Perp panel-traceried window in the N transept. Heavily restored. *R.K. Penson* restored the nave in 1859, adding the plate-traceried windows on the N side. In 1868 *E.H. Lingen Barker* added the vestry and the present bellcote, whose earlier broad base suggests that it was like others in the vicinity, e.g. Hasguard. *T.P. Reynolds* between 1888 and 1894 added new roofs in chancel and transept, and fittings. Repaired in 2000 by *Wyn Jones*. Rounded inner doorway plastered and undatable. Squint window each side of the chancel arch, the detail all C19. Reynolds discovered the long-blocked windows *in situ*, but found it necessary to rebuild the whole chancel arch. Cavernous squint passage between transept and chancel. Was there a S transept? The recess in the chancel may be an associated feature. – FONT. Norman, cushion type, retooled. – PEWS by *Reynolds*. – STAINED GLASS. E window of 1962 by *Celtic Studios*.

Immediately to the N, an IRON AGE CAMP, a low-lying oval enclosure, with a single bank and ditch; an additional outer bank on the flatter N side. The ground slopes steeply away on the S side.

CROSS FARM; opposite the church. Modernized and altered farmhouse of four bays, but with a barrel-vaulted undercroft from the medieval house.

All that remains of ROSEMARKET HOUSE is a big medieval circular DOVECOTE on the E side of the village. The house was the ancient home of the Walter family (among whom was Charles II's mistress, Lucy Walter). In ruins by Fenton's time, the last fragments were demolished *c.* 1960.

THE GLEN, ⅓ m. E. Former vicarage of 1855, by *Hugh Hoare*. Three bays by three. Steeply pitched hipped roof with central chimneys. Bay windows added *c.* 1890.

GREAT WESTFIELD, 1 m. E. Mid-C18 house of five bays and two storeys, with longer parallel rear range. Above the door, a Venetian window adds an unusual note of sophistication. Some

good detail inside, including a staircase with turned balusters, three to each tread, like that at Camrose. A painted wood Adam-style chimneypiece and a round-backed cupboard in moulded surround in the drawing room.

JORDANSTON HALL, 1 m. SW. Large, three storeys and five bays, the detail and perhaps the two r. bays are early C19 alterations to an C18 house.

In 1936–7 a small-holding scheme centred on the Jordanston estate was set out by *T. Alwyn Lloyd*, for the Welsh Land Settlement Society. This provided thirty-four houses for families drawn from the mining areas of south Wales, and from Pembroke Dock. The scattered HOUSES are of several designs, roughcast and colourwashed, mostly arranged in pairs. Plain detail, relatively unaltered but for some replacement windows and truncated chimneys.

THE HANGING STONE, 1 m. E. Near the hedgebank, remains of a NEOLITHIC BURIAL CHAMBER, the large capstone supported by three uprights, one within the hedge.

# RUDBAXTON

ST MICHAEL. Set in a broad hollow. Tapering W tower, no battlements, completely lime-rendered in 2001, by *Frans Nicholas*. Trefoiled S belfry-light and a pair of lancets on the W side. The simple two-light panel-traceried W window C15 or C16. Ground floor with shallow barrel vault. Nave, chancel, long S aisle and barrel-vaulted S porch. The nave appears to be the earliest medieval fabric, the narrower chancel slightly later. The porch is probably C15, the aisle certainly a C16 addition, with Perp straight-headed windows, the easternmost with crudely carved label masks. Incised SUNDIAL, SE corner of the aisle, dated 1689. Four-bay arcade, two bays each in chancel and nave. Roughly cambered arches on round piers with simple caps. The plain pointed chancel arch has a large carved male and female head corbel on each side of the reveal; much repaired, perhaps placed in this odd position when the chancel arch was rebuilt in 1845, as part of a restoration by the young *Ewan Christian*. The Oxford Society in 1845 praised the vicar for the care taken in restoration, though Christian rebuilt and heightened the chancel arch, and completely replaced the roof. Restored again in 1892 by *R. G. Pinder* of Bournemouth, replacing Christian's roofs. – FONT. C12 square bowl with scallops, circular pedestal. – PEWS and STALLS 1892. – STAINED GLASS. Aisle S, Saints, *c.* 1920, by *R. J. Newbery* – MONUMENTS. Rudbaxton is justly famed for its earliest monument, the splendidly large memorial to the Howard family of nearby Fletherhill, erected soon after 1685 by Joanna Howard, blocking the E window of the aisle. Set high, crowded within three recesses, are several theatrical full-length figures, nearly life-sized, all bearing skulls. In the centre, James (†1668) and Joanna hand in hand, in unusually splendid dress. In the l.-hand opening

their son, George Howard (High Sheriff in 1659, †1665). On the other side, more children: Thomas (M.P. for Haverfordwest in 1681, †1682) and Mary, in similar pose to their parents, but with the female figure slightly more prominent. Are these confidently carved figures imports from Bristol? – there are certainly no others like this in the county. They have been repainted in bright modern colours without research as to the original scheme. The more rustic framework may be local work. Leafy spandrels, large swan-neck pediment with cartouche. Well-lettered inscriptions below each group. – Thomas Picton and his son John, both †1727. Inscription in two superimposed ovals with skulls in the spandrels, limestone. – William Meredith †1770. Small white marble tablet with urn and broken pediment. – General William Picton †1811, who served at the Siege of Gibraltar in 1782. Moulded frame with shield above. – Major General John Picton †1815. Large sarcophagus-type tablet with recumbent lion, shield and banners above. By *Daniel Mainwaring* of Carmarthen, who had clearly never seen a lion. – General Sir Thomas Picton †1815, bust cast in 1907, from the memorial at St Paul's Cathedral by *S. Gahagan*. – Frances Phillips †1840. Wide tablet set in frame, signed by *J. Thomas*, Haverfordwest. – William Owen (the architect) †1879. Simple tablet by *Currie* of London.

BETHLEHEM BAPTIST CHAPEL, 2 m. E. 1820. Slate-hung three-bay lateral façade with tall rounded windows. Entry at the gable-end (masked by the modern schoolroom), an alteration of *c.* 1875, when the interior was refitted. Gallery along three sides on marbled timber columns. Small ORGAN of 1829 by *John Smith Sen.* of Bristol, from the Moravian chapel, Haverfordwest. Adjoining MANSE, rebuilt 1907. In the graveyard, MONUMENT to the Rev. D. Rees †1827, slate between big stone piers, a treasure of rustic detail.

POYSTON, 1 m. SE. Hip-roofed house of three bays and three storeys, the family home of General Sir Thomas Picton, born in Haverfordwest in 1758 as the house was being rebuilt. The rear wing has a projecting chimney indicating earlier work. The front range looks *c.* 1820–40, *see* the panelled shutters and the glazed framing to the door, but there are oddly thick glazing bars and some fielded panelled doors which look older. After Picton's death at Waterloo, the house was sold to the Rev. T.S. Martin of Withybush, next door, and he may have rebuilt. Both estates were bought *c.* 1860 by the architect *William Owen* but he seems to have added little but a porch, now removed. The major renovation was in 1899–1901 by *D.E. Thomas* for Owen's son Henry, solicitor and antiquary, replacing the stucco with a softer roughcast, adding a handsome timber cornice and a matching two-storey library.

The interior was much remodelled by *Thomas*. The front hall has an Arts and Crafts chimneypiece containing a plaster relief of Picton, surrounded by the names of his various battles. Armorial stained-glass stair window by *A.F. Dix*. Best of all is

the splendidly collegiate LIBRARY, in early C18 style, galleried on all four sides, with little opposing theatrical balconies, panel-fronted with gilt detail, all rather too grand for a country house but very effective in such a small space. Coved ceiling; chimneypiece with arms of George Owen of Henllys, the historian, from whom Dr Owen claimed to be descended. The bookcases are in the gallery which has a very avant-garde timber overmantel with beaten copper ornament. The quality of the whole library suggests that Thomas had an outside collaborator here.

BOWLING HOUSE ½ m. E. The former rectory, 1845 by *William Phillips*. Hipped, with the door in the side wall, the main façade thus blank in the middle, a plan much favoured for parsonages.

CRUNDALE RATH, 2 m. SE. Large, circular hilltop IRON AGE ENCLOSURE, defended by a double bank-and-ditch system, the outer bank slighter on the steeper N side. No sign left of the outer ditch. Original entry on the N side. A low bank enclosing a small area to the SW may be medieval. A medieval chapel to St Leonard lay on the bank to the NE, with nothing surviving, except ST LEONARD'S WELL, its masonry repaired 1904.

# ST BRIDES

The church stands near the sea, above a little rocky cove. An ancient fishermen's chapel once stood at the cliff edge and is said to have been swept away by the sea. Early STONE COFFINS have been exposed due to erosion. Some scattered cottages, fine views towards the St Davids peninsula, and a LIMEKILN, one of many along the West Wales coast.

ST BRIDGET. Long nave, chancel, N transept, tiny aisle N of the chancel, and S porch. The nave has a bellcote at each end, each with paired openings, lintels to the W and arched to the E. Traces of a lost S transept. Well-preserved rood stair, the E door with slightly ogee moulded head. Corbels of the rood loft visible. The E window of the transept looks Dec, with trefoiled head. Another medieval lancet to the chancel S. Plain pointed chancel arch. PISCINA with pointed head, the bowl corbelled out. The arch into the chancel aisle is segmental, and appears to be post-medieval. Restored in 1869 by *Charles Buckeridge*, his windows simple lancets. – FONT. Square bowl with scallops, a standard Norman type: it stands on the upside-down octagonal bowl of another font. – FURNISHINGS by *Buckeridge*. – Timber REREDOS of 1911, the arcading on spiral shafts. – Part of a late medieval SCREEN, a rare survivor in west Wales. Two bays, with crudely carved Perp tracery. – Carved cupboard DOOR, early C17. – WOODCARVING, possibly originally from a ship. Semicircular, *c.* 2 ft wide, apparently depict-

ing the visit of Sheba to Solomon, shown enthroned with his retinue. Confidently carved, with a riot of beasts and figures. The thick carved frame looks early C18. Discovered in the church in 1869, and cleaned of its paint. – STAINED GLASS. Good E window of 1869, Life of Christ. By *Bell & Almond*, according to M. Harrison. – Three chancel S windows, SS Michael, Gabriel and Raphael, 1911. – Transept S, *c.* 1870, Raising of Lazarus and the Daughter of Jairus, and another of *c.* 1880, Blessed are the Pure in Heart: both of some quality. – Transept N, *c.* 1875, Resurrected Christ. – In the nave, a set of six by *Herbert Davis*, 1901; depictions of Christ, e.g. as King, Good Shepherd etc. in a sketchy style. – Two W windows of 1892, by *Cox & Son*, SS David and Bridget. – MONUMENTS. In the transept, three very mutilated C14 slabs, all with carved heads, and a damaged recumbent effigy, with shroud-like drapery. – William Philipps †1792. Wide draped urn. – Sir Godwin Philipps †1857. Shaped tablet by *T. Morgan & Son*.

Outside, a set of Celtic memorials to the Lords Kensington of St Brides Castle, 1881–1981, including three wheel-crosses and two tombs. Plenty of Celtic detail and Freemasonry symbols. By the porch, a Grecian chest-tomb to Benjamin Ferrior †1836. Well carved by *Thomas Morgan*.

CRANFORD, SE of the church. Former rectory of *c.* 1800, a curious perhaps pattern-book design with the façade under a broad gable with centre chimney. Three-bay, slate-hung S front, the middle bay slightly advanced containing a giant recessed arch. A garden gate is dated 1757.

ST BRIDES CASTLE, ½ m. WSW. A large castellated mansion of 1833 for Charles Philipps, much enlarged after 1905. Thin stucco detail, corner turrets, battlements, hoodmoulded windows, the whole effect collegiate, in odd but attractive contrast with the wild rocky shore at the edge of the rolling park. Wide Tudor-Gothic porch on the N side. E front of seven bays, the centre three rising to three storeys. Could the architect be *Thomas Rowlands*? Large extensions for Lord Kensington, 1905–1913, by *James Barbour & Bowie* of Dumfries (who worked for Lord Kensington's family at Lockerbie). A large rear service wing was added, the two r. bays of the N side were heightened as a four-storey tower, making that façade asymmetrical. Fine red sandstone bay window added in the centre of the E side (probably on the site of the original entrance). The additions keep to the Tudor style with great success; and the whole is unified by a coat of roughcast cement. Crowstep gables to the service wing. Interiors of 1905–1913: the ENTRANCE HALL on the N side, has a coffered ceiling, and fireplace with Kensington's arms. Octagonal LIBRARY in the centre of the E front (former entrance hall?). This C20 remodelling constitutes the last major country house work in Pembrokeshire.

Large STABLE BLOCK of 1833, the entrance range Tudor, with a cupola. To the W, a WALLED GARDEN with FARM

BUILDINGS to the S. The house was sold in 1923, and became a hospital; converted to holiday apartments 1990–2 with surprisingly little visual impact, by *David Williams Associates*.

THE ABBEY. Along the main driveway to St Brides Castle. Ruins, not monastic, but possibly the remains of the house of John de St Bride, a powerful supporter of Henry VII. The largest is a small roofless building of three storeys, possibly in origin a late medieval first-floor hall house. Much altered in the C18, no original openings intact. Stubs of walling to the SE indicate a stair-turret. The main building is attached to a pair of WALLED GARDENS, some walls with corbelled, embattled parapets. On the N side, an impressive embattled GATEWAY with cambered arch, possibly C16; early C19 pretty colour-washed cottages alongside.

WINDMILL PARK, ¾ m. E. An attractive and well-preserved farm-house of the early C19, four bays and two storeys, the front and W end hung in slate.

THE NAB HEAD, ¾ m. W. IRON AGE PROMONTORY FORT, facing out to sea, lying on a rocky headland. One inner and two less prominent outer banks and ditches, the N end of the defences eroded away. Single entry in the centre. Excavation in 1971 revealed a circular stone hut with single entrance and hearth, and indicated that the inner defensive bank was built in two phases.

9800                    ST DANIELS

ST DANIEL. Isolated hilltop site, overlooking Pembroke. Disused. Nave, chancel, and tapering C15 W tower, with splayed base. The thin broach spire may be slightly later. Nave, with tall barrel vault, probably C14; later chancel, also vaulted, (*see* the exterior masonry joint). Repaired 1849, restored 1893 (the spire rebuilt after being struck by lightning in 1896). Lancets of 1893. Bare interior with a late C18 panelled PULPIT, no longer in its original position. In the C18 the church was used by the Calvinistic Methodists; Wesley (barred from St Mary's Pembroke) preached here from 1769 to 1790 and the Baptists worshipped here before it was converted to a mortuary chapel in 1849.

# ST DAVIDS

## ST DAVIDS/TYDDEWI

7525

The setting of the great cathedral, hidden in the valley of the river Alun, in the bare and rocky landscape of Dewisland, testifies to the harsh world of Saint David (*c.* 520–89), a world whose life-lines were on the sea rather than on the land. The geologically complex landscape was intensely colonized in Neolithic times, dotted with burial chambers and standing stones. The Celtic occupation of the first millennium B.C. still defines the region. Richard of Cirencester's medieval story of a Roman port at a place called Menappia remains unproven, but new discoveries of a Roman road across mid-Pembrokeshire make it more likely. In the C5 the area was colonized from Ireland, and it remained bilingual and linked to Ireland until C11, a part of that sea-borne Celtic Christian world of the Irish Sea, SW England and Brittany.

In the C5 Ireland had been converted by missionaries from Britain, including St Patrick. David came from Ireland *c*. 550 to set up his ascetic community at a place called *cille muni* in Irish, the cell of the bush or scrub, from which the old Welsh name Mynyw, and the Latin Menevia derive. The name Tyddewi (David's house) is of much more recent date. St David was reputedly baptized by St Ailbe of Munster, missionary to Demetia (Dewisland), and his Rule was based on that of St Finnian of Clonard. St Madoc of Ferns was a pupil of St David *c*. 580 before returning to Ireland.

St David's Rule was harsh: 'he that does not work, neither shall he eat', animals were not used or eaten, the land was tilled by hand, gifts were not accepted, and nothing was individually owned. Any buildings of his time would have been of the simplest, and no trace remains. The ascetic tradition continued to the late C10, but little is known of the later history. Asser went from St Davids in the late C9 to promote learning in Wessex, and wrote the life of King Alfred. The community was repeatedly attacked from the sea, eleven times between 906 and 1089 according to the Welsh Annals. William the Conqueror came as a pilgrim in 1081, and on the death of Rhys ap Tewdwr in 1093 the Normans were able to take over the monastery and shrine, and establish an episcopal seat with secular canons. The canonization of St David, *c*. 1120, and the decree that two pilgrimages there were the equal of one to Rome, ensured that St Davids remained a centre of pilgrimage right through the medieval period. The first Norman cathedral was consecrated in 1131 but demolished for the much larger present building in 1176. For the subsequent history *see* below. The bishopric was very large, extending over most of mid- and sw Wales, but at the Reformation the removal of the bishop's seat to Abergwili, near Carmarthen, began the long period of decline, arrested in the late C18 with the first restoration programme.

The town of St Davids was always small, the Close wall enclosing the Bishop's Palace, subordinate buildings and canons' houses in the valley, while the settlement without, on the hilltop, was a ribbon of houses down the road from Haverfordwest to the market cross and smaller fingers out to the sw towards the port at Porthclais and NE on the road to Fishguard.

## THE CATHEDRAL

### BY ROGER STALLEY

St Davids is the most sophisticated cathedral in Wales, and, for a church of such importance, has an unassuming, almost secretive location. Far from dominating the skyline, the cathedral is tucked away in a valley below the modern town, a sheltered spot where St David had founded a monastery in C6. While the setting may have been ideal for eremitic monks, it was not very satisfactory for a great medieval church. From the start, architects

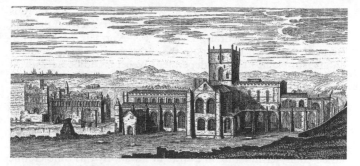

St Davids Cathedral and Palace from the south east. Engraving by
Samuel Buck, 1740

had to wrestle with the problems posed by a sloping site and
uncertain foundations, difficulties that have afflicted the building
throughout its history. There are two main approaches to the
cathedral, both remarkable. Coming from the town, the visitor
passes through Porth y Twr, the E gateway into the close, and
suddenly the whole building is laid out below. At this point one's
eyes are level with the centre of the crossing tower, and the spec-
tator looks down on the roofs of the cathedral as if gazing at an
aerial photograph. The cathedral at Llandaff has a similar situa-
tion, but this first glimpse of St Davids is altogether more dra-
matic. The second approach is along the valley of the river Alun
from the SW, the favoured route in the middle ages for travellers
arriving from the harbour at Porth Clais, less than 1 m. away.
From this vantage the cathedral seems to hug the floor of the
valley, with the huge crossing tower and Scott's façade of purple
sandstone dominating the view. A meadow now stretches up the
valley towards the cathedral, where cattle sometimes graze within
a few yards of the W front.

*Acknowledgements*: In preparing this account I owe much to the
assistance of the vergers Barrie Webb, John Caines and Byron
Davies, as well as to the cathedral librarian, Nona Rees. I am
also grateful for valuable comments provided by Stuart Harrison
and David Robinson. But most thanks must go to the Dean, the
Very Reverend Wyn Evans, whose knowledge of his own cathe-
dral must be unsurpassed within the Anglican world. R.S.

*1. History*

Apart from an extensive collection of decorated stones and
crosses (now housed in Porth y Twr), there are no visible remains
of the monastery founded by St David. In line with the practice
of the pre-Norman church, it is likely that a number of small
churches existed at the site until the C12. A dedication was
recorded in 1131, an indication that Bernard (1115–48), the first

Norman bishop, had erected a new church, but of this there is no trace (unless it is reflected in the irregularities seen in the plan of the existing cathedral). Despite his Norman background, Bernard did much to promote the interests of the see, reviving an ancient claim for an independent Welsh archdiocese with St Davids at its head. It was a claim that kings of England and archbishops of Canterbury firmly resisted. The annals record that the old cathedral was destroyed in 1182, when a new building was started under the auspices of Bishop Peter de Leia (1176–98). The core of the existing cathedral survives from this time. It takes the form of a six-bay nave with aisles, transepts and a four-bay aisled choir, terminating in a straight E wall. By this time Gothic architecture had made an appearance in the west of England, most conspicuously at Wells cathedral, but St Davids was more Romanesque than Gothic. Unfortunately the sequence of construction is difficult to determine with precision, the situation clouded by two disasters that befell the cathedral in the C13. In 1220 the new crossing tower collapsed, and this was followed in 1247/8 by an earthquake that destroyed a 'great part' of the church. The impact of the earthquake, however, is not easy to discern in the fabric.

For the rest of the middle ages the story is one of additions, rather than reconstruction. At some point in the first half of the C13, the cathedral was extended to the E, with the construction of a retrochoir and Lady Chapel, additions perhaps associated with arrangements made between 1231 and 1247 for a daily mass in honour of the Virgin Mary. Although there is a record that Bishop Martin (1293–1327) built 'St Mary's chapel', the few fragments that remain from the original building look more C13 than C14. The E enlargement, with low level aisles and chapels, follows a pattern adopted in several cathedrals in the south of England, cf. Winchester, Salisbury and Wells. It increased the length of the building to something in excess of 300 ft. In later centuries there were many alterations to the retrochoir and chapels, the history of which is hard to unravel. As Jones and Freeman, the C19 historians of St Davids, observed in 1856, 'nothing but a personal inspection can give the slightest notion of the difficulties to be encountered at every step'.

In 1274–5 a shrine was erected in the choir to contain the relics of St David, which had been 'miraculously' discovered shortly before. The cathedral had long been regarded as the principal shrine of St David, attracting visits from Henry II on two occasions in 1171–2. The cathedral also possessed the relics of St Caradog †1124, a local hermit and holy man, whose tomb is situated in the N transept.

Extensive changes are associated with the episcopate of Bishop Henry de Gower (1328–47) also the builder of the Bishop's Palace (q.v.). An elaborate pulpitum, that also contained the tomb of the bishop, was erected under the W arch of the crossing, probably in the 1340s, and this splendid Dec work remains one of the highlights of the cathedral. At about the same time the aisles of the cathedral were remodelled.

In 1365 Bishop Adam Houghton (1361–89) founded, with the encouragement of John of Gaunt, the college of St Mary on a site immediately to the N of the cathedral, the college being designed for a master and seven fellows whose task was to ensure the proper maintenance of divine offices. In his will he endowed the college with a sum of £100. The architecture of the college included a substantial chapel and a cloister, the whole arrangement recalling some of the early colleges at Oxford and Cambridge. St Mary's was dissolved in 1549, and the buildings fell into ruin soon after.

Returning to the cathedral, only a modest amount of building seems to have been undertaken in the century after de Gower's episcopate. In the decades around 1500, the Lady Chapel was reconstructed, the adjoining retrochoir remodelled, and a new timber ceiling installed over the choir. Perp tracery was inserted into the windows in the nave. None of this work was particularly distinguished, but the early C16 brought two innovations of outstanding quality. First, under Bishop Vaughan (1509–22), the space between the choir and retrochoir was converted into a fan-vaulted chapel (the Trinity Chapel), the whole design being executed in an accomplished manner in yellow limestone. Then in about 1538 an ornate pendant ceiling was added to the nave, a ravishing piece of carpentry that remains one of the architectural glories of the cathedral. Apart from the loss of St Mary's college, the Reformation had little immediate effect on the architecture of St Davids. There was, however, a threat of a different sort. Under Bishop William Barlow (1536–48), an ardent protestant, St Davids almost lost its cathedral status, for Barlow was keen to transfer the see from 'a barbarous desolate corner' to a more accessible location at Carmarthen, a proposal resisted successfully by the canons.

Far more destructive was the occupation by Cromwellian troops in 1648, which marked a turning point in the fortunes of the cathedral. As well as the loss of stained glass and bells, lead was stripped from the E end of the building. The roofs disintegrated, leaving extensive sections of the church (choir aisles, transepts, and retrochoir) vulnerable to the elements. Although the transepts were re-leaded in 1696, most of the E limb of the cathedral lay abandoned for over two hundred years. The Lady Chapel was protected for a while by its stone vaults, but these eventually collapsed in 1775. By this stage the cathedral was a forlorn and segregated monument, the choir cut off from the nave by a solid wall under the W arch of the crossing. The structural problems got worse when the outward rotation of the W front threatened to bring down parts of the nave: old prints and drawings show the façade temporarily supported by wooden props. In 1791–3 *John Nash* undertook a more substantial repair, reconstructing the upper parts of the façade in a hybrid Gothic style, complete with large freestanding buttresses to the W. Regarded with contempt by Victorian purists, this was replaced in the 1880s by a neo-Romanesque façade designed by *George Gilbert Scott*.

The reconstruction of the façade was one of several Victorian interventions that gradually rectified the problems caused by two centuries of neglect. In the 1840s *William Butterfield* carried out alterations in accordance with the principles of the Ecclesiologists. The s transept was fitted up as a parish church, and Dec tracery was inserted throughout the cathedral. Butterfield's tracery still survives, albeit much restored. It includes a huge curvilinear window, inserted in the N transept at a cost of £130, modelled on one at Sleaford in Lincolnshire. More substantial was the programme of restoration and refurbishment started by *George Gilbert Scott* in the 1860s and continued by his son *John Oldrid Scott*, a programme that lasted for almost half a century. Scott had provided a report of the fabric in 1862 and he was especially alarmed by the precarious state of the crossing tower. The W crossing piers were rebuilt without harming the tower above, an audacious feat of engineering of which the architect was justifiably proud. Scott also reinstated the aisles of the choir, and repaired the C15 panelled roof. He installed timber vaults in the transepts, raising the outer roofs to the C13 pitch. The nave clerestory was restored and the W façade completely rebuilt using a strident purple stone taken from quarries on the cliffs nearby (*see* below). The Lady Chapel was re-roofed and restored in 1901 under the direction of *J.O. Scott*; the aisles of the retrochoir followed soon after. By 1910 all those areas of the ancient cathedral that had been abandoned in C17 and C18 had been brought back into use. Attention subsequently turned to the ruins of St Mary's college, which in 1965–6 were converted by *A. Caroe* for use as a general hall. Since the death of J.O. Scott, the work of repair and restoration has remained in the hands of the architectural practice founded by *W.D. Caröe*. At the time of writing there are plans to rebuild the cloister, using timber as the basic material.

One of the most distinctive features of St Davids is the character of the dressed masonry, most of it obtained from the sea cliffs at Caerfai and Caerbwdy, close to the cathedral. The material is a tough sandstone, which comes in two colours, a grey or greeny grey, and a more vehement purple. The quality of the stone helps to explain why the details on the late Romanesque capitals are so well preserved. The same quarries provided the stone for G.G. Scott's work on the façade, though for some reason the architect opted for the material with the purple hue. By the early C13 the local stone was being supplemented by a yellow oolitic limestone, imported from Dundry near Bristol. This was used in the transepts, the tower and the E chapels, often in an alternating sequence with the local grey sandstone. The alternating pattern was rarely maintained with any consistency, a consequence perhaps of the irregularity of supplies from Dundry. The quarries at Dundry supplied stone for many buildings along the Bristol Channel (including Llandaff Cathedral) and there was also an extensive trade with Ireland. Yellow limestone, possibly from Dundry, was the material used for Bishop Vaughan's chapel and for three flying buttresses inserted on the

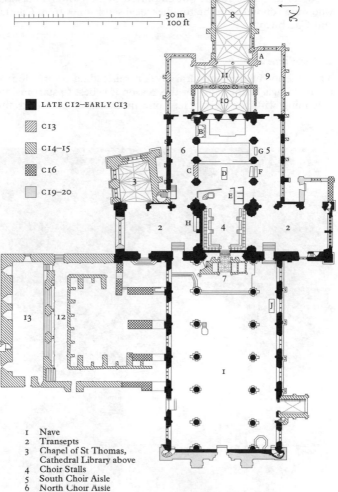

30 m
100 ft

LATE C12–EARLY C13

C13

C14–15

C16

C19–20

8

A

11 9

10

B

6 G 5

C D F

3 E

2 H 4 2

7

J

13 12

I

| | |
|---|---|
| I Nave | |
| 2 Transepts | |
| 3 Chapel of St Thomas, Cathedral Library above | |
| 4 Choir Stalls | |
| 5 South Choir Aisle | |
| 6 North Choir Aisle | |
| 7 Pulpitum | A Tomb of the Countess of Maidstone |
| 8 Lady Chapel | B Monument to Thomas Lloyd |
| 9 Retrochoir | C St David's Shrine |
| 10 Trinity Chapel | D Tomb of Edmund Tudor |
| 11 Cross Passage | E Bishop's Throne |
| 12 Cloister walk | F Tomb of Bishop Anselm |
| 13 St Mary's College (Former Collegiate Church above) | G Tomb of Rhys ap Gruffydd |
| | H Shrine of St Caradog |
| | J Tomb of Bishop Morgan |

St Davids Cathedral. Plan

N side of the nave. It was not employed by de Gower's masons, who were content with the tougher local sandstones from Caerfai and Caerbwdy.

20  *2. Nave interior*

The exterior of the cathedral gives a misleading impression of the building's history and for this reason it is best to start inside, beginning with the nave. Here one immediately confronts the

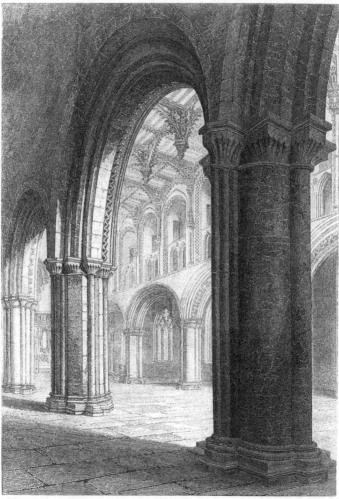

*O. Jewitt del.*                                    *J.H. Le Keux fc.*

St Davids Cathedral. View of the nave looking south east.
Engraving, 1856

problems of the site: the floor has a pronounced slope and none of the main architectural lines appear to be horizontal. Moreover, the main walls have rotated outwards, and, increasing the feeling of instability, the piers lean towards the w, as if the whole structure is about to tumble down the valley like a pack of cards. Despite the lack of equilibrium, the overall design is a coherent and highly ornate piece of late Romanesque, dating from *c.* 1182–1200. Notice the breadth of the nave in relation to its height (less than 46 ft). There is an absence of vertical lines, so here we encounter that stress on horizontality so often associated with English building of the time. Equally significant is the broad spacing of the piers, almost 22 ft from centre to centre, far greater than was normal. This allows for only six bays, when eight or nine would have been possible (and perhaps advisable, given the slope). The piers themselves are what the French term *pilier cantonné,* a circular core with four shafts attached. Although complex piers with extra shafts were a feature of English architecture at this period, there are no exact parallels for St Davids, where the core

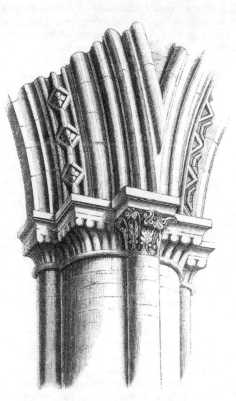

St Davids Cathedral. Detail of capital in the nave. Engraving, 1856

alternates between a circle and an octagon. There is one further
subtlety to notice. On the side facing the aisles, three extra shafts
were provided to take the ribs of a vault, which was never in fact
erected. This is our first encounter with a recurrent peculiarity of
St Davids, namely the provision of vaulting shafts, most of which
remained unused. One gets the impression that stone vaults were
regarded as an 'optional extra', to be added only if resources and
the structure of the building allowed.

p. 393 Throughout the nave, the capitals are carved with great pre-
cision in the local sandstone, most taking the form of trumpet
scallops. A few have crisply carved foliage, and one has tiny
human figures. In several instances the capitals are devoid of
necking rings, a mannerism, like the trumpet scallops, derived
from the English 'west country school'.

The main arches consist of three orders, the centre one with
chevron, the patterns varying from bay to bay (in the 4th bay
they are interrupted by a circular motif, later copied by Scott on
the W façade). On the side facing the aisle, the chevron was
omitted, an economy that highlights the importance of the
central vessel. In the upper storeys, triforium and clerestory are
combined, a scheme that foreshadowed more advanced schemes
of linkage in English Gothic architecture. The rhythm of the
design quickens noticeably at this point, with two bays in the tri-
forium/clerestory corresponding to one below. Each sub-bay is
enclosed by a high arch, embellished with chevron in a variety
of patterns, carefully matched N and S. The whole design was
worked out with care, the broad arches below being wide enough
to allow for the doubling of the bays above. The triforium
includes circular motifs in the spandrels, alternately embellished
with dogtooth and intersecting beaded semicircles. In the struc-
ture of the upper parts, although there appears to be a passage
in front of the clerestory windows, there is in fact just one tall
slot of space, over 9 ft high, rising from the floor of the triforium.
So the triforium arches are really no more than an open screen,
the whole of the upper stage being made of two separate skins of
masonry. Also significant are the engaged shafts, resting on a
narrow ledge at the base of the triforium.

Here we encounter one of the major problems of St Davids.
Was the 1182 nave covered by a ribbed vault, and if so was it
made of stone? The triforium shafts alternate between single
shafts and clusters of three, an arrangement that implies sexpar-
tite vaults. Visible above the clerestory windows are remnants of
arches intended to mark the junction of vault and wall, most of
them chiselled off when the Tudor ceiling was installed. Note too
the way in which the C16 wall posts are set in channels intended
for the medieval springers. The evidence for sexpartite vaults is
compelling, though difficult to believe. The hollow structure of
the upper walls seems too fragile to support a stone vault, and
for this reason wooden vaults have been suggested; alternatively
lightweight vaults of tufa. A vault rising some distance above the
wall heads would have enhanced the overall proportions of the
design, but whatever form was envisaged, there is no certainty
that it was constructed.

The consistency of the nave breaks down in the sixth and most westerly bay. This is narrower than the others, the arches are pointed and badly distorted, the chevron in the N arch is made of two different forms and the W responds have detached rather than engaged shafts (the shafts themselves were restored by *Scott*). The anomalies may well be connected with the W lean of the building, the result perhaps of a structural crisis either in the 1180s or following the earthquake of 1247/8. There has been a considerable amount of rebuilding in this area, most notably by *Nash* and *Scott*. While the lower sections of the W wall survive from the late C12 (the stones contain masons' marks), from window level upwards it is mostly *Scott*. Note the unfinished capital on the W respond (S side). Is this a product of the C19 restoration?

So to the pendant CEILING, one of the most spectacular pieces 61 of carpentry in Wales. It is said to be made from Irish oak. The craftsmen took care to match the design to the Romanesque fabric, with four panels per bay, and six across the full width of the nave, making 144 altogether. The direction of the planking is sytematically varied. After every second panel, there are three cusped arches, and it is from these that the pendants hang. They arc worth patient study. Each is square in plan with concave sides, and decorated with openwork tracery, along with foliage scrolls, dolphins, cornucopia etc. Above the cusped arches, sections of openwork tracery. But was the carving actually done at St Davids? It remains a possibility that the

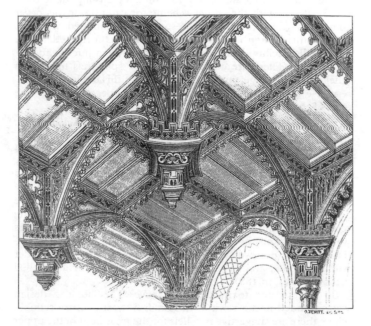

St Davids Cathedral. Detail of pendant ceiling. Engraving, 1856

components were carved elsewhere and shipped to the cathedral in a prefabricated state. Wyn Evans has produced evidence to show that the ceiling was installed *c*. 1538–9, though it seems extraordinary that such ornate and expensive work was commissioned when the ecclesiastical climate was so uncertain. The design is unique in medieval church architecture, and it was executed against the wishes of the bishop, William Barlow (1536–48), who disapproved of the expenditure. While the craftsmanship is admirable, the flatness of the ceiling places a firm lid on the architecture below, exacerbating the low, rather stunted proportions of the Romanesque church.

The aisles bring further anomalies. Instead of communicating directly with the transepts, they terminate in solid walls at the E end, pierced only by doorways, presumably because the floor levels were so different (or do the W walls of the transepts survive from a previous church with an aisleless nave?). In the S aisle against the transept wall, a rebate for a vault, also at a low level. This ties in with the three attached shafts at the back of the main piers, showing that a ribbed vault was planned. But there are no signs of vault springers, so the vault was never executed. Along the outer wall the original late C12 string course survives; in the W wall the remains of two rose windows, one above the other, showing that the 1182 aisle has been heightened. In the C14 came a second attempt to vault the S aisle, this time at a higher level. The late C12 shafts against the outer wall were extended upwards, and springer blocks inserted above the capitals. This work coincided with the introduction of larger windows in the aisles, and dates from the time of Bishop de Gower (1328–47). As with the earlier scheme for vaulting, it was never completed (the project was presumably abandoned with the death of the bishop). In the C16 the aisle was furnished with a flat panelled ceiling, simple in design, and much inferior to that in the nave. There are curved braces, the spandrels filled with relief carving, foliage, coats of arms etc. Was this the local joiners' response to the great ceiling of the nave, or an earlier effort? The infill of the panels is C19.

The N aisle was also increased in height in the C14, the extension being marked by a decrease in the width of the outer wall. Triple shafts of the late C12 were extended upwards to support a vault, the line of the putative vault cells being indicated by offsets above the windows. Flying buttresses of *c*. 1500 are located behind the first, third and fourth piers, cutting through the ceiling to support the exterior of the clerestory. At their base against the aisle wall, corbels with sculptured angels, holding respectively a mitre, a crown and a chalice. By the time the flyers were inserted, all thought of vaulting the aisle had been abandoned. A C12 doorway leads into the N transept, the inner order with a trefoiled arch. The N aisle is now covered by a panelled ceiling erected in 1881.

So what is one to make of the nave? The late C12 design was grounded in the work of the English 'west country school', where there are suggestive parallels for the treatment of the upper

storeys (cf., e.g. the blind arches on the west front of Malmesbury Abbey). The broad arcades at ground level, the double bays above, along with the plan for compressed sexpartite vaults, formed a coherent and logical design. The major weakness is the lack of height, a problem accentuated by the Tudor ceiling. Part of the rationale of combining triforium and clerestory was that, while economizing on height, the notion of a three-storey elevation was retained, an essential requirement for any great church at the time. Dominating the design is an extravagant range of chevron ornament in more than twenty different forms, making St Davids the *locus classicus* for this type of decoration. Along with workshops at Glastonbury (Lady Chapel) and Bristol (gatehouse), St Davids represents the final flourish of this most Romanesque of ornaments. The ostentatious display was evidently seen as a way of asserting the prestige of the cathedral at a time when the clergy still harboured ambitions for archiepiscopal status.

### 3. Transepts

The transepts differ in tone from the nave and are slightly later in date. The chief points of interest are three moulded arches along the E walls, the inner ones leading into the aisles of the choir. The outer arch, in the N transept, provides the entrance to the chapel of St Thomas, but the others were originally little more than frames for altar recesses. The arches contain an order with a distinctive triple roll and they rest on elaborate compound piers, incorporating an unusual shaft with two nibs. Dundry stone now appears, mixed with the local grey sandstone. The elevations above are simple in the extreme, with no middle storey, no clerestory and no chevron. This, together with the pointed arches and a new set of mouldings, sets the design apart from the nave. *George Gilbert Scott*'s wooden vaults, sexpartite in form, were inspired by an alternating set of medieval corbels, with single and triple shafts. Note also the vertical shafts in the angles. So there must have been an intention to add a vault *c.* 1200. As in the nave, there is no sign that it was built. Adjoining the crossing a unique feature, a cylindrical column, almost free-standing apart from a sloping wedge of stone that connects it to the main body of the pier. With its square abacus and scalloped capitals the design looks mid-C12, though it cannot be this early. Its purpose is hard to discern, unless it was intended to relate to parts of the pre-1182 church before they were demolished.

In the S façade three tiers of windows with Perp tracery, the top one designed by *G.G. Scott*, the tracery in the others extensively remade. A passage runs in front of the middle windows. This follows the course of a passage of *c.* 1200, and provides the only way of reaching a newel stair starting at a high level in the SW angle. The main stairs are opposite in the SE corner. These lead up to a passage that traverses the E wall and continues to the crossing tower (a similar passage in the W wall once connected with the nave triforium).

The N transept differs from the south in several respects. Instead of a single window in the W wall, there is a large double window, the central shaft (with three nibs) recessed back slightly into the fabric, a trick encounted again in the choir aisles. Below, a segmental-headed doorway, which on the outside (now visible from within the choir room) has three continuous orders, the outer a 'Worcester' roll, the inner a nibbed roll. The original windows in the N façade were replaced by a large Perp effort, which in turn was replaced in the 1840s by *Butterfield*'s curvilinear design with transom. On the E wall, the outer arch opens into the chapel of St Thomas, and is worth scrutiny. Instead of the triple rolls used elsewhere in the transepts, there is a nibbed roll, continuing without a break around the arch and jambs. This is characteristic of the 'west country school'; something similar was intended at the E end of the choir. There are mouldings on both sides of the arch, showing there was always a chapel at this point. It has been suggested that this was the site of one of the early churches, later incorporated into the N transept, with the door in the W wall providing an independent entrance. The idea is supported by an ancient dedication of the transept to St Andrew, one of the patron saints of the cathedral.

The history of St Thomas' chapel is difficult to unravel. It is not aligned with the rest of the cathedral, encouraging speculation that it makes use of old foundations. In its present form it dates from the C14, but there is a double piscina in the S wall, that must belong to the 1220s. This has trefoil arches, and fine stiff-leaf capitals, made from Dundry stone. The spandrels are decorated with a bird (l.), foliage, and two fighting men with square shields (r.). The whole composition recalls the dado arcades in the Lady Chapel at St Augustine's Bristol (now Bristol cathedral). Was the piscina moved from elsewhere, or was it merely added to a chapel of *c.* 1200? The chapel consists of two bays, covered with simple tierceron vaults, furnished with twelve sculptured bosses. The two principal ones show Christ between censing angels and a cross-nimbed head of Christ. The vault was poorly executed and the springers are a mess. Windows with Dec tracery, the details all C19.

The cathedral library above the chapel is reached from a stone stair in the N aisle of the choir. It is a tall cube-like space, once divided into separate floors, but now with an internal gallery. Restored by *J. O. Scott* in 1896. The windows contain Dec tracery, largely remade in the C19. A piscina niche in the S wall shows that an altar was located here at some stage. In the N wall is a delightful two-light window, furnished with seats, the latter covered by nodding ogee canopies adorned with miniature ribbed vaults. The quality of this work is far superior to that in the chapel below and it is hard to believe it was carried out at the same time. Although the presence of a fireplace, garderobe and window seats might suggest domestic accommodation, this upper room apparently served as a chapter house, with a treasury located on the floor above (now the gallery level of the library).

## 4. Crossing

The crossing is occupied by the choir stalls, as must always have been the case. Separated from the nave by the pulpitum, and from the N transept by a stone wall, this is an enclosed, intimate space, and it is only by looking up that one gets any sense that it is the meeting point of the four arms of the church. The arches to the N, S and E are pointed and spring from a lower level than the round arch on the W side. This reflects the work of rebuilding after the collapse of 1220: only the W arch survives from the original crossing (according to Jones and Freeman, 1856, there was 'a most marked seam' at the junction of old and new before Scott's reconstruction). The tower must have fallen towards the E, leaving the wall above the nave intact. The post-collapse work is characterized by shafts with thin fillets and by capitals with a soft curvaceous type of waterleaf, also found at Strata Florida abbey. The piers were enlarged on their inner faces, and at various points on the E piers one can distinguish vertical breaks in the masonry. The W piers are reconstructions by Scott, whose work is distinguished by red mortar.

Higher up within the tower the distinction between the pre- and post-collapse work is equally visible. On the W side a blind arcade with pointed arches supported on engaged shafts, the centre one terminating in a corbel in the shape of a fox's head. Four arches that once opened into a passage have been blocked in an effort to stabilize the tower. Built into the rubble masonry are several stones carved with intersecting arcs (pieces left over from the string course below the E window of the choir?). The arcaded passageway survives on the other three sides. The engaged shafts in the centre, singled out for special treatment with alternating Dundry and Caerbwdy stone (the alternating sequence fizzles out on the S side). Moving up to the next storey we reach the C14. There are stone springers for a vault in the angles, now redundant. The wooden vault of c. 1500 was originally placed at this level, but it was shifted upwards by Scott in order to clear the windows, a definite improvement. The vault is furnished with tiercerons and Perp panelling, forming a large cross with a circular motif in the centre, the original effect rather disfigured by two heavy arched braces, added to reinforce the floor of the belfry. The bright polychrome is by Scott; his painters are said to have copied an ancient scheme still visible at the time.

## 5. Choir

The choir is a curious and frustrating piece of architecture, an anticlimax after the nave. It contains four bays, much narrower than those in the nave, the main arches pointed not round. They are decorated with chevron, but only three patterns are employed and these are stretched and poorly executed. There is no triforium, the clerestory starting immediately above the main string course. An impoverished atmosphere in what should be the climax of the cathedral. Even the wooden ceiling is tame

compared with the extravagance of that in the nave. The original design must be slightly later than that of the nave, perhaps *c.* 1190, and it has obviously been modified, no doubt as a result of the collapse of the crossing tower (and possibly the earthquake of 1247/8). There has been much speculation about the nature of the original design, with one scholar arguing in favour of a 'giant' order on the lines of that in the nave of St Frideswide's, Oxford. Round arches, with relatively low vaulted aisles, were evidently envisaged at the start, but the precise ordering of events has still to be established.

The E window is the one high spot, late Romanesque at its most sumptuous. It is composed of three graded lancets, flanked by continuous orders of chevron ornament, deeply undercut. But it is not all of a piece. The foliate capitals with round abaci in the centre, along with the filleted shafts, look far later than the simple scallop capitals and square abaci used at the sides. Note also the lack of shaft rings on the upper parts of the outer jambs. Was the window reconstructed after the collapse of the tower or perhaps after the earthquake? The chevron belongs to types found in the nave *c.* 1182–90, whereas the pointed arches and filleted shafts must be several decades later. Below the window a decorative string course with Greek key ornament and intersecting beaded semicircles. This part of the E wall might represent the earliest work in the choir.

The main piers are more developed than those in the nave, with circular bases and abaci in place of the stepped arrangement. The alternating circular and octagonal cores are retained, but the shafts are limited to the N and S faces. There are discrete variations, with five shafts on the cylindrical piers, and just three on the octagonal ones. The design of the piers is not reflected in the responds, which are curiously out of tune with the rest of the arcade. Those at the E end were designed for an arch with a continuous moulding, as in the entrance to the chapel of St Thomas; they are at variance with the existing steeply pointed arcades as well as with the freestanding piers. Equally puzzling are the responds to the W (against the crossing piers) where there is an unusual half-quatrefoil, with a cluster of three shafts in the middle, cf. Strata Florida (the evidence of masons' marks suggests that the Cistercian abbey employed some of the same craftsmen). These W responds belong with the reinforcement of the crossing piers after the collapse of the tower, when the arcades (though not the free-standing piers) were reconstructed.

In the W bay, near the crossing, there are traces of wall ribs, showing that a vault was envisaged over the main space of the choir at the time the arcades were rebuilt. The scheme was soon abandoned, and decorative niches now occupy the spandrels on the N side where the vaults would have been. The clerestory is simple enough, the window openings framed by two continuous orders, the outer with chevron, simplified and very debased. A clerestory passage on the S side only, stopping short before the W bay (the short-lived scheme for ribbed vaults evidently involved a solid clerestory without passages).

Above the clerestory the character of the masonry changes, a result of the remodelling of the roof in the C15. It marks the point at which the walls were raised and the roof pitch lowered, alterations that coincided with the installation of the panelled ceiling. Compared with that in the nave, the ceiling is a relatively sober affair. Arched braces, with further braces along the walls, and spandrels filled with tracery. A plethora of sculptured bosses, with foliage and numerous coats of arms, the latter indicating a date of the later C15. The painting is by *Scott*, chiefly cream, blue and red against a yellow ground. Much zig-zag. The upper levels of the E wall also belong to Scott, who took out a Perp window and replaced it with a line of four lancets, set behind an arcaded passage. C13 dressed masonry, extracted from the surrounding walls, was incorporated into the reconstruction.

The aisles belong to at least two periods. As first constructed (*c.* 1190) they were very low, and were intended to be covered by ribbed vaults, a point demonstrated by the curved offsets visible on the E wall and by the cluster of shafts attached at the back of the main piers. Here we encounter one of the most peculiar features in a building which has more than its fair share of oddities. The capitals of the 'vault' shafts are located two courses below those on the main body of the pier, and a vault springing at this level could *never* have been erected in conjunction with the existing pointed arches of the choir. There is no trace of any vault springers, and no evidence that anything was ever supported on the capitals. Just as in the nave aisles, it appears that vaults were planned but not installed. It provides further evidence that, as first designed, the choir must have had arcades with much lower round-headed arches.

At some stage before *c.* 1300 the outer wall of the S aisle was rebuilt about 13″ to the S. The bases of the wall shafts were left in their original position, isolated and projecting a long way from the wall. In the C14 both aisles were further remodelled with traceried windows, and there was yet another abortive attempt at ribbed vaulting. The triple shafts were extended upwards to support the putative vaults, and some of the late Romanesque capitals were re-used. The extra pieces of shafting are very noticeable in the N aisle, since they differ from the original shafts, which were recessed into the wall (as in the windows of the N transept). Springers were put in place (in the S aisle) and there are deep recesses above the windows to take the vault cells. Again there is no indication that vaults were actually built.

## 6. *Retrochoir and Lady Chapel*

Standing in the choir, one would never guess that the cathedral extends a good distance further E. Only the presence of doorways at the end of each aisle offers a clue. They open into a C13 elongation of the aisles, leading in turn to a N–S passage providing access to the Lady Chapel. A gap was left behind the choir, perhaps to avoid blocking the three E windows, or possibly for religious reasons (*see* below). This was a unique arrangement, for

in most cathedrals there is a direct link between the main vessel and the retrochoir. Almost three centuries later, the gap was filled by the Trinity Chapel.

It is worth examining the exterior of the late Romanesque cathedral, parts of which are visible *inside* the church. The east façade had four nook-shafted buttresses, and sections of two of them, embellished with nook shafts, can be seen in the S aisle of the retrochoir (at the NE angle almost all the *c*. 1200 buttress survives, but this is visible only outside the building). The lancet windows (inside the Trinity Chapel) were framed by elaborate mouldings, including an order of chevron, very battered. A continuous inner order is returned across the base of the sill, another trick of the 'west country school', and one repeated on occasions in Ireland. The windows themselves were built up in the C16, and the central lancet was completely obscured by new masonry. To the N of the N window, quite high up, a flat-headed doorway, now blocked, opens in mid-air. It must have provided access to some form of wooden balcony or watching chamber overlooking the space outside the E windows. At a low level within this area, an arched opening, in line with the high altar, is filled with an openwork cross, and framed by further ornamental crosses above and to the sides. Through the openings outsiders could get a glimpse of something inside the cathedral, presumably relics within the high altar. These must have been relics associated with St David, but not his corporeal remains, which were only 'rediscovered' in the second half of the C13. The careful treatment of this niche suggests that, far from being a redundant yard outside the cathedral, this site was a place of sanctity, a gathering place for pilgrims perhaps? The recess now contains a casket with ancient bones, none apparently pre-dating the C12.

Of the original C13 retrochoir not much survives except for the paired arches leading into the cross passage, which differ in design N and S. On the S side the central pier, made of yellow Dundry stone, has four detached shafts. Moulded capitals, some with minute nailhead ornament. The inner order has intricate mouldings; an outer order facing the aisle seems to have been removed. There are redundant capitals either side. The central pier on the N side is made of grey sandstone and the arches are steeper. The moulded capitals here are not so refined and there are just three detached shafts.

In the N aisle there are springers of Dundry stone, the remains of a C13 vault, with well-shaped ribs carved with filleted rolls. Further evidence of the vault can be seen in the two bases on the stone bench against the N wall, and there is a fine stiff-leaf corbel in the NW angle. There was room for four or even five narrow bays of vaulting, and here we encounter a rarity at St Davids, a ribbed vault that may have been completed. If so, it was removed in the C15, when a much higher vault was planned. Grey stone springers of this secondary scheme remain. The aisle projects slightly beyond the cross passage, providing space for an altar (now St Nicholas Chapel), restored in 1906 by *J. O. Scott*. In the

s wall a simple trefoil-headed piscina, consistent with the c13 phase.

There is no trace of a c13 vault in the s aisle, but plenty of evidence (in the form of springers) of a later vault. A rough corbel, an atlas figure, is perched above the double arch into the cross passage. As on the N side, the aisle projects to the E, now the chapel of St Edward the Confessor, restored by *J.O. Scott*. E window 1890, the others 1912–14. The alabaster tomb and altar were commissioned by the Countess of Maidstone in the 1920s. In the wall above the tomb a blocked window, from the adjoining Lady Chapel, shows that the chapel already existed when the aisle of the retrochoir was extended. In the E angles of the aisle are corner shafts, massive polygonal affairs. These are quite different from the delicate triplets arranged along the side walls, which relate to the moulded string course. Was the aisle remodelled twice in the later middle ages, the clumsier work belonging to the c14 and the finer work a century later? Against the w wall (leading back into the choir) the marks of a roof creasing of uncertain date, with a gentle pitch, well below the putative vault line. Both aisles were in ruins until the early c20 restoration.

The cross passage is lit by Perp windows, set high in the walls N and S. Three bays of tierceron vaulting, and three bosses with coats of arms, early c16. The passage must originally have been roofed at a lower level. There are seven sculptured corbels, presumably for wall posts, confirming the existence of the previous ceiling, the headdress on one of the corbels implying a c14 date. There must have been a third, earlier ceiling, possibly at a lower level. Above the entrance from the s aisle, round wall arches of Caerbwdy stone. Also a strange chunk of masonry projecting from the wall, its function unclear.

A wide c13 double arch leads into the Lady Chapel, supported on a central pier with four coursed shafts (filleted) and four detached shafts. Made from both Dundry and Caerbwdi stone. The arches above spring at an angle from the jambs, no doubt to suit the height of the original c13 chapel.

The Lady Chapel was a ruin from 1775 until it was restored by *J.O. Scott* in 1893 and 1900–1. Two broad bays with Perp windows N and S. But curvilinear tracery in the E window including a wheel motif with eight spokes (why the inconsistency?). Lierne vault with octagonal motif in the centre designed with concave sides. It was remade by Scott, using some of the original bosses, the latter decorated with foliage, coats of arms, and fabulous beasts. The medieval springers survive at all six points, so the reconstruction must be reasonably accurate. This chapel of *c.* 1500 was merely a remodelling of a c13 structure. This too was vaulted, to judge from the shafts in the E angles, and the corbels in the w corners. This first Lady Chapel once stood free from the s aisle of the retrochoir, as indicated by the blocked window of c13 character in the s wall. There are also c13 shafts and mouldings around the jambs of the E window. The most peculiar feature of the chapel is its lack of alignment with the main axis of the cathedral, giving rise to speculation that it was

founded on the site of an ancient pre-1182 church (for which there is no archaeological evidence).

The Trinity Chapel was the work of Bishop Vaughan (1509–22), and is all the better for being so unexpected. Fitted into the gap left between the choir and the retrochoir, the chapel is covered by fan vaults, making a rare appearance in Wales. In his will of 20 May 1521 the bishop promised £20 for the completion of the vaulting. Ideally fan vaults require square-shaped bays, and as the Trinity Chapel is slightly longer than two squares, short sections of barrel vault were fitted at either end. The fans are defined by a curved rim and there is a large circular motif in the centre, containing quatrefoils. Also two ornate bosses, both recently painted. They are carved with the royal coats of arms and with those of Bishop Vaughan (a Latin cross, a St Andrews cross and a mitre). The vault has analogies with that in the porch at Crowcombe (Somerset), and the cosmopolitan flavour of the work shows that the architect was not a local man. It is worth remembering that Bishop Vaughan spent much of his career in London, where he was Treasurer of St Paul's Cathedral. His grave in the Trinity Chapel is marked by a slab in front of the altar, formerly commemorated by a brass (now lost). The centre of the chapel is defined by delicate shafts, terminating in corbels in the form of sculptured angels, that above the altar holding a shield with the instruments of the Passion. Either side of the altar simple paired lights look into the retrochoir, further out more elaborate three-light Perp windows. Ornate canopies with pinnacles and ogee-headed gables are located between the windows. There are also finely decorated pedestals (now occupied by modern figures of Bishop Vaughan and Gerald of Wales). Clumsy junctions show that the tracery screens separating the chapel from the aisles were an afterthought, but without them there would have been none of the privacy associated with a chantry chapel. Most of the light comes from the Perp windows set high in the N and S walls, each with four lights and a triangular head. They are aligned with the centre of the vault, not with the arch below, one of the few discordant notes in what is otherwise an ingenious and accomplished design.

## 7. Exterior

As most of the external fabric has been reworked in later centuries, the exterior of the cathedral offers few clues about the early history of the building. The best place to start is near the river on the N side of the nave, where some of the 1182 building has survived. The aisles here have rubble walls, rendered, with thin buttresses in purple sandstone. In the second bay (from the W) a late Romanesque doorway in three orders, the inner one a continuous 'Worcester roll'. There are two orders of chevron and much decayed capitals. The label is decorated with another Worcestershire motif, the so-called line of shuttlecocks or ice-cream cornets, found in Glamorgan at St Bride's and further afield at Christ Church Cathedral in Dublin c. 1190. The odd

thing about the doorway is that the arch does not prescribe a full
semicircle, as if one course of voussoirs is missing (has the door
been rebuilt?). The aisle windows all have Dec tracery, but only
one (3rd from the E) was there before the C19. Massive rubble
buttresses of the C16 or C17 (the two W ones enlarged later)
extend far into the cloister garth. The clerestory and corbel table
were rebuilt in purple Caerbwdy sandstone by *G. G. Scott* (in the
E bay the form of the previous window tracery was retained).

The W façade, designed by *G. G. Scott*, belongs to the 1880s. In
purple sandstone, with recent repairs (1998–2000) in greyer
hue. In the central section, a pair of deep buttresses rising to
square turrets, with lower octagonal turrets on the angles of the
aisles. Two levels of blind arches on the buttresses, with inter-
secting arches at the top, a composition taken from the Lady
Chapel at Glastonbury. The aisles have rose windows with cart-
wheel tracery. Doorway in five orders, three with continuous
'Worcester rolls', one with chevron and another with a circular
motif copied from the nave arcades. Label moulding with
shuttlecocks. The gable, outlined by running zig-zag, encloses a
niche containing the seated figure of Bishop Connop Thirlwall
(1840–74), studying plans for the restoration. It was Bishop
Thirlwall who was the prime mover in organizing Scott's restora-
tion, the façade being treated as his memorial. Above the gable
three round-headed windows embellished with chevron, and five
graded windows higher up. The vocabulary of the W front was
scrupulously copied from the late Romanesque nave: the result,
as a consequence, is static and doctrinaire.

The S aisle of the nave was rebuilt in the C14 with a double
chamfered plinth and deep buttresses. Windows with Dec
tracery, all by *Butterfield* 1847–9, supervised by *James Stone*. The
two storey porch was largely rebuilt by *G. G. Scott*. Note the label
stops with portraits of Queen Victoria and Bishop Jones. The
porch is covered by a quadripartite vault, with filleted ribs, resting
on corbels. The doorway into the cathedral is a C14 replacement
for the Romanesque doorway, the foundations of which were left
in place as a stumbling block for the unwary. The inner order has
square rosettes and pellet ornament, and the outer order is
carved with what is said to be a Tree of Jesse. There are reclin-
ing figures at both sides but it is not immediately obvious which
is Jesse. The other is thought to be Adam. Eleven figures are
carved around the arch, most badly worn. They include David
with his harp, a crucifixion and (?) seated evangelists, so the
iconography is far from conventional. The label rises to three
sculptured panels above the door, depicting a Trinity with two
angels. There are several puzzling features about this door, quite
apart from the iconography. The way in which it was squashed
under the vault meant that there was no room for pinnacles pre-
pared either side. Then there is the uneven wear of the sculp-
tured stones, as if some have been exposed to the elements for a
long period. Was the porch erected at a later period than its style
suggests? Or was the doorway cannibalized from elsewhere and
inserted after the porch was built?

Moving to the s transept, a single buttress on the w wall corresponds with the division of the interior into two bays. The wall narrows about three-quarters of the way up, as if the top section was an afterthought (the same feature is encountered on the N side). Nook-shafted buttresses at the corners, along with turrets, all renewed by *Scott*. The s façade framed by a round arch. Everything below was cut out in the late C14 or C15. Perp tracery renewed in the C19. Stretching E from the SE corner a huge buttress like those on the N side of the nave, forming the outer wall of a later chapel. There was much rebuilding and alteration in this area between the C16 and C19. High in the E wall a line of tiny windows marks the course of the internal wall passage.

The choir aisles were rebuilt under *Scott*, with three-light Dec windows and octagonal pinnacles rising from the parapet. Above the clerestory, a clear break in the masonry shows where the walls were raised in the C15 to allow for the low pitched roof. The original roofline is marked by the remains of a corbelled cornice, well preserved on the N side. Trefoil-headed niches and engaged rolls decorate the main buttresses at the E angles.

The aisles of the retrochoir continue to the E, again with renewed Dec windows. Peeping above the roof, the Perp tracery of the Trinity Chapel, and a smaller window alongside, lighting the cross passage. Parapet adorned with sculptured beasts, lions, grotesques etc. The side walls of the Lady Chapel have two Perp windows, that to the w smaller and squeezed into a space at the end of the retrochoir. Diagonally set buttresses with pointed faces mark the E angles. In the E gable a niche containing a sculpture of the Virgin Mary and the infant Christ, the child crowned and holding an orb. All this work dates from around 1901. Low down on the N side of the Lady Chapel a fragment of a C13 buttress, abandoned when the chapel was rebuilt with more widely spaced buttresses in the C15.

At this point it is worth noting the extent to which the E end of the cathedral has been cut into the side of the valley. Also apparent is the heterogeneous collection of roofs and parapets, assembled beyond the original choir. The fact that the Lady Chapel lies to the s of the main axis is equally obvious. Continuing round to the N side of the cathedral, there is an awkward junction between the N choir aisle and retrochoir, where the two external walls were not aligned: a substantial section of the *c.* 1200 nook-shafted buttress was left in place to conceal the problem.

The NE corner of the cathedral is dominated by the three-storey building that contains the chapel of St Thomas on the ground floor, the modern library above. The Dec tracery is entirely C19. The elaborate mouldings on the jambs of the second-floor window, however, are original, confirming the impression that this upper room was a chamber of some status. The top window takes the form of a curved triangle, the type popularized after Westminster in the second half of the C13 (the C19 reconstruction was apparently based on reliable evidence). In the N wall a projection for the garderobe. There is a rough

junction with the N transept, the façade of which is filled by *Butterfield's* enormous curvilinear window of 1846–7, the most elaborate essay in Dec style to be found at St Davids.

## 8. Crossing tower

Built in three stages, a rather dour affair in rubble, 116ft high. The three levels are poorly integrated. The first stage is C13, with angle shafts. Visible on the E and W faces are marks of the C13 pitched roofs, that *Scott* wanted to reinstate. Steeper roofs would certainly have improved the balance of the architecture. The middle stage of the tower is the tallest, a line of ballflower at the base confirming a date in the first half of the C14. Tall, two-light traceried windows in the centre of each side. Flanking the windows ogee-headed niches, rather floating in the wall. The upper stage is *c.* 1500 with very modest openings to the belfry chamber. A simple arcaded parapet with eight hexagonal pinnacles, each sporting a weather vane. Onion-shaped ribs to the pinnacles with projecting beasts, giving a prickly silhouette. All too refined to have much impact on the monumental forms below.

## 9. Furnishings and Monuments

Although St Davids contains a wide range of medieval effigies and tomb chests, it is important to be aware that they have been subject to a great deal of reorganization, and very few are in their original location.

### Lady Chapel

SEDILIA. C15 or C16, stone, extensively restored by *J. O. Scott* between 1897 and 1901. Cornice with foliage and evangelist symbols. – SCULPTURE. Two loose carved heads in yellow limestone set on shafts in the eastern angles, that in the SE corner a bishop and definitely medieval. – Freestanding wooden image of the Virgin Mary holding the Christ child, made in Oberammergau in the 1950s and executed in C14 style. – STALLS. By *A. Caroe*, in Tudor revival style, 1954–5. – MONUMENTS. – N wall, memorial to Bishop John Owen †1926, though not his tomb as he was buried elsewhere. Effigy carved by *Brooke Hitch* in full Gothic splendour with elaborate canopy and meticulously carved crosier and pectoral cross. Crosier pierces mouth of a snake. An appropriate style and location for the bishop who was responsible for the restoration of the chapel. Set under a steep gabled canopy containing three traceried oculi. Pinnacles surmounted by sculptured figures (a bishop on the central one). Largely the work of *W. D. Caröe*, but based on medieval fragments. – A second ornate tomb on the south wall reinstated by *J. O. Scott* and *W. D. Caröe*, re-using a few medieval pieces. Tall gabled canopy with tracery motif based on pointed trilobe. Apex coincides with springing of

vault ribs, so the original monument was evidently designed as part of remodelling of the chapel about 1500. – Grave-slab, C13, in the cross passage, with head and cushion raised in relief, and inscription mentioning John de . . . , with hand raised in relief and inscriptiom; Jones and Freeman suggest John de Fakenhan, archdeacon of Brecon †1274. – STAINED GLASS. E window. The Virgin Mary standing and holding the Christ child flanked by the evangelists and music-making angels. By *Kempe & Co.*, *c.* 1924. Pallid, sickly hues. – GATES. Metal alloy designed by *M. Caröe*, executed 1977–8 by *Frank Roper*. An abundance of extruding square crockets.

### Retrochoir

MONUMENT. Dean Howell †1903, bronze plaque with low relief portrait, by *W. Goscombe John*.

### Retrochoir S aisle

MONUMENTS. Tomb of the Countess of Maidstone †1932, who paid for the restoration of this part of the church, and also commissioned the altar and reredos as part of a unified programme. Designed by *W. D. Caröe*, carved by *Brooke Hitch* (though the original drawing for the tomb chest is by J.O. Scott). Everything executed in alabaster, in a style purporting to be late Gothic, despite the intrusive Greek key ornament copied from the Romanesque building. Massive tomb chest decorated with tracery. On the front a panel in thin relief showing a penitent figure with an angel behind. Effigy of Lady Maidstone in high relief, a life portrait of a formidable lady. At her feet a dog, but not any dog, for this is her pet Pomeranian (an urn to the south of the altar reputedly holds the remains of the animal, though it has a hound rather than a Pomeranian on the top). – On an ancient corbel to the E, an alabaster angel watches over the countess. – Behind the effigy a brass sundial with the inscription VITA PERFECTA AD UMBRAS REDEO. – Reredos with Greek inscription in centre panel, flanked by four evangelist symbols. – Altar table resting on two decorated posts. Underneath a large relief of the adoration of the lamb. – Floor of the aisle furnished with inlaid coats of arms and decorated stone, also paid for by the countess. The whole conglomeration of altar, tomb and reredos is a glistening, milky intrusion amidst the grey stone walls of the cathedral. An astonishing display of craftsmanship, fascinating rather than beautiful. The Countess of Maidstone, apart from being rich, was the granddaughter of Bishop Jenkinson (1825–39). The programme reveals how much the dean and chapter of the 1920s were prepared to concede in return for much needed cash. The aisle is the C20 equivalent of a chantry chapel. – VESTMENTS. In a cupboard the vestments worn by Bishop Jenkinson (1825–39) at the coronation of Queen Victoria in 1838.

*Retrochoir N aisle (Chapel of St Nicholas)*

SCULPTURE. Crucifixion, with Mary and St John, C15, carved in relief in grey stone, in wall above tomb of John Hiot. – Relief of a woman with elaborate headdress, heavily worn (N wall). – Behind the altar, huge medieval corbel with two heads. – STAINED GLASS. St Nicholas, holding book and three golden balls, set against a background of foliage and lilies, by *Powell*, 1904.

MONUMENTS. Priest, C14, head placed under a raised and floriated canopy. Tomb chest below with triangular tracery motif, largely restored. Set within an ogee-headed recess, with fragments of a traceried canopy, not necessarily of same date. – Cross-legged knight, C14, head resting on a double cushion. L. arm holds shield, r. hand seizes sword. Not as agitated as the famous example from Dorchester, but of similar epoch. Once a splendid piece of carving. Modern tomb chest with fragmentary canopy. – Sword-seizing knight, C14, badly worn. – John Hiot †1419, archdeacon of St Davids (1400–19), in yellow limestone (from Dundry?). Effigy badly decayed, the result of exposure to the elements for over two hundred years. Tomb chest better preserved, with simple trefoil-headed arcades and Gothic inscription. – Remnant of ogee-headed canopy, C14 or C15, destroyed when the arch and screen of the Trinity Chapel were inserted.

*Trinity Chapel (Bishop Vaughan's Chapel)*

REREDOS. C15 (?), stone panels with crucified Christ flanked by St John and Virgin Mary, and four apostles – SS James, Andrew, Peter and Paul. Discovered beneath the pavement of the nave. Arranged to form a reredos by *W. D. Caröe* in the 1920s. In the W wall, RELIQUARY behind an iron grille, 1920s by *Caröe*, inventive C16-style metalwork. – SCULPTURE. Many ancient pieces built into the altar. – Slab, partly broken, with cross enclosed in a circle decorated with interlace, and incised compass arcs below, perhaps unfinished or used as a trial piece. – Small slab with cross in circle in deeper relief. – Latin cross with circle enclosed by quatrefoil, C13? – Two magnificent pieces of C13 foliage carving in yellow Dundry stone. – Fragmentary relief representing (?) Presentation in the Temple. Also much abraided C13 relief of Nativity, with the Christ child in crib above the Virgin and Mary, and Joseph leaning on his arm at the foot of the bed. Perhaps from the original choir screen. – In niches on E wall 1920s figures of St David and Gerald of Wales †1223, the latter with the mitre he desired, but never obtained, at his feet. – MONUMENT. Medieval grave-slab, reused C18 with added inscription DH, 1745.

*Choir*

SEDILIA. Late C15, to S of sanctuary. Three canopies with fine pinnacles and miniature lierne vaults carved on the underside. Angels in prayer (much restored) at base of each pinnacle, twelve altogether. Openwork buttresses divide the seats, and an openwork grille of Perp tracery provides the backing. – SCREEN. Parclose screen of wood, separating sanctuary from choir, a puzzling work, of at least two different periods. Solid lower section with blind trefoiled arcading, open Perp tracery above. The lower section appears to be C14, but the return section on the N side has Geometrical tracery, which should be about 1250–1300. Silhouettes of painted figures on the front. – BISHOP'S THRONE. A magnificent construction with ornate canopy over the bishop's seat, and smaller canopies over the seats alongside. Refined ogee-headed gables. The centre canopy provides a base for a two-storey tower that terminates in an openwork spire, 29 ft high. Flying buttresses support the lower section. Exeter apart, this is the finest in Britain. The date is controversial, but the style is consistent with C14. Was it commissioned by Bishop de Gower (1328–47)? Presumably moved and altered when choir stalls constructed C15. – CHOIR STALLS. Made during the treasurership of Owen Pole (1493–1509). Both front and back of the stalls survive, with eleven seats down each side and a further six on the return. Back panels with delicate tracery, combining Perp forms with ogee arches set in front. Parapet cantilevered forwards like a rood screen and furnished with buttresses containing vertical slots, perhaps for hangings. The underside of canopy has delicate lierne vaults, with a concave octagonal motif in centre like that in the vaults of Lady Chapel. The superstructure has been extensively restored. On the W side the former pulpit projects towards the choir. Misericords, 21 of the 28 original, oak leaves, owl, green man, shipbuilders, sea-sickness etc. The front of stalls furnished with poppyheads and curvilinear tracery. Christa Grössinger points out the close similarity with those at Fairford, Glos.

TILES. Large expanse of C16 tiles re-laid in sanctuary, with four individual tiles making up roundels containing fleurs-de-lys, animals, running foliage etc. The designs copied by *G. G. Scott* for C19 tiles elsewhere in choir, the tiles by *Godwin*.

MOSAICS in Gothic style by *Salviati*, to the design of *Hardman*, 1871, set within the blocked E lancets. Crucifixion in the centre, with worship of brazen calf below, flanked by Synagogue and Ecclesia. A logical alternative to stained glass, but without artificial light rather dull; the detail struggles against the dense Romanesque ornament alongside.

STAINED GLASS. Four upper lancets in E wall, depicting Nativity, Resurrection, Ascension and (?) Supper at Emmaus. 1870 by *J. H. Powell* for *Hardman*.

SHRINE. Set between two piers on the N side of the choir. Made *c*. 1275 for the relics of St David. Below, a base or 'chest'

with three open arches and small quatrefoils in the spandrels. Hidden compartments within the two centre quatrefoils, presumably for the receipt of offerings. Above, three arches supported on detached shafts, with sculptured label stops. The backing wall is plain but records indicate that it was once painted. Presumably the reliquary casket (lost) was placed at a high level, safe from prying hands, where there is said to have been an arched superstructure. On the N side facing the aisle, three round-headed openings allowing pilgrims to crouch below the relics. The whole design very simple (cf., e.g., the shrine bases at Oxford or St Albans).

MONUMENTS. – Thomas Lloyd †1612 (treasurer of the cathedral), an elaborate Jacobean monument in sanctuary. Framed by classical columns, now without anything to support. Effigy with right arm clasped to side of head, worn carvings of son and daughter on front of tomb chest. An outline remains of Thomas's widow behind the effigy. – Edmund Tudor †1456, Earl of Richmond and father of Henry VII. Purbeck marble tomb brought from the Greyfriars at Carmarthen in the 1540s and placed in the centre of the choir as a transparent gesture of loyalty to the Tudor dynasty. Imposing tomb chest with tracery patterns and coats of arms. No effigy but an inlaid brass made in 1873 by *Thomas Waller* showing the earl at prayer, his feet resting on a dog.

*S choir, aisle*

MONUMENTS. Priest, C14, worn; hands together in prayer, head set on cushion under a round-arched canopy; fully vested with maniple, chasuble etc. Set within segmental cinquefoiled recess, badly damaged, the top cut by a late medieval string course. – Grave-slab with floriated cross, an inscription on the edge recording Sylvester 'Medicus', along with an apposite warning that 'his ruin shows that medecine does not stand in the way of death' [Eius Ruina Monstrat Quod Morti [Non] Obstitit Medecina']. – Priest, C14/15, broken in two places, holding book in r. hand, remains of an inscription down l. edge. – Bishop, C13 effigy in high relief, badly damaged, with crosier broken and feet missing. Said to be monument of Bishop Iowerth †1231, but the angular folds of drapery are not possible before the second half of the century. – Bishop Anselm †1247 one of the finest C13 carvings in Wales. Head set under a trefoiled canopy with an inscription recording the name of the bishop. Well-preserved facial details with curled hair and beard. Censing angels in the spandrels. Crosier with floriated head and simple knop piercing one of two leopards at the bishop's feet. – Knight, C14; pointed bascinet, with head resting on a lion-crested helm. Part of r. arm missing. An outstanding and characteristic example of effigial carving of *c.* 1370–80. Plate armour, with details carefully delineated, including an elaborate belt. Tunic over body armour carved in thin relief with rampant lion. Feet rest on a lion with

unusually long tail. Carved in yellow Dundry limestone and perhaps imported ready made from the Bristol area. Said to commemorate Lord Rhys ap Gruffydd †1197, but if so a belated memorial. A pair with second effigy in N choir aisle (*see* below). – Priest, C14, under a simple pointed canopy, resting on modern chest. Head smashed, so too the angels that flanked the canopy. Reputed to be tomb of Gerald of Wales †1223, an implausible attribution.

## N *choir aisle*

MONUMENTS. C14 cinquefoiled tomb recess, almost entirely remade in C19, now containing remains of Bishop Houghton †1389, removed from St Mary's College in 1965. – Knight, C14, legs broken at top of thighs, a pair with that in S choir aisle. Thought to be Rhys Gryg, †1233, a younger son of Rhys ap Gruffydd, who was buried in the cathedral, although the label with three points indicates an eldest son. Some details slightly altered, e.g. round links on the belt rather than square. If identified correctly, it must be a late memorial. Set under a modern cinquefoiled recess.

## S *transept*

PANEL PAINTING. Large icon of Elijah seated in front of a cave and being fed by ravens, with smaller scenes inset showing the prophet departing for heaven in a chariot of fire and Elisha catching his robe. Thought to be C17 Cretan. Gift to the cathedral in 1960s, a bright addition to a building otherwise short on colour. – MONUMENT. Fragment of C14 grave-slab, upper section only, body carved in shallow relief, head and cushion in the round.

## N *transept*

SHRINE. Undecorated recess, the setting for the shrine of St Caradog †1124. Plain chest below with two simple pointed openings. – MONUMENT. Priest, C14, the head on a double cushion under an ogee-headed canopy. Tomb chest probably of different date, decorated with tracery in diamond frames. Set under ogee-headed recess, with cinquefoiled arch and flanking pinnacle.

## Chapel of St Thomas

STAINED GLASS. E window 1958 by *Carl Edwards*, depicting Thomas Becket with crown of martyrdom being placed on his head, flanked by angels holding coats of arms. Below three soldiers with swords pointing unconvincingly at prostrate figure of Becket. Tortured expressions in thin, tepid colours. N window 1909, by *Shrigley & Hunt*, depicting St David and St Asaph with outrageously detailed vestments. Victorian in

flavour. – SCREEN. Neo-Tudor *c.* 1900 by *Boulton* of Cheltenham to designs by *J. O. Scott.*

*Pulpitum*

An outstanding feature of the cathedral. Far more than a screen, for the structure contains three funerary monuments, the most conspicuous being that of Bishop de Gower †1347 who paid for it. It is likely that the bishop had seen the recently completed screens at Tintern Abbey (known from fragments, *c.* 1325–30) and Exeter Cathedral (finished 1324). The incorporation of the bishop's tomb within the screen reveals an admiration for the way Bishop Grandisson had incorporated his tomb into the façade at Exeter (after 1329). Although the detail at St Davids seems coarse when compared with the other screens, it is an intriguing and unique structure, carefully designed to enhance the memory of de Gower himself. The structure is adorned with square floral motifs, pinnacles, floriated gables, cusps with tiny human heads (many restored), and pellet motifs, the latter not found much before the 1340s. Central passage leading through to the choir covered by two bays of vaulting with flying ribs, i.e. the ribs themselves are detached from the cells behind, a technique borrowed from the sacristy of the Berkeley Chapel, Bristol. Cusped arches flank the passage, opening into vaulted chambers either side, containing the tombs of two unidentified priests. De Gower's tomb lies further to the S, also enclosed within a rib-vaulted chamber and visible from two sides through ornate cusped arches. The N section of the pulpitum has a plain base and was presumably the site of the altar of the Holy Cross. Above a cornice with seven sculptured heads, two with coifs of mail, and at a higher level three niches (restored by *G. G. Scott*). At the NW corner a curious detached buttress containing openwork tracery. Round the corner on the N side a doorway with a semi-octagonal top, like one in the bishop's palace, giving access to a winding stair up to the rood loft. The wooden tracery below the canopy on the front of the pulpitum is a C15 or C16 addition; the horizontal band of vine scroll is of 1847 by Butterfield. Top panelling added in 1953 (?) by *A. Caroe.* The ORGAN above is a composite of the *H. Willis* organ of 1883, rebuilt in a late Gothic to Renaissance case in 1953 by *A. Caroe*, which in turn formed the basis of a new and larger case of 2000 by *Peter Bird*, of *Caroe & Partners.*

MONUMENTS. – Bishop de Gower †1347. Double cushion held by angels, now broken. Tomb chest carved on one face only with eight apostles set against a plain background. Apostles identified by their attributes, Peter with keys, Andrew with saltire cross etc. An early example of the apostles used as 'mourners', but where are the remaining four? – Priest, C14, hands clasped in prayer, cushions held by angels, and feet resting on lions. In alcove on N side of passage. – Priest, C14, similar to above on S side of passage. – SCULPTURES. On

the W face of the pulpitum, figures of Christ, St John the Evangelist and St Paul, in Neo-Gothic style by *W. D. Caröe* 1909. Also figure of St David, *c.* 1915, holding crosier, with dove on his shoulder, more robust and less insipid than the other three. – The pulpitum also retains remnants of its C14 PAINTED DECORATION: fragments of polychrome on the vault of the central passage, foliate scrolls with three birds on rear of central arch, in bright colours against a white background. – In the N chamber, evangelist symbols in the vault, all but Luke well preserved.

*Nave and aisles*

ROOD. Hanging from ceiling of nave, by *Brooke Hitch* to the design of *W. D. Caröe*, *c.* 1931. Cross with four evangelist symbols, flanked by figures of Mary and St John. Boldly carved in Neo-Gothic style. – FONT. Medieval bowl, octagonal, each face with a pair of pointed arches. – MURAL PAINTING. Third pier from E, in S arcade, outline of knight with a sword. On same pier a figure under three ogee-headed arches, thought to be the Virgin Mary. Second pier S arcade, traces of (?) crowned figure within red rectangular frame. – STAINED GLASS. W windows of aisles, both N and S by *William Morris Studios* 1956. N aisle with apocalyptic scenes, *Agnus Dei* in centre, seven candlesticks etc. S aisle with baptismal subjects, passage of Red Sea, Noah's ark, along with cross and anchor. Brilliant, intense colour, the best glass in the cathedral. – W windows of the nave, Christ flanked by SS George and David, along with saints and angels, by *Kempe & Co.* 1924.

MONUMENTS. (S aisle) Priest, C14, hands clasped in prayer, originally with angels holding cushion. Set under canopy of Bristol type with concave curves, badly damaged. – Bishop John Morgan †1504, in full episcopal robes with mitre and crosier etc. Decorated tomb chest. Front face with two groups of apostles (six altogether), one end with resurrection, the other with winged lion holding coat of arms. Lively, deeply cut figures.

# CLOISTER AND ST MARY'S COLLEGE

Founded in 1365 by Bishop Houghton, St Mary's College consisted of a chapel raised over a vaulted basement, a tower and a cloister. Enough survives to form a reasonable impression of what must have been a group of buildings of some quality. The cloister walks were covered with stone vaults, quadripartite in form with ridge ribs, the use of four centred arches giving it a fairly flat trajectory. Only the foundations are left of the inner wall facing the cloister garth, but nine bays of the rear arcade are visible against the wall of the college, each bay being defined by a single shaft set on a high plinth with a moulded capital. Sculptured bosses, in the form of foliage and human heads, mark the

junction of ridge ribs and wall arches. Above the vault, corbels in the wall indicate the position of the wall-plate of the lean-to roof. In the NE corner of the cloister are the remains of a two-storey block constructed above the cloister vault. The first-floor chamber was a sacristy (there is a piscina in the E wall) and a doorway (now blocked) gave access to the chapel alongside. On the E side of the cloister, the rear wall of five bays survives, extending as far as the NW angle of the transept. The W side of the cloister is ruined almost to ground level, but fragments remain, built into one of the added buttresses. Three large buttresses projected into the garth at this point, so the W walk of the cloister evidently had an upper floor. There is no evidence for the existence of the S range. The cloister was already in ruins when the massive rubble buttresses were constructed along the north side of the nave in the later C16 or C17.

The chapel itself is reached by a flight of steps, placed under a plain belfry tower at the SW corner. There were originally two bays of vaulting over the steps and the wall arches and springers include yellow limestone and purple sandstone from Caerbwdi. A modern door leads into the chapel, the interior of which was completely renovated in 1965–6 by *A. Caroe*. It is a gaunt, rather cold space. Fragments of the late C14 string course remain, and a rubble arch in the N wall marks the position of Bishop Houghton's tomb, located in the standard position for a founder, close to the altar. A rough arch in the S wall indicates the position of the doorway to the sacristy. The chapel was designed with four broad bays, the E bay blank, the others filled by large transomed windows, 24 ft high and 9 ft wide, with an equivalent window in the E wall. Fragments of Perp tracery survive, along with a broad casement moulding on the jambs. The openings are now filled with concrete mullions, a brutal but rational solution, in that every effort was made to spare the remains of the medieval work. Caröe's low copper roof overhangs the eaves where there would have been battlements and pinnacles. At the W end, visible from the garden on the N side, a stair-turret gives access to upper chambers. The basement of the chapel is covered by a longitudinal barrel vault, cut by severies on the N side to allow light to enter from narrow windows. To the NE are ruined walls and vaults, the remains of the domestic accommodation of the fellows.

## THE CHURCHYARD

The dramatic slope of the churchyard from Porth y Tŵr sets the cathedral and Bishop's Palace in a green bowl. The broad flight of slate steps down, the THIRTY-NINE STEPS, are illustrated in 1810, though a shorter flight is marked on Lord's map of 1720. The raised bank to the lane, SW of the cathedral, covers a blocked undercroft, over which the FREE SCHOOL was built in 1557, replaced in 1791 by *John Nash*'s CHAPTER HOUSE, a stuccoed four-bay Gothic room, much disliked, and demolished in 1829.

## THE CLOSE

The area within the Close walls roughly divides into four, quartered by the river and the lanes running from the ford up to the NW, and to the SE. The CLOSE WALL itself is ruinous, the best stretches running down from the Porth y Tŵr (*see* below) to the E end of the cathedral, and from the Deanery to Pont Cerwyn Dewi on the SW side. There were four gates, of which Porth y Tŵr at the SE is the survivor. The others were Patrick's Gate or Porth Padrig (SW) w of the Deanery, Porth Gwyn (NW) at the top of the lane by the Bishop's Palace, and Porth Boning (N) by

A. The Cathedral.
B. The Cloysters now in ruins over the West Side of which was ÿ Library.
C. St Marys College Chapell Ante Chapell and Tower now in ruins.
D. St Marys College and gate way.
E. The Vicars Ground on which stood their College & Houses now all ruined but one.
F. The East gate and rooms adjoyning to it where the Bishops & Mayors courts were held.
G. The Stepps leading into the Churchyard & Streets & ways about the Church & close.
H. The Chaunters House and offices Court Yard & Ground belonging to it.
I. Ground called the Chaunters Orchard.
K. Prebendary of LLand dewi's Ground.
L. Archdeacon of Carmarthen's Ground and ruins of his House.
M. South West alias Patrick's gate & Street leading to it.
N. The Free Schoole.
O. The River Alan over which are 2 Bridges.
P. The Bps Palace with the gate house Chapell, Hall, Kitchen & other rooms & Offices and ground belonging to it.
Q. The Prebendary of St Nichola's House.
R. The Treasuers House & offices.
S. Bonnings gate & way to it.
T. The Archdeacon of Cardigans ground & ruins of his House.
U. The Archdeacon of St Davids House & Offices.

St David's Cathedral Close. Plan by Joseph Lord, 1720

The Canonry. Mention of a white gate in 1172, suggests there was a wall then. Bishop de Gower (1328–47) is said to have rebuilt the Close wall, but the walls were old and decayed according to Bishop Houghton (1362–89). On the SW length, by Pont Cerwyn Dewi (*see* below), a square SLUICE TOWER over the mill-leat to Felin Isaf, the former Bishop's mill, with rough barrel vault. At the W corner was a round tower, identified in 1720 as the Bishop's dovecote.

Lord's map shows the Close before the pre-Reformation buildings were swept away. In the E quarter are the cathedral, churchyard, free school, bell-tower, and St Mary's College (the present

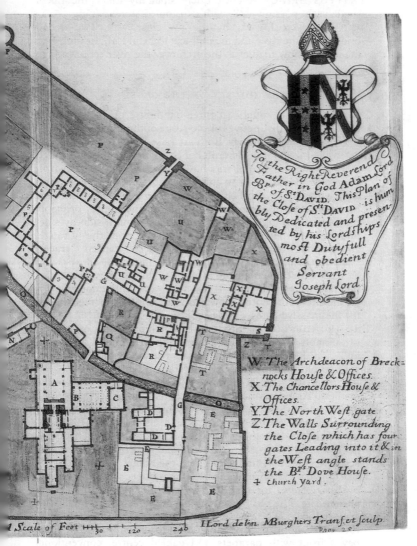

To the Right Reverend Father in God Adam Lord Bp. of St DAVID. This Plan of the Close of St DAVID is humbly Dedicated and presented by his Lordships most Dutyfull and obedient Servant Joseph Lord

W. The Archdeacon of Breck= nocks House & Offices.
X. The Chancellors House & Offices.
Y. The North West gate.
Z. The Walls Surrounding the Close which has four gates Leading into it & in the West angle stands the Bps. Dove House.
✝ Church Yard.

Scale of Feet ╟┼┼┼─── 30 ─── 120 ─── 240          I.Lord delin. M.Burghers Transf. et sculp.
Pag. 26.

Cloister Hall), behind which were the Vicars' college and houses, then derelict. In the s quarter, was the Chanter's House, now the Deanery, and sites of already demolished houses of the Prebendary of Llanddewi and the Archdeacon of Carmarthen, fields now. In the w quarter was the Bishop's Palace, as now. The N quarter had, as now, most of the houses: those of the Prebendary of St Nicholas (now Penyffos), of the Treasurer, of the Archdeacons of St Davids and of Brecon, and of the Chancellor, all of which survive rebuilt. Ruined then and not rebuilt was the Archdeacon of Cardigan's house, N of the Treasurer's.

PENYFFOS BRIDGE. Picturesquely small by the cathedral, a single arch, possibly C18, with C19 tooled stone coping.

PONT CERWYN DEWI, by the sw close wall. Two-arched bridge, over the river and the mill-leat to Felin Isaf, the arch over the leat possibly medieval, the arch over the river rebuilt 1834.

THE HOUSES OF THE CLOSE

CLOISTER HALL, roughcast three-bay house of c. 1830, three bays; to the l. a distinctive rubble-stone outbuilding with excessively tall square chimney. Both are raised over part of the very extensive medieval undercrofts of St Mary's College, founded in 1356 (for the chapel see above). The college, as shown in 1720, was H-plan with w and E ranges separated by a cross-wing with gateway, and a service wing ran w to the river. Three barrel-vaulted undercrofts in line under the house, probably the original E range, two at right angles behind, side-by-side, under the former cross-wing, and others under the w range, and running towards the river under raised garden terraces. From the courtyard behind the scale of the medieval work can be seen, with broken entries into the undercrofts, now used for building stores. The large Tudor archway into the courtyard is on the site of the entry shown in 1720, and has pierced stones for the massive gates.

THE ARCHDEACONRY. Stone three-bay hipped villa of c. 1830, presumably once roughcast. The 1720 map shows an L-plan house on the corner of the site, said to have been late C17, but with an older chaper chapel, still standing in 1811.

BRECON HOUSE. Built 1820–1 by William Owen, to replace the medieval Archdeacon of Brecon's house, which was described in the mid-C18 as having a 'hansome hall reching up to ye roof'. Fenton recorded a porch with arms of Henry VII. Three-bay roughcast villa, with low hipped roof and arched timber hood to the doorcase. John Maund of Brecon signed the accounts, he presumably designed the house.

THE CANONRY, former chancellor's house, 1846, possibly by James Stone, for the Rev. E. Melville, chancellor, on the ancient site. The old house, rebuilt in the C16, had a hall with armorial glass. The new one is in a heavy Tudorbethan style, rock-faced stone with big mullion-and-transom windows. Five-bay s front with parapets and gabled centre, conventional

except for a thin square tower left of centre breaking the sym-
metry. Tudor porch on the E end with bay window over. Much
panelling inside. Paired ashlar arches at the foot of a Jacobean
stair. An older garden wall along the lane has two chamfered
pointed doorways; the W one may be medieval. The N end of
the wall is the site of the N gate, Porth Boning.

THE TREASURER'S HOUSE. Rebuilt before 1811, incorporating
a small part of the late C15 house, which had a three-sided
court, a hall and embattled tower, the present house being on
the site of the service range. Two storeys, four bays, extended
from three, roughcast with tripartite sashes and an open pedi-
mented doorcase. An eroded stone course at the eaves looks
pre C19, otherwise no clues. An odd plan, with passage along
the rear wall, early C19 staircase. Tudor-arched gateway, C19,
with, in the E jamb, a rounded porter's recess, the seat said to
be the stone on which St Patrick had the vision summoning
him to Ireland.

PENYFFOS. Small mid-C18 house; Edward Yardley, c. 1740–60,
said that a new house of brick had been built in the last ten
years. A brick house at this date would be remarkable, but the
house is roughcast, showing only nogged brick at the eaves.
Two storeys, three bays, with cemented slate roof. Staircase
with shaped flat balusters.

THE DEANERY. Previously the Chanter's or Precentor's House,
it is shown to roughly the same plan in 1720, but was thor-
oughly remodelled in 1851 by *Thomas Roberts*, in a matter-of-
fact Tudor style. The main range was stuccoed, and NE drawing
room wing and SE library wing added (the latter on the site of
a previous range). Large hoodmoulded timber mullion-and-
transom windows. N end gable with the drawing-room wing to
l. Tudor arched E porch behind in the angle, on to a yard
enclosed by the library wing. Some old rubble walling in the
cellars, otherwise plain mid-C19 detail inside.

# PORTH Y TŴR                                         5

## BELL TOWER AND EAST GATEWAY

An octagonal structure, now part of the E gate to the close, pre-
sumably built to replace the crossing tower after it collapsed in
1220. A number of cathedrals had belfry towers set well apart
from the church, including Llandaff, Chichester and Salisbury. At
St Davids the site near the top of the valley must have significantly
improved the range of the bells. Entrance door in two orders
(much restored), with nibbed rolls consistent with a 1220s date.
There are moulded capitals and a continuous inner order. The N
base is decorated with upstanding fleurs-de-lys. Inside on the
ground floor eight free-standing piers, inserted c. 1930 to support
an octopartite vault with an oculus in the centre for hauling up
the bells. Two narrow windows, furnished with deep embrasures
and round-headed rear arches, like those in contemporary castles.
In the belfry stage eight broad lancets, one on each face.

In the C14 a fortified gate was attached to the S side. Rubble built with little in the way of dressed masonry. A central passage, segmental headed, has two portcullis slots. The most interesting feature is the curved alcove for pedestrians, with its own gate, allowing individuals to pass when the main gates were locked. To the S the building terminates in a D-shaped tower, which together with the belfry creates the impression of a twin-towered gatehouse. Battlements over the central passage, elsewhere a parapet supported on plain corbels. A door on the N side of the gate opens to a modern stair, which leads up to the first floor, now housing an exhibition on the history of the cathedral. Here one can examine the S wall of the belfry, complete with one of the lancets, enclosed within the later gatehouse. A doorway (now blocked) at the SW corner must have given access to an external wooden staircase. Further S an octagonal room with a garderobe in the W wall. At this point we are in the S section of the gatehouse, and down below, alongside the main passage, is a room that houses all the early stone carvings. This has an octopartite vault, without ribs. On the E and W sides deep embrasures with narrow slit windows. Underneath an *oubliette*. Until recently the chambers in the gateway were ruined, but the building was re-roofed and restored as an exhibition area in the year 2000 by *Peter Bird* of *Caroe & Partners*.

The EARLY CARVED STONES gathered together in Porth y Twr range from the late C5/C6 to the C12, testifying to the early importance of the St Davids peninsula as an ecclesiastical centre.* The earliest examples from the Cathedral Close date from the C9. They include a fragment of a crosshead with interlace, dragons and three-winged angel, suggesting links with Ireland in the C9, and the famous 'Abraham' stone, a cross-inscribed slab in memory of the sons of Bishop Abraham, who was killed by the Danes in 1080.

38

# THE BISHOP'S PALACE

Ruinous from the C17, the Bishop's Palace escaped the changes usual to palaces in use, and is the most instructive medieval palace in Britain, remarkable for being almost all of the earlier C14. The palace was largely built by Henry de Gower, bishop from 1328–47. There was a palace before, for Henry II dined there in 1171 and 1172, and Archbishop Baldwin in 1188. The modest and much altered W range may date from this time, but no palace at all is mentioned in a survey of 1327. De Gower's buildings comprise two main ranges at r. angles, a duplicated suite of private and state apartments: the E range containing the Bishop's Hall, solar and a rear wing, was built first, followed shortly, still in the 1330s, by the S range with the GREAT HALL, CHAMBER, and CHAPEL at the NW angle, all raised on vaulted

*For a discussion of these *see* N. Edwards, 'Monuments in a landscape, the Early Medieval Sculpture of St Davids', *Image and Power in Early Medieval Britain*, ed. H. Hamerow and A. MacGregor, 2001.

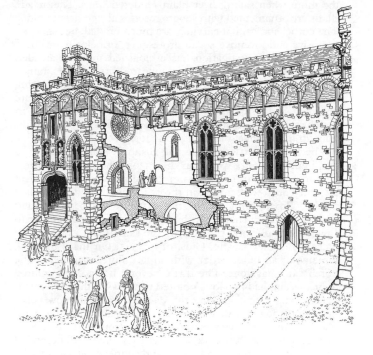

St David's, Bishop's Palace, Great Hall. Reconstruction drawing

undercrofts. The KITCHEN on the S end of the Bishop's Hall, porch and lower connecting corridor came in the 1340s, as also the bishop's chapel at the N end of the E range, which links to a formerly detached GATEHOUSE of *c.* 1300. The plain W range was remodelled by de Gower as lodgings with undercrofts.

*Description*

Plain late C13 GATEHOUSE in the N wall of the enclosure, originally detached, three storeys with broad pointed arch and battlements without corbelling. The approach to the palace is oddly understated. Within, a large grassed court with de Gower's ranges along two sides. The extraordinary arcaded parapet that characterizes de Gower's works here, as at Lamphey Palace (q.v.) and at Swansea Castle, unifies the whole work. An open pointed arcade with simple chamfered arches on piers springing from corbels set below the eaves level, runs along the wall faces, with carved grotesques on corbels and some capitals. The stone tiles of the roofs swept through these arcades, which were entirely decorative, although all originally battlemented. Decoration is clearly the motive for the alternate purple Caerbwdy and yellow Somerset cut stone in the arch voussoirs and spandrel chequerwork, and would have stood out

the more when sailing over plain rendered walls. The arcade shafts are ornamented with square rosettes at significant points. The corbel and capital carvings are much eroded, but show an extensive and inventive set of grotesques, principally on the E range. Recent investigation has established that the arcaded parapets are not all original, but appeared first on the S range, which seems to have been modified to greater richness during building, as the porch and E end with wheel window are changes of plan. Parapets then were added to the E range to match, and were incorporated in the kitchen and porch additions to the E range, made in the 1340s.

The EAST RANGE includes the Bishop's Hall with solar to left, built in the first phase in the 1330s. The kitchen at the S end, together with the lower porch and passage which project into the court, were added in the 1340s, with similar wallplate arcade. Broad steps up to the PORCH, the reconstructed doorway column-shafted with half-octagonal head, similar to English Bristol work, possibly by the same hand as the porch arch at Berkeley Castle, Glos. of *c.* 1345. On the l. minimal remains of an outer order with square floret ornament. The porch vault has gone. The HALL beyond has a plain pointed doorway, and had two long pointed windows to the l., one two-light, a single light lighting the dais, a large one, now gone, lighting the lower end, and a third lighting the solar. The simplicity of the walls with windows in local purple stone shows that de Gower's first work was relatively modest. The added wall arcade has grotesque corbels and simple capitals; until the mid-C19 there was a chequered circular stack. To the l. of the porch, pointed doorway to two UNDERCROFTS. Inside the dais was at the N end, fireplace on the E wall. Corbels with finely-carved heads for the roof trusses. Sockets for a screen at the S end and stairs in the SE corner to the wall-walk and undercroft. At the NW corner, corbel for a wooden dais canopy, one of five originally, the canopy top reached from a winding stair in the NE corner. Adjacent, a diagonal passage through to the NE wing, from which the solar is reached. The narrow NE WING is lower, the walls with blind arcading and battlements. The upper room was probably the bishop's bed-chamber. Massive fireplace on the S wall with circular chimney, and a second round SE chimney, venting latrines at the E end. The circular chimneys suggest a C16 remodelling. Blocked door to the precinct wall-top. Single undercroft below. The SOLAR is square, with large N fireplace and tall window each side with thin colonnettes, these part-blocked when a floor was inserted before 1500. A latrine is set within the N wall of the NE wing, a servant's door in the NW corner. Access to three undercrofts, below the solar and the dais of the hall, from the courtyard. The BISHOP'S CHAPEL, built along the N end wall at a slightly later date, may not always have been such, as it did not have private access from the solar. It never had a fireplace. Externally arcaded, with blind arcading across the W end wall under corbelled battlements, but the E gable plain. Raised on an

undercroft with ouside stone steps to a very wide s arch which
presumably framed a door and window. Single w lancets, two
on the n, a large pointed e window. Carved head corbels within
of alternating sizes. A single undercroft below, with inserted
fireplace and a latrine up a stair in w wall. The outside walls
of the e range show the original render, square turrets at each
end cap the stairs.

Returning to the BISHOP'S HALL, the passage to the r. of
the porch passes the KITCHEN added c. 1340 on the s end of
the Bishop's Hall, to the same roof and parapet height. The s
end wall is corbelled with the se square stair-turret. There was
a kitchen here at ground level, replaced by undercrofts to the
new kitchen which was of four square bays divided by low seg-
mental arches, springing from a central octagonal pier. This
collapsed before 1800. Each bay was in effect a very large
chimney hood, two venting to n and two to s, serving open
fires. On the s wall there was also an ordinary fireplace. Domed
cupboards on s and w. The passage to the w runs n to a lean-
to on the end of the s range, for service access, with under-
croft below interrupted by the diagonal passage that gives
access to the outside of e and s ranges.

The s RANGE is entered from the court through an ornate
raised PORCH, the most elaborate single feature of the palace,
and a joyous piece of architecture. Asymmetrical, a long
pointed window to r., the entry to l., up steps through a large
arch with ogee head. Above are two gabled and crocketed
statue niches which reach up to the most decorated of the
palace parapets, four bays but the arch over the entry of double
width, with coloured voussoirs and corbelling for lost battle-
ments. Much carving, square florets in the arcade arches and
piers, gargoyle capitals and corbels. Though eroded, the two
niches were fine pieces. The main arch is in three orders, the
outer two ogee with big finial, all with traces of a carved vine
scroll. It seems that all this carved work was set against a red
render. The steps climb to the inner pointed door, set to the
r., into the hall. The GREAT HALL is of three bays, with a
fourth for the Great Chamber to the r., lit with long pointed
windows. Two doors to the six parallel undercrofts beneath the
whole range. These undercrofts are of near uniform size apart
from the narrow e one, with corner stairs from the hall, the
second may have been a buttery, with glazed small windows,
and the fifth provides a throughway to the rear s side. The e
gable-end, facing the cathedral, was splendidly treated, with a
seven-bay blind arcade, richly treated with carved corbels,
capitals and florets on the shafts. The shafts of the middle arch
are removed for a fine Bath stone wheel-window with sixteen
mouchettes and a centre quatrefoil. The Bishop of Winches-
ter's London palace in Southwark, also earlier c14, has a
circular window (of different design) set higher in the gable.
The tracery here is restored, but follows the original. In the
chequerwork, white quartz instead of Bath stone. Corbelling
under a short centre gable and two outer square turrets, also

chequered. The lean-to service corridor has pointed openings to small undercrofts. Inside the magnificent HALL, 88 by 29 ft (27 by 9 metres), appears larger, as the wall to the Great Chamber has gone. Originally there was a rafter roof, without corbels, a centre hearth, timber screen at the E end and dais at the W. Mural stairs from the undercrofts in the E corners and one to the wall top just by the entry. Moulded window reveals in purple stone, the E wheel window with a double ring with square florets Below is a door to a lean-to service area and the passage N to the kitchen. Almost windowless S wall.

Foundations remain of the dais which backed on to the wall to the Great Chamber. The GREAT CHAMBER had a fireplace on the cross-wall. A narrow SW range at right angles contained the latrine with cess-pit below. In the entry, access to a mural stair to the SW turret. Externally the latrine block is battlemented but arcaded only on the E side. From the NW corner of the Great Chamber a passage leads into the GREAT CHAPEL, the only access. The chapel added by de Gower a little later than the building of the S range has the arcaded parapet still with surviving battlements, blank arcading across the E end in five bays, also with parapet, originally screening a low roof. The arcades are enriched, the centre bay of the E arcade broken for the E window, originally three-light, with statue niches in the sides. The N wall has two pointed windows and an added porch of c. 1500 in the angle to the W range. At the NW corner, a plain square bell-turret capped with a thin broached spire, oddly rustic and underscaled. Inside, to the r. of the E window, a purple stone ogee-headed PISCINA with crockets and finials, finely carved but eroded, part restored. Undercroft beneath.

The steeply roofed W range is much plainer, it may be the late C12 palace, or possibly a C13 rebuilding, but there is not enough evidence. Except at the far N end, the ground floor has inserted undercrofts of de Gower's time, supporting two long rooms above that may have been used as lodgings. On the cross-wall of the upper floor, two back-to-back fireplaces with corbelled jambs for stone hoods, and small lamp-brackets each side.

## THE CITY

The diminutive town, a city since 2000, with modest houses mostly of the C19, has three main streets, meeting at Cross Square: High Street to E, Nun Street to N, and Goat Street to W. A fourth, much shorter street, the Pebbles, runs NW down to the cathedral close.

### CHAPELS

BETHEL WESLEYAN CHAPEL, Goat Street. Disused, rebuilt in 1837, plain rendered long-wall front with door between arched

windows. Interior with panel-fronted galleries on timber columns, possibly of 1837.

EBENEZER INDEPENDENT CHAPEL, Nun Street. 1871, handsome pedimented stucco front with four long arched windows above a pair of doors. Inside, gallery on three sides with cast-iron balustrading.

SEION BAPTIST CHAPEL, New Street. Dated 1843, so an early gable front, redone in 1897 with new stucco dressings. Door with four windows over, the centre ones set higher. Plain panelled gallery on three sides and ribbed boarded roof, all of 1897, box pews presumably of 1843.

TABERNACLE CALVINISTIC METHODIST CHAPEL, Goat Street. 1874–7 by *Richard Owens* of Liverpool, a chapel of remarkable scale, and unusually full Gothic. It cost £3,678/19/4d. Winged front in brown stone with grey limestone dressings, centre big traceried three-light window over gabled door and an asymmetrical spirelet. The stair wings have two-light windows and five-sided roofs. Less remarkable interior, the gallery with boarded front and fretwork panels at intervals. Fretwork panels also on the elaborate canted-fronted pulpit and the great seat. Organ behind the pulpit. 118

PUBLIC BUILDINGS

YSGOL DEWI SANT, High Street. Built as the County School, 1902 by *D. E. Thomas*, rubble-stone single-storey ranges, centre hall flanked by the gable-ends of classroom blocks.

YSGOL BRO DEWI, Quickwell Hill. 2001 by *Pembroke Design* (job architects *J. Mansel-Thomas* and *M. Williams*). Primary school on an extended linear plan to allow the classrooms to face w over the cathedral. An attractive grouping of monopitch roofs each side of the centre spine, buttressed by the double-height hall at the far end. Yellow stucco with some stone and fashionable acid-green verge boards.

TOURIST INFORMATION CENTRE, High Street. An emphatically Post-Modern introduction to the ancient city. 2001 by *Peter Roberts*. A sensitive and environmentally-aware design, well landscaped. A long curving glass-fronted block is linked to a distinctive stone round tower with conical slate roof, fronting a courtyard making much of the local boulder stones, with a landscaped car park separate to the E. As at Roberts' other buildings (Aberystwyth Arts Centre, Lower Treginnis Farm, Castell Henllys Visitor Centre), curving forms soften the scale, plate glass allows easy visual flow from outside to inside, and the materials have a carefully considered simplicity. The main roof overhangs for shelter, the trusses carried on well-finished concrete conical piers. The tower, almost separate, has an admirable solidity against the glass walls of the main building, the lower stonework strongly sloped. The rear overlooks a small wooded area, and is appropriately softer, a turf roof over oak mullions. 135

PERAMBULATION

At CROSS SQUARE, the medieval town CROSS, the shaft origi-
nal, the head of 1873, and turned granite DRINKING FOUN-
TAIN of 1912. On the W side, CARTREF, dated 1778, low,
two-storeyed with grouted roof, the dormers added *c.* 1900.
On the N side, MENAI, built as Cross House *c.* 1860, the best
house in the town, a substantial three-bay front in unpainted
stucco with pedimented Doric doorcase; a contemporary
shop-window to l. with arched lights and coloured glass. The
OLD CROSS HOTEL was mid-C18, five bays, but gutted and
raised a storey in the 1960s. On the S side, LLOYDS BANK con-
verted from a pair of later C19 houses in the 1920s, a later C19
chemist's shop, and COURT HOUSE, early C19, three bays, set
back with a wing coming forward to the street, porch with
grouted hipped roof. THE PEBBLES running down to Porth y
Tŵr (*see* above) has early to mid-C19 houses in a varied row
on one side, and a field sloping down to the cathedral on the
other.

In HIGH STREET, No. 1, on the N, mid- to later C19, still
late Georgian in style, with twelve-pane sashes, three bays.
Opposite, Nos. 6 and 8, a pair of similar stone three-bay
houses, probably as late as the 1870s. The CITY HALL,
1922–4, by *D.F. Ingleton*, nondescript roughcast front,
enlivened by a new porch and colour, 2002. Nos. 18 and 20
are vernacular houses with cement-grouted roofs, framing a
small courtyard. Late C19 shopfront on No. 20. Opposite, No.
15, of three storeys, much altered, was the COMMERCIAL
HOTEL, earlier C19. MANOR HOUSE. No. 19, pre-1840, three-
bays but with entry in the end wall. Further out, on the S, Nos.
44 and 46, a mid- to later C19 pair with bargeboarded double
gable in very purple stone, and brick window heads. THE
GROVE, at the upper end, is a large early C19 three-bay hipped
villa built for James Propert, magistrate. Presumably once
roughcast, but now with exposed stone, showing large corner-
stones, said to have been reused from St Mary's College (q.v.).
A garden wall is dated 1816. For the TOURIST INFORMATION
CENTRE and YSGOL DEWI SANT *see* above. In NEW STREET,
running N off the High Street, Seion Baptist Chapel (q.v.) also
the R.C. CHURCH, a minimal stone Gothic building, begun
1866 as a town hall and never completed.

Starting again at Cross Square, NUN STREET, to the N, has
two-storey houses at first, mid- to later C19. MILTON HALL
on the E side, three bays, was built *c.* 1870, when a stone
vaulted structure was on the site, of which traces survive in the
back of the boundary wall. No. 32, much rebuilt, is dated 1788.
CATHEDRAL VILLAS, on the W side, *c.* 1860–70, is a row of
three gabled stuccoed houses with large sashes. ROYAL
TERRACE, Nos. 43–51, five stuccoed three-storeyed houses,
the largest in the town, was built in 1882 for coastguard offi-
cers. By Ebenezer Chapel (q.v.) QUICKWELL HILL curves
down the hill to the W. Nos. 4, 6 and 8, are earlier C19 cottage-

scale houses. The former PRIMARY SCHOOL, 1873, is Gothic; purple stone with yellow dressings, and two circular chimney-stacks. Nos. 10 and 12 are a pair of single-storey cottages with grouted roofs, the brick window heads suggesting a C19 date. Behind, the ROUND HOUSE, 1964–8, by *James Gowan*, built as a holiday house for E.W. Parkes, Professor of Engineering at Leicester University, where Stirling & Gowan designed the famous Engineering Building of 1959–63. A simple white two-storey cylinder with metal windows between horizontal bands, and a slim half-inset cylinder with entrance and stairs. International Modern in conception, this is already nostalgia, homage both to Le Corbusier and to the moderne of the 1930s, a playfulness apt for a holiday house. Open-plan ground floor with just a centre pillar and a quarter-circle room divider, bookshelves to the inner side, and kitchen to the outer. At the foot of the hill, PONT Y PENYD, single-arched bridge over the Alun, on the old pilgrim path.

130

Returning to Cross Square, in GOAT STREET, two-storey houses and on the N, Tabernacle and Bethel chapels (qq.v.). On the s, Nos. 15 and 17, are a pale mauve display of Caer-bwdy stone, while No. 35 contrasts mauve dressings with greenish sandstone walls, both mid- to later C19. No. 37 is older, possibly late C18, with small upper windows under the eaves. On the other side, two late C18 to early C19 three-storey WAREHOUSES associated with the coastal trade, and a third further on in CATHERINE STREET. Nos. 47–63 Goat Street, Priskilly Terrace, built before 1840, run s to WELLFIELD, now ST NON'S HOTEL, a mid-C19 villa with Gothic stair light at the back, the front altered.

## THE SURROUNDINGS

The St Davids peninsula is a landscape of scattered farms, but unusually with a number of tiny hamlets, generally one or two farms and some cottages. The farms were once characterized by their cemented roofs, but this makeshift against poor slate and strong wind is rapidly disappearing. Typically the outbuildings are small, and high-door barns almost unknown.

*1. NW of St Davids: Carn Llidi, St Davids Head, Whitesands Bay*

The rocky outcrop of CARN LLIDI, 2 m. NW, closes the view. On the w end N slope are two half buried BURIAL CHAMBERS (SM 735 279). The w chamber has a capstone on one sidestone, another having collapsed. The smaller chamber is similar. To the w, on ST DAVIDS HEAD, an Iron Age PROMONTORY FORT, (SM 722 279), defended from the E by a dry stone rampart. Within the fort, the footings of circular huts, and under the bracken to the E, the walls of FIELD SYSTEMS. COETAN ARTHUR, (SM 725 280), is a Neolithic burial

chamber, a single large capstone propped by one sidestone may be the burial chamber as designed, or the two stones under the capstone may indicate that the tomb was originally upright and a passage grave. The scatter of stones around may be part of a cairn with passage entry from the W. At WHITESANDS BAY, S of the head, the remains of a medieval Chapel of St Patrick, (SM 734 272), are covered by the dunes. The bay was a reputed Roman embarkation point.

## 2. *W of St Davids: Porthstinian, Treleddyn and Treginnis*

N of the Porthstinian road, PENLAN, the estate farm of the bishops, a large five-bay farmhouse remodelled in the late C19, the large chimney on the service wing indicating an early C19 date. In the NW pier of the garden wall, a medieval fragment of a carved face. Very large FARMYARD, some buildings with grouted roofs, others later C19, and a roofed WELL on the approach.

PORTHSTINIAN, 2 m. W, was a medieval embarkation point for Ireland. ST JUSTINIAN'S CHAPEL, dedicated to St Stinian, was the subject of a local cult through the medieval period. Probably rebuilt in the early C16 on an ancient site; now roofless. The rectangular chapel has features not found elsewhere: a continuous corbel table right around and relatively broad end walls, suggesting a low roof behind parapets. W door and, oddly, two N doors, but only three very small windows: one each side and one at the E end, breaking the corbel line. Internally the walls have segment-headed arcading and a similar broad arch across the E end. A chancel division is marked by a step and holes for a rood beam. At the SW angle, traces of a stair.

ST JUSTINIAN'S WELL nearby, a holy well in a C19 stone housing. Two LIFEBOAT HOUSES, one in corrugated iron, of 1911, by *W. T. Douglas*, on a concrete slipway over the stone one of *c.* 1870 and 1886.

CASTELL HEINIF, $\frac{1}{4}$ m. S, (SM 724 247). Small Iron Age promontory fort with bank and ditch on the land side.

73  RHOSSON UCHAF. $\frac{1}{4}$ m. E. The best example of the C17 N Pembrokeshire house type where the hall has a massive square inglenook on the side wall, crowned by a tapering round stack. There were eight in Dewisland in the late C19, only Rhosson and Hendre Eynon survive here today (and Garn in the Gwaun valley: *see* Llanychaer). The low outshuts each side occurred in most of the examples, one being the porch, here with arched door within, the other functioning as an extension of the hall. Rhosson was rewindowed after 1902, and now has two regular bays each side of the chimney, formerly there were much smaller windows to the right, and the left bay was thatched. RHOSSON GANOL, opposite, has a massive chimney on the ridge and entry into the lower end, possibly C18.

TRELEDDYN, $\frac{3}{4}$ m. NE. Two closely-spaced farms: TRELED-

DYN ISAF, c. 1800, five bays, whitewashed and slate-hung. Two lofted outbuildings, one with a round enclosure in front for a horse engine. TRELEDDYN UCHAF was a gentry house, built for Thomas Williams, High Sheriff, 1778. Two lofty storeys, three bays, double-pile, with roughcast front and long stair light at the back. This lights a stair with Chinese Chippendale balustrade. There was a painted ceiling with royal arms in a bedroom. CROESWDIG, NE of Treleddyn, dated 1829, is slate-hung, three bays with massive chimney on the service range. Outbuildings with grouted slate roofs.

CLEGYR BOIA HILLFORT, 1 m. E, (SM 737 251). Rectangular fort on the S side of a rocky outcrop, associated with the Irish chieftain Boia, with whom St David struggled in the early C6. An important Neolithic settlement: hut circles, one partly covered by the later rampart; pottery fragments and stone axes were found. Earth ramparts link outcrops around the rectangular site, and may also be pre C6. SW entry curved for defence.

TREGINNIS, 2 m. WSW of St Davids. TREGINNIS UCHAF, large mid- to later C19 three-bay farmhouse, with L-plan range of outbuildings dated 1854. Dove-holes under the eaves.

TREGINNIS ISAF was the most extensive of the St Davids farms, with loosely scattered buildings, earlier to later C19, with grouted slate roofs. Restored from 1990 for the National Trust. Farmhouse rebuilt in the earlier C19, an older drawing shows a lateral chimney as at Rhosson Uchaf. Small OUTBUILDINGS around a yard: mostly earlier C19. In the middle a circular dovecote over the well, later C19, and rare in the region.

SW of the yard is a large later C19 MODEL FARM group with two walled yards, converted to children's accommodation, 1990–2, by *Niall Phillips Architects*, job architect *Peter Roberts*. The principal building was a 100-ft lofted cart-shed with hipped roof, facing E and backing on to a walled yard, with cow-house at the N. A second large walled yard attached to the SE may have been older. The main building is restored as dormitories with little alteration to the five-bay E front. Behind, the cow-house has become a play-room with new buildings added along the W side, backing on to a corridor along the back wall which links to a timber covered walkway along the back wall of the grassed lower yard with a quiet room in the NW corner. Study rooms are in restored buildings on the outside NW corner. The long back wall becomes the spine of the complex, open walkway at the lower end, then enclosed with glazed pitched roof, behind the quiet room, boot-room and kitchen and into the dining room, the principal space of the upper court. This has a large bay window on the back wall, internally framed by a broad arch, like an Arts and Crafts inglenook, and echoed by a similar but smaller real inglenook opposite. The new work is robust and tactile: whitewashed stone, roughly trimmed painted timber posts, cast-concrete arch stones and conical plinths for the posts, and kept to a child-scale with deep-eaved roofs. Children's need for places to stop and look inspires the delightful range of sitting places: window seats, a

platform outside the bay window, a curving bench behind the inglenook, and round seats around veranda posts.

At Penmaenmelyn, to the SW, there was a small COPPER MINE on the cliff, worked from the 1820s to 1883. Nearby are the remains of a Neolithic BURIAL CHAMBER, (SM 717 236).

*3.  S of St Davids: Caerfai, Caerbwdy, Saint Non's and Porthclais*

SE of Tourist Information Centre, TWR Y FELIN includes the tower of a windmill of 1806, heightened as part of a large house of 1907. At CAERFAI bay, on the SE point, PROMONTORY FORT, (SM 763 240), relatively small but with unusually massive banks and ditches on the N. At CAERBWDY bay, to the E, the purple stone was quarried from the C11. On the bank above, a very large square LIMEKILN, said to date from 1815.

From Goat Street, a lane runs S to SAINT NON'S BAY. On the way, WARPOOL COURT HOTEL, heavily altered Gothic villa of 1865, by *T. Talbot Bury*, built for the Rev. A. J. Green. The original work has been swamped: the Romanesque porch in stone and black brick, and the little projection on the garden side with terracotta dragon and drain-pipe columns, are presumably late C19. Black and red brick garden features, one gateway dated 1870, and a tower pumphouse. Inside extensive sequences of wall tiles, delicately painted from 1893 by *Mrs Ada Williams*, wife of the then owner. Mostly genealogy, also Welsh history, topography, and nursery rhymes.

At St Non's Bay, a place of pilgrimage since medieval times, as the reputed birthplace of Saint David, is SAINT NON'S WELL, a holy well in a low tunnel-vaulted well-house, probably early C19. SAINT NON'S CHAPEL, in the field below, is recorded from the C14. Now just low walls, rectangular, and impossible to date. Within, a C7 to C9 STONE with incised cross. Nearby, R.C. CHAPEL OF OUR LADY AND ST NON, 1934, by *David Thomas* of St Davids, a little essay on local themes, with corbel table copied from St Justinian's (q.v.) and W bellcote. Nave and chancel. – STAINED GLASS by *William Morris Studios*. In the ALTAR, reused medieval fragments, small medieval FONT found at Gwrhyd (*see* p. 431), and battered PISCINA from Caerforiog Farm, Solva. It was the chapel to ST NON'S HOUSE, the large plain stone house behind, of 1929, which became a R.C. retreat house from 1939.

The road to Porthclais runs past Y FAGWR, a hipped three-bay earlier C19 villa. At PORTHCLAIS, the tiny harbour at the mouth of the Alun river, the river is crossed by a small clapper BRIDGE, the main stone some 10 ft (3 metres) long. Two pairs of circular LIMEKILNS, one on each side, early C19, and PENPORTHCLAIS, above the harbour on the W, vernacular with grouted roofs, originally two cottages, one with C19 upper storey. Well restored 2002.

*4. N and NE of St Davids: Treleddyd Fawr, Rhodiad, Gwrhyd,
Tretio, Llanfyrn*

From Pont y Penyd (*see* above, p. 427) the lane runs N past
PENRHIW, 1882–4, by *Middleton & Son*, former vicarage for
St David's parish, L-plan, in reddish stone, with steep gables,
ashlar mullion and transom windows, and large Gothic porch
in the angle. Gothic hall and fireplaces with tiles by *William de
Morgan*. Further out, PENARTHUR, much altered to the front,
has a gabled rear stair-tower, possibly C18. The road runs N to
TRELEDDYD FAWR, a hamlet amid potato fields. YR HEN
GAPEL was Bethania Chapel, half-hipped, altered to a house
1987. In the centre, TRELEDDYD FAWR, the best example of
the local vernacular, a small double-fronted two-storey house,
colourwashed with thickly grouted roof and large kitchen
chimney one end. Probably late C18 or early C19. TY CANOL,
just E, is a tiny farm, with single-storey farmhouse and low out-
buildings in line, the farmhouse with later attic dormers.

At RHODIAD, 1½ m. NE from St Davids, on the B4583,
RHODIAD Y BRENIN INDEPENDENT CHAPEL, 1784, the
oldest in the county. A low whitewashed façade with three
windows and a door, the window by the door set higher for
the pulpit. The plain late C19 interior has been stripped. MAEN
DEWI farmhouse to the S has the pointed stair light, a feature
of local houses in the mid-C19. GWRHYD to the N was the site
of a medieval chapel. In the hamlet. GWRHYD GANOL is a low
two-storey vernacular house, like Treleddyd Fawr (q.v.),
double fronted with grouted roof. GWRHYD BACH to the SW
had a big conical chimney in the late C19, and the service wing
still has a round-arched door that may be C17. On Dowrog
Moor, to the E, behind the cottages, MAEN DEWI STANDING
STONE, (SM 775 275). HENDRE EYNON, to the N, still has the
big C17 conical chimney, but the rest was rebuilt in the 1920s,
the chimney standing in the centre of the N front on a massive
square base. Inside a stone arch to a very deep inglenook.
Further NW, N of the road, TREMYNYDD FAWR, late C18 or
early C19 house with hipped rear stair-tower, and walled rear
yard. S of the road, TRETIO, a hamlet of scattered farms and
cottages. CAPEL BETHEL, 1839, plain rendered gable front,
early for the type. Interior mostly of 1902, but the end gallery
with long panels under slender turned balusters may be orig-
inal. TRETIO COTTAGE was restored in 2001 by the owner,
*Richard Cotton*, with *W. A. Spees*, single storey with thatched
roof edged in slate, an exemplary rescue of one of the smaller
cottages. The new rope underthatch reproduces a local feature
of which almost all the original examples have gone. BEREA
INDEPENDENT CHAPEL, to the NE, 1881, rock-faced green
stone and Perp Gothic windows. At LLANFYRN-Y-FRAN, 400
metres E of Berea, a pair of pig-sties with corbelled stone roofs
of thin slabs, this apparently pre-medieval construction prob-
ably dating from the early C19.

## 5. *E and NE of St Davids: the Fishguard and Haverfordwest roads*

On the Fishguard road, HENDRE, 2 m. NE, large stone square farmhouse of 1847 with broad pyramid roof and long single apex chimney. Segmental-arched openings, all more architectural than usual, and the interior to a centralized plan with heavily-detailed stair and gilt pelmets in one room. At CARN-HEDRYN, 3 m. NE, the former CHURCH of ST JAMES, 1879 by *E. Lingen Barker,* now a house, and former SCHOOL on the main road. At CRUGLAS, earlier C19 small gentry house, much altered, a later C19 horse-engine house behind one of the buildings. S of the main road, 2½ m. ENE, CAERFARCHELL, attractive small settlement around a green, overlooked by CAERFARCHELL FARMHOUSE, early C19 three-bay rendered front with purple Caerbwdy stone stacks. Typical garden wall crested in white quartz blocks. N of the chapel, the MANSE, of the 1870s, still Georgian in proportion, but of hard green Middle Mill granite, a stone used only in the later C19.

CAERFARCHELL CALVINISTIC METHODIST CHAPEL. A picture-book example. Prettily set in a forecourt with purple stone gatepiers and beachstone rounded finials. Near-square stone chapel, 1827: hipped roof, two arched windows and outer doors, simple but nicely proportioned. Inside, five-sided gallery, on timber columns, possibly original, panel-fronted.

On the Haverfordwest road, at VACHELICH, Y BWTHYN, single-storey C19 cottage, with larger kitchen chimney. To the E was ST DAVID'S AIRFIELD, Second World War, cleared and returned to fields in the 1990s.

# ST DOGMAELS/LLANDUDOCH

*1646*

English and Welsh names commemorate two different saints, a memory of two pre-Norman churches. St Dogmael, or Dogfael, on the abbey site, and St Tudoc, more shadowy, possibly on the coast between Ceibwr and Hendre. St Dogfael probably founded a Celtic monastery in the C6, an establishment of some importance on the evidence of carved stones found on the abbey site. The surrounding settlement was already known as Llandudoch in 988, when attacked by Viking raiders.

## ABBEY OF ST MARY

*17*

St Dogmaels was the only abbey of the Order of Tiron in England and Wales. The order, strictly following the Rule of St Benedict, was founded by St Bernard of Abbeville at Nogent in 1109, moving to Tiron in 1114. Robert FitzMartin (cf. Nevern and Newport) visited him in 1113, returning with thirteen monks and a prior to found a priory in 1115, raised to an abbey in 1120. St Dogmaels was the mother house of small priories at Caldey

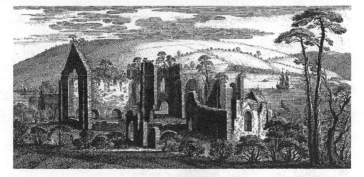

St Dogmaels, Abbey of St Mary from the south west.
Engraving by Samuel Buck, 1740

*c.*1120 and Pill (Milford) *c.* 1200 in Pembrokeshire, and Glas-carreg in County Wexford.

The buildings were complete enough for Gerald of Wales to stay in 1188. The church may have been finished, to a reduced plan, after Norman power was re-established around 1240. The cloister buildings, also complete by this date, were altered in the late C13 to early C14, though the abbot pleaded impoverishment due to war in 1297 and could not pay taxes in 1318. A larger rebuilding of the E cloister appears to have been abandoned. The Black Death in 1349 much reduced the abbey and its income, and at the visitation in 1402 there were only four monks, con-demned for licentiousness. At about this date the abbot's lodg-ings in the W range were rebuilt and a guest wing added. In 1502 there were six monks but the house was in good order, with the chancel restored from ruin. This is the period when the N transept was rebuilt with – extraordinarily for west Wales – a fan vault. The abbey was dissolved in 1536 and sold to John Bradshaw of Presteigne (who also purchased Caldey), whose house may have been built in the W range, but was ruined by the early C17. The Buck engraving of 1740 shows the ruins much as they are today. Walls across nave and N transept suggest some post-Reformation use, possibly in the C17, before the parish church was built.

The stone is mostly the grey local stone quarried at Cilgerran, and perhaps nearer. The dressings of the C14 N door and the C16 transept vault are in a hard, coarse grey sandstone.

The CHURCH was planned as an aisled nave with transepts, chancel and three eastern apses. The E part, including transepts and crossing, was probably built by 1150, with the beginnings of the S arcade and S wall, but the aisles were abandoned and the nave built in the C13 on the site of the arcades. Beginning at the CROSSING, the C12 piers are cruciform, with chamfered angles and big paired demi-shafts on the inner faces, after the western English model (cf. Malmesbury and Tewkesbury). Scallop capitals have been found that fit these shafts.

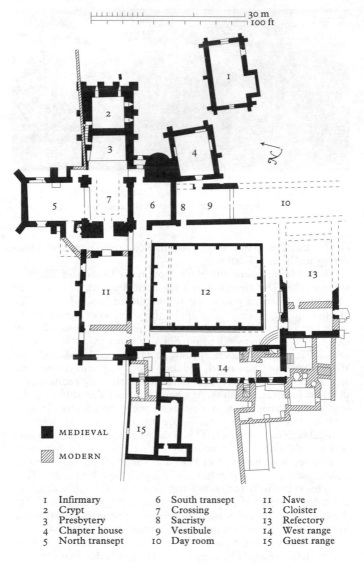

| | | | | | |
|---|---|---|---|---|---|
| 1 | Infirmary | 6 | South transept | 11 | Nave |
| 2 | Crypt | 7 | Crossing | 12 | Cloister |
| 3 | Presbytery | 8 | Sacristy | 13 | Refectory |
| 4 | Chapter house | 9 | Vestibule | 14 | West range |
| 5 | North transept | 10 | Day room | 15 | Guest range |

St Dogmaels, Abbey of St Mary. Plan

Foundations of the PULPITUM across the W arch and of a solid wall across the S arch, backing presumably to choir stalls, and echoed on the N, though the thin foundation here is post-medieval. The three-bay PRESBYTERY was aisleless; the first part mid-C12, rebuilt in the early C13 and extended with a straight E end, over a vaulted crypt – perhaps entirely rebuilt, as the external buttresses are uniform. The CRYPT, unknown in other Welsh foundations, is square and must have had four vaults carried on a centre pier. The surviving responds are

column-shafts with trumpet capitals. Both TRANSEPTS were
walled off from the crossing and had access to the presbytery
via a narrow passage behind the E crossing piers. The founda-
tions of the walls and of the apsidal SE chapel give no detail.
The apse was later blocked off. The two-bay N transept walls
stand to full height, entirely C16, with exterior buttresses, and
a large N window with a smaller window each side, the tracery
missing. The springers of a fan vault on carved corbels remain;
with ogee heads to the cells, and corbels carved with fairly
crude figures – an angel, a lion, St Michael. A full fan vault,
so rare in Wales, suggests a formal commemorative purpose,
perhaps connected with the two plain tomb recesses in the
NE corner. The W and N walls of the NAVE remain. The
foundations of the S wall include the walled-in square C12
piers. There was a S door into the W cloister range. Footings of
a wall across the nave, between S and N doors, may be post-
medieval. The W WALL has a large pointed window, probably
early to mid-C14, also the N DOOR with unusually fine ball-
flower ornament. The C13 nave N wall is windowless towards
the W end, with the N door and two big pointed recesses. There
was a large four-light N window by the crossing. – FLOOR
TILES. Some eroded C14 to C15 tiles in the nave.

THE MONASTIC BUILDINGS lay to the S. From the
CLOISTER, the base of the wall remains, of stone, buttressed
every three bays. Columns and shafts from the arcades found
in excavation show that there were double columns, paired in
depth, with carved capitals datable to the mid-C13. The N walk
occupies the site of the intended S aisle. W and S ranges were
rebuilt c. 1300–40. The W RANGE basement survives better
than the others: C12 parlour at the N end, and the rest, cellars.
The abbot's lodgings would have been above, reached by spiral
stairs in the SW corner of the church. Curved steps at the SW
corner of the cloister may relate to another stair, replaced by
one on the W wall. Minimal foundations of a C15 GUEST
RANGE behind to the NW. The S RANGE was built in the C13,
with the kitchen and refectory. The SW corner appears to have
been rebuilt as a house after the Dissolution, and has the
remains of three round ovens and the base of a stair. To the l.,
red stone remnants of a C13 laver, or trough for washing, mark
the entrance to the refectory. The next room to the l. may have
been a warming room. The E RANGE was the undercroft of the
dormitory; the SE corner room, S of the through-passage, may
have been the day room, the room N of the passage perhaps a
parlour. Then comes the CHAPTER-HOUSE entry, marked by
the bases of a broad doorway, originally leading to the C13
chapter house, but altered around 1300, when this became a
vestibule to the new chapter house to the E. The S wall of this
survives, a small window to the l. and a pointed-arched recess
below.* To the N of the vestibule, a narrow room against the S
transept.

* The chapter-house alignment, skewed from the E range, suggests that this range
was intended for rebuilding, but the plan was abandoned.

The detached INFIRMARY off to the E is late C13. Three walls remain. It was stone-vaulted, with pointed barrel vaults originally to the single main chamber, and surviving on a gabled projection to the s. Small pointed w door.

By the edge of the site, STABLES, presumably mid-C19, sandstone with gabled centre, built for the vicarage, and proposed for conversion to house the various carved fragments and inscribed stones collected at the site and presently grouped around the infirmary. The stones from the abbey include some very ornate bosses and capitals, and numerous column-shafts. The INSCRIBED STONES include a square C9 or C10 pillar with incised ring-cross, found under the chapter-house wall; a C9 or C10 pillar with an encircled cross and a long shaft ornamented with spirals; a C10 or C11 broken cover slab with half of a ring-cross lettered D and l; and an C11 or C12 pillar stone with a confused pattern of crosses and circles, perhaps within a shield, found at Pantirion, $1\frac{1}{2}$ m. w.

ST THOMAS. The medieval parish church of St Thomas stood on the hill E of the abbey, and may have moved to within the abbey itself in the C17. In the early C18 a new church was built on the present site N of the abbey, replaced by the present church of 1848–52 by *Arthur Ashpitel* of London supervised by *Daniel Evans*. Starkly economical, but one of the first ecclesiologically correct churches of the area, with steep pitched roofs, careful – if repetitive – lancets with carved hoodmould stops, and stepped buttresses. Long aisleless nave and chancel, w bellcote. Ashpitel wanted a tower and spire, but there was not enough money. Matching porch of 1925. Plain interior with thin trusses on corbels, ceiled above the collars. Deeply moulded stone chancel arch and shafted big E triplet window. – A handsome stone PULPIT shows good plate-traceried detail, while the FONT imitates the local scalloped type. – Slightly Art Nouveau brass angel LECTERN of c. 1900. – Poppyhead chancel STALLS and simple Gothic RAILS. – STAINED GLASS. E window of 1852 by *Joseph Bell* of Bristol. Six scenes in C14 style against deep blue skies. – Chancel s window 1885 by *Clayton & Bell*, in a disappointing pictorial style. – MONUMENTS. On each side of the E end, Neo-Grecian plaques with urns: Rev. W. Jones, † 1825; Rev. H. J. Vincent †1865. – INSCRIBED STONES. At the w end, SAGRANUS STONE, C5 or C6, inscribed in capitals and in Ogham to Sagranus, son of Cunotamus. – By the s door, broken slab with low-relief wheel cross. – By the pulpit, the broken foot of a slab with base of a cross in incised lines, knob foot, and two spiral-ended flanking lines. Reset upside-down.

BETHSAIDA BAPTIST CHAPEL, High Street. Rebuilt 1856. Unhappily stucco-faced in 1933 by *J. Owen Parry*, with fluting misapplied under the gable and full-width ground-floor opening. Interior of 1933.

CAPEL DEGWEL INDEPENDENT CHAPEL, Poppit Road. 1877.

Rendered gable front with open pedimental eaves and long flanking windows.

GERIZIM BAPTIST CHAPEL, Cippyn, 2 m. NW. 1882, by *George Morgan*. Rock-faced with simplified Romanesque colander window of seven holes, over shafted Gothic doorway. Nearby the roofless CAPEL SOAR, 300 yds E, of *c.* 1840, and the plain rendered CIPPYN CHAPEL of *c.* 1875 on the valley slope opposite, both with lateral façades.

BLAENYWAUN BAPTIST CHAPEL, ½ m. SW. Exceptionally large rendered chapel of 1885–6, by *Owen Lewis* of London, with long plain windows and panelled galleries.

PRIMARY SCHOOL, Maeshyfryd. Built 1868 as the British School, single-storey long front with two long rear wings, openings with neat grey stone arches. Addition with two large centre windows under gablets, 1906, by *D. E. Thomas*. The pair of houses across the yard appear to be of the same date, perhaps for teachers.

## PERAMBULATION

The town is pleasantly set in a bowl of hills where the Degwel stream runs down to the Teifi, but the hillside houses, mostly late C19, are undistinguished, except for the local peculiarity of banding the hard brown local stone with a blue-grey slaty marl, first seen in medieval times in the W wall of the abbey infirmary. In the HIGH STREET, PEMBROKE HOUSE and TYRHEDYN, the latter dated 1877, are the best examples in the centre. CHURCH STREET leads down to the church and abbey, with the mill pond picturesquely at the foot. The MILL, rebuilt 1825, heightened later, has a tall front gable and big 16-ft iron-rimmed wheel behind, restored 1982, the machinery still largely early C19. Beyond the abbey precinct, the VICARAGE, a surprisingly large, five-bay stone house with big sash windows, 1870, but only the bargeboards obvious Victorianisms. Uphill from the vicarage, the former SCHOOL, an early C19 chapel converted to a schoolroom in the late C19. Could this be one of the 'church chapels' built by George Bowen *c.* 1800 (cf. Newport and Nevern)? Said to be on the site of the medieval parish church. OLD SCHOOL COTTAGE, in the schoolyard, is a rare surviving single-storey cottage, probably early C19. PLAS NEWYDD, Longdown Street, a square house with pyramid roof and centre stack, was a villa built *c.* 1800 (for Sir Watkin Lewes, Lord Mayor of London in 1780), but altered 1848 and later. By the Teifi, JEWSONS, a mid-C19, five-bay stone WAREHOUSE of four storeys. N of the centre, off the road to Poppit, a nice group of banded stone houses on the lane to PENTRE LANGWM.

ALBRO CASTLE, Poppit Road. Just beyond the N end of the village, up a lane to the l. The former Cardigan workhouse, now flats, 1839–40, built, like those at Narberth and Haverfordwest, to a plan by *George Wilkinson*, architect to the Poor Law Guardians, modified by *William Owen*. Remarkably

unaltered, mostly of two storeys, rubble stone, the front recep-
tion building embellished with cut Cilgerran stone, Tudor-
arched door and two little gablets, with single-storey wings.
Behind, two ward blocks at right angles to a spine range cre-
ating four small courtyards, the first two complete, the back
two completed piecemeal. The spine range here was the bakery
(now roofless). Octagonal centre block, with angle windows to
oversee the courtyards. The wards are single rooms accessed
from stone stairways, lit from both sides – bleak certainly, but
not gloomy. On the end of the E centre wing, vagrant cells of
1884, still with their grilles for passing out the broken stone –
stone-breaking was the price of the bed.

On CEMAES HEAD, N of Poppit, PENRHYN CASTLE, the
coastguard station of *c.* 1850, with full-height canted bay.
Adjoining, an attractive COASTGUARD COTTAGE of *c.* 1930. At
Cei Bach, the cove below, the old LIFEBOAT HOUSE of 1876.
On the hilltop NE of Cippyn, BRYNTIRION, a three-bay farm-
house, entry with broad fanlight, *c.* 1830–40. W of Cippyn,
PANTIRION, much-restored three-bay house with pedimental
lunette, the fireplace beam dated 1785. MANIAN FAWR, at
Poppit, is C16 to C17 with raised cruck blade and scarfed crucks
in the rear wing.

PARC-Y-PRATT, I m. SE, by the main road. Three-bay house of
*c.* 1825 with large whitewashed farm courtyards.

# ST DOGWELLS/LLANTYDDEWI

The church lies on the Anghof tributary NE of the main settle-
ment at Wolfscastle. The SEALYHAM SLATE QUARRIES, owned
by the Edwardes of Sealyham, were downstream of the church
(SM 960 275). They were exploited from 1825, intermittently until
1900, occasionally with considerable production.

ST DOGFAEL. Low, double-roofed medieval church with W bell-
cote on the N nave, and a big S porch on the narrow S aisle,
which is shorter at the W. All the detail re-done in 1872 when
aisle and nave were restored by *E.H. Lingen Barker* and the
chancel by *E. Christian*. Rough walling and bellcote give little
away. The inner S door is depressed-arched, post-medieval.
More attractive inside, whitewashed with late medieval arcades
in grey stone. The nave has two four-centred, hollow-moulded
arches on a round pier with rope-moulded ring below the cap,
and chamfered responds, one with an eroded carved head.
Small niche at the W end. Two similar arches to the chancel.
All of this looks C16 (cf. Rudbaxton). Small shield in the
moulding of the E arch, a cross set diagonally, and carving of
two addorsed beasts. Whitewashed, plastered pointed chancel
arch, the sides stepped in. Wall recess in the S aisle. C19 open
roofs, pine fittings and iron rails. – FONT. C12 scalloped square
bowl chamfered below to a round shaft. – STAINED GLASS. E
window, C15 style, Christ with SS Peter and John, 1906. – Aisle
E and W, 1874, the one by *A. Gibbs*, the other *C. Gibbs*. –

MONUMENTS. – Ashlar memorial to John Tucker †1740, Baroque with heavy drapes, pediment above, shield and cherub head below. – Rev. John Jenkins †1815, painted plaque with ornate lettering. – Early C19 plaque with draped urn to J. Owen Edwardes of Treffgarne, signed *Tyley*, by whom probably also the memorial with mourning female to John Tucker †1794. – Mary Tucker †1835, draped urn over a sarcophagus plaque. – W. Tucker Edwardes †1858, woman mourning over an urn, signed *Gardner* of Leamington. – Plaque with urn of 1827 to Admiral Thomas Tucker †1766. – Two early C19 oval plaques to Ann Tucker †1782 and Thomas Tucker †1807.

By the porch, iron-railed burial enclosure of the Tucker Edwardes of Sealyham. In the churchyard, INSCRIBED STONE, with NOGTIVIS FILI DEMETI and OGTENE, or OGTENLO, in Ogham strokes, dated to the late C6.

SEALYHAM, ¼ m. w. Early C19 country house, rebuilt for William Tucker Edwardes *c.* 1830, around an earlier house owned by the Tucker family from the C16. Large three-storey, hipped, nine-bay block in painted roughcast; 3 + 3 + 3 bays, the outer bays wider, with square attic windows, and cornices (probably added) to the main windows. The more compact centrepiece has a half-achieved Neoclassical elegance. Enclosed Roman Doric single storey portico with detached fluted columns and triglyph entablature. First-floor fluted pilasters and entablature framing a tripartite window under a shallow arch with blank roundel, flanked unevenly by a niche and a (later) sash window. Above, two roundels flank a long horizontal light. Service range to the l. Neo-Grecian entrance hall with a pair of columns and a Greek cornice, some panelled shutters, the staircase very plain, late C18.

GARN TURNE BURIAL CHAMBER, 1 m. E (SN 979 272). Collapsed Neolithic chambered tomb with impossibly massive capstone. There appears to be a sort of façade or V-shaped forecourt of diminishing stones which may be the remnant of a long cairn.

## ST EDRENS *see* HAYSCASTLE

## ST ELVIS *see* SOLVA

## ST FLORENCE

0801

A very attractive ancient village, rare in Wales, densely grouped around the parish church. Mostly C19 in character, but some good medieval detail survives, attesting to the days when St Florence was a thriving centre, accessible from the sea until the early C19.

ST FLORENTIUS. In the village centre, one of the best S Pembrokeshire churches. Cruciform, with tall, tapering tower of *c.* 1500, unbuttressed and battlemented, raised over the S transept. Parapet on a moulded string course with corner

gargoyles: both unusual features locally. The w half of the nave
is C12, *see* the round-arched SW window. The nave was length-
ened and the chancel added in the late C13. Chancel, s transept
and porch are all vaulted, the vaults of the chancel and transept
perhaps secondary. The s transept is C14. Its rugged, cav-
ernous, whitewashed interior has a squint and deep altar
window (the deep holes, later glazed, may be associated with
a tie-beam, added when the tower above was built). N of the
chancel, a small C15 bay, with later chapel to the E, its vaulted
roof corbelled into the chancel wall. C16 s chapel, the chancel
s arcade of two four-centred arches on a central round pier
with shield-ornamented capital. The chancel arch was perhaps
removed at this time, leaving a gravity-defying overhang of the
N transept vaulting much rebuilt. C15 s porch. Restored in 1836
by *Richard Barrett* (his is the mullioned W window). Major
work began in 1871, by *Daniel Birkett* of Carlisle, the incum-
bent's brother. The lancets and nave roof are his. – FONT.
Norman, scalloped square bowl. – In the porch a broken
PILLAR STOUP, also possibly Norman. Crude circular bowl
with tapering pedestal. – Vast ugly PULPIT of 1871 with black
marble colonnettes. – STAINED GLASS. N transept window of
1873 by *Morris & Co.*, Annunciation, a design by *Morris*
himself, first used at Dalton Church, Yorkshire in 1868, small
scene on clear ground, – E window 1880 by *Ward & Hughes*,
Life of Christ in eight vignettes. – Nave s by *Powell* of Leeds,
1880, Baptism of Christ. – MONUMENTS. Griffith Toy †1601.
Clear inscription, guilloche moulding with broken pediment
above. – Robert Rudd †1648. Good brass of *c.* 1655 in a frame
of 1767. – George Lock †1765. Incised roses. – John Williams
†1704. Huge ledger stone with heraldic shield, set upright.

Outside, the medieval PREACHING CROSS with stepped
base and fragments of the shaft and head. On the s side of the
church, a slate SUNDIAL of *c.* 1870, telling the time across the
world, with central and four subsidiary dials. Signed by *Melvin*
of London, and set on a stone pulpit base of *c.* 1840.

The village retains the form of a Norman nucleated settlement.
A brief tour begins with ELM GROVE NE of the church, a stuc-
coed three-bay house with wide eaves and a hipped roof, built
*c.* 1860. Easily the most charming house in the village is OLD
CHIMNEYS, to the s, two storeys and whitewashed, with two
broad lateral chimneys. The front chimney has a conical shaft,
the back one a stack of D-section. Central pointed-arched door
with chamfered head, rough jambs and imposts. The rear
chimney may be secondary; Peter Smith claims a pre-Refor-
mation date for this plan type, so *c.* 1500 is likely. Downhill,
an isolated chimney with broad base and the remains of a
conical shaft, which has outlived at least two houses. Further
s, HALL HOUSE has an attractive three-bay stuccoed front of
the mid-C19, a conical chimney embedded in the rear wing.
Just E, BETHEL CHAPEL of 1858, a dressed-stone gabled front;
large pointed windows with intersecting tracery – self-con-
scious and above average for the typical village chapel.

GRUMBLE BUSH, further down the village, was built *c.* 1860 as the manse for the chapel. Finally, THE GROVE is an unspoilt, whitewashed C19 cottage, but with a much earlier pointed door (cf. Old Chimneys).

MANOR HOUSE, 1 m. NE. Formerly Ivy Tower, named for Paul Ivy, C16 engineer sent to survey the defences of the Haven, who settled here. Seat of the Williams family from *c.* 1650. The house was remodelled in the 1830s, but is dated 1757 in the roof. Long parapeted and stuccoed five-bay façade, wide portico with paired Doric columns like Tenby houses of the time. The grounds are now a wildlife park.

EAST JORDESTON, $\frac{1}{3}$ m. NW. C17, referred to as a mansion in 1663. Imposing front of five bays and two storeys, with a tall, gabled central porch, the doorway with stone elliptical head. Projecting rear stairwell, originally with timber newel stair.

# ST ISHMAELS

Close-knit village; church and former vicarage some $\frac{1}{2}$ m. W in the wooded valley that runs down to the sea at Monk Haven. At Sandy Haven to the E, a few cottages on the lane down to the inlet, with LIMEKILN and lime-burner's hut on the turn.

ST ISHMAEL. Romantic location deep in a valley full of rhododendrons; a stream runs through the graveyard. Low nave, small chancel, unequal transepts with squint passages. Broad, low S porch, early C19. Medieval fabric, but little that is datable. The projecting W bellcote with pair of arched bell-openings is an addition, a common type in the area, plain and flat-topped (cf. Talbenny or Hasguard), though unusually large; perhaps C15 or C16. N transept with broad semicircular arch, squint, and small traces of the rood stair. In the S transept, empty tomb recesses. Plain, steeply pointed chancel arch. The E end of the chancel rebuilt, with simple Perp S window. Plain PISCINA. Clumsy restoration in 1853, with thin arch-braced roof trusses. More work in 1884 by *D. E. Thomas* of Haverfordwest, who added the flat-headed Perp windows in the nave. Thomas also designed the ugly Bath stone pulpit and the timber vestry screen with odd coloured transfer panels of the Life of Christ. – FONT. C12 square scalloped bowl. – STAINED GLASS. E window of 1886. – Two INCISED CROSS-SLABS, probably C7–C9, one with an equal-armed cross within a circle, each quadrant with simple cusping, the other also equal-armed, the arms narrowing at the centre. Broken slab with shaft of a cross bordered with simple plaitwork, and a small cross on the rear, C9–C10. – MONUMENT. Lucia Thomas †1841, by *J. Thomas* of Haverfordwest. Plain.

MONK HAVEN MANOR, W of the church. Built as the vicarage, 1835, by *Richard Barrett*, unexpectedly ornate and in fact copying a Tudor design from *J.B. Papworth's Rural Residences* of 1818, an explicit example of the use of pattern books in

remote areas. Roughcast, two-storey, three-bay, originally with coped gables each side of a stepped gable and with a battle-mented porch. Altered in 1884 by *D.E. Thomas*, who added the bargeboards. Windows with pretty Gothic small-paned glazing to flat-headed casements.

TREWARREN, ½ m. N. Plain substantial country house of *c.* 1844, built for Gilbert Warren-Davis, probably by *William Owen*. Long six-bay, two-storey front, hipped, with French windows and a veranda, the centre two bays stepping forward slightly. Side entry to a long spine passage with staircase centre rear, giving full space to the s-facing main rooms. Plain three-sided stable-yard behind. The grounds are extensively walled down to the sea at MONK HAVEN, where a high battlemented wall behind the beach may have sheltered an orchard. In the grounds a roofless Gothic COTTAGE with battlements. Further E on the cliff is a ruinous small TOWER, probably earlier C19. ½ m. SW at Musselwick, THE BUNGALOW, single storeyed under a hipped roof, four bays long, built for the Warren-Davis family, probably by *William Owen*, but all internal detail late C19, when a two-bay service wing was added.

BUTTERHILL, N of St Ishmaels. Ruinous mansion of the Roch family, the plain three-storey, eight-bay front clearly of two periods. The r. three bays *c.* 1830, presumably when the whole front was rendered; the rest is a double-pile house of the mid-C18 or earlier, *see* the massive W end chimneys. One roof truss was dated 1830, but all was inaccessibly collapsing in 2002. What little interior detail survives is of *c.* 1830. CART-SHED to the E, with C18 roof trusses. Behind, a roofless small BEE-HOUSE with shelves for steps. The lost garden in front of the house has a semicircular SHELL GROTTO, in the upper wall, once embossed with seashells inside, but now only their prints remain.

SANDYHAVEN HOUSE, 1 m. E. On a windswept site above Sandy Haven. Owned by Admiral Sir Thomas Button, †1634; leased from 1641 to Thomas Stepney, †1669, whose son inherited the Stepney baronetcy. First impressions are C17, but the house is suggested as C15 or C16 in origin.* Tall, narrow N–S range, three storeys and attic, with coped gables with dummy chimneys, big external stacks on both side walls, and ovolo-mullioned attic windows in the end gables. Red sandstone rubble with remnants of roughcast and false quoins; the S end is cement-rendered. Two-storey SE wing with main entrance, and C19 battlements. Narrow NE stair tower. The N end has staggered windows, for a later stair. NW parlour wing with big C20 windows, and extending S, a service wing with massive end stack.

The house is said to have originated as a tower house at the s end, extended by the SE wing, which has a vaulted under-croft, possibly once under a first-floor hall, and then by a NE stair-tower (now without its stair). Probably in the mid- to later

* Report by RCAHMW.

C17 the main tower was heightened, extended N for a grand staircase, and given a NW parlour wing, with lobby in the angle. The service wing is probably C18, altered in the C20.

The interior has been successively altered. The vaulted room in the SE wing, latterly a dairy, has a four-centred profile to the vault, and a four-centred doorway in the S wall. The roof of the wing is C17 (collar trusses with lap-joints). In the ground floor to the tower, some splayed window reveals and an arch to the former stair-tower. The grander C17 stair added in the N extension was replaced in the C20, but the first-floor NW parlour is a fine fully-panelled room of *c.* 1700: fielded panels in bolection frames, horizontally-panelled frieze, and a low dado. On the S wall a panelled recess and double doors to an arched doorway.

On the approach, a lofted STABLE, probably C18.

LEADING LIGHT, Great Castle Head, ¼ m. SE. On the headland, a pair of flat-roofed, single-storey houses behind a short tower. Built in 1870 by *James Douglass* as part of the navigation system into the Haven. The leading light on the tower was lined up with a rear light on the rise behind, replaced by a late C20 concrete structure.

SOLDIER'S ROCK, Watch House Point (SM 8330 0628). The remains of an emergency battery of 1940, in use 1940–3. Brick and flat concrete roofs to two 6″ gun houses, with a battery observation post, two curved-fronted coastal searchlight positions and other associated structures. The gun houses have underground magazine stores.

# ST ISSELLS

The church is attractively placed on the side of a wooded valley, N of Saundersfoot (q.v.).

ST ISSELL. Broad C15 W tower, battered base with string course framing the W door, but no taper and no vault, so closer to the Carmarthenshire type, despite the distance from the border. Earlier nave and chancel: the high chancel arch with half-shafts between the chamfers looks E.E. The N aisle, with its four-bay arcade of chamfered arches on octagonal piers, is late C14, or more likely C15. Much restored in 1864 by the young *F. R. Kempson*, who refaced all but the tower in coursed stone, installed new windows and added the matching lean-to S aisle. *E. V. Collier* added organ chamber and vestry N of the chancel in 1911. – Very good FONT. Square Norman bowl, the sides carved with scroll patterns, different on each side; on one, the crescent moon, sun and stars. Pedestal and base with corner scallops and simple carved faces. – Richly carved oak PULPIT, with St George and the dragon, 1920 by *W. D. Caröe*. – STALLS by *Collier*, 1925. Old-fashioned arcaded fronts. – STAINED GLASS. N aisle E, 1865 by *Wailes*: typically intense colours. – By *R. J. Newbery*, the E window of 1902, and N aisle

w, 1921. – Chancel s and s aisle e by *Kempe & Co.*, 1912. –
MONUMENTS. Vickerman family, 1850. Sarcophagus-shaped.
– Emma Townshend †1861. Shield-shaped, by *T. Morgan* of
Haverfordwest.

Outside, the four-stepped base of the medieval CHURCH-
YARD CROSS, surmounted by its broken head. Cast-iron
MEMORIALS in the cemetery, late C19, cast by the foundry of
*David & Co.*, at Coppet Hall. Good late C19 CHURCHYARD
GATES possibly also locally made.

WAR MEMORIAL. On an island at the road junction. Slender
Celtic cross, 1921 by *A. Caroe*.

BETHESDA CALVINISTIC METHODIST CHAPEL, 1 m. SW.
Dated 1864. Rendered, but with stone quoins and window
surrounds. Windows with simple stone Gothic tracery. Timber
glazing around the back. Nice interior, simple rear gallery on
wooden columns. Probably by *Davies & Roberts*, contractors
of the Pembroke & Tenby Railway, who built other Calvinistic
Methodist chapels for railway workers and colliers.

NETHERWOOD, ¼ m. NW. Three-bay stuccoed house of 1845–6
with hipped roof and hoodmoulded windows. Now a private
school.

HEAN CASTLE, ⅓ m. ENE. Victorian baronial pile of 1875–6 for
the local industrialist, C. R. Vickerman (*see* Stepaside), by *Pen-
nington & Bridgen* of Manchester, who were called in to work
up designs originally by the very difficult client, who had
already consulted *F. R. Kempson* and *W. G. Bartleet* of Essex.
Attractively set on an eminence among the trees, overlooking
the sea. Part of the NE wing is older, *c.* 1840 (two plain bays,
one gabled). Rock-dressed red Runcorn stone, laid in small
regular courses, with paler Forest of Dean stone detailing.
Vickerman brought the Runcorn stone back from Liverpool in
his coal ships. The battlemented s front is of eight bays and
two storeys, with polygonal end turrets rising an extra storey.
The three r. bays advance, containing the principal rooms, with
the Vickerman coat of arms on the bay window. The junction
is marked by a tall four-storey square tower, with polygonal
turret and corner oriel window. Mullion-and-transom
windows with arched lights, some in full-height bays, giving a
strong vertical emphasis to an otherwise sprawling plan. w
entrance under a large Gothic *porte cochère*, dated 1876. To the
l. slightly advanced, a 1926 extension in matching style by
*Hampton & Sons*.

To the SW, MONUMENT to Lady Anne Lewis †1902; a Tuscan
column of red granite.

MARYLAND, s of Hean Castle. A pretty *cottage orné* very much
of the early C19 pattern-book type, but apparently built in the
late C19.

*See also* Saundersfoot and Stepaside.

# ST LAWRENCE

9327

No village. The church lies just across the Western Cleddau from Welsh Hook. WELSH HOOK BRIDGE, dated 1774, narrow and twin-arched. On the spur to the NW, ST LAWRENCE CAMP, a hillfort defended by a double bank to the N. Across from the church, ST LAWRENCE HOUSE, the former rectory of 1856. Roughcast two-bay front; entry in the end wall, a common plan for vicarages locally from the 1820s. Long rear wing with traditionally massive kitchen chimney.

ST LAWRENCE. Low nave and chancel with outsize twin bellcote, all heavily restored in 1877 by *E. Lingen Barker*. The battered S wall may be medieval, and also the big S porch, plastered and vaulted within, both inner and outer doors chamfered with diagonal stops. Lancet windows of 1877. Whitewashed plastered interior, with attractive slate and tile floors of 1877. Undateable, low rounded chancel arch, plastered over, presumably medieval. Behind is a corbelled support for a rood beam. – FONT. C12–C13, square, with chamfered underside and round shaft. – MONUMENTS. On the N wall, two attractive two-colour marble plaques to the owners of Stone Hall, *c.* 1800, both signed by *Greenways* of Bristol.

NODDFA NEWTON BAPTIST CHAPEL, 2 m. w. 1924, but wholly in later C19 mode, with a giant arch in the main gable.

STONE HALL. ¼ m. SW. A gentry house of the powerful Wogan family from the early C16 to the late C17, then passing by marriage to the Fords, originally of Crewkerne, Somerset, until 1823. Two-storey, L-plan, the long, low whitewashed stone front of three bays of large sashes, the door in an attractive early C19 columned porch between the first two. The r. bay is the end wall of a late C17 range, as shown by the heavy roughbeamed ceilings and the stone spiral stair in the rear range. The front range may be remodelled and has good, earlier to midC18 detail to the entrance hall: fielded panelling, and fireplace with pulvinated frieze. Two arches behind, one to a staircase with dado panelling, turned balusters and thick ramped rail. In the room to the l., heavy beams encased in plaster. The chimneypiece here, presumably imported, is to a design by *Lord Burlington* published in Vardy's 1744 book of designs by Inigo Jones and William Kent. Other examples are in No. 10 Downing Street, London and the House of Lords, Dublin (R. Hewlings).

TYRHOS, ½ m. w. Earlier C19, roughcast and hipped-roofed villa, L-plan with two-window front, entry from the rear wing.

# ST NICHOLAS/TREMARCHOG

9035

The largest settlement of Pencaer, the rocky promontory w of Fishguard. Unusually, a nucleated village but few distinctive buildings.

ST NICHOLAS. Medieval, low and simple, of the North Pembrokeshire type. Much restored 1865 by *R. K. Penson*, leaving intact the sturdily buttressed w bellcote and vaulted s transept. Plain, early C19, nave E bellcote and Y-tracery windows. Plastered interior with low chancel arch, higher arch to the transept, and a squint. C19 roofs. – FONT. Medieval, plain, square bowl on a round shaft. – INSCRIBED STONES. In the chancel E wall, reset, three stones, one inscribed TUNC-CETACE UXSOR DAARI HIC IACIT, and two pillar stones, one marked PAAN-, the other uncertain, possibly NES-.

CAERAU INDEPENDENT CHAPEL, Rhosycaerau, 1½ m. NE. 1826. Charmingly simple rural chapel, half-hipped grouted roof over broad gable front, anticipating the later gable-entry type. Wide-spaced doors, sash windows above. In front, railed MEMORIAL to the Rev. W. Jones †1833. Box pews and panelled three-sided gallery on thin iron columns, raised on high bases.

TRELLYS BURIAL CHAMBER, (Ffyst Samson, or Samson's Quoit) ½ m. SE. (SM 906 349). Neolithic, the massive capstone impressively on only two side-stones, 6 ft (2 metres) apart.

FFYNNON DRUIDION BURIAL CHAMBER, 1½ m. NE (SM 919 368 and 921 365). Only the capstone remains, in a hedge s of the farm. STANDING STONE further s by the same lane.

RHOS Y CLEGYRN STANDING STONE, ½ m. E (SM 913 354). Exceptionally fine, (2.7 metres), described by Fenton in 1810 as a 'druidical circle', not apparent now. Low circular banks SW and NE; excavation has shown there was a paired stone to the NE.

# ST PETROX

ST PEDROG. An exposed site, overlooking the Angle peninsula. Small. Nave, chancel, tiny N transept, s porch. The tall, tapering w tower is C14 or C15, with battered base, and domed roof rising behind the battlements (cf. St Twynnells). All except the chancel roofed with barrel vaults of pointed form. In 1855 *R. K. Penson* refaced the s side in hot red Runcorn stone, an odd choice, and rebuilt the chancel. Lord Cawdor of Stackpole Court paid for the restoration, his coat of arms appears among the *Minton* TILES in the chancel. After the bankruptcy of the contractor, Cawdor fell out with Penson, and turned instead to David Brandon for the restoration of his other churches. – Massive, late C19 FONT, imitating the local Norman type. – FITTINGS by *Penson*. – Late C19 COMMANDMENT PLAQUES, painted lettering on brass. – MONUMENTS. William Lloyd †1674. Small brass in simple frame. The lettering, in Latin, is excellent; crossed bones flank the epitaph, and tiny coat of arms. – Lady Jane Mansel †1692. Large, well-lettered tablet, with accomplished decoration: scrolled apron with festoons flanking a putto head, intricately undercut cartouche above, with garlands of flowers, containing a painted coat of arms. –

Rev. Charles Pigott Pritchett †1815. Long and clear inscription with urn, signed by *Wood* of Bristol. – Charlotte Pritchett †1836. Urn finial. By *H. Phillips* of Haverfordwest.

CHURCHYARD CROSS: four steps and a C19 crucifix.

OLD RECTORY. Mellow, three-bay front, earlier long rear wing; a farm after 1878.*

To the S, at COED MELYN, a lateral chimney with diagonally set flues, C17.

## ST TWYNNELLS                                    *9497*

ST GWYNOG. Windswept hilltop site. C14 or C15 W tower with shallow domical vaulted roof, (cf. St Petrox). Long C13 or C14 nave, S transept and S porch, all with barrel-vaulted roofs, of pointed form. Squint from S transept to chancel. N transept long demolished. *David Brandon* restored the church in 1858 for Lord Cawdor of Stackpole Court; his are the lancets and the scissor-truss roof in the chancel. – FONT. Square Norman bowl of cushion type. – FURNISHINGS by *Brandon*. – STAINED GLASS. E window, after 1918, Crucifixion. – Nave NE by *Heaton, Butler & Bayne*, 1894. – *Minton* TILES in the chancel, some with the Cawdor heraldry. – Late C19 painted-metal COMMANDMENT PLAQUES. – MONUMENT. Katherine Owen †1698. Well-lettered convex tablet, perhaps from a larger ensemble.

THORNE COTTAGE, $\frac{3}{4}$ m. SSW. Puzzling farmhouse, of several builds. It appears as a low, C17 three-unit house with tapering lateral chimney, but the chamfered pointed entry and four-centred doorway inside suggest a C16 core. The date of 1679 within may refer to enlargement of a hall house. Two-bay N addition dated 1726 inside.

## SAUNDERSFOOT                                    *1304*

'Saundersfoote' is first mentioned by George Owen in 1595. The place owes its origins almost solely to the mining and export of anthracite coal, prized worldwide for its low gas content and high output of heat. Coal was being extracted in the area in 1324; Leland saw 'coal pittes', probably those mentioned in a grant of 1529, and by the end of the C16 coal was being shipped to France and Ireland. In 1820 the village had barely half a dozen cottages and two inns, but in 1831–6 the Saundersfoot Railway and Harbour Company built a large new harbour, with a railway to the new collieries in the Begelly area, some 3 m. away, and a branch to further collieries around Kilgetty. This was an impressive and remarkably early undertaking.

Building began along High Street in 1837, and along Milford

*James Pigott Pritchett, architect, was the son of the incumbent and was born here in 1789.

Terrace, houses were erected in 1850, by the Saundersfoot Building Company on land belonging to the Picton estate. In 1847 Charles Ranken Vickerman, a solicitor from Essex, established the Pembrokeshire Iron and Coal Company, with an ironworks at Stepaside. By 1860 Saundersfoot was booming, with at least eight hostelries. Business rapidly declined following the closure of Bonvilles Court Colliery in 1930, but by this time the village was developing as a tourist overspill for Tenby. Tourism is much in evidence today, resulting in some unwise 1960s development along the sea-front and clifftops, while the old village is swamped by much recent housing.

The parish church is at St Issells, some $\frac{1}{2}$ m. N.

St Bride (R.C.), The Ridgeway. 1966, by *Kennedy, Griffiths & Associates*, on a shallow, sloping site. The nave has a triplet of tall, fully glazed dormers, the porch, an overhanging flat-roofed canopy. A quiet blend of brick, coursed sandstone, and whitened render. Inside, the nave has a five-bay roof of smooth timber cruck trusses.

Wesleyan Chapel, The Ridgeway. Dated 1892. Small and rendered. The front gable has a triple lancet with hoodmould, a hallmark of *J. Preece James* of Tenby. Simple interior, no gallery.

Thomas Memorial Congregational Chapel, High Street. An early C19 chapel, remodelled 1899, by *J. Preece James*, who added the pediment with side obelisks. Two round-arched windows over the door: the original arrangement. Long interior with no gallery, apse behind the pulpit.

Hebron Baptist Chapel, Church Street. Extremely simple chapel of 1881, rendered, with paired tall outer windows, and a wider one over the entry.

Community Centre, The Ridgeway. Formerly the British School of 1870, by *W. Griffiths*. Long and low symmetrical design, the alternate bays rising to dormers.

PERAMBULATION

The harbour was completed in 1835 by *R. W. Jones*, C. E., of Loughor, in order to export anthracite coal. The engineer *Francis Giles* proposed a floating dock in 1841, but this was not executed. The large, broadly rectangular harbour, nestling against the cliff, is largely as built (the little circular beacon on the w side was reconstructed in 1970). The information centre to the e dates from *c.* 1870, and was the Colliery Office, three bays, with the centre gabled. The three-storeyed Cambrian Terrace, facing the harbour, was built *c.* 1865. Milford Terrace to the N, in progess in 1850 for the Saundersfoot Building Company, has simple, stuccoed two-bay houses, the upper row of seven picked out in bright colours. The robust later C19 railings were made at Stepaside. s down High Street, past the Congregational Chapel (q.v.),

the dominating HEAN CASTLE HOTEL, three storeys and bays. It started life as a simple, though large, inn of *c.* 1840; a machicolated porch bay was built *c.* 1875, and the rest given a corbelled parapet and big timber transomed windows. The big-boned result is due to Charles Vickerman, then rebuilding Hean Castle (*see* St Issells). Other buildings in the village of this date are in a simple Tudor style, e.g. the CAPTAIN'S TABLE (built as St Issells House), near the harbour. The STRAND, to the SE, obtained its grand name in 1950, eleven years after the coal trains stopped passing through. Plenty of small mid-C19 cottages, but many with their detail lost. The line of the railway to the harbour can be followed N of the Strand. Back up High Street, ROSE COTTAGE, the best early C19 cottage in the village, has an attractive rusticated front of three bays and a fluted round-arched portal. In the steep WOGAN TERRACE, WOGAN HOUSE, rebuilt in the 1870s in an emaciated Picturesque style. Centre bay jettied over the Gothick door, with bay window on timber posts. On the uphill side, a slender chimney-breast, with diapered brickwork. Finally, to the N, in FRANCIS LANE, THE COTTAGE, a higgledy-piggledy Arts and Crafts cottage of 1925, by *Kenneth Dalgleish* of London, who specialized in wayside inns of this style in south-east England: whitewashed brick, low thatched roof, eyebrow dormers and tall chimneys. Nicely preserved interior.

COEDRATH, off the S end of Church Street. Mid-C19 Tudor style, mainly of two storeys. Enlargements *c.* 1875, for Pudsey Dawson, less dramatic than those he made at his principal home at Hornby Castle, Lancashire, probably by his son, *A. P. Dawson*, then settled here. Irregular gabled E front, tall bay window with timber Gothic mullion-and-transom windows. The entrance front is dominated by massive balancing chimneys, with big terracotta pots.

BONVILLE'S COURT, 1 m. WNW. Amid the caravan site, the buildings of Bonville's Court COLLIERY, operational between 1842 and 1930, stand intact, including the HEAPSTEAD (upon which the winding-head stood), the ENGINE HOUSE and the WEIGHBRIDGE HOUSE. By 1925 the colliery was responsible for 82 per cent of Pembrokeshire's coal output, its excellent anthracite being especially valuable to the malting industry.

*See* also St Issells and Stepaside.

## SKOKHOLM ISLAND
### Dale
7305

Flat-topped island of some 240 acres surrounded by cliffs of red sandstone, for centuries farmed for rabbits.

From South Haven, the jetty built in 1916 for Trinity House, the path climbs past a large LIMEKILN with single front kiln-eye to THE COTTAGE, the only farmhouse. Fenton in 1810

described it as built 'after a whimsical manner' by a gentleman tenant. Picturesque, with coped gables and cemented roof, all whitewashed, with windows in the front gable, similar in miniature to the former rectory at St Brides. No external dating features; inside, an C18 fielded two-panel door.

SKOKHOLM LIGHTHOUSE, 1915. The last to be built in Britain, by *Sir Thomas Mathews*, engineer-in-chief to Trinity House. Two-storey square accommodation and equipment block, octagonal tower above with domed lantern. The design is remarkably unchanged from that of St Ann's Head Lighthouse, Dale, built some seventy years earlier, even down to the detail of the railings. Still in use, though no longer manned.

## SKOMER ISLAND
*7209*
Marloes

The largest of the Pembrokeshire islands, now a nature reserve. Farmed for rabbits in the Middle Ages and for sheep later, its principal landmark is the large and roofless early C19 FARM at the centre of the island, slate-hung against the gales. The barn is dated 1843. Also of this era, the LIMEKILN on the approach from the landing stage.

The lack of vegetation displays very clearly the prehistoric SETTLEMENTS and FIELD SYSTEMS of about 1000 B.C., the fields often rectangular and boundaried by rows of stones or low earth banks. Settlement sites cluster at the N, SW and S edges of the main island, with footings of round-houses, often in pairs. At the E of the main part of the island, the HAROLD STONE, a Bronze Age standing stone. Later PROMONTORY FORT on the SW headland of The Neck, the E peninsula.

## SLEBECH
*0314*

Slebech in the Midde Ages belonged to the Knights Hospitallers of the order of St John. The church on the bank of the estuary, previously granted to Gloucester Abbey by Wizo, lord of Wiston (q.v.), was given to the Hospitallers by 1161, and the commandery became the headquarters of the Order in West Wales. After the Dissolution the church became the parish church and the domestic buildings the seat of the powerful Barlow family, their house presumably of considerable scale but replaced in 1776. The C19 story of Slebech is bound up with the eccentric and highhanded Baron de Rutzen, a native of Courland (Latvia), who married the rich Slebech co-heiress in 1822. De Rutzen considered that the medieval church brought the local rustics too close to his private domain, and determined on a replacement, which he sited ostentatiously on the busy new turnpike road to Haverfordwest, beside an intended new drive to his house. His large new church was also intended to serve the neighbouring parishes

of Minwear and Newton North; contributions came from Queen Adelaide and the Duchess of Kent. The three old churches were to be unroofed as soon as the new building was ready. De Rutzen carried out this plan in 1844, without permission, an action that brought him before the Ecclesiastical Court and resulted, after long procrastination, in the reinstatement of Minwear, although the other two churches remained shells. The new church, 'built to the glory of the de Rutzens and in memory of God' was only reluctantly handed over in 1848, so that it could be consecrated. The Baron also had plans to double the size of Slebech Hall, but these came to nothing, as did his later efforts to divert the route of the South Wales Railway around his estate.

ST JOHN THE BAPTIST. Closed in 1990 due to subsidence. E.E., built of rather forbidding grey ashlar limestone 1838–40, by *J. H. Good Jr.* for Baron de Rutzen (*see* above). Cruciform, but oriented to the NE, possibly to find solid foundations on the wet site. W tower with pinnacles. Big belfry lancets and a tall ashlar spire of 160 ft, with lucarnes near its base. Two-stage buttresses, those at the corners capped with lumpish pinnacles. Tall lancets, paired in the transepts, and a triplet for the E window. Entry under the tower, its hoodmoulds with carved heads of Baron de Rutzen and his wife, with their arms above. Barn-like plastered interior, now very plain, with most fittings removed. Timber-fronted W gallery and short chancel – the church was not ecclesiologically progressive. Flat ceiling with ribs on carved angel corbels. The interior was fitted up, probably very decoratively, by *Mr Fairs* of Hanover Square, London, and *William Owen* (the latter probably responsible for the woodwork). What partly survives is an impressive tiled floor by *Chamberlain* of Worcester, incorporating large de Rutzen coats of arms. Pervading dampness has obliterated a major painted scheme of 1893 by *C. E. G. Gray* of Cambridge, but some work survives on the boarded chancel ceiling. Monuments brought from the old church, and other fittings, are now in the county museum. They include the important C15 alabaster effigies presumed to be Sir Henry Wogan †1475 and his wife, and some mural tablets.

SLEBECH OLD CHURCH (ST JOHN THE BAPTIST). Built for the Knights Hospitallers (*see* above). Adjacent to Slebech Hall, ½ m. SE of the new church, on the banks of the Eastern Cleddau. Deliberately unroofed in 1844 by Baron de Rutzen when his new church was finished. The evocative shell remains, consolidated in recent years by the Order of St John.

Nave, chancel and transepts, and a tower to the NW. Earliest are the nave and chancel, the chancel arch Dec with fine wave mouldings. Pointed E window devoid of tracery; N and S windows with brick heads of the C18 or C19. Wide tomb recess to the S, projecting outside. The N transept, originally the Picton Castle chapel, is C16, with four-centred moulded arch on crenellated imposts. Trefoiled recess in the E respond, perhaps an aumbry or blocked squint. Windows of three lights with

trefoiled heads. The tall tower, also C16, has a corbelled parapet; it was heightened in brick in the late C18 to make it a better eye-catcher, but the brickwork has since been removed, and the battlements have not been replaced. Barrel-vaulted base. Tudor belfry-lights, paired to N and S. Very good N doorway into the tower (the main entrance into the church), with label and blank shields in the spandrels. The S door has a segmental head under a hoodmould, and ovolo mouldings: probably late C17. Now to the S transept, much rebuilt in the mid-C18 – when there was virtually no church building in Wales. Robust classical detail. Big round-arched windows to N and S with Gibbs surrounds. Oculi in the S wall, under a now depleted pediment, through which rose the flue of the fireplace. Internal walls faced with red brick, an early use of this material in the area. The transeptal arch was rebuilt also, a simplified echo of its counterpart. – The round FONT is probably C18. – Sir William Hamilton is buried here with his wife, Catherine Barlow of Slebech, but his monument was removed by de Rutzen and allegedly cut up for chimneypieces.

SLEBECH HALL. Gloriously set above the water. The site of the commandery of the Knights Hospitallers (*see* above), later the seat of the Barlows. John Symmons of Llanstinan, who married Anne Barlow in 1773, demolished the old structure and had completed the present house by 1776. Unsigned drawings and the bow-fronted wings point to the hand of *Anthony Keck*.* This is his largest known house and the biggest Georgian single build in the county. *John Calvert* of Swansea was either site architect or clerk of works. 'Mr Miller', whose name appears on a drawing, is probably *Millart*, a marble mason often used by Keck.

The house was castellated which given the date of building is significant. Adam's fortress-like Wenvoe, and John Johnson's castellated Gnoll (both in Glamorgan), are exact contemporaries sharing the same basic shape. At Slebech the front and rear nearly match save that the entrance front is of three storeys, the rear of four, because of the sloping ground. Five bays (four to the rear), and then full-height bowed wings, advanced at each end, all containing three bays of windows. Was the design a modern competitor of its neighbour, Picton Castle (*see* p. 359) with its corner bastions? Small semicircular porch with crenellations and plain columns. Three-bay service wing to the l. with massive end chimney. Repairs in 1805: the antiquarian John Carter noted 'many artificers . . . busily employed on some external repairs'. This may be associated with payment in 1803 to *Thomas Bedford* of Llandeilo, for 'altering offices'. More repairs in 1830 by *Thomas Rowlands*. Shorn of its grandly scaled battlements in 1955, its appearance is now more severe and more heavily proportioned than intended.

The internal layout is disappointingly straightforward, though grand in scale. A spinal corridor rather too high and

---

*Pers. comm. Nicholas Kingsley.

narrow runs from the back of the entrance hall to each end. Flanking the hall are enclosed staircases opening off the corridor, the primary stair not obviously grander than the secondary one. Keck was a craftsman turned architect, not trained in the art of modelling spaces. The fireplace in the hall is in the C17 style, complete with strapwork, and is not original to the house. Directly behind the hall is the three-bay SALOON, its C18 chimneypiece, clearly by *Henry Cheere*, salvaged from Stackpole Court. Red veined marble, with white marble enrichment, central tablet with a hound chasing a hare. The other principal ground-floor rooms bowed and equal in size contain detail of high quality. In each room, the central tablet of the delicate classical chimneypiece matches the plaster frieze. In the DRAWING ROOM (SE) there were originally large oval and square wall panels of plaster, in the manner of Adam, since scraped off. In the LIBRARY (NE), along one wall, a contemporary bookcase with pedimented centre. Charming detail in the first-floor MUSIC ROOM (SW), the tablet and frieze depicting musical instruments. Strips of gilded carving set in the door surrounds to the main rooms are also salvaged from Stackpole Court.

Several of the plans show pencilled alternatives, perhaps by Symmons himself, who was clearly concerned with making the entrance front grander, adding a colonnade between the bows, and inserting an oval colonnade within the hall. Another unrealized idea was to add an apse to the drawing room, to echo the bow, as well as what appears to be a conservatory E of the house.

Immediately E of the house, a fine STABLE-YARD, surely by *Keck*, in a more lively Adam mode, with three ranges around an open yard, the two castellated ranges facing the house and gardens. The eleven-bay W entrance range is of two storeys, the two bays at each end advanced slightly in the manner of pavilions, with sham attic storeys. Central bay with entrance (blocked), and clock face in the parapet, the latter matching those of the pavilions in height. Diocletian windows along the ground floor above a string course.

LODGE *c.* 1 m. W, designed by *P. F. Robinson*, the prototype of his much-to-be-copied 'design no. 1' illustrated in his *Designs for Lodges and Park Entrances* of 1833, as 'erected in South Wales'. Coped end gables, the W end facing the road, with rectangular bay window. The broad porch has sadly been removed, as have the round-shafted chimneys. The driveway to the house from here is conceived in the Picturesque manner, running through pockets of woodland interspersed with open fields. A small bridge near the gate to the house incorporates some carved masonry which looks C16 to C18. To the SW, stepping down to the estuary the unexpected survival of TERRACED GARDENS formed by the Barlows in the late C17, noted by Fenton in 1810 as 'much in vogue about a century ago'. On the N side, foundation walls of greenhouses erected *c.* 1820 by *William Hoare* of Lawrenny.

Along the wooded shoreline walk, some 1 m. sw, a small ped-imented SUMMER-HOUSE, built of brick, with ashlar detail, surely C18.

Visible from the A40, 1½ m. NE of Slebech Park, the prominent survival of a square cross-gabled TOWER, thought to have been a hunting stand. Probably C17 or even C16, constructed of well-laid masonry, it originally stood to three storeys: large window openings, and a corner stair. The lower chamber was heated.

SOUTH DAIRY BAPTIST CHAPEL, 1 m. WNW. Built in 1832 on a homely scale. Slate-hung front of three bays, central door. Inside, one of the finest galleries in a sw Wales rural chapel, three-sided, painted fronts with moulded panels and a row of elegant turned timber balusters for every two panels. Simple iron columns. – Early C19 pulpit, taken from Bethesda, Haverfordwest (rebuilt 1880): it has chamfered corners, with reeding. – On the rear wall above the pulpit, a Neoclassical marble tablet to Phoebe Brown †1844: a rarity in a chapel. – Fine early C19 wrought-iron GATES, incorporating the name of Bethesda, from which they came, like the pulpit. Probably made by the *Marychurch Foundry*.

## SMALLS ROCK

*4608*

SMALLS LIGHTHOUSE. 22 m. w of St Ann's Head. The red-and-white painted lighthouse is the second on the site, replacing an extraordinary oak-piled structure of 1776, by *Henry Whiteside*, which lasted eighty years, and for which postholes survive on the rock. The new lighthouse, designed in 1855 by *James Walker*, and built 1855–61 under *James Douglass*, stands 142 ft (43 metres) overall, the 114-ft (35 metres) granite tower modelled on Bishop Rock Light, Cornwall. The helicopter landing pad on top disfigures the outline. Superb granite masonry all cut on the quay at Solva, for safer assembly on the extraordinarily exposed rock. The lower courses are stepped to break up the waves.

## SOLVA/SOLFACH

*8024*

Solva's long inlet made it one of the few safe anchorages N of Milford Haven, and there was considerable maritime trade from *c.* 1750 to 1850, mostly in importing lime and culm. The two halves of the village are dramatically divided, Lower Solva in the deep valley of the Solva river, Upper Solva on the hill to the w. Lower Solva is a single street, picturesque if architecturally modest. HARBOUR HOUSE was reputedly built for Henry White-side, constructor of the first Smalls Lighthouse (*see* Smalls Rock) in 1776, but the detail is all C19. LLYS ABER and the OLD PRINTING HOUSE are early C19, stuccoed, and further up, TAN-YR-ALLT is a mid-C19, three-bay villa, associated with the

big, three-storey stone WAREHOUSE next door. On the E bank of
the river, two LIMEKILNS. More spectacular is the group of four, 86
lower down on the E side of the estuary. Lower Solva once had
ten, filling the valley with smoke in the early C19.

Upper Solva has a long High Street, largely undistinguished:
No. 23 is early C19, three-bay. In the lane opposite the Baptist
Chapel (*see* below), CAPEL BACH, 1816, the original Baptist
chapel, small and quite plain, but once galleried. Further up, the
MEMORIAL HALL was the 1812 Wesleyan chapel, with lateral
front altered in the conversion. Between street and headland,
more scattered houses and cottages with fields between, all
altered, but Nos. 30–32 PENYRABER still with the thickly colour-
washed slate-hanging that was once typical, and a few with
cemented slate roofs.

ST AIDAN. 1877–8, by *J. L. Pearson*, a minor but interesting work
by a major architect, in quite a different spirit from his urban
work. It cost £1,600. Pearson was employed by Canon Gilbert
Harries, rector of Gelligaer, Glam., whose family home Lla-
nunwas was in Solva. Harries had employed Charles Buck-
eridge, who died in 1873, and Pearson finished his outstanding
works for Harries (Marloes, Pembroke, St Brides,
Whitchurch). Solva is the only new work wholly by Pearson.
Nave and chancel in one; hipped-roofed brick bellcote, N porch
and SE vestry. Remarkably colourful materials: green Middle
Mill granite with yellow Doulting stone window heads and
sills, red brick bellcote, eaves, window reveals and string
course: blue-purple slate roof with red clay ridge tiles. Careful
detail: the string course that links the window sills rising to
mark the chancel, and carried around the eaves of the N porch.
The windows are plain lancets; playful plate tracery only in the
vestry windows. Inside, a fine open timber roof runs right
through, enhanced with wind-bracing in the chancel, which is
otherwise marked only by a rood beam. – FITTINGS. PULPIT
and RAILS, 1889, vigorous Gothic forms in pitch pine. Stone
REREDOS, since painted white. – STAINED GLASS. E window,
1892, *Clayton & Bell*. – FONT. C12 scalloped square bowl, from
the lost church of St Elvis (*see* below). – INSCRIBED STONE,
with cross, in the porch, also from St Elvis.
MOUNT PLEASANT BAPTIST CHAPEL, High Street. 1863.
Stucco gable front with a Tudor arch and odd granite finials.
Arched windows still with small-paned glazing. Good un-
altered interior with three-sided gallery on marbled wood
columns, the pulpit front ornamented with intersecting half-
circles, and on the rear wall, an open-pedimented aedicule. The
masons were *William Harris* and *John Richards*, the carpenters
*Joshua Morris & Son* of Newport. Very similar to Bethlehem
Baptist Chapel, Newport, of 1855, so one may assume Morris
was the architect here. Manse of 1900 by *D. E. Thomas*.
MOUNT ZION INDEPENDENT CHAPEL, Whitchurch Road.
Dated 1896, a lateral façade, so presumably a remodelling.
Side wall built out for two porches; an odd pedimental gable

between is held up on a single florid iron column. Three-sided gallery on iron columns and panelled pine pulpit, all of 1896.

CALVINISTIC METHODIST CHAPEL (former), Lower Solva. 1887. Gothic, in grey limestone with triple lancet to the gable front.

LIFEBOAT HOUSE, Lower Solva. 1869 by *C.H. Cooke*, architect to the Lifeboat Institution. Plain stone.

SOLVA HEAD PROMONTORY FORT (SM 802 239). On the E side of the estuary, overgrown Iron Age fort with bank and ditch, the bank, some 12 ft high, on the landward side, where there is also an outer bank.

PORTH Y RHAW PROMONTORY FORT, on the coast, S of Nine Wells (SM 786 242). Impressive Iron Age site, with large outer ditch and complex entry arrangement of well-defended S-bends.

ST ELVIS, ½ m. E. The site of a small medieval church, just visible S of St Elvis Farm. Beyond (SM 812 239) is a collapsed Neolithic BURIAL CHAMBER, apparently a double tomb with a massive capstone over the low E chamber and the second capstone displaced to the W.

# SPITTAL

The name refers to a lost medieval hospice on the route from Carmarthen to St Davids. Nucleated village centred on a sizeable green. To the E, a single-storey roughcast building with deep eaves, the former POLICE STATION of 1844, and, behind, the Tudor Gothic NATIONAL SCHOOL, 1855 by *Joseph Jenkins* of Haverfordwest, of stone with pretty cast-iron glazing to three-light windows. The church is on the S edge of the village, opposite IVY COURT, an expensive pedimented Neo-Georgian house of 1989–91, by *J. Mansel-Thomas* of *Pembroke Design*, with the owner.

ST MARY. A much-restored small medieval church: low nave, W and E bellcotes, large S porch, chancel, and late C19 gabled S vestry. The battered W wall may be medieval; a blocked arched N door and the porch are pre-C19. C19 Bath stone lancets dominate. Restored 1834–6, by *W. Phillips* of Haverfordwest, again in 1853, and probably most thoroughly in 1896–7 by *Pinder & Fogarty* of Bournemouth. In the porch, INCISED STONE, C5 or C6, inscribed EVALI FILI DENO/ CUNI OVENDE/ MATER EIVS, (Evali, son of Denocunus, Ovende his mother). Close-spaced nave roof trusses and plain plastered chancel arch of 1897, flanked by small pointed openings, one a reworked medieval SQUINT. Cambered-arched recess on the chancel S wall. – Of 1897, the encaustic TILES, and the oak fittings by *Jones & Willis*. – REREDOS. White marble copy of Leonardo's *Last Supper c.* 1920. – FONT. C12 square bowl, scalloped and chamfered below to a round pier and base. – STAINED GLASS. Two-light E window, 1920, by *Mary Lowndes*. A soldier led by an angel to the Cross-bearing Christ. Arts and Crafts opaque

colour, let down by a static composition. – Nave N lancet, St Michael, *c.* 1920, and nave S lancet, the Angel at the Tomb, frenetically crowded, *c.* 1898. Both by *A.L. Moore.* – MEMORIALS. Plaque with cherub head and hourglass to John Higgon †1737, and C19 plaques to Higgons of Scolton, from 1785 to 1837.

ZIONS HILL INDEPENDENT CHAPEL, ½ m. N. 1841–2, but everything visible of the remodelling of 1892–3, by *D. E. Thomas* of Haverfordwest. Stucco gable front with arched windows.

SCOLTON MANOR, 1 m. E. Country house of 1840–2, built for James Higgon, by *William Owen*. Serious if unadventurous late Georgian going early Victorian, in unpainted stucco with overhung hipped roofs. Three-bay E entrance front with ground-floor entrance recessed behind an Ionic screen, five-bay S garden front, with tripartite sashes to recessed centre bay. A neat plan with stair hall and corridor behind the front rooms. The entrance hall gives no hint of the generous stone-flagged stair hall beyond with cantilevered stone stair on N and W walls; cast-iron double-branch balusters. The front rooms, drawing room, small library and dining room, are relatively plain, with marble fireplaces already showing Victorian heaviness. The County Council has restored the house and opened it to the public, making a feature of the NW kitchen and servants' rooms, and the partly brick-vaulted cellars.

N of the house, a STABLE COURT, three-sided but to a small scale, the wings lower than the main range, all with hipped roofs.

The grounds have become a country park with VISITOR CENTRE of 1993, by *Peter Holden Architects* of Pembroke. An octagonal timber pavilion structure designed to reflect environmental concerns, the first public building in the county to do so. Electricity comes from wind power, underfloor heating from solar panels, and thickly insulated walls. Big overhanging slate roof, with steeper-pitched octagonal roof-light. From inside the roof is a spiral of poles. It is a pity that a static display of information panels seems the only function of the main space.

## STACK ROCK FORT
½ m. offshore from South Hook Point (Herbrandston)     8604

The most spectacular of all the C19 forts guarding the Milford Haven (*see* Introduction, p. 105), in mid-channel on an outcrop   109 of rock. The original gun-tower of 1852 was a trefoil-plan battery like the NW Gun Tower at Pembroke Dock, with platform for three guns and barracks for about 20 men. It was wrapped around by a circular fort of 1870, indented in plan to the NE, providing casemates for sixteen 18-ton guns, and three turrets for heavier guns at parapet level, and barrack accommodation for 150 men. Fine ashlar masonry on a rock-faced battered base. The extensions cost £96,000. Within, the barracks are two-storey

and brick-walled. Like many of the other forts, derelict and vandalized.

## STACKPOLE

9897 The church is in Stackpole, also called Cheriton (i.e. Churchtown). Stackpole village is ½ m. SW.

SS JAMES AND ELIDYR. Idyllically set in a wooded dell. Cruciform, with tall, thin tapering C15 tower N of the N transept, dug out of the steep hillside: it has a corbelled parapet, but had no battlements by Glynne's visit of 1851. All four storeys of the tower are vaulted (cf. Castlemartin), another instance of the local mania for vaulting. Big pointed belfry-lights. Also medieval are the transepts, both with pointed barrel vaults and squint passages, the chancel, and the C14 Lort family chapel S of the chancel, which has crude rib-vaulting. In the S transept a Dec trefoil-headed PISCINA. The overall appearance is due to *George Gilbert Scott*'s restoration of 1851–2 for John Frederick Campbell, first Earl Cawdor, of Stackpole Court. Cawdor restored all the churches on his south Pembrokeshire estate in the 1850s: Stackpole was the earliest and most expensive, costing £1,804, and the only one restored by Scott. Similarly in Carmarthenshire Cawdor used Scott only for his estate church at Golden Grove. He rebuilt the long nave, and added the S porch, vestry, and Dec windows. Tall chancel arch, hoodmould with poorly carved heads of king and bishop. Nave roof of the wagon type with kingposts; chancel roof boarded, with ribs and big carved bosses. – *Scott's* fittings are intact: large octagonal FONT on a cluster of colonnettes; PULPIT with carved vinework and Bath stone base; PEWS with shaped ends. Bright patterned chancel TILES by *Minton & Co.*, some depicting Cawdor arms. – STAINED GLASS. S transept S window, 1862, signed by *O'Connor*. Lord Cawdor as Solomon overseeing the temple. – E window 1881 by *Clayton & Bell* (according to M. Harrison), surprisingly rich: it depicts the Resurrection. – W window *c.* 1880, life of Moses and the enactment of the Ten Commandments. – Elsewhere, good original Victorian grisaille-patterned glass. – Splendid MONUMENTS. The best is in the chancel, traditionally Sir Elidyr de Stackpole but clearly later in date. Well-preserved cross-legged knight, mid-C14 (face restored), on a beautifully carved chest with four-petal flowers along the top and ballflowers on the plinth; the front has six ogee-headed niches sprouting wavy leaves, framing crudely carved, but animated, figures. The western niche has a young knight in swaggering, spiralling pose, and the second from the E, a stooping woman. Large crocketed canopy made up of six straight sections, much repaired; Fenton's 1810 illustration does not show the carved angle finials or the pinnacles. – Opposite a late C14 praying effigy, said to be Lady Elspeth de Stackpole, smoothly carved with memorable intricate passages, especially the curled locks of hair over her shoulders. Chest with ballflower orna-

ment, carved figures in niches and grotesque faces in the spandrels. The additional C19 small figures swarming about the head and feet are best forgotten. – George Pryse Campbell †1858. Alabaster, carved portrait medallion in a Gothic frame. – The LORT CHAPEL is crammed with remarkable monuments, including two early C14 female praying effigies, moved from their original locations. – Roger Lort †1613. Wall tomb: praying figures in niches between fluted Ionic half-columns. Crowd of 67 kneeling children below, large heraldic roundel above – the original paintwork survives. – Sir John and Hester Lort, erected 1712. Large, of veined marble, concave tablet with sides breaking back in three stages; winged skull below, large cartouche above flanked by cherubs' heads, and topped by a little pediment. – John Frederick, Earl Cawdor †1860. By *James Forsyth* of London: this major work was illustrated in *The Builder* in 1862. Large, ornate chest with highly carved effigy, the head supported by winged angels. – s transept. Ronald Campbell †1879. Small chest of carved alabaster with heraldic shield and Gothic canopy. – Epitaph to George Ellis †1659. Careful inscription. – Two large painted HATCHMENTS of Lord Cawdor †1860 and Lady Cawdor †1881. – In the Lort Chapel is a rough PILLAR STONE, possibly C6, reading CAMULORICE. FILI. FANNUCI.

CHURCHYARD CROSS. Four steps and shaft; the head is modern.

LYCHGATE of 1898, to the second Earl, by *Christopher Hatton Turnor*, a relative of Lady Cawdor. An Arts and Crafts 125 work of the highest quality, red sandstone, with sprocketed hipped roof. Lead crestings representing the Galley of Lorne (taken from the Cawdor arms), and lead heraldic panels flanking the gate; the leadwork is by *William Dodds*.

Just uphill to the N, the former RECTORY, 1878 by *Ewan Christian*. Large. Three-bay front with centre gable, entrance to irregular rear. Bulky with minimal detail, typical of Christian.

CHERITON LODGE, near the entrance to the church car park. 1857 by *Henry Ashton*. Front gable with canted bay window and open porch alongside. Tall, diagonally set flues.

WIDOWS' COTTAGES, ⅛ m. E. Mid-C19, single-storey; broad symmetrical wings with bay windows, central gabled porch. Originally three houses, the middle one entered from the front, the others via side doors. Lord Cawdor was interested in these picturesque compositions (cf. April Cottage, Golden Grove, Carms.); he published a patternbook of rather simpler workers' cottage designs in 1869.

BANGESTON, ¼ m. WSW. Large, spreading two-storey farmhouse with W and E wings, the latter dominated by an enormous projecting square chimney with large oven projection. The core, together with the E wing, appears to be C17; the s unit and W wing are later.

At STACKPOLE, ½ m. SW, are some C19 estate cottages, some modernized but others retaining hoodmoulded windows and

diagonally set chimneys. Picturesqueness was attempted by the Cawdor estate, but not on a large scale. The STACKPOLE INN is a pleasant composition, its low single-storey front with labelled window and overhanging roof, hipped to one side. Opposite, SCHOOL HOUSE is similarly picturesque, but contains earlier fabric, notably a large inglenook.

PARK HOUSE. The secondary house to Stackpole Court, clearly visible from across the lake. A window pane is dated 1752, and construction probably followed closely on from the Court. It was reduced in size at some unknown date. Originally the house would have been of seven bays, the outer bays slightly advanced. The three l. bays are the current house, the rest survives as walls to a garden court. Two storeys, the lower windows with keystones merging into a platband. The l. bay was remodelled c. 1800, with a pair of sashes to each floor and parapet. Inside, two good rooms: dining room with a delicate Rococo plaster ceiling with sinuous vine trails, c. 1770 (by the same hand as the drawing room at Cresselly); drawing room with decorated arched recess on each side. Sympathetically altered and repaired from the mid-1950s by Baron Bernard Friesen, Lord Cawdor's brother-in-law, using fine salvage from Stackpole Court (doorcases, doors, plasterwork and two chimney-pieces). One of these – in the Kent manner, with a Siena marble pulvinated frieze – may have originally been in Park House as it fitted the outline of a missing one. Mid-C18 dog-leg stair. The entrance behind, from a charming walled garden, subsequently became the front door, now beneath a classical balustraded porch of the 1950s. At the edge of the garden courtyard, a late C19 square dovecote.

PARK LODGE, $\frac{1}{2}$ m. SW. Isolated location at the edge of woods. Small three-bay cottage with tiny casements. Originally the roof was thatched and swept down to the porch and veranda, both supported by tree trunks. An unsigned plan for enlargement (perhaps by Lord Cawdor) is dated 1832. The cottage must have been in place by then and was clearly an exercise in the rustic style.

ROWSTON, $\frac{1}{4}$ m. E. The farmyard was designed for Lord Cawdor in 1866 by *J. W. Poundley* of Kerry, Powys, model farm specialist. Built of well-dressed limestone, H-shaped in plan, with cow-house in the centre and a barn projecting N. The NW wing is a cart-house, the NE a lofted stable. The S wings are both cow-houses with the muck-yard between, overlooked by a grand Venetian window.

WEST TREWENT, $\frac{1}{2}$ m. E. Two-storey, early C18 stuccoed house with added fourth bay: the battered base indicates earlier foundations. Rear wing probably C16, with big projecting, tapering gable chimney, corbelled lateral chimney and barrel-vaulted basement room.

EAST TREWENT, I m. E. On first impression, a spacious, whitewashed three-bay farmhouse of the late C19. But the rear cross wing is built up against a small two-storey medieval building with barrel-vaulted undercroft. Entry to this originally on the

s (lateral) side, below an arched stone lintel. Against the N gable, a flight of steps to the first-floor entry. No fireplaces, so perhaps a dairy or similar outbuilding, belonging to an older house.

GREENALA POINT, 1 m. E. On the rocky headland, an IRON AGE PROMONTORY FORT, cut off by a massive series of four banks and ditches. Main entrance on the N side, but the inner entrance is reached on the W side, after a long passage. Probably much lost to the sea; small interior, sites of round-houses are still discernible.

# STACKPOLE COURT

The demolition of Stackpole Court in 1963 was one of the saddest losses in Wales. It was the largest house in south west Wales, the centre of the vast Welsh estate of the Earls Cawdor. The rolling parkland and lakes survive remarkably intact, the most westerly great landscaped garden in Wales, uniquely taking in some magnificent coastal scenery.*

The earliest known owner of Stackpole is mentioned by Gerald of Wales, Elidyr de Stackpole. By the mid-C14, it passed to the Vernons of Haddon Hall, Staffordshire, and two centuries later, to Sir Thomas Stanley, son of the Earl of Derby. His widow and her second husband leased Stackpole to their attorney, George Lort in 1578. Over the following forty years the Lorts steadily acquired surrounding lands, finally purchasing Stackpole in 1611. Elizabeth Lort, wife of Sir Alexander Campbell of Cawdor, Nairnshire, inherited the estate in 1698. The Campbells made Stackpole their chief residence in the early C18 and owned the estate until 1978 when the parkland and lakes were given to the National Trust.

The site is clearly defensible, the land falling steeply away north and east. The house withstood Civil War attack but little is known of its structure other than a vaulted undercroft, which survived rebuilding. The rebuilding of the house was under way in July 1734 and continued until 1736 at least. This was of utmost importance – an essay in pure Palladianism, all the more unexpected in so remote a location. The obvious comparisons are with houses such as Stourhead (1721–4) by Colen Campbell (†1729), who was a cousin to John Campbell of Stackpole. Letters survive during the period of rebuilding, but no architect is mentioned; although accounts show that John Campbell and his clerk of works *Frank Evans* worked out some alterations together. Did *Colen Campbell* design the house, and Evans carry out the work with amendments? The detail of the house strongly suggests it.

As originally conceived, the W (entrance front) of the house consisted of a Palladian villa of seven, or possibly eleven, bays, the centre three pedimented. The entrance, above a tall basement, was reached by opposing staircases, flanking an oculus. Two wings projecting three bays forward were built at the same

*marginal notes:* 9796  
p. 462

* The help of Arabella Friesen is gratefully acknowledged.

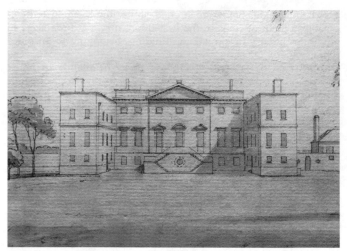

Stackpole Court. Entrance front in the later C18

time; perhaps designed by John Campbell and Frank Evans. The E front, eleven bays long after the addition of the wings, was plain but for the striking chimneys – seven in total – arranged along the parapet.

In the 1780s alterations were carried out by *William Thomas*, including the stable block (see below), illustrated in his *Original Designs in Architecture* of 1783 but simpler in execution. Not executed was the elaborately Adamesque re-fronting of the southern service wing, but plinths were set against the wings for Roman statues brought home by John Campbell II. Major, but extremely plain alterations were made from 1839 for the first Earl Cawdor by *Sir Jeffry Wyatville* and his assistant, *Henry Ashton*.

The W front was remodelled as a 2-5-2 bay composition in grey stone with cornices and parapets, achieved by raising the wings and bringing forward the centre two bays which led to lighting problems inside, only partly solved by complicated light wells.

Of the house itself, only its E-facing stone revetted terrace survives. Most impressive of the ancillary buildings is the STABLE BLOCK of the 1780s by *William Thomas*, altered by *Wyatville* and *Ashton*. The sash windowed N front facing the house is rendered. Two-storeys with arched carriageway now surmounted by a two-stage clock turret raised by Wyatville, crowned by a lead dome. Seven-bay return wings, rendered, the cambered archways glazed in when the stables were converted to flats. Just NE, an attractive if forlorn group, the BREWHOUSE and DAIRYMAIDS' QUARTERS, by *Ashton*, the former single storey and three bays, the latter rising to two storeys, the junction marked by a tall bridge-like chimney-stack. Big louvred cupola over the brewhouse. Attached to the l., a small GAME LARDER; to the SW, the estate GASWORKS, converted from a carthouse *c.* 1865, the two S bays rebuilt as a retort

house, and given tall round-headed windows. Converted to a dwelling *c.* 1998. Further along the track to the sw, the hipped GARDEN COTTAGE with little gabled upper windows and big off-centre porch. Probably by *Ashton*. The attached WALLED GARDENS comprise a pair of large enclosures divided after *c.* 1830 by a wall running E–W. This dividing wall contains a charming pair of classical summer houses with hipped roofs and Serliana openings.

Now to the GROUNDS. A watercolour of 1758 shows the house overlooking the valley, grazed by cattle, with walled gardens to the SE on the steep slope. By the later C18 this view was entirely transformed, when the Campbells began damming and flooding the three limestone valleys which finger their way inland from the sea at Broad Haven to the S. The lakes were begun by *John Mirehouse*, Cawdor's skilful land agent (see Brownslade, Castle-martin). After problems arose, Campbell engaged *James Cock-shutt*, canal engineer, in the mid-1790s, then engaged in industrial south Wales. The vast prospect was probably completed in the 1840, with the flooding of the western area. The long and stately sheets of water were complemented by fine BRIDGES, notably the EIGHT ARCH BRIDGE, built by 1796–7. The bridge, designed by *Cockshutt*, also acted as a controlling dam, the dam itself cleverly hidden under the arches. This great landscape feature is promi-nently visible from the house, carrying an ornamental park ride. [85]

The impressive ONE-ARCH BRIDGE at the N head of the lakes seems to be an early C19 remodelling of an earlier bridge, which carried the main drive to the house. 100 metres E, where the lake begins to open out, is the HIDDEN BRIDGE, just a low walk on segmental arches, set slightly below a low controlling dam, which provides a gentle waterfall to great effect. This was built between 1840 and 1875. The lakes were complemented by the planting of the valley sides and with clumps of trees, some walled around in the outlying fields; the whole vast project clearly conceived in the manner of Capability Brown.

Inland, in LODGE PARK WOOD, W of the house, woodland walks, including a fine classical SUMMER HOUSE, built of rusti-cated limestone, three arches facing the house with exaggerated keystones and urn finials as the parapet, presumably by *Wyatville*. To the W, the former FLOWER GARDEN, with semicircular stone SEAT, built before 1840 by *Richard Westmacott Jnr*. 300 metres W, remains of what appears to be an ICE HOUSE, partly embedded in the bank, the exposed walls rock-faced in weathered limestone. NE of the house, on the turn of the lake, a small GROTTO, con-sisting of an arched recess skilfully built of sea-eroded limestone: just to the N, a similarly constructed archway.

STACKPOLE HOME FARM ($\frac{1}{3}$ m. S). Large three-bay hip-roofed farmhouse of *c.* 1800, doorcase with Corinthian columns. The farm buildings to the rear were mostly converted *c.* 1985 to a centre for the disabled by *Mitchell & Holden* of Pembroke. Limestone rubble walls and slate roofs.

# STEPASIDE
St Issells

Coal has been mined in the valley, 2 m. N of Saundersfoot, since at least the C14. By the late C18, over twelve collieries operated around Stepaside. In 1792 an attempt by Lord Milford to build a canal down to the sea at Wiseman's Bridge failed, due to problems with levels. A large overshot wheel was set up in 1839 for pumping the canal works, by *Thomas Dyson* of Downham (engineer of the Bedford Levels), and the plentiful anthracite, limestone and iron ore inspired Charles Ranken Vickerman, an Essex solicitor, to set up the Pembrokeshire Iron & Coal Co. in 1847. An ironworks was laid out in 1848 (the engineer, *Thomas Hay*), but only two of the planned four furnaces were built, and production had ceased by 1877. On the hillside above the ironworks, GROVE COLLIERY was begun in 1855, as a convenient source of coal. The shaft was 210 yds deep and 20 ft wide, described as the largest in Wales at the time.

Some buildings of the IRONWORKS survive, and can be reached by following the line of the dismantled railway built to link the

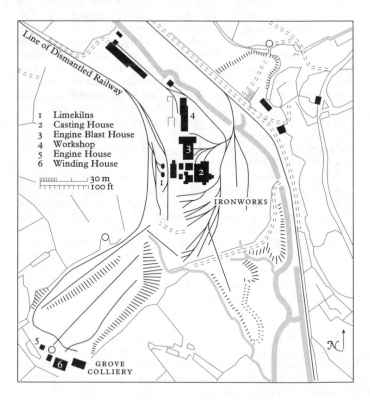

Stepaside, Kilgetty Ironworks and Grove Colliery. Plan

collieries with Saundersfoot harbour in 1835 (*see* p. 448). At the
highest level is a row of five LIMEKILNS, with a further one
beneath. Below a curious, half-buried vaulted building is the
shell of the large CASTING HOUSE, formerly dated 1848. It has   101
a striking three-bay, segmentally gabled front of dressed stone,
with three arches, and oculi above. To the S, remains only of the
ENGINE BLAST HOUSE and a long, late C19 WORKSHOP. The
shells of the Grove Colliery buildings also survive, even though
production ceased in 1884: tall ENGINE HOUSE, and
WINDING-HOUSE. Below, in the village, are the remains of
KILGETTY COLLIERY, closed in 1939. These include a small,
early C19 WEIGHBRIDGE, and an early C19 ENGINE HOUSE,
which probably housed a beam engine. Adjacent is the base of
the square CHIMNEY (demolished 1972) which served the
boilers of the winding engine and a ventilation furnace. Above,
on the steep valley side, the former PRIMARY SCHOOL, built
as the Board School in 1877, by *J. M. Thomas* of Narberth.
Long, dressed-stone front with paired windows between three
taller round-arched ones, and an L-plan house at the end.

SARDIS CONGREGATIONAL CHAPEL, ⅔ m. S. 1926 by *J. Howard
Morgan*, in a Gothic Arts and Crafts style, a rare break from
the standard chapel form. Low and spreading, with a polygonal
corner turret containing the entry. Much use of concrete, e.g.
for the lancets, and the flat roofs of vestibule and schoolroom
porch (N end). Church-like interior with an E transept. Open
roof of massive span, the cross-beams on little arch-braced
wall-posts. Behind the pulpit, a large schoolroom, the inter-
vening arcade with removable partitions.

# STEYNTON                                            9107

The church is a prominent landmark, on the Haverfordwest to
Milford road, with three-bay stuccoed VICARAGE next door,
(repaired 1850, altered 1901).

SS PETER AND CEWYDD. A hilltop church, with sheer
Pembrokeshire tower, C15 detail – see the flat-headed W
window and chancel side windows – but heavily restored in
1882–3 by *E. H. Lingen Barker*. The aisled nave and E bellcote
are all C19 in detail. Inside, the low whitewashed, plastered
three-bay arcades look medieval, but were inserted when aisles
were built, with gabled roofs, in 1799 by *Griffith Watkins* of
Haverfordwest. Plastered tower vault. Roofs of 1883 and fit-
tings, including the heavy stone PULPIT. Much more attractive
is the 1914 LECTERN, with an Arts and Crafts delicacy to the
metalwork, the eagle on a baluster stem entwined with vine. –
In the nave, C5 or C6 CROSS-INSCRIBED STONE with Ogham
inscription. – MONUMENT. Rev. J. Jordan †1808, by *W. Williams*
of St Florence, in grey and white marble. – STAINED GLASS.
Chancel windows of *c.* 1878, *c.* 1895 and 1927.

CASTLE PILL FARM, 1½ m. S. All ruinous now, but the farmhouse
was C17 and had ovolo stone-mullioned windows in the porch

gable, exceptional in the area. Extensive C19 FARM BUILDINGS behind, the main range in purple stone with grey limestone dressings, with near-matching end blocks. In the woods to the S, at the head of Castle Pill, an EARTHWORK, possibly an Iron Age hillfort.

HARMESTON, ¾ m. NE. Early C18 gentry house, low six-bay front with narrow sashes. Simple C18 panelling in the drawing room with fluted pilasters, closed-string stair. A reset later C17 overmantel with carved knob finials in a bedroom. Probably rebuilt for David Hughes who bought it before 1705.

UPPER SCOVESTON, ¾ m. ESE. Stuccoed three-bay, three-storey house of c. 1860 with one-storey wings. Burnt 1985 and rebuilt simpler, but the formal FARMYARD survives. Hipped lofted barn with Gothic lantern, between L-plan wings, the r. one a cow-house with a row of well-formed broad arches in grey limestone.

## TALBENNY

ST MARY. Long and low, clinging to its clifftop windswept churchyard. Broad W bellcote, like a tapering buttress, double openings with slightly elliptical heads, and flat top: similar to others in the area (e.g. Hasguard). C15 or C16. Long nave, with chancel rebuilt in 1893 by *D.E. Thomas*. The nave was restored in 1869, leaving no datable detail. Plain pointed chancel arch. Door to former rood with four-centred head. – Open BENCHES of 1869. – Norman FONT, retooled square bowl. – STAINED GLASS. E window of 1974 by *Frank Roper* of Penarth. Emaciated figures, minimal coloration. – Four single lights in the chancel of 1978, also by *Roper*, saints in strident colours.

## TEMPLETON

A good example of Norman linear planning: a long, sloping street flanked by cottages and farmhouses with burgage plots behind. It developed to the E of the strangely named SENTENCE CASTLE, a motte with no sign of a bailey, first mentioned in 1116. The name derives from the Order of the Templars, but there, is no clear evidence that they established a religious house here. Fenton saw 'ruins of pretty large houses with round chimneys' and a ruined chapel; a portion of its preaching cross later set up outside the C19 church to the S.

ST JOHN. A very plain church of 1862 by *Prichard & Seddon*, with coloured stone bands. Nave, chancel, small S porch and tall W gabled bellcote. Lancets, some grouped. Light interior with steep scissor-truss roof. – The FONT, a tall octagonal bowl, is of 1862, as are the FURNISHINGS. – STAINED GLASS. Chancel S, by *W. P. Wilkins*, 1958, St John the Baptist.

Outside, the lower part of a medieval CROSS SHAFT (*see* above), octagonal in cross section.

Mounton Chapel (St Michael), 2 m. wnw. Derelict and isolated. Nave with tall w bellcote, chancel of different build, the latter with a trefoiled lancet to the s. Later w porch with reset c15 chamfered doorway with broach stops. The narrow nw projection originally housed a gallery stair. Inside, two shallow niches flanking the altar and a PISCINA with trefoiled head. c19 restorations in the nave, including square mullioned windows and kingpost roof, which incorporates a piece of its predecessor, dated 1743.

United Reformed Chapel, at the n end of the village. Modest gabled front of 1879. Tall arched outer windows and central door with shorter arched window above. Gallery around three sides, incorporating panels of pierced ironwork.

Molleston Baptist Chapel, 1 m. w. The first English Baptist chapel in Pembrokeshire. Meetings are first recorded in 1667, the church was formed in 1731, and the first chapel built 1763, enlarged 1842 and rebuilt 1869. The appearance now is of this later date. Rendered gable front, door with window overhead, both arched. Three-sided gallery inside, with a remarkable continuous front of Jacobean-style, wooden open fretwork – suggesting the hand of *Rev. Henry Thomas* of Briton Ferry (cf. Calfaria, Clydach, Glam.). Also unusual is the approach via a short tree-lined avenue.

Poyer's Farm, at the lower end of the village. Colourwashed four-bay farmhouse with lateral chimney. Before alterations, a date of 1672 was found on a bressumer.

Templeton Farm, on the w side of the village street. Broad c17 farmhouse of four bays, lateral chimney with diagonally set shaft. Odd projection to the lower end, possibly the base of another chimney.

Great Molleston Farm, 1 m. wnw. Stuccoed three bay farmhouse with hipped roof, the date of *c.* 1820, the w bay added. Portal with Tuscan columns.

The Grove, 1½ m. wnw. The five-bay, three-storey front range is of *c.* 1740, with tall sashes and a moulded plaster cornice on little corbels. Remodelled in 1874 for the Lewis family of Henllan, Llanddewi Velfrey, by *J. P. Seddon*, who added the stuccoed Gothic rear wing with gabled dormers and upper windows with oddly decorated blind Gothic heads. Much of the interior is by *Seddon*, all on a homely scale.

# TENBY

## INTRODUCTION

1
p. 475 Situated on its limestone promontory, jutting SE into Carmarthen Bay, Tenby is one of Britain's most beautiful seaside towns. The Elizabethan George Owen of Henllys remarked on 'one of the finest little towns . . . that I ever came in', and 300 years later the resident Augustus John found that 'you may travel the world over, but you will find nothing more beautiful'. Tenby's architecture is a perfect picturesque addition to the landscape.

Following Viking and Norman settlement, Tenby was until the C17 a thriving sea-port. The nearby Ritec valley was fertile, while small coalfields to the E yielded valuable anthracite. The town's prosperity necessitated frequent strengthening of its castle, and by the late C13 the town walls had gone up; large stretches are intact, ranking Tenby next after Conwy and Caernarfon among walled towns in Wales. They were perhaps instigated by the last of the Marshals, Earls of Pembroke. The church, in the centre of town, is first recorded in 1210, when Gerald of Wales was rector. After siege in 1644 and 1648, depression and plague set in, and the town became virtually derelict. Sir Joseph Banks, a visitor in 1767 and 1778, described it as 'the most complete ruin'. Today, only fragments of old houses survive, chiefly the Tudor Merchant's House on the Quay Hill, while below a number of Victorian houses stone barrel-vaulted cellars of their predecessors are still intact. The ruins of the remarkably splendid C15 and C16 merchants' houses, all built of stone, some very richly adorned, were meticulously recorded by *Charles Norris*, in his *Etchings of Tenby*, 1812.

Tenby as a resort was born in the 1780s. Baths were formed in the old chapel on the pier in 1781. In 1805 Sir William Paxton

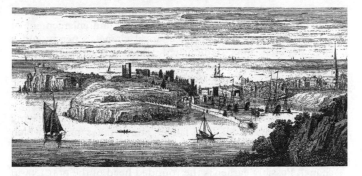

Tenby Castle from the east. Engraving by Samuel Buck, 1740

of Middleton Hall, Carms., began leasing land, commissioning *S.P. Cockerell* to build a fine bath-house (now Laston House), and removing two town gates to get better access to the narrow neck of land containing the harbour. New houses began to appear in St Julian's Street and High Street, while the Norton became a fashionable suburb beyond the walls, following the building of Sion House by *John Nash c.* 1790 (burnt 1939 and demolished). The town within the walls is mainly C19, using the old street pattern. The growth was piecemeal, and little is known of its designers, mostly a small group of builders. Lexden Terrace, Tenby's finest group, was built and probably designed by *John Smith* in 1843. *Henry Rumley* of Bristol built houses in Frog Street *c.* 1830, probably Frogmore Terrace. The coming of the railway in 1863 led to large-scale growth outside the walls, for holiday-makers The Southcliffe area was developed as superior boarding houses, with lesser terraces to the NW. The late C19 Tenby builders still inclined towards simple stucco and colourwash, never matching the more opulent seaside architecture of places like Llandudno. The C20 has been relatively kind except for the wretchedly overscaled concrete Croft Court flats, built far too close to the sea-front in 1961.

### CHURCHES AND CHAPELS

ST MARY, High Street. One of the largest medieval parish churches in Wales. Until the 1830s cottages backed hard on to it to the N and E. The unbuttressed, battlemented tower of the C14 or C15 stands SW of the chancel, tall enough to be visible for miles. Simple belfry lancets. Its ashlar spire is late C15, close in design to the C14 one at St Mary, Bridgwater, illustrating Tenby's maritime links with the West Country. The church is the result of extensive C15 enlargement of a C13 predecessor, which seems to have consisted of nave, chancel, and S aisle. A N aisle was added, in the late C14 or early C15, followed by the S chancel aisle. The late C15 work is datable by the rebus of Dr John Smith, rector 1461–75, visible in the chancel roof. It

consisted of the spire, the virtual rebuilding of the chancel, the matching roof of the nave, the rebuilding and enlargement of the S arcade and aisle, the N chancel chapel, S porch, and a large W porch, since demolished, which was dated 1496. The CHANTRY COLLEGE, now ruined, to the SW, was probably built *c.* 1500. The result was a great town church, comparable with those of other prosperous trading towns of Britain, but exceptional in SW Wales.

The church is best described chronologically. Surviving from the old church is a lancet above the S porch, which originally lit a chapel off the S aisle, the gable of which was embedded in the C15 aisle. The position seems odd for a chapel. Possibly earlier is the rounded head of the PISCINA in the N tower wall, perhaps a reused C12 window head. The late C14 or C15 N aisle arcade is of five bays with no capitals or bases, hollow mouldings in the diagonals, the shafts with broad fillets. Clearly, the influence is Somerset. Slightly later came the S chancel (St Thomas') aisle, the two-bay arcade with the common type of Perp quatrefoil piers and coarsely carved capitals clearly pre-dating the later C15 enlarging and heightening of the chancel. The damaged Dec trefoil-headed PISCINA in the S chancel aisle was probably reset from the old chancel.

The important late C15 campaign which enlarged the chancel also provided a clerestory and a fine raised sanctuary, crowned by an elaborate wagon roof. The effect is self-consciously spectacular, the sanctuary dramatically and unusually approached by ten broad steps. Evidence was found in the 1960s that part of the chancel was lofted. There are blocked beam sockets, and the lower half of the loft door is visible in the NW corner of St Thomas' aisle, reached by a gallery set against the E face of the tower (a corbel is visible). Was this the chantry chapel of St Anne, mentioned in the C16 as 'St Anne's Queere'? Again, the arrangement is unusual but explains the great height of the chancel and the lowness of its later N arcade. Small, square clerestory windows, irregularly spaced. The wagon roof, again of west country inspiration, is panelled between the arched braces and longitudinal ribs, with carved bosses at the intersections, the braces rising from crudely carved, corbelled wooden angel figures bearing shields. The eight bosses over the sanctuary N side have the rebus of Dr John Smith, later bishop of Llandaff.

The wagon roof of the nave is also late C15, the eastern bays treated like the chancel with large bosses. Among these is a striking group showing the Father enthroned with crucifix (the figure of Christ missing), with angels bearing tapers, above and below on separate bosses. The westernmost bosses are mostly C19. Contemporary with the roof must be the chancel arch, springing from a high level with shallow triple mouldings. Towards the end of the C15 the S aisle was enlarged, the arcade with standard Somerset piers (hollows in the diagonals), foliage capitals and hoodmoulds with human headstops. The

wider E arch dates from 1828. Fine late C15 arch-braced collar- 58
truss roof of impressive span. Large five-light Perp S aisle W
window, the only surviving medieval tracery; carefully remade
in 1982. The N chancel aisle (St Nicholas' Chapel) has an
arcade of three four-centred arches. Its terminal date is
provided by the tomb of Bishop Tully †1481, against the
sanctuary steps.

The battlemented S porch is of c. 1500, the arched entry with
shallow continuous mouldings, similar side entries. Arched
stone barrel vault. Rusticated C18 inner door. The battlements
were renewed and the sundial added in 1726. There was a
large, single-storey cruciform W porch, demolished 1830 – a
fragment with the date 1496 survives. Its unusually splendid
inner door is now the W entry: outer mouldings and hood of
double ogee outline, multiple very shallow mouldings with
repeated inscription BENEDICTUS DEUS IN DONIS SUI and
four-petal flowers, creating an illusion of depth. These curi-
ously shallow mouldings on the S porch, W door and the former
college must all be the work of the same mason designer.

The restoration of 1855–63 was by *David Brandon*, who
added the heavy Perp windows (replacing some straight-
headed ones) and N porch. His skilful mason was a local man,
*James Rogers*. Vestry E of the S chancel aisle, 1884 by *J. P. Seddon*,
adding a third gable to the striking E end. Some Victorian
stained glass removed after 1960, under the supervision of
*A.D.R. Caroe*. He also stripped the pews and added the
inner porches, all to good effect.

FURNISHINGS. – FONT. 1886 by *F.A. Walters*. Caen stone,
large and elaborately carved octagonal bowl on angel brackets,
steep cover with lucarnes. Large, Perp-looking octagonal font
in S chancel aisle, long disused – PULPIT. Dated 1634, lower
panels with rusticated arches, upper with cartouches. Above
are brackets with heads. – SCREEN. 1892. Perp style. By *A.P.
Dawson*. Moved to the N aisle in 1907, as recommended by
*J.D. Coleridge*. – ALTAR. Table of 1878 by *J. L. Pearson*, with
C15 slab. – CHOIR STALLS by *E.H. Lingen Barker*, 1903. – PEWS
by *Brandon*. – STAINED GLASS. Very good E window of 1856
by *Wailes*, Life of Christ with Old Testament scenes below. –
Sanctuary N by *Karl Parsons*, 1909, depicting the Virgin. – W
window, 1869 by *Clayton & Bell*, the Ascension in rich glowing
reds. – St Nicholas' Chapel E by *W. Taylor* of 1894 (St Nicholas).
S window, after 1916 by *Kempe & Co.* – Central N window by 124
*Karl Parsons*, a family memorial of the 1914–18 war, the young
soldier crowned by Christ. Arresting and intense purple hues,
contrasting with the flames encircling the heads. Highly skilled
sketching and modelling: an important piece of work. – S aisle
W by *Kempe & Co.*, a large war memorial of 1920.

MONUMENTS. The outstanding set in the county. –
Mutilated female figure in C14 dress, the head-band finely
worked. Reset under a Dec cusped and crocketed ogee canopy.
– Isabella Verney †1415. Upturned slab, incised cross with
damaged head in relief, marginal inscription. – Bishop Robert

Tully †1481. Simple chest lacking brass figure and inscription.
– Thomas White †1482. Against the altar steps. Fine alabaster
chest, carved stone effigy in merchant's dress with peacock at
the head and a hart below. The chest has cusped panels con-
taining family scenes, a little damaged, but beautifully carved,
showing from the l.: one of White's wives and their daughters
kneeling before a saint, his other wife and a daughter before
St Catherine, White at prayer with his three sons and, finally,
what appears to be a curious arcaded open shrine containing
three bodies with an inscribed tablet above. White sheltered
the future Henry VII before his flight to Brittany in 1471, and
the tomb suggests that he was well rewarded. Adjacent, John
White †1507, son of Thomas, and likewise a wealthy former
mayor of Tenby. Similarly dressed effigy. The alabaster chest
follows the same pattern. The first panel shows White's second
wife and daughter and a saint. Next, White's first wife and
daughter before St John the Baptist. In the third scene, White
kneels with his six sons, and in the final one, the same shrine
with three bodies, but no inscription. End panels with shields
to both tombs. They share a carved base, but slight differences
suggest that they are not of the same date. – w of the N door,
an ecclesiastic, possibly John Denby or Tynby, archdeacon of
St Davids †1499. Well-preserved cadaver within crocketed
canopy. – Margaret Mercer †1610. Large wall tomb, recum-
bent on chest, seven children below and husband praying
above in Corinthian-columned canopy. – Rudolph Mercer
†1613. Panelled chest. – William Risam †1633. Kneeling figure
framed by paired Ionic columns, inscription in entablature.
Norris sketched it as perfect when it was in St Nicholas'
Chapel in the 1830s. – John Moore †1639. Small, with fes-
tooned scrolled pediment. – John Sayes †1693, brass with
incised skull. – Rees Price †1729. Corinthian pilasters, mor-
tality symbols below. – Elizabeth Johnes †1730. Side drapery,
putti finials. – John Philipps of Picton Castle †1733. Scrolled
pediment with torches, entablature with acanthus leaves. Pan-
elled pilasters with leafy scrolls, flowers and shield underneath.
– Thomas Rogers. Tall, fluted Corinthian column on consoled
pedestal, elaborate shield above. Erected 1737 by Rogers' son,
a London mercer. A striking piece of high quality, unsigned. –
Roger Lort and family. 1778 by *Gheys* of London. Consoles
flanking inscription, huge urn above on wreathed pedestal,
small end trophies. – Morgan Williams †1790. Open pediment,
pilasters and shield. – Peggy Davies †1809 aged eighty-two,
'seized with apoplexy' while bathing. – Catherine and George
Hickman, 1833 by *Tyley* of Bristol, weeping woman before sar-
cophagus. – Captain Bird Allen †1841, signed by *E. Physick*: his
best work according to Gunnis. Seated mourning
Athenian youth with the folds of a banner falling behind him.
Pilastered, pedimented frame, all very crisp. – Robert Recorde
†1558, native mathematician and inventor of the equality sign.
Bust in roundel erected in 1910 by *Owen Thomas*. – Bessie

Henderson †1919. Mosaic by *Karl Parsons*, Pre-Raphaelite female with lamp and angels.

To the SW are the remains of the COLLEGE, apparently for chantry priests. Probably *c.* 1500 but its date and history remain unknown. Only the E wall remains. It has a lesser door with similar mouldings to the church S porch. The bigger arch with four-petal flowers has an inscription like the church W door, but less bold. Small Perp windows reset from the lost upper storey.

ST JULIAN. Fishermen's chapel at the harbour-side. 1873 by *W. Newton Dunn*. Small and plain with lancets. Simple interior, decorated with fishing gear. – STAINED GLASS. Windows of 1881, 1898 and 1900 by *Joseph Bell & Son*. The old seamen's chapel on the pier was converted to baths in 1781 and demolished in 1842.

CEMETERY CHAPEL (now an aquarium), Narberth Road. 1855 by *William Rogers* of London. Severely E. E. with lancets, plain buttresses and small SW turret. – STAINED GLASS. E window, 1855 by *David Evans*.

HOLY ROOD AND ST TEILO (R.C.), St Florence Parade. 1892 by *F. A. Walters*. Grand plans, but the N aisle was not built. The raw unfinished edges look sad. Small transept and side chapel to the S. Small high Dec windows and NW embattled turret containing the stair to the rear gallery. E end with large niche in the gable containing a figure of St Teilo. Scissor-truss nave roof and mostly C20 fittings. – STAINED GLASS. Two E windows of 1929, Crucifixion and Ascension. – On the S side, two by the same unknown maker, depicting saints. – Above the side chapel, Annunciation, *c.* 1900. – Transept S, SS David and Teilo, of similar date. – The most recent and uninspiring is the W window, which depicts martyrs.

The adjacent CONVENT OF ST TERESA of 1896 is also by *Walters*, originally intended as a seminary. Tudor and asymmetrical, wide mullion-and-transom windows.

ST JOHN (United Reformed and Methodist Church), South Parade. 1868 by *Paull & Robinson* of Manchester, built for the Congregationalists. Large, of local sandstone rubble with Bath stone. Gabled front with paired plate-traceried windows, aisles of four bays, each with a gable and lancet windows. Three-stage tower in NW angle with a little quadrant-plan corridor tucked in the front corner. Upper stage added in 1907 to amended plans by *E. Glover Thomas*. Stunted spire, the square base with big lucarnes and colonnettes. Lofty interior with rear gallery. Steep arch-braced roof, on thin iron posts. Rostrum with painted texts. SCHOOLROOMS to rear, added 1872 by *Paull & Robinson*. MANSE behind of 1872, by the same, with big barge-boarded gable.

BAPTIST CHAPEL, Deer Park. 1885, by *George Morgan*. Strong and carefully designed Gothic front of native grey limestone and Bath stone. Large Geometric window flanked by lancets beyond buttresses (spirelets removed). Full-width porch linked

by little flying buttresses, with rose window in the tympanum. The manse, intended to balance (but not repeat) the attached caretaker's house, was not built. Impressive interior with wide double arch-braced roof upon short wall-posts. Gallery with open arched panels. Tall apsidal organ recess behind arcaded pulpit. Bright, patterned STAINED GLASS of 1885 in the apse. The loss of the equally large WESLEYAN CHAPEL, Warren Street, in 1989 was unfortunate, since it was the best work of *K.W. Ladd* of Pembroke. It had a Romanesque façade of 1881. These three large chapels suggest considerable wealth among Nonconformists in Tenby.

PUBLIC BUILDINGS

p. 469   CASTLE AND MUSEUM, Castle Hill. Only fragments of the castle remain. Since it was raised on a rocky headland, perhaps a complete circuit of walls was unnecessary. To the N, a short stretch with embrasures and wall-walk, and to the S, a similar length adjacent to the gate. Adjoining the MUSEUM, itself built into a medieval domestic building (the hall?), another much-repaired piece of wall. Entry was via the simple square GATE in the curtain wall, secured by an impressive D-shaped BARBICAN, which straddles the approach. Inside, a WATCH TOWER, formed by a circular and square tower joined, low footings of lost buildings on the landward side. The crude limestone masonry is probably late C13 or later, replacing an earthwork, captured by the Welsh in 1153. The Museum was built as the National School in the early C19 and enlarged in 1842: all very plain. Is the small circular chimney shaft C16? Exterior tile MURAL by *Jonah Jones*, 1991. (For the Albert Memorial, *see* perambulation 2.)

54       THE TUDOR MERCHANT'S HOUSE, Quay Hill. The most complete medieval town house in Wales. Late C15, three storeys, gabled. Upper front-wall chimney and two-light mullion window corbelled out together. Large cylindrical N chimney, NW latrine turret – unhealthily close by. Inside, painted decoration on the ground-floor partition, apparently later. Five-bay roof structure of raised crucks. No internal stair; a blocked opening in the first floor N wall may indicate an exterior stair. Was the house part of a bigger complex? Certainly the adjoining houses conceal C15 features – see two doorways on the gable-end of that further downhill, suggesting that a courtyard existed before the breaking through of the present lane (*see* Perambulation 2, below). Owned by the National Trust, who have created a Tudor garden.

MAGISTRATES' COURT, The Croft. Built as Croft House *c.* 1825. Three storeys and five bays, unrelieved except for the (later) porch. Described in 1839 as 'an ugly square lump which could be turned inside out or upside down without injuring its proportions'.

TOWN HALL AND MARKET, High Street. Market built 1829. Town Hall front added 1861 by *John Cooper*. Three-bay façade

with round-arched entries of grey limestone ashlar under a central pediment, which incorporates a plaque of 1829. Upper storey stuccoed, with simple pilaster strips. Modern market interior behind. Plain rear market elevation of 1829, very similar to the market at Pembroke Dock.

LIBRARY, Greenhill Road. Formerly Greenhill, a house of c. 1830. Plain and stuccoed. Adapted as a County School in 1896 when *J. Henry Christian* added schoolrooms.

RAILWAY STATION, Warren Street. Attractively Gothic work of 1871, by *J. W. Szlumper*, engineer. Nice Bath stone details, including grouped chimneys. Some windows under arched

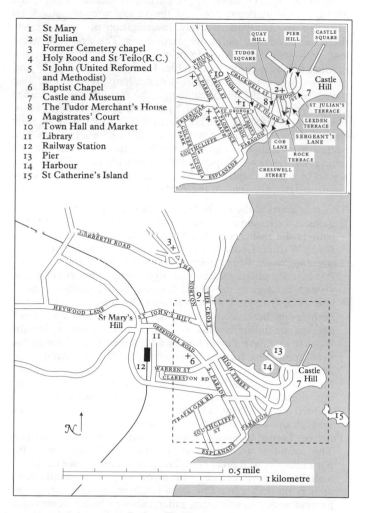

1  St Mary
2  St Julian
3  Former Cemetery chapel
4  Holy Rood and St Teilo (R.C.)
5  St John (United Reformed and Methodist)
6  Baptist Chapel
7  Castle and Museum
8  The Tudor Merchant's House
9  Magistrates' Court
10  Town Hall and Market
11  Library
12  Railway Station
13  Pier
14  Harbour
15  St Catherine's Island

Tenby

tympana and gables. Original cast-iron canopy. *Davies & Roberts* of Denbigh were the contractors of the Pembroke & Tenby Railway, built 1862–3.

*1. The Town Walls*

The tour explores the town roughly anti-clockwise, starting with High Street, followed by the harbour.

Of the walls, approximately half survive; those to the N and E, seaward, were virtually obliterated by the early pioneers of tourism. A date between 1240, during the tenure of the last Marshal earls of Pembroke, and the 1260s, after the attack by Llywelyn ap Gruffydd, is likely. Investigation in 1993 suggests there was an earlier defensive earth bank. The first walls were low, with loops defended from this earlier bank within; the original height is quite discernible. One of the three gates and seven of twelve towers remain, in excellent preservation. Two towers belong to the initial campaign, the rest followed a murage grant of 1328 and an order of 1457 from Jasper Tudor, earl of Pembroke, to refortify, which added a 6-ft (1.8 metres) wide walk behind the wall. The moat was mostly filled by the late C18. The walls achieved their present height (7 metres) between the two main refortifications. Upper crenellations with loops were added, served by a timber wall-walk. Many putlogs are still visible. Some repair in 1588, the year of the Armada.

This tour starts at the top of HIGH STREET. The name and remnants in the basement of the ROYAL GATEHOUSE HOTEL perpetuate the memory of the NORTH GATE, removed in 1782. Along WHITE LION STREET, a straight stretch with a solid stone walkway of 1457 behind, embedded in the DE VALENCE PAVILION, which blocks the C13 loops. The circular NW TOWER belongs to the initial campaign, its corbelled parapet later. The SOUTH PARADE follows the moat line. Loops at both levels here, as well as putlogs above wall-walk level, perhaps for timber hoardings. BELT'S ARCH TOWER, like the BARBICAN GATE beyond, were added probably following the 1328 grant. The former is semicircular, the side embrasures destroyed in 1784 when the pedestrian passage was made. Inner door C19, below the outline of the original one. Within this stretch, traces of the C15 masonry wall-walk, raised on pointed arches. Towards the barbican Dec trefoil-headed niche set high up, a piece of reused tracery.

The large D-plan barbican is better known as the FIVE ARCHES. The round N arch adjacent to the wall is the entry, the portcullis slot well preserved. The pointed arches are C19; originally these were recesses with arrow loops. The simple inner arch is the C13 gate. The later heightening here turned the parapet walk into a fighting gallery, above which a new crenellated parapet and walkway were built, thus defending the

unroofed structure inside and out. The later stair to the upper level is seen inside the town entry.

Continue along ST FLORENCE PARADE. More putlogs, and inside, more c15 arched walk is visible. The semicircular SOUTH POOL TOWER is of uncertain date, later than the heightening of the walls. Between here and the barbican, a datestone of 1588 indicates repairs. The SQUARE TOWER clearly replaces a wider structure. Corbelled embattled parapet and, on the N, where the tower oversails the curtain, a garderobe. Both storeys are vaulted and have inverted keyhole gun-ports. The date is probably contemporary with the 1457 strengthening. To the N, remains of a garderobe with inserted gun-port. The BELMONT ARCH was made in 1862, polychrome stone voussoirs. The adjacent BELMONT TOWER belongs with the early wall, and perhaps delimited the southern end of the c13 defences. Later parapet and c19 turret belonging to the adjoining hotel. The short extension of wall towards the sea is probably of 1457, with traces of the earlier wall. The small, square IMPERIAL TOWER stands on the cliff edge and is c15. Little is known of the seaward defences, but on the E side, N of the BRECKMENCHINE, are remains of a D-plan tower. At the HARBOUR, leading up from CASTLE BEACH, remains of the WHITESANDS GATE, mostly demolished 1797. The present arch is c19 and of brick; on its N side a blocked door, above street level. The masonry blocking it is the end of the stub wall projecting towards the harbour. Of the harbour fortifications little evidence survives. The QUAY GATE stood about 40 yds W of ST JULIAN'S CHURCH, long removed, but recorded by Norris as a segmentally arched gate with portcullis slot.*

2. *The Walled Town*

A start is best made in HIGH STREET, at the LION HOTEL of *c.* 1800 but certainly earlier masonry, on the corner with White Lion Street. Four storeys with later canted wooden bay windows: note the scrolls each end of the parapet. LAVALLIN HOUSE was incorporated in 1914. Three bays, stuccoed with heavy cornice, it dates from 1832. Much of the rest of High Street consists of tall, plain c19 façades with bay windows looking over the harbour and Carmarthen Bay. Out of this, however, shines the PRIZE HOUSE; the design apparently (but not identifiably) won a prize at the 1851 Great Exhibition and was built soon after. The façade of three bays and storeys is of Bath stone. Arched ground-floor openings, with imposts and carved leafy consoles supporting little bow-fronted balconies. The long first-floor windows have segmental heads, the upper ones, lugged and shouldered surrounds. Bold carved cornice with brackets, and a balustrade. Toplit stair and good plaster cornices. Whoever designed this suave little palazzo remains

111

---

* S. Garfi provided very useful information on the town walls.

frustratingly unknown. The large ASHLEY HOUSE, formerly
the COBOURG HOTEL, of four storeys, was built in 1816 by a
local builder, *William Maddox.*\* The stacked bay windows are
later. Shopfronts added after 1983.

CRACKWELL STREET, a narrow lane, forks off to the l. No. 4 of
*c.* 1835 has a doorcase with fluted pilasters. SUN ALLEY to the
s has two medieval jettied walls of stone, incorporated in later
work – a peep of old Tenby. OYSTER COTTAGE further down
Crackwell Street, although mostly C19, has two much-defaced
lancets of an earlier structure. Nos. 8 and 9 are a tall mid-C19
pair possibly created from an earlier C18 house, with stuccoed
double portal and central pediment. Lower down, the old
FISH MARKET is now a garden, perched on the cliff edge. The
Tudor gateway of 1847 has the name of the builder, *John Smith.*
The CHARLES NORRIS HOUSE has a medieval core, much
remodelled. On the gable-end abutting QUAY HILL are two
blocked doors, the lower round-arched with rough voussoirs,
the upper fashioned of rough jambs and imposts with key-
stone. The work looks C15, and the proximity to the TUDOR
MERCHANT'S HOUSE (*see* above), which faces down BRIDGE
STREET, perhaps indicates that a large courtyard house
stood here. PLANTAGANET HOUSE above also has C15 detail,
including a fine large conical chimney to the rear, and inside,
a vast hearth, arched doorway with broach stops and some
painted decoration – all behind a plain, early C18 front. Back
down Bridge Street, HARBOUR COURT was built as fisher-
men's tenements *c.* 1890. Harsh front of silver limestone,
window heads of coloured brick. On the quayside, in Crack-
well Street, to the l., PIER HOUSE and SPARTA HOUSE, late
C19 stucco. In Bridge Street to the r. the houses are early C19.
The best are GWYNNE HOUSE and KEMENDINE, a good,
stuccoed three-storey pair of *c.* 1830. Pedimented doorways
with good fanlights, little iron Gothick balconies. ST JULIAN'S
HOUSE is of three bays, the round-arched portal with rusti-
cated vermiculated blocks. From here, a splendid view of the
HARBOUR. The long PIER replaced the medieval one in 1842.
It was strengthened and partly rebuilt in 1854 by *T. E. Black-
well*, a Bristol engineer. Further renovations *c.* 1880 by *H. T.
Morley.*

### Castle Square to Castle Hill

From CASTLE SQUARE, a number of routes can be taken.
First, w down towards the harbour, past *W. Newton Dunn*'s
simple Gothic FISHERMEN'S ROOMS dated 1874. Opposite,

\* A telling inscription was found during renovations of 1987: '*Evan Davies*, foreman
of the building, but not of the stairs, for he could not undertake it. *Henry Watkins*
[or *Wilkins*] and *Thomas James Maddox* carried up this staircase. Dated this day
the 7 of June. *William Maddox* sen., Architect of this building departed this life
November 17, 1815. *Ambrose Smith* and *William Lewis*, mason and plasterer.
Ambrose Smith summonsed before Dr. Roach for fighting of Billy Reece. June 9,
1816.'

the stone supporting ARCHES of Sir William Paxton's scheme of 1813 to link town and harbour, superseded by the road above and now a garden terrace. Ahead, past St Julian's Church (see above), a picturesque C18–C19 collection around the C17 SLUICE. This was a dock for small boats, and retained sea water to be slowly released at low tide, scouring the area in front of the old wharf. The most prominent building is a three-storey warehouse, now home to the sailing club. The wharf to the S was constructed in 1763. High up in the cliff, below the old Fish Market, are storage rooms with large circular openings, one of which was for a long period the town mortuary.

Castle Square itself is a picture-postcard group with sea-facing cottages and taller stuccoed houses behind. Of the latter, Nos. 2–3 are late C18, with widely spaced small windows and some early C19 bay windows. Tucked in the corner is LASTON HOUSE, built in 1810 as a public bath-house for Sir William Paxton. His architect was *S. P. Cockerell*, as at Middleton Hall, Carms. Elegant stuccoed entrance elevation, single storey (with deep basement behind) of five bays, windows under blank arches. Enclosed bowed porch with Greek inscription from Euripides: 'The sea cleanses all men's pollution'. Rusticated below impost level. Arrangements were elaborate, including two swimming baths, as well as baths for sweating and fumigation. A huge reservoir to the rear fed them, the water changing with every tide. Long converted to a house. A circular entrance hall survives. The attached cottage to the l. for the bath-attendant is also by *Cockerell*. Next door, a distracting early C20 frontispiece attached to an earlier building (formerly the ALBION HOTEL), probably by *Cockerell*. The last cottage has corbelling: a remnant of fortification? Below, down PIER HILL, are the charming, taller front elevations of the above, all simple and colour washed. The projecting end house, much grander, with a bowed end facing the sea, was *Cockerell*'s ASSEMBLY ROOMS, which provided Paxton's bathers with accommodation. Rendered walls, but limestone battlements and a tall chimney, the shafts linked by an arch. Large upper windows with intersecting glazing bars. The whole forms a very distinctive and graceful composition.

Leading off Castle Square to the SE is CASTLE HILL, dominated by the castle remains and the Welsh National ALBERT MEMORIAL, erected 1865. The Prince Consort, of eroding Sicilian marble, is in Field Marshal's uniform, standing 9 ft (2.7 metres) high. The sculptor was *J. Evan Thomas*. High grey limestone plinth, designed by *H. Maule Ffinch* of Tenby. Marble heraldic panels of course by *Thomas*. As public statuary goes, a memorable piece both in its quality and setting. The site is superb, with a good view of the slate-hung, seaward-facing sides of houses in St Julian's Street and, further on, of Lexden Terrace, which has fine covered first-floor iron verandas facing the sea. The cast-iron ROYAL VICTORIA PIER

of 1899 by *R. St George Moore* was demolished in 1953, but its
steps remain near the present Lifeboat station. To the s is ST
CATHERINE'S ISLAND (*see* below).

*St Julian's Street to Tudor Square*

sw off Castle Square is ST JULIAN'S STREET. ST JULIAN'S
TERRACE is a good early C19 stuccoed group. Nos. 1–2 have
round-headed portals, the lower two pedimented doorcases.
No. 5, a later rebuild, has a delicate iron balcony. Nos. 2–3 St
Julian's Street have portals with rusticated heads. ALBERT
VIEW above has a medieval narrow loop, exposed when
the stucco was renewed. Opposite, LEXDEN TERRACE, a
speculation of 1843, is Tenby's best C19 work: a three-storey
stuccoed row of six set back from the street. Upper storeys
divided by simplified giant Ionic pilasters. Rusticated ground
floor with lugged door surrounds and lozenge-type glazing. The
speculator was John Rees: his house is wider, and distinguished
by an Ionic portico – all a little crude. Inside, a plaster groin-
vaulted vestibule with corner columns and an oval well-stair
with niches. The other houses have top lit stairs. The builder,
*John Smith*, may also have been the designer. Continuous rear
balcony with fine wrought-iron work; clearly, the aim was to
bring a little slice of Brighton or Cheltenham to west Wales.
EAST ROCK HOUSE above is of *c.* 1800, tall and narrow, the
columns of the portal with marked entasis; that at CALDEY
VIEW is similar. Good plasterwork in the former. TIDE'S
REACH and GREY ROCK HOUSE, stuccoed and of three
storeys, have broad ornamented parapets. The latter has a
plaster groin-vaulted lobby. The date is *c.* 1830. Nos. 1–2 ROCK
HOUSES are of similar date, with upper giant Ionic pilasters and
double Ionic portal. The detail crude, the style similar to Lexden
Terrace. LANSDOWNE COTTAGES opposite are of similar date,
a cleverly designed stuccoed terrace of five tiny two-storey
cottages with a corbelled, panelled parapet. The penultimate
houses step outwards, the lower one forming a lobby to the
flanking houses with a blind window above. Nos. 3–4 ROCK
TERRACE sit back behind railed gardens. An attractive rusti-
cated pair of *c.* 1830, the doors behind a trellised porch. Behind
is an ingenious late C19 (lavatory) extension perilously raised
on stilts. Stone Ionic portal to No. 2, and a more detailed one
to GRIFFITH LODGE, with out-turned volutes and the familiar
pulvinated frieze, indicating an 1840s date. To the r. is
SERGEANT'S LANE, with unmodernized C19 stables and stores.
LOCK HOUSE above is of *c.* 1850, Tudor with gables and labelled
windows. VERNON HOUSE has a simple Ionic portal. IVY
HOUSE opposite was built for the town clerk in 1817. Three
storeys and bays, and attractive portal with Gothick fanlight and
fluted sides. Unspoilt late C19 shopfronts, very simple. Inside, a
plaster groin-vaulted vestibule and good plasterwork.

The narrow winding charm of St Julian's Street broadens into
TUDOR SQUARE, a wedge formed in 1836 by demolishing

the original market with its cross and attached row. Named after the Tuder family of Tenby, it has no royal connections as implied by the misspelling. Though beautifully terminated by the E end of St Mary's Church (*see* above), the square offers little architectural excitement, especially after the removal of Thomas Josiah Wedgwood's memorial fountain, erected in 1860 by the young *F. R. Kempson*. Will this Ruskinian landmark ever be reinstated? The surrounding buildings are C19 and plain. The appearance of the TENBY HOUSE HOTEL dates from 1807, when an old house was remodelled as the Globe Inn, another Paxton project (though not by Cockerell). Three storeys and four bays, the detail all slightly later, including the bulky Tuscan portal. The canopied iron balcony was reinstated in 1999. The MEDICAL HALL has a fine mid-C19 SHOPFRONT, the lettering of fired glass; a cast-iron balcony above, the detail classical. Well preserved interior, an extremely rare survival. There are three banks in the square, but only the NATIONAL WESTMINSTER BANK attempts a show, the 1912 frontispiece with Corinthian columns, probably by *Palmer & Holden*. The gabled mock-Tudor former LIBERAL CLUB, 1912 by *E. Glover Thomas*, is distinctly out of place. The first-floor balcony allowed a speaker to address street crowds.

*From Tudor Square to the N and W*

Tudor Square now funnels back into High Street. Turn W along ST NICHOLAS' LANE under the link building of T. P. HUGHES, 1909 by *E. Glover Thomas*, with cupola and iron balustrading. To the N, along UPPER FROG STREET, a back lane parallel to High Street, is BRYCHAN YARD, formerly stables for visitors. The main segmental brick arch is dated 1807; the architect was *Cockerell*, working again for Paxton. The archways each side with polychrome stone heads must be later, as must the top storey. THE MEWS above was built in the early C19 as racing stables, the town being well known for horse training until the Second World War. Severe front of dressed limestone with battlements and dropped keystones. Returning downhill is ST GEORGE'S STREET. The FIVE ARCHES TAVERN was until the mid-C19 part of the medieval Town Hall and retains a blocked four-centred doorway, probably late C15 or early C16. Behind the next building, formerly the REGENT HOTEL, a little Perp window and a blocked round-headed door. Norris depicted the old Town Hall, which had a fine ribbed undercroft. Adjoining is the former SOUTH GATE to St Mary's Church with the former courtroom above. Rebuilt in the early C19, the two-bay upper storey with round-arched sashes, but also a Perp two-light mullioned window with trefoiled heads. From the E end of St George's Street, CRESSWELL STREET with its tiny cottages leads back to the sea-front. To the l., IVY COTTAGES, a long, low row of Regency cottages, much restored. At the sea-facing PARAGON, the C19 PARAGON HOTEL near its W end and its neighbour are of three storeys,

remodelled 1904 by *E. Glover Thomas* with fancy sash windows
and balcony. The plain IMPERIAL HOTEL, originally houses
of the 1830s, abuts the town wall with a turret astride a
medieval bastion on one side and a simple Edwardian addition
on the other. The BELMONT ARCH was punched through the
town wall in 1862: coloured stone voussoirs with sawtooth
carving.

LOWER FROG STREET leads off the w end of the Paragon;
opposite the Imperial Hotel FROGMORE TERRACE is an
unspoilt three-storey Regency terrace with round-arched
windows, possibly by *Henry Rumley* of Bristol, built in the
1830s. Opposite is the former PRESBYTERIAN CHAPEL of
1837, remodelled in 1894 by *E. Glover Thomas*. The pointed
openings may be earlier, but the pediment and sturdy obelisks
are of 1894, as is the interior, which has a double arch-braced
roof, and rear gallery with arcaded front and organ. Further
on, FROGMORE HOUSE, dated 1856, has a splendid
SHOPFRONT of *c.* 1910 with tiles and ceramic letters. Parallel
to the e is ST MARY'S STREET, mostly late C19 cottages and
boarding houses. OLIVE BUILDINGS are a good three-storey
stuccoed group of *c.* 1830, hipped roofs and pedimented
portals with attenuated columns.

*3. The Norton and Heywood Lane*

A beginning is made in the same area as the former tours, at the
site of the North Gate. The ROYAL GATEHOUSE HOTEL,
1859 by *James Thomson* of London, is an ambitious undertak-
ing. Italianate, square and stuccoed, four storeys formerly
capped with a bold consoled cornice. The sea front has
odd bracketed bay windows on the first floor, almost like
balconies glazed over. The entrance front to the side has
conventional canted bay windows, and upper floors carried
over the pavement on plain iron columns. In the basement,
traces of the medieval North Gate. The NORTON, n of the
hotel, is mostly a plain terrace of the early C19. No. 10 of 1859
by *Ewan Christian* is the exception, in Venetian Gothic for
Charles Allen. Its dressed stone front with coloured brick
trim must have stood out among its stuccoed neighbours
until covered by its present white paint. Three storeys, the first-
floor windows daringly grouped in a triplet to the l. behind
a balcony on chunky brackets. Windows above with iron
balconnettes, rich cornice. Lots of tooth ornament. Lower
down, Nos. 24–25 are of 1903 by *J. Preece James* of Tenby,
gabled with decorative bargeboards and fluted shell-head door
canopies. No. 31, early C19, has a wooden Doric portal.
NORTON HOUSE is of *c.* 1840 with broad, two-storey stuccoed
front, the upper casements Gothick. Double return stair inside
and much woodwork with Tudor arch motifs. The OLD
RECTORY has an C18 core with additions dated 1856 by
*William Rogers* of London, including the gabled porch with
colonnettes. On the e side, the stuccoed SOUTH ZION

LODGE, former lodge to *John Nash*'s SION HOUSE, burnt in 1939. The lodge belongs to 1870, when Nash's three-bay house was enlarged and heavily Italianized; it has a rusticated portal and simple corbelled parapet. The site is now occupied by the unsightly CROFT COURT flats of 1961 (*F. D. Williamson & Associates* of Port Talbot). Further N along NARBERTH ROAD is the vast BRYN-Y-MOR, 1892 by *Whitfield* of Birmingham, formerly a pair. Three storeys with bay windows and two tiers of dormers in the red-tiled roof. The client, Mr Tonks, made a fortune in patented door fittings, much in evidence here.

Return s to the junction with THE CROFT. The tall OCEAN HOTEL of *c.* 1840 has Gothick casements and labels, and curly bargeboards, recently restored. ST STEPHEN'S, next door, was neatly shoehorned in by *Healey & Marston*, 1901, of Sutton Coldfield. Vernacular Revival, clad in red tile with skied bay window and wooden balcony. Also for the Tonks family. The TENBY AND COUNTY CLUB is of 1877 by *W. Newton Dunn*, in his usual solid Gothic. Asymmetrical, with porch on red granite columns to the l., off-centre gable with wide bay window below. The iron balcony is lost. CROFT TERRACE, adjacent, is stuccoed and of three storeys, now mostly converted to hotels. CROFT HOUSE and the FOURCROFT HOTEL date from 1833 and have little Gothick balconies. The middle houses with fluted arched doorcases and iron balconies are of 1839; the taller end pair of 1864. The whole is a satisfying group, when seen from the beach below. High on the cliff to the w is the Queen Anne NYTH ADERYN, 1889 by *Ernest Newton*, a remote and early commission for that architect, illustrated in the *Building News*. Red brick and tile, the front symmetrical, with large full-height bay windows flanking the veranda. Alas, the wonderfully varied chimneys have gone. It was originally called Sparrow's Nest. The client was Arthur Sparrow, of the Wolverhampton iron family, for whom R. Norman Shaw had built Preen Manor, Shropshire in 1870. Newton had been Shaw's assistant and this house is in the tile-hung Sussex vernacular that Shaw restyled as 'Queen Anne' (cf. Bedford Park, London). Newton made additions in 1893. At the bottom of ST JOHN'S HILL to the w is the mighty RAILWAY VIADUCT of 1865, by *James Mathias*, engineer of the extension of the Pembroke & Tenby Railway to the main line at Whitland. Seven round arches with imposts, of giant blocks of rock-faced grey local limestone. The viaduct guards the main way into town, and one cannot help being reminded of a medieval entry. Beyond what once was Tenby's green lies HEYWOOD LANE, originally a fashionable little C19 suburb with villas of mixed styles built mostly in the 1840s for a local speculator, Richard Rice Nash: the seaside *cottage orné* style of genteel places like Sidmouth was obviously the inspiration. The architect, if there was one, is unknown; there is no connection with John Nash, as is sometimes suggested. One of

the best – and conveniently near – is THE GABLES, *c.* 1850. Attractive decorative bargeboards and marginally glazed casements with Tudor hoodmoulds. Above, ST MARY'S HILL is of 1838, hip-roofed with minimal Tudor detail. ROSEMOUNT, plain, bulky and gabled, 1845 by *John Cooper.* BELMONT has a villa of *c.* 1840 as its core, visible from behind, with hoodmoulded windows. Undistinguished rambling red brick additions of 1895, by *F. L. Pither,* and a large half-timbered porch, dated 1913, by *Philip Tree.* To the w, HEYWOOD LODGE has a pretty stone front of 1844, the gable with curly bargeboards. HAFOD Y WERYDD was built in 1933 for Major Gwilym Lloyd George, son of the prime minister, by *Idwal Williams* of Criccieth. It introduces a slight Art Deco note, symmetrical, with low, wide windows and stone tiled roof. BROADMEAD is neat stucco of *c.* 1840, three bays with porch jettied over the Gothic door, bay windows flanking. Large, extensions of *c.* 1990. HEYWOOD MOUNT, 1847, has a bargeboarded centre gable.

### 4. The South Cliff

128    Begin on the SOUTH PARADE, at the WAR MEMORIAL, a crisp classical cenotaph of 1923 by *J. Howard Morgan.* Tall ashlar pedestal with white marble tablets, Ionic pilasters with bronze capitals. Shorter tier above, containing the arms of Tenby and Latin, Welsh and English inscriptions. Bronze flame finial. Southwards, most streets were laid out in a grid plan, in 1864 by *J. H. Shipway* (engineer of the Whitland & Milford Haven Railway), to cater for the masses of visitors arriving by train, following the sale of the Tuder estate. *H. Maule Ffinch,* related to the owner of the estate, was involved from the beginning. Also involved was *F. Wehnert,* then associated with the expansion of Milford. Wehnert had gained experience with seaside terraces at Llandudno. The sea-front plots were developed soonest; others were let to local building speculators, a notable one being *William Davies* of Culver Park.

The speculative work was of little note: this is certainly true of VICTORIA STREET (1872–82) to the sw, reached via Southcliffe Street, with its tall N–S bay-windowed boarding houses. Mostly by *Davies,* the HALLSVILLE HOTEL with a canted corner, dated 1879. The prestigious street is the sea-facing ESPLANADE (1864–80), running E–W along the front. Blocks of four-storey stuccoed hotels, the one at the E end with wide canted bay windows rising to tablet-like dormers, 1872–80. To the w, the CLARENCE HOTEL is taller, rusticated to the ground floor and balcony. The ATLANTIC HOTEL began life with four storeys, but in 1914 two houses were joined and the two top floors removed, the interior lavishly fitted up as a private house for Warren de la Rue, whose horse 'Trayles' won the Ascot Gold Cup in 1889 (the horse's carved head appears over the door). The architect of this costly exercise was *D. W. Pollock* of London. Further w, the rest of the row is mostly

plainer. SOUTHCLIFFE STREET, parallel to the N, has some tall houses of the 1870s, but CLEMENT DALE and MORAY VILLA add a little Edwardian zest, both gabled with canted bay windows and fancy porches. At the W end is the stolidly Gothic KINLOCH COURT HOTEL, formerly the rectory of 1878 by *W. Newton Dunn*. Dressed grey limestone front with gable to one side and crenellated upper oriel. CULVER PARK off Southcliffe Street has simple two-storey terraces largely of 1868. TRAFALGAR ROAD, N again, is a long straggle of early C19 cottages. Hidden in an alleyway at the junction with the South Parade, a late medieval cylindrical chimney.

ST CATHERINE'S ISLAND, accessible at low tide, off Castle Sands. The small rocky island is dominated by the stern line of the FORT, built 1868–70 to defend the Milford Haven against anticipated French threat. Two lines of land-fortifications were planned in 1860 to protect the Haven from the S, with coastal forts at possible landing places. Of the outermost line from Tenby to Trewent, only St Catherine's was built, but its isolation meant that the fort was of little military value. The site was originally occupied by a small medieval chapel to St Catherine, evidence of the significant Early Christian community in the Tenby–Penally area. Plans for the fort were prepared under *Col. W. D. Jervois*, Assistant Inspector General of Fortications, responsible for the overall design of forts from 1858. It is rectangular, with three Moncrieff batteries forming rounded bastions to the E. Construction of massive limestone ashlar, with Lundy granite detail. The entrance faces W towards town, accessed via a drawbridge over the chasm in the rocks. Symmetrical elevation, the round-arched entry with original door and vermiculated quoins: dated 1870 above. To each side, matching caponiers, with rifle loops in each of the three storeys. Three levels at the W side, where the cliff falls away, the basement of the caponiers with bombproof, brick barrel-vaulted chambers. The main body houses six casemates at the main level: barrel-vaulted D-shaped chambers each side of a spinal corridor. Under the open batteries, vaulted tunnels lead E to the magazines, off which a vice leads up to battery level. Disarmed 1906, and sold to the wealthy Windsor Richards family of Caerleon in 1914, who employed *J. Preece James* to fit it out as a house. Some C20 fittings from this time; the original gun-races survive under later flooring. Derelict for decades, the fort urgently deserves a new use.

SCOTSBOROUGH, 1 m. W. Very ruined. The seat of the Perrots, from the early C15 until the early C18. Tenements when abandoned *c.* 1825. Enough survives to suggest a typical medieval layout, a rectangular hall with W service wing. Little detail remains save for a double corbel for an oriel on the N side of the wing and a two-centred N door to the hall with double-chamfered jambs and diagonal stops. Probably all early C15. Of greater interest is the two-storey, late C15 addition, joined at the SE, which had a vaulted undercroft. In type, it is similar

to small local hall houses, such as Carswell or West Tarr (Penally), and although an addition, it seems to have been self-contained. The upper chamber has a corbelled lateral chimney with conical shaft, its fireplace a simple hood. In the NW corner, traces of an internal stair. Gabled SW turret, with flattened barrel vault, presumably a garderobe. The loops suggest a defensive building. The wider S window is inserted. The service range was extended S in the C16; only bits remain. Between the two ranges was a low wall with decorative battlements, probably of the C17, forming a small court. (A sundial dated 1610 has been discovered.) At this time, the porches were added, those to the N intact with a segmentally headed door, rough voussoirs. Traces of a building at r. angles to the service range. Fragments of C16 Spanish tiles have been found, indicating not just the original spendour of the house, but also Tenby's European trade links.

# TRECWN
### Llanfair Nant y Gof

The modern settlement is around the former naval depot, a very large facility built in the secluded valley that had been the estate of Trecwn, an important C16 to C18 double-pile house, demolished in the 1950s. Also on the land were several single-storey stone cottages. Sir Cyril Fox's recording of these before demolition in 1937 was a milestone in the serious study of Welsh vernacular architecture. Outside the gates, MAMRE CALVINISTIC METHODIST CHAPEL, a small long-wall chapel of 1843, remodelled in 1908 by *H. W. Evans*, with thick pilastered surrounds to Gothic windows. To the N, the OLD RECTORY, mid-C19 stucco with deep bracketed eaves.

ST MARY, on the hill, ½ m. SW of the depot. The parish church of Llanfair Nant y Gof. 1855, probably by *Joseph Jenkins* (cf. Walton East). Simple nave and chancel with cusped lancets, bellcote and N porch. – Square FONT, looking medieval but dated 1695. – Poppyhead PEWS and some nice patterned GLASS by *Powell*, all 1855. One nave S window by *Celtic Studios*, 1975. – MONUMENTS: John Vaughan †1738, later C18 with broken pediment and scrolled sides. Martha Vaughan †1803, wreathed oval.

TRECWN NAVAL DEPOT. Former storage depot for naval munitions and mines, begun 1939, in use until 1994. The plans of 1937 are signed by *J. R. P. Norton*, Civil-Engineer-in-Chief to the Admiralty. The site was for the storage, proving and testing of munitions. For the purpose, a special railway line was built and fifty-eight very large storage tunnels were driven into the valley sides, the spoil being used to level its floor. The tunnels were either 110 or 240 ft long, 35 ft wide, and 32 ft high, of rendered seven-ring brickwork. Narrow-gauge rail tracks served each one. Elsewhere were blast-proof proving sheds and transfer sheds for the changeover to standard gauge.

TRECWN PRIMARY SCHOOL, in the valley above the naval depot. Built in 1876–7 for the Barham family of Trecwn by *E.C. Lee*. Closed and derelict. Two-storeyed, twin gables flanking a centre with bellcote, much larger than usual in the region. An oddly personal design in rock-faced grey stone with Bath stone windows gathered under big over-arches, suggesting the Romanesque, although the windows are mullion-and-transom, and the bellcote Gothic. The rear classrooms step down the hill with a random assembly of hipped roofs, dormers and gables, reminiscent of Philip Webb.

BUCKETTE CAMP, 1 m. SW (SM 950 310). An almost perfect circle ringed by a single bank, and with two short banks out to the NW, said to be an Iron Age defensible enclosure.

CAER PENBICAS, ½ m. W (SM 959 357). Iron Age horseshoe-shaped enclosure.

# TREFFGARNE/TREFGARN

9523

River, road and railway are all confined in the dramatic Treffgarne Gorge. At its entry from the N, GREAT TREFFGARNE ROCKS, a castle-like natural outcrop shielding an Iron Age camp (SM 956 250). The scattered village lies along the lane running N from Treffgarne Bridge to the church. CHURCH HILL HOUSE was the rectory, pyramid-roofed, of 1832. By the bridge, TREFFGARNE LODGE, 1840, a stone Gothic lodge to Treffgarne Hall (*see* below).

ST MICHAEL. Small, predominantly Victorian, of no special character, restored in 1881, 1894–7 by *Pinder & Fogerty* of Bournemouth, and 1911. Nave, chancel and W bellcote. Inside, C19 rafter roofs and an octagonal plain medieval FONT. – STAINED GLASS. A later C19 set of five single lights, given to the church from elsewhere. W window, Sermon on the Mount; nave S, Suffer the Little Children, with painterly Victorian children; nave N, Ascension and Nativity. The E window, the Crucifixion in streaky colours, could be by *Mayer* of Munich.

TREFFGARNE HALL, ¼ m. W. Late Georgian country house, built in 1824 for David Evans. Two-storey stone front with hipped, slightly projecting end bays framing a three-bay centre on the garden front. Entrance porch on the end wall, opening into an axial passage, interior with two large staircases, presumably altered.

# TREVINE/TREFIN

8432

Llanrhian

Long linear village, a typical medieval 'planted' settlement just inland from the N coast, with broad-verged and treeless main street flanked by rendered and colourwashed houses, mostly later C19, rising to a rocky triangular green at the E end, with Capel Trefin just beyond. Many houses with nicely idiosyncratic

details: stuccoed windows and door surrounds inset with peb-
bledash panels.

CAPEL TREFIN. Calvinistic Methodist chapel of 1834, with
lateral façade, the half-hipped roof typical of the 1830s and
with the grouted slates typical of the region. Four tall arched
windows, the centre pair broader with marginal glazing bars.
Galleried interior.

ELIM BAPTIST CHAPEL, on the main street. Said to date from
1843, but looking later C19 with gable front and hoodmoulded
arched openings. w gallery.

ABERFELIN, ½ m. w. A small rocky cove with the ruins of a mill
and a row of C19 single-storey cottages.

0204

# UPTON

1½ m. NE of Cosheston

25 UPTON CASTLE. Secluded location, 2 m. NE of Cosheston. Still
occupied, and despite centuries of alteration and additions,
much remains of the original apparently C13 fabric. Upton was
properly a medium-sized fortified first-floor hall house, having
no evidence of secondary defences, but the turrets on the N
side give it an obviously castellar appearance.

From the C13 Upton was occupied by the Malefants,
descending to the Bowens in the mid-C15. Their house is
instantly recognizable as the main rectangular N block. Late
C17 improvements added a wing to the SW corner, but it seems
that little improvement was made to the older fabric – a sketch
by Norris of c. 1800 shows the old first-floor N door still in
use. After 1758, the semi-ruinous castle was sold to Captain
John Tasker, and then passed to Rev. William Evans, whose
descendants held Upton up to 1927. They made several
improvements, including the alteration of floor levels, sash
windows, and new wings s and w of the C17 wing.

The N (entrance) front is of three storeys, with corbelled-out
battlements. Cliff-like walls, with terminating corner turrets,
that to the NE circular, and that to the NW semicircular and
much later. The entrance is towards the w end, between two
semicircular turrets. Just below parapet level, a projecting
chamfered arch between the turrets, on eroded face corbels.
This entry is a C19 creation; the original first-floor entrance
was between the l. turret and the NE tower. An early C19 tall
arched opening now occupies its space. Above, a blocked
lancet with trefoiled head (another in the upper floor of the
tower l. of the entrance). Plenty of cross-oeillet loops in the
towers, suggesting a late C13 date, some restored. The s eleva-
tion also has few windows. On the ground floor two blocked
pointed doorways close together, one with a broach stop, and
a blocked trefoil-headed lancet. Above is a blocked door,
confirming that there were first-floor entries to N and S. The
positioning of the s doors clearly evokes a first-floor hall

with undercroft. Evidence also of two large blocked first-floor windows.

The sw wing is late c17, with c19 sashes. Three bays, rising to four storeys, the medieval height, with battlements incorporating gabled dormer windows. The w elevation consists of two semicircular towers, both c19. That to the l., terminating the n front, is early c19, the other is an extension of 1860–1 by *John Cooper*, hiding a probably c17 hip-roofed projection. Further two-storey additions of the late c18 or early c19 back on to the sw wing, of four bays, with a crowstepped gable facing w, and a parallel, lower three-bay block to the w, all with battlements. The larger e block contains a barrel-vaulted ground-floor room, perhaps suggesting that the medieval house did not simply consist of the rectangular e–w block.

Inside, the entrance hall is barrel-vaulted. The first floor of the main block was reached from a blocked stair in the e-most tower, from which a newel stair led to the upper floor (the original upper door now blocked). The ground floor of the turret is barrel-vaulted. The c13 hall seems to have been at second-floor level, where there is a fine fireplace on the n wall with a square-headed hood on plain corbels. Corbels survive of the original roof structure. Plain late c17 staircase, with square balusters and newels. In the late c17 wing, the roof has heavy chamfered principals with naturally curved collars.

UPTON CHAPEL, just se of the castle. Nave and chancel, simple w bellcote. The nave is probably c13, the chancel no later than the c14. Much restored, probably in the late c18, with brick round-arched surrounds and Bath stone imposts and keystones. A blocked c14 trefoiled lancet survives in the chancel s wall. Cheerfully painted, simple wooden windows, but none in the n wall. s door, and traces of the blocked n door. No Victorian touched the whitewashed interior. Plain collar-truss roofs, probably later c18, that in the nave with slightly curved collars. Narrow round-headed chancel arch. To the l. in the nave wall, a splendidly preserved CANDLE-HOLDER carved in the shape of a clenched fist. – PISCINA with octagonal bowl. – FURNISHINGS. c19, salvaged from other churches. – FONT. Probably c13, square bowl with small undercut scallops. – The chapel is best known for its MONUMENTS. In the chancel, set within a recess with moulded arch, c14 slab with incised floriated cross and damaged marginal inscription. Well-preserved head of a priest in relief. – To the e, a well-preserved effigy of a lady within an ogee-headed recess with low pinnacles. She is at prayer, with angels at her feet: high-quality carving of headdress and robe. – On the s side, a large, damaged effigy of c14 knight with shield and sword, discovered by Fenton (1810), among rubble at Nash church. – The most impressive is the large Dec monument, dominating the nave n side, said to commemorate William Malefant †1362. Chainmailed praying figure, his feet resting on a lion. Fine ogee-cusped canopy with

crocketed pinnacles and big leafy finial, and blind cinque-foiled-panelled tomb-chest. Note the small canopied figures set within the angles. – Morris Bowen †1758. White marble, painted shield. – John Tasker †1800. Similar.

Outside, the finial and shaft of the medieval PREACHING CROSS.

9614

# UZMASTON

ST ISMAEL. Large churchyard, with splendid views over the Cleddau estuary. Not a large church, but irregular in outline. Nave with short N aisle, small chancel with S chapel and squint passage. S porch. The low tower, unusually far removed N of the aisle, has a barrel-vaulted ground floor. The saddleback roof is not original; the tower had a pyramidal roof in 1843, which suggests that the original C15 or C16 tower had been truncated. Entry at first-floor level via stone steps on the E side. N squint. Straight-headed, two-light Perp windows in the chancel chapel, and panel-traceried E window (all reset). Otherwise, the church is much rebuilt. *Joseph Mathias* length-ened the nave 1837–9, and *Thomas Rowlands* raised the roof in 1844 for a gallery (removed). Almost entirely rebuilt 1871–3 in harsh rock-faced masonry to plans by *F. Wehnert*, undertaken after his death by *Lingen Barker*. The aisle replaced a transept. Early Dec windows. Three-bay arcade on round piers. Arch-braced roofs in nave and aisle, with kingposts, ribbed wagon roof in the distinctly off-centre chancel. – FONT. C12 scalloped square bowl, circular pedestal with cabling. – Simple timber PULPIT of 1873. – Late Georgian ALTAR TABLE in the aisle, from Boulston church. – Pews removed in a renovation by *Wyn Jones* in 1992. – STAINED GLASS. E window, *c.* 1954 by *Powell*, Adoration. – Nave S, erected 1908 to the memory of G. and A. Bland, whose son-in-law, *R.J. Newbery*, made the window (pre-sumably his local connection accounts for his many commis-sions in Pembrokeshire). The window depicts Cornelius and Dorcas. – Good, strongly coloured W window of 1873 by *Wailes*. Christ bearing the Cross, and Feed my Lambs. – MONUMENTS. Locked in an outhouse, a well-preserved, C14 miniature male effigy, the head within an ogee cusped canopy. Originally at Boulston church. – Charles Gibbon †1779. Ionic pilasters and broken pediment: a good piece. – Sparks Martin †1787. Broken pediment with urn. – Mary Mathias †1820. High quality. Wide tablet of dark veined marble, convex sides and fluted urn (renovated 1934). – Mary Mathias †1829. Pedi-ment with torches. – John Martin †1832. Wide urn and droop-ing foliage. – Richard Mathias †1833. Veined marble frame, vase. In the churchyard a roughly hewn boulder with long early C18 inscription to the Wogans of Boulston, also from Boulston.

GOOD HOOK, 1½ m. NE. Low-lying house of six irregular bays, not large. That it is early is given away by the C17 storeyed porch on the third bay. The house originally faced the oppo-

site (E) direction, retaining a fine lateral chimney with tall cir-
cular shaft, and a pointed door alongside: both clearly C16. Evi-
dence of rebuilding at the S end, and much late C17 alteration,
when the house was reoriented, and a stair wing built along-
side the chimney. The service end appears to have been rebuilt
in the C17 and much reduced later, to a simple lean-to, the
first-floor doorway blocked, and replaced by a fireplace.
Perhaps a C17 upper storey was removed also, as the upper
windows are cramped under the eaves. Inside at the parlour
end two wide four-centred arched recesses, (medieval?) almost
opposite one another – are they cupboard recesses? The main
fireplace has a huge stone lintel. The staircase is, for S W Wales,
a very rare survivor of the late C17, two flights, with massively
twisted balusters, a moulded handrail with inverted gadroon-
ing, and ball finials on big ogee pedestals. Newels with
simple strapwork. The C17 remodelling was probably for James
Wogan, living here 1670.

HIGGON'S WELL, ½ m. NW. HOLY WELL of the C13 or C14.
Small, rectangular barrel-vaulted building, of local millstone
grit. Arched doorway at one end. Stone benches around the
in-side. At the other end, a CHAPEL was added later, but only
the altered shell remains.

# WALTON EAST

0223

The village has a green, with two farms, NORTH FARM
and NORTH EAST FARM on one side, the church in a large
graveyard on the other. To the E, the plain stuccoed Gothic
CALVINISTIC METHODIST CHAPEL, 1875, by *Watts & Harries*
of Spittal, builders. Interior without galleries.

ST MARY MAGDALENE. Small church of 1849–53, by *Joseph
Jenkins*: nave, chancel, bellcote and porch, a little more elabo-
rate than usual, Dec E and W tracery and overdone buttressing.
Preseli dolerite with grey limestone dressings. Interior bleakly
cemented, including the chancel arch. Plain pine FITTINGS. –
FONT. C12 square bowl, scalloped and tapered below. –
STAINED GLASS. Unusually, all the windows have stained glass,
mostly by *C. C. Powell* of London for the Lloyds of Penty Park,
the five nave lancets after 1938, the W window of 1945. All con-
ventional C16 style. – The E window, Crucifixion, in C15 style, is
early C20. – Chancel S lancet, by *Celtic Studios*, 1967, crudely
Modernist.

PENTY PARK, 1 m. SW. Victorianized C18 house said to date from
1710, built for a branch of the Philipps family of Picton and
enlarged for Capt. F. Lloyd-Philipps in the 1870s. Unpainted
stucco, H-plan, 1 + 3 + 1 bays to the S, with hipped wings and
heavy Bath stone C19 eaves, the dentils as large as corbels.
Large E porch and wings appear to be later C19, but the centre
is earlier C18. N of the spine passage is a study, announced
by a pilastered doorcase with fanlight repeated within the

study, which has large-fielded panelling and a bolection-moulded overmantel panel, looking of the 1730s. The staircase adjoining to the w also has 1730s detail: fielded-panelled dado, square newels, ramped rails and turned balusters. Upstairs, in the principal bedroom, overmantel painted with an ideal landscape. Late C18 wrought-iron gate into the walled garden commemorating the marriage of Mary Philipps to Lord Milford.

IRON AGE CAMPS. Just s of the village, WALTON RATH (SN 022 232), and $\frac{1}{2}$ m. N on the Woodstock road, SCOLLOCK RATH (SN 019 242), both embanked enclosures.

<sup>8612</sup>

# WALTON WEST

ALL SAINTS. The churchyard was originally circular. Splendid views over Broad Haven. Small church, but with a varied outline, especially from the w. w tower, truncated by the late C18, and given a gabled roof, with a bellcote. The blocked w trefoiled lancet suggests the C14. Otherwise, much rebuilt, largely to the old plan, in 1854 by *R. K. Penson*. Lancets and plate tracery. Nave with E bellcote and s porch, very narrow N aisle, chancel. Bare stone inside, with dressed stone arches. Two-bay arcade with segmental arches. From the medieval church two INCISED STONES in the NW corner, one with a crude mask of a lady, the other with a bell or shield-shaped outline. C13 or C14. – FONT. Norman square bowl, with little scallops underneath. – STAINED GLASS. E window *c.* 1860, the centre depicting Christ bearing the Cross, brightly coloured. – w window, dated 1870. An unusual depiction of Faith and Hope, almost in grisaille, against a citrus tree pattern. – MONUMENTS. Fine INCISED CROSS, on a rounded stone with a wheel-head cross, splayed arms. Near the top, the monograms of Alpha and Omega, and below, IHC XPC. Plaitwork edges. It stands *c.* 3 ft high; datable to the C10 or C11. – Small effigy, now set upright in the w wall. Apparently a woman, but much worn.

*See* also BROAD HAVEN.

<sup>8711</sup>

# WALWYN'S CASTLE

St JAMES THE GREAT. Strikingly placed on a raised churchyard at the centre of the tiny close-knit village, the w tower visible from afar. Late C14/C15 tower, tall and tapering, the ground storey barrel-vaulted. Battlements and belfry lights date from a rebuilding by *F. Wehnert*, begun 1869, finished by *E. H. Lingen Barker* in 1878, to the original plans. Above-average restoration, the exuberant Dec windows with flowing tracery. The plan follows the old church: nave, N porch and chancel with the odd N and s recesses encountered in the area (cf. Herbrandston). The Dec theme continues inside with the tall

chancel arch, which has a continuous triple roll, the central one filleted. Sparse dogtooth ornament. Steeply pitched roofs, cusping in the chancel. – Medieval FONT, a plain square bowl. – PEWS and PULPIT by *Lingen Barker*. – Cheerful REREDOS by *John Coates Carter*, erected *c.* 1925 as a war memorial. Three bays long, brightly painted panels united by weaving texts and a rainbow. – STAINED GLASS. E window, 1928 by *Powell* of Whitefriars. – MONUMENTS. William Cozens †1784. Veined marble frame, painted shield, signed by *Jones & Co.*, Bristol. – Anne Cozens †1821. By *Williams* of Haverfordwest, fluted sides.

The earthworks of the CASTLE, 100 yds WSW, consist of two wards – probably an adaptation of an Iron Age site. There is another earthwork at SYKE, ½ m. S, which, like CAPESTON FORT (1 m. SSW), defended the river valley inland of the tidal Sandyhaven Pill.

ROSEPOOL, ¾ m. W. Broad rendered early C18 house of six bays and three storeys.

# WARREN

9397

ST MARY. Dramatic windswept setting, overlooking the vast wild Castlemartin R. A. C. range. Although the church is gently buffeted by the effect of gunfire and explosions, all credit is due to the British and German forces for carefully rescuing it from dereliction in 1988 (architects, *Mitchell & Holden* of Pembroke). The body of the church is dwarfed from afar by the broad, tapering late medieval W tower, built of well-coursed limestone, and topped by a tall spire, perhaps a navigational aid for shipping. The stair-turret projects slightly at the NW corner. Nave, chancel, S transept and S porch. The long nave has a pointed stone barrel vault, probably C14; transept and porch similarly roofed. Corbels of the former rood loft. The N aisle, also vaulted, was demolished in 1770. Its blocked three-bay arcade can be seen, as can the blocked arches of a S squint passage. Restoration in 1856 by *David Brandon* (patron, Lord Cawdor), who rebuilt chancel and spire, and added the lancet windows. – FONT. Shallow square bowl on circular pedestal, perhaps retooled Norman. – *Brandon*'s surviving fittings include the simple panelled PULPIT and encaustic TILES in the chancel, by *Minton*, incorporating the Cawdor arms. – PIPE ORGAN of 1842, which reputedly belonged to Mendelssohn (it was brought to Angle church from Sibton, Suffolk, in 1867). The case has fluted Corinthian pilasters. – STAINED GLASS. E window 1894 by *Heaton, Butler & Bayne*. Crucifixion in dark and sombre colours. – Nave NE by *Powell* of Whitefriars, 1923, heraldic.

In the churchyard, four steps of the PREACHING CROSS; the shaft and simple wheel-head are by *Brandon*, also the stone surround of HOLY WELL.

Opposite the church, WARREN FARM, an unspoilt, rendered

four-bay farmhouse, probably C18, with a large gable chimney, r. and a projecting granary wing, l.

WARREN HOUSE. Originally the vicarage, 1860 by *John Cooper*, enlarged in 1869. Three bays, stuccoed with hipped roof. Further N, former SCHOOL, 1854, with master's house, hardly altered.

MERRION COURT, $\frac{1}{2}$ m. SE. Early C19 three-bay farmhouse. Rear courtyard with DAIRY; at its angle with the rear wing a KILN for drying corn. Good and extensive FARM BUILDINGS built for the Cawdor estate about 1874. There was a narrow railway to transport feed.

MERRION CAMP, $\frac{1}{2}$ m. E. An IRON AGE FORT, roughly oval in shape.

7925

# WHITCHURCH/TREGROES

A scatter of houses and the church, N of Solva, for which this was the original parish church. VICARAGE of 1842, by *John Williams*, hipped with three-bay front. The door, in an Ionic doorcase, is on the end wall – a plan favoured for parsonages at this time (cf. Camrose and St Lawrence).

ST DAVID. Medieval, much restored 1872–4 by *C.E. Buckeridge*, completed after his death by *J.L. Pearson*. Nave, chancel, N transept with squint passage and W bellcote. C19 details externally, attractive roofs of small green slates. Purple stone ogee lancets also nicely detailed. Plastered interior with C19 open nave roof and panelled chancel roof, simple but well handled. Seat built into the SE window and piscina. – FONT. Plain octagonal late medieval bowl on C19 base. – STAINED GLASS. E window by *Powell*, 1905.

1536

# WHITECHURCH/EGLWYSWEN

The church stands alone by the Blaenffos to Crosswell road.

ST MICHAEL. 1872–3 by *R.J. Withers*, closed 1999. Simple nave and chancel with cusped lancets in pairs, neatly done. Ashlar octagonal W bell-turret, corbelled out, with punched quatrefoil openings and tiny lucarnes. In the porch, a reset plaque of 1591. Inside, Withers' thoughtful economy shows, the bowl FONT and two-bay ashlar PULPIT front modelled without extraneous ornament. – Single-light STAINED-GLASS window, 1956, by *Celtic Studios*.

PENYGROES INDEPENDENT CHAPEL, Penygroes. Small stone chapel, formerly stuccoed, built 1828. Blocked doors on the side wall. Altered 1854 and 1883, the last by *John Evans*, putting the entry on the end wall and presumably adding the narrow galleries.

*See* also Pontyglasier.

## WISTON/CASTELL GWYS                          <span>0218</span>

Although a small, deeply rural village, Wiston played an important role in the Norman conquest of Pembrokeshire. Early in the C12, Henry I began to encourage colonists with grants of lands previously in Welsh hands. Prominent among the colonists in SW Wales were Flemings, and it was Wizo, 'chieftain of the Flemings', who set up Wiston as a borough by 1112, and established the church and castle. These survive as the main features of a linear village: a good example of a Norman planted settlement. The castle and borough were owned by the Wogans until 1794 when sold to Lord Cawdor.

CASTLE. The high motte is visible from the road. Wiston is the  15
best example of a motte-and-bailey castle in SW Wales. It was founded in the early C12 possibly on an existing Iron Age rath, or enclosed settlement. The Welsh captured the castle in 1147, and again in 1193, before Llywelyn the Great destroyed it and burnt the town in 1220. Henry III ordered the rebuilding of the castle before 1231, the last known record of the site. There is now a large bailey and high motte, surrounded by a deep dry ditch, and crowned with the remains of a probably C13 polygonal shell keep. Entry is through a simple arched doorway on the S side. Remains of stone steps within indicate that the keep was originally of at least two storeys. It seems that these steps are secondary, and that a third phase involved the interior thickening of the walls. The unusually large bailey S of the motte is defended by an earthen bank and ditch. Remains of medieval buildings underneath the turf. Access to the bailey would have been from the E, adjacent to the manor house, and not through the gap facing the church.

ST MARY. Set in a large churchyard S of the castle, with a lime avenue. Very odd, roughly built battlemented W tower, tapering pronouncedly from about halfway up, suggesting later repairs to the C14 or C15 masonry. The two lowest storeys are barrel-vaulted. Long nave, heavily buttressed, earlier than the tower. Inside, the battered walls of the nave are very prominent, the inner N and S doors round-headed: suggesting a C12 or C13 date. C15 chamfered chancel arch. Good barrel-vaulted N porch, the doorway with an ogee head, of c. 1500. Within the porch, stoups, and on one side, plain C17 MEMORIAL TABLETS to the Lloyd family. Some Perp chancel windows: panel tracery in the E window (much restored), and straight-headed windows with two cinquefoiled lights to N and S. The simple lancets date from the restoration of 1864–5 by *David Brandon* for Lord Cawdor, who owned the estate of Wiston. – FONT. Square scalloped Norman bowl, cable moulding on the pedestal. Retooled. – FURNISHINGS by *Brandon*. – STAINED GLASS. E window of c. 1865, by *Heaton, Butler & Bayne*. Colourful Parable of the Talents. – Chancel N and S, 1934 by *Shrigley & Hunt*. – Chancel S, 1982, by *Celtic Studios*. – Nave

s, 1920, by *Kempe & Co.* – MONUMENT. Eleanor Roberts
†1795. Tall, draped urn.

VICARAGE, SW of the church. Simple and rendered, with a barge-
boarded gable. Designed in 1859 by the incumbent, *Rev. J.
Philipps.*

NATIONAL SCHOOL (former), prominently sited in the village
centre. 1859, by *Henry Ashton*, Lord Cawdor's architect. Long
single-storey range, with a central chimneystack. Tower-like
house attached to one end, with a pyramidal roof.

CALVINISTIC METHODIST CHAPEL, $\frac{3}{4}$ m. N. 1873, altered 1911.
Rendered, with half-hipped roof. Simple gable front with
arched window each side of the porch (the original entry on
the long side). The interior is remarkable for the way the pews
slope down to the pulpit.

WISTON MANOR. Fragments only of the manor house, reduced
to a farmhouse *c.* 1870. Freestanding remnant of a vaulted
basement in an outbuilding. A view by Buck of 1740 shows a
gabled gatehouse obscuring a long range behind. Inside an
early C18 cupboard and a round-backed shelf-recess.

COLBY FARM, I m. SE. Large farmhouse of *c.* 1850 with bare
Tudor detail. Paired gables, central porch. Presumably built
by Lord Cawdor as the principal farmhouse for his Wiston
estate.

9526
# WOLFSCASTLE/CASBLAIDD
### St Dogwells/Hayscastle

A Norman castle site, on a headland between the Western
Cleddau and Afon Anghof. MOTTE and BAILEY survive of the
C12 castle, the motte some 20 ft high and 45 ft across (6 × 13.5
metres). The modern village is in two halves, Wolfscastle on the
high ground and Ford S of the Cleddau, the river spanned by an
attractive stone BRIDGE of 1793. A re-routing of the A40 with
new bridge has been carried out with complete insensitivity. W
of the village lies the most significant Roman find in the county
to date. In 1806 a pit with wide flues had been found together
with foundation walls nearby. Fenton identified the site as a bath,
and noted quantities of scattered Roman bricks, pipes, slate tiles
and bits of painted stucco. He also noted a near-square enclo-
sure just W with possible signs of building within.

ST MARGARET, Ford. Chapel-of-ease to Hayscastle, rebuilt in
the earlier C19. Rubble-stone single cell some 30 ft by 15 ft,
(9 × 4.5 metres) with W bellcote and C20 porch. W door with
cambered head, two S lancets and a larger E window with
wooden Y-tracery. Plain plastered interior with close-spaced
trusses.

NANTYCOY MILL, $\frac{1}{2}$ m. S. Mill of 1844, at the entry to Treffgarne
Gorge. The house is attached at r. angles to the mill and malt-
house, with a large overshot iron wheel behind.

# WOODSTOCK
### Ambleston

0225

Modern village on the main Haverfordwest to Cardigan road.

WOODSTOCK CALVINISTIC METHODIST CHAPEL. Founded by Howell Davies, the 'apostle of Pembrokeshire' and one of the fathers of Welsh Methodism. The first Methodist chapel in Pembrokeshire, originally of 1754–5, and the first in which Holy Communion was celebrated. Dated 1808 and 1890, the long façade could be of 1808, with its nogged brick eaves and hipped roof, but the render and timber detail are of 1890. Three well-spaced arched windows and outer arched doors. Unusually, there are two parallel roofs giving a square interior, the valley carried on two iron columns, presumably of 1890, as are the fittings. The double pile with columns is an early chapel form; cf. Daniel Rowland's second chapel of 1764 at Llangeitho, Cards. – Marble MEMORIAL of 1895 to Howell Davies †1770.

LLEWELLIN MONUMENT, Scollock West Farm, sw. In a corner of a field w of the farm, an extraordinary memorial with pedestal flanked by near life-size white marble standing figures of Martha and John Llewellin †1906 and 1918, of Scollock West. The figures, remarkable for being in the everyday dress of the later c19, were carved in Italy from plaster models made from a wedding photograph. The inscription records that 'by their joint industry and thrift they bought this farm and hand it down without encumbrances to their heirs'.

# YERBESTON

0600

ST LAWRENCE. Abandoned and ivy-covered. Nave and chancel, possibly medieval. Later s porch. The most remarkable feature is the odd w belfry-turret, perhaps c16, projected on triplets of corbels. Large openings with roughly four-centred stone lintels. Inside, an early c19 panelled PULPIT with reading desk opposite. The altar table is now at Martletwy.

# ARCHITECTURAL GLOSSARY

Numbers and letters refer to the illustrations (by John Sambrook) on pp. 508–15.

ABACUS: flat slab forming the top of a capital (3a).

ACANTHUS: classical formalized leaf ornament (3b).

ACCUMULATOR TOWER: see Hydraulic power.

ACHIEVEMENT: a complete display of armorial bearings.

ACROTERION: plinth for a statue or ornament on the apex or ends of a pediment; more usually, both the plinth and what stands on it (4a).

AEDICULE (*lit.* little building): architectural surround, consisting usually of two columns or pilasters supporting a pediment.

AGGREGATE: see Concrete.

AISLE: subsidiary space alongside the body of a building, separated from it by columns, piers, or posts.

AMBULATORY (*lit.* walkway): aisle around the sanctuary (q.v.).

ANGLE ROLL: roll moulding in the angle between two planes (1a).

ANSE DE PANIER: see Arch.

ANTAE: simplified pilasters (4a), usually applied to the ends of the enclosing walls of a portico *in antis* (q.v.).

ANTEFIXAE: ornaments projecting at regular intervals above a Greek cornice, originally to conceal the ends of roof tiles (4a).

ANTHEMION: classical ornament like a honeysuckle flower (4b).

APRON: raised panel below a window or wall monument or tablet.

APSE: semicircular or polygonal end of an apartment, especially of a chancel or chapel. In classical architecture sometimes called an *exedra*.

ARABESQUE: non-figurative surface decoration consisting of flowing lines, foliage scrolls etc., based on geometrical patterns. Cf. Grotesque.

ARCADE: series of arches supported by piers or columns. *Blind arcade* or *arcading*: the same applied to the wall surface. *Wall arcade*: in medieval churches, a blind arcade forming a dado below windows. Also a covered shopping street.

ARCH: Shapes *see* 5c. *Basket arch* or *anse de panier* (basket handle): three-centred and depressed, or with a flat centre. *Nodding*: ogee arch curving forward from the wall face. *Parabolic*: shaped like a chain suspended from two level points, but inverted. Special purposes. *Chancel*: dividing chancel from nave or crossing. *Crossing*: spanning piers at a crossing (q.v.). *Relieving* or *discharging*: incorporated in a wall to relieve superimposed weight (5c). *Skew*: spanning responds not diametrically opposed. *Strainer*: inserted in an opening to resist inward pressure. *Transverse*: spanning a main axis (e.g. of a vaulted space). *See also* Jack arch, Triumphal arch.

ARCHITRAVE: formalized lintel, the lowest member of the classical entablature (3a). Also the moulded frame of a door or window (often borrowing the profile of a classical architrave). For *lugged* and *shouldered* architraves *see* 4b.

ARCUATED: dependent structurally on the arch principle. Cf. Trabeated.

ARK: chest or cupboard housing the

tables of Jewish law in a syna-gogue.

ARRIS: sharp edge where two surfaces meet at an angle (3a).

ASHLAR: masonry of large blocks wrought to even faces and square edges (6d).

ASTRAGAL: classical moulding of semicircular section (3f).

ASTYLAR: with no columns or similar vertical features.

ATLANTES: see Caryatids.

ATRIUM (plural: atria): inner court of a Roman or C20 house; in a multi-storey building, a toplit covered court rising through all storeys. Also an open court in front of a church.

ATTACHED COLUMN: see Engaged column.

ATTIC: small top storey within a roof. Also the storey above the main entablature of a classical façade.

AUMBRY: recess or cupboard to hold sacred vessels for the Mass.

BAILEY: see Motte-and-bailey.

BALANCE BEAM: see Canals.

BALDACCHINO: free-standing canopy, originally fabric, over an altar. Cf. Ciborium.

BALLFLOWER: globular flower of three petals enclosing a ball (1a). Typical of the Decorated style.

BALUSTER: pillar or pedestal of bellied form. Balusters: vertical supports of this or any other form, for a handrail or coping, the whole being called a balustrade (6c). Blind balustrade: the same applied to the wall surface.

BARBICAN: outwork defending the entrance to a castle.

BARGEBOARDS (corruption of 'vergeboards'): boards, often carved or fretted, fixed beneath the eaves of a gable to cover and protect the rafters.

BAROQUE: style originating in Rome c. 1600 and current in England c. 1680–1720, characterized by dramatic massing and silhouette and the use of the giant order.

BARROW: burial mound.

BARTIZAN: corbelled turret, square or round, frequently at an angle.

BASCULE: hinged part of a lifting (or bascule) bridge.

BASE: moulded foot of a column or pilaster . For Attic base see 3b.

BASEMENT: lowest, subordinate storey; hence the lowest part of a classical elevation, below the piano nobile (q.v.).

BASILICA: a Roman public hall; hence an aisled building with a clerestory.

BASTION: one of a series of defensive semicircular or polygonal projections from the main wall of a fortress or city.

BATTER: intentional inward inclination of a wall face.

BATTLEMENT: defensive parapet, composed of merlons (solid) and crenels (embrasures) through which archers could shoot; sometimes called crenellation. Also used decoratively.

BAY LEAF: classical ornament of overlapping bay leaves (3f).

BAY: division of an elevation or interior space as defined by regular vertical features such as arches, columns, windows, etc.

BAY WINDOW: window of one or more storeys projecting from the face of a building. Canted: with a straight front and angled sides. Bow window: curved. Oriel: rests on corbels or brackets and starts above ground level; also the bay window at the dais end of a medieval great hall.

BEAD-AND-REEL: see Enrichments.

BEAKHEAD: Norman ornament with a row of beaked bird or beast heads usually biting into a roll moulding (1a).

BELFRY: chamber or stage in a tower where bells are hung.

BELL CAPITAL: see 1b.

BELLCOTE: small gabled or roofed housing for the bell(s).

BERM: level area separating a ditch from a bank on a hill-fort or barrow.

BILLET: Norman ornament of small half-cyclindrical or rectangular blocks (1a).

BLIND: see Arcade, Baluster, Portico.

BLOCK CAPITAL: see 1a.

BLOCKED: columns, etc. interrupted by regular projecting blocks (*blocking*), as on a Gibbs surround (4b).

BLOCKING COURSE: course of stones, or equivalent, on top of a cornice and crowning the wall.

BOLECTION MOULDING: covering the joint between two different planes (6b).

BOND: the pattern of long sides (*stretchers*) and short ends (*headers*) produced on the face of a wall by laying bricks in a particular way (6e).

BOSS: knob or projection, e.g. at the intersection of ribs in a vault (2c).

BOW WINDOW: *see* Bay window.

BOX FRAME: timber-framed construction in which vertical and horizontal wall members support the roof (7). Also concrete construction where the loads are taken on cross walls; also called *cross-wall construction*.

BRACE: subsidiary member of a structural frame, curved or straight. *Bracing* is often arranged decoratively e.g. quatrefoil, herringbone (7). *See also* Roofs.

BRATTISHING: ornamental crest, usually formed of leaves, Tudor flowers or miniature battlements.

BRESSUMER (*lit.* breast-beam): big horizontal beam supporting the wall above, especially in a jettied building (7).

BRICK: *see* Bond, Cogging, Engineering, Gauged, Tumbling.

BRIDGE: *Bowstring*: with arches rising above the roadway which is suspended from them. *Clapper*: one long stone forms the roadway. *Roving*: *see* Canal. *Suspension*: roadway suspended from cables or chains slung between towers or pylons. *Stay-suspension* or *stay-cantilever*: supported by diagonal stays from towers or pylons. *See also* Bascule.

BRISES-SOLEIL: projecting fins or canopies which deflect direct sunlight from windows.

BROACH: *see* Spire and IC.

BUCRANIUM: ox skull used decoratively in classical friezes.

BULLSEYE WINDOW: small oval window, set horizontally (cf. Oculus). Also called *oeil de boeuf*.

BUTTRESS: vertical member projecting from a wall to stabilize it or to resist the lateral thrust of an arch, roof, or vault (IC, 2c). A *flying buttress* transmits the thrust to a heavy abutment by means of an arch or half-arch (IC).

CABLE or ROPE MOULDING: originally Norman, like twisted strands of a rope.

CAMES: *see* Quarries.

CAMPANILE: free-standing bell tower.

CANALS: *Flash lock*: removable weir or similar device through which boats pass on a flush of water. Predecessor of the *pound lock*: chamber with gates at each end allowing boats to float from one level to another. *Tidal gates*: single pair of lock gates allowing vessels to pass when the tide makes a level. *Balance beam*: beam projecting horizontally for opening and closing lock gates. *Roving bridge*: carrying a towing path from one bank to the other.

CANTILEVER: horizontal projection (e.g. step, canopy) supported by a downward force behind the fulcrum.

CAPITAL: head or crowning feature of a column or pilaster; for classical types *see* 3a; for medieval types *see* Ib.

CARREL: compartment designed for individual work or study.

CARTOUCHE: classical tablet with ornate frame (4b).

CARYATIDS: female figures supporting an entablature; their male counterparts are *Atlantes* (*lit*: Atlas figures).

CASEMATE: vaulted chamber, with embrasures for defence, within a castle wall or projecting from it.

CASEMENT: side-hinged window.

CASTELLATED: with battlements (q.v.).

CAST IRON: hard and brittle, cast in a mould to the required shape. *Wrought iron* is ductile, strong in tension, forged into decorative patterns or forged and rolled into

e.g. bars, joists, boiler plates; *mild steel* is its modern equivalent, similar but stronger.

CATSLIDE: *See* 8a.

CAVETTO: concave classical moulding of quarter-round section (3f).

CELURE or CEILURE: enriched area of roof above rood or altar.

CEMENT: *see* Concrete.

CENOTAPH (*lit*. empty tomb): funerary monument which is not a burying place.

CENTRING: wooden support for the building of an arch or vault, removed after completion.

CHAMFER (*lit*. corner-break): surface formed by cutting off a square edge or corner. For types of chamfers and *chamfer stops see* 6a. *See also* Double chamfer.

CHANCEL: part of the E end of a church set apart for the use of the officiating clergy.

CHANTRY CHAPEL: often attached to or within a church, endowed for the celebration of Masses principally for the soul of the founder.

CHEVET (*lit*. head): French term for chancel with ambulatory and radiating chapels.

CHEVRON: V-shape used in series or double series (later) on a Norman moulding (1a). Also (especially when on a single plane) called *zigzag*.

CHOIR: the part of a cathedral, monastic or collegiate church where services are sung.

CIBORIUM: a fixed canopy over an altar, usually vaulted and supported on four columns; cf. Baldacchino. Also a canopied shrine for the reserved sacrament.

CINQUEFOIL: *see* Foil.

CIST: stone-lined or slab-built grave.

CLADDING: external covering or skin applied to a structure, especially a framed one.

CLERESTORY: uppermost storey of the nave of a church, pierced by windows. Also high-level windows in secular buildings.

CLOSER: a brick cut to complete a bond (6e).

CLUSTER BLOCK: *see* Multi-storey.

COADE STONE: ceramic artificial stone made in Lambeth 1769–

*c*.1840 by Eleanor Coade (†1821) and her associates.

COB: walling material of clay mixed with straw. Also called *pisé*.

COFFERING: arrangement of sunken panels (coffers), square or polygonal, decorating a ceiling, vault, or arch.

COGGING: a decorative course of bricks laid diagonally (6e). Cf. Dentilation.

COLLAR: *see* Roofs and 7.

COLLEGIATE CHURCH: endowed for the support of a college of priests.

COLONNADE: range of columns supporting an entablature. Cf. Arcade.

COLONNETTE: small medieval column or shaft.

COLOSSAL ORDER: *see* Giant order.

COLUMBARIUM: shelved, niched structure to house multiple burials.

COLUMN: a classical, upright structural member of round section with a shaft, a capital, and usually a base (3a, 4a).

COLUMN FIGURE: carved figure attached to a medieval column or shaft, usually flanking a doorway.

COMMUNION TABLE: unconsecrated table used in Protestant churches for the celebration of Holy Communion.

COMPOSITE: *see* Orders.

COMPOUND PIER: grouped shafts (q.v.), or a solid core surrounded by shafts.

CONCRETE: composition of *cement* (calcined lime and clay), *aggregate* (small stones or rock chippings), sand and water. It can be poured into *formwork* or *shuttering* (temporary frame of timber or metal) on site (*in-situ* concrete), or *pre-cast* as components before construction. *Reinforced*: incorporating steel rods to take the tensile force. *Pre-stressed*: with tensioned steel rods. Finishes include the impression of boards left by formwork (*board-marked* or *shuttered*), and texturing with steel brushes (*brushed*) or hammers (*hammer-dressed*). *See also* Shell.

CONSOLE: bracket of curved outline (4b).

COPING: protective course of masonry or brickwork capping a wall (6d).

CORBEL: projecting block supporting something above. *Corbel course*: continuous course of projecting stones or bricks fulfilling the same function. *Corbel table*: series of corbels to carry a parapet or a wall-plate or wall-post (7). *Corbelling*: brick or masonry courses built out beyond one another to support a chimney-stack, window, etc.

CORINTHIAN: *see* Orders and 3d.

CORNICE: flat-topped ledge with moulded underside, projecting along the top of a building or feature, especially as the highest member of the classical entablature (3a). Also the decorative moulding in the angle between wall and ceiling.

CORPS-DE-LOGIS: the main building(s) as distinct from the wings or pavilions.

COTTAGE ORNÉ: an artfully rustic small house associated with the Picturesque movement.

COUNTERCHANGING: of joists on a ceiling divided by beams into compartments, when placed in opposite directions in alternate squares.

COUR D HONNEUR: formal entrance court before a house in the French manner, usually with flanking wings and a screen wall or gates.

COURSE: continuous layer of stones, etc. in a wall (6e).

COVE: a broad concave moulding, e.g. to mask the eaves of a roof. *Coved ceiling*: with a pronounced cove joining the walls to a flat central panel smaller than the whole area of the ceiling.

CRADLE ROOF: *see* Wagon roof.

CREDENCE: a shelf within or beside a piscina (q.v.), or a table for the sacramental elements and vessels.

CRENELLATION: parapet with crenels (*see* Battlement).

CRINKLE-CRANKLE WALL: garden wall undulating in a series of serpentine curves.

CROCKETS: leafy hooks. *Crocketing* decorates the edges of Gothic features, such as pinnacles, canopies, etc. *Crocket capital*: *see* 1b.

CROSSING: central space at the junction of the nave, chancel, and transepts. *Crossing tower*: above a crossing.

CROSS-WINDOW: with one mullion and one transom (qq.v.).

CROWN-POST: *see* Roofs and 7.

CROWSTEPS: squared stones set like steps, e.g. on a gable (8a).

CRUCKS (*lit.* crooked): pairs of inclined timbers (*blades*), usually curved, set at bay-lengths; they support the roof timbers and, in timber buildings, also support the walls (8b). *Base*: blades rise from ground level to a tie- or collar-beam which supports the roof timbers. *Full*: blades rise from ground level to the apex of the roof, serving as the main members of a roof truss. *Jointed*: blades formed from more than one timber; the lower member may act as a wall-post; it is usually elbowed at wall-plate level and jointed just above. *Middle*: blades rise from halfway up the walls to a tie- or collar-beam. *Raised*: blades rise from halfway up the walls to the apex. *Upper*: blades supported on a tie-beam and rising to the apex.

CRYPT: underground or half-underground area, usually below the E end of a church. *Ring crypt*: corridor crypt surrounding the apse of an early medieval church, often associated with chambers for relics. Cf. Undercroft.

CUPOLA (*lit.* dome): especially a small dome on a circular or polygonal base crowning a larger dome, roof, or turret.

CURSUS: a long avenue defined by two parallel earthen banks with ditches outside.

CURTAIN WALL: a connecting wall between the towers of a castle. Also a non-load-bearing external wall applied to a C 20 framed structure.

CUSP: *see* Tracery and 2b.

CYCLOPEAN MASONRY: large irregular polygonal stones, smooth and finely jointed.

CYMA RECTA and CYMA REVERSA: classical mouldings with double curves (3f). Cf. Ogee.

DADO: the finishing (often with panelling) of the lower part of a wall in a classical interior; in origin a formalized continuous pedestal. *Dado rail*: the moulding along the top of the dado.

DAGGER: *see* Tracery and 2b.

DEC (DECORATED): English Gothic architecture *c.* 1290 to *c.* 1350. The name is derived from the type of window Tracery (q.v.) used during the period.

DEMI- or HALF-COLUMNS: engaged columns (q.v.) half of whose circumference projects from the wall.

DENTIL: small square block used in series in classical cornices (3c). *Dentilation* is produced by the projection of alternating headers along cornices or string courses.

DIAPER: repetitive surface decoration of lozenges or squares flat or in relief. Achieved in brickwork with bricks of two colours.

DIOCLETIAN or THERMAL WINDOW: semicircular with two mullions, as used in the Baths of Diocletian, Rome (4b).

DISTYLE: having two columns (4a).

DOGTOOTH: E.E. ornament, consisting of a series of small pyramids formed by four stylized canine teeth meeting at a point (1a).

DORIC: *see* Orders and 3a, 3b.

DORMER: window projecting from the slope of a roof (8a).

DOUBLE CHAMFER: a chamfer applied to each of two recessed arches (1a).

DOUBLE PILE: *see* Pile.

DRAGON BEAM: *see* Jetty.

DRESSINGS: the stone or brickwork worked to a finished face about an angle, opening, or other feature.

DRIPSTONE: moulded stone projecting from a wall to protect the lower parts from water. Cf. Hood-mould, Weathering.

DRUM: circular or polygonal stage supporting a dome or cupola. Also one of the stones forming the shaft of a column (3a).

DUTCH or FLEMISH GABLE: *see* 8a.

EASTER SEPULCHRE: tomb-chest used for Easter ceremonial, within or against the N wall of a chancel.

EAVES: overhanging edge of a roof; hence *eaves cornice* in this position.

ECHINUS: ovolo moulding (q.v.) below the abacus of a Greek Doric capital (3a).

EDGE RAIL: *see* Railways.

E. E. (EARLY ENGLISH): English Gothic architecture *c.* 1190–1250.

EGG-AND-DART: *see* Enrichments and 3f.

ELEVATION: any face of a building or side of a room. In a drawing, the same or any part of it, represented in two dimensions.

EMBATTLED: with battlements.

EMBRASURE: small splayed opening in a wall or battlement (q.v.).

ENCAUSTIC TILES: earthenware tiles fired with a pattern and glaze.

EN DELIT: stone cut against the bed.

ENFILADE: reception rooms in a formal series, usually with all doorways on axis.

ENGAGED or ATTACHED COLUMN: one that partly merges into a wall or pier.

ENGINEERING BRICKS: dense bricks, originally used mostly for railway viaducts etc.

ENRICHMENTS: the carved decoration of certain classical mouldings, e.g. the ovolo (qq.v.) with *egg-and-dart*, the cyma reversa with *waterleaf*, the astragal with *bead-and-reel* (3f).

ENTABLATURE: in classical architecture, collective name for the three horizontal members (architrave, frieze, and cornice) carried by a wall or a column (3a).

ENTASIS: very slight convex deviation from a straight line, used to prevent an optical illusion of concavity.

EPITAPH: inscription on a tomb.

EXEDRA: *see* Apse.

EXTRADOS: outer curved face of an arch or vault.

EYECATCHER: decorative building terminating a vista.

FASCIA: plain horizontal band, e.g. in an architrave (3c, 3d) or on a shopfront.

FENESTRATION: the arrangement of windows in a façade.

FERETORY: site of the chief shrine of a church, behind the high altar.

FESTOON: ornamental garland, suspended from both ends. Cf. Swag.

FIBREGLASS, or glass-reinforced polyester (GRP): synthetic resin reinforced with glass fibre. GRC: glass-reinforced concrete.

FIELD: see Panelling and 6b.

FILLET: a narrow flat band running down a medieval shaft or along a roll moulding (1a). It separates larger curved mouldings in classical cornices, fluting or bases (3c).

FLAMBOYANT: the latest phase of French Gothic architecture, with flowing tracery.

FLASH LOCK: see Canals.

FLÈCHE or SPIRELET (*lit.* arrow): slender spire on the centre of a roof.

FLEURON: medieval carved flower or leaf, often rectilinear (1a).

FLUSHWORK: knapped flint used with dressed stone to form patterns.

FLUTING: series of concave grooves (flutes), their common edges sharp (arris) or blunt (fillet) (3).

FOIL (*lit.* leaf): lobe formed by the cusping of a circular or other shape in tracery (2b). *Trefoil* (three), *quatrefoil* (four), *cinquefoil* (five), and *multifoil* express the number of lobes in a shape.

FOLIATE: decorated with leaves.

FORMWORK: see Concrete.

FRAMED BUILDING: where the structure is carried by a framework – e.g. of steel, reinforced concrete, timber – instead of by load-bearing walls.

FREESTONE: stone that is cut, or can be cut, in all directions.

FRESCO: *al fresco*: painting on wet plaster. *Fresco secco*: painting on dry plaster.

FRIEZE: the middle member of the classical entablature, sometimes ornamented (3a). *Pulvinated frieze* (*lit.* cushioned): of bold convex profile (3c). Also a horizontal band of ornament.

FRONTISPIECE: in C16 and C17 buildings the central feature of doorway and windows above linked in one composition.

GABLE: For types *see* 8a. *Gablet*: small gable. *Pedimental gable*: treated like a pediment.

GADROONING: classical ribbed ornament like inverted fluting that flows into a lobed edge.

GALILEE: chapel or vestibule usually at the w end of a church enclosing the main portal(s).

GALLERY: a long room or passage; an upper storey above the aisle of a church, looking through arches to the nave; a balcony or mezzanine overlooking the main interior space of a building; or an external walkway.

GALLETING: small stones set in a mortar course.

GAMBREL ROOF: see 8a.

GARDEROBE: medieval privy.

GARGOYLE: projecting water spout often carved into human or animal shape.

GAUGED or RUBBED BRICKWORK: soft brick sawn roughly, then rubbed to a precise (gauged) surface. Mostly used for door or window openings (5c).

GAZEBO (jocular Latin, 'I shall gaze'): ornamental lookout tower or raised summer house.

GEOMETRIC: English Gothic architecture *c.* 1250–1310. *See also* Tracery. For another meaning, *see* Stairs.

GIANT or COLOSSAL ORDER: classical order (q.v.) whose height is that of two or more storeys of the building to which it is applied.

GIBBS SURROUND: C18 treatment of an opening (4b), seen particularly in the work of James Gibbs (1682–1754).

GIRDER: a large beam. *Box*: of hollow-box section. *Bowed*: with its top rising in a curve. *Plate*: of I-section, made from iron or steel plates. *Lattice*: with braced framework.

GLAZING BARS: wooden or sometimes metal bars separating and supporting window panes.

GORSEDD CIRCLE: modern stone circle; one is erected annually at different Welsh sites in connection with the national Eisteddfod.

GRAFFITI: *see* Sgraffito.

GRANGE: farm owned and run by a religious order.

GRC: *see* Fibreglass.

GRISAILLE: monochrome painting on walls or glass.

GROIN: sharp edge at the meeting of two cells of a cross-vault; *see* Vault and 2b.

GROTESQUE (*lit.* grotto-esque): wall decoration adopted from Roman examples in the Renaissance. Its foliage scrolls incorporate figurative elements. Cf. Arabesque.

GROTTO: artificial cavern.

GRP: *see* Fibreglass.

GUILLOCHE: classical ornament of interlaced bands (4b).

GUNLOOP: opening for a firearm.

GUTTAE: stylized drops (3b).

HALF-TIMBERING: archaic term for timber-framing (q.v.). Sometimes used for non-structural decorative timberwork.

HALL CHURCH: medieval church with nave and aisles of approximately equal height.

HAMMERBEAM: *see* Roofs and 7.

HEADER: *see* Bond and 6e.

HEADSTOP: stop (q.v.) carved with a head (5b).

HELM ROOF: *see* 1c.

HENGE: ritual earthwork.

HERM (*lit.* the god Hermes): male head or bust on a pedestal.

HERRINGBONE WORK: *see* 6e (for brick bond). Cf. Pitched masonry.

HEXASTYLE: *see* Portico.

HILL-FORT: Iron Age earthwork enclosed by a ditch and bank system.

HIPPED ROOF: *see* 8a.

HOODMOULD: projecting moulding above an arch or lintel to throw off water (2b, 5b). When horizontal often called a *label*. For label stop *see* Stop.

HUSK GARLAND: festoon of stylized nutshells (4b).

HYDRAULIC POWER: use of water under high pressure to work machinery. *Accumulator tower*: houses a hydraulic accumulator which accommodates fluctuations in the flow through hydraulic mains.

HYPOCAUST (*lit.* underburning): Roman underfloor heating system.

IMPOST: horizontal moulding at the springing of an arch (5c).

IMPOST BLOCK: block between abacus and capital (1b).

IN ANTIS: *see* Antae, Portico and 4a.

INDENT: shape chiselled out of a stone to receive a brass.

INDUSTRIALIZED or SYSTEM BUILDING: system of manufactured units assembled on site.

INGLENOOK (*lit.* fire-corner): recess for a hearth with provision for seating.

INTERCOLUMNATION: interval between columns.

INTERLACE: decoration in relief simulating woven or entwined stems or bands.

INTRADOS: *see* Soffit.

IONIC: *see* Orders and 3c.

JACK ARCH: shallow segmental vault springing from beams, used for fireproof floors, bridge decks, etc.

JAMB (*lit.* leg): one of the vertical sides of an opening.

JETTY: in a timber-framed building, the projection of an upper storey beyond the storey below, made by the beams and joists of the lower storey oversailing the wall; on their outer ends is placed the sill of the walling for the storey above (7). Buildings can be jettied on several sides, in which case a *dragon beam* is set diagonally at the corner to carry the joists to either side.

JOGGLE: the joining of two stones to prevent them slipping by a notch in one and a projection in the other.

KEEL MOULDING: moulding used from the late C12, in section like the keel of a ship (1a).

KEEP: principal tower of a castle.

KENTISH CUSP: see Tracery and 2b.

KEY PATTERN: see 4b.

KEYSTONE: central stone in an arch or vault (4b, 5c).

KINGPOST: see Roofs and 7.

KNEELER: horizontal projecting stone at the base of each side of a gable to support the inclined coping stones (8a).

KNOTWORK: see Interlace. Used on early Christian monuments.

LABEL: see Hoodmould and 5b.

LABEL STOP: see Stop and 5b.

LACED BRICKWORK: vertical strips of brickwork, often in a contrasting colour, linking openings on different floors.

LACING COURSE: horizontal reinforcement in timber or brick to walls of flint, cobble, etc.

LADY CHAPEL: dedicated to the Virgin Mary (Our Lady).

LANCET: slender single-light, pointed-arched window (2a).

LANTERN: circular or polygonal windowed turret crowning a roof or a dome. Also the windowed stage of a crossing tower lighting the church interior.

LANTERN CROSS: churchyard cross with lantern-shaped top.

LAVATORIUM: in a religous house, a washing place adjacent to the refectory.

LEAN-TO: see Roofs.

LESENE (lit. a mean thing): pilaster without base or capital. Also called pilaster strip.

LIERNE: see Vault and 2c.

LIGHT: compartment of a window defined by the mullions.

LINENFOLD: Tudor panelling carbved with simulations of folded linen. See also Parchemin.

LINTEL: horizontal beam or stone bridging an opening.

LOGGIA: gallery, usually arcaded or colonnaded; sometimes freestanding.

LONG-AND-SHORT WORK: quoins consisting of stones placed with the long side alternately upright and horizontal, especially in Saxon building.

LONGHOUSE: house and byre in the same range with internal access between them.

LOUVRE: roof opening, often protected by a raised timber structure, to allow the smoke from a central hearth to escape.

LOWSIDE WINDOW: set lower than the others in a chancel side wall, usually towards its W end.

LUCARNE (lit. dormer): small gabled opening in a roof or spire.

LUGGED ARCHITRAVE: see 4b.

LUNETTE: semicircular window or blind panel.

LYCHGATE (lit. corpse-gate): roofed gateway entrance to a churchyard for the reception of a coffin.

LYNCHET: long terraced strip of soil on the downward side of prehistoric and medieval fields, accumulated because of continual ploughing along the contours.

MACHICOLATIONS (lit. mashing devices): series of openings between the corbels that support a projecting parapet through which missiles can be dropped. Used decoratively in post-medieval buildings.

MANOMETER or STANDPIPE TOWER: containing a column of water to regulate pressure in water mains.

MANSARD. see 8a.

MATHEMATICAL TILES: facing tiles with the appearance of brick, most often applied to timber-framed walls.

MAUSOLEUM: monumental building or chamber usually intended for the burial of members of one family.

MEGALITHIC TOMB: massive stone-built Neolithic burial chamber covered by an earth or stone mound.

MERLON: see Battlement.

METOPES: spaces between the triglyphs in a Doric frieze (3b).

MEZZANINE: low storey between two higher ones.

MILD STEEL: see Cast iron.

MISERICORD (lit. mercy): shelf on a carved bracket placed on the underside of a hinged choir stall seat to support an occupant when standing.

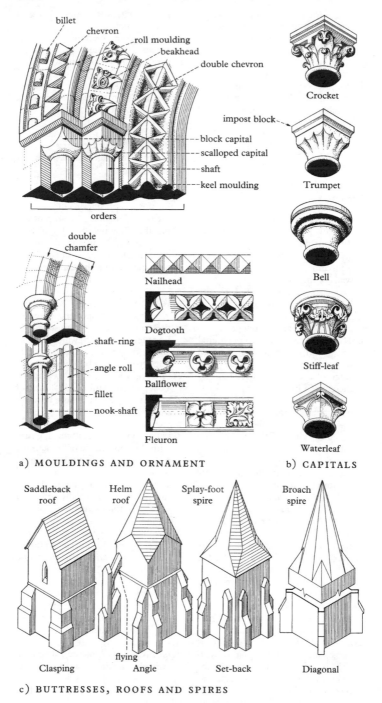

a) MOULDINGS AND ORNAMENT

b) CAPITALS

c) BUTTRESSES, ROOFS AND SPIRES

FIGURE 1: MEDIEVAL

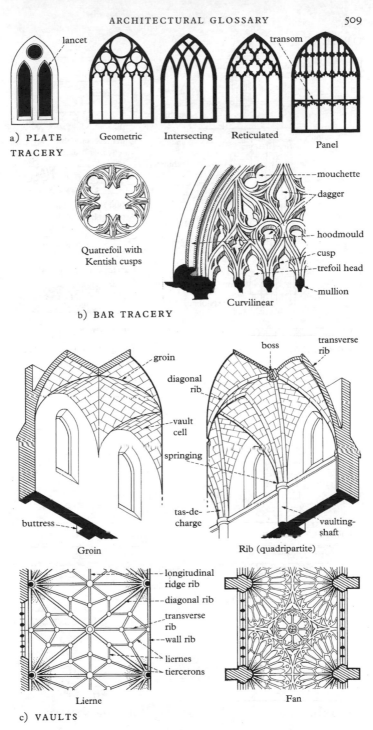

a) PLATE TRACERY

Geometric · Intersecting · Reticulated · Panel

b) BAR TRACERY

Quatrefoil with Kentish cusps

Curvilinear

c) VAULTS

Groin · Rib (quadripartite)

Lierne · Fan

FIGURE 2: MEDIEVAL

# ORDERS

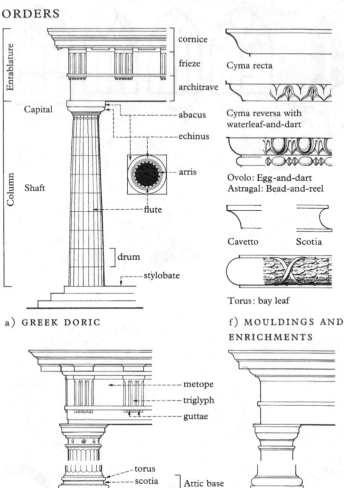

a) GREEK DORIC

f) MOULDINGS AND ENRICHMENTS

Cyma recta

Cyma reversa with waterleaf-and-dart

Ovolo: Egg-and-dart
Astragal: Bead-and-reel

Cavetto    Scotia

Torus: bay leaf

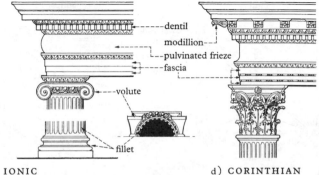

b) ROMAN DORIC

e) TUSCAN

c) IONIC

d) CORINTHIAN

FIGURE 3: CLASSICAL

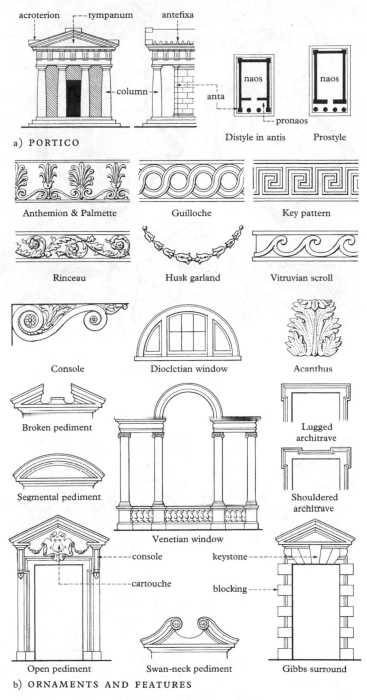

a) PORTICO

Distyle in antis · Prostyle

Anthemion & Palmette · Guilloche · Key pattern

Rinceau · Husk garland · Vitruvian scroll

Console · Diocletian window · Acanthus

Broken pediment · Lugged architrave

Segmental pediment · Shouldered architrave

Venetian window

Open pediment · Swan-neck pediment · Gibbs surround

b) ORNAMENTS AND FEATURES

FIGURE 4: CLASSICAL

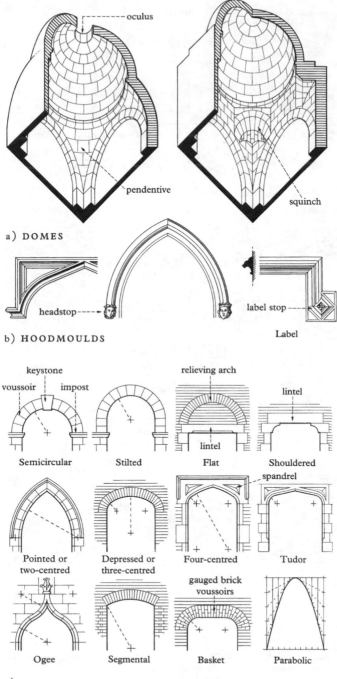

a) DOMES

b) HOODMOULDS

Label

c) ARCHES

FIGURE 5: CONSTRUCTION

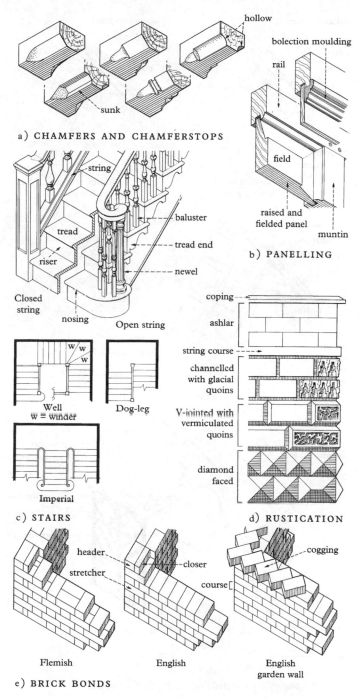

a) CHAMFERS AND CHAMFERSTOPS

b) PANELLING

c) STAIRS

d) RUSTICATION

e) BRICK BONDS

FIGURE 6: CONSTRUCTION

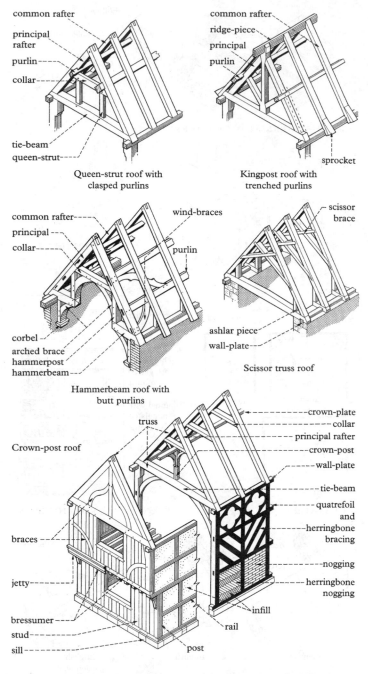

Queen-strut roof with
clasped purlins

Kingpost roof with
trenched purlins

Hammerbeam roof with
butt purlins

Scissor truss roof

Crown-post roof

Box frame: i) Close studding       ii) Square panel

FIGURE 7: ROOFS AND TIMBER-FRAMING

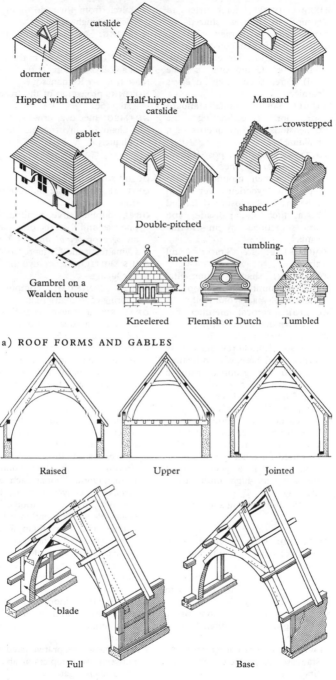

Hipped with dormer

Half-hipped with catslide

Mansard

Double-pitched

Gambrel on a Wealden house

Kneelered

Flemish or Dutch

Tumbled

a) ROOF FORMS AND GABLES

Raised

Upper

Jointed

Full

Base

b) CRUCK FRAMES

FIGURE 8: ROOFS AND TIMBER-FRAMING

MIXER-COURTS: forecourts to groups of houses shared by vehicles and pedestrians.

MODILLIONS: small consoles (q.v.) along the underside of a Corinthian or Composite cornice (3d). Often used along an eaves cornice.

MODULE: a predetermined standard size for co-ordinating the dimensions of components of a building.

MOTTE-AND-BAILEY: post-Roman and Norman defence consisting of an earthen mound (motte) topped by a wooden tower within a bailey, an enclosure defended by a ditch and palisade, and also, sometimes, by an internal bank.

MOUCHETTE: see Tracery and 2b.

MOULDING: shaped ornamental strip of continuous section; see Cavetto, Cyma, Ovolo, Roll.

MULLION: vertical member between window lights (2b).

MULTI-STOREY: five or more storeys. Multi-storey flats may form a *cluster block*, with individual blocks of flats grouped round a service core; a *point block*: with flats fanning out from a service core; or a *slab block*, with flats approached by corridors or galleries from service cores at intervals or towers at the ends (plan also used for offices, hotels etc.). *Tower block* is a generic term for any very high multi-storey building.

MUNTIN: see Panelling and 6b.

NAILHEAD: E.E. ornament consisting of small pyramids regularly repeated (1a).

NARTHEX: enclosed vestibule or covered porch at the main entrance to a church.

NAVE: the body of a church w of the crossing or chancel often flanked by aisles (q.v.).

NEWEL: central or corner post of a staircase (6c). Newel stair see Stairs.

NIGHT STAIR: stair by which religious entered the transept of their church from their dormitory to celebrate night services.

NOGGING: see Timber-framing (7).

NOOK-SHAFT: shaft set in the angle of a wall or opening (1a).

NORMAN: see Romanesque.

NOSING: projection of the tread of a step (6c).

NUTMEG: medieval ornament with a chain of tiny triangles placed obliquely.

OCULUS: circular opening.

OEIL DE BOEUF: see Bullseye window.

OGEE: double curve, bending first one way and then the other, as in an *ogee* or *ogival arch* (5c). Cf. Cyma recta and Cyma reversa.

OPUS SECTILE: decorative mosaic-like facing.

OPUS SIGNINUM: composition flooring of Roman origin.

ORATORY: a private chapel in a church or a house. Also a church of the Oratorian Order.

ORDER: one of a series of recessed arches and jambs forming a splayed medieval opening, e.g. a doorway or arcade arch (1a).

ORDERS: the formalized versions of the post-and-lintel system in classical architecture. The main orders are *Doric*, *Ionic*, and *Corinthian*. They are Greek in origin but occur in Roman versions. *Tuscan* is a simple version of Roman Doric. Though each order has its own conventions (3), there are many minor variations. The *Composite* capital combines Ionic volutes with Corinthian foliage. *Superimposed orders*: orders on successive levels, usually in the upward sequence of Tuscan, Doric, Ionic, Corinthian, Composite.

ORIEL: see Bay window.

OVERDOOR: painting or relief above an internal door. Also called a *sopraporta*.

OVERTHROW: decorative fixed arch between two gatepiers or above a wrought-iron gate.

OVOLO: wide convex moulding (3f).

PALIMPSEST: of a brass: where a metal plate has been reused by turning over the engraving on the back; of a wall-painting: where one overlaps and partly obscures an earlier one.

PALLADIAN: following the examples and principles of Andrea Palladio (1508–80).

PALMETTE: classical ornament like a palm shoot (4b).

PANELLING: wooden lining to interior walls, made up of vertical members (*muntins*) and horizontals (*rails*) framing panels: also called *wainscot*. *Raised-and-fielded*: with the central area of the panel (*field*) raised up (6b).

PANTILE: roof tile of S section.

PARAPET: wall for protection at any sudden drop, e.g. at the wall-head of a castle where it protects the *parapet walk* or wall-walk. Also used to conceal a roof.

PARCHEMIN PANEL: with a vertical central rib or moulding branching in ogee curves to meet the four corners of the panel; sometimes used with linenfold (q.v.).

PARCLOSE: *see* Screen.

PARGETTING (*lit.* plastering): exterior plaster decoration, either in relief or incised.

PARLOUR: in a religious house, a room where the religious could talk to visitors; in a medieval house, the semi-private living room below the solar (q.v.).

PARTERRE: level space in a garden laid out with low, formal beds.

PATERA (*lit.* plate): round or oval ornament in shallow relief.

PAVILION: ornamental building for occasional use; or projecting subdivision of a larger building, often at an angle or terminating a wing.

PEBBLEDASHING: *see* Rendering.

PEDESTAL: a tall block carrying a classical order, statue, vase, etc.

PEDIMENT: a formalized gable derived from that of a classical temple; also used over doors, windows, etc. For variations *see* 4b.

PENDENTIVE: spandrel between adjacent arches, supporting a drum, dome or vault and consequently formed as part of a hemisphere (5a).

PENTHOUSE: subsidiary structure with a lean-to roof. Also a separately roofed structure on top of a C20 multi-storey block.

PERIPTERAL: *see* Peristyle.

PERISTYLE: a colonnade all round the exterior of a classical building, as in a temple which is then said to be *peripteral*.

PERP (PERPENDICULAR): English Gothic architecture *c.* 1335–50 to *c.* 1530. The name is derived from the upright tracery panels then used (*see* Tracery and 2a).

PERRON: external stair to a doorway, usually of double-curved plan.

PEW: loosely, seating for the laity outside the chancel; strictly, an enclosed seat. *Box pew*: with equal high sides and a door.

PIANO NOBILE: principal floor of a classical building above a ground floor or basement and with a lesser storey overhead.

PIAZZA: formal urban open space surrounded by buildings.

PIER: large masonry or brick support, often for an arch. *See also* Compound pier.

PILASTER: flat representation of a classical column in shallow relief. *Pilaster strip*: *see* Lesene.

PILE: row of rooms. *Double pile*: two rows thick.

PILLAR: free-standing upright member of any section, not conforming to one of the orders (q.v.).

PILLAR PISCINA: *see* Piscina.

PILOTIS: C20 French term for pillars or stilts that support a building above an open ground floor.

PISCINA: basin for washing Mass vessels, provided with a drain; set in or against the wall to the S of an altar or free-standing (*pillar piscina*).

PISÉ: *see* Cob.

PITCHED MASONRY: laid on the diagonal, often alternately with opposing courses (*pitched and counterpitched* or herringbone).

PLATE RAIL: *see* Railways.

PLATEWAY: *see* Railways.

PLINTH: projecting courses at the

foot of a wall or column, generally chamfered or moulded at the top.

PODIUM: a continuous raised platform supporting a building; or a large block of two or three storeys beneath a multi-storey block of smaller area.

POINT BLOCK: see Multi-storey.

POINTING: exposed mortar jointing of masonry or brickwork. Types include *flush*, *recessed* and *tuck* (with a narrow channel filled with finer, whiter mortar).

POPPYHEAD: carved ornament of leaves and flowers as a finial for a bench end or stall.

PORTAL FRAME: C20 frame comprising two uprights rigidly connected to a beam or pair of rafters.

PORTCULLIS: gate constructed to rise and fall in vertical gooves at the entry to a castle.

PORTICO: a porch with the roof and frequently a pediment supported by a row of columns (4a). A portico *in antis* has columns on the same plane as the front of the building. A *prostyle* porch has columns standing free. Porticoes are described by the number of front columns, e.g. tetrastyle (four), hexastyle (six). The space within the temple is the *naos*, that within the portico the *pronaos*. *Blind portico*: the front features of a portico applied to a wall.

PORTICUS (plural: porticūs): subsidiary cell opening from the main body of a pre-Conquest church.

POST: upright support in a structure (7).

POSTERN: small gateway at the back of a building or to the side of a larger entrance door or gate.

POUND LOCK: see Canals.

PRESBYTERY: the part of a church lying E of the choir where the main altar is placed; or a priest's residence.

PRINCIPAL: see Roofs and 7.

PRONAOS: see Portico and 4a.

PROSTYLE: see Portico and 4a.

PULPIT: raised and enclosed platform for the preaching of sermons. *Three-decker*: with reading desk below and clerk's desk below that.]

*Two-decker*: as above, minus the clerk's desk.

PULPITUM: stone screen in a major church dividing choir from nave.

PULVINATED: see Frieze and 3c.

PURLIN: see Roofs and 7.

PUTHOLES or PUTLOG HOLES: in the wall to receive putlogs, the horizontal timbers which support scaffolding boards; sometimes not filled after construction is complete.

PUTTO (plural: putti): small naked boy.

QUARRIES: square (or diamond) panes of glass supported by lead strips (*cames*); square floor-slabs or tiles.

QUATREFOIL: see Foil and 2b.

QUEENSTRUT: see Roofs and 7.

QUIRK: sharp groove to one side of a convex medieval moulding.

QUOINS: dressed stones at the angles of a building (6d).

RADBURN SYSTEM: vehicle and pedestrian segregation in residential developments, based on that used at Radburn, New Jersey, U.S.A., by Wright and Stein, 1928–30.

RADIATING CHAPELS: projecting radially from an ambulatory or an apse (*see* Chevet).

RAFTER: see Roofs and 7.

RAGGLE: groove cut in masonry, especially to receive the edge of a roof-covering.

RAGULY: ragged (in heraldry). Also applied to funerary sculpture, e.g. *cross raguly*: with a notched outline.

RAIL: see Panelling and 6b; also 7.

RAILWAYS: *Edge rail:* on which flanged wheels can run. *Plate rail:* L-section rail for plain unflanged wheels. *Plateway:* early railway using plate rails.

RAISED-AND-FIELDED: see Panelling and 6b.

RAKE: slope or pitch.

RAMPART: defensive outer wall of stone or earth. *Rampart walk:* path along the inner face.

REBATE: rectangular section cut out of a masonry edge to receive a shutter, door, window, etc.

REBUS: a heraldic pun, e.g. a fiery cock for Cockburn.

REEDING: series of convex mouldings, the reverse of fluting (q.v.). Cf. Gadrooning.

RENDERING: the covering of outside walls with a uniform surface or skin for protection from the weather. *Lime-washing:* thin layer of lime plaster. *Pebble-dashing:* where aggregate is thrown at the wet plastered wall for a textured effect. *Roughcast:* plaster mixed with a coarse aggregate such as gravel. *Stucco:* fine lime plaster worked to a smooth surface. *Cement rendering:* a cheaper substitute for stucco, usually with a grainy texture.

REPOUSSÉ: relief designs in metalwork, formed by beating it from the back.

REREDORTER (*lit.* behind the dormitory): latrines in a medieval religious house.

REREDOS: painted and/or sculptured screen behind and above an altar. Cf. Retable.

RESPOND: half-pier or half-column bonded into a wall and carrying one end of an arch. It usually terminates an arcade.

RETABLE: painted or carved panel standing on or at the back of an altar, usually attached to it.

RETROCHOIR: in a major church, the area between the high altar and E chapel.

REVEAL: the plane of a jamb, between the wall and the frame of a door or window.

RIB-VAULT: see Vault and 2c.

RINCEAU: classical ornament of leafy scrolls (4b).

RISER: vertical face of a step (6c).

ROCK-FACED: masonry cleft to produce a rugged appearance.

ROCOCO: style current *c.*1720 and *c.*1760, characterized by a serpentine line and playful, scrolled decoration.

ROLL MOULDING: medieval moulding of part-circular section (1a).

ROMANESQUE: style current in the C11 and C12. In England often called Norman. *See also* Saxo-Norman.

ROOD: crucifix flanked by the Virgin and St John, usually over the entry into the chancel, on a beam (*rood beam*) or painted on the wall. The *rood screen* below often had a walkway (*rood loft*) along the top, reached by a *rood stair* in the side wall.

ROOFS: Shape. For the main external shapes (hipped, mansard etc.) see 8a. *Helm* and *Saddleback: see* 1c. *Lean-to:* single sloping roof built against a vertical wall; lean-to is also applied to the part of the building beneath.
Construction. *See* 7.
*Single-framed* roof: with no main trusses. The rafters may be fixed to the wall-plate or ridge, or longitudinal timber may be absent altogether.
*Double-framed* roof: with longitudinal members, such as purlins, and usually divided into bays by principals and principal rafters.
Other types are named after their main structural components, e.g. *hammerbeam, crown-post* (*see* Elements below and 7).
Elements. *See* 7.
*Ashlar piece:* a short vertical timber connecting inner wall-plate or timber pad to a rafter.
*Braces:* subsidiary timbers set diagonally to strengthen the frame.]
*Arched braces:* curved pair forming an arch, connecting wall or post below with tie- or collar-beam above. *Passing braces:* long straight braces passing across other members of the truss. *Scissor braces:* pair crossing diagonally between pairs of rafters or principals. *Wind-braces:* short, usually curved braces connecting side purlins with principals; sometimes decorated with cusping.
*Collar* or *collar-beam:* horizontal transverse timber connecting a pair of rafter or cruck blades (q.v.), set between apex and the wall-plate.
*Crown-post:* a vertical timber set centrally on a tie-beam and supporting a collar purlin braced to it longitudinally. In an open truss lateral braces may rise to the

collar-beam; in a closed truss they may descend to the tie-beam.

*Hammerbeams:* horizontal brackets projecting at wall-plate level like an interrupted tie-beam; the inner ends carry *hammerposts*, vertical timbers which support a purlin and are braced to a collar-beam above.

*Kingpost:* vertical timber set centrally on a tie- or collar-beam, rising to the apex of the roof to support a ridge-piece (cf. Strut).

*Plate:* longitudinal timber set square to the ground. *Wall-plate:* plate along the top of a wall which receives the ends of the rafters; cf. Purlin.

*Principals:* pair of inclined lateral timbers of a truss. Usually they support side purlins and mark the main bay divisions.

*Purlin:* horizontal longitudinal timber. *Collar purlin* or *crown plate:* central timber which carries collar-beams and is supported by crown-posts. *Side purlins:* pairs of timbers placed some way up the slope of the roof, which carry common rafters. *Butt* or *tenoned purlins* are tenoned into either side of the principals. *Through purlins* pass through or past the principal; they include *clasped purlins*, which rest on queenposts or are carried in the angle between principals and collar, and *trenched purlins* trenched into the backs of principals.

*Queen-strut:* paired vertical, or near-vertical, timbers placed symmetrically on a tie-beam to support side purlins.

*Rafters:* inclined lateral timbers supporting the roof covering. *Common rafters:* regularly spaced uniform rafters placed along the length of a roof or between principals. *Principal rafters:* rafters which also act as principals.

*Ridge, ridge-piece:* horizontal longitudinal timber at the apex supporting the ends of the rafters.

*Sprocket:* short timber placed on the back and at the foot of a rafter to form projecting eaves.

*Strut:* vertical or oblique timber between two members of a truss, not directly supporting longitudinal timbers.

*Tie-beam:* main horizontal transverse timber which carries the feet of the principals at wall level.

*Truss:* rigid framework of timbers at bay intervals, carrying the longitudinal roof timbers which support the common rafters. *Closed truss:* with the spaces between the timbers filled, to form an internal partition.

*See also* Cruck, Wagon roof.

ROPE MOULDING: *see* Cable moulding.

ROSE WINDOW: circular window with tracery radiating from the centre. Cf. Wheel window.

ROTUNDA: building or room circular in plan.

ROUGHCAST: *see* Rendering.

ROVING BRIDGE: *see* Canals.

RUBBED BRICKWORK: *see* Gauged brickwork.

RUBBLE: masonry whose stones are wholly or partly in a rough state. *Coursed:* coursed stones with rough faces. *Random:* uncoursed stones in a random pattern. *Snecked:* with courses broken by smaller stones (snecks).

RUSTICATION: *see* 6d. Exaggerated treatment of masonry to give an effect of strength. The joints are usually recessed by V-section chamfering or square-section channelling (*channelled rustication*). *Banded rustication* has only the horizontal joints emphasized. The faces may be flat, but can be *diamond-faced*, like shallow pyramids, *vermiculated*, with a stylized texture like worm-casts, and *glacial* (frost-work), like icicles or stalactites.

SACRISTY: room in a church for sacred vessels and vestments.

SADDLEBACK ROOF: *see* 1C.

SALTIRE CROSS: with diagonal limbs.

SANCTUARY: area around the main altar of a church. Cf. Presbytery.

SANGHA: residence of Buddhist monks or nuns.

SARCOPHAGUS: coffin of stone or other durable material.

SAXO-NORMAN: transitional Romanesque style combining Anglo-Saxon and Norman features, current *c.* 1060–1100.

SCAGLIOLA: composition imitating marble.

SCALLOPED CAPITAL: *see* 1a.

SCOTIA: a hollow classical moulding, especially between tori (q.v.) on a column base (3b, 3f).

SCREEN: in a medieval church, usually at the entry to the chancel; *see* Rood (screen) and Pulpitum. A *parclose screen* separates a chapel from the rest of the church.

SCREENS or SCREENS PASSAGE: screened-off entrance passage between great hall and service rooms.

SECTION: two-dimensional representation of a building, moulding, etc., revealed by cutting across it.

SEDILIA (singular: sedile): seats for the priests (usually three) on the s side of the chancel.

SET-OFF: *see* Weathering.

SGRAFFITO: decoration scratched, often in plaster, to reveal a pattern in another colour beneath. *Graffiti*: scratched drawing or writing.

SHAFT: vertical member of round or polygonal section (1a, 3a). *Shaft-ring*: at the junction of shafts set *en delit* (q.v.) or attached to a pier or wall (1a).

SHEILA-NA-GIG: female fertility figure, usually with legs apart.

SHELL: thin, self-supporting roofing membrane of timber or concrete.

SHOULDERED ARCHITRAVE: *see* 4b.

SHUTTERING: *see* Concrete.

SILL: horizontal member at the bottom of a window or door frame; or at the base of a timber-framed wall into which posts and studs are tenoned (7).

SLAB BLOCK: *see* Multi-storey.

SLATE-HANGING: covering of overlapping slates on a wall. *Tile-hanging* is similar.

SLYPE: covered way or passage leading E from the cloisters between transept and chapter house.

SNECKED: *see* Rubble.

SOFFIT (*lit.* ceiling): underside of an arch (also called *intrados*), lintel, etc. *Soffit roll:* medieval roll moulding on a soffit.

SOLAR: private upper chamber in a medieval house, accessible from the high end of the great hall.

SOPRAPORTA: *see* Overdoor.

SOUNDING-BOARD: *see* Tester.

SPANDRELS: roughly triangular spaces between an arch and its containing rectangle, or between adjacent arches (5c). Also non-structural panels under the windows in a curtain-walled building.

SPERE: a fixed structure screening the lower end of the great hall from the screens passage. *Spere-truss*: roof truss incorporated in the spere.

SPIRE: tall pyramidal or conical feature crowning a tower or turret. *Broach:* starting from a square base, then carried into an octagonal section by means of triangular faces; and *splayed-foot:* variation of the broach form, found principally in the south-east, in which the four cardinal faces are splayed out near their base, to cover the corners, while oblique (or intermediate) faces taper away to a point (1c). *Needle spire:* thin spire rising from the centre of a tower roof, well inside the parapet: when of timber and lead often called a *spike*.

SPIRELET: *see* Flèche.

SPLAY: of an opening when it is wider on one face of a wall than the other.

SPRING OR SPRINGING: level at which an arch or vault rises from its supports. *Springers:* the first stones of an arch or vaulting rib above the spring (2c).

SQUINCH: arch or series of arches thrown across an interior angle of a square or rectangular structure to support a circular or polygonal superstructure, especially a dome or spire (5a).

SQUINT: an aperture in a wall or through a pier usually to allow a view of an altar.

STAIRS: *see* 6c. *Dog-leg stair:* parallel flights rising alternately in opposite directions, without

an open well. *Flying stair:* cantilevered from the walls of a stairwell, without newels; sometimes called a *Geometric* stair when the inner edge describes a curve. *Newel stair:* ascending round a central supporting newel (q.v.); called a *spiral stair* or *vice* when in a circular shaft, a *winder* when in a rectangular compartment. (Winder also applies to the steps on the turn). *Well stair:* with flights round a square open well framed by newel posts. *See also* Perron.

STALL: fixed seat in the choir or chancel for the clergy or choir (cf. Pew). Usually with arm rests, and often framed together.

STANCHION: upright structural member, of iron, steel or reinforced concrete.

STANDPIPE TOWER: *see* Manometer.

STEAM ENGINES: *Atmospheric:* worked by the vacuum created when low-pressure steam is condensed in the cylinder, as developed by Thomas Newcomen. *Beam engine:* with a large pivoted beam moved in an oscillating fashion by the piston. It may drive a flywheel or be *non-rotative*. Watt and *Cornish:* single-cylinder; *compound:* two cylinders; *triple expansion:* three cylinders.

STEEPLE: tower together with a spire, lantern, or belfry.

STIFF-LEAF: type of E.E. foliage decoration. *Stiff-leaf capital see* 1b.

STOP: plain or decorated terminal to mouldings or chamfers, or at the end of hoodmoulds and labels (*label stop*), or string courses (5b, 6a); *see also* headstop.

STOUP: vessel for holy water, usually near a door.

STRAINER: *see* Arch.

STRAPWORK: late C16 and C17 decoration, like interlaced leather straps.

STRETCHER: *see* Bond and 6e.

STRING COURSE: horizontal course or moulding projecting from the surface of a wall (6d).

STRING: *see* 6c. Sloping member holding the ends of the treads and risers of a staircase. *Closed string:* a broad string covering the ends

of the treads and risers. *Open string:* cut into the shape of the treads and risers.

STUCCO: *see* Rendering.

STUDS: subsidiary vertical timbers of a timber-framed wall or partition (7).

STUPA: Buddhist shrine, circular in plan.

STYLOBATE: top of the solid platform on which a colonnade stands (3a).

SUSPENSION BRIDGE: *see* Bridge.

SWAG: like a festoon (q.v.), but representing cloth.

SYSTEM BUILDING: *see* Industrialized building.

TABERNACLE: canopied structure to contain the reserved sacrament or a relic; or architectural frame for an image or statue.

TABLE TOMB: memorial slab raised on free-standing legs.

TAS-DE-CHARGE: the lower courses of a vault or arch which are laid horizontally (2c).

TERM: pedestal or pilaster tapering downward, usually with the upper part of a human figure growing out of it.

TERRACOTTA: moulded and fired clay ornament or cladding.

TESSELLATED PAVEMENT: mosaic flooring, particularly Roman, made of *tesserae*, i.e. cubes of glass, stone, or brick.

TESTER: flat canopy over a tomb or pulpit, where it is also called a *sounding-board*.

TESTER TOMB: tomb-chest with effigies beneath a tester, either free-standing (tester with four or more columns), or attached to a wall (*half-tester*) with columns on one side only.

TETRASTYLE: *see* Portico.

THERMAL WINDOW: *see* Diocletian window.

THREE-DECKER PULPIT: *see* Pulpit.

TIDAL GATES: *see* Canals.

TIE-BEAM: *see* Roofs and 7.

TIERCERON: *see* Vault and 2c.

TILE-HANGING: *see* Slate-hanging.

TIMBER-FRAMING: *see* 7. Method of construction where the struc-

tural frame is built of interlocking timbers. The spaces are filled with non-structural material, e.g. *infill* of wattle and daub, lath and plaster, brickwork (known as *nogging*), etc. and may be covered by plaster, weatherboarding (q.v.), or tiles.

TOMB-CHEST: chest-shaped tomb, usually of stone. Cf. Table tomb, Tester tomb.

TORUS (plural: tori): large convex moulding usually used on a column base (3b, 3f).

TOUCH: soft black marble quarried near Tournai.

TOURELLE: turret corbelled out from the wall.

TOWER BLOCK: *see* Multi-storey.

TRABEATED: depends structurally on the use of the post and lintel. Cf. Arcuated.

TRACERY: openwork pattern of masonry or timber in the upper part of an opening. *Blind tracery* is tracery applied to a solid wall.
*Plate tracery*, introduced c. 1200, is the earliest form, in which shapes are cut through solid masonry (2a).
*Bar tracery* was introduced into England c. 1250. The pattern is formed by intersecting moulded ribwork continued from the mullions. It was especially elaborate during the Decorated period (q.v.). Tracery shapes can include circles, *daggers* (elongated ogee-ended lozenges), *mouchettes* (like daggers but with curved sides) and upright rectangular *panels*. They often have *cusps*, projecting points defining lobes or *foils* (q.v.) within the main shape: *Kentish* or *split-cusps* are forked (2b).
Types of bar tracery (*see* 2b) include *geometric(al)*: c. 1250–1310, chiefly circles, often foiled; *Y-tracery*: c. 1300, with mullions branching into a Y-shape; *intersecting*: c. 1300, formed by interlocking mullions; *reticulated*: early C14, net-like pattern of ogee-ended lozenges; *curvilinear*: C14, with uninterrupted flowing curves; *panel*: Perp, with straight-sided panels, often cusped at the top and bottom.

TRANSEPT: transverse portion of a church.

TRANSITIONAL: generally used for the phase between Romanesque and Early English (c. 1175–c. 1200ff).

TRANSOM: horizontal member separating window lights (2b).

TREAD: horizontal part of a step. The *tread end* may be carved on a staircase (6c).

TREFOIL: *see* Foil.

TRIFORIUM: middle storey of a church treated as an arcaded wall passage or blind arcade, its height corresponding to that of the aisle roof.

TRIGLYPHS (*lit.* three-grooved tablets): stylized beam-ends in the Doric frieze, with metopes between (3b).

TRIUMPHAL ARCH: influential type of Imperial Roman monument.

TROPHY: sculptured or painted group of arms or armour.

TRUMEAU: central stone mullion supporting the tympanum of a wide doorway. *Trumeau figure:* carved figure attached to it (cf. Column figure).

TRUMPET CAPITAL: *see* 1b.

TRUSS: braced framework, spanning between supports. *See also* Roofs and 7.

TUMBLING or TUMBLING-IN: courses of brickwork laid at right-angles to a slope, e.g. of a gable, forming triangles by tapering into horizontal courses (8a).

TUSCAN: *see* Orders and 3e.

TWO-DECKER PULPIT: *see* Pulpit.

TYMPANUM: the surface between a lintel and the arch above it or within a pediment (4a).

UNDERCROFT: usually describes the vaulted room(s), beneath the main room(s) of a medieval house. Cf. Crypt.

VAULT: arched stone roof (sometimes imitated in timber or plaster). For types *see* 2c.
*Tunnel* or *barrel vault:* continuous semicircular or pointed arch, often of rubble masonry.

*Groin-vault:* tunnel vaults intersecting at right angles. *Groins* are the curved lines of the intersections.

*Rib-vault:* masonry framework of intersecting arches (ribs) supporting *vault cells,* used in Gothic architecture. *Wall rib* or *wall arch:* between wall and vault cell. *Transverse rib:* spans between two walls to divide a vault into bays. *Quadripartite* rib-vault: each bay has two pairs of diagonal ribs dividing the vault into four triangular cells. *Sexpartite* rib-vault: most often used over paired bays, has an extra pair of ribs springing from between the bays. More elaborate vaults may include *ridge ribs* along the crown of a vault or bisecting the bays; *tiercerons:* extra decorative ribs springing from the corners of a bay; and *liernes:* short decorative ribs in the crown of a vault, not linked to any springing point. A *stellar* or *star* vault has liernes in star formation.

*Fan-vault:* form of barrel vault used in the Perp period, made up of halved concave masonry cones decorated with blind tracery.

VAULTING SHAFT: shaft leading up to the spring or springing (q.v.) of a vault (2c).

VENETIAN or SERLIAN WINDOW: derived from Serlio (4b). The motif is used for other openings.

VERMICULATION: *see* Rustication and 6d.

VESICA: oval with pointed ends.

VICE: *see* Stair.

VILLA: originally a Roman country house or farm. The term was revived in England in the C18 under the influence of Palladio and used especially for smaller, compact country houses. In the later C19 it was debased to describe any suburban house.

VITRIFIED: bricks or tiles fired to a darkened glassy surface.

VITRUVIAN SCROLL: classical running ornament of curly waves (4b).

VOLUTES: spiral scrolls. They occur on Ionic capitals (3c). *Angle volute:* pair of volutes, turned outwards to meet at the corner of a capital.

VOUSSOIRS: wedge-shaped stones forming an arch (5c).

WAGON ROOF: with the appearance of the inside of a wagon tilt; often ceiled. Also called *cradle roof.*

WAINSCOT: *see* Panelling.

WALL MONUMENT: attached to the wall and often standing on the floor. *Wall tablets* are smaller with the inscription as the major element.

WALL-PLATE: *see* Roofs and 7.

WALL-WALK: *see* Parapet.

WARMING ROOM: room in a religious house where a fire burned for comfort.

WATERHOLDING BASE: early Gothic base with upper and lower mouldings separated by a deep hollow.

WATERLEAF: *see* Enrichments and 3f.

WATERLEAF CAPITAL: Late Romanesque and Transitional type of capital (1b).

WATER WHEELS: described by the way water is fed on to the wheel. *Breastshot:* mid-height, falling and passing beneath. *Overshot:* over the top. *Pitchback:* on the top but falling backwards. *Undershot:* turned by the momentum of the water passing beneath. In a *water turbine,* water is fed under pressure through a vaned wheel within a casing.

WEALDEN HOUSE: type of medieval timber-framed house with a central open hall flanked by bays of two storeys, roofed in line; the end bays are jettied to the front, but the eaves are continuous (8a).

WEATHERBOARDING wall cladding of overlapping horizontal boards.

WEATHERING or SET-OFF: inclined, projecting surface to keep water away from the wall below.

WEEPERS: figures in niches along the sides of some medieval tombs. Also called *mourners.*

WHEEL WINDOW: circular, with radiating shafts like spokes. Cf. Rose window.

WROUGHT IRON: *see* Cast iron.

# LANGUAGE GLOSSARY

Adapted, with omissions and a few augmentations, with the permission of the Director General of the Ordnance Survey, from the OS publication *Place Names on Maps of Scotland and Wales*. Crown copyright reserved.

> a = *adjective*
> ad = *adverb*
> f = *feminine*
> n = *noun masculine*

> nf = *noun feminine*
> np = *noun plural*
> pl = *plural*
> pr = *preposition*

abad, *n* abbot

abaty, *n* abbey

aber, *n & nf* estuary, confluence, stream

adeiladu, *verb* to build

aderyn, *pl* adar, *n* bird

ael, *nf* brow, edge

aelwyd, *nf* hearth

aethnen, *nf* aspen, poplar

afallen, *nf* apple tree

afon, *nf* river

ailadeiladu, *verb* to rebuild

allt, *pl* elltydd, alltau, *nf* hillside, cliff, wood

Annibynnol, *a* Independent

ar, *pr* on, upon, over

ardd, *n* hill, height

argoed, *nf* wood, grove

bach, *a* small, little, lesser

bach, *pl* bachau, *nf* nook, corner

bala, *n* outlet of a lake

banc, *pl* bencydd, *n* bank, slope

bangor, *nf* monastery originally constructed of wattle rods

banhadlog, *nf* broom patch

banw, *n* young pig

bar, *n* top, summit

bechan, *a see* bychan

bedd, *pl* beddau, *n* grave

Bedyddwyr, *a* Baptist

beidr, *nf* lane, path

beili, *pl* beiliau, *n* bailey, court before a house bailiff

bellaf, *a* far

bendigaid, *a* blessed

betws, *n* oratory, chapel

beudy, *n* cow-house

blaen, *pl* blaenau, *n* end, edge; source of river or stream; highland

bod, *n & nf* abode, dwelling

bôn, *n* stock, stump

bont, *nf see* pont

braich, *n & nf* ridge, arm

brân, *pl* brain, *nf* crow

bre, *nf* hill

brith, *f* braith, *a* speckled; coarse

bro, *nf* region; vale, lowland

bron, *pl* bronnydd, *nf* hillbreast (breast)

bryn, *pl* bryniau, *n* hill

bugail, *pl* bugelydd, bugeiliaid, *n* shepherd

bwla, *n* bull

bwlch, *pl* bylchau, *n* gap, pass

bwth, bwthyn, *n* cottage, booth

bychan, *f* bechan, *pl* bychain, *a* little, tiny

caban, *n* cottage, cabin

cader, cadair, *nf* seat, stronghold

cadlas, *nf* close, court of a house

cae, *pl* caeau, *n* field, enclosure

caer, *pl* caerau, *nf* stronghold, fort

cafn, *n* ferry-boat, trough

canol, *n* middle

cantref, *n* hundred (territorial division)

capel, *n* meeting house, chapel

carn, *pl* carnau, *nf* heap of stones, tumulus

carnedd, *pl* carneddau, carneddi, *nf* heap of stones, tumulus

carreg, *pl* cerrig, *nf*   stone, rock
carrog, *nf*   brook
carw, *n*   stag
cas (in Casnewydd etc.), *n*   castle
castell, *pl* cestyll, *n*   castle; small stronghold; fortified residence; imposing natural position
cath, *nf*   cat. (In some names it may be the Irish word cath meaning 'battle'.)
cau, *a*   hollow; enclosed
cawr, *pl* ceiri, cewri, *n*   giant
cefn, *pl* cefnydd, *n*   ridge
cegin, *nf*   kitchen
ceiliog, *n*   cock
ceiri, *np*   *see* cawr
celli, *nf*   grove
celynen, *pl* celyn, *nf*   holly tree
celynog, clynnog, *nf*   holly grove
cemais, *n from np*   shallow bend in river, or coastline
cennin, *np*   leeks
cerrig, *np see* carreg
cesail, *nf*   hollow (arm- pit)
ceunant, *n*   ravine, gorge
cewri, *np   see*   cawr
chwilog, *nf*   land infested with beetles
cil, *pl* ciliau, *n*   retreat, recess, corner
cilfach, *nf*   nook
clas, *n*   quasi-monastic system of the Celtic Church, existing in Wales, Cornwall and Ireland from the Dark Ages to *c.* 1200. *Clasau* comprised a body of secular canons
clawdd, *pl* cloddiau, *n*   ditch, hedge
cloch, *nf*   bell
clochydd, *n*   sexton, parish clerk
cloddiau, *np   see* clawdd
clog, *nf*   crag, precipice
clogwyn, *n*   precipice, steep rock hanging on one side
clwyd, *pl* clwydydd, *nf*   hurdle, gate
clynnog, *nf   see* celynog
coch, *a*   red
coeden, *pl* coed, *nf*   tree
collen, *pl* cyll, coll, *nf*   hazel
colwyn, *n*   whelp
comin, *pl* comins, *n*   common
congl, *nf*   corner
cornel, *nf*   corner
cors, *pl* corsydd, *nf*   bog
craf, *n*   garlic
craig, *pl* creigiau, *nf*   rock
crib, *n*   crest, ridge, summit

crochan, *n*   cauldron
croes, *nf*   cross
croesffordd, croesheol, croeslon, *nf*   cross-roads
crofft, *pl* crofftau, *nf*   croft
croglofft, *nf*   garret, low cottage with loft under the roof
crug, *pl* crugiau, *n*   heap, tump
cwm, *pl* cymau, cymoedd, *n*   valley, dale
cwmwd, *n*   commote (territorial division)
cwrt, *n*   court, yard
cyffin, *n*   boundary, frontier
cyll, *np   see* collen
cymer, *pl* cymerau, *n*   confluence
Cynulleidfaol, *a*   Congregational
cywarch, *n*   hemp

dan, *pr*   under, below
derwen, *pl* derw, *nf*   oak
diffwys, *n*   precipice, abyss
dinas, *n & nf*   hill-fortress (city)
diserth, *n*   hermitage
disgwylfa, *nf*   place of observation, look-out point
dôl, *pl* dolau, dolydd, *nf*   meadow
draw, *ad*   yonder
du, *a*   black, dark
dwfr, dŵr, *n*   water
dyffryn, *n*   valley

eglwys, *nf*   church
(ei)singrug, *n*   heap of bran or corn husks
eisteddfa, *nf*   seat, resting place
eithinog, *nf*   furze patch
elltyd, *np   see* allt
ellyll, *n*   elf, goblin
eos, *nf*   nightingale
erw, *pl* erwau, *nf*   acre
esgair, *nf*   long ridge (leg)
esgob, *n*   bishop
ewig, *nf*   hind

-fa, *nf   see* ma-
fach, *a   see* bach
faenor, *nf*   Vaynor. cf. maenor
fawr, *a   see* mawr
felin, *nf   see* melin
ffald, *pl* ffaldau, *nf*   sheep-fold, pound, pen, run
ffawydden, *pl* ffawydd, *nf*   beech tree
fferm, *nf*   farm
ffin, *nf*   boundary

ffordd, *nf* way, road

fforest, *nf* forest, park

ffridd, ffrith, *pl* ffriddoedd, *nf* wood; mountain enclosure, sheep walk

ffrwd, *nf* stream, torrent

ffynnon, *pl* ffynhonnau, *nf* spring, well

fron, *nf* *see* bron

fry, *ad* above

gaer, *nf* *see* caer

ganol, *n* *see* canol

gardd, *pl* gerddi, garddau, *nf* garden; enclosure or fold into which calves were turned for first time

garreg, *nf* *see* carreg

garth, *n* promontory, hill enclosure

garw, *a* coarse, rough

gefail, *nf* smithy

(g)eirw, *np* rush of waters

gelli, *nf* *see* celli

glan, *nf* river bank, hillock

glas, *a* green

glas, glais (as in dulas, dulais), *n & nf* brook

glo, *n* charcoal, coal

glyn, *n* deep valley, glen

gof, *n* smith

gogof, *pl* gogofau, *nf* cave

gorffwysfa, *nf* resting place

gris, *pl* grislau, *n* step

grug, *n* heath, heather

gwaelod, *n* foot of hill (bottom)

gwastad, *n* plain

gwaun, *pl* gweunydd, *nf* moor, mountain meadow, moorland field

gwely, *n* bed, resting place, family land

gwen, *a* *see* gwyn

gwerdd, *a* *see* gwyrdd

gwernen, *pl* gwern, *nf* alder tree

gwersyll, *n* encampment

gwrych, *n* hedge, quickset hedge

gwryd, *n* fathom

gwyddel, *pl* gwyddyl, gwyddelod, *n* Irishman

gwyddrug, *nf* mound, wooded knoll

gwyn, *f* gwen, *a* white

gwynt, *n* wind

gwyrdd, *f* gwerdd, *a* green

hafn, *nf* gorge, ravine

hafod, *nf* shieling, upland summer dwelling

hafoty, *n* summer dwelling

helygen, *pl* helyg, *nf* willow

hen, *a* old

hendref, *nf* winter dwelling, old home, permanent abode

heol, hewl, *nf* street, road

hir, *a* long

is, *pr* below, under

isaf, *a* lower (lowest)

isel, *a* low

iwrch, *pl* iyrchod, *n* roebuck

lawnd, lawnt, *nf* open space in woodland, glade

llaethdy, *n* milkhouse, dairy

llan, *nf* church, monastery; enclosure

Llanbedr St Peter's church

Llanddewi St David's church

Llanfair St Mary's church

Llanfihangel St Michael's church

llannerch, *nf* clearing, glade

lle, *n* place, position

llech, *pl* llechau, *nf* slab, stone, rock

llechwedd, *nf* hillside

llethr, *nf* slope

llety, *n* small abode, quarters

llidiard, llidiart, *pl* llidiardau, llidiarrau, *n* gate

llom, *a* *see* llwm

lluest, *n* shieling, cottage, hut

llumon, *n* stack (chimney)

llwch, *n* dust

llwch, *pl* llychau, *n* lake

llwm, *f* llom, *a* bare, exposed

llwyd, *a* grey, brown

llwyn, *pl* llwyni, llwynau, *n* grove, bush

llyn, *n & nf* lake

llys, *n & nf* court, hall

lôn, *nf* lane, road

ma-, -fa, *nf* plain, place

maen, *pl* meini, main, *n* stone

maenol, maenor, *nf* stone-built residence of chieftain of district, rich low-lying land surrounding same, vale

maerdref, *nf* hamlet attached to chieftain's court, lord's demesne (maer, steward + tref, hamlet)

maerdy, *n* steward's house, dairy

maes, *pl* meysydd, *n* open field, plain

march, *pl* meirch, *n* horse, stallion

marchog, *n* knight, horseman

marian, *n* holm, gravel, gravelly ground, rock debris

mawnog, *nf* peat-bog

mawr, *a* great, big

meillionen, *pl* meillion, *nf* clover

meini, *np* *see* maen

meirch, *np* *see* march

melin, *nf* mill

melyn, *f* melen, *a* yellow

menych, *np* *see* mynach

merthyr, *n* burial place, church

Methodistaidd, *a* Methodist

meysydd, *np* *see* maes

mochyn, *pl* moch, *n* pig

moel, *nf* bare hill

moel, *a* bare, bald

môr, *n* sea

morfa, *n* marsh, fen

mur, *pl* muriau, *n* wall

mwyalch, mwyalchen, *nf* blackbird

mynach, *pl* mynych, menych, myneich, *n* monk

mynachdy, *n* monastic grange

mynwent, *nf* churchyard

mynydd, *n* mountain, moorland

nant, *pl* nentydd, naint, nannau, *nf* brook

nant, *pl* nentydd, naint, nannau, *n* dingle, glen, ravine

neuadd, *nf* hall

newydd, *a* new

noddfa, *nf* hospice

nyth, *n & nf* nest, inaccessible position

oen, *pl* ŵyn, *n* lamb

offeiriad, *n* priest

onnen, *pl* onn, ynn, *nf* ash tree

pandy, *n* fulling mill

pant, *n* hollow, valley

parc, *pl* parciau, parcau, *n* park, field, enclosure

pen, *pl* pennau, *n* head, top; end, edge

penrhyn, *n* promontory

pensaer, *n* architect

pentref, *n* homestead, appendix to the real 'tref', village

person, *n* parson

pistyll, *n* spout, waterfall

plas, *n* gentleman's seat, hall, mansion

plwyf, *n* parish

poeth, *a* burnt (hot)

pont, *nf* bridge

porth, *n* gate, gateway

porth, *nf* ferry, harbour

pwll, *pl* pyllau, *n* pit, pool

rhaeadr, *nf* waterfall

rhandir, *n* allotment, fixed measure of land

rhiw, *nf & n* hill, slope

rhos, *pl* rhosydd, *nf* moor, promontory

rhyd, *nf & n* ford

saeth, *pl* saethau, *nf* arrow

sant, san, *pl* saint, *n* saint, monk

sarn, *pl* sarnau, *nf* causeway

simnai, simdde, *nf* chimney

siop, *nf* shop

sticil, sticill, *nf* stile

swydd, *nf* seat, lordship, office

sych, *a* dry

tafarn, *pl* tafarnau, *n & nf* tavern

tai, *np* *see* tŷ

tâl, *n* end (forehead)

talwrn, *pl* talyrni, tylyrni, *n* bare exposed hillside, open space, threshing floor, cockpit

tan, dan, *nf* under, beneath

teg, *a* fair

tir, *n* land, territory

tom, tomen, *nf* mound

ton, *pl* tonnau, *nf* wave

ton, tonnen, *pl* tonnau, *n & nf* grassland, lea

torglwyd, *nf* door-hurdle, gate

towyn, *n* *see* tywyn

traean, traen, *n* third part

traeth, *n* strand, shore

trallwng, trallwm, *n* wet bottom land

traws, *a & n* cross, transverse

tref, *nf* homestead, hamlet, town

tros, *pr* over

trwyn, *n* point, cape (nose)

twr, *n* tower

twyn, *pl* twyni, *n* hillock, knoll

tŷ, *pl* tai, *n* house

tyddyn, ty'n, *n* small farm, holding

tylyrni, *np* *see* talwrn

tywyn, towyn, *n* sea-shore, strand

uchaf, *a* higher, highest

uchel, *a* high

uwch, *pr*   above, over

ŵyn, *np*   *see* oen

y, yr, 'r (definite article) the
yn, *pr*   in
ynn, *np*   *see* onnen
ynys, *pl* ynysoedd, *nf*   island; holm,
   river-meadow

ysbyty, *n*   hospital, hospice
ysgol, *pl* ysgolion, *nf*   school
ysgubor, *pl* ysguboriau, *nf*   barn
ystafell, *nf*   chamber, hiding place
ystrad, *n*   valley, holm, river-
   meadow
ystum, *nf & n*   bend shape

# INDEX OF ARTISTS

# INDEX OF PATRONS AND RESIDENTS

Indexed here are families and individuals (not bodies or commercial firms) recorded in this volume as having owned property and/or commissioned architectural work in Pembrokeshire. The index includes monuments to members of such families and other individuals where they are of particular interest.

# INDEX OF PLACES

Principal references are in **bold** type; demolished buildings are shown in *italic*.